Donatello and His World

Sculpture of the Italian Renaissance

Donatello and His World

Sculpture of the Italian Renaissance

Joachim Poeschke

Photographs by Albert Hirmer and Irmgard Ernstmeier-Hirmer

Translated from the German by Russell Stockman

Harry N. Abrams, Inc.

Publishers

EDITOR, ENGLISH-LANGUAGE EDITION: *Joanne Greenspun*
DESIGNER, ENGLISH-LANGUAGE EDITION: *Judith Michael*

LIBRARY OF CONGRESS CATALOGING-IN-PUBLICATION DATA

Poeschke, Joachim.
[Skulptur der Renaissance in Italien. English]
Donatello and his world: sculpture of the Italian Renaissance/by
Joachim Poeschke; translated from the German by Russell Stockman.
p. cm.
Includes bibliographical references and index.
ISBN 0–8109–3211–3
1. Donatello, 1386?–1466—Criticism and interpretation.
2. Sculpture, Italian. 3. Sculpture, Renaissance—Italy.
I. Title.
NB623.D7P59213 1993
730′.92—dc20 92–38115
CIP

Printed and bound in Germany

Contents

Foreword

Over seventy years ago, Paul Schubring's comprehensive study of the Italian sculpture of the Early Renaissance was published in Germany. The only works of comparable scope to appear in the last few decades have come from England and America. The best of these, unquestionably, is John Pope-Hennessy's *Italian Renaissance Sculpture*, first published in 1958. His book has become an indispensable reference, both for experts and for laymen interested in Italian sculpture. The present volume is indebted to Pope-Hennessy in many respects, although the knowledgeable reader will readily see that it reflects a certain shift of emphasis, both in its text and in its illustrations. Its plates, for example, consist almost entirely of new photographs and are more comprehensive in their coverage of the sculptural masterpieces of the epoch. Also, we have included Ghiberti in the artist section, for despite his Gothic beginnings he must be counted among the chief masters of the Early Renaissance. Jacopo della Quercia and Nanni di Banco are likewise represented, and we present the works of Donatello in their entirety, recognizing him to be the most important sculptor of the Quattrocento. Our approach to the material is therefore different, as even the title of the book suggests, and surely no justification for this is needed. With but a few exceptions, we have not included smaller works in bronze, as these constitute a genre of their own within the field of Renaissance sculpture, one far too extensive to be accommodated in the confines of this overview.

The majority of the photographs were shot specifically for this publication. Not only were we interested in visual uniformity, but we also had another compelling reason. Photographing sculpture, as anyone who has tried it can attest, is a problematic undertaking. Earlier pictures of the works shown here, such as those by Alinari, Brogi, or Anderson, are of considerable merit in themselves, but in their choice of angles they sometimes fail to do justice to the sculptures. Other more recent photographs frequently seem too forced in their attempt to highlight certain artistic qualities in the works in question that the photographers found more interesting than those apparent from a frontal perspective. We have deliberately avoided such arbitrary angles in an effort to capture the impressions the sculptors themselves intended to convey. Those impressions were necessarily tied to the subject matter and directed at the viewer seeing these works from the front. Wherever possible, then, each work is presented here in its entirety and from the ideal angle, for this is the only kind of photography that can assist one in comprehending a work of art.

The present volume is to be followed by a second one covering Italian sculpture from 1490 to 1560. Nonetheless, this first book is complete in itself. It is primarily thanks to Albert Hirmer that the book could appear in this form at all. With his photographs, taken with the assistance of Irmgard Ernstmeier-Hirmer, he is the work's major contributor. And as publisher of the German edition, he nursed it into being with the greatest of

care. Anyone familiar with the art-book market will admire his courage in undertaking such an ambitious project. The excellent reproductions are the work of Helga Thomas. In the preparation of the book we have enlisted the service of friends and colleagues at the Bibliotheca Hertziana in Rome and the Kunsthistorisches Institut in Florence. My thanks to all of them, especially Wolfger Bulst, Christiane Denker Nesselrath, and Steffi Röttgen, for their considerable help. I am also particularly grateful to the Gerda Henkel Foundation, which provided ideal working conditions in Düsseldorf. Above all, however, I thank my wife, for without her active involvement I could scarcely have completed the project.

Joachim Poeschke

Düsseldorf

August 1990

The Changing View of the Early Renaissance

With the exception of classical antiquity, no historical epoch has been so highly celebrated by a later period as was the Renaissance by the nineteenth century. Nineteenth-century thinkers glorified the Renaissance not as some remote golden age—like antiquity—but as a period that continued to have an influence in their own time and was honored as the true source of modern culture. The expressions they coined to describe the Renaissance, such as the "Age of Exploration" or the "Discovery of Man," had an unmistakable contemporary resonance; they were to be understood not only as a commentary on history but also, as Jules Michelet wrote, an "appeal to living forces" (*appel aux forces vives*). This view of the Renaissance had been advanced by writers of the French Enlightenment in the eighteenth century, but it only really gained acceptance—its Enlightenment character having meanwhile assumed a certain romantic, poetic coloring—thanks to novelists, historians, and art critics like Stendhal, Michelet, and Burckhardt. By the close of the century it had culminated in a universal passion for the Renaissance, the scholarly fruits of which survive in groundbreaking monographs, catalogues raisonnés, and collections of source documents on Renaissance art. Those same years saw the founding of art-history research centers in Florence and Rome that continue to serve today as the most important institutions of their kind.

By that time scholars were no longer focusing so exclusively on the age of Raphael, as Jacob Burckhardt had done before them. Instead, they were turning increasingly to the Early Renaissance, the fifteenth century. A predilection for the early Italians had already emerged, at first under wholly different auspices, with the Romantics. Friedrich Schlegel's "Nachrichten von den Gemälden in Paris," published in the journal *Europa* in 1803, was chiefly responsible for it. This essay not only gave a considerable boost to the rediscovery of early German and Netherlandish painting, but also expressly directed the public's interest to Italian painting before Raphael—to Perugino, Bellini, and Mantegna. The qualities most admired in these earlier masters were simplicity, austerity, naïveté, genuine religiosity, and intensity of feeling. This new appreciation for the "primitives," implying a simultaneous rejection of the "maniera grande" of the Cinquecento, was soon to become extremely widespread, due in part to the influence of the Nazarenes.

The first great history of Italian sculpture was Leopoldo Cicognara's monumental survey of the subject from the Pisani to Canova, which he began publishing in 1813. In it we can already see the author acknowledging such a position, although he himself was wholly committed to classicism. Carl Friedrich von Rumohr, whose writings in the *Italienische Forschungen* (1827–31) were soon to pave the way for further exploration of early Italian art, likewise gives it its due. Needless to say, the criteria for judgment employed by both of these writers

were not those of the Romantics. They knew more about the history of art than the Romantics did, and their responses were based not so much on some affinity of feeling as on aesthetic reflection. Accordingly, they were able to distinguish more clearly between the artistic directions of the earlier epochs. Thus we find them treating Donatello and Ghiberti more distinctly than ever—but still with no more precise analysis of their historical contexts—as representatives of opposing artistic ideals. And having established them as such they proceeded to judge them accordingly. Rumohr is more pointed in the expression of his allegiances than Cicognara. He strongly favors Ghiberti, for to him Donatello seems "crude." Cicognara is more conciliatory in voicing his reservations about the latter: "Yet if Donatello had done everything, what would have been left for Canova?"

Artlovers had been interested in early Italian painting for some time, but now, thanks to Cicognara and Rumohr, they discovered the *sculpture* of the Renaissance as well. The Prussian consul Bartholdi, who had lived in Rome since 1815 and had commissioned the Nazarenes to decorate his apartment in the Palazzo Zuccari with frescoes, already owned a collection of sculpture that later found its way into the Berlin Museum. The first additions to that collection were purchases arranged for by Gustave Friedrich von Waagen in 1840 and 1842— among them the so-called "*Marietta Strozzi*" (plate 202). It would be a few years more before Renaissance sculpture would begin to occupy a more significant amount of space in world museums. The foundations of one of the largest and most imposing collections, that of the Victoria and Albert Museum in London—formerly the South Kensington Museum—were laid by John Charles Robinson beginning in 1854. Not long afterward, in the early 1870s, Wilhelm von Bode followed his example and set out to expand the holdings of Renaissance sculpture in Berlin. In those years the sculpture of the Early Renaissance was becoming more widely admired than ever before, a fact to which the rapid rise in prices paid for it attests.

Bode was not only responsible for building the Berlin collections, however. He also contributed greatly to critical appreciation of Renaissance sculpture. We are indebted to him for countless discoveries in the field and attributions still valid today. Not so much a scholar as a connoisseur, he was an art historian who, although contributing enormously to the building of the great museums, could not necessarily count on the respect of his "academic" colleagues. Even so, their share of the relevant literature, especially in the field of Renaissance sculpture, cannot be dismissed.

Bode, who was a friend of the painter Max Liebermann, began his career as an art historian with studies on Netherlandish painting, specifically Frans Hals and his school. What he admired in these painters above all was their *realism*, which seemed to him "the fresh and modern approach." Throughout his life it was its realism that drew him to the art of the Early Renaissance. The one Quattrocento artist who seemed to him most representative of that realism was Donatello. Such a position by no means challenged Rumohr's objective criteria, but it did signify a change in attitude toward them. Bode was not alone in focusing on the realism of the Early Renaissance; his view was almost universally shared. It even shows up in Aby Warburg, a scholar who was the complete opposite of Bode in interest and method. Caught up in the notion of realism as he was, Warburg was ultimately forced to invent somewhat involved explanations for stylistic phenomena that he found to be extremely unrealistic, like the fluttering drapery of Botticelli's female figures. As often happens, his own pattern of thought clearly got in the way of understanding.

The example of Jacob Burckhardt, on the other hand, shows that at about this same time it was altogether possible to approach such problems without being hampered by chronology. In his late lectures, obviously

skeptical of tendencies like the one just described, Burckhardt expressly states: "It is one-sided to think of the Quattrocento only as the period characterized by realistic forms and naturalistic situations and to reserve full-blown idealism . . . for the beginning of the Cinquencento." Burckhardt had come to such a conclusion himself only after long and comprehensive contemplation of art. The warning it contains is one well worth taking to heart even today: that we must not force upon the Renaissance the sterile either/or of realism versus idealism that was so indispensable to the late nineteenth century.

As a rule, working artists have been among those least confined by conceptual barriers of this kind and have generally not made any fundamental distinction between Early and High Renaissance. Many of them—like Auguste Rodin and Adolf von Hildebrand—have been attracted to both Donatello and Michelangelo in equal measure, automatically separating each sculptor's artistic methods from the content of his works. The example of Hildebrand is especially instructive in this regard. What fascinated him initially about Renaissance sculpture—of the sixteenth century as well as the fifteenth—was least of all its realism, or as he put it, "the boring view of the modern naturalist, for whom sculpture is only supposed to imitate what can appear." Instead, he delighted in the way artistic form becomes a law unto itself in Renaissance sculpture, independent of reality. What he found was something akin to the "harmony parallel with nature" that Paul Cézanne felt to be the artist's goal. He also echoes the general reaction against what was then sensed to be the lack of "style" in realism and Impressionism that began to be felt in France in the 1880s. So, while the art of the Early Renaissance was admired by the Romantics for its intensity of feeling, and by the champions of realism for its accurate depiction of nature, it appealed to critics toward the close of the century for a number of altogether different reasons. They emphasized its logical and disciplined forms, its pictorial order, its calculated balance of part and whole, movement and repose, figure and space. And it is because of these qualities that the Quattrocento has continued to fascinate sculptors and painters of the twentieth century as well.

E ven this brief backward glance reveals how successive generations have extolled very different features of the art of the Early Renaissance and thought them to constitute its essence. It also shows that the art of the Quattrocento has a number of fascinating aspects, and that no one stylistic label does it justice, especially if that label comes to stand in the way of direct appreciation of the work itself. To see how this can happen, one need only recall the violent quarrels that took place concerning the origin and dating of the Early Renaissance as a result of an over-emphasis on realism. As for the date of the beginning of the Renaissance, Burckhardt was able to discover in the thirteenth century rudiments of much of what was to unfold in the fifteenth and sixteenth, yet he was convinced that the entire process should be thought of as having taken place within Italy itself. It was this view that the French art historian Louis Courajod set out to refute toward the end of the century. As a true representative of his generation, he based his arguments on the sole criterion of realism. Realism did not first appear in the Italian Renaissance, Courajod insisted; it was already evident in French Gothic sculpture. Therefore, one has to think of the Italian Renaissance as a continuation and a late phase of the development begun in the Late Middle Ages in France.

This is not the place to trace in detail the controversy over the nature of the Renaissance that was unleashed by scholars who claimed that it had nothing to do with the medieval culture of the North. Nevertheless, the example of Courajod shows how any attempt to reduce the art of the Early Renaissance to a single conceptual denominator only leads to confusion. The late nineteenth century, committed as it was to the idea of *Entwicklungsgeschichte*, tended to do so as a matter of course, whereas Burckhardt had no interest in such schematic "exactitude" and deliberately avoided such thinking. When arguing for the continuity or discontinuity between the Middle Ages and the Renaissance it depends on what specific quality one emphasizes. In a general sense, Courajod was correct in pointing out the realism of Gothic sculpture, but ultimately his observations were too vague and only tended to obscure the profound differences between French art of the thirteenth century and Italian art of the fifteenth. Moreover, he only confirmed the fact that realism has appeared again and again in the history of art— and continues today. But realism is not what defines an epoch; it only describes an artistic tendency. Moreover, realism is always selective, and in any given period one must take into account what other artistic aims and conventions it is linked to. In distinct contrast to the nineteenth-century art known as Realism, the art of the Quattrocento was just as concerned with beauty and proportion, suitability and decorum—that is to say ideal standards—as it was with fidelity to nature. While realism may predominate in one work and idealism in another, on the whole it is precisely this blend of realism and idealism, of subjectivity and objectivity, that constitutes a work's most consistent quality and its chief charm.

W hen seeking to define the art of the Early Renaissance, it is not particularly helpful to consult the writers on art from the fifteenth and sixteenth centuries. For them the Renaissance was still too contemporary; they could not know precisely what it had achieved or exactly when it began. They understood it to be first of all a reawakening of the arts, and only secondarily the reawakening of antiquity. And for them this rebirth of the arts was something that had taken place exclusively within Italy itself. They found it necessary to distinguish only three epochs or styles: antiquity and its *buona maniera* (true manner), the Middle Ages and their *maniera tedesca* (German manner), and their own present day, which was attempting to overcome the *maniera tedesca* and claim for itself the *buona maniera* of antiquity. In fact it was not until the sixteenth century, in the writings of Giorgio Vasari, that the concept of a *rinascità* (rebirth) came to be applied to art. Yet the consciousness of what had occurred had already been there long before this term was applied to it. It must have begun to make itself felt with the first appearance of the new art.

The earliest definite evidence of it is from 1435, in Leon Battista Alberti's treatise on painting. In the foreword to that work, addressed to Brunelleschi, Alberti writes that he had once been convinced that his own time would not produce anything great in the field of art, since nature itself was old and exhausted (*antica e stracca*) but that in Florence the works of Brunelleschi and Donatello, as well as those of Ghiberti, Luca della Robbia, and Masaccio, had taught him otherwise. These works are especially praiseworthy, he continues, inasmuch as their creators had no great examples to guide them, as did the artists of antiquity. "Our glory,"

Alberti writes, "is all the greater since we, with neither precursors nor models, are creating arts and sciences of a kind never seen or heard of before."

It was a common complaint of the humanists from about 1400 that the period was exhausted and arts and sciences at a low point. Alberti is the first to express a new self-esteem vis-à-vis the exemplary creations of antiquity. The awakening of the arts and sciences is not explained as a mere return to classical models. Instead, it had come about as the result of newly awakened talents and efforts of their own, a resurgence that Alberti understood to be a renewal of nature itself.

Even so, it is true that while the first generation of Renaissance artists devoted itself with a new intensity to the study of nature, it was also rediscovering and reevaluating the art of antiquity, and ultimately this helped to protect them from a superficial realism. At the same time, it avoided mere classicism in that its increasing fascination with antiquity was an outgrowth of its study of nature and was thus subordinate to it. With this in mind, it makes sense that writers in the fifteenth and sixteenth centuries thought of the new era as having begun not with the onset of a new regard for antiquity, but earlier, in the time of Giotto. Just as Leonardo Bruni could recognize Dante, Petrarch, and Boccaccio as the precursors of his own time, in his treatise on painting Alberti did not hesitate to recommend to his contemporaries as a model for the successful portrayal of figures the Navicella mosaic that Giotto had created in the atrium of Old St. Peter's over a century before. Ghiberti is even more explicit in that he restates what was the general opinion about Giotto even in the fourteenth century: *Areccò l'arte nuova* (He brought the new art into being). Ghiberti and his contemporaries felt that Giotto had given art in general a new life after it had been "buried" for over six hundred years. The new regard for nature was what was decisive. As a result, artists eventually found themselves imitating classical models and competing with them, but this was only later and did not begin in its full extent before the fifteenth century.

The New Beginning in Sculpture Between 1400 and 1430

Around 1400, the art of Europe exhibited a rare uniformity, for everywhere it was dominated by the Gothic style emanating from France. This glorious style, in which reality was resolutely subordinated to aesthetics, was of courtly origin, but it rapidly captivated the wealthy bourgeoisie as well. It was a style that appealed to the most cultivated taste. Its native domain was the art of the gold- and silversmith, exquisite works in small format. Above all it sought to be singular and precious. It relied on the subtle enrichment of its materials, extreme refinement in the poses of its figures, and a high formal polish, even in the play of drapery folds. Despite this exquisite stylization, it was not uncommon to find distinctly realistic details—especially in facial features—but these did nothing to lessen the ethereal magic; they only set it off all the more clearly as a lovely illusion. At that time, the most brilliant works of this kind were being produced in Paris and Burgundy, in Cologne and Prague; these included magnificent manuscripts for the Duc de Berry, the altarpieces of Konrad von Soest, and illuminated books from the court of King Wenceslas. Among the sculptural counterparts to these creations in the realm of painting and illumination were the *Schönen Madonnen* so popular in central and eastern Europe in that age.

At that time the courtly Gothic style was exerting a considerable influence on Italian art as well, from which it had received substantial stimuli three generations before. At the beginning of the fifteenth century, it dominated artistic taste not only in northern Italy, most notably Milan and Venice, but also in Tuscany, to the south of the Apennines. One sees it in the early works of Ghiberti and Quercia just as unmistakably as in the altarpieces of Lorenzo Monaco and the Maestro del Bambino Vispo. In fact, the majority of painters and sculptors active in Florence and Siena continued to be loyal to the conventions of the International Gothic style until well into the 1420s, and thus had no real share in the new artistic developments that surfaced in Florence in the first decade of the Quattrocento.

According to Johan Huizinga, the common denominator between the Late Gothic style of the North and the Early Renaissance was an "aesthetic of living form." Yet the new art of Florence was not as slavishly devoted to that aesthetic as he suggests, for it was less concerned with refined stylization than with the exploration and revelation of life in its external variety and internal consistency. This spirit of exploration, coupled with the search for a unity of nature and style, reality and beauty, the real and the ideal, variety and uniformity, the momentary and the lasting, was what distinguished this art from the conventional "beautiful style" of the International Gothic.

The two trends confront each other in Florence—and only in Florence—in the years after 1400. In many instances one also influenced the other. Nevertheless, the dividing line between them remains clear, and there is hardly any other time when it is possible to fix so precisely the beginning of a new epoch in the history of art and to link it with the names of specific creative personalities as here. It is also perfectly clear that the new

14

beginning of the early fifteenth century first announced itself not in architecture and painting but in sculpture. Seeds of it are already apparent in the two bronze reliefs submitted by Brunelleschi and Ghiberti in the competition for the second bronze door for the Florence Baptistry in 1401–2 (plates 1, 5), and it is further developed in the statues Donatello created beginning in 1408 and in his reliefs after 1417.

Artists, not their patrons, were chiefly responsible for the new style. The sculptural challenges presented by the first three decades of the fifteenth century were the same ones that Florentine sculptors had sought to meet in the fourteenth century. They came primarily from the desire of the merchant class to provide suitable appointments and adornments for the churches of the city and were, therefore, still entirely in the medieval tradition. The chief Florentine monuments involved in 1400 were the Duomo, Orsanmichele, and the Baptistry. In fulfilling the various commissions set before them in relation to this limited number of structures, by no means unusual in magnitude or in kind, the founding generation of Renaissance sculptors took its first tentative steps between 1400 and 1430.

The ambitious project of decorating the Duomo with sculptures had begun almost a hundred years before. Essentially, however, Arnolfo di Cambio and his workshop had managed to complete only the three portals for its façade. Not until the late fourteenth and early fifteenth centuries was their work taken up again. This new campaign continued until roughly 1435, although it too failed to extend above the level of the portals. At the same time, there was an effort to complete the figural decoration of the side portals, the choir buttresses, and the Campanile. The threats to Florence on the part of the Milanese in 1398–1402 and by King Ladislaus of Naples in 1408 failed to interrupt this work to any significant degree. A large number of statues were produced, all of them for the Cathedral's exterior. This campaign came to a halt once the cupola was in place—Brunelleschi had undertaken its construction in 1420 and completed it in 1436—and attention shifted to the interior, especially the area around the crossing and the choir chapels. The sculptors who contributed most decisively to the adornment of the Duomo in the first decades of the fifteenth century were Donatello, Nanni di Banco, and Luca della Robbia, all of whom, unlike Ghiberti, who was essentially a goldsmith, had started their careers as sculptors in stone.

As was the case with the Duomo, the range of assignments presented by Orsanmichele to the generation of sculptors emerging in Florence in 1400 was in large part preordained. In about 1340 the most prominent Florentine guilds had begun to commission statues of their patron saints for the niches in the exterior pillars of the church. However, by the close of the fourteenth century only a few of the fourteen statues called for had been completed. Only in 1403 was there a renewed effort to finish the cycle. To speed things up, the Signoria stepped in in 1406 with the ruling that each of the delinquent guilds was to fulfill its obligation within the next ten years. However, this schedule was not met either. Nevertheless, one statue after another was now executed in quick succession. The chief artists represented were Ghiberti, Donatello, and Nanni di Banco, so that the collection of statues created in these years for Orsanmichele present in unparalleled proximity the abilities, interests, and changing styles of the most important Florentine sculptors in the early years of the Renaissance.

The third great assignment from these years, the creation of a bronze door for the Baptistry, was of a very different kind. However, it was by no means a new departure. In fact, in this case, even more specifically than in that of the statues created at the same time for the Duomo and Orsanmichele, the contract referred to earlier designs and precedents. The new door, entrusted to Ghiberti in 1403 (plates 6–11), was to match as closely as

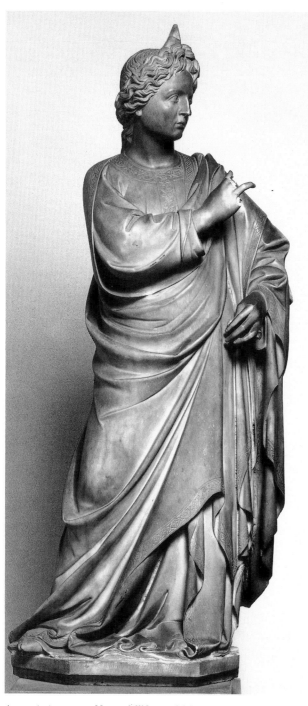
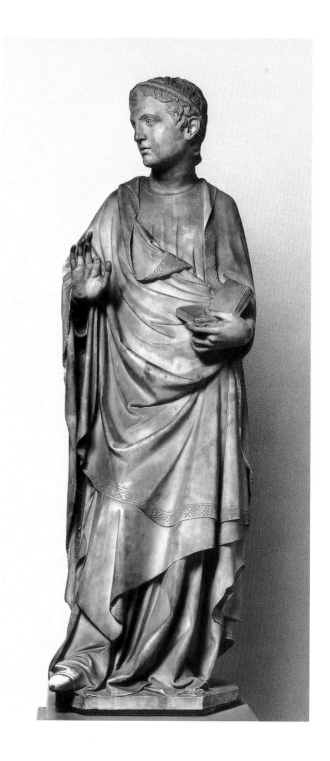

Annunciation group. Museo dell'Opera del Duomo, Florence

possible the older bronze door created by Andrea Pisano between 1330 and 1336 (fig. 2). With the overall layout of his door and the quatrefoil frames of the individual scenes, the artist completely satisfied that condition.

The awarding of this contract to Ghiberti was the result of the famous competition of 1401, the event that is frequently identified as the actual birth of Renaissance sculpture. A total of seven artists took part, with Ghiberti emerging with the prize. Each contestant was required to submit a sample relief. Its subject matter— Abraham's sacrifice of Isaac—was prescribed, as were the Gothic shape of the frame and probably even the number of figures to be included. The reliefs of the two main contestants, Ghiberti and Brunelleschi, are the only ones that have survived, and they demonstrate in almost textbook fashion how different the artistic responses to a given assignment could be at this time.

The differences between them are profound and have to do with both their method of arranging figures and their approach to the central event itself. Brunelleschi has adapted his arrangement more closely to the available surface and infused the sacrifice with more concrete details and greater tension (plate 1). Ghiberti's responses are much more conventional in both respects (plate 5). However, in specific details of both reliefs there is evidence of an equally strong interest in the sculpture of antiquity. In itself this was not altogether new, as the Italian sculptures of the Middle Ages, from Wiligelmo to Arnolfo di Cambio, had already drawn upon the same tradition. Yet in the fourteenth century there had been virtually no encounters with classical sculpture. Only toward the end of the century can one observe a renewed interest in it, most evidently on the jambs of the Duomo's Porta della Mandorla, created between 1391 and 1397 (fig. 18). There, between half-figures of angels and acanthus vines, nude and seminude figures of a classical type suddenly appear as a matter of course— among them a Hercules with a lion's skin.

The earliest evidences of a reawakening of interest in antiquity in Florence are typically copies of specific works. They tend to be small in format and consigned to the margins. The competition reliefs of Brunelleschi and Ghiberti are hardly more adventuresome in this regard. A short time later, however, there are indications of the growing interest in ancient sculpture in statues and jamb figures of large format as well. A notable example is the *Annunciation* group in the Museo dell' Opera del Duomo in Florence (illus. p. 16). Its date and authorship are a matter of debate, but it was probably carved in the first decade of the fifteenth century. The faces, the hairstyles, and the articulation of the bodies beneath the drapery constitute its chief classical touches. Overall, however, a Gothic approach to the figure continues to dominate even this group. Only in the early statues of Donatello does this become increasingly unimportant. His borrowings from classical examples also appear to be less superficial. Only in these works do the new concept of the statue and the new figural style of the Early Renaissance begin to take on sharper contours.

From this point on, Donatello continued to set the pace for further developments. As Vasari later put it, he served as the *regola degli altri*, the measure and example for all of the other sculptors of the Early Renaissance. This is evident quite early, for one can easily see the influence of his work on Nanni di Banco, Ciuffagni, Nanni di Bartolo, Ghiberti, and Quercia. Moreover, he continued to have a broad and lasting impact on the sculpture of three subsequent generations, some of the more illustrious representatives of which are Michelozzo, Luca della Robbia, Filarete, Bernardo and Antonio Rossellino, Desiderio da Settignano, Mino da Fiesole, Bellano, Bertoldo, and even the early Michelangelo. Painters studied Donatello's statues and reliefs just as closely as these sculptors did, or at least they did so up until the time of Raphael. When Raphael arrived in Florence in

1506, he looked not only at the works of Michelangelo and Leonardo but also those of the early Donatello, as his drawings of the St. John the Evangelist from the façade of the Duomo and the St. George from Orsanmichele attest.

At about the time that Raphael was making these drawings, the historical view of Quattrocento sculpture was beginning to consolidate. Writers on art were beginning to give Donatello, who had meanwhile taken on virtually mythic proportions, a place of honor among all the sculptors from the fifteenth century. For all of the adulation awarded him in the Quattrocento itself, there had also been a certain amount of criticism from those—such as Filarete (c. 1451–64) or Manetti (c. 1485)—who disapproved of the innovation in his work in defiance of traditional standards. Now, however, praise for Donatello was altogether unrestricted and enthusiastic. Writers admired above all the unprecedented sovereignty of his skill, his extremely lifelike figures, and the seemingly inexhaustible variety in his repertoire of figures and decorative forms. With increasing critical awareness, meanwhile, the sixteenth century had singled out artistic objectives of its own, and to a large extent it found them already realized in the works of Donatello more than those of any other artist of the Quattrocento. Vasari states this somewhat rhetorically when he insists that he had long debated whether to make a place for Donatello among the lives of artists of his own time, so close was the earlier sculptor to the manner of Michelangelo, so important his contribution to the "Renaissance" of the arts.

Even the very earliest surviving works of Donatello, the wooden *Crucifix* in Santa Croce (plate 40) and the marble *David* in the Bargello (plate 41), the latter dating from the years 1408–9 and originally intended for one of the buttresses of the Duomo, show the young sculptor pursuing new paths. Gothic reminiscences still cling to these works, but they are overshadowed by a new conception of the human figure, a more realistic understanding of its physical and psychic existence. The body is not only a volume filled with movement and tension; it is enlivened from within, thus receiving at the same time warmth and weight. Whether the head and trunk bend forward, as in the crucified *Christ* or stretch upward as in the *David*, inner forces are engaged in a new way, even if it is only pure gravity that is made visible. Donatello's figures are no longer simply set in motion by external forces. Rather, they themselves appear to take command of their setting and the space surrounding them, establishing a new and more direct relationship with the viewer.

What is more, Donatello explores the specific moment depicted and the individuality of his subject more intently than earlier artists had done. Not only does the slayer of Goliath stand triumphant above the severed head of the Philistine at his feet; at the same time he displays the impudence of youth. By contrast, physical exhaustion suffuses the figure of the crucified Christ, although it does nothing to diminish his beauty. That beauty is in part the product of a clarity of outline and a distinctly physical presence. Donatello's Christ is neither deformed into a figure of skin and bones, as in the crucifixes of a Giovanni Pisano, nor prettified like the one in Ghiberti's *Crucifixion* relief on the North Door. Within its taut outline the figure is rounded and richly modeled. The same feeling for the body, evident not only in the articulation of its volumes and surface details but

also in the way it is animated from within, characterizes the sinewy figure of the youthful *David*. His pose and gestures are only in part dictated by the subject matter; they also reflect the fact that the figure was intended to stand high atop a buttress.

The Santa Croce *Crucifix* and the marble *David* still retain some Gothic elements. The most obvious ones are their taut and curving outlines and the construction of their drapery. Yet these do not define the overall appearance of Donatello's figures nearly as much as they do Nanni di Banco's *Isaiah* from 1408 (plate 34). In fact, the only non-Gothic feature of this latter work is its strong emphasis on the body, which is much more ponderous beneath its thin garment than that of Donatello's marble *David*.

Even so, it is possible that Nanni took the lead from Donatello in his increasing exposure of the body underneath its drapery. This was different from merely emphasizing the body's form, which sculptors of the Trecento had done as a matter of course. Remarkably enough, Ghiberti appears not to have been influenced by such trends. His bronze *St. John the Baptist* (plate 12), created for Orsanmichele between 1413 and 1416, serves as almost a textbook example of the adherence to Gothic formulas and their extreme refinement in the production of statuary in these years. It displays no clear vitality and no twisting, no inner motivation, no firmness either in its stance or in the grip of its hands. The statue's chief structural elements are the large, sharp-edged folds of its elegantly draped cloak.

If one compares this statue with Donatello's *St. Mark* (plate 44), which was also created for Orsanmichele at about the same time, one can appreciate the latter's altogether different approach. This was an assignment quite unlike the one that gave rise to the marble *David*. The figure was to occupy a niche, not stand alone atop a tall buttress. The difference would have been of little importance for most sculptors of the period, but for Donatello it was crucial. It is clear that he deliberately made allowances for it, adapting his figure to its niche in quite specific ways.

Donatello completely abandons the formulaic Gothic curve still preserved in Ghiberti's *Baptist* and instead invests his *St. Mark* with a classical *contrapposto*. His figure thus stands firmly on the ground, yet appears to be fully relaxed. Most important, however, is the way the figure twists out of the plane of the niche frame, thereby commanding a larger space for itself and presenting an effective image to the viewer at some distance away. This was the quality that made Donatello's *St. Mark* the model and point of departure for all later niche statues of the Early Renaissance—even of the early Michelangelo. And this was what Renaissance writers had in mind when they praised Donatello for establishing a new figural order, in that his figures, whatever their settings, seem like living creatures.

Only in a general sense can one trace the pose of this *St. Mark* back to classical models. In its details, the composition of the figure is most unclassical, betraying the sculptor's desire to go beyond the statuary of antiquity. The fact that the statue turns in on itself, appearing to the viewer at an angle rather than in immediate frontality, was unusual in itself. Despite its twist to the side, the sculpture was surely intended to be seen from directly in front of the niche, not at an angle, as is often the case in misleading photographs. For only when seen from the front does the figure seem fully self-contained. Moreover, it is by turning away from the viewer and seemingly fixing its gaze on some distant object that the figure creates for itself an unlimited forward space, a wholly new spatial unity with the viewer of which there is as yet no trace in Ghiberti's *St. John the Baptist*.

Not only does Donatello's *St. Mark* take into account the perspective of the viewer and create its own space, it

also exhibits other peculiarities of composition that fundamentally distinguish it from older statues, whether of the Trecento or antiquity. The most important of these is the contrast set up between its distinctly passive and distinctly active gestural motifs. The former predominate on the side turned back toward the interior of the niche, the latter on the side thrust forward. With this repeated juxtaposition of opposing gestures, Donatello produces an image that is calm and restrained, yet expressive of purposeful movement. The early Michelangelo made use of this same ambiguity, a quality unknown in earlier statues, in his figure of St. Paul for the Piccolomini Altar in Siena.

The effect is created in large part by the powerful left hand holding a book in front of the body. It serves to block off the figure toward the front and at the same time lends greater urgency to the turning of the head and the distant gaze. In older statues the hands almost always hung down at the sides of the body, usually symmetrically posed at hip level. With the simple innovation of placing this hand out in front of the body, Donatello creates a new degree of complexity; his figure no longer presents itself so directly to the viewer, and the forward thrust adds unprecedented depth, so that the figure again appears to exploit its space to the full. It was no mere accident that a hand thrust to the front of the body became one of the favorite motifs of the early Donatello.

Other sculptors were quick to take up the gesture, the first of them being Nanni di Banco. In his *St. Philip* (plate 36), however, it fails to define the statue's space to the degree that it does in Donatello's *St. Mark*. Along with this forward hand, Nanni also made use of the corresponding turning of the head and the knee pressing through the drapery below the hand, yet in his figure the various motifs are not so logically connected. Nor are they so logically the result of the figure's twisting, as they are in the *St. Mark*. The same may be said of Nanni's *St. Luke* (plate 35). Here, again, the motif of a hand thrust forward to support an open book fails to function as the accent that ties the whole figure together, as it did in Donatello.

With its accommodation to the viewer's perspective, its bold command of space, and its classical ponderation, Donatello's *St. Mark* (plate 45) was one of the groundbreaking achievements of Early Renaissance sculpture. Donatello's innovations were far in advance not only of contemporary sculpture in Florence but also that of Claus Sluter, the leading sculptor in the North at the time. If he shares anything at all with the great Netherlandish master, it is his extreme differentiation of material values and his highly individual characterization of the persons portrayed.

In Donatello, specific characterization is never achieved merely by the use of realistic details or recognizable facial features. Rather, it is built up out of the overall posture and gestures with which the figure confronts the viewer. For example, it is not only from his face that we see that the *St. Mark* is calm and self-possessed, but from his whole bearing, which led Michelangelo to speak of him—Vasari tells us—as an *uomo da bene* (an honest man). As here, Donatello was never content with merely suggesting the identity and character of his subject by means of conventional attributes or unusual features. He sought instead to emphasize important aspects of their nature in their bearing and gestures, or *habitu et gestu*, as Alberti later put it when prescribing the same method for painters. The psychological subtlety with which he did so is in large part what constitutes the uniqueness and artistic greatness of his works. The only other artist from the Quattrocento who comes close to him in this regard is Leonardo.

Donatello's *St. George* (plate 48), also created for Orsanmichele, reveals such characterization by means of the entire figure even more clearly than his marble *David* or his *St. Mark*. The sculptor was obviously concerned to

capture the youth, courage, and bold determination of the warrior saint, and he portrayed him in an attitude of utmost tension and watchfulness. Like no other artist of his time, Donatello sought to convey the nature of his subject as fittingly as possible by means of pose, gesture, and expression. Appropriately, he constructed this figure with an uncommon rigidity. He deliberately emphasized the torso rising above the shield and the sharply focused distant gaze. There is nothing that strikes one as superficial and rhetorical, as is commonly the case in monuments to modern heroes. In a most unaffected manner, the *St. George* combines a relaxed wariness and readiness for combat, and it is just this interplay of latent and visible strength that led Donatello's contemporaries to admire his *St. George* as the ideal portrait of the type of warrior saint. Its *prontezza*, the alertness and tension pervading the entire figure, was the quality that they praised in it above all else.

Aside from these specific character traits, which are largely prescribed by the nature of the subject itself, the *St. George* displays many of the compositional features that are first evident in the *St. Mark* and that are typical of the entire series of Donatello's early statues. Here again the figure presents itself to the viewer at an angle. And here as well the flow of movement through the figure culminates in the slight turn of the head and the steady gaze into the distance. The right side is drawn back into the niche, the arm hanging straight down. The left side thrusts forward, and this hand reaches out to steady the shield standing in front of the body. In this case the contrast between the two sides is developed even further than in the *St. Mark* (fig. 20), for not only is the hand placed well forward but also the entire left forearm. Correspondingly, there is here a more pronounced twist to the body overall, and in fact the *St. George* (fig. 23) was constructed as a more three-dimensional statue in every way.

Donatello's later niche statues carry this tendency toward full three-dimensionality still further, anticipating his eventual freestanding works. They culminate in the statues of prophets created for the Campanile of the Duomo in Florence between 1416 and 1436 (plates 51–58). The last of these, the *Zuccone* and the *Jeremiah*, might just as well have been placed where they could be seen from all sides. In these two figures it is also apparent how Donatello, toward the end of the early phase of his career, takes psychological characterization to the extreme. Never had prophets been portrayed as such crazed ascetics, and it is easy to see why some of Donatello's contemporaries rebuked him for his drastic means of expression. Here the sculptural qualities of the drapery itself are emphasized more strongly than ever, yet these bodies work themselves free of the drapery more than those in his earlier statues. Not only are their limbs exposed, but they are given a nervous tension and energetic movement never attempted before. In each case the right hand presses tight to the thigh, as though the figure needed a firm hold somewhere, even on itself. Both figures gaze downward and slightly to the side. To heighten the pathos of these prophets, Donatello deliberately gave them ugly, distorted features. The open mouth and trembling eyebrows of the *Zuccone* and the glowering gaze of the *Jeremiah* suggest a degree of *terribilità* that later artists would attempt to equal in their own prophet figures for years to come.

To see the extent to which other sculptors were influenced by these figures, in fact by all of Donatello's early statues, one need only look at Nanni's statues of St. Luke and St. Philip (plates 35, 36), Ghiberti's *St. Matthew* (plate 11), or the figures created by Michelozzo for the Brancacci tomb in Naples and the Aragazzi tomb in Montepulciano (plates 154, 155, 157). Although none of his contemporaries made literal copies of his works, it is easy to recognize how much their statues—whether in pose, gestures, drapery forms, or facial features— follow patterns he established.

Much the same can be said of the art of relief, the other major branch of sculpture in these years. Here, too, Donatello was the first to come forward with innovations that would pave the way for further developments. The earliest example of his new approach is the well-known relief on the base of the tabernacle for his *St. George* statue on Orsanmichele (plate 50). He carved it in 1417, only a short time after Nanni di Banco had produced the one on the base of the niche for his statues of the Four Crowned Martyrs (plate 37). This was the niche belonging to the stonecutters' guild, and accordingly Nanni depicted in his relief representative members of the guild engaged in their respective trades. Characteristically, Nanni carved his individual workmen as relatively compact figures in half-relief, setting them off from the undeveloped background surface by rigid outlines. There is no indication of depth, of space stretching back behind the figures. The background surface is an impenetrable boundary. In all of this, Nanni conforms to the relief conventions of the fourteenth century.

Donatello's method is altogether different. In his relief, also a wide rectangle, St. George's encounter with the dragon is set before a section of landscape. Genuine three-dimensional space surrounds his figures, and it is treated in a variety of different ways. In the foreground, it is restricted by the perspective angles of a rock cliff on the left and the royal palace on the right. But behind these it opens out into a vast prospect of delicately graduated ranges of hills receding into the distance. This is the first convincing depiction of virtually limitless space in the history of art, and it was an advance of extraordinary consequence for the art of the Early Renaissance. To make his space believable, Donatello employs both linear and atmospheric perspective. For unlike the details of the foreground, those farther back—the mountains, trees, and clouds—are only suggested in very delicate, sketchy relief, so that the farther away they are, the more they appear to dissolve and blend in with each other. Thus he contrives to suggest great depth of space without overuse of the rigid schematics of linear perspective. He could only achieve such effects thanks to a technique he developed here for the first time. In it the carving is extremely subtle, as though a draftsman were working the stone. His new technique came to be widely imitated, and art historians have come to know it as *rilievo schiacciato*—literally, squashed relief.

The *St. George* relief was a definite advance if only for its depiction of spatial depth and its refined technique. Moreover, it also made use of an innovative narrative style. What is most unusual about this portrayal is the immediacy with which the artist presents the violent struggle. This is especially apparent in the figure of the horseman, who drives his lance into the dragon's body with all his strength. One sees the effort involved in the curve of his back and the way he digs his knees into the body of his mount. It is certain that Donatello based his mounted saint on classical depictions of horse and rider, for the rider is shown seated in the way he was in antiquity. In Donatello's time, it was customary to depict horsemen straight-legged, standing in their stirrups. Undoubtedly Donatello was not so much concerned with copying classical precedent as with taking advantage of this more expressive posture.

It is just this search for unity of movement and expression that characterizes Donatello's early reliefs. One sees it even more clearly in the bronze relief of the Feast of Herod that he created for the baptismal font in Siena roughly ten years later (plate 68). Here the setting is the interior of a large palace. A high, ashlar balustrade and three large arches separate the area of the main action from the sequence of connecting rooms to the back. This

artful arrangement is novel both in its spaciousness and in its lack of a foreground frame. Nothing comes between the viewer and the event portrayed. The placement of the soldier with his back to us in the foreground serves to heighten the effect. At the moment he presents the severed head of the Baptist to the king, all of the witnesses to the event shrink back in horror. The eye of the viewer is directed to Herod, who recoils at the sight of the head so calmly presented to him, by the gesture of one of his companions at the table. This man obviously disapproves of the king's action and has just extended a hand toward him accusingly. Never before had a scene such as this been so concentrated on a single moment. And never had the reactions of the chief figures and auxiliary ones been depicted with such variety and drama.

The event in the foreground of the Siena relief alone provides a fine example of what contemporary writers on art referred to as *storia*, a most lifelike portrayal of a scene from literature with the greatest possible variety of narrative motifs and objects. The abundance of narrative detail in the Siena relief is further enhanced by a varied background in which less violent scenes serve as contrast to the drama of the foreground. In the chamber farthest back, for example, we see the same servant bringing the head to Herod, while in the middle distance a violinist concentrates on his playing under the suspicious gaze of two evil-looking members of the palace guard.

All of this takes place in an interior space that is broken up into a number of rooms and structured according to the rules of central perspective. Yet these rules have not been applied with absolute rigidity; the artist has included deliberate deviations from them, but these do not detract from the effectiveness of the space. From this we can see that for Donatello the tricks of central perspective were important aids in the organization of space but were by no means superior to all others. In fact, in his total artistic output they are less crucial than newer forms of thematic arrangement. His preferred methods were to provide narrative variety and to fill his figures and actions with life, so that they spoke directly to the viewer.

Donatello's innovations in his *St. George* relief and his *Herod* relief in Siena are reflected in Ghiberti's later reliefs for the North Door of the Baptistry. The latter's portrayals of Christ Driving the Moneychangers from the Temple and the Flagellation of Christ, for example (plates 8, 9), display a new approach to space and a more expressive narrative style. These features are even more apparent in Ghiberti's reliefs for the baptismal font in Siena, but it is in the reliefs for his *Gates of Paradise* that he employs them to maximum effect (see plates 14, 15, 19–24). Only in these does he achieve the spatial depth and scenic variety of Donatello's *Herod* relief, exploring the whole range of sculptural values from full three-dimensionality to *schiacciato*.

W̲hile its statues and reliefs from the second and third decades of the fifteenth century provide the earliest evidence of the new priorities of Florentine sculpture and permit us to trace most readily its gradual abandonment of Gothic traditions, there is another branch of sculpture that is generally somewhat overlooked but eminently worthy of attention. This is the field of sculptural architecture and structural decor. Here, too, Donatello made significant advances as soon as he was given the opportunity. It came when he was commissioned to create his *St. Louis of Toulouse* tabernacle (fig. 28), and with it he introduced to Florence a wholly new type of niche *all'antica*. For certain of its classical forms he was clearly

indebted to Brunelleschi, but these he varied and combined in ways the older artist had never attempted. Already in this early structure he combines twisted columns and checkered moldings, spandrel reliefs and corner masks. He also blends purely architectural forms with unusual decorative motifs suggestive of everyday materials, as, for example, the mat of cording placed between the tabernacle's base and its supporting consoles. It was not so much because of details such as this, but rather thanks to its overall design wholly free of Gothic reminiscences, that the *St. Louis* niche became the prototype for all subsequent tabernacles in the antique style in Florence and environs. Examples are Ghiberti's *St. Matthew* tabernacle (plate 13 right), Bernardo Rossellino's figural niches on the façade of the Misericordia in Arezzo, and the *Sacrament* tabernacle by Luca della Robbia in Peretola (plate 167). Donatello's structure continued to be copied until well into the 1450s, by which time the sculptor himself had long since abandoned its relatively simple classical ornaments. By about 1430 he had come to favor richer and more heterogenous ornamental forms in his sculptural architecture.

At the beginning of the new century, Florentine sculptors were still being offered the same sorts of commissions they had been granted in the Trecento. Only in the 1420s did they begin to receive new types of contracts. The most important of these were the large wall tombs that Donatello executed in collaboration with Michelozzo, one for Pope John XXIII (plate 63), who had been deposed at the Council of Constance and died in 1419, the other for Cardinal Rinaldo Brancacci (fig. 42). These works were highly innovative in form, in their classical decor, and in numerous details. The assignments themselves were not entirely unprecedented, for wall tombs of comparable proportions had become fashionable in Italy in the second half of the thirteenth century. It was only in Florence that tombs of more modest dimensions had continued to be preferred. Typically, one of the monuments that Donatello and Michelozzo produced was intended for Naples. The other was exceptional in that it was Florence's only monument to a pope—deposed or not. Monumental wall tombs did not become common in Florence until later, about the middle of the century, from which point they represent one of the main creative outlets for the city's own sculptors as well as for Early Renaissance sculptors generally.

The only other new assignments from the earliest years were for works of considerably smaller format. Chief among these were *Madonna* reliefs, most of them half-figure. One of the earliest examples is Donatello's "*Pazzi Madonna*" in Berlin (plate 59). On the theme of the Mother and Child the sculptors of the Early Renaissance played a broad range of variations, from the solemn and tender to the charming and playful. In these reliefs they could concentrate on the intimacy of the scene as they could not in more public altarpieces, and they placed their figures in close proximity to the viewer. This they achieved often as not by presenting only portions of the figures, as though they were too large for their frames. Italian artists had been producing similar portrayals of the Madonna and Child for some time, of course, but in the fifteenth century the demand for such reliefs, for use in private worship in the home or in tabernacles on the street façades of houses and public buildings, increased dramatically. To meet this greater demand, sculptors began to execute them more and more in materials that were less expensive and more easily worked than marble. Terra-cotta became a common medium, and casts of carved works could be virtually mass-produced in stucco and papier-mâché.

The use of new and varied materials was characteristic of the Early Renaissance in general. Stucco and terra-cotta, used only sporadically heretofore, found increasing favor as early as the 1420s. In fact, the sculptors of the Quattrocento made greater use of terra-cotta, or fired clay, than have those of any other century. In part, this may be owing to Pliny's assurance that the material was popular with the sculptors of antiquity. Its first appearance in Florence is from 1410, when Donatello created a large terra-cotta figure of the prophet Joshua—no longer extant—for one of the buttresses of the Duomo. Other works in terra-cotta from the early Quattrocento in Florence are Dello Delli's *Coronation of the Virgin* above the portal of Sant'Egidio, which dates from before 1424, a number of *Madonna* reliefs from the circle around Ghiberti from about 1430, and the bust of "Niccolò da Uzzano" (plate 73). If the latter is indeed the work of Donatello, as I maintain, it can only date from about 1430, which would make it the earliest surviving portrait bust from the Renaissance. It clearly found no imitators for a long time, however, for the sculptors of Florence only began producing portrait busts in any quantity in the middle of the century.

In contrast to the "*Uzzano*," later portrait busts tended to be executed in marble—unless, of course, they were studies for later carvings. Marble was the favored material of the sculptors of the Quattrocento, as it had been for their counterparts in the Middle Ages. It was supplied to Florence from Carrara by way of the Arno. Sculptors like Donatello and Nanni di Banco, who began their careers in the workshops of the Duomo, became familiar with it in their youth. Sandstones, either macigno or pietra serena, were most often used for capitals, moldings, coats of arms, etc., or architectural sculpture in the narrower sense. Rarely were they employed for figural sculpture and not at all before the 1420s. Even then it was highly uncommon. Artistically, the most important work in sandstone is Donatello's Cavalcanti tabernacle (plate 85). The smoothness of the gray stone is here offset by especially rich gilding. Sculpture in white marble was also usually gilded or painted if it was to be set up indoors, the color applied only sparingly to the hems of garments, the hair, or touches of ornament. In the early years of the Quattrocento, color was occasionally provided by inlays of colored marble or enamels. Colored glazes and exotic antique marbles only came into use somewhat later.

Bronze was a favorite medium even at the beginning of the Quattrocento, second only to marble. In fact, one of the superficial characteristics of Early Renaissance sculpture is its frequent use of bronze. Italian sculptors of the Middle Ages had used it relatively seldom, chiefly for church doors. Typically enough, its first appearance in the fifteenth century was in that same traditional function. Soon, however, it also came to be used in Florence for statues, a distinct innovation, for up to that time statues were customarily executed in marble. The first such work was Ghiberti's figure of St. John for Orsanmichele, completed in 1416 (plate 12). Donatello followed his example a short time later with his statue of St. Louis (plate 61), and the figure of the deceased for his Coscia tomb (plate 63). However, he chose to gild his first bronze figures, providing added richness against the framing architecture of marble. At roughly this same time, the first gilt bronze reliefs appeared, such as those created for the baptismal font in Siena (plate 68). Bronze was valued for its greater durability and its rich appearance, but surely the fact that it was widely used in antiquity had something to do with its increasingly popularity among the sculptors of the Early Renaissance. In Book VII of his treatise on architecture, Alberti has a section on ornamental statues on buildings, and in it he emphasizes the durability of bronze: "I like statues of bronze

very much, although I can be captivated by the white gleam of pure marble. Yet bronze has permanence, for which reason I prefer it above all else."

Wood, although a common medium in Late Gothic sculpture north of the Alps, played a very subordinate role in the sculpture of the Early Renaissance. As in previous centuries, it was used chiefly for crucifixes in the Quattrocento. Statues of wood were far less common. Among the most famous of them is Donatello's statue of the Magdalene (plate 128). At one time there was a wooden version of the same subject by Brunelleschi—just as Donatello's *Crucifix* in Santa Croce (plate 40) had its Brunelleschi counterpart in Santa Maria Novella—but that work was destroyed in the Santo Spirito fire in 1471. Wooden sculpture was much more popular in Siena than in Florence. There it was commonly used by even the most prominent sculptors, such as Jacopo della Quercia, Francesco di Valdambrino, Vecchietta, and Francesco di Giorgio. Thus it may be said of Quattrocento sculpture in general, as compared to the thirteenth and fourteenth centuries, that it employed an increasing variety of materials, often in innovative combinations. Most importantly, these new materials were more easily worked. They could be built up, applied, or modeled, and thus lent themselves to rapid and relatively inexpensive production—even reproduction, as in the case of *Madonna* reliefs to meet a widening demand. The new materials—especially terra-cotta and stucco—only began to play a significant role relatively late in the century. It is chiefly in works in stone and bronze that one is able to trace the actual beginnings of Early Renaissance sculpture.

Artistic Aims and Their Formulation in Theory

T he decision in early 1408 by the Operai of Florence's Duomo to place statues atop the buttresses supporting the choir was consistent with the tradition of Gothic cathedrals. There was to be a cycle of twelve prophet figures atop the three choir apses—upon which Brunelleschi would raise his dome—and its planners were more concerned with the overall decorative effect of the ensemble than with the artistic merits of its individual figures. This seems clear enough from their specifications when they contracted with Donatello and Nanni di Banco for the first two statues in the series (plates 34, 41), for the finished works were to be only 1.9 meters high. Given the height of the buttresses themselves, at roughly 18 meters, and the imposing bulk of the structure behind them, figures as small as this can only have seemed adequate if they were intended to be mere architectural ornament.

If so, it seems odd that once the first two figures were delivered, the original plan was abandoned because it was now apparent that they were too small for such a height. One of them was actually set in place, but six months later, on July 3, 1409, it was decided to remove it. The committee then determined to commission the buttress prophets in a larger size, and the first of this new series—also never completed—was the terra-cotta *Joshua* figure, specifically referred to in the documents as a *homo magnus*, for which Donatello received the sum of 128 florins in August 1412.

Nowhere in the documents do we learn why the Operai suddenly objected to the disproportionate size of the statues given the height of the buttresses, or who was ultimately responsible for changing the board's mind. Nevertheless, the incident reflects the fundamental change taking place in these years in the public perception of sculpture, its relation to architecture, and, of course, its impact on the viewer. It introduces for the first time two formal considerations that would dominate Early Renaissance art in the years to come: the question of a proper relationship between the part and the whole and a sensitivity to the perspective of the viewer. Both considerations are fundamental to artistic production in the Quattrocento, and they are virtually inseparable. The idea of proportion, so crucial to this epoch, was not only keyed to the relationships exhibited by the human form, but also affected the sizes of all things in relation to the person viewing them. The latter concern is revealed in the use of central perspective in the construction of pictures, for as Piero della Francesca defined it toward the end of the century, the new method was an attempt to depict distant objects *con proportione*. But the same consideration had a bearing on the relative dimensions of a statue and the building for which it was intended, for as Alberti emphatically states in Book VII of his treatise on architecture: "A statue must be of a size appropriate to its setting."

Only a short time after Florence's Operai had discovered that the figures commissioned from Nanni di Banco and Donatello failed to satisfy that principle, considerations of proportion and perspective were affecting the planning of statues and reliefs for other projects in Florence to an increasing degree. This is especially

apparent, as already mentioned above, in Donatello's statue of St. Mark and his *St. George* relief (plates 44, 50). These works could hardly have taken the form that they did were it not for the thorough study of perspective to which Brunelleschi had dedicated himself in his early years, as a result of which he came to be the real founder of *perspectiva artificialis*. The early Donatello had clearly learned a great deal from the older artist. The laws of perspective and the method of organizing pictures by means of one-point perspective would only became common knowledge for artists in the 1420s and 1430s, when their use in the construction of pictures and reliefs became increasingly refined. Among the most famous applications of them are the two *Herod* reliefs by Donatello, one in Siena and the other in Lille (plates 69, 81), Masaccio's *Trinity* fresco in Santa Maria Novella, and Ghiberti's *Esau* relief on his *Gates of Paradise* (plate 22).

These principles, first realized in artistic practice, were soon given formulation and justification in theory in Leon Battista Alberti's treatise on painting of 1435, the first work on art theory in the truest sense from modern times. For it is one of the novel features of Early Renaissance art that alongside it, and emerging from it, the theory of art, heretofore little more than a few rudimentary observations mixed with practical formulas, came into its own. More than ever before, the principles of artistic creation now became a subject for literary analysis, and the stature of the creative artist was considerably enhanced in the process. Alberti was the logical person to introduce the new literary genre, for he had the necessary literary background and was also well acquainted with artists like Brunelleschi and Donatello and knowledgeable about their works. Renaissance art criticism may be said to begin with his treatise on painting, *De pictura*, from 1435 and his great work on architectural theory, *De re aedificatoria*, completed roughly fifteen years later. Thanks to him, artists like Ghiberti and Filarete would soon take up their pens as well, although they had little of his literary polish.

Despite its title, which speaks only of painting, Alberti's treatise of 1435 contains a wealth of rules and rationalizations that are of fundamental importance for all Early Renaissance art and can be applied without hesitation to the sculpture being produced at the time. This is true of the instructions he presents in Book I for organizing a picture by means of one-point perspective, for these were as valid for relief scenes as for paintings. It was Alberti's express intention in this book to deduce the perspective construction of pictures from the "principles of nature," and his method in doing so quite clearly reveals that in the Early Renaissance all representation of reality was subjected to ideal standards. For by intention it was an integral vision of things filled with notions of proportion, a projection of reality in which every detail bore its special relation to the picture as a whole. Alberti states in this regard, "In seeing we take the measure of all things," and accordingly even the space of the picture took on a measurable form.

The point of arranging the objects in a picture according to the rules of perspective, or according to a concept of visual perception that employs the simple model of an optical pyramid, was to re-create the "objective" proportions generally acknowledged to govern creation in general and in the Early Renaissance considered to constitute the essence of beauty. In Book I of his *I Commentarii*, Ghiberti insists that "proper relationships

alone constitute beauty" (*la proportionalità solamente fa pulchritudine*). His was only one of the many ways in which this general principle was expressed at the time. In acknowledging this principle, the Early Renaissance borrowed from classical teachings, ultimately derived from Pythagoras and Plato. These had never been forgotten, even in the Middle Ages, but had not been applied so directly to art. Now that they were, Vitruvius' notion that the beauty of a building is rooted in a harmony of its parts analogous to that of the human body took on new significance.

Like Vitruvius, Renaissance thinkers saw the whole substance of beauty revealed in the proportions of the well-formed human body. As a consequence, they began studying those relationships more intensely than before, gradually modifying and refining the canon of proportions set by Vitruvius, which had been their starting point. Alberti's brief work of uncertain date, *De statue*, serves as evidence of such reworking of the ideal canon of Vitruvius, for Alberti had taken pains to determine his proportions empirically on the basis of a number of living models, even models in motion. The dissatisfaction with empty schemata and abstract norms implicit in his approach would continue to characterize studies of proportion in the later Quattrocento. It is even more pronounced in Leonardo than in Alberti, for in his notes Leonardo repeatedly insists that the proportions of the human body vary according to sex, age, racial type, and the specific posture or movement, and that when portraying a person one has to consider all such variations if one does not wish to offend against the proportions provided by nature.

Leonardo's comments also tell us something about how the teachings of proportion came to be applied in the Quattrocento in general. Their use was obviously limited to the extent that they failed to allow for individual variation, for which the Quattrocento had a high regard. Scholars have attempted to confirm the influence of Vitruvius' laws of proportion on Brunelleschi's *Crucifix* in Santa Maria Novella (plate 3) just as they have looked for Alberti's ideal proportions in both the bronze *David* of Donatello (plate 105) and Ghiberti's *St. Stephen* on Orsanmichele (plate 18). It is difficult to prove their application, however, for the statues in question are simply not lifeless textbook figures. On the contrary, each of them has its own complex movement and torsion, and, moreover, their bodies are to some extent obscured by drapery. Yet it is possible to see how the approach to the figure changed over the years. Comparison of Ghiberti's statues of St. John and St. Stephen (plates 12, 18) or the two Donatello crucifixes in Santa Croce and the Santo in Padua (plates 40, 115) reveals a general shift in the direction of more balanced, idealized proportions.

Meanwhile the notion of proportion governed not only what could be measured, it also influenced — in the sense of appropriateness — the choice of subject matter, that is, the artist's approach to his subject and the way he presented his figure. In this sense it served above all as a powerful check on the general trend toward *similitudo* or *similitudine*, as it is called in contemporary documents and treatises, toward representing reality as accurately as possible. Fidelity to nature was primarily an issue in the presentation of living persons, or at least remembered ones, notably in portraiture. The fifteenth century was not the first to value such a quality. The portrait as such was not even an innovation of the

Leonardo da Vinci. *Adoration of the Magi* (detail). Uffizi, Florence

Quattrocento, but in this period it became increasingly common, and there was a marked tendency toward the monumental in portrayals of contemporaries. A favored type was the three-dimensional portrait bust, and at times such busts were obviously patterned—in the matter of costume, for example—after those from antiquity so that the result was a highly idealized portrayal. Such enhancement was surely called for when the work was a monument to some notable personage, a prince or a general, although here, too, there was always a definite emphasis on *similitudo*.

While lifelike portraits were not unique to the fifteenth century, it is a specific characteristic of art from the Quattrocento that *similitudo* was even required in portraits of historical or Biblical figures. In such cases the artist's knowledge of literature and his creative imagination came into play. Alberti was most explicit about the artist's responsibility in this regard. In his *De statue* he distinguishes between those sculptors who content themselves with only a superficial likeness and those who endeavor to capture the distinct personality of the subject in his facial features, his physical makeup, and his posture. Alberti was not thinking solely of portraits of contemporaries in this passage, for Caesar and Cato are the personalities he uses as examples. With this distinction he is attempting to define a quality first achieved by Donatello in his marble *David* and his *St. George* (plates 41, 49), namely, a sense of the unique individuality of an "historical" person.

30

Alberti's thinking in this regard is expressed even more clearly in his books on architecture, where he insists that the artist should capture his subject's life and character (*vitam et mores*) as clearly as possible in his statues by means of bearing and gestures (*habitu et gestu*). He then adds that in the portrayal of "heroes" — by which he clearly means saints — there must always be a certain harmony and majesty appropriate to the dignity of the subject. Alberti thus acknowledges that individual characterization and lifelike expression must be subordinated to the demands of propriety, suitability, and decorum. Filarete says much the same thing when he suggests that certain persons, saints for example, are to be portrayed in a manner appropriate to their *qualità*, by which he means not so much an individual "quality" as a collective one. Convention thus set certain limits on individual characterization, and this again confirms that even the manner of portrayal was a question of proportion, that the question of commensurability played a considerable role in his artistic judgment.

The artists of the Early Renaissance display a heightened sense of reality. They regarded objects close at hand with increasing interest, and at the same time they cultivated a view of nature that was "panoramic"; they were fascinated by the variety of the visible world. More clearly than ever before in post-classical art, it became one of the artist's tasks to reflect that variety. People of various types and ages, animals, trees, plants, mountains, buildings — all of these, according to Alberti, were necessary components of a picture. A picture was supposed to delight the viewer with its variety of objects. *Varietà* was, moreover, a stylistic ideal of the Quattrocento in a more general sense, expressed not only in its painting and sculpture but also in its architecture. The depiction of a scene required such variety as a matter of course, and if only for this reason Alberti singled out *storia* as art's highest task. He held that the greatest challenge to the artist was not to create a *colosso*, as Pliny had insisted, but to invent a proper *storia*. To Alberti this meant presenting a variety that was carefully selected and properly arranged, not merely arbitrary and disorganized.

Variety was called for not only in the presentation of objects but also in the expressions of the figures. Their poses, their gestures, and the movements of their clothing were to reflect their emotions, their *movimento dell'animo*, as vividly as possible, clearly defining their particular role in the context of the scene. The artist was required to portray a wide range of reactions and to coordinate them convincingly within the picture as a whole, creating consistency in variety. The need for cohesion served to curb an excessive variety of pictorial motifs, while a sense of decorum, or *moderatio*, regulated the representation of emotions. Movements and gestures were not supposed to be too furious or violent, but always to maintain moderation and dignity. At least that is what Alberti prescribed, and in the realm of sculpture Ghiberti and Luca della Robbia obeyed him. Not Donatello, however, who certainly did not avoid violent gestures and emotions, but rather seemed to prefer them. In doing so he reclaimed the expressive possibilities of classical art, which were imitated only rarely by other artists in the early Quattrocento, or only relatively late. Examples of Donatello's extreme emotions are found in his figures of mourners and warriors or the dancing putti on his pulpits in Prato and Florence.

The other fifteenth-century artist who came closest to Donatello in this regard was Leonardo, as can be seen from his designs for the Sforza monument (illus. p. 36) or his unfinished *Adoration of the Magi* in the Uffizi (illus. p. 30). In Leonardo's *Adoration*, unlike those painted in the same period by Botticelli or Ghirlandaio, there is virtually no sign of ceremony, majesty, pomp — nothing of Alberti's *dignità* and *gravità*. Instead, he opts for the most direct, vivid depiction of the moment he has chosen, for his main concern was to do away with the distance between the viewer and the event portrayed. Leonardo makes it clear that this was one of his most important

artistic goals in his own treatise on painting. He repeatedly claims that the movements of the figures must above all express their *accidenti mentali* and *passione dell'animo*—that is to say, their feelings. Alberti had said the same thing before but not so emphatically. And Leonardo goes far beyond Alberti in his noteworthy demand that any emotion in a picture should be depicted with such vividness that the viewer is moved to a corresponding emotion in spite of himself. Terror, pain, lamentation, joy, or mirth must be presented in such a way that the viewer cannot help but repeat the movements of the painted figures with his own body, to respond as though he himself were involved in the event portrayed. If he does not, then the artist has labored in vain.

Leonardo demands that the distance between the viewer and the action of the picture be overcome in the emotional sense as well as the visual. The painting should sweep up the viewer and virtually place him in the midst of the action. The artist wishing to achieve such a result does not need realistic effects as much as imagination and creative control of his picture. His figures need to be dramatic, their gestures extreme, and with them he must necessarily overstep the bounds of seemliness and decorum. Both Alberti and Filarete had warned against such intensity of expression, which could erase the boundaries between fiction and reality and ultimately between the sacred and the profane. Donatello, however, was on the side of Leonardo. In his *Herod* relief in Siena (plate 68), his Cavalcanti tabernacle (plate 85), and the pulpit reliefs in San Lorenzo (plates 139–53), he follows Leonardo's instructions *ante litteram*, as it were. Yet Donatello and Leonardo were by no means one-sided in their approach. They presented the viewer with violent figures with extreme gestures, to be sure, but also quiet ones and numerous gradations between the two. They appeal to the viewer's emotions not with their individual figures alone but rather with a diversity of correlated actions.

The artists of the Early Renaissance were thus pulled in two directions. Their concern for the "real" led them to study the way we see and develop perspective, to present *varietà* in imitation of the plenitude of nature and to strive for *similitudo*. Their idealist streak, on the other hand, led them to formalize perspective into a system of rules for the arrangement of pictures, or *costruzione legittima*, to see beauty as the sum of ideal proportions and to accept decorum as an arbiter in the choice of subject matter. Each of these tendencies affected artistic creation in its own way, producing varying results. In the career of an artist like Donatello, one tendency might predominate at one stage, the other at another. Alberti sums up the dilemma nicely in Book III of his treatise on painting, where he insists that it is not enough to achieve *similitudo* in a work of art, that is, an approximation of reality. One must create an approximation of reality that is at the same time beautiful. For his definition of beauty, Alberti was content to rely primarily on the teachings of the ancients.

Convention and Artistic Freedom

It is important to distinguish these new concerns on the part of artists from the expectations of patrons when awarding them commissions. The wording of contracts was at times quite specific, and fifteenth-century artists were no more inclined to question them than were those of earlier periods. With but very few exceptions, the works they created were made for hire and intended to serve a public function as altarpieces, tomb monuments, statues, or whatever. Their subject matter was prescribed and binding. City councils, guilds, societies, or private individuals had a hand in their execution as both patrons and judges.

Yet it would be a mistake to overestimate a patron's contribution to a finished work of art. The tolerance between a patron's expectations and his artist's final vision of the work was, after all, considerable, and their respective approaches were bound to differ. One can appreciate this tolerance in the Early Renaissance especially, for from this period there are already sufficient numbers of surviving documents and literary anecdotes to tell us something about the desires of patrons of known works, and thus the relative influence of convention and artistic freedom. The main documents are, of course, actual contracts with artists, minutes of council meetings, and protocols of claims of breach of contract. Those having to do with painting shed equal light on the field of sculpture, and documented cases tell us much about those for which no documents survive.

The fifteenth-century patron was likely to specify in his contract the type of work he desired, the length of time he was prepared to wait, and the fee agreed upon by both parties. In addition, he might indicate the amount to be spent on decorative touches (*ornamenti*), and the materials to be used—especially if there was to be any gold—for he wished to be certain that his work was no less imposing than other comparable ones. This same element of competition often led patrons to dictate the size of an altarpiece or a statue. For example, the contract concluded between the Arte del Cambio and Ghiberti in 1419 for the statue of St. Matthew (plate 13 right) expressly stated that the figure was to be at least as large as the *St. John* (plate 12) that the sculptor had created for the Arte di Calamala some years before—if possible even larger.

It was not uncommon to find a stipulation that the master himself was to be involved as much as possible in the creation of the work, or that at the least he was expected to execute its most important features—in the case of an architectural monument the figures, in the case of a statue the head. When Ghiberti's contract for his first Baptistry door was renewed in June 1407, the sculptor agreed to have a hand in the preparation of the wax models and the chiseling of the reliefs and to execute those portions requiring special mastery himself, specifically "the nudes, the hair, etc." As in this case, patrons were generally concerned to receive works of special beauty and quality. No one would have been content with a work that filled only the letter of the contract.

Contracts generally contain no more than very general instructions about the particular form of the planned work and the number and type of projected figures. In this regard there is often reference to verbal agreements between the two parties or to a drawing or model that the artist had already submitted. Examples of such

drawings are the one from the Ghiberti workshop in the Louvre, depicting the figure of St. Stephen (fig. 7), or the two fragments in London and New York showing Quercia's plans for the *Fonte Gaia* (figs. 11, 12). The earliest surviving three-dimensional models in terra-cotta are from the second half of the fifteenth century. The majority are either from the workshop of Verrocchio, such as the *bozzetto* (design) for the Cardinal Forteguerri cenotaph (fig. 88), or by Benedetto da Maiano, like the models for the pulpit reliefs in Santa Croce (fig. 91). The gilding of the latter is a clear indication that even then such models were also valued as independent works of art and displayed as such. Further evidence of this is the fact that in 1483 the Signoria acquired from Verrocchio the model (now lost) of his *St. Thomas* figure for Orsanmichele, with the intention of displaying it in the meeting room of the Università de' Mercatanti.

In some instances, however, specific details regarding the work in question are spelled out in the contract, either in the form of a precise description of the relevant figures or a demand that the artist pattern his work after a specific older work. In the latter case, the conventional wording is that the work contracted for is to be executed *ad formam* or *ad similitudinem* of a given precedent. Clearly Ghiberti was required to abide by such a clause when he agreed to produce his first Baptistry door in 1403 (plate 6), for his design follows the pattern of the older door by Andrea Pisano precisely (fig. 2). Even as late as 1425, when the guild commissioned the third door for the Baptistry (plate 19), it was first assumed that the work should be another copy of the Pisano door, a *simile*. By that time, however, the older pattern would have failed to satisfy the new artistic standards, and a change of plan was accordingly permitted—doubtless at the insistence of Ghiberti. The sculptor was allowed to organize the doors in a new way so as to permit a greater scenic variety to his reliefs. This is a typical example of what could happen between the signing of a contract for a work and its execution, for patrons tended to be conservative in their expectations, and ultimately it was the artist who decided what form the commission would take.

The history of the execution of the exterior pulpit for the Duomo in Prato (fig. 31) provides another instance of the way creative artists could modify the conditions of a contract. The commission was awarded to Donatello and Michelozzo in July 1428. The contract specified that two putti were to form the pulpit's console and that two additional putti, bearing the communal coats of arms, were to constitute the main adornments of its balustrade. It further stipulated that the work was to be completed by September 1429; however, by that time the sculptors had not even begun work. They did get a start on it in about 1430, when they completed some of its architectural elements. Then again they did nothing further for some time, so that in 1433, when Donatello was sojourning in Rome, Prato's Operai had no choice but to demand through his assistants that he come back and attend to the commission. Even so, it was 1438 before the pulpit was finished.

The final balustrade reliefs showed no signs of the heraldic motifs requested, but rather highly animated groups of dancing putti, a completely unprecedented type of figural ornament (plates 76, 77). Donatello's patrons would never have proposed such unheard-of decor, which displayed none of the solemnity and grandeur they had envisioned. It must be assumed that Donatello chose the new subject matter himself in the course of his work on the *Cantoria* for Florence's Duomo, begun in 1433 and completed in 1438. In the case of the *Cantoria* (plates 82–84), the train of gaily dancing putti extending across the length of its balustrade had a direct relation to the work's function. On the Prato pulpit, however, the putti are an arbitrary decorative motif. The sculptor's portrayal of dancing putti on the *Cantoria* was already unusual enough. The Duomo's Operai could hardly have anticipated such bacchantic abandon or carefree nudity when they commissioned the work. Nude and half-

naked putti had been common enough before in places where they were not so obvious, on tabernacle bases, in spandrels, or on sarcophagi, but never had they been displayed so prominently as the dominant motif.

Donatello's disregard of convention and decorum is evident throughout his career, and no other sculptor from the Quattrocento comes close to it. All artists were granted a certain *licentiae* in the working out of details, but he extended that privilege to the actual substance of the work. One sees this again in his equestrian monument of Gattamelata (plate 111) from about 1450, although here he demonstrates his independence in different way than he had in his pulpits from the 1430s. In the Quattrocento a monument of this sort was automatically expected to display *similitudo*, to resemble the subject as much as possible. It reproduced the subject's physical features as a matter of course and also details of his customary dress—or, in this case, armor. Today we have no way of knowing to what degree Donatello's *Gattamelata* is an accurate portrait. More than likely it is not. But as for the condottiere's armor, *similitudo* is totally ignored. Instead of the contemporary costume one would expect, Donatello's hero wears a wholly imaginary one patterned largely after classical examples. Not surprisingly, a Paduan humanist's response to the new monument was that because of his *magnificentia* the *Gattamelata* could be compared to one of the ancient emperors.

Donatello's highhandedness was not universally admired by his contemporaries, as is clear from the remarks of Filarete, a man anything but modest about his own skills as a sculptor in bronze. His criticism of Donatello's work makes it clear that to him such a flagrant disregard for convention nullified the artistic achievement as a whole. In Book XXIII of his treatise on architecture (c. 1451–64), Filarete rails that no artist should follow the example of Donatello, who produced a monument in bronze to the Gattamelata that one can only call deformed (*sconforme*), and for which he has won little praise. A figure from our own time should be portrayed in the clothing he actually wore, not in classical costume. How bizarre it would be, he concludes, if one intended to create a likeness of the Duke of Milan and chose to present him in garments that he never wore.

This is the first appearance in art history of the "costume question," one that would continue to affect the planning of monuments until well into the nineteenth century. Filarete's objections reflect a firmly established point of view that more than likely was representative of the patrons of his time. It certainly was not Donatello's view. This is clear from another instance of Donatello's resolute intervention in the planning of his patrons. In this case he simply lost interest in a potential contract once it was obvious it would include demands altogether contrary to his own ideas. On October 16, 1450, the council of the city of Modena decided to erect a monument to the duke of Ferrara, Borso d'Este. A few months later they invited Donatello, then working in Padua, to join them in their deliberations. At the very first meeting he suggested that the monument should not be done in marble, as originally planned, but rather in bronze, and that it should be fully gilt. The city fathers were quick to agree with him, although the change added considerably to the cost of the work. Only two days later, on March 10, 1451, they officially commissioned Donatello to create the statue in gilt bronze within a year, for a price of 300 guldens.

The work was never completed, however. It appears that as in a number of other cases, Donatello ultimately found the project uninteresting. One can assume that he thought Modena's worthies too specific in their notion of how the prince was to be portrayed. What they wanted was the truest possible likeness. To that end they had already asked the duke for a portrait showing down to the smallest details of clothing just how he wished to appear in the monument. Accordingly, Donatello's contract contained the admonition that the bronze statue was

Leonardo da Vinci. Design for an equestrian statue of Francesco Sforza. Royal Library, Windsor Castle

to be executed *ad similitudinem et ymaginem ipsius domini*. It even insisted that the work suggest the prince's true stature, although it did give the sculptor permission to make it somewhat larger if he chose, so that when seen from below or from a distance it would not appear to be smaller than the prince actually was. Moreover, the figure was to be dressed in the costume the prince preferred. Given the fashion and princely customs of the period, this would have meant portraying him in ceremonial robes of considerable splendor.

Even a cursory glance at Donatello's œuvre enables one to see that he must not have thought much of such demands. Considering the costume question alone, it is striking how little of contemporary fashion is reflected in his work. In the case of his *Gattamelata*, where realistic clothing was automatically called for, he chose instead a costume *all'antica*. This is not to suggest that Donatello's disregard for convention in his conception of a work was limited to mere details of clothing. It is only one indication of how this sculptor, like no other artist from the first half of the fifteenth century, refused to be bound by the wishes of his patrons. Even without reference to the documents, the trained eye can easily spot in his works those features that could not have been prescribed in the wording of the contract. For it is well attested that patrons of the period were in the habit of approaching artists with notions and desires that can only be described as conventional.

Leonardo da Vinci. Design for the Tomb of Gian Giacomo Trivulzio. Royal
Library, Windsor Castle

Those same patrons were not above refusing to accept a commissioned work if it failed to meet their
expectations. This could even happen to Donatello. In August 1434 his patrons returned to him the small
tabernacle door of gilt bronze (now lost) that he had created for the baptismal font in Siena. With it was an
explanation that they found it unsatisfactory (*non è riescito per modo che piaccia a essi operajo e consiglieri*). In
this instance, unfortunately, there are no specific reasons given for the rejection of the work. One must assume
that the Sienese felt the manner in which the subject matter was portrayed was somehow unsuitable—or once
again "inappropriate."

Donatello's offence in this instance may have been similar to the one he committed at about the same time with
respect to the bronze doors of the Old Sacristy in San Lorenzo (plate 88). In each of the square panels he
portrayed a pair of martyrs, Apostles, Evangelists, or Church Fathers. The emotions implicit in their poses and
expressions range from calm serenity to the height of passion, and to the modern viewer it is the pairs of
Apostles engaged in heated debate that are most intriguing. To many of Donatello's contemporaries, however,
they were shocking. Filarete's response is altogether typical. He found Donatello's depiction of such impas-
sioned, even violent, argument an artistic defect as fundamental as Donatello's use of classical armor for his

Gattamelata. These figures, he sneered, are behaving like "fencers," and, therefore, as portrayals of Apostles they are wildly distorted. Filarete was convinced that no Apostle—as though by definition—would have employed such violent gestures. They were by nature men of great seriousness, dignity, and restraint, and therefore it was incumbent on the artist to present them with an appropriate *gravitas*. Surely some such breach of the standards of propriety on Donatello's part was what led to Siena's rejection of his tabernacle door.

One also sees how an artist's intentions could come into conflict with standards such as these in the work of Leonardo. This is evident not only in his paintings, but also in his designs from roughly 1483 for the monument to Francesco Sforza, which, if executed, would have surpassed all other equestrian monuments of the Renaissance. The contract for the work has not survived; however, Leonardo's various preparatory sketches reveal clearly that at least in the beginning he envisioned a work that was both typical of his own artistic ambitions and revolutionary, but one that his patron, Lodovico Sforza (Il Moro), could hardly have countenanced.

It was unusual enough that he first thought of portraying his subject on a rearing horse (see illus. p. 36), although in fact we see the same idea in designs for the Sforza monument by Antonio del Pollaiuolo (fig. 80). But it was unheard of that horse and rider should be depicted in the heat of battle, filled with violent movement and opposing tensions. Leonardo pictured the horse with its forelegs high in the air and his head turned sharply to the side. In his sketch, his rider faces at times toward the rear, at times toward the front, in either case pointing in the opposite direction with the baton held in his right hand. The necessary support for the horse's front legs was to be provided by either the stump of a tree or a fallen warrior protecting his head with a shield.

It is easy to imagine the formidable technical problems entailed in realizing such a conception in bronze—especially given the massive size of the projected monument. But beyond that, one cannot imagine that the duke would have agreed to such a monument to his illustrious ancestor. Certainly Leonardo's design had none of the dignity and pomp he himself would have envisioned. For with such emphasis on the movement of horse and rider, there was little chance to project the rider's personality and ultimately to develop the requisite gravity. This may have been one of the reasons behind the duke's appeal to Lorenzo the Magnificent in July 1489. In it he asked that two more sculptors be sent to Milan, as it was doubtful whether Leonardo would ever produce the monument Francesco desired. His request, for whatever reasons, was ignored. Leonardo himself began to work on the project again the following April. Now, however, his concept was altogether different from his first design. On the one hand, it seems more closely indebted to classical precedent, and on the other, it reflects somewhat more the function of such monuments as visible symbols of power. Indirectly, these changes tend to confirm that Leonardo's initial proposal was dropped in the face of objections on the part of the duke. For it is clear from designs he produced roughly twenty years later for the tomb monument of Prince Trivulzio (illus. p. 37) that Leonardo himself still favored his original idea. Here again his first thought was of a rearing horse.

If patron and artist failed to agree on the execution of a commission, they could, of course, argue their cases in court. The most notorious instance of this kind—admittedly dealing with painting rather than sculpture—is the lawsuit brought by Imperatrice Ovetari against Mantegna in 1457. Here again it was primarily a question of the artist's vision being interpreted as a breach of convention. Some legal squabbles, like this one, were genuine debates about the artist's conception of a work. In others the patron only claimed to be dissatisfied in the hope of saving himself money. In 1476, for example, the heirs of Raimondo Solimani in Padua tried to get out of making

a final payment to the sculptor Bartolomeo Bellano for Raimondo's tomb. They argued in court that the work was completely unsatisfactory, claiming that the finished work was far less imposing than they had been led to expect from the wax model submitted by the artist. They insisted that the model on which the contract was based was *longe pulcrior et formosior* and, moreover, included a larger number of figures. To make matters worse, all of the figures on the completed tomb were in their view ugly and squat. Neither the tomb nor the model has survived, so it is no longer possible to determine to what extent the Solimani heirs were correct in their objections. As was customary in such cases, the court asked some of Padua's stonecutters and sculptors for their opinion. The case was decided in Bellano's favor.

Needless to say, the interests of patrons did not always coincide with those of artists. Yet one must admit that, as a rule, patrons tended to be highly indulgent of artists, not only with respect to deadlines, which were often ignored for years, but also regarding the manner in which they executed their commission. Whenever a patron did refuse a work or criticize its execution—assuming that his criticism was not motivated by financial considerations—it was more often than not because he found the artist's approach unconventional. Yet only a generation or two later that same approach was likely to be generally accepted, indeed expressly desired. All in all, the patrons of the Renaissance tended to let themselves be guided—although at times only after a generation's delay—by the ideas and abilities of artists, especially those considered to be preeminent. These artists were in great demand, and communes and princes frequently vied for their services, often enough in vain.

The Further Development of Sculpture
in Florence Between 1430 and 1490

In the years immediately after 1430 Florentine sculpture was still chiefly architectural sculpture, and as such closely tied to the city's major projects. However, two of these, both directed by Brunelleschi but very different in kind and in magnitude, would soon change architecture forever. One was the Old Sacristy of San Lorenzo, already completed in 1428, in which Brunelleschi presented his contemporaries with a new architectural ideal. The other was the dome for the Cathedral, a structural marvel that amazed the city on its completion in 1436 and established Brunelleschi's fame as architect and engineer. These structures also changed the relationship between architecture and sculpture. The adornment of the exterior of the Duomo with statuary, begun in the thirteenth century and revived again in the fourteenth, was now set aside. Instead, sculptors were now engaged to ornament the interior with marble altars, organ and choir tribunes, lavabos, and bronze doors.

Sculpture was to be the sole ornamentation in the Old Sacristy, instead of the traditional frescoes. That project was also the first sculptural commission from the Medici, who had gained political control of Florence in 1434 and would be the major patrons of Florentine sculptors for decades. Cosimo the Elder, the family's greatest patron of the arts, was primarily a builder of churches and monasteries, but even so he provided a number of commissions to Donatello, the artist he favored above all others. Donatello was asked to create all of the decorations for the Old Sacristy as well as individual works for the Palazzo Medici and the choir of San Lorenzo. Although he represented a new and truly "modern" type of artist more than any of his contemporaries, Donatello was anything but a "court sculptor." Even during the 1430s, while working on the bronze doors and stucco reliefs for the Old Sacristy (plates 88–101), he continued to work for the Opera del Duomo. In addition he created the great *Annunciation* retable for the Cavalcanti family (plate 85) as well as the reliefs for the exterior pulpit of the cathedral in Prato (plates 76, 77). Yet even with this relatively large number of commissions, he continued to live in modest circumstances.

After Donatello, Luca della Robbia emerged as the main sculptor for the Duomo. Like Bernardo Rossellino, he belonged to the generation born about 1400. Both were largely independent of the Gothic tradition, although still linked to it by way of Ghiberti. Ghiberti's influence on their early works—Rossellino's *Madonna of Mercy* for the lunette above the portal of the Misericordia in Arezzo from 1434 and the choir tribune that Luca began in 1432 (fig. 45)—is most evident in their gently curving figures and the elegant lines of their drapery. Luca's tribune reliefs were also indebted to the works of Donatello from the 1430s as well as to classical models. In style he seems especially drawn to the latter. So strong is this attraction that he introduces into the sculpture of the Early Renaissance an almost classicistic streak not evidenced before, one also visible at about this same time in Michelozzo's statues and reliefs for the Aragazzi tomb in Montepulciano (plates 156–58). In works like these one sees not only a deliberate borrowing of individual motifs from antique sculpture, but also an attempt to emulate

classical form and style as fully as possible. With his obvious preference for classical examples and the terminology of ancient writers, Alberti promoted such borrowing in his treatise on painting from this period.

Donatello had been the first to borrow heavily from classical sculpture in his works from the late 1420s and early 1430s. These, far more than his earlier work, reveal a growing interest in the art of antiquity. One sign of it is their increasing nudity, his liberation of the body from its drapery. Another is his lavish use of a variety of decorative motifs based on classical examples. His new fascination with the naked body is apparent in his last two statues for the Campanile (plates 56, 57), the dancing putti on the *Cantoria* (plate 84), and the Prato pulpit (plates 76, 77). His interest in classical decor is most evident in his *Sacrament* tabernacle for St. Peter's (plate 79) and the Cavalcanti *Annunciation* (plate 85). Although very different from each other, all of these works attest to Donatello's deepening appreciation for the art of antiquity. They also show that he was not remotely interested in merely reproducing classical works. He was wholly free of classicistic tendencies. What he took from the art of antiquity he completely reworked for his own purposes.

Moreover, unlike Ghiberti and Luca, he was appreciative of a number of very different aspects of classical art. Of course he valued its idealism, its graceful figures, and its moderation, but he was also fascinated by its ability to portray emotion and its seemingly inexhaustible variety of ornamental details. Now, more than ever before, Donatello's work becomes dominated by *varietas*, a diversity of expression, emotions, narrative motifs, and decor. Of the works he created in the 1430s, those that illustrate this new *varietas* most vividly are the *Herod* relief in Lille (plate 81), the Cavalcanti tabernacle (plate 85), and the relief decorations in the Old Sacristy of San Lorenzo (plates 92–101).

In Donatello's new style, the figures are increasingly independent of their surrounding architecture or any type of frame. There is greater contrast and variation in the interplay between architecture and figures, for the latter are permitted a freedom of movement they had not enjoyed before. This is especially apparent in the Cavalcanti *Annunciation* and the *Cantoria*. In these works the figures are confined to a shallow stage in the foreground, yet because of the framing architectural elements they appear to have complete freedom of movement. The reliefs of these years provide a similar freedom thanks to their expanded settings. The *Herod* relief in Lille is the first one to have this new sense of spaciousness, but it is also visible in the *St. John* tondo for the Old Sacristy (plate 94), and most notably in the one depicting the Awakening of Drusiana (plate 95). The severe symmetry of the monumental architecture that here serves as the setting for the figures recurs a short time later in Ghiberti, in the last relief for his *Gates of Paradise* (plate 24), and would continue to influence other artists for a long time. Raphael's *School of Athens* fresco, painted nearly a century later, is still a reflection of it.

Donatello's liberation of the figure from its architectural frame in the 1430s constituted a fundamental change in the relationship between architecture and figural sculpture, which was of great importance for the further development of sculpture in the Quattrocento. Ultimately it prepared the way for a work like Donatello's own bronze *David* (plate 105), which he probably created in 1444–46, at the time construction was begun on the Palazzo Medici, the setting for which it was originally intended. This work was the first freestanding statue since antiquity that was meant to be viewed from every angle. Its appearance at this time was the direct result of a step-by-step liberation of figural sculpture from architecture in the decades before. Donatello's finial and buttress figures, such as the marble *David* (plate 41) or the small bronze putti for Siena's baptismal font (plate 75), were still in the tradition of architectural sculpture. There had been a few independent statues, but these

were meant to be placed on columns, like Donatello's "*Dovizia*" (now lost) from the late 1420s, which stood atop the Mercato Vecchio in Florence until 1721. But monuments of this type were not unknown even in the Middle Ages. The bronze *David* is a freestanding statue in the true sense, like classical examples of the form. Not only was it intended to be placed where it could be viewed from all sides, but here for the first time since antiquity was a lifesize naked human form imbued with an ideal beauty. With this figure the tradition of medieval sculpture, the sort of sculpture produced in the stonecutting shed of a major building project, comes to an end.

The bronze *David* marked a new departure if only because it was not meant to be seen by the general public. It is perfectly clear from the statue's delicacy and almost total nudity, not to mention the intimate nature of the sculptor's portrayal, that it was conceived as a work for the interior of a private house or a palace, as a decorative object rather than a monument. This was the first time a statue of such size was meant to serve such a function. Its subject matter was obviously chosen in large part only because it provided the sculptor an opportunity to produce an idealized figure equal to those of antiquity, and to create a new artistic standard.

By the 1440s, the bronze *David* was no longer the only such work in the private sphere. At about this time there is evidence of a new interest—at least on the part of the Medici—in collecting examples of the new art. Suddenly there was a demand for works of art not necessarily meant to serve a specific public function as altarpieces or devotional images, memorial portraits or public monuments. Artists were now free to create masterpieces intended solely as adornments to the private houses of connoisseurs and collectors. Perhaps the earliest surviving example of such a work is Donatello's marble *Herod* relief from the early 1430s (plate 81). Presumed to have come from the Medici collections, it is now preserved in the Musée Wicar in Lille. In it the sculptor produced a model of *storia*, fulfilling in advance, as it were, all of the demands regarding invention and composition that Alberti was soon to set forth in his theoretical treatise on the art of painting.

Included in this genre and especially typical of the Early Renaissance are the small bronzes that become increasingly common after the middle of the fifteenth century. These were primarily meant to be showpieces of classical learning and virtuoso modeling. Characteristic examples are Antonio del Pollaiuolo's group of Hercules and Antaeus (plate 259) and Bertoldo's *Bellerophon* (plate 278). Needless to say it was exclusively in this branch of sculpture appealing to the connoisseur that new subjects derived from ancient myth and history, so prized by the Early Renaissance, were truly at home. Elsewhere they tended to play only a subordinate role. In Filarete's bronze doors for St. Peter's (plates 174–77), for example, one discovers them only in the borders. This despite the fact that in his 1435 treatise on painting, Alberti had referred almost exclusively to classical examples in painting and sculpture to illustrate his theoretical pronouncements and never mentions the subject matter of contemporary art.

In 1435 there were no works on specifically classical subjects as yet. These only make their appearance in the 1440s. The earliest example is Donatello's small bronze statue of "Amor-Atys" (plate 104). Although it is difficult to identify this figure precisely, its pagan character is obvious, and while it is impossible to determine what setting it was created for, it can only have been intended for a private house. This alone makes it comparable to a work like the bronze *David* (plate 105). Both were conceived primarily for connoisseurs. These are also the two Donatello works in which he vies most clearly with the sculptors of antiquity. Another such work in competition with classical precedent was his equestrian monument of Gattamelata of a few years later. It is true that the work was created in Padua, but even so it rightly belongs in this chapter on Florence. Geographical consistency is rare in the history of art.

Secular commissions like the figure of the Gattamelata were among the growing number of new outlets for Early Renaissance sculptors after the middle of the fifteenth century. Italy's cities had been commissioning depictions of their illustrious military leaders, more often than not on horseback, for a century or more. In the earliest period these generally took the form of wall frescoes in public buildings. One thinks of the painting of Guidoriccio da Fogliano in Siena's Palazzo Pubblico or those of John Hawkwood and Niccolò da Tolentino in the Duomo in Florence. Three-dimensional memorials were less common. One such work, a wooden statue of Piero Farnese on horseback, was placed in Florence's Duomo in 1390, only to be replaced shortly afterward by a fresco. Another, depicting the Sienese captain Gian Tedesco da Pietramala, is said to have been executed by the young Jacopo della Quercia, but it was not made to last. In the following decades it was the custom, especially in northern Italy, to honor condottieri by placing equestrian statues of them in churches atop their tombs. Most often these were of wood. Even the bronze *Gattamelata* (plate 111), which Donatello must have begun planning as early as 1444, stands on a base obviously conceived as a tomb (fig. 35). In this instance, thanks in large part to the forcefulness of the statue, the monumental aspect of the design predominates. Only the doors to Hades and the mourning angels on the base (fig. 36) suggest that the structure is at the same time a sepulcher.

Despite the great differences in concept and scale, there is still a similarity between the *Gattamelata* and the bronze *David*. For the *Gattamelata* also presents itself as a freestanding statue and takes account of its situation in a very specific way. While the bronze *David* was planned for the inner courtyard of a palace, the placement, proportions, and gestures of the *Gattamelata* were designed to make it the focal point of the urban ensemble in which it stands. Its appropriateness in its architectural setting is, in fact, what makes it the first modern monument for a city square. By comparison, the equestrian monument of Niccolò III d'Este erected in Ferrara in 1450 seems much more modest and old-fashioned. In no way does it command its site as Padua's *Gattamelata* does. For one thing it is considerably smaller, and, moreover, it is too closely tied to the architecture of the former ducal palace. No other equestrian statue of the period was so obviously patterned after classical models as the *Gattamelata*. Like them it stands alone, exhibiting a definite grandeur in its gestures; even its armor is borrowed from antiquity. Yet nowhere in the past was there precedent for the monumentality of the work or its calculated integration into an urban setting.

While in Padua, Donatello created another major work unlike the *Gattamelata*, namely, the high altar for the Santo (plates 116–26). Since his altar was replaced by a new one in the sixteenth century, scholars can only guess its original form. It is certain that it stood alone in the choir of the basilica. It consisted of a superstructure housing seven bronze statues and a predella adorned with a number of bronze reliefs and a stone *Entombment* relief on the back. The framing elements were also of stone. Even from these few facts it is clear that the work was a highly unusual retable for the time, whose overall form was most likely derived from painted altar panels. Interestingly enough it is also in painting that the work was most influential, as we see, for example, from Mantegna's altarpiece for San Zeno in Verona.

By this time Donatello had already created a number of freestanding statues, and here as well his figures were largely independent of the altar's framing architecture. The splendid reliefs (plates 124, 125) also make use of his innovations from the 1430s and early 1440s. They present expansive spaces, elaborate architectural prospects, and large numbers of figures in motion—many of them seminude in the classical manner. At the same time they already represent a step in the direction of Donatello's late works. For he now pays less attention to the clear and logical perspective arrangement of figural groupings that characterized his relief compositions

from the 1430s. Instead he concentrates on the main figures and their individual emotions. Typically, the action takes place almost exclusively on the plane of the foreground, clearly set off from the background architecture. The latter is treated more like a backdrop than a means of structuring space. In these scenes the sculptor clearly emphasizes the emotions of his figures.

However, in the *Entombment* relief (plate 126) he created a short time later for the back of the altar, emotion is his sole concern. Clearly the subject matter in this work is altogether different from that of the predella reliefs, and the number of figures correspondingly much smaller, yet its intensity of expression and the way it thrusts these few agonized figures in front of the viewer are altogether startling. It is useful to compare this work with Donatello's earlier *Entombment* relief (plate 80) on the *Sacrament* tabernacle in St. Peter's, for then it becomes obvious that his determined rejection of all spatial illusion, his compression of the action into a single narrow plane, and his contorted, angular figures in the later work are all part of a new and highly expressive style. They are not merely a response to this particular subject matter; rather, they are characteristic of his late work in general. The ideal forms of antiquity have lost their hold on the sculptor and remain in the background for the rest of his career.

Donatello's tendency to reduce the pictorial architecture to a mere backdrop or dispense with it entirely, first evidenced in these Paduan reliefs, remains a constant in his last reliefs as well, especially those of the bronze pulpits for San Lorenzo (plates 139–53). If one studies his treatment of architecture alone in his reliefs from all stages of his career, one comes to recognize that Donatello's artistic development follows anything but a straight line. Most notably, he ultimately lost interest in the ideal of the perspective, illusionist picture space so prized by the Early Renaissance in general and that he himself had promoted at one time with such bravura. In his late works he is no longer concerned with composition and illusion, with logical order, perspective depth, or artistic arrangement, but rather with portraying human emotions as forcibly as possible.

Donatello's late statues tell much the same story. They have none of the masterful ponderousness, the expansive gestures, or the power and grace of his early ones. On the contrary, they seem extremely constricted in their movements, battered by fate, hesitant in their gestures, the victims of powerful emotions. These late Donatello works give the lie to the cliché that the Renaissance was a period concerned solely with the triumph of the individual and the pursuit of beauty. This makes them essential to a more rounded view of the age, as they illustrate most impressively its inner conflicts. One cannot imagine a greater contrast than that between the statue of the Magdalene in the Opera del Duomo (plate 128), carved shortly after Donatello's return to Florence from Padua in 1453, and the bronze *David* he had created only a few years before (plates 105–9).

Donatello's late work is also very different from all of the rest of the work being produced in the workshops of Florentine sculptors at that time. In 1450 the leading lights were Bernardo Rossellino and Luca della Robbia. Essentially, both had remained loyal to their origins, the influences of the early Donatello, Ghiberti, and Michelozzo. As a creator of figures, Luca was unquestionably the more important of the two. The traces of classical forms he preserved in those figures have their parallel in Rossellino, increasingly employed as an architect over the years, in the realm of ornament. Both drew on a

relatively narrow and clearly circumscribed repertoire of ancient motifs, which is why their work strikes one as classicistic. Neither of them assimilated the more individual aspects and more animated expressive forms of classical figural sculpture. Instead, their figures are characterized by calm, sedate movements and a uniform lack of emotion in expression and gesture, wholly representative of the *moderatio* prescribed by Alberti. This alone places them in sharp contrast to the work of the late Donatello.

Until well into the 1430s, nearly all of the sculptors of Florence had been engaged in the decoration of the Duomo, but about the middle of the century, that structure had long ceased to be the focus of sculptural activity. Instead of one great project, there were now a number of smaller commissions, an increasing number of them for private patrons. Lavish wall tombs for prominent clerics and noblemen were the main new assignments for Florence's sculptors. The two tomb monuments produced by the Donatello and Michelozzo workshop, one for Baldassare Coscia in the Baptistry in Florence (plate 63), the other for Bartolomeo Aragazzi in Montepulciano (plates 156–58), had given a definite impetus to this trend. The latter served in large part as the model for the first wall tomb of the new type in Florence, the tomb Bernardo Rossellino created for Leonardo Bruni about 1450.

The Bruni monument (plate 187) introduced the classical type of wall tomb in Florence. With certain modifications, its basic design would be imitated both in Florence and elsewhere for a long time to come. A number of scholars have suspected that Leon Battista Alberti had a hand in its design, and although this has not been proven, it is certainly possible, especially since at the very time Bernardo began the work he was in charge of the construction of the Palazzo Rucellai, working closely with Alberti.

The Bruni tomb clearly served as the starting point for Luca della Robbia when he undertook the Tomb of Bishop Benozzo Federighi a few years later (plate 170). Significantly, however, his work became less architectonic than the earlier monument and more like a picture, for he placed a frame of colored majolica around all four sides of the square wall niche containing the sarcophagus. The delicate floral ornament of this frame— unmistakably patterned after Ghiberti's—and the use of colorfully glazed terra-cotta are typical of Luca. He had begun to specialize in glazed terra-cotta in the early 1440s. It was his work in this medium that led to his popularity as an artist and would become for many the very quintessence of Quattrocento sculpture. He used it for figural reliefs, like the lunettes above the sacristy doors in the Duomo (plates 168, 169) and the apostle tondi for the Pazzi Chapel, as well as for purely decorative works, such as coats of arms or ceiling ornaments (plate 171). The medium was both inexpensive and highly ornamental. His most popular works, even today, are his *Madonna* reliefs in simple white-and-blue glazed terra-cotta, which were produced in great numbers by his workshop. In large part thanks to them, Luca's art is frequently seen as the culmination of the classicist style and thus the high point of Early Renaissance sculpture in general. Critics point to the calm and integrity of his figures, praising his formal clarity and extreme cultivation of his style as somehow "classic," even "Greek," as opposed to the overly emotional art of Donatello.

Unlike Bernardo Rossellino and Luca della Robbia, the generation of Florentine sculptors that came to the fore about 1450 reveals the influence of the late Donatello. This is especially true of Desiderio da Settignano, who at a very young age created his masterpiece in the tomb for the Florentine chancellor Carlo Marsuppini (plate 199), who died in 1453. It is virtually certain that he was requested to follow the pattern of the Bruni monument (plate 187), for the similarities between the two works are numerous, however telling their differences in detail. Above all he softens the design's contours and lightens its individual elements, so that the

architecture seems less austere. The forms are enriched and refined. Curving outlines soften the pattern of verticals and horizontals, the decor is elegant, the figures delicate. Everything has been thinned down, even the botanical ornaments. Some of the purely decorative details, such as the sphinxes on the base or the acanthus foliage on the sarcophagus, are executed with a subtlety and delicacy previously unknown.

Moreover, Desiderio varies and combines his decorative elements more creatively than either Bernardo Rossellino or Luca had, and in this he would soon be followed by Antonio Rossellino and Verrocchio. Desiderio favors extremely flat relief and angular figures that barely fit in their frames. One sees this most clearly if one compares the lunettes from the Bruni and Marsuppini tombs (plates 188, 200). This was a feature obviously borrowed from the late works of Donatello. The same is true of his statues, which display the slenderness, delicacy, scanty clothing, and lively expressions of the late Donatello. In his search for maximum expression, however, Desiderio frequently succumbs to a certain mannerism, so that his faces, usually with open mouths, seem somewhat rigid and masklike. Of all his works, the "*Panciatichi Madonna*" in the Bargello (plate 198) seems least forced in this regard, and this alone identifies it as among his earlier sculptures.

Desiderio's works provide ample illustration of the increasing demand for sculpture on the part of private patrons. To satisfy it he created not only *Madonna* reliefs and portrait busts—now suddenly fashionable—but also relief portraits of Roman emperors and statues, busts, and reliefs depicting Christ and St. John the Baptist in their childhood, which were meant to be displayed in private houses for pedagogical purposes. Among these last are the "*Giovannino Martelli*" (plate 203) and the relief tondo with Christ and St. John in the Louvre. From this point on, Florence's sculptors could count on private commissions such as these in addition to the customary tombs, tabernacles, and altarpieces.

Desiderio died quite young, at roughly thirty-four. Of the artists from his own generation, Mino da Fiesole continued to be most indebted to him. Antonio Rossellino, by contrast, made his own mark in his masterpiece, the Tomb of the Cardinal of Portugal from 1466 (plate 193). He is more sparing in his use of mere ornament and gives greater prominence to his figures. He invests even his secondary figures with more lively expressions and greater movement and underscores these with draperies that once again display more excess fabric than those of Desiderio and Mino. Following Donatello's lead, Antonio incorporates his animated figures into the ensemble of the monument with uncommon freedom, emphasizing their delicate balance and seeming weightlessness in contrast to the architecture. His two kneeling angels, tentatively perched on jutting sections of the entablature, are especially successful, superbly expressive of the transitory moment. Figures like these, or like the hovering angels supporting the *Madonna* tondo, will later become standard features in the work of Verrocchio and Benedetto. But it is not with such details, but rather with his altogether masterful balance of architectural elements and figures that Antonio Rossellino set a new standard for the following years. The most obvious testimonial to his influence is Verrocchio's *Christ and the Doubting Thomas* group for Orsanmichele (plate 269).

Desiderio, as a follower of the late Donatello, tended to create extremely thin, angular figures and exhibited a marked preference for relief. In his Portugal monument, Antonio restores a certain physical weight to the figure, a heightened sense of inner and superficial movement, and obviously prefers creating figures in the round. He provides a superb example of the latter in his *St. Sebastian* in Empoli (plate 196). This figure, probably created as late as the mid-1470s, is one evidence of the heightened interest in Florentine art in general at this time in both the animated nude and increasing pathos.

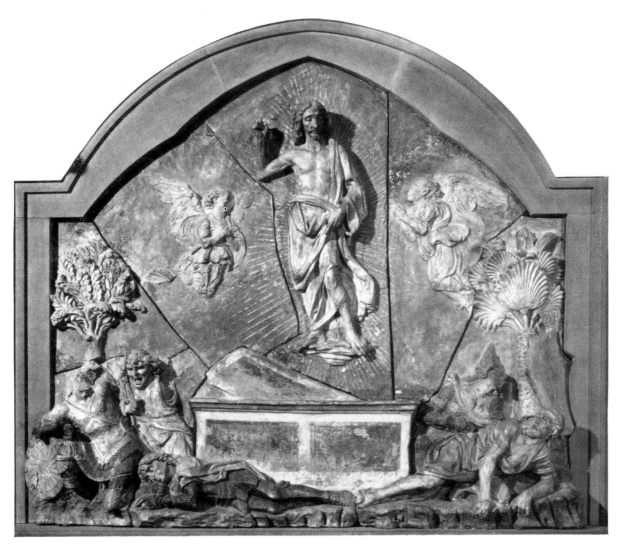

Verrocchio and Leonardo da Vinci (?). *The Resurrection*. Museo Nazionale del Bargello, Florence

Unlike Donatello, neither Desiderio nor Mino devoted themselves to the study of the manifold possibilities of movement and expression in the human figure. From the 1470s on, however, all of Florence's artists tended to do so as a matter of course. Systematic studies of the nude, anatomy, and drapery become ever more important, as is amply demonstrated by the surviving drawings by Leonardo, Verrocchio, and Antonio del Pollaiuolo. The point of this study was not so much a precise rendering of the model or of reality as it was a mastery of expression in movement. Alberti had stated the problem succinctly when he insisted that "the motions of the soul can only be expressed in the movements of the body." While Donatello had known this, it only now became a concern of artists generally. Leonardo's drawings explore every possible aspect of the problem. Small bronzes like the *Hercules and Antaeus* group of Antonio del Pollaiuolo (plate 259) and the *Bellerophon* of Bertoldo (plate 278) are attempts to resolve it in three dimensions. The small format of these latter works, and the fact they were intended exclusively for the connoisseur, made them an ideal medium for experimentation, and one in which sculptors could readily demonstrate their new ideas. Large-format works offered fewer opportunities, for more often than not they were commissioned for public spaces and their subject matter was prescribed, so that the artist was necessarily required to compromise.

In the 1470s, a new type of artist emerged, one trained in the local craft tradition but attuned to new artistic concerns. In any case, the boundaries between the various specialties were becoming increasingly fluid. This was not entirely new for Florence, to be sure, for Brunelleschi, Ghiberti, and Michelozzo had already made names for themselves in fields far removed from their training as goldsmiths. Yet about the middle of the fifteenth century the most prominent sculptors in Florence, Luca della Robbia, Bernardo Rossellino, Desiderio da Settignano, Mino da Fiesole, and Antonio Rossellino, were all men who had apprenticed as sculptors in stone and belonged to the stonecutters' guild. Almost the only one to continue the tradition after Antonio Rossellino was Benedetto da Maiano. Antonio del Pollaiuolo and Verrocchio were goldsmiths, Bertoldo a medallist who limited himself to small-format works in bronze. The former were painters as well, a talent they shared with Leonardo da Vinci, who for his part, since he worked in Verrocchio's workshop from 1469 to 1476, undoubtedly had more than superficial knowledge of sculpture. Otherwise, he could hardly have undertaken a project as large as the Sforza monument in 1483. If his design had been realized, it would have surpassed all other large-format sculptural projects of the period.

In his letter to Lodovico Sforza applying for the assignment, Leonardo described himself as an artist capable of executing sculptures in marble, bronze, and terra-cotta. Scholars are nevertheless divided about whether and to what extent Leonardo actually worked as a sculptor in his early years in Florence. Most recent scholarship has overwhelmingly rejected earlier attributions to him. These reconsiderations may be justified, but it does not alter the fact that a number of the works of Verrocchio and his workshop reveal the definite influence of Leonardo. One of these is the *Resurrection* relief from Careggi—now in the Bargello (illus. p. 47). Its dramatic gestures and expressions suggest that Leonardo himself was either the work's creator or at least a collaborator. Another is the relief of the Beheading of St. John the Baptist from the silver altar in the Florence Baptistry (plate 272).

Verrocchio was unquestionably the most prominent of the Florentine sculptors of the period. No one was as versatile as he, so skilled in both stone and bronze, so capable of combining grandiose forms with the delicacy of small sculpture. In his early years he enjoyed the favor of the Medici more than any other artist. For them he executed a number of important works, including his bronze *David* (plate 266). In many respects—like the lavabo in the Old Sacristy of San Lorenzo, the attribution of which is disputed—that work is still reminiscent of Desiderio. In the 1470s and 1480s, however, his work takes on some of the characteristics of Antonio Rossellino and Leonardo. At the same time there is an astonishing variety in his style during this period. A lightness and grace of movement and distinct formal elegance predominate in works like his *Christ and the Doubting Thomas* group for Orsanmichele (plate 269), his Forteguerri cenotaph (plate 273), and his small bronze putto (plate 271). By contrast, works like his relief for the silver altar and his equestrian monument of Bartolommeo Colleoni in Venice, which occupied him during his last years, are much more concerned with expression and are in this respect closer to Leonardo.

In the fifteenth century, monumental bronze works like the Colleoni statue (plates 276, 277) were the exclusive province of Florentine sculptors, so that it is not surprising that the Venetians turned to Verrocchio with this commission. Donatello had been summoned to Padua for the same reason forty years before, and Leonardo was called to Milan in the 1480s. Anyone in Italy contemplating a large work in bronze during these decades automatically turned to the artists of Florence. One such patron was Cardinal Giuliano della Rovere—

the later Pope Julius II—who engaged the brothers Antonio and Piero del Pollaiuolo to erect a tomb in St. Peter's for his uncle, Pope Sixtus IV (fig. 82). That he chose these specific artists is a definite indication that the pope had in mind a bronze monument from the beginning, although at that time wall tombs in marble were the rule. The Sixtus tomb is thus to be compared to the Tomb of Pope Martin V in San Giovanni in Laterano (fig. 34), for which Donatello had supplied the bronze slab in the 1440s. The two monuments differ considerably in detail and clearly reflect the changes that had come about in Florentine sculpture in the interval. Despite all its delicate detail, the Tomb of Pope Martin V is characterized by simplicity, severity of form, and modest dimensions. Not so the Sixtus tomb, which far surpasses the earlier work both in size and in sumptuous decor, with its allegories of the Virtues and the Sciences. The variety, grace, weightlessness, and nimbleness of these allegorical figures, the airiness and playful excess of their drapery, the springlike strength of the framing acanthus volutes—all are characteristic of Florentine sculpture of the time, rooted as it was in the art of goldsmithing, and the work as a whole represents its culmination.

Against this background of decorative splendor and virtuosic artistry, the figure of Benedetto da Maiano seems almost an anachronism. He had trained in the workshop of Antonio Rossellino and was the only one of the well-known Florentine artists of the 1480s who worked almost exclusively in marble. He produced a number of marble altars, shrines, tombs, pulpits, Madonna reliefs, and busts, not only for Florence, but also for Faenza, San Gimignano, Naples, and other towns. Nevertheless, he did not command either the delicacy and dexterity that mark the figures of Antonio del Pollaiuolo or the energetic gestures and lively expressions found in the late works of Verrocchio. Only in his late years do his figures take on a unique expressiveness and power, as is seen above all in the coronation group he produced for Naples (plate 290) or his *St. Sebastian* (plate 292). One does note even in his earlier work a more limited decorative variety and an increasing emphasis on the three-dimensional volume in his figures. This latter characteristic leads in his late work to massive figures of monumental heaviness. In this respect this sculptor in stone was markedly different from the bronze sculptors of his generation. And the same feature serves to link him to the early Michelangelo, an apprentice painter who in about 1490, in a move quite unusual at the time, turned his talents to sculpture in stone, which he would soon lift to new and transcendent heights.

The Diffusion of Early Renaissance Sculpture
in the Rest of Italy

The history of Early Renaissance sculpture in Italy centers around its development in Florence. Although Siena was quick to adopt the new style, it was only after the middle of the century that it slowly began to spread to the rest of the country. Examples of the new sculpture seen in other cities before that time were almost exclusively exports from Florence. Among such exports were the bronze reliefs provided by Donatello and Ghiberti for the font in Siena's Baptistry, the Brancacci tomb in Sant'Angelo a Nilo in Naples (fig. 42), the exterior pulpit for the cathedral in Prato (fig. 31), and the bronze slab for the Tomb of Pope Martin V in Rome (fig. 34). From the 1430s on, the sculptors of Florence were increasingly in demand even outside their native Tuscany. Donatello worked in Rome and Padua, Filarete in Rome and Milan, Agostino di Duccio in Rimini and Perugia, and Mino da Fiesole in Rome. Only in the 1450s do we find non-Tuscan sculptors and stonecutters adopting the forms of the Early Renaissance in Florence and carrying them to far-flung regions of the country. Most of these were either Lombards or Dalmatians, itinerant artists skilled in sculpting in marble who worked wherever they could find commissions. Only rarely did they settle in one place permanently. The best known of these are Pietro Lombardo, Andrea Bregno, Francesco Laurana, Giovanni Dalmata, and Niccolò dell'Arca.

Outside of Florence, Siena was the only city to develop a sculptural tradition of its own at the beginning of the fifteenth century and to produce a constant quantity of work. New developments in Florentine sculpture soon left their mark here as well. It is most apparent in the work of Jacopo della Quercia, the most important Sienese sculptor of this period. In his earliest surviving works, the *Madonna Silvestri* for the cathedral in Ferrara and the tomb for Ilaria del Carretto in the cathedral at Lucca (plate 27), Quercia shows himself to be a typical exponent of the International Gothic style. However, by the second decade of the century one can see a distinct change in him. It was then that he created the *Fonte Gaia* in Siena (plates 28, 29) and the Trenta Altar (fig. 14) in Lucca, whose figures already reveal the influence of Donatello. His new style is even more apparent toward the end of the 1420s in the bronze relief he contributed to the baptismal font in Siena (plate 33). In its use of space, its architectural background, its arrangement of figures, and the poses of those figures it is directly indebted to the *Herod* relief of Donatello (plate 68). Collaboration on the baptismal font also forced another Sienese artist to come to terms with the innovations of Florentine sculpture, namely, Giovanni di Turino. A third local artist, Francesco di Valdambrino, who like Quercia had taken part in the competition for the door of Florence's Baptistry in 1401, remained much more independent of them. He worked only in wood throughout his career.

Quercia, Francesco di Valdambrino, and Giovanni di Turino were succeeded by Antonio Federighi, Vecchietta, Neroccio di Bartolomeo, Giovanni di Stefano, and Giacomo Cozzarelli. Despite their uniquely Sienese qualities and individual differences, their works make it clear that even in the following decades Siena's sculptors continued to be strongly influenced by developments in Florence. After Quercia, the one most affected

by them was Vecchietta. Federighi, for example, continued to be largely indebted to Quercia, producing voluptuous draped figures and nudes. However, Vecchietta was quick to adopt many of the features of Donatello, who had settled in Siena for a time in 1457, particularly those of his works produced after 1460. And it was in Vecchietta's workshop that Neroccio di Bartolomeo, Giovanni di Stefano, and Francesco di Giorgio received their training. Interestingly enough, Vecchietta and the sculptors who worked under him had first apprenticed as painters. The prominent Florentine sculptors at this time, Verrocchio and Antonio del Pollaiuolo, had also changed careers in this way. And just as Florence saw the emergence of a new type of virtuoso artistry in the 1470s, Siena had its Francesco di Giorgio, who was equally accomplished in a number of fields. It is significant that as a sculptor he preferred to work in bronze, which at this time was supplanting stone as the favored medium in Siena just as it was in Florence.

Lucca's artistic output in this same period was in no way as rich as Siena's. Nevertheless, Lucca was the only city in Tuscany, after Florence and Siena, to develop its own sculpture workshop. It was founded in the 1460s by Matteo Civitali, who, as we can see from his tomb for Pietro da Noceto (plate 216), had obviously begun his career in Florence as a pupil of Antonio Rossellino. Throughout his career, Civitali worked almost exclusively in marble. The one important exception would have been the bronze equestrian statue for France's King Charles VIII that he was asked to create with the goldsmith Francesco da Marti in 1495, but that commission was never completed.

Outside of Tuscany, two very different projects, each with its own distinctly classical character, were largely responsible for the further development of Early Renaissance sculpture in Italy. Both were undertaken by princes as monuments to themselves. One was the Tempio Malatestiano in Rimini, started in 1450 (fig. 47), the other the Triumphal Arch of Alfonso I in Naples, begun in 1453. The sculptor most responsible for the former was the Florentine Agostino di Duccio, who had been summoned to Rimini from Venice. Sigismondo Malatesta had determined to subject a Gothic Franciscan church to a complete renovation, with an imposing new exterior designed by Alberti. The sculptural decorations created under Duccio's supervision were an integral part of the project. It is assumed that Alberti had also helped to outline the ambitious sculptural program for the interior. One feature that would tend to confirm this is the highly unusual appearance of statues of saints in aediculae — in unmistakable imitation of classical shrines — in place of altar retables. The remaining decor of the church's six chapels, two of which house the splendid sarcophagi of the Malatesta and Isotta families, consists of statues of Virtues and Sibyls and reliefs presenting allegories of the Planets (plate 182) and the Arts and depictions of frolicking children making music (plate 183). As a whole, the interior of the church gives the impression of being a Malatesta mausoleum, mainly because of the uncommon proliferation of references to Sigismondo himself (plate 181).

Everywhere one turns there is his coat of arms, a portrait of him, or some commemorative inscription. The predominantly secular nature of the entire pictorial program was highly unusual and was accordingly criticized in the sharpest tones by Pius II, who felt it altogether inappropriate. In his view, Sigismondo had filled the new San Francesco with so many heathen images that it no longer seemed like a place for Christian worship but rather a temple for godless demon-worshippers. One can see how this Piccolomini pope approached a project just as ambitious as the Tempio Malatestiano in the Duomo at Pienza, which he had rebuilt in the years 1460–62. The sculptor-architect Bernardo Rossellino was in charge of the renovation, yet sculpture is very little in evidence. And although the old Corsignano was redesigned in the true Renaissance spirit, one cannot help but notice how

careful its artists were not to overstep the bounds of propriety in drawing on the wealth of classical motifs so universally employed in the preceding years. These examples make it clear that in the Quattrocento, when classical and medieval ideas were so confusingly intermingled, an artist often had real reason to consider what sort of decor was appropriate for a sacred structure as opposed to a secular one.

As a purely secular monument, the marble triumphal arch (fig. 55) erected by Alfonso I at the entrance to the Castelnuovo in Naples was not so likely to give offense in this regard as the Tempio Malatestiano. The Naples monument was a deliberate imitation of triumphal arches of antiquity in its overall design and architectural details. Yet whereas classical arches were freestanding, this one was attached to existing architecture. The result is a distinctly vertical portal more reminiscent of the medieval tradition. Medieval elements are, in fact, more strongly in evidence in a surviving drawing of the project than in the finished work. The drawing (fig. 56), attributed to the Pisanello circle, is preserved in Rotterdam, and in it both the architecture and the decor appear to be a mixture of classical and late medieval motifs.

The completed monument has a much more genuinely classical feeling. Formal purity of this sort was now valued even outside of Florence, and sculptors capable of producing it could now be found outside of Florence as well. Alfonso summoned his artists from northern Italy, Dalmatia, and Rome. Pietro da Milano was placed in charge of the project. However, the most important of the sculptors involved in the execution of the arch was the Dalmatian Francesco Laurana. Laurana would later work in Sicily and France as well and moving about as frequently as he did, he contributed greatly to the spread of the new style. Alfonso's project did not bring with it a flowering of sculpture in Naples. As in Rimini, the itinerant artists engaged on it promptly left as soon as they had completed their work or when external reasons forced a cessation of activity for a time. Accordingly, no local school had a chance to develop.

The situation in Rome was quite different. Since the return of the papal court to the city in 1420 there was a renewed interest in church structures and their decoration, and especially after the middle of the century the demand for painters and sculptors increased dramatically. Up until then the only Early Renaissance sculptures in the city were isolated works created by Florentine artists. Notable examples were the Tomb Slab of Giovanni Crivelli in Santa Maria in Aracoeli (plate 78), the *Sacrament* tabernacle in St. Peter's (plate 79), and the Tomb Slab of Pope Martin V in the Lateran (fig. 34) — all by Donatello — and Filarete's bronze doors for the main portal of St. Peter's (plate 175). Sustained production of sculpture in Rome only began with artists like Isaia da Pisa and Paolo Romano. As it happens, both of them worked on the triumphal arch in Naples, but they had been active in Rome even before that commission called them away.

Isaia da Pisa trained in Donatello's workshop. In the late 1440s he had executed the tomb for Cardinal Chiavez in the Lateran, a work designed by Filarete and now preserved only in fragments. Paolo Romano, on the other hand, belonged to a younger generation much more aggressive in its adoption of classical style. He only emerged as a major sculptor in the early 1460s, and during these years he created his masterpieces, the large, freestanding statues of Sts. Peter, Paul (plate 226), and Andrew. It is possible that toward the end of his life he also collaborated on the wall tomb for Pope Pius II (fig. 67), the largest and most lavish tomb monument in Rome up to that time.

In the second half of the 1460s there was suddenly a dramatic increase in the demand for lavish marble wall tombs in Rome. Once reserved exclusively for popes, they were now commissioned by cardinals and bishops as

well. Soon increasing numbers of non-native sculptors were migrating to Rome. Two of these would achieve special prominence in subsequent years: Andrea Bregno, from Lombardy, and Giovanni Dalmata, born in Trogir (Tràu) in Dalmatia. Bregno's first work in Rome was probably the marble epitaph to Nicolas von Kues in San Pietro in Vincoli, while Dalmata made his reputation with his tomb for Cardinal Tebaldi in Santa Maria sopra Minerva. A third major presence was the Florentine Mino da Fiesole. He did not settle down like his colleagues, however, but only stayed in Rome for a few years on two occasions. Bregno, Dalmata, and Mino collaborated on a number of tombs for Roman prelates in the 1470s. Undoubtedly the most important of these was the one for Pope Paul II (plates 211, 227, 228), which occupied Dalmata and Mino in the years 1475–77. Both subsequently left the city, leaving Bregno and his workshop, with their refined but somewhat academic classical forms, as Rome's chief producers of sculpture—at least sculpture in marble—during the last two decades of the fifteenth century. It is probable that Luigi Capponi was trained under Bregno. Whenever bronze tombs were called for, as in the case of Sixtus IV (fig. 82) and Innocent VIII (plate 264), only Florentine artists like Antonio and Piero del Pollaiuolo would do.

The Late Gothic tradition lingered longest in the Veneto and Lombardy, while it was abandoned in the rest of northern Italy after the middle of the century at the latest. Donatello had produced a series of important works in the new style in Padua around the middle of the century, but it was a long time before these found local imitators. In the tombs of Erasmo and Giannantonio Gattamelata in the Santo, for example, one still finds Gothic reminiscences. Donatello's pupil Bellano was the first native sculptor to free himself of that tradition. Bellano began working continuously in Padua in the 1460s, but it was not until the 1480s and 1490s that he produced his masterpieces. In a process similar to what had taken place in Rome, it was primarily thanks to the demand for large wall tombs of the new—that is, Florentine—type that Early Renaissance sculpture conquered the Veneto. The first sure sign of this in Padua is the Tomb of Antonio Roselli in the Santo, created by Pietro Lombardo in 1467. In it the Florentine design is expanded to colossal proportions, and at the same time it is adorned with a northern Italian abundance of decorative detail.

Pietro Lombardo, whose early works betray a thorough familiarity with Florentine sculpture of the time, soon moved to Venice, where he was to assume a leading role. Beginning with his redesign of the choir of San Giobbe and his creation of the tomb for the doge Pasquale Malipiero (plate 236), he produced over the years an enormous amount of work both as architect and sculptor, gradually requiring the support of a large workshop. The most predictable employment for Venice's resident sculptors in this period was in the production of tombs of rapidly increasing dimensions for the doges. Pietro's monument for Pietro Mocenigo in Santi Giovanni e Paolo (fig. 70) represents his most important contribution to the form. It is far superior to his earlier tombs— especially in its figural sculpture—surely thanks to the influence of Antonio Rizzo. While Pietro was working on his Mocenigo monument, Rizzo was engaged in the tomb for the doge Niccolò Tron in Santa Maria dei Frari (fig. 69). As a sculptor of figures, especially as *statuario*, Rizzo was unquestionably the more important of the two. His earliest attested works, the altars for St. Paul (fig. 68) and St. James for San Marco from 1464 to 1469, are already ample proof of his preeminence. They were the first works to introduce Early Renaissance forms into Venetian sculpture. Rizzo's greatest achievements as a creator of statues are his figures of Adam and Eve (plates 234, 235), intended for the Arco Foscari in the courtyard of the Palazzo Ducale and presumably created in the early 1480s.

The main source of employment for Lombard sculptors in the fifteenth century was the Certosa di Pavia (fig. 74), founded in 1396 by Gian Galeazzo Visconti. And it is here that one finds the first penetration of Early Renaissance forms into the sculpture of Lombardy in the 1460s, when the Mantegazza brothers, Cristoforo and Antonio, and Giovanni Antonio Amadeo were entrusted with the sculptural decoration of the Certosa's two cloisters (fig. 71). It is easier to trace Amadeo's artistic development in the following years than that of the Mantegazza brothers. With his masterpiece, the Colleoni Chapel (figs. 72, 73), he was to become the quintessential Lombard sculptor in the last decades of the fifteenth century. The Lombard style differs from that of the other regions of Italy in that it frequently combines the standard Renaissance or classical repertoire of forms and motifs with highly expressive, unclassical figures and an exuberant variety of decor. Amadeo, in part under the strong influence of the Mantegazzas and obviously in part thanks to the early Bramante, represents it to perfection. In his works he uses the rhetoric of classicism far more than was customary at the time. No other tomb from the Early Renaissance is so predominant as it is in his monument to Bartolommeo Colleoni (fig. 73), soon to be imitated in Venice by Pietro Lombardo in his tomb for Pietro Mocenigo (fig. 70). Nowhere in the tomb sculpture of either Florence or Rome is there such an outpouring of classical references.

In the sculpture of Bologna, however, such references are altogether lacking. Bologna's situation also differs in other ways from that of other cities in Italy. With Quercia's statues and reliefs for the main portal of San Petronio (plates 31, 32), a link to the newest developments in Tuscan sculpture had been established early on. Yet Quercia was essentially their sole exponent. It was not until the 1460s that local sculpture took a clear step forward with the appearance of Niccolò dell'Arca. He, like Quercia before him, was not native-born. He came from either Apulia or Dalmatia and only settled in Bologna in 1460. His artistic origins are obscure, yet it appears that he was thoroughly familiar with the works of Donatello and Desiderio, even though his style would remain strongly independent of Florentine influence throughout his career.

With his earliest documented work, the extremely emotional *Lamentation* group (fig. 76) for the Ospedale di Santa Maria della Vita in Bologna, he initiated a series of monumental terra-cotta groups unique to Emilian sculpture. His chief follower in this genre was Guido Mazzoni of Modena. Unlike Mazzoni, however, Niccolò by no means limited himself to work in terra-cotta. His masterpiece, for which he became known by the epithet "dell'Arca," is the marble top for the Shrine of St. Dominic in Bologna's San Domenico (fig. 77). The work was still unfinished at his death in 1494. The twenty-year-old Michelangelo, who spent a year in Bologna beginning in the autumn of 1494, was entrusted with its completion. Typically, it was again an outsider who was asked to take on such a work. This alone makes it clear that Bologna could point to no other sculptor of importance at the time besides Niccolò dell'Arca.

Looking back, one is astonished by the variety of important sculptors and the wealth of major projects provided by Florence through the whole of the century—to say nothing of the city's brilliant achievements in architecture and painting in the same period. All in all, however, it was mainly through sculpture that the Early Renaissance in Florence gradually spread to the other cities and regions of Italy. Even in the late fifteenth century it was common to import marble works from Florence, and Florentine sculptors were being summoned to Venice, Milan, and Rome. It is instructive that the young Michelangelo, although having fled the city and scarcely proven as an artist, was able to capitalize on the fame of Florence's sculptors and land his first major contract in Bologna.

Plates

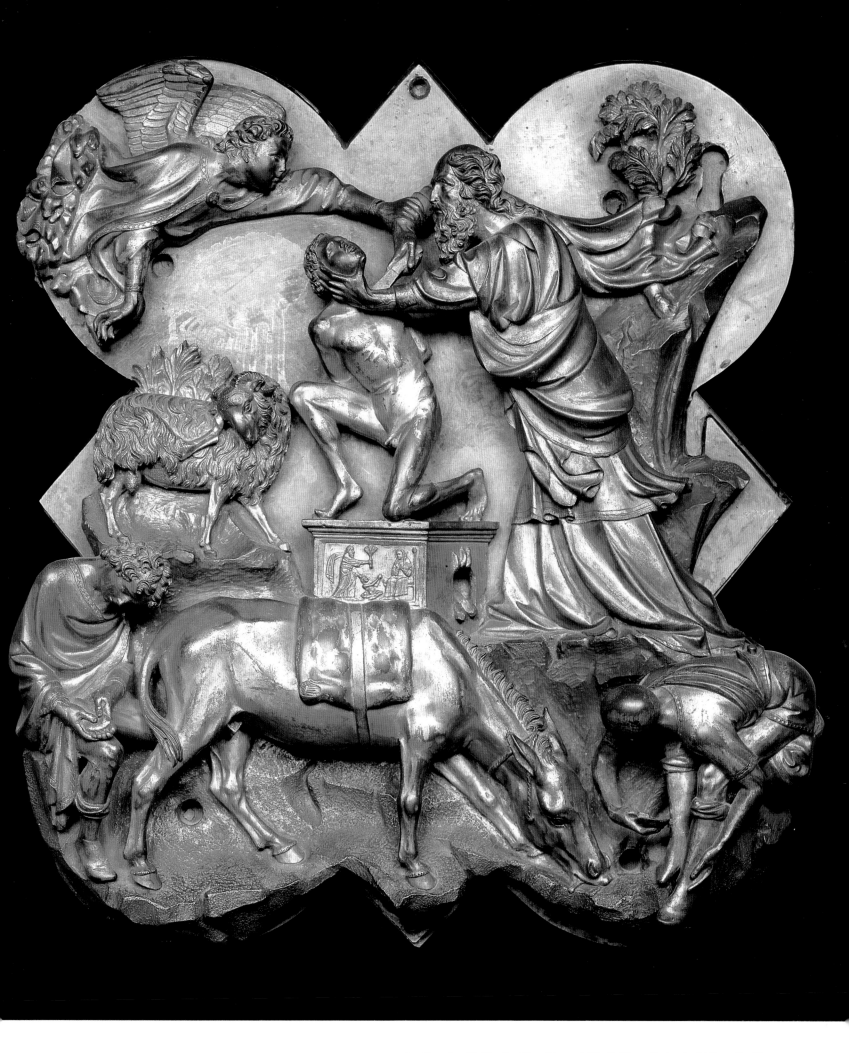

1 Brunelleschi. *The Sacrifice of Isaac*. 1401–2. Museo Nazionale del Bargello, Florence

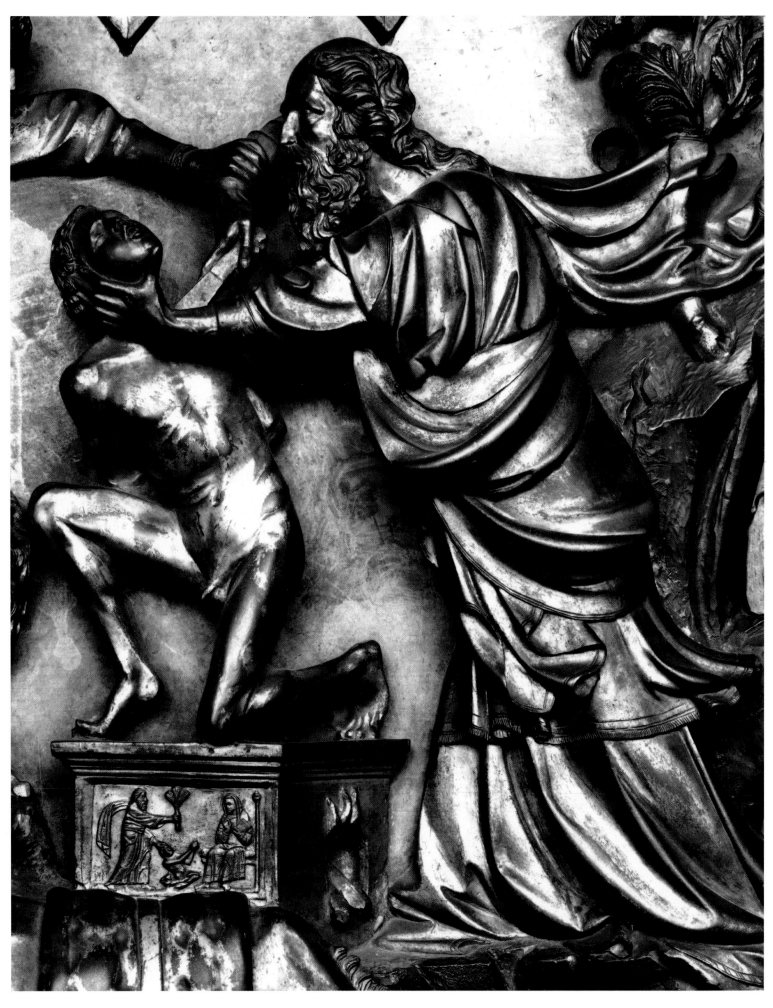

2 Brunelleschi. *The Sacrifice of Isaac* (detail: Abraham and Isaac). 1401–2.
Museo Nazionale del Bargello, Florence

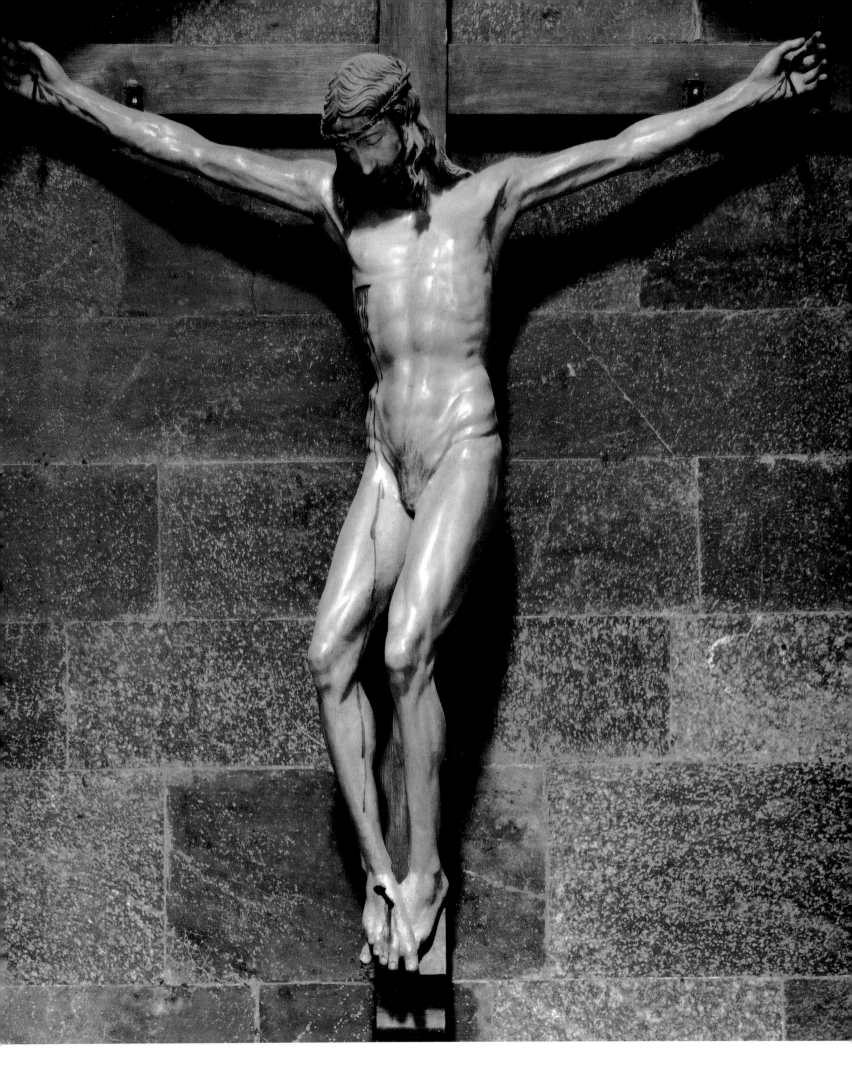

3 Brunelleschi. *Crucifix.* c. 1425. Santa Maria Novella, Florence

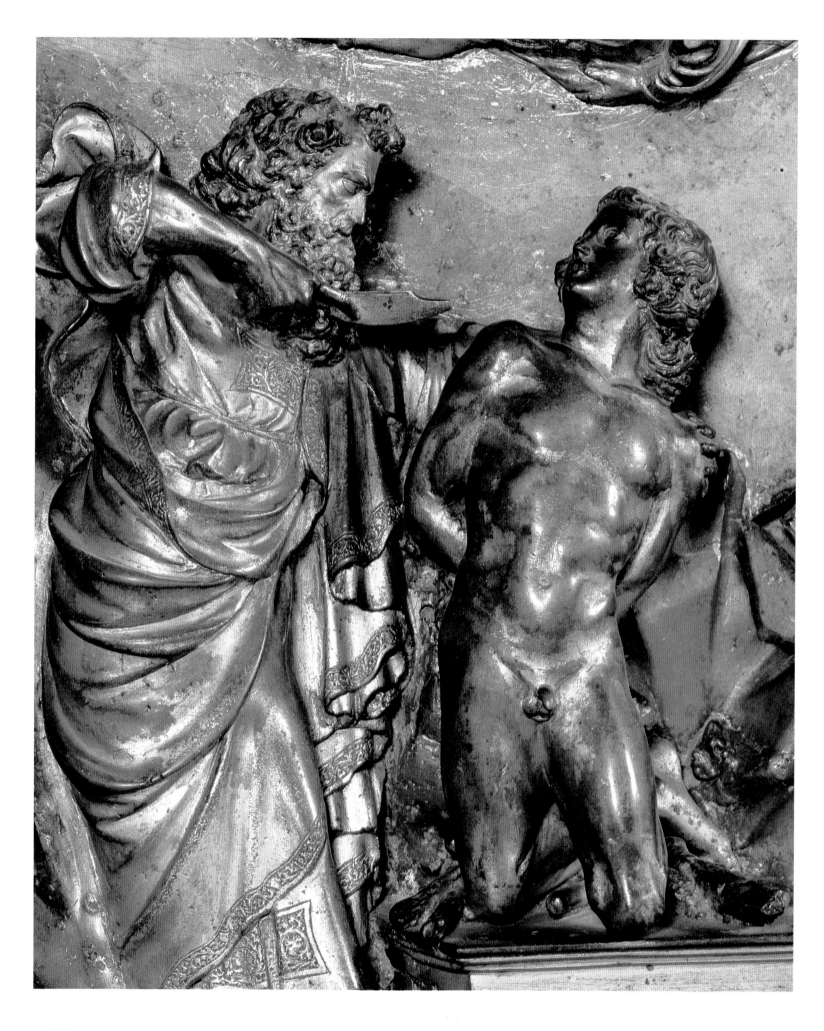

4 Ghiberti. *The Sacrifice of Isaac* (detail: Abraham and Isaac). 1401–2.
Museo Nazionale del Bargello, Florence

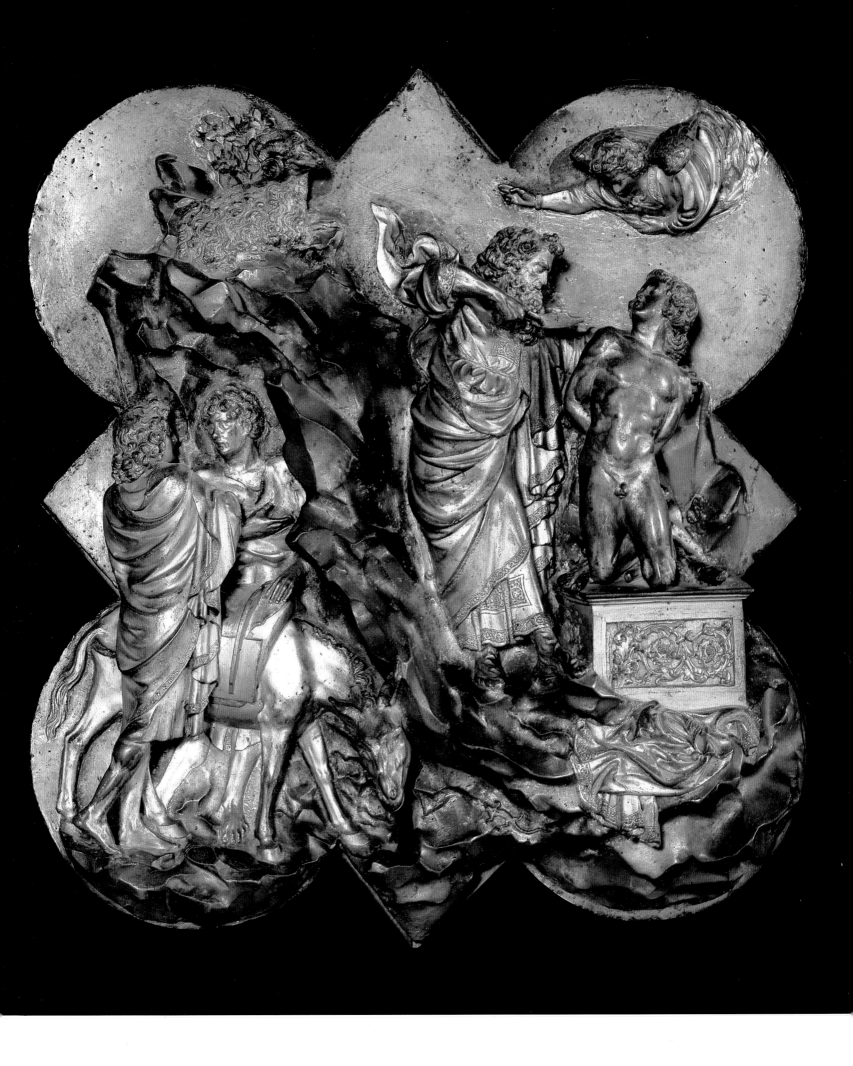

5 Ghiberti. *The Sacrifice of Isaac*. 1401–2. Museo Nazionale del Bargello, Florence

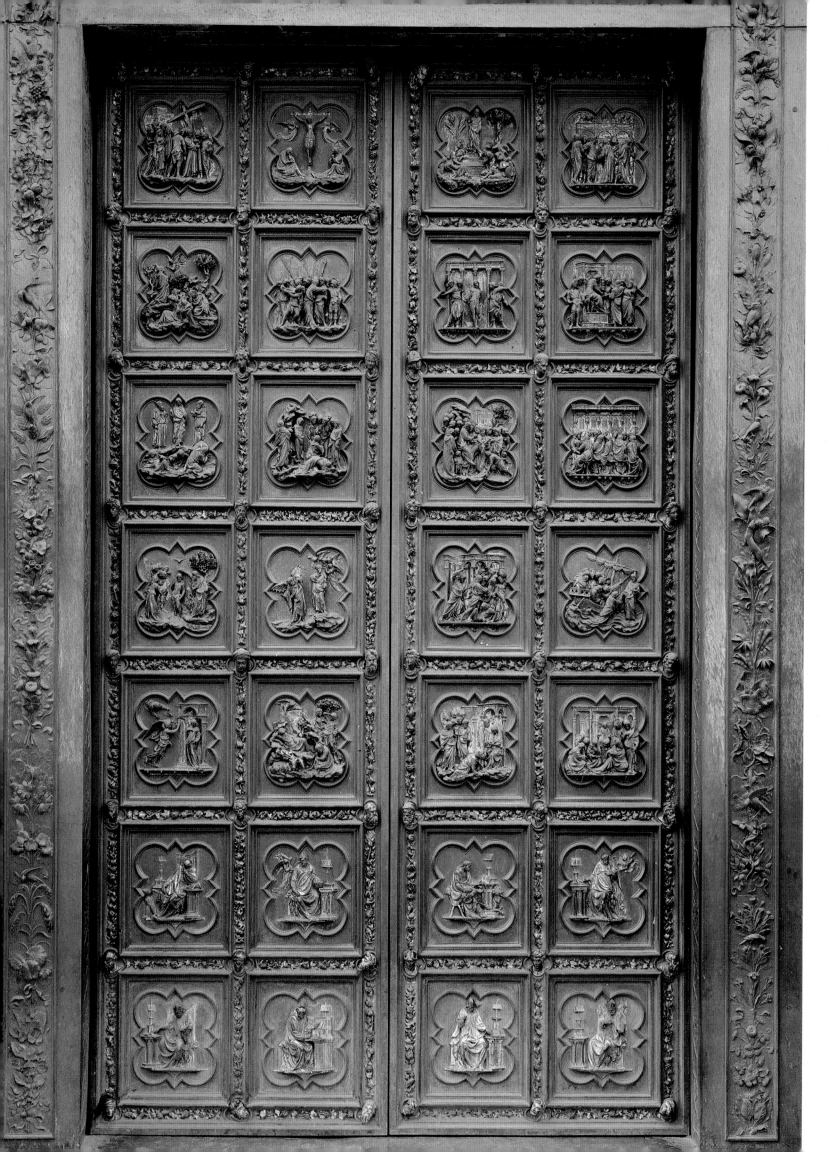

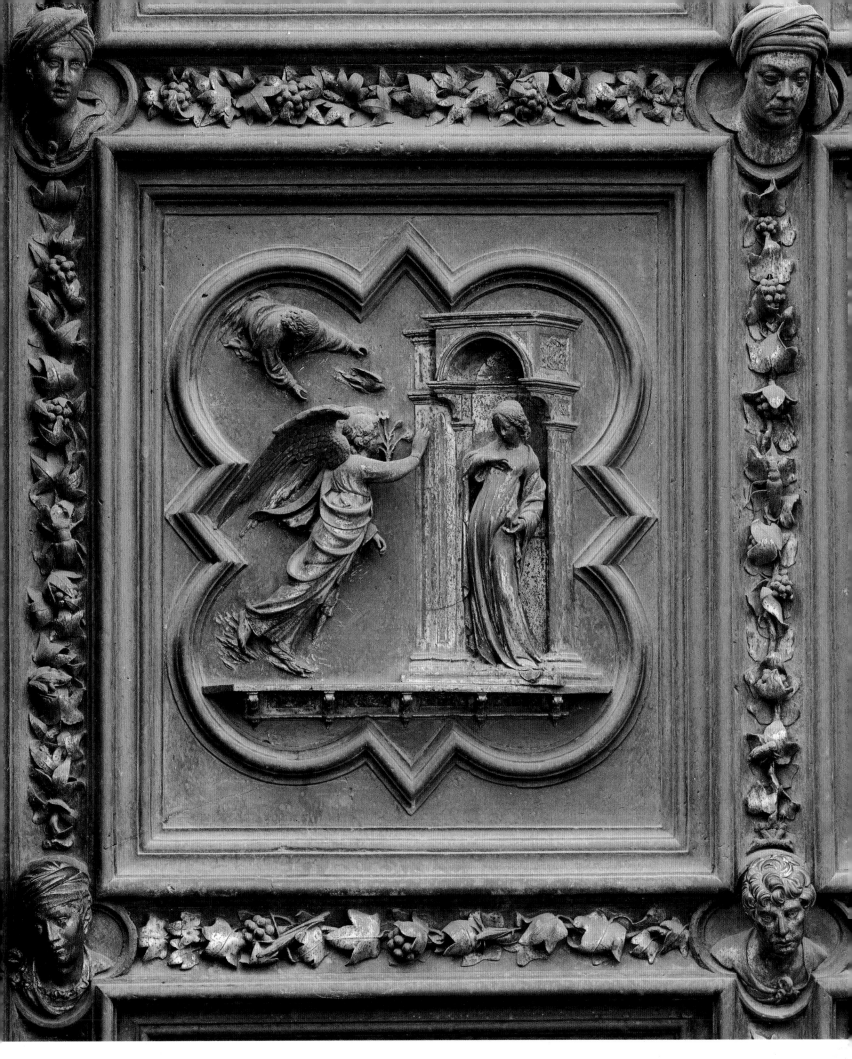

OPPOSITE:
6 Ghiberti. North Door. 1404–24. Baptistry, Florence

7 Ghiberti. *The Annunciation*. 1404–24. North Door, Baptistry, Florence

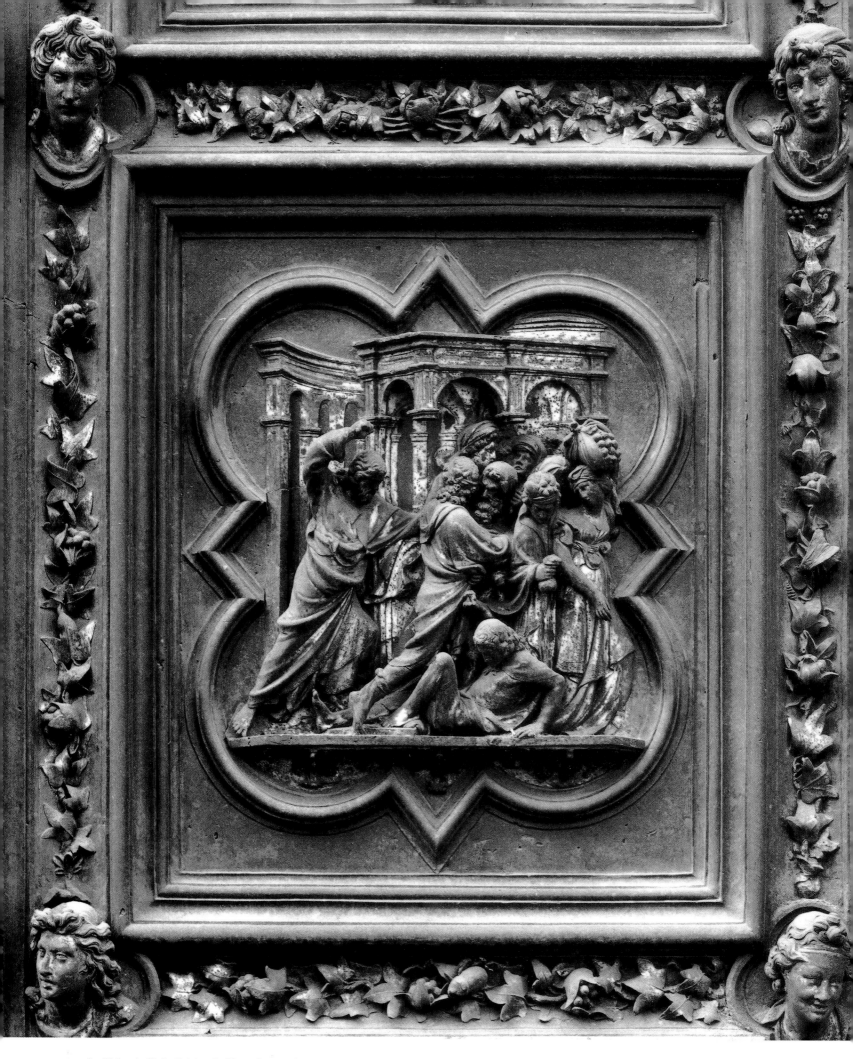

8 Ghiberti. *Christ Driving the Moneychangers from the Temple.* 1404–24. North Door, Baptistry, Florence

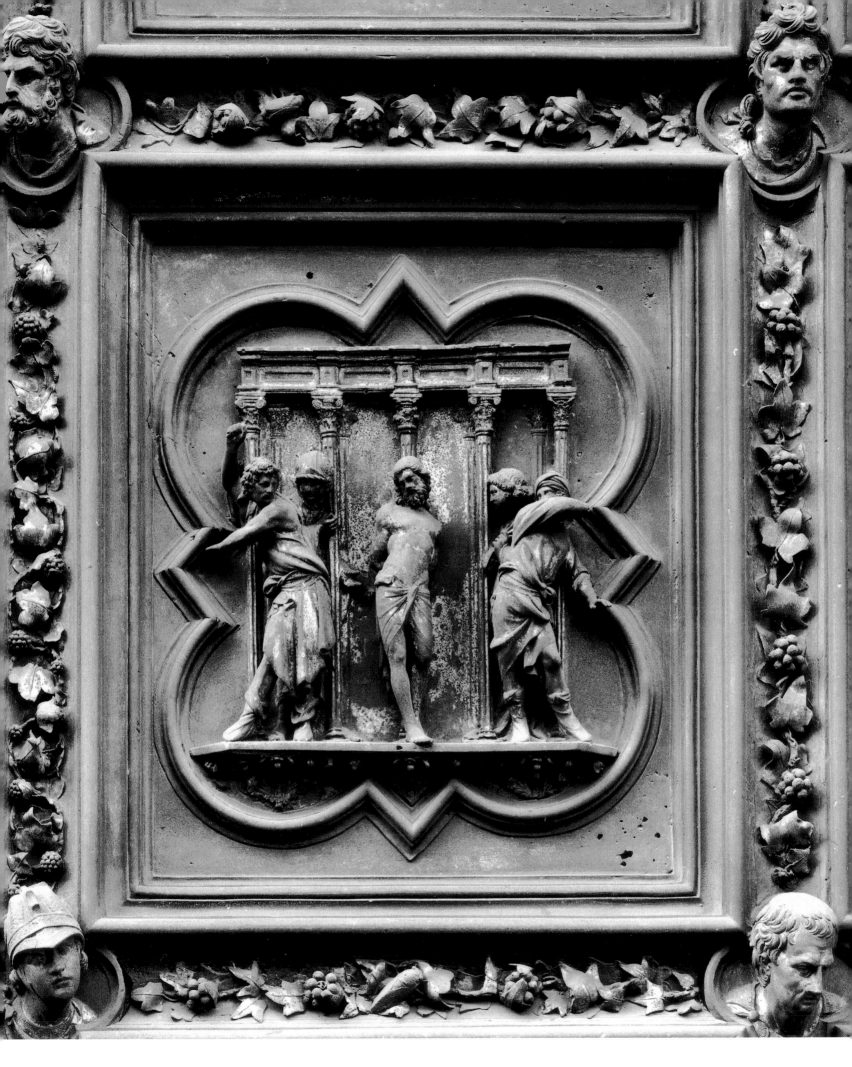

9 Ghiberti. *The Flagellation of Christ*. 1404–24. North Door, Baptistry, Florence

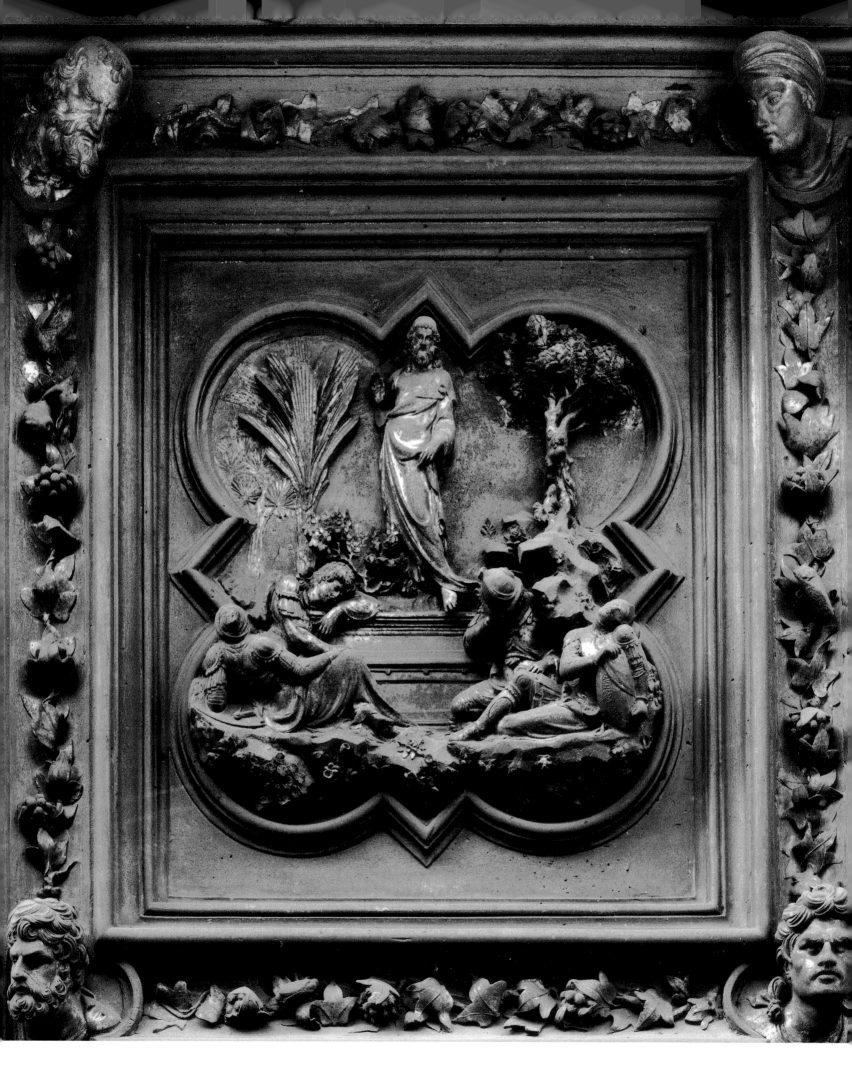

10 Ghiberti. *The Resurrection*. 1404–24. North Door, Baptistry, Florence

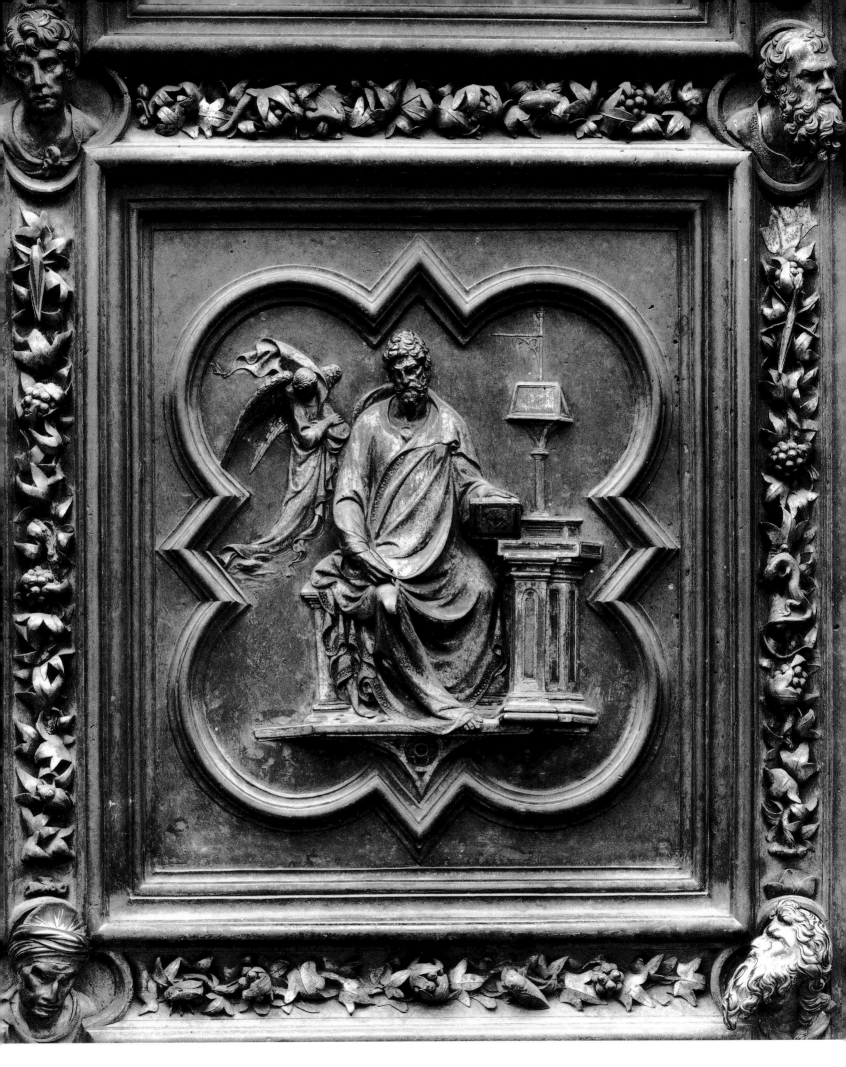

11 Ghiberti. *St. Matthew*. 1404–24. North Door, Baptistry, Florence

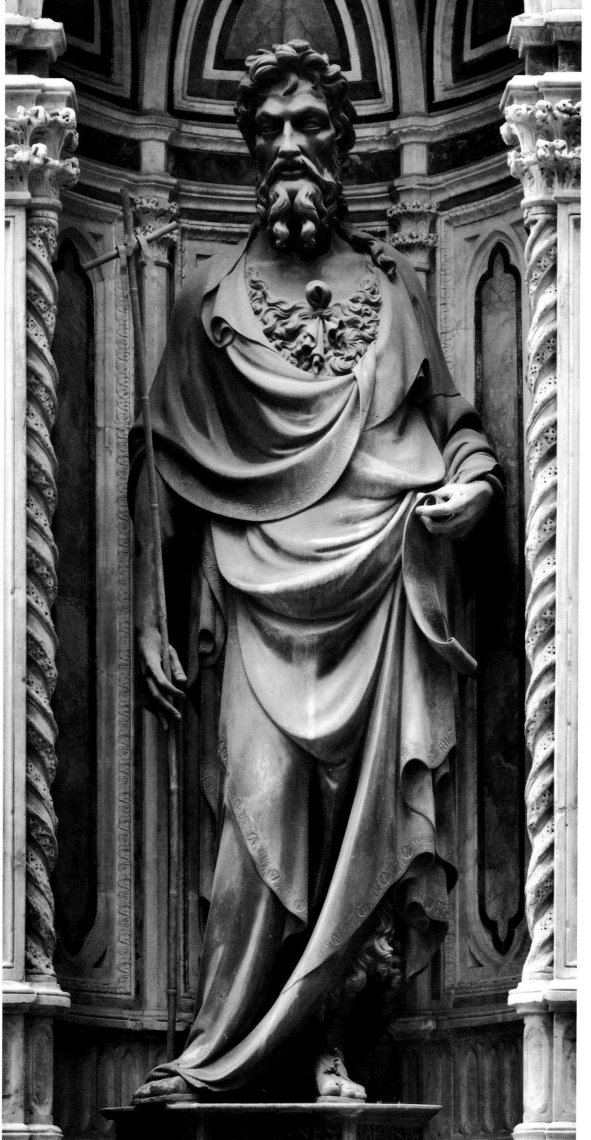

12 Ghiberti. *St. John the Baptist*. 1413–16. Orsanmichele, Florence

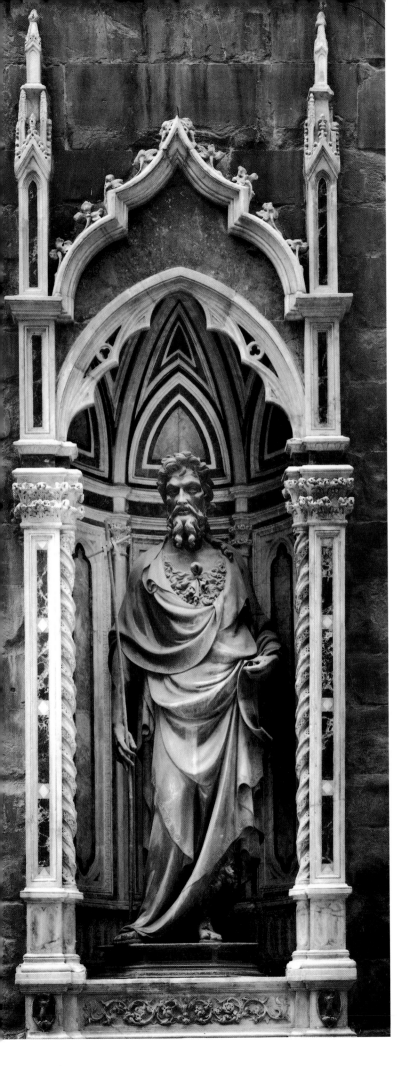
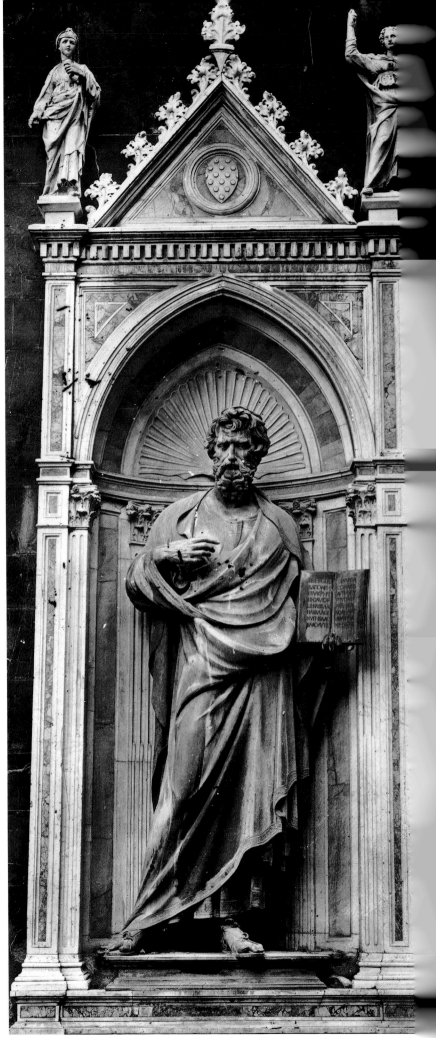

13 LEFT: Ghiberti. *St. John the Baptist*. 1413–16. Orsanmichele, Florence
RIGHT: Ghiberti. *St. Matthew*. 1419–22. Orsanmichele, Florence

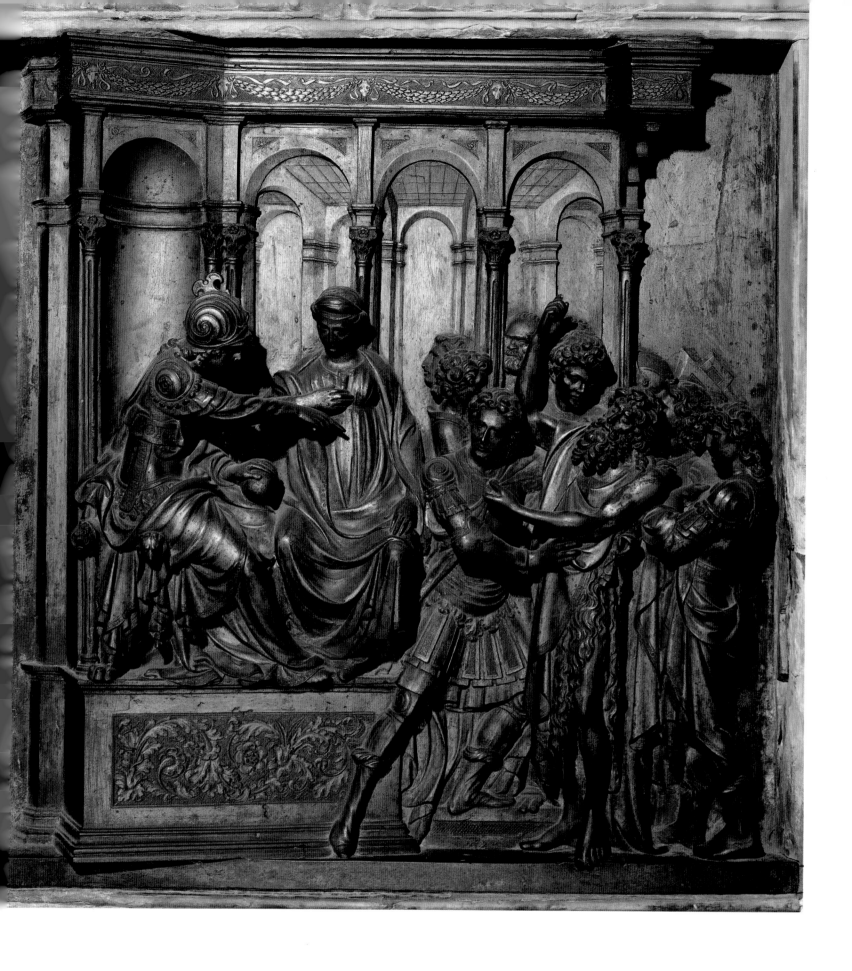

14 Ghiberti. *St. John the Baptist Before Herod.* c. 1424–27. Font, Baptistry, Siena

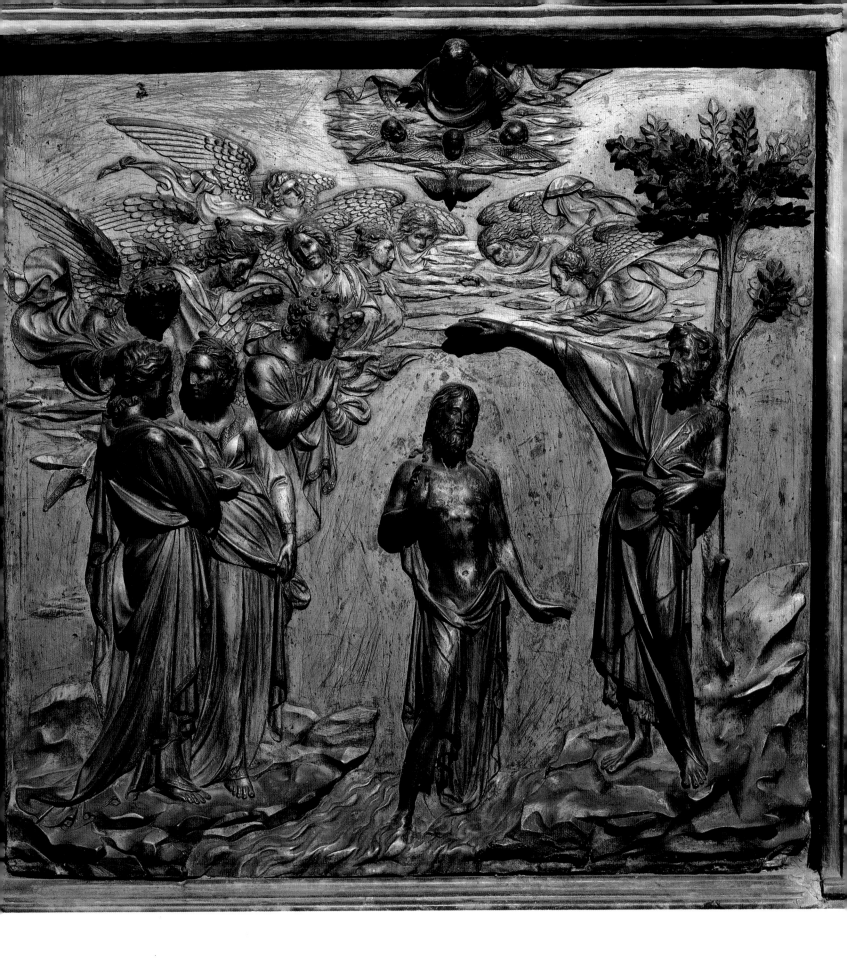

15 Ghiberti. *Baptism of Christ*. c. 1424–27. Font, Baptistry, Siena

16 Ghiberti. Tomb of Leonardo Dati. c. 1426–27.
Santa Maria Novella, Florence.

17 Ghiberti. Shrine of Sts. Protus, Hyacinth, and Nemesius. c. 1427–28. Museo Nazionale del Bargello, Florence

OVERLEAF, LEFT:
18 Ghiberti. *St. Stephen*. 1427–29. Orsanmichele, Florence

OVERLEAF, RIGHT:
19 Ghiberti. East Door *(Gates of Paradise)*. 1425–52. Baptistry, Florence

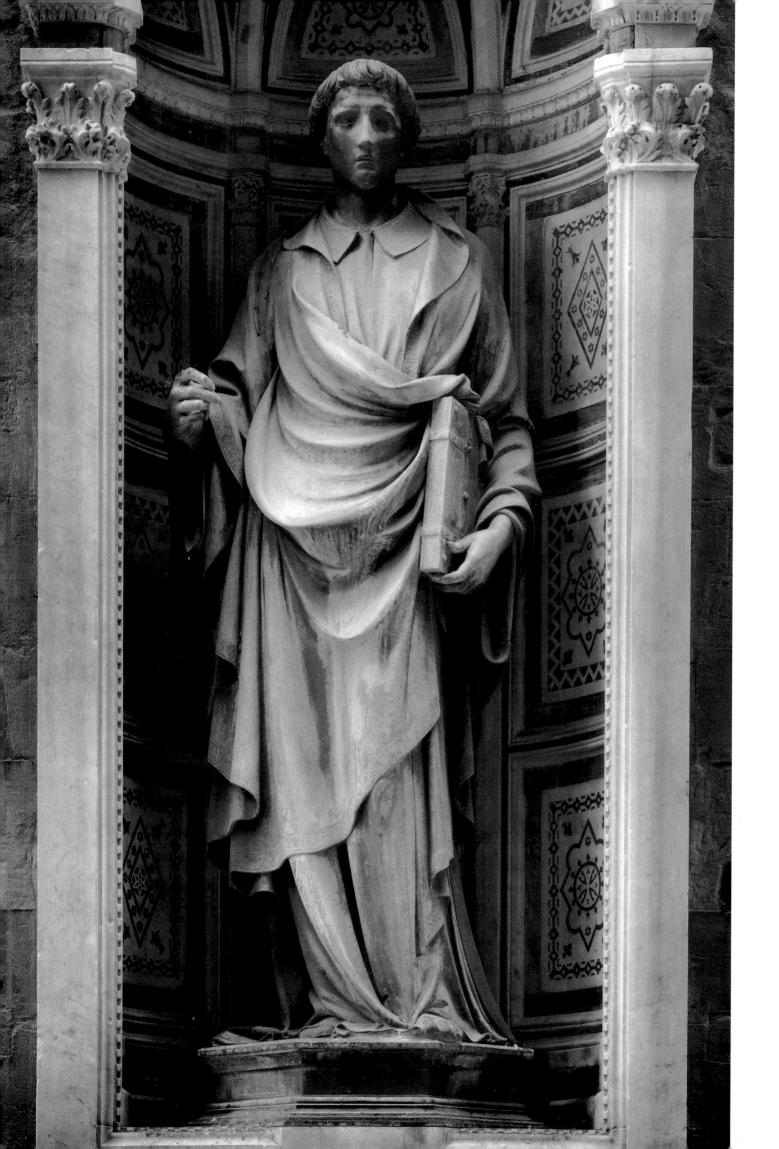

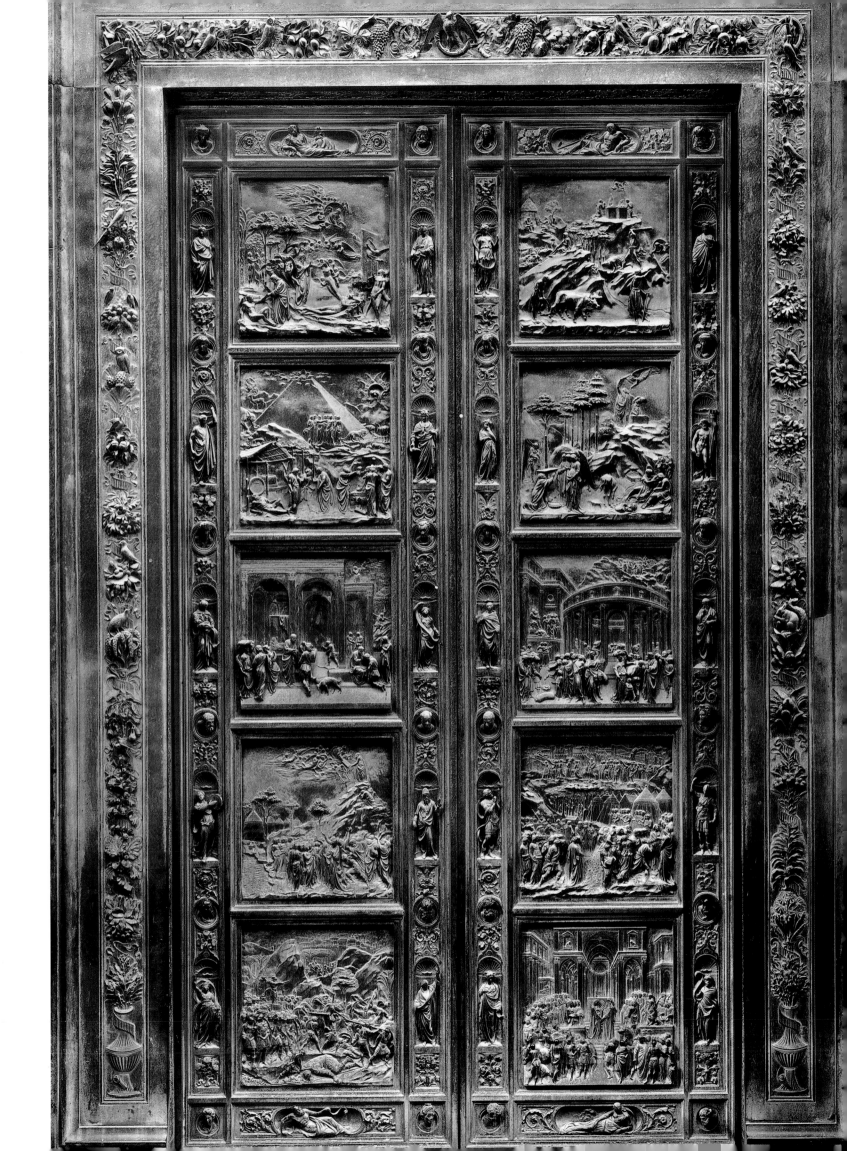

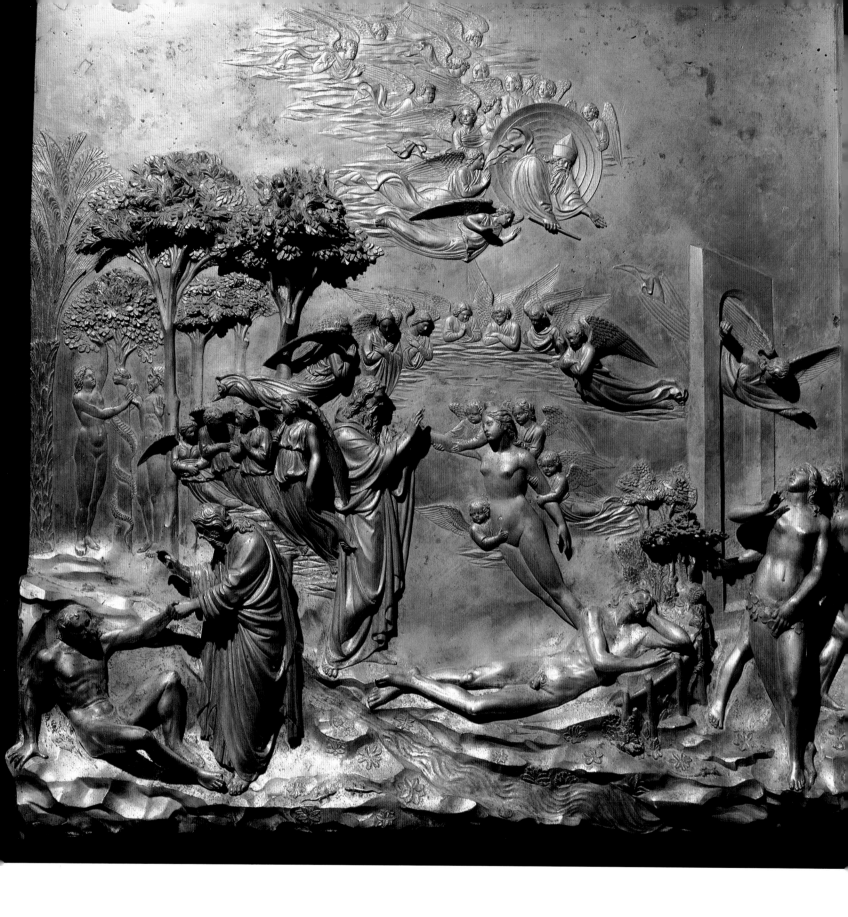

20 Ghiberti. *Creation of Adam and Eve, the Fall, and the Expulsion from Paradise.* 1425–52. East Door, Baptistry, Florence

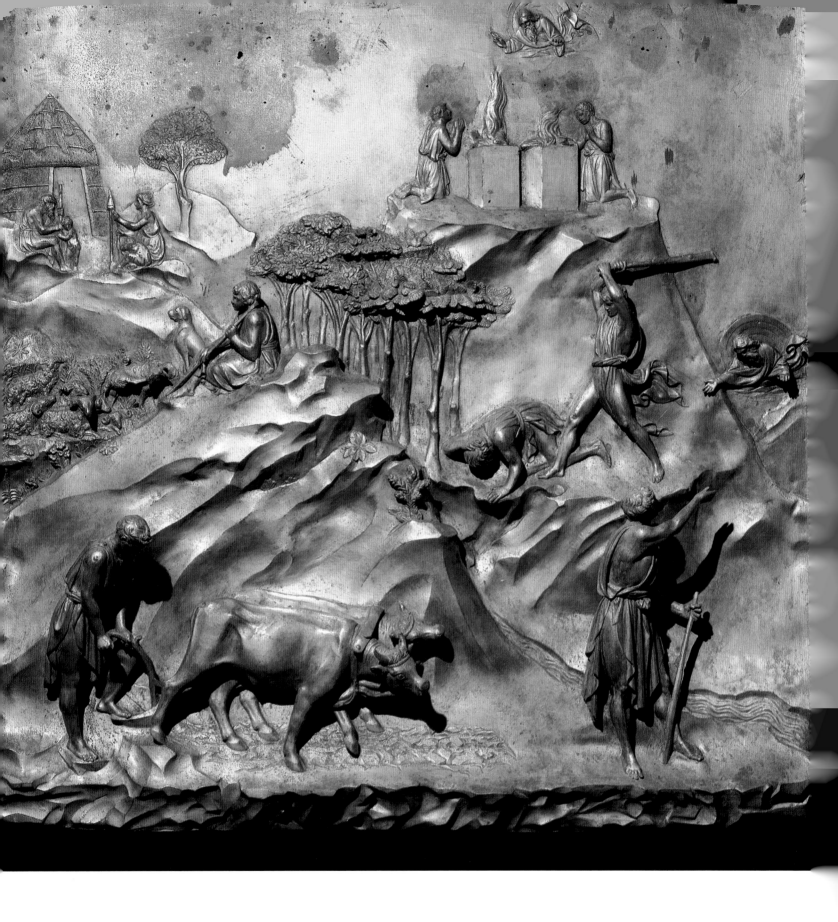

21 Ghiberti. *Cain and Abel*. 1425–52. East Door, Baptistry, Florence

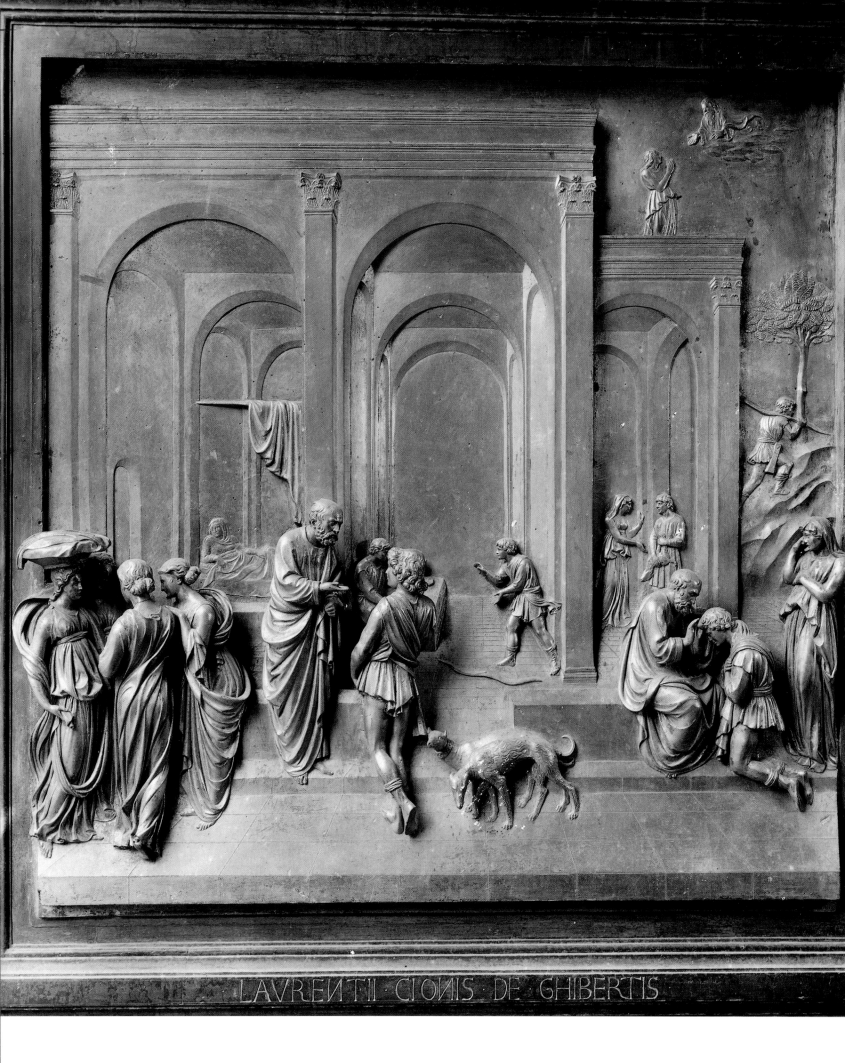

22 Ghiberti. *The Story of Jacob and Esau.* 1425–52. East Door, Baptistry, Florence

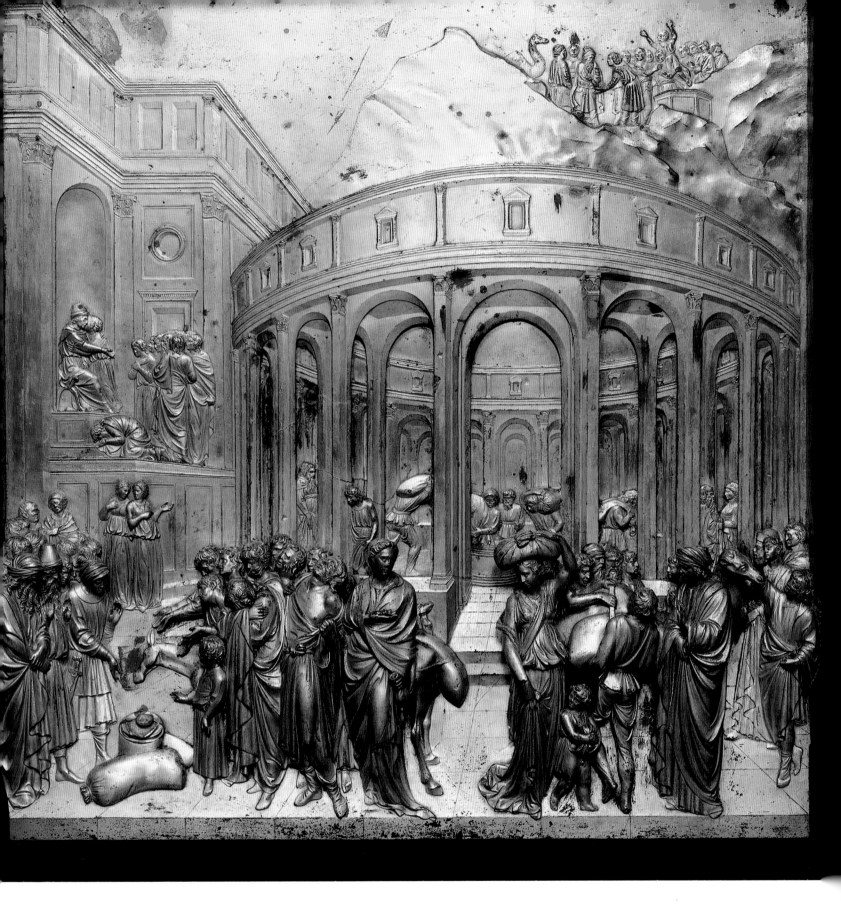

23 Ghiberti. *The Story of Joseph.* 1425–52. East Door, Baptistry, Florence

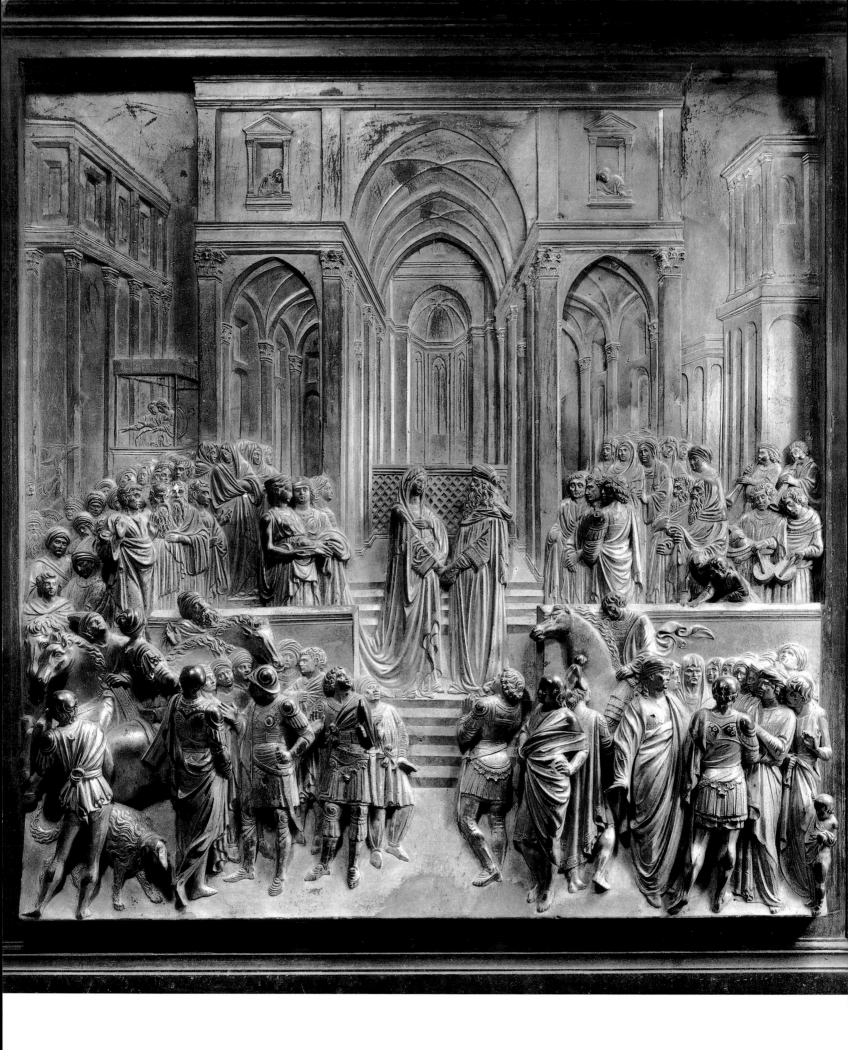

24 Ghiberti. *Solomon and the Queen of Sheba*. 1425–52. East Door, Baptistry, Florence

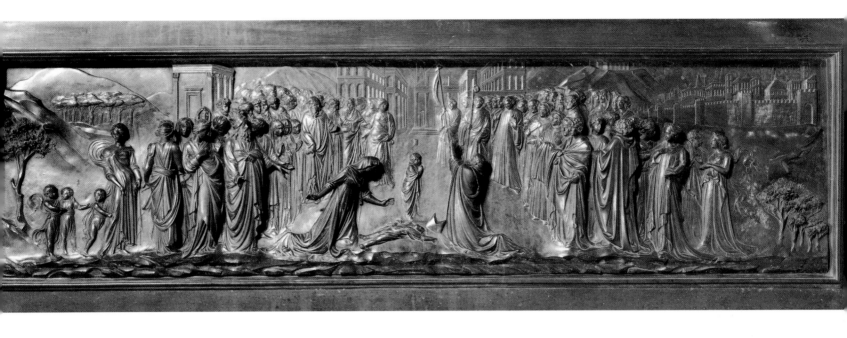

25 Ghiberti. Shrine of St. Zenobius. ABOVE: *Miracles of St. Zenobius;* BELOW: Medallion with inscription. 1434–42. Cathedral, Florence

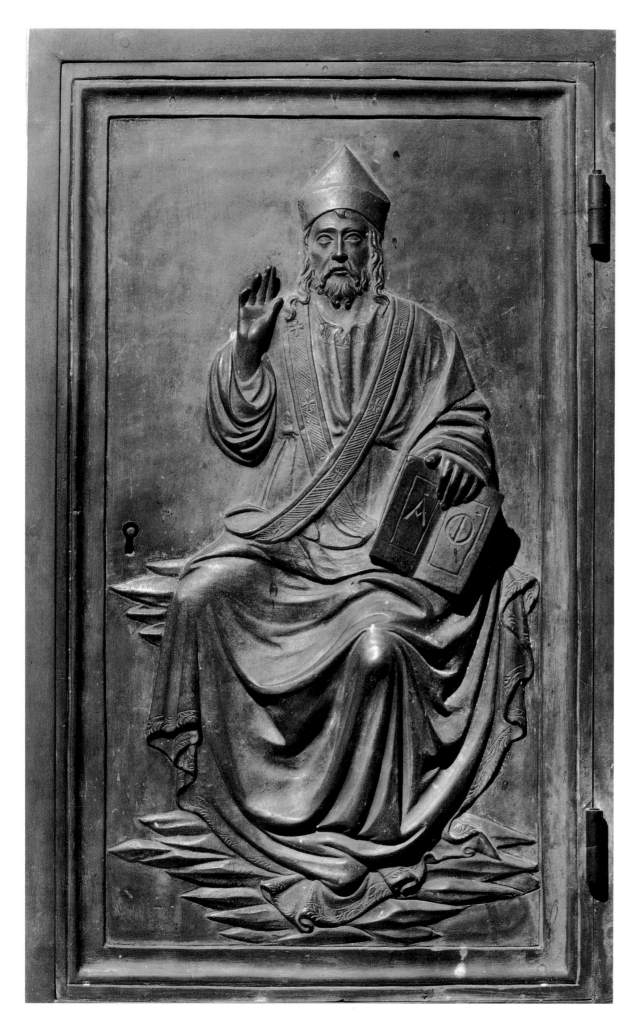

26 Ghiberti. Tabernacle Door. 1450. Sant'Egidio (Ospedale di Santa Maria Nuova), Florence

27 Jacopo della Quercia. Tomb of Ilaria del
Carretto. c. 1408. Cathedral, Lucca

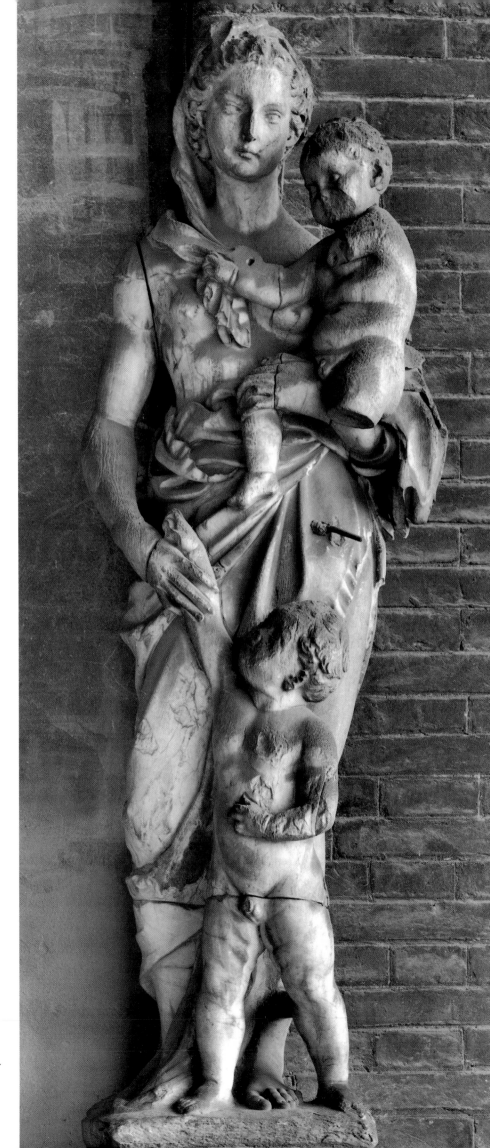

OPPOSITE:

28 Jacopo della Quercia. *Wisdom*, from the
Fonte Gaia. c. 1409–20. Palazzo Pubblico, Siena

29 Jacopo della Quercia. *Rea Silvia*, from the *Fonte Gaia*.
c. 1409–20. Palazzo Pubblico, Siena

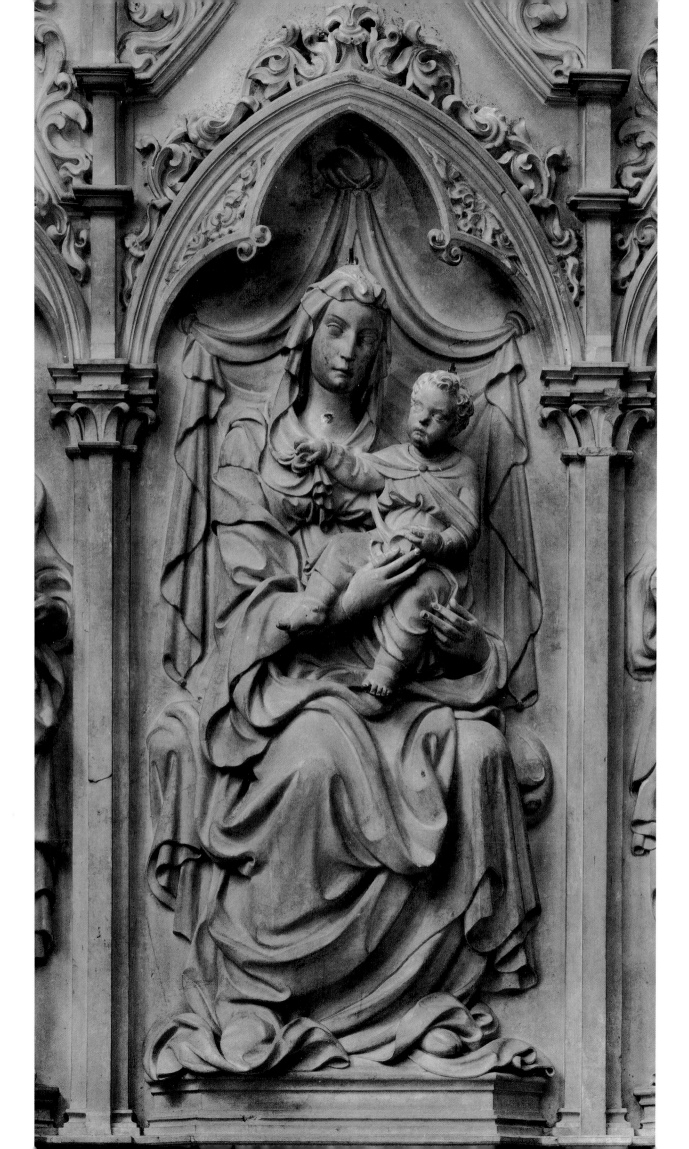

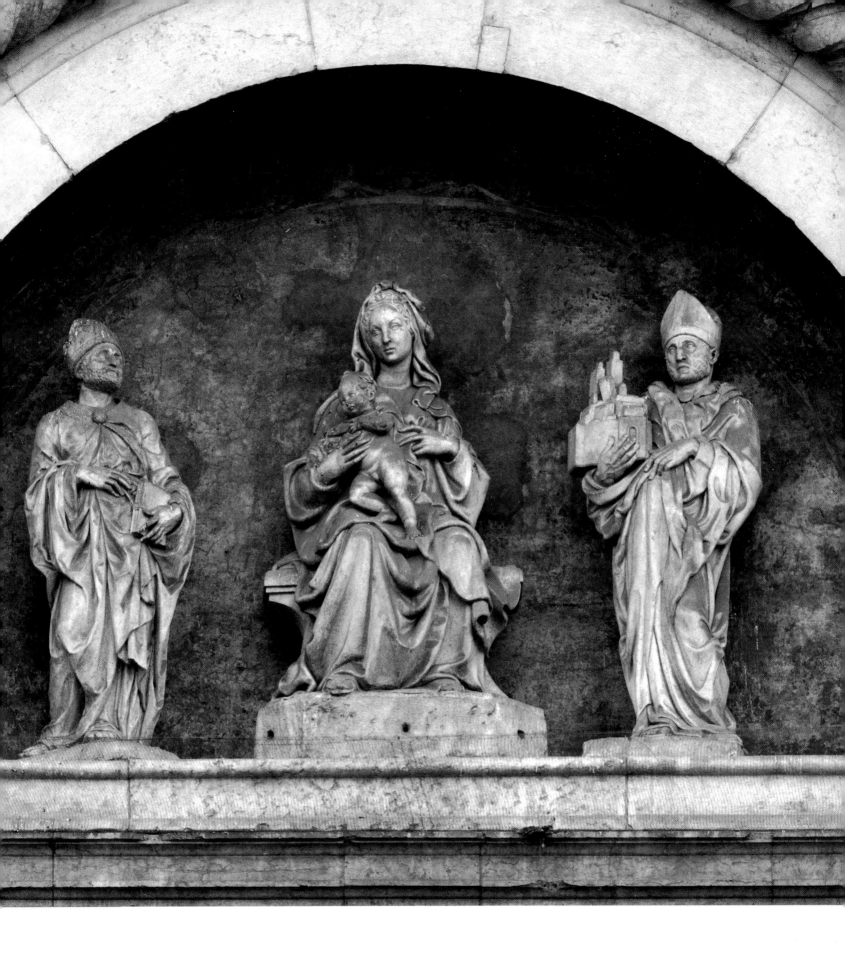

31 Jacopo della Quercia. *Madonna and Child Enthroned Between St. Ambrose* (by Domenico da Varignana) *and St. Petronius.* 1425–37. Main Portal, San Petronio, Bologna

OPPOSITE:
30 Jacopo della Quercia. *Madonna and Child Enthroned* (Trenta Altar). 1416–22. San Frediano, Lucca

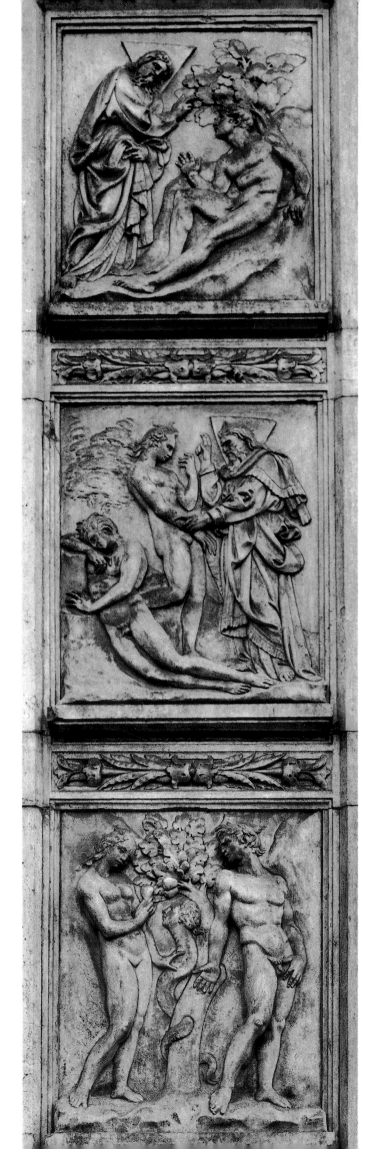

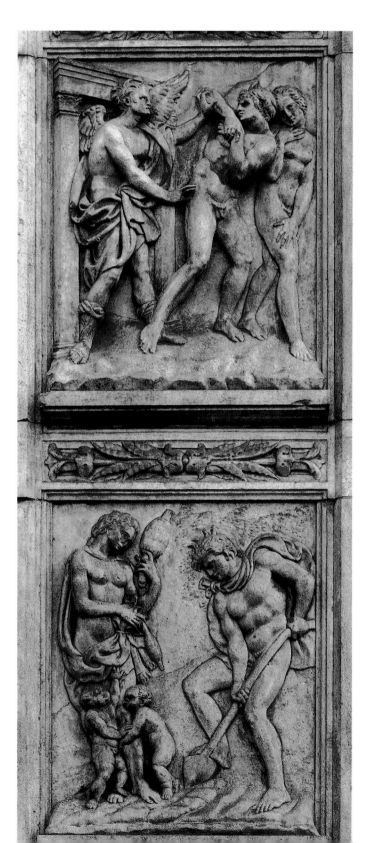

32 Jacopo della Quercia. *Scenes from Genesis*. 1425–37.
Main Portal, San Petronio, Bologna

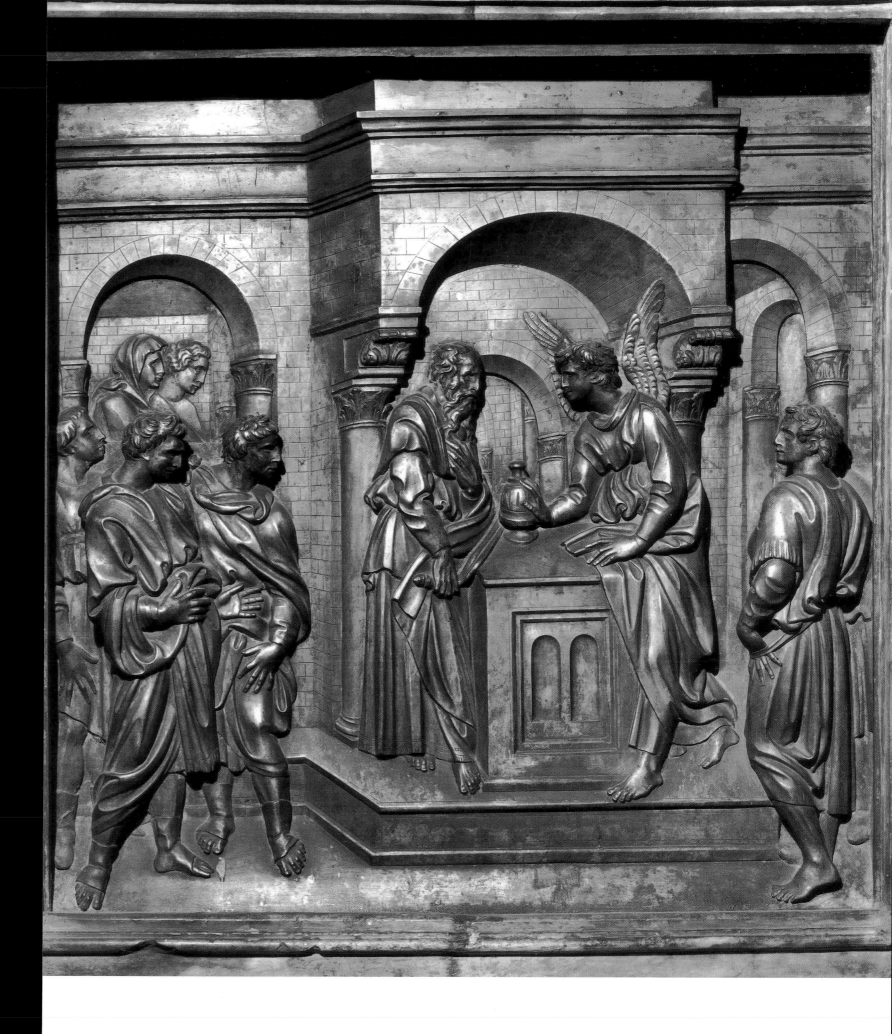

33 Jacopo della Quercia. *The Annunciation to Zacharias*. 1428–30. Font, Baptistry, Siena

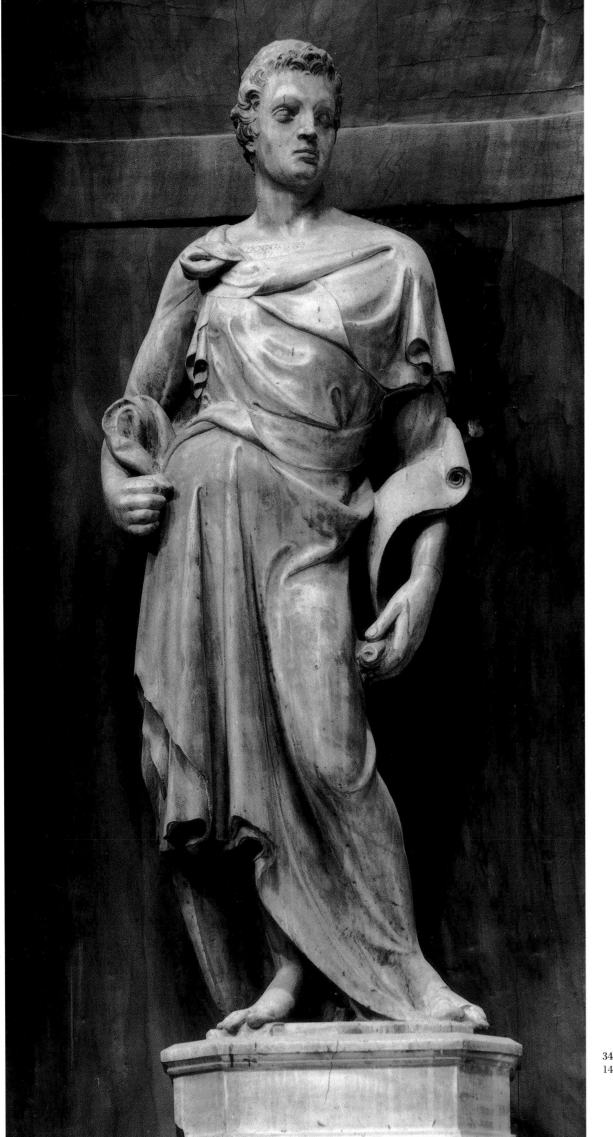

34 Nanni di Banco. *Isaiah*.
1408. Cathedral, Florence

35 Nanni di Banco. *St. Luke*.
1408–13. Museo dell'Opera del
Duomo, Florence

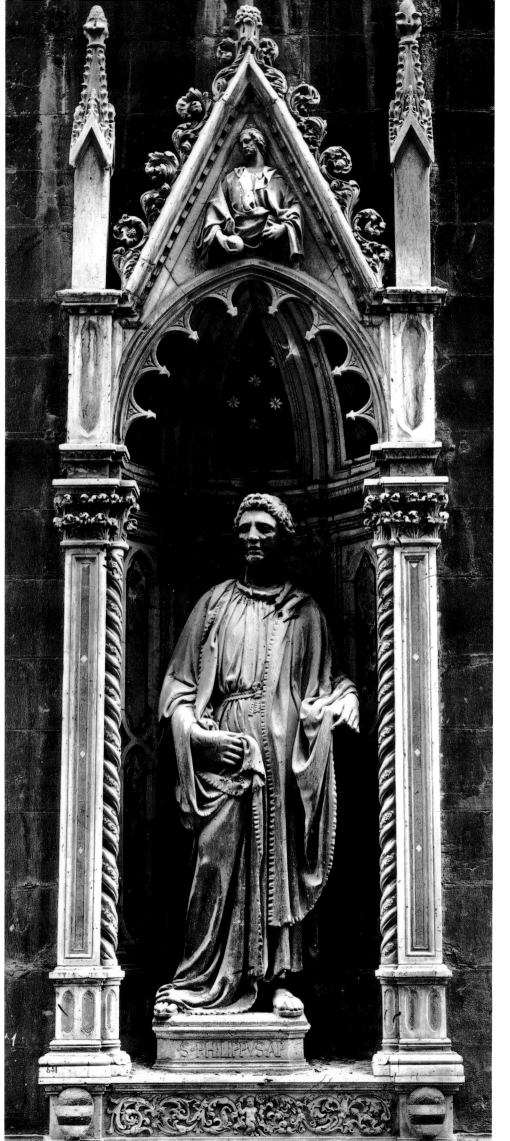

36 Nanni di Banco. *St. Philip.* c. 1413–14.
Orsanmichele, Florence

37 Nanni di Banco. *Four Crowned Martyrs.*
c. 1414–16. Orsanmichele, Florence

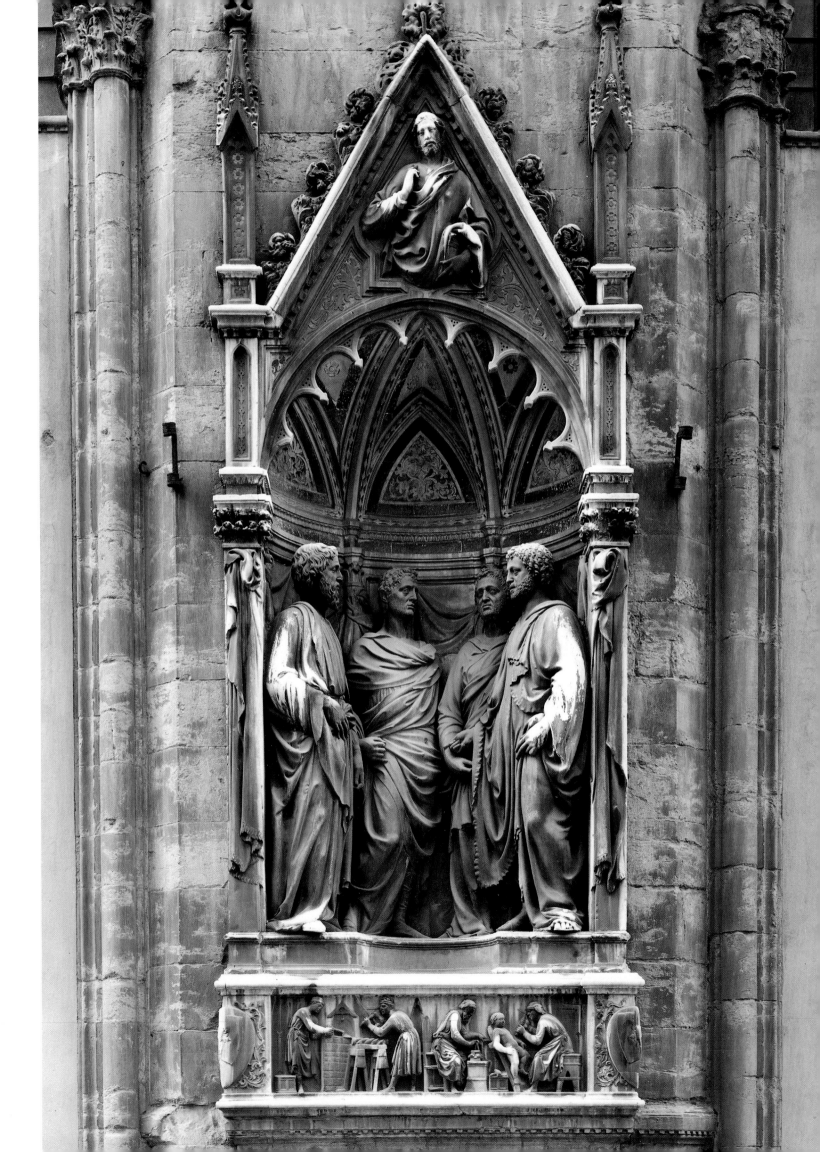

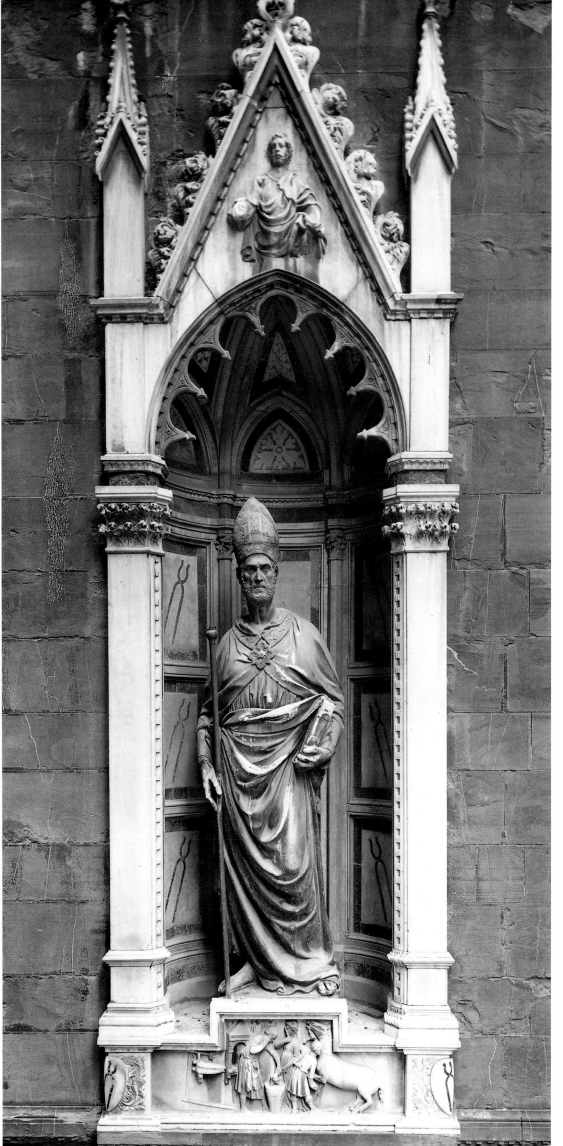

38 Nanni di Banco. *St. Eligius.* c. 1417–18. Orsanmichele, Florence

39 Nanni di Banco. *The Assumption of the Virgin.* 1414–21. Porta della Mandorla, Duomo, Florence

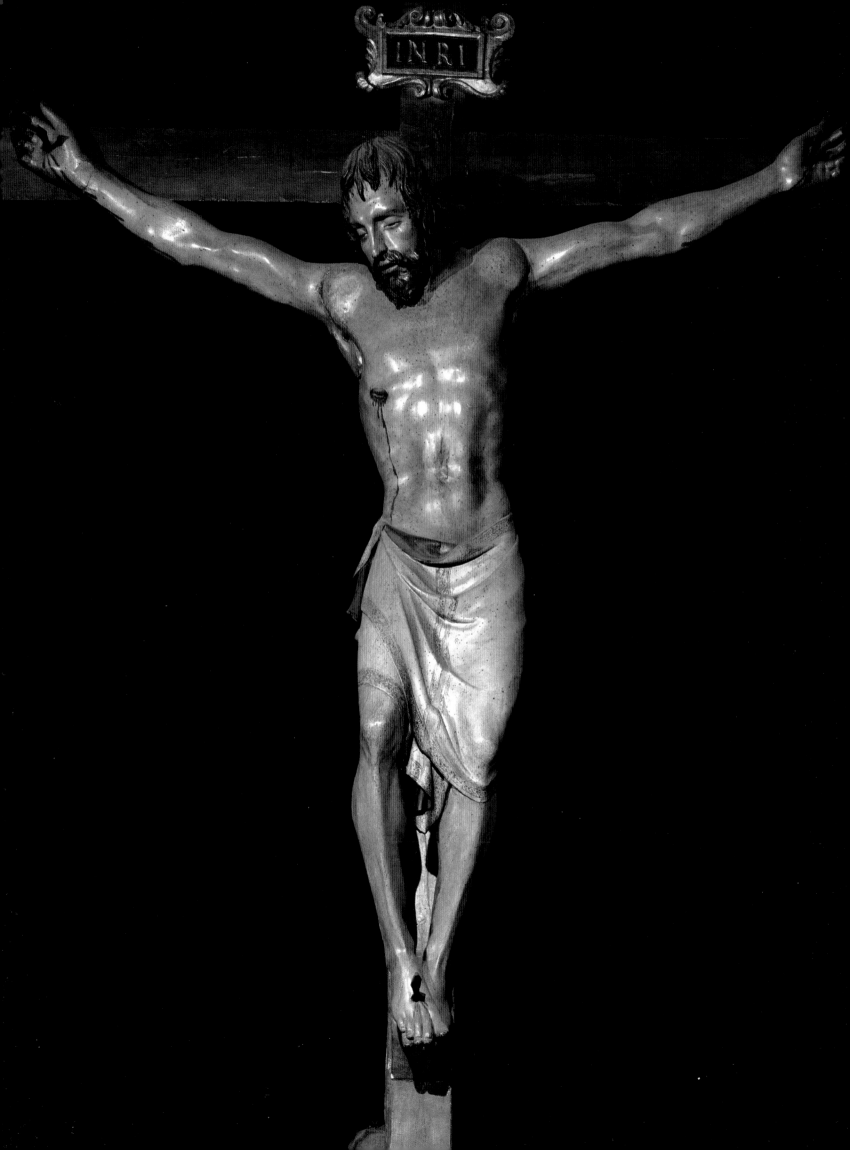

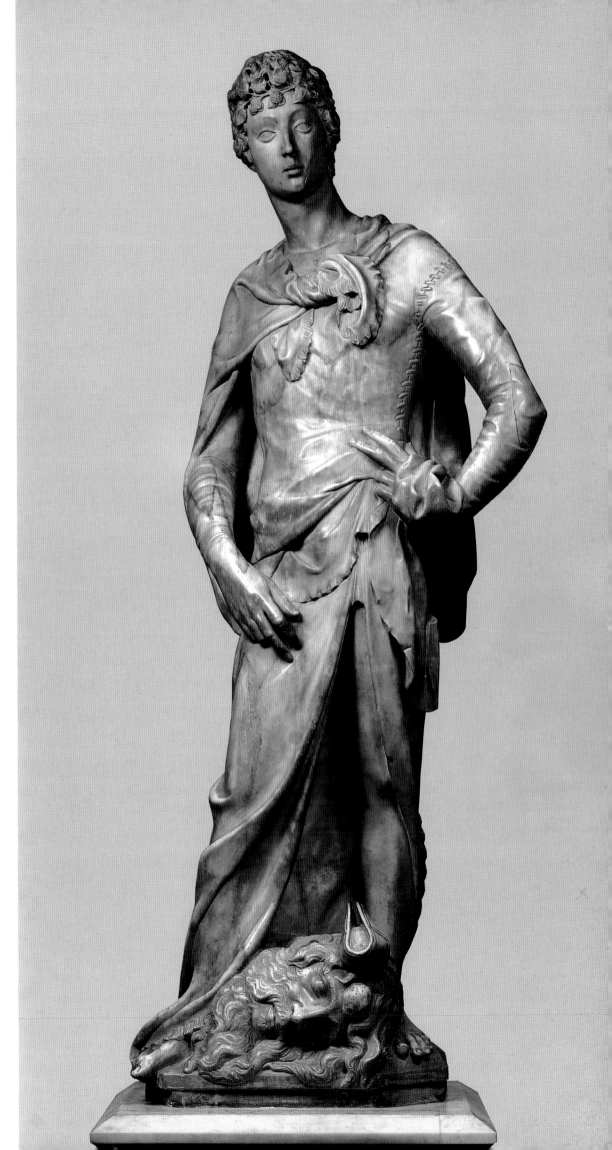

40 Donatello. *Crucifix*. c. 1407–8.
Santa Croce, Florence

41 Donatello. *David*. 1408–9. Museo
Nazionale del Bargello, Florence

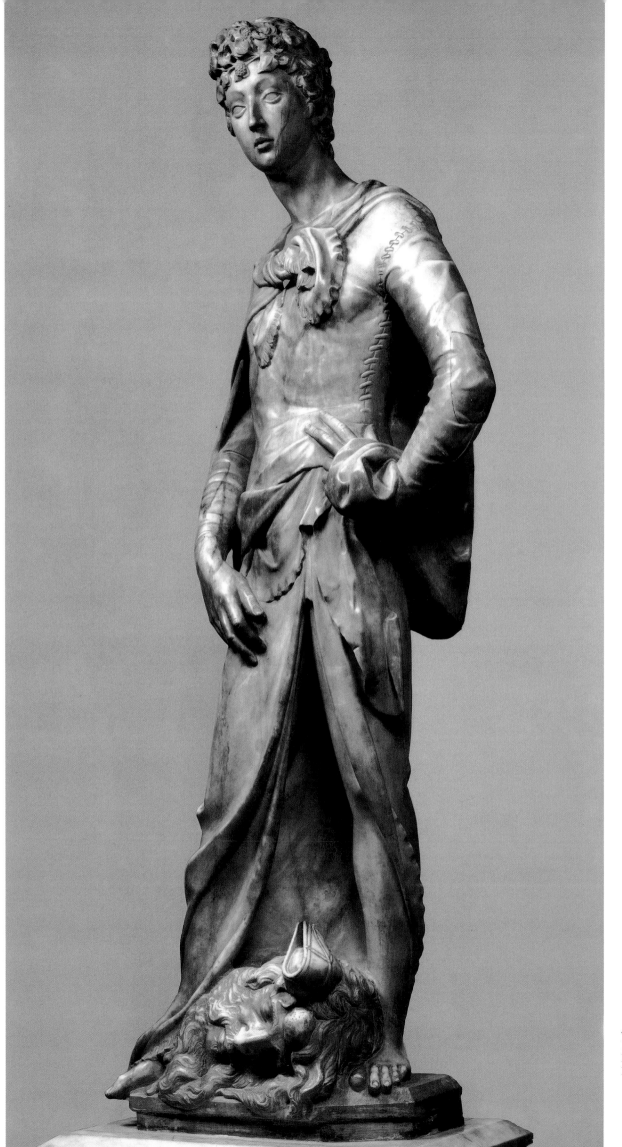

42 Donatello. *David*.
1408–9. Museo
Nazionale del Bargello,
Florence

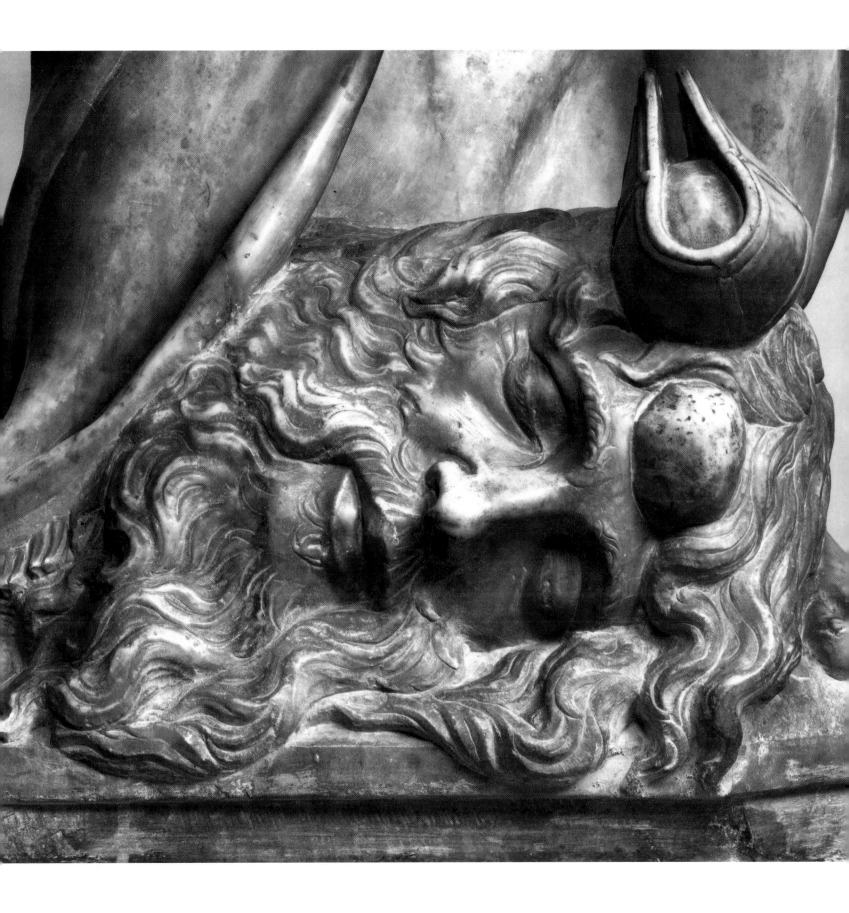

43 Donatello. *David* (detail: head of Goliath). 1408–9. Museo Nazionale del Bargello, Florence

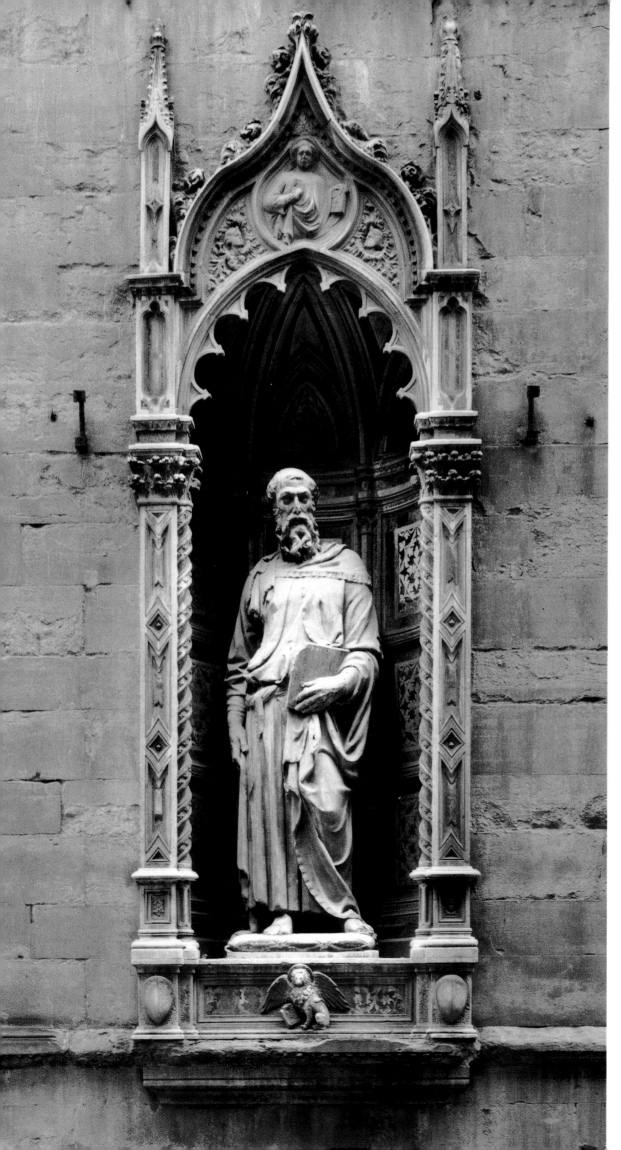

LEFT AND OPPOSITE:
44, 45 Donatello.
St. Mark. 1411–13.
Orsanmichele, Florence

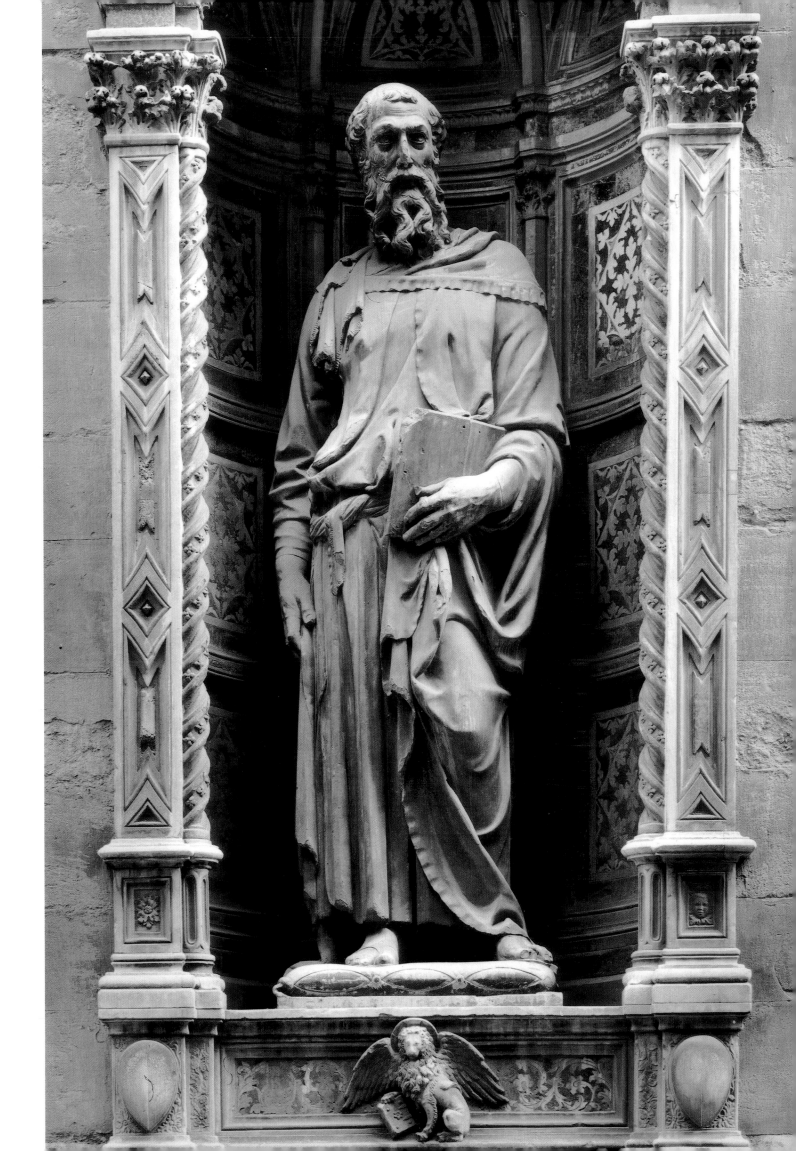

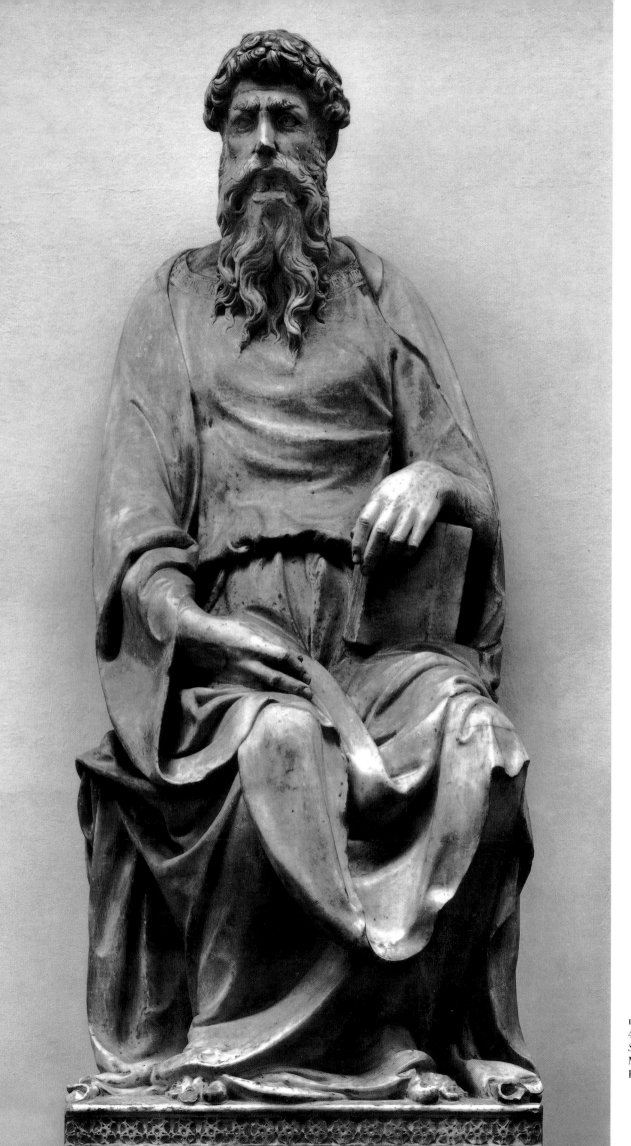

LEFT AND OPPOSITE:
46, 47 Donatello.
St. John the Evangelist. 1408–15.
Museo dell'Opera del Duomo,
Florence

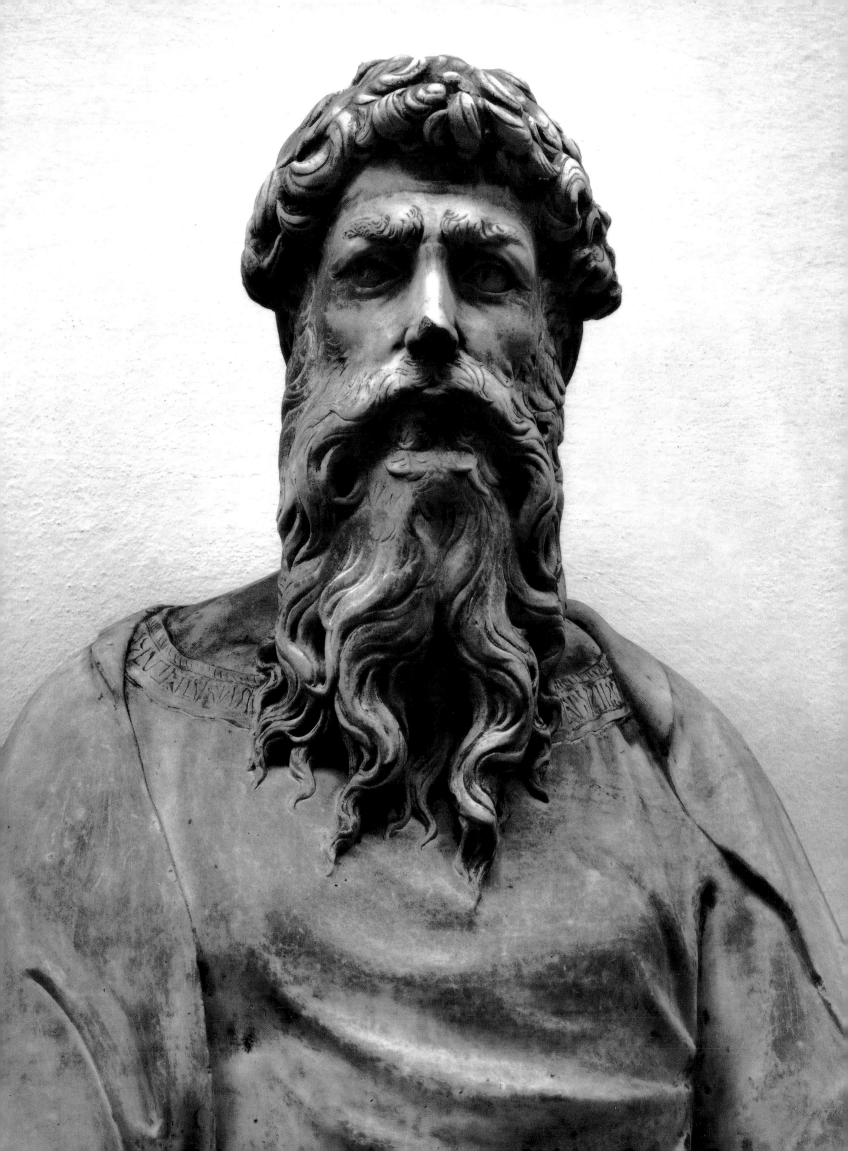

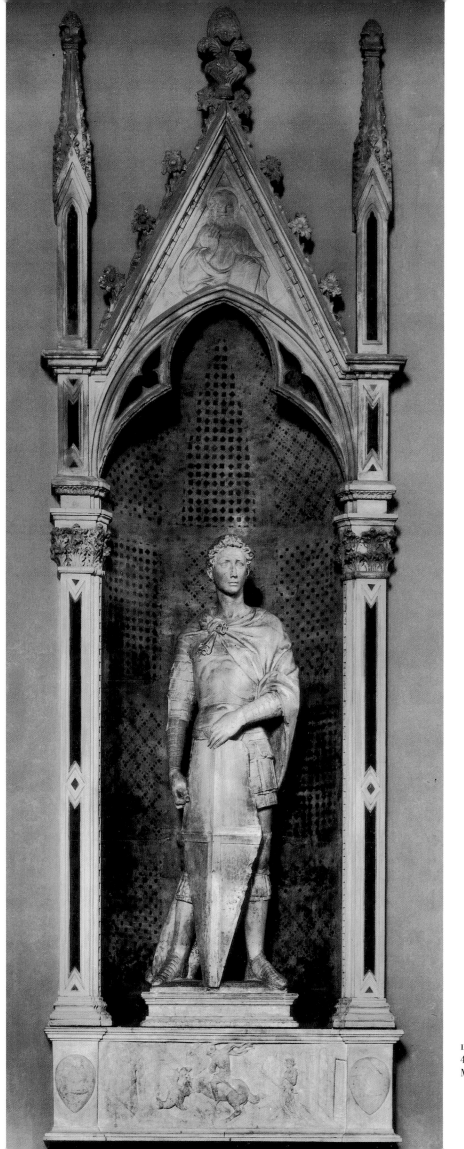

LEFT AND OPPOSITE:
48, 49 Donatello. *St. George.* c. 1416–17.
Museo Nazionale del Bargello, Florence

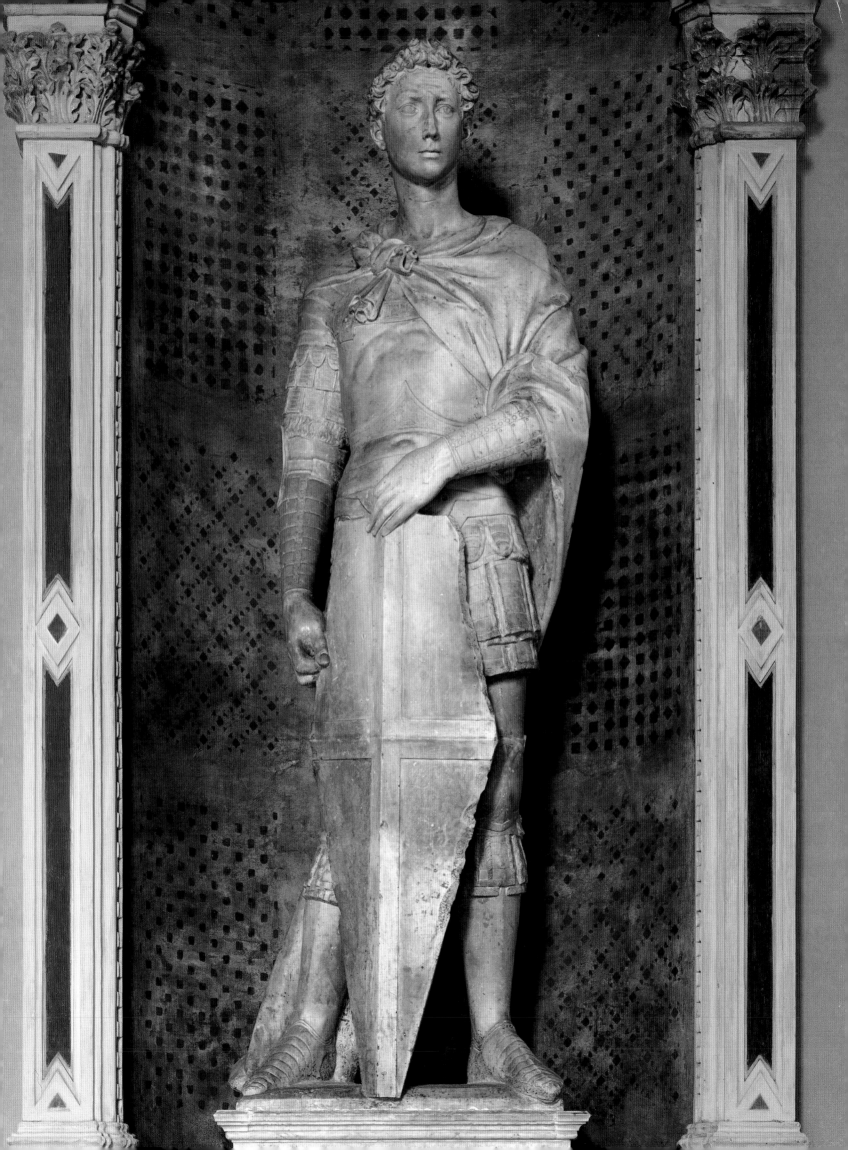

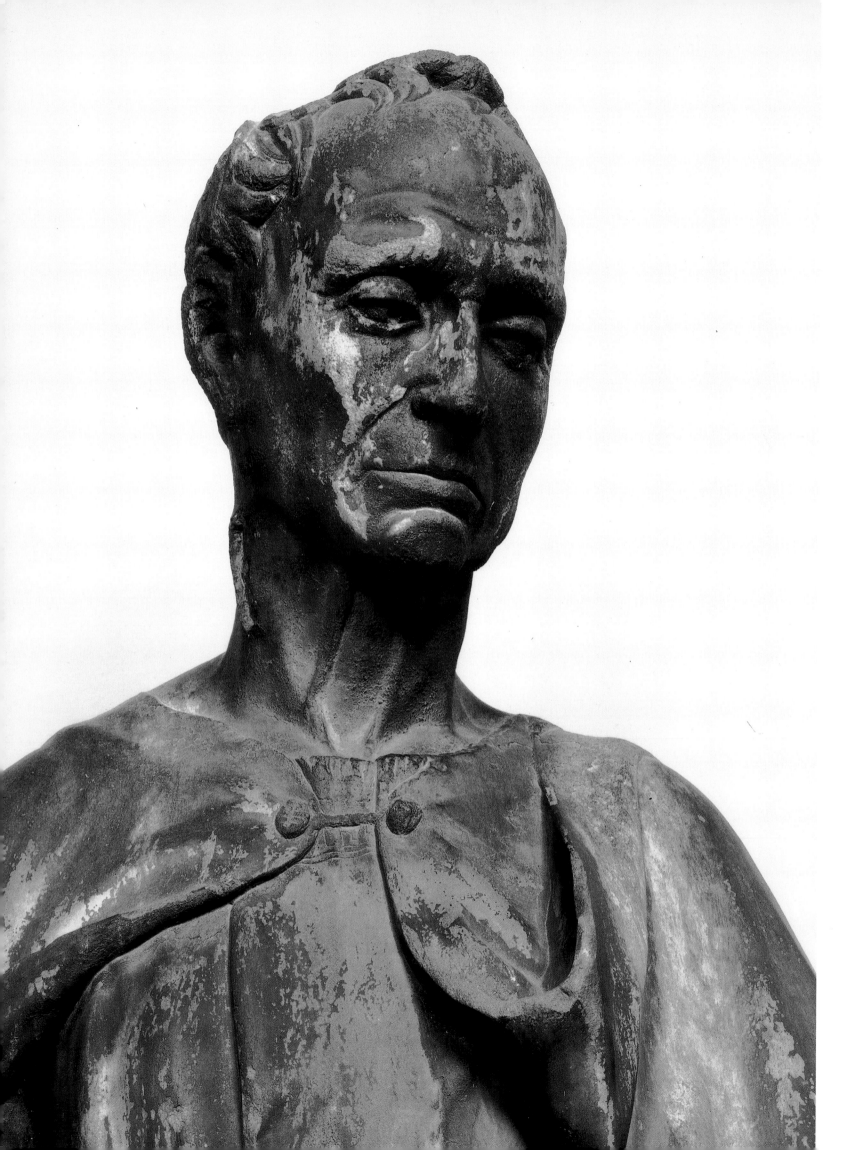

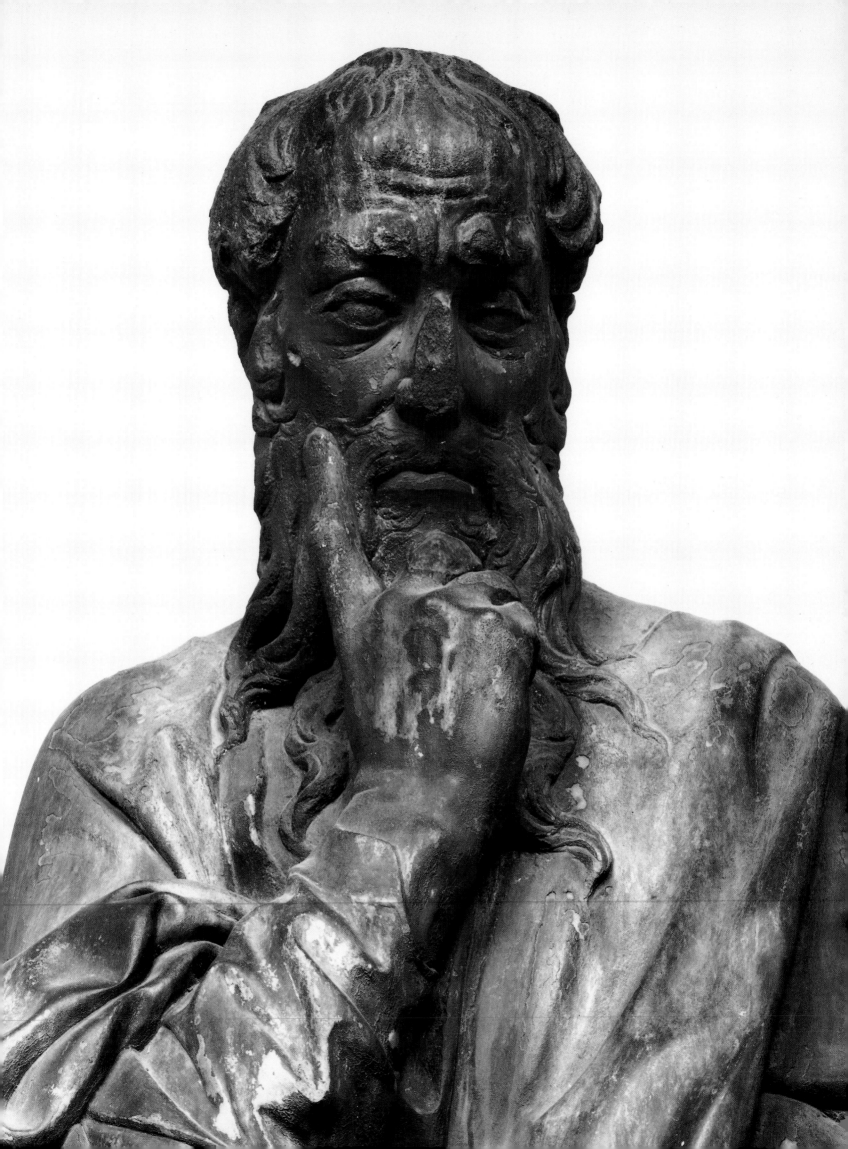

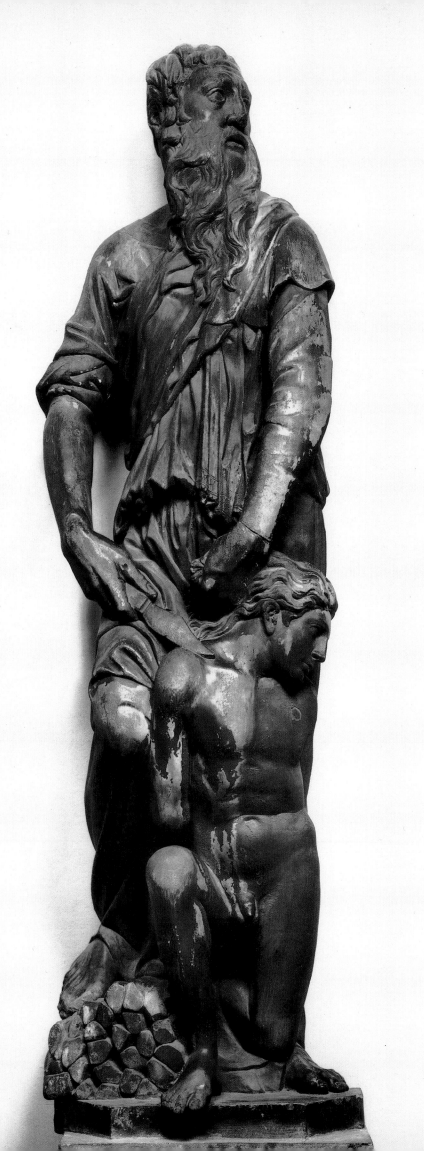

LEFT AND OPPOSITE:
54, 55 Donatello. *Abraham and Isaac*.
1421. Museo dell'Opera del Duomo,
Florence
55 detail: Isaac

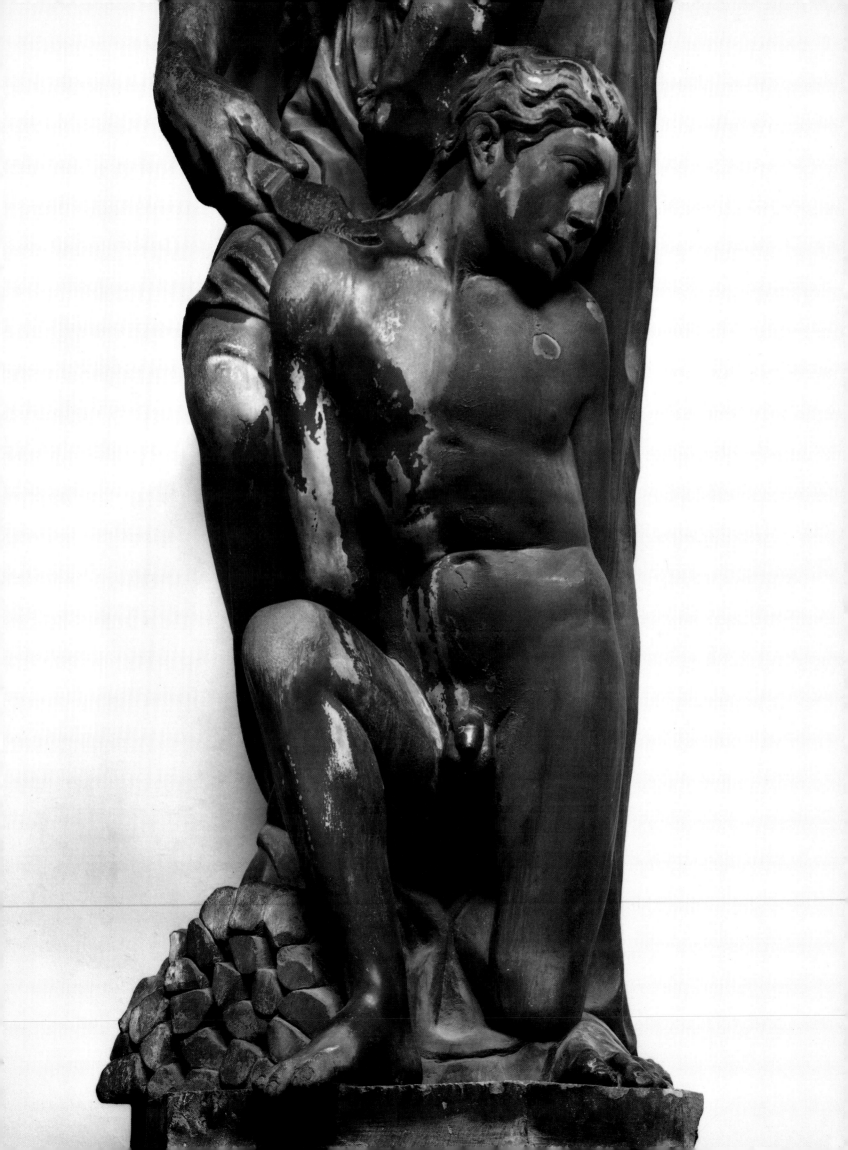

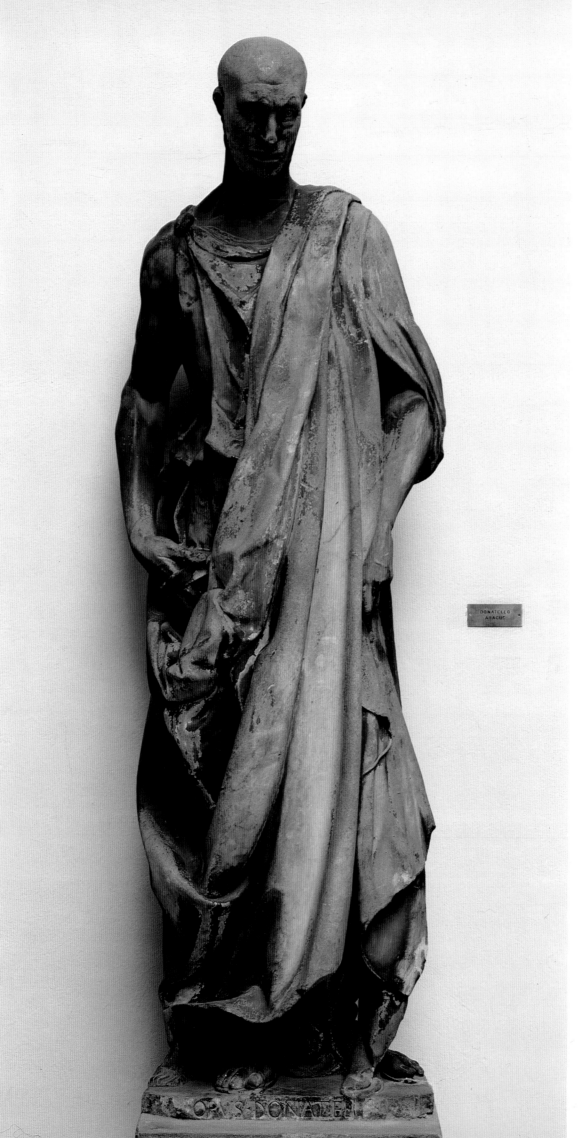

56 Donatello. *Zuccone*.
1423–26. Museo dell'Opera
del Duomo, Florence

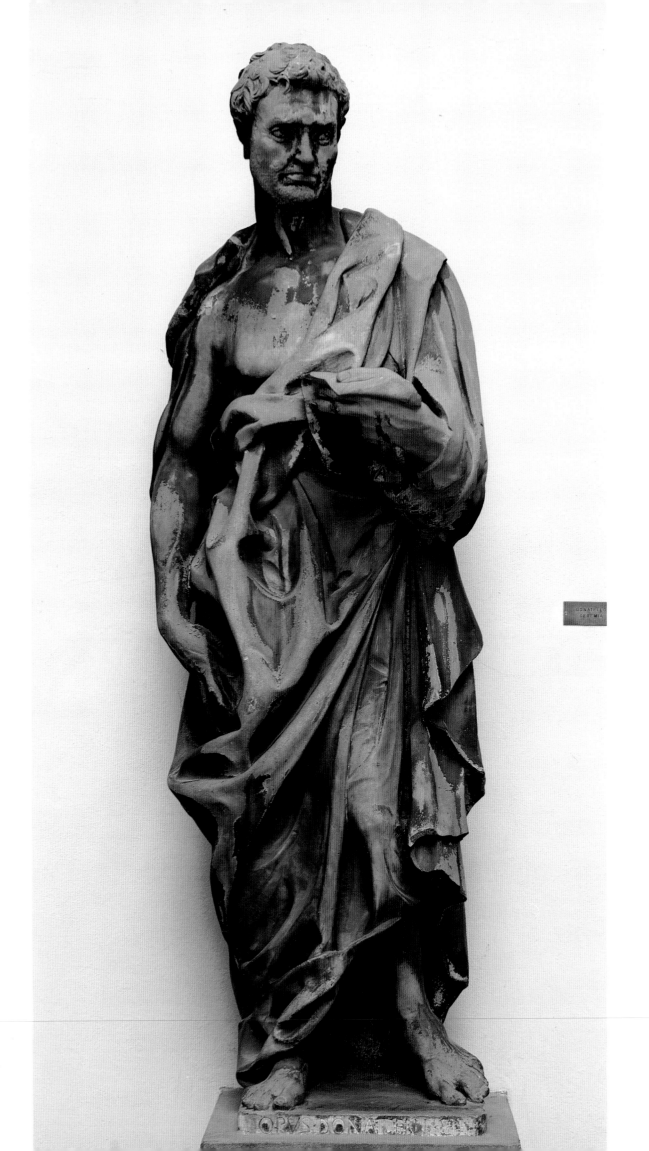

57 Donatello. *Jeremiah*.
1427–36. Museo dell'Opera
del Duomo, Florence

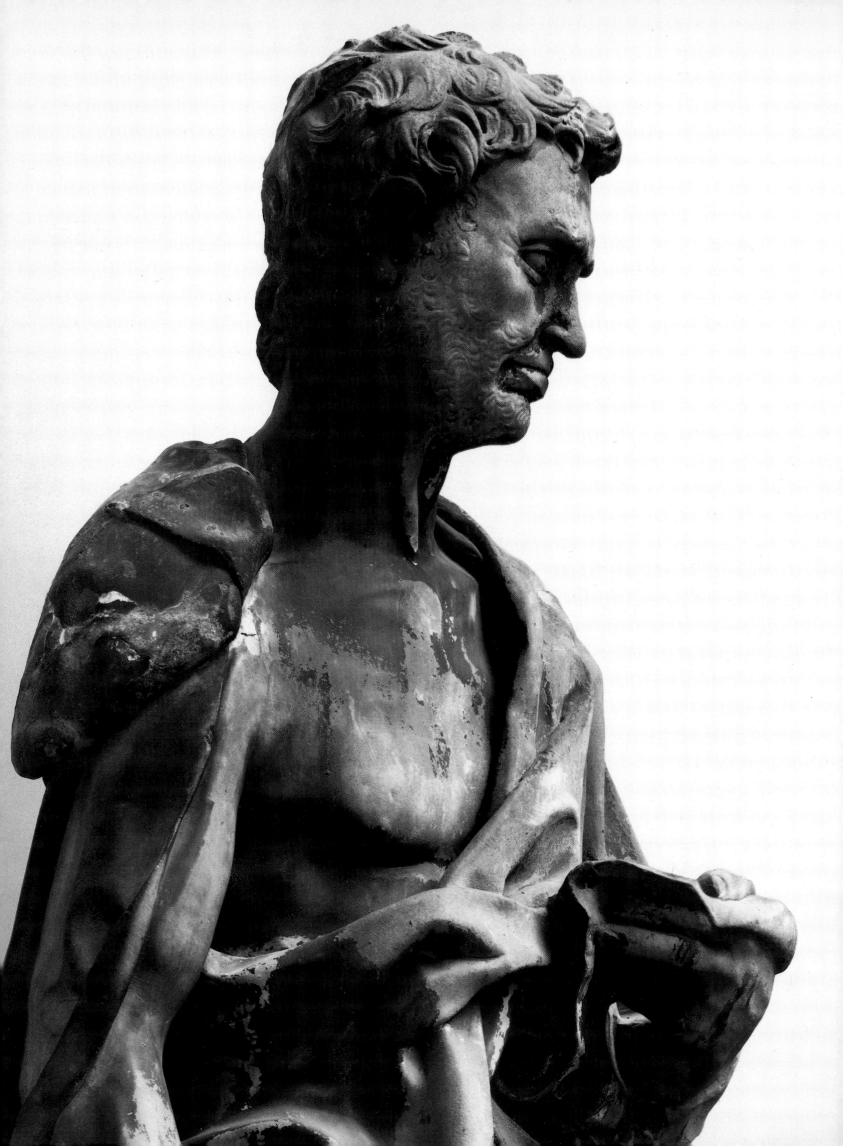

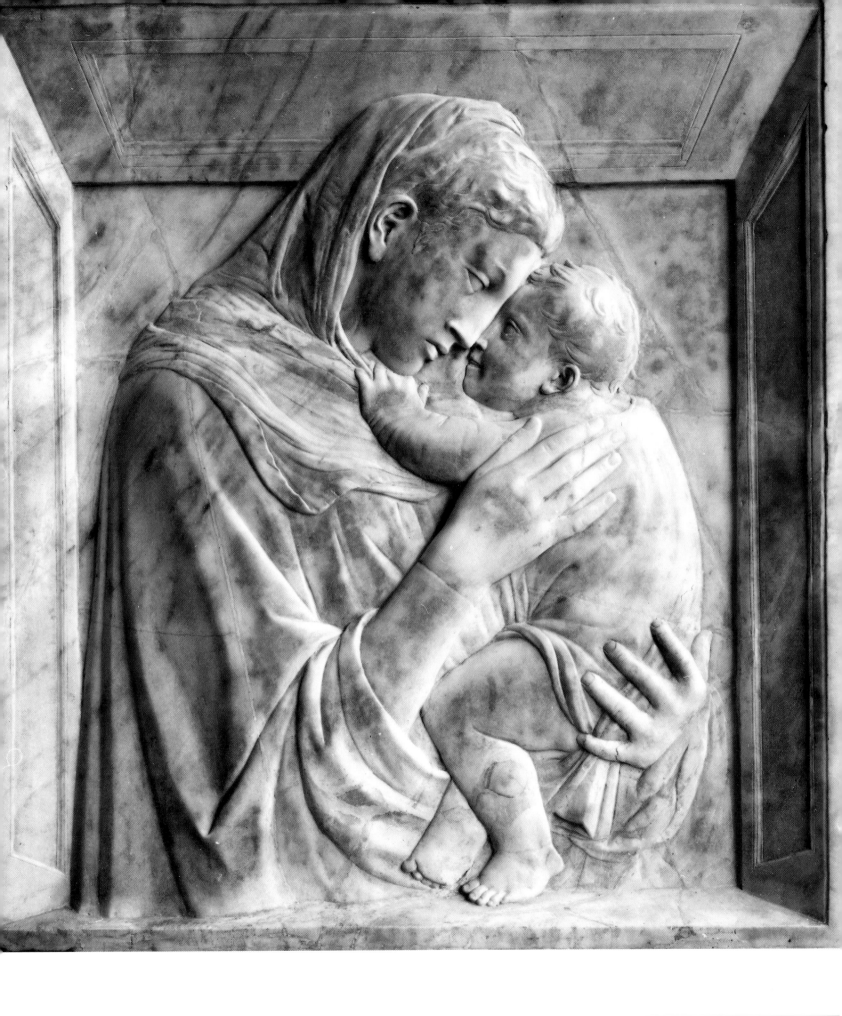

59 Donatello. *The "Pazzi Madonna."* c. 1417–18. Staatliche Museen, Berlin-Dahlen

OPPOSITE:
58 Donatello. *Jeremiah* (detail). 1427–36. Museo dell'Opera del Duomo, Florence

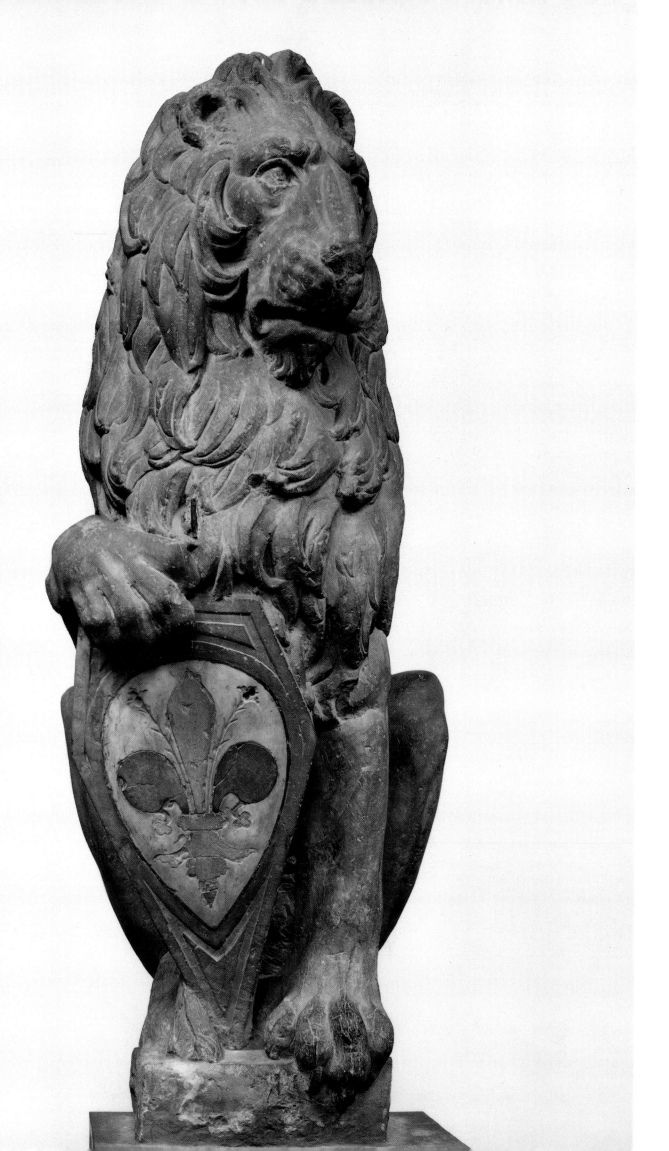

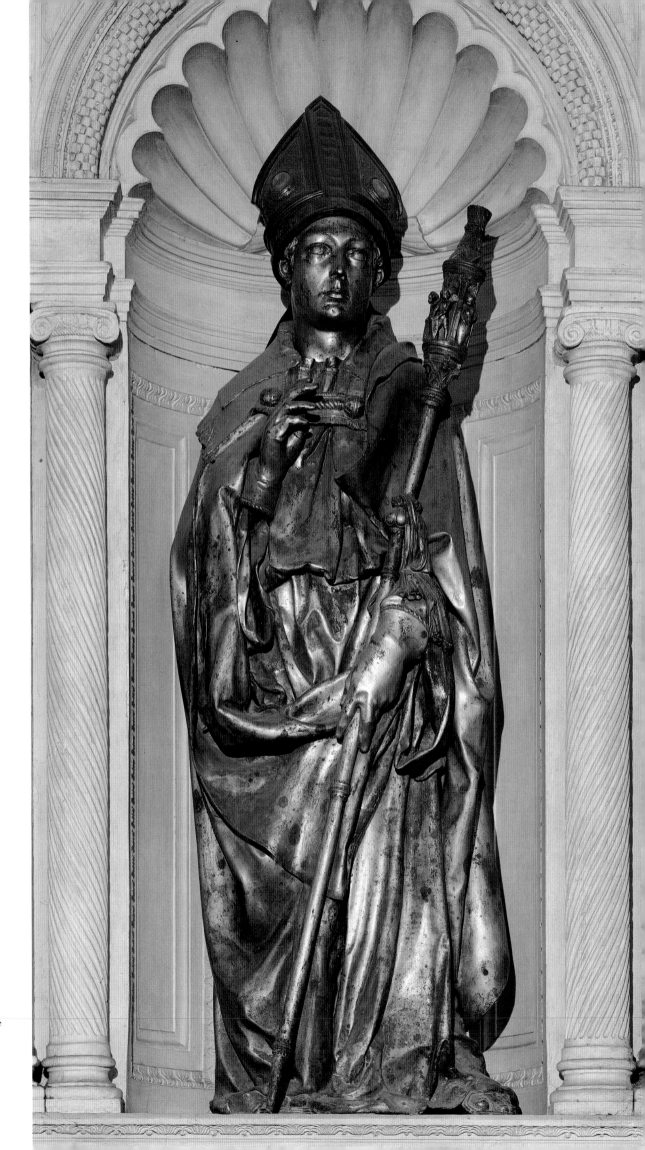

60 Donatello. *Marzocco*. 1418–20.
Museo Nazionale del Bargello, Florence

61 Donatello. *St. Louis of Toulouse*.
1418–22. Museo dell'Opera di Santa
Croce, Florence

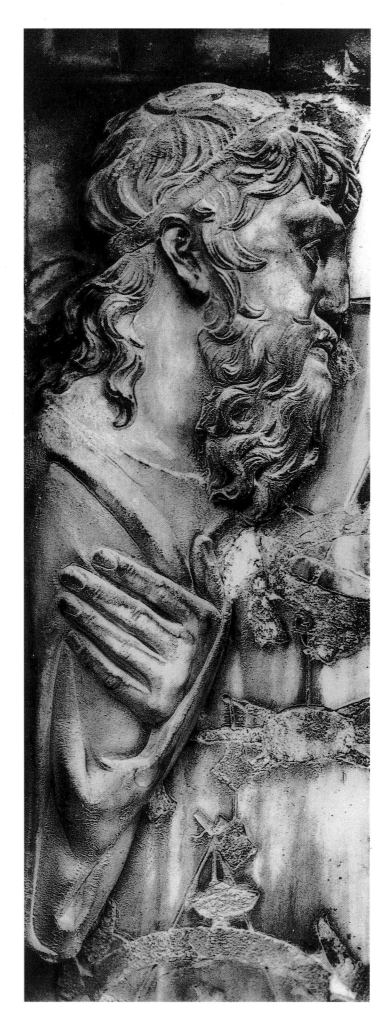
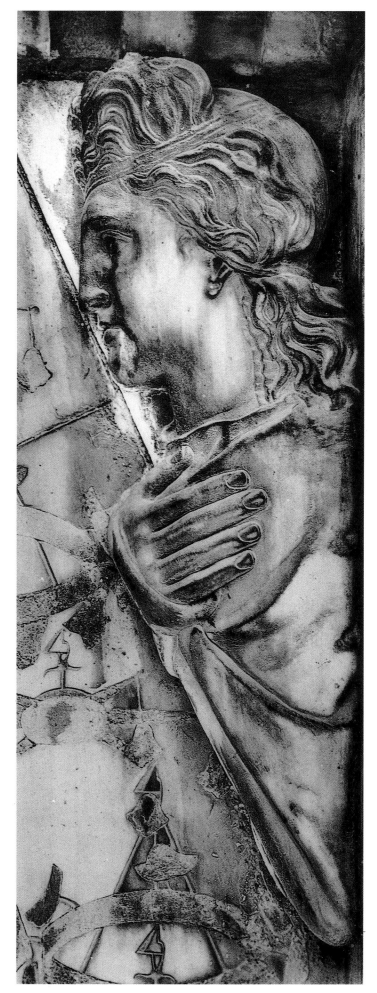

62 Donatello. *Prophet and Sibyl*. 1422. Porta della Mandorla, Duomo, Florence

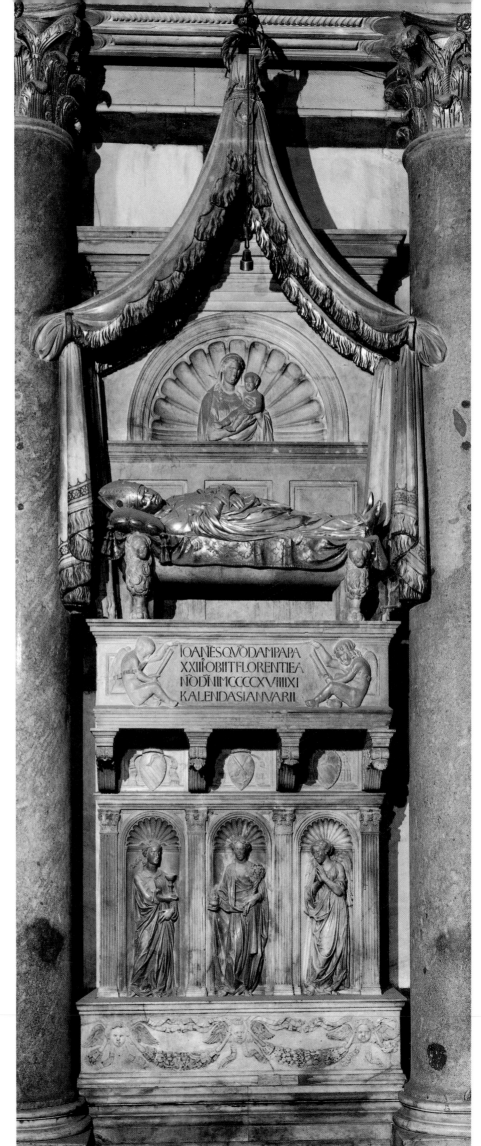

63 Donatello and Michelozzo. Tomb of Pope John
XXIII (Baldassare Coscia). c. 1421–27. Baptistry,
Florence

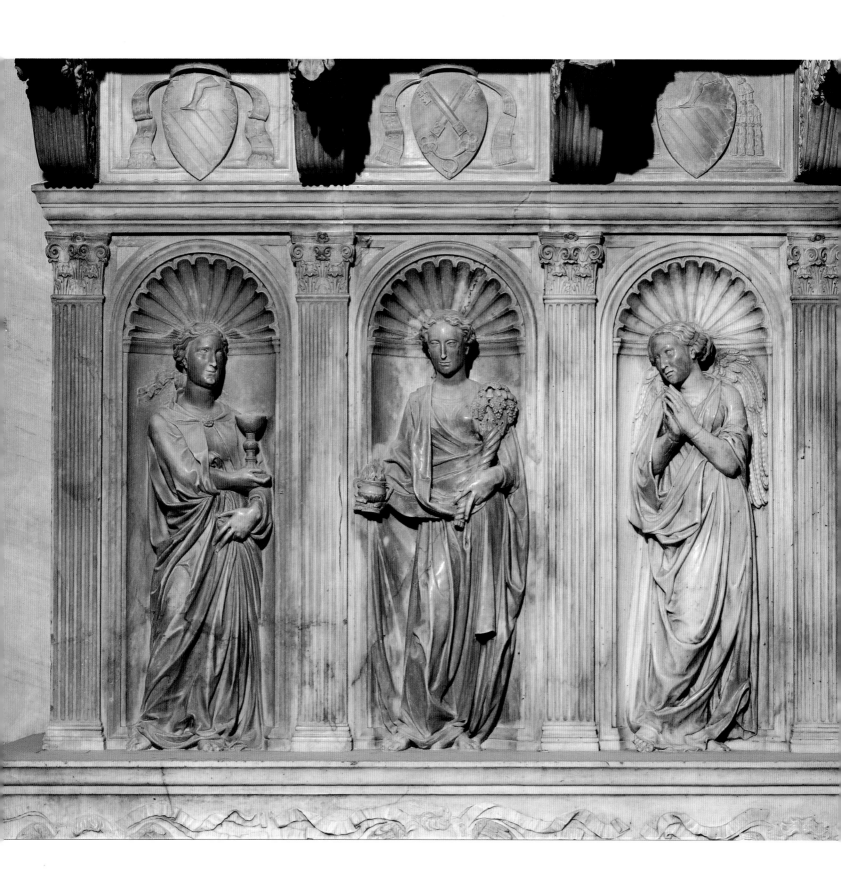

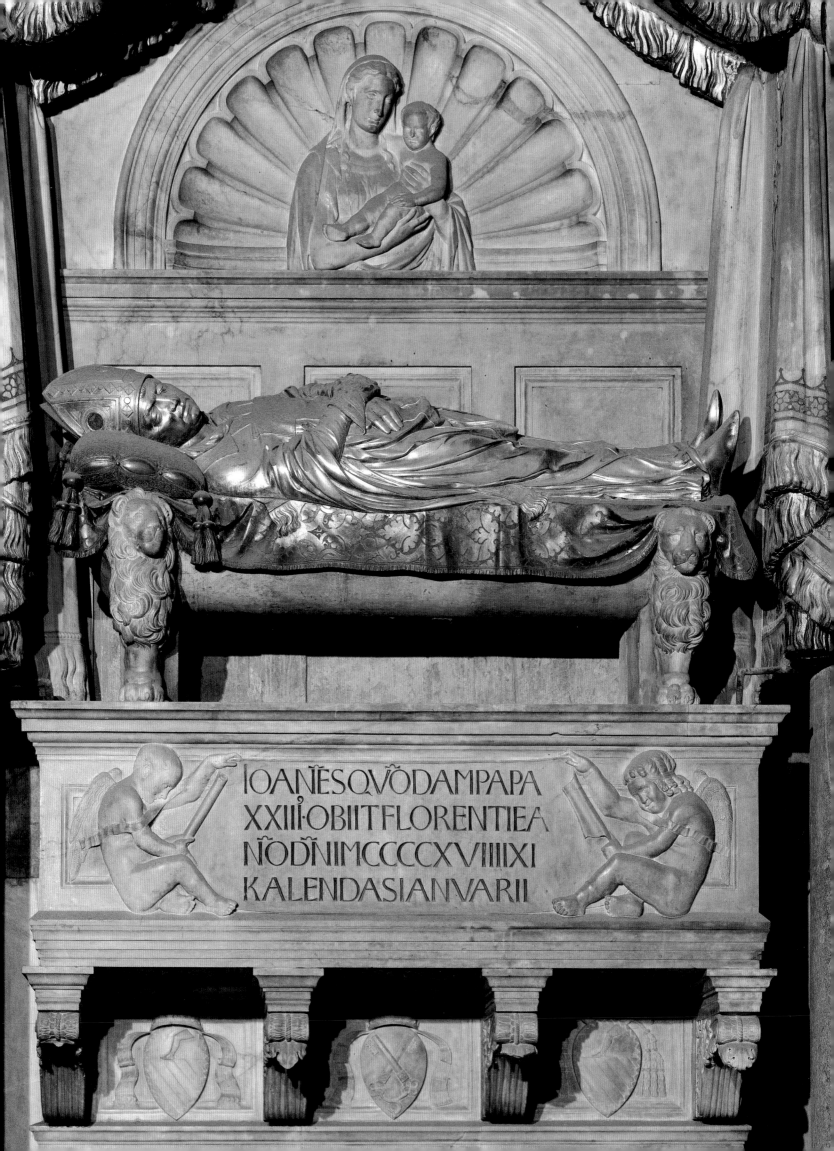

IOANESQVODAMPAPA
XXIII·OBIITFLORENTIEA
ÑODÑIMCCCCXVIIIIXI
KALENDASIANVARII

66 Donatello. *Reliquary Bust of St. Rossore*. c. 1424–25. Museo Nazionale di San Matteo, Pisa

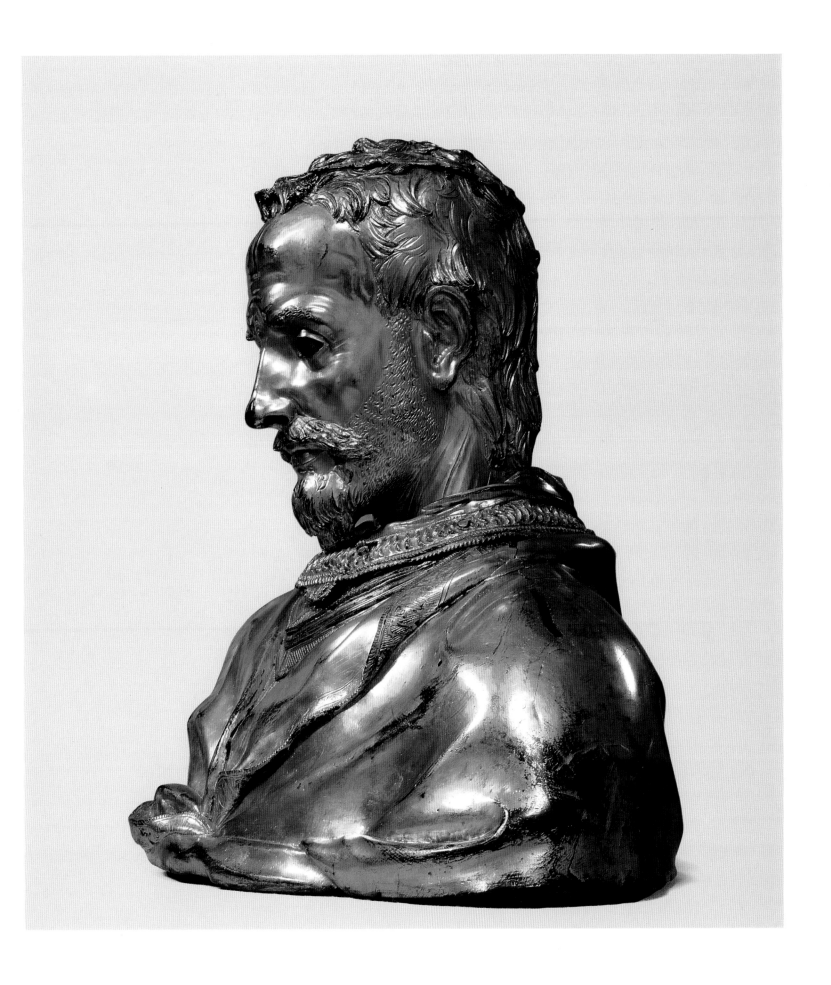

67 Donatello. *Reliquary Bust of St. Rossore.* c. 1424–25. Museo Nazionale di San Matteo, Pisa

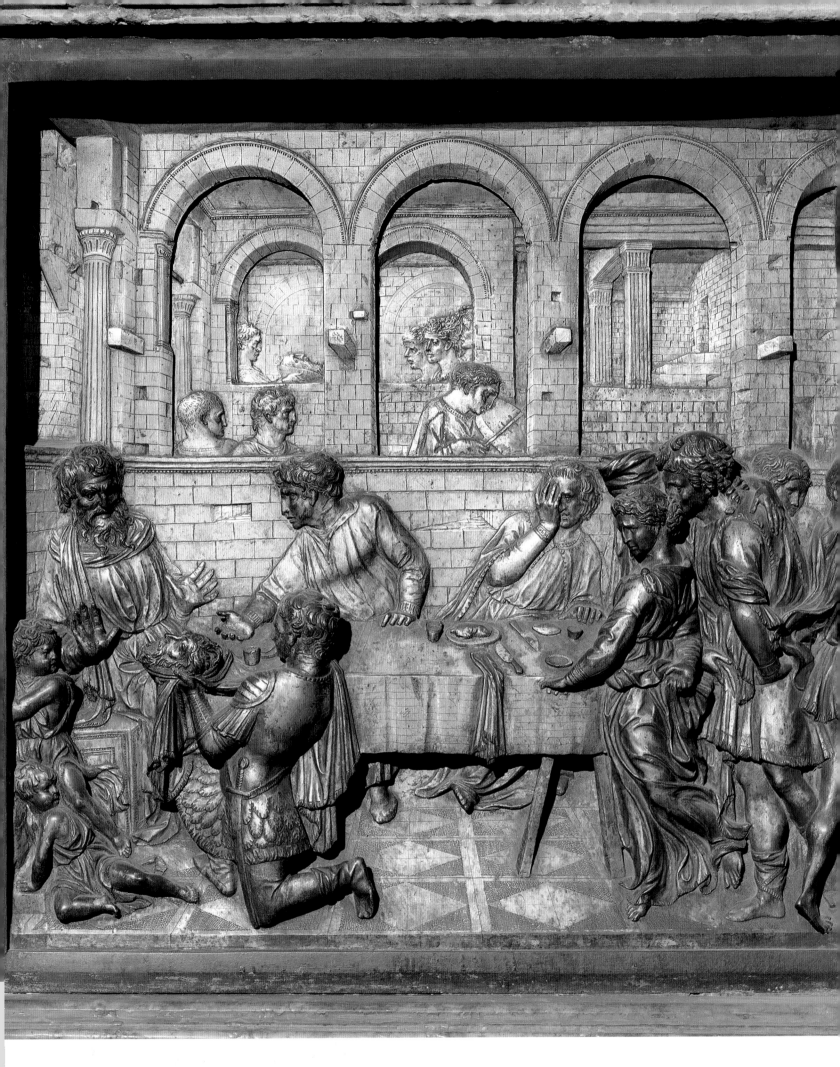

68, 69 Donatello. *The Feast of Herod.* c. 1425. Font, Baptistry, Siena

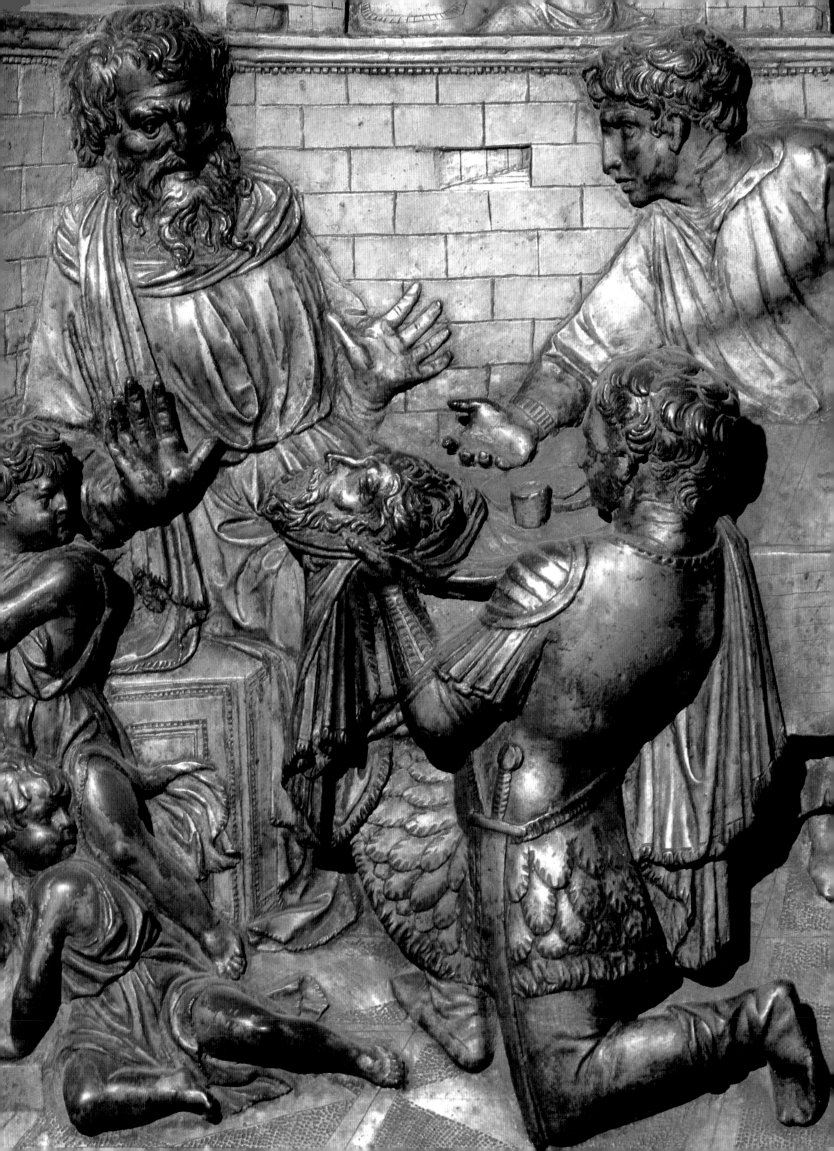

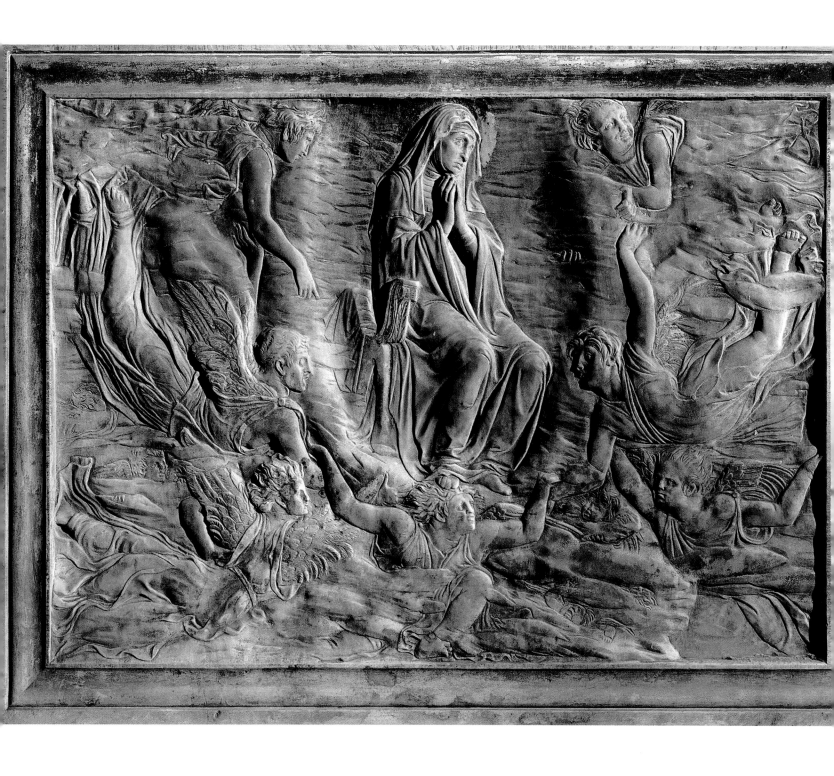

70 Donatello. *The Assumption of the Virgin*. c. 1425–26. Tomb of Cardinal Rinaldo Brancacci,
Sant'Angelo a Nilo, Naples

OPPOSITE:
71 Donatello. *The Ascension and Delivery of the Keys to St. Peter*. c. 1426–27. Victoria and Albert
Museum, London

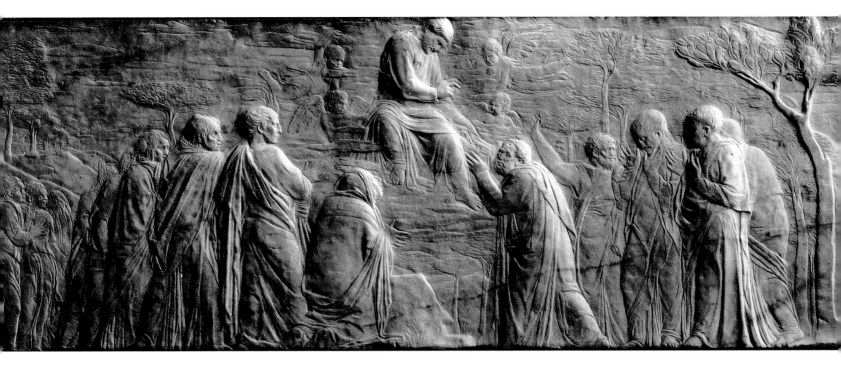

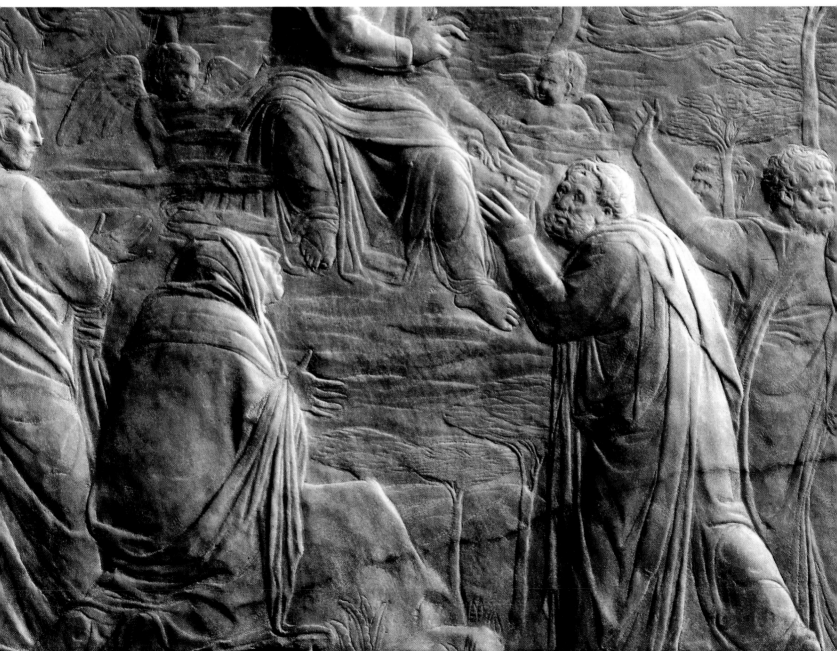

72 Donatello. Tomb Slab of Bishop Giovanni Pecci. c. 1426. Duomo, Siena

73 Donatello. *"Niccolò da Uzzano."* c. 1425–30. Museo Nazionale del Bargello, Florence

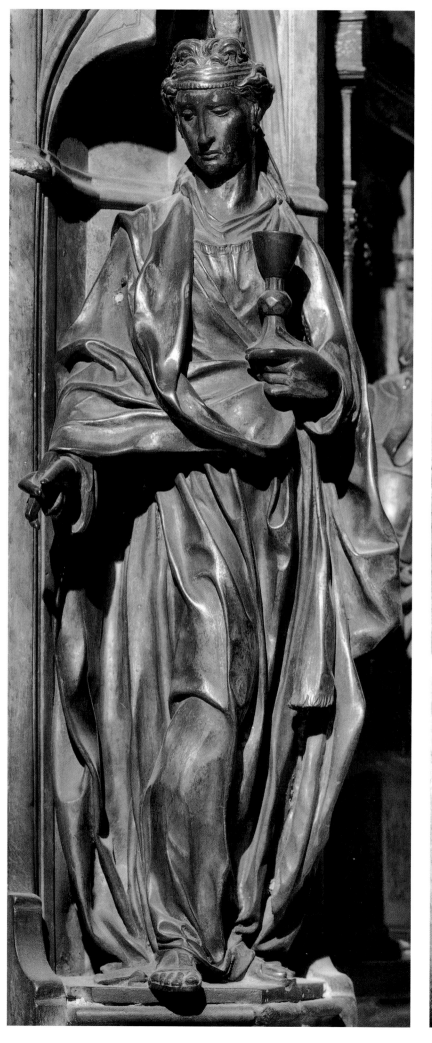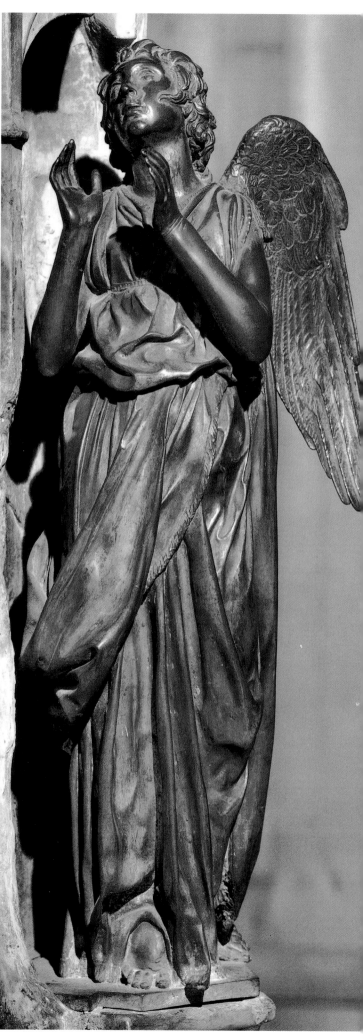

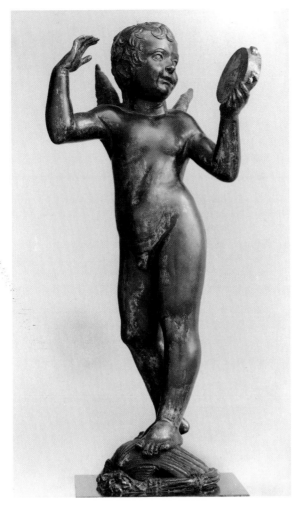

74 Donatello. *Faith; Hope*. 1428–29.
Font, Baptistry, Siena

75 TOP: Donatello. Putto from
the Sienese Font. c. 1429.
Staatliche Museen, Berlin-Dahlem

75 BOTTOM: Donatello. Two Putti
from the Sienese Font. c. 1429.
Baptistry, Siena

76 Donatello.
Reliefs of Putti from
the Exterior Pulpit.
1428–38. Museo
dell'Opera del
Duomo, Prato

OPPOSITE:
77 TOP: Donatello.
Relief of Putti from
the Exterior Pulpit.
1428–38. Museo
dell'Opera del
Duomo, Prato

77 BOTTOM:
Donatello. Bronze
Capital from the
Exterior Pulpit.
1433. Duomo, Prato

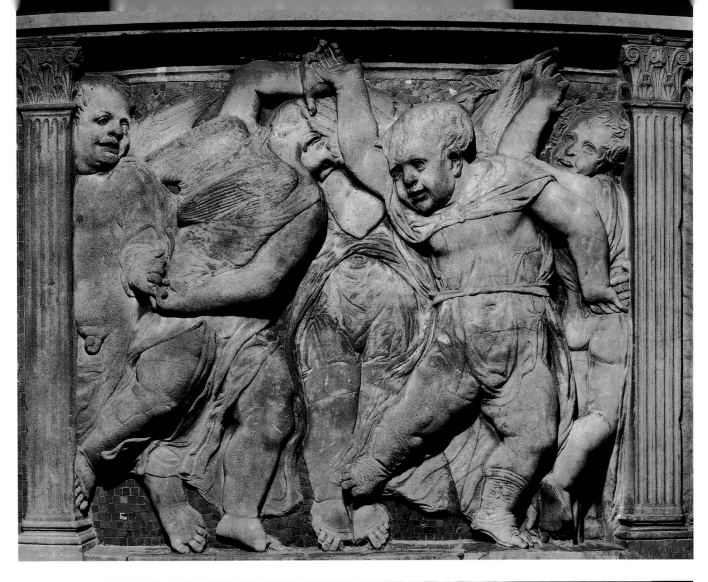

78 Donatello. Tomb Slab of Giovanni
Crivelli. c. 1432–33. Santa Maria in
Aracoeli, Rome

OPPOSITE:
79 Donatello. Tabernacle of the Sacrament.
c. 1432–33. Tesoro, St. Peter's, Rome

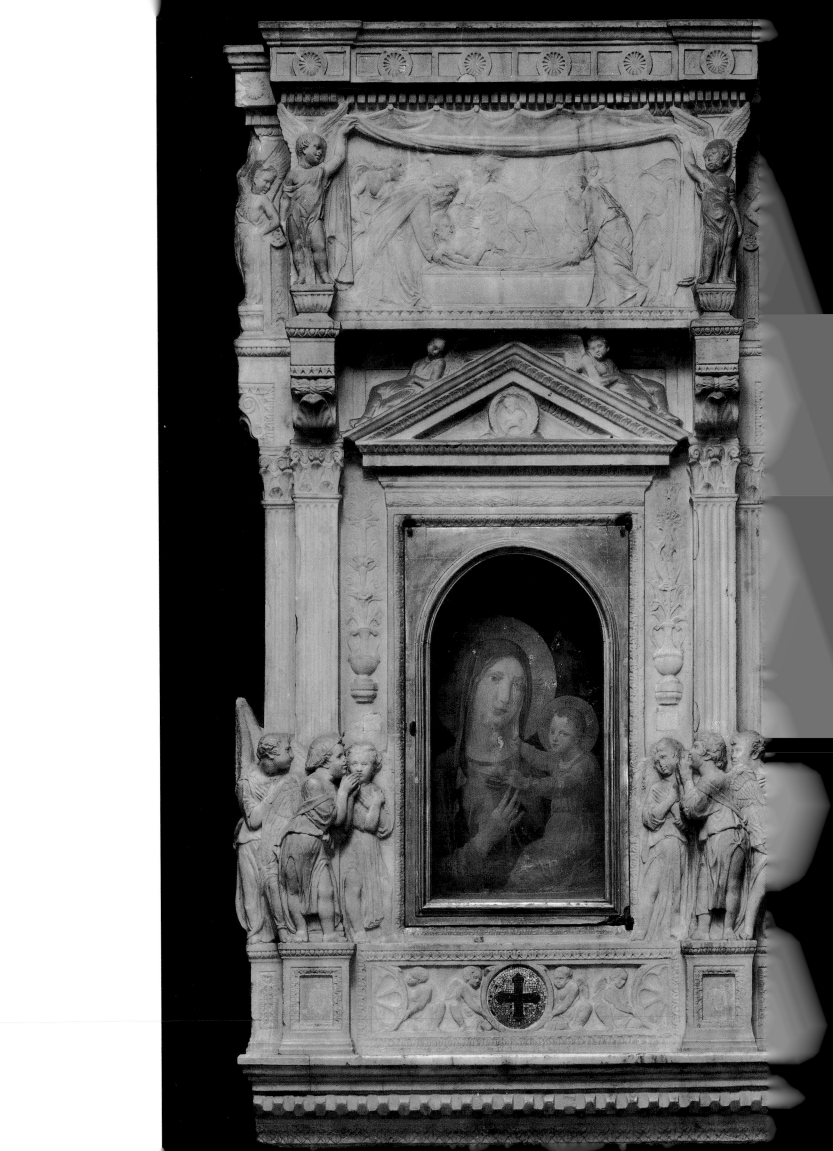

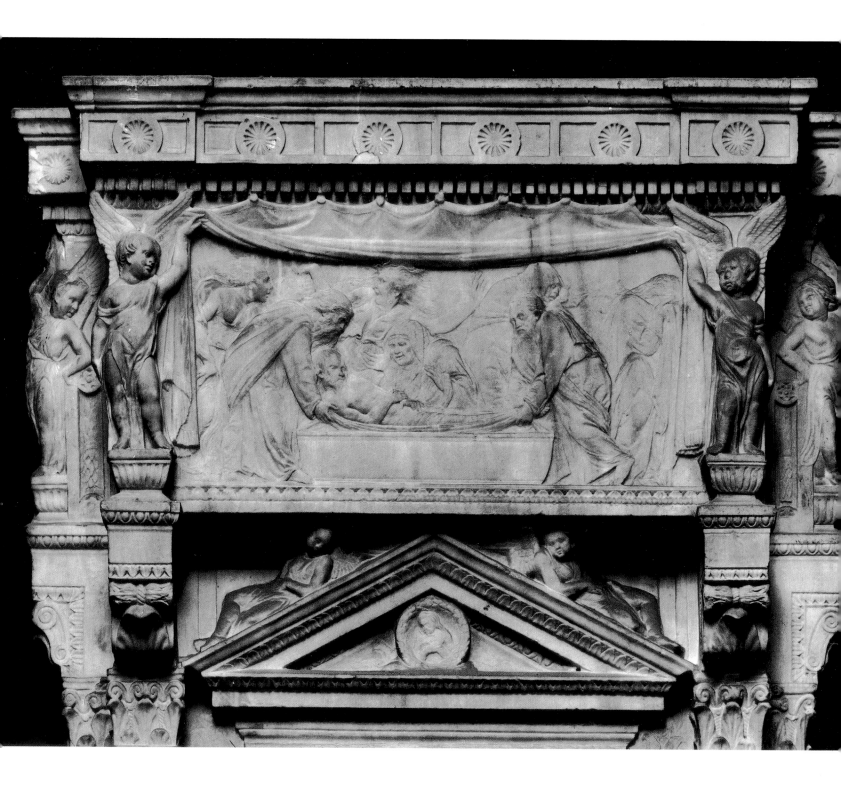

80 Donatello. Tabernacle of the Sacrament (detail: The Entombment). c. 1432–33. Tesoro,
St. Peter's, Rome

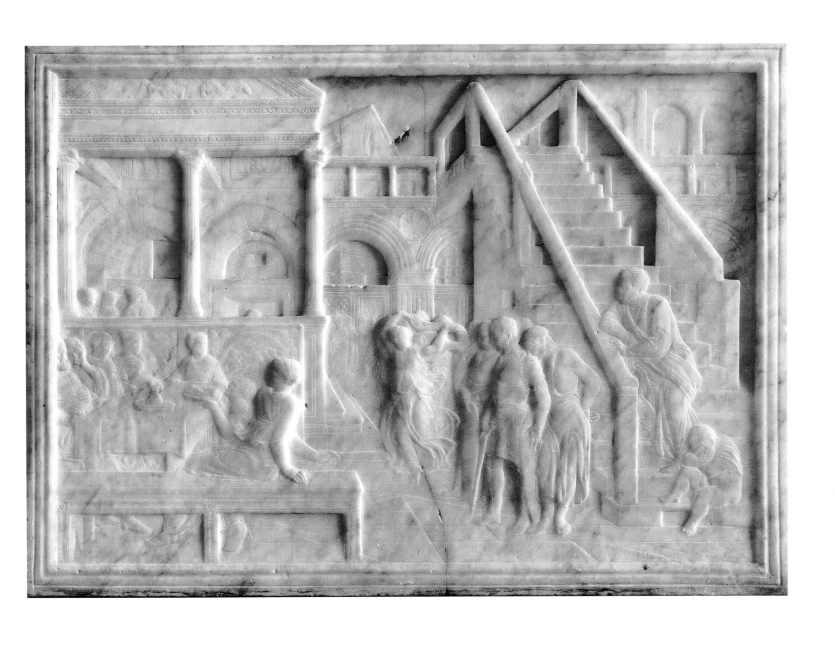

81 Donatello. *The Feast of Herod*. c. 1433–34. Musée Wicar, Lille

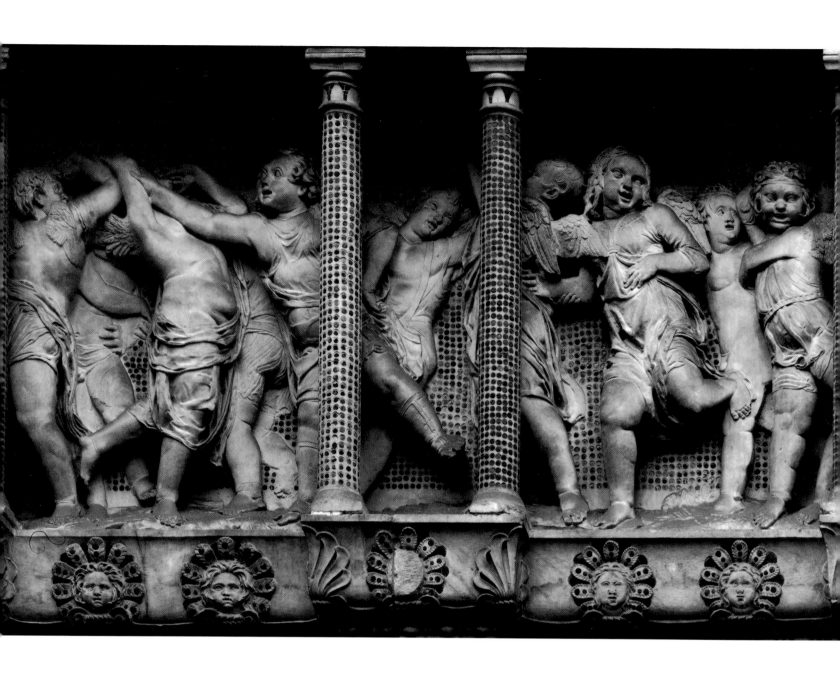

82, 83 Donatello. *Cantoria* (details). 1433–38. Museo dell'Opera del Duomo, Florence

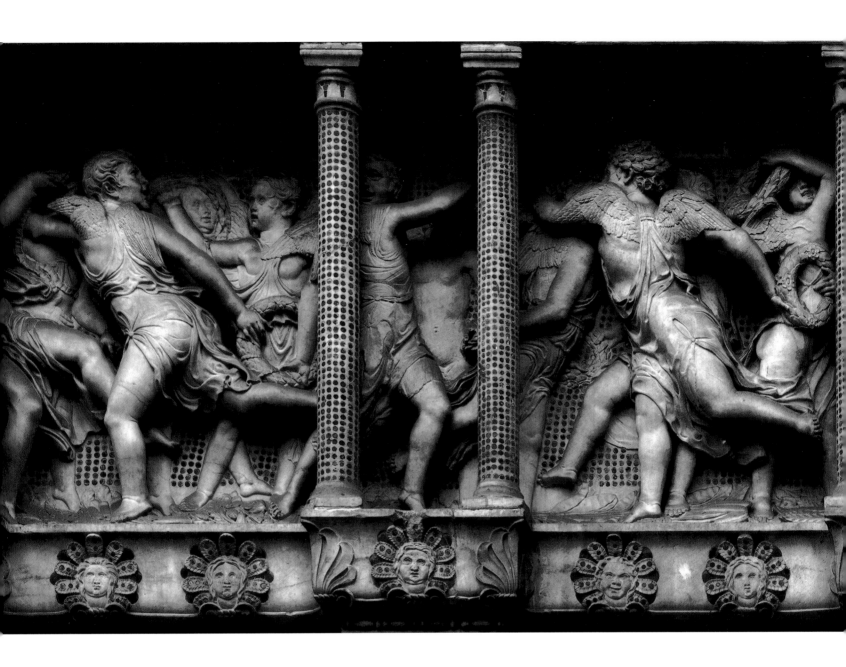

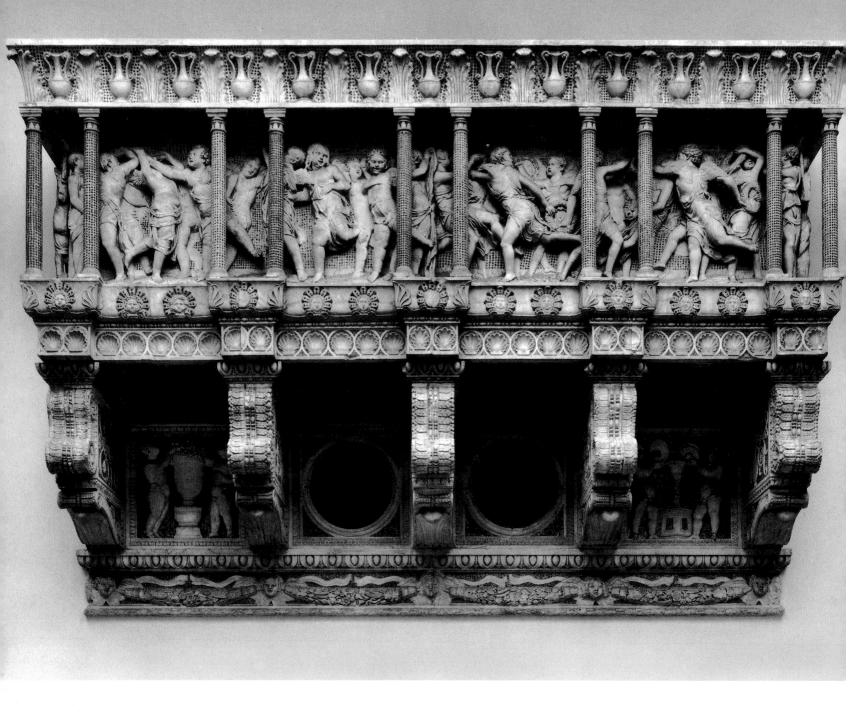

84 Donatello. *Cantoria*. 1433–38. Museo dell'Opera del Duomo, Florence

OPPOSITE:
85 Donatello. *The Annunciation* (Cavalcanti Tabernacle). c. 1435. Santa Croce, Florence

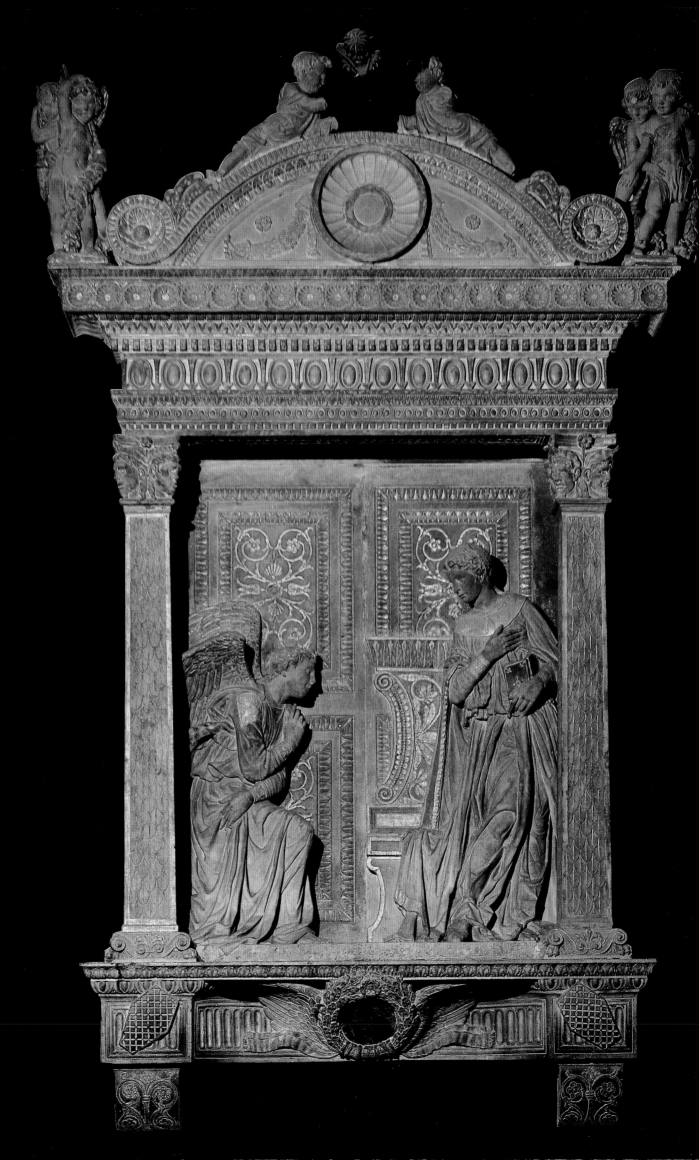

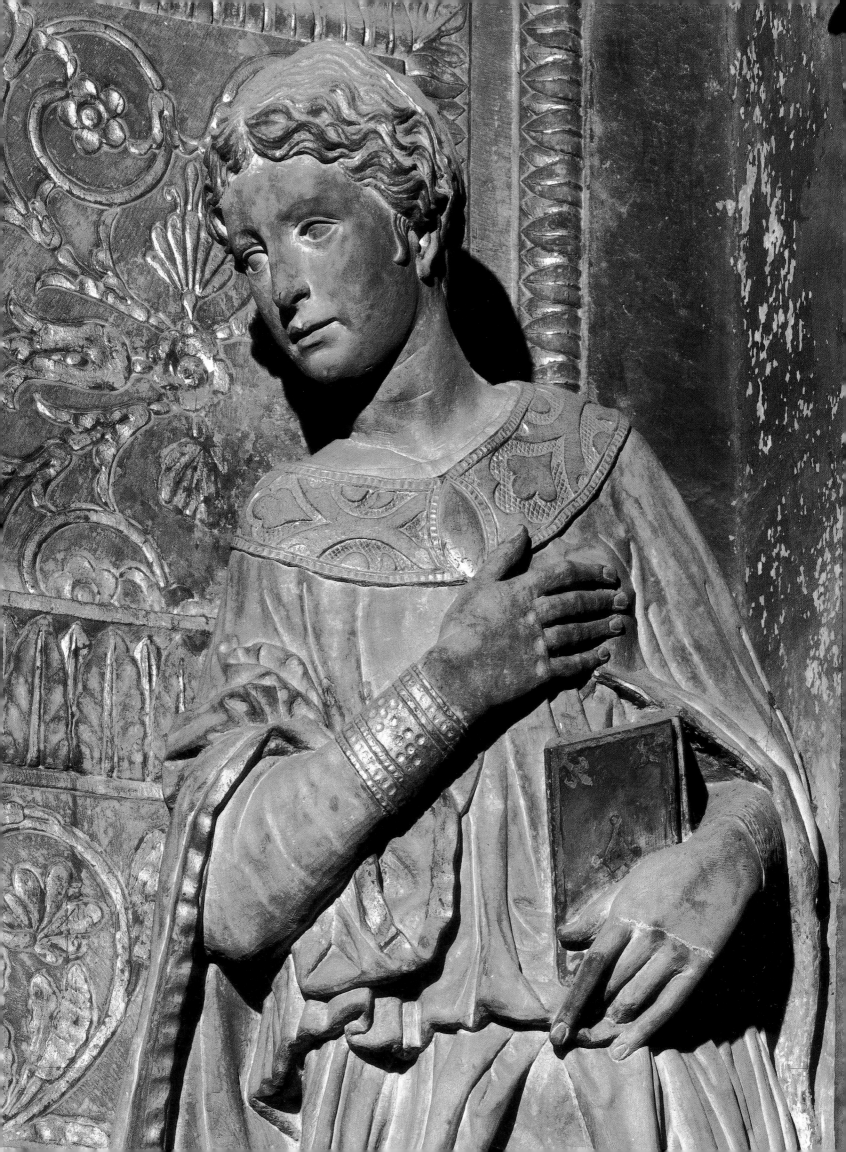

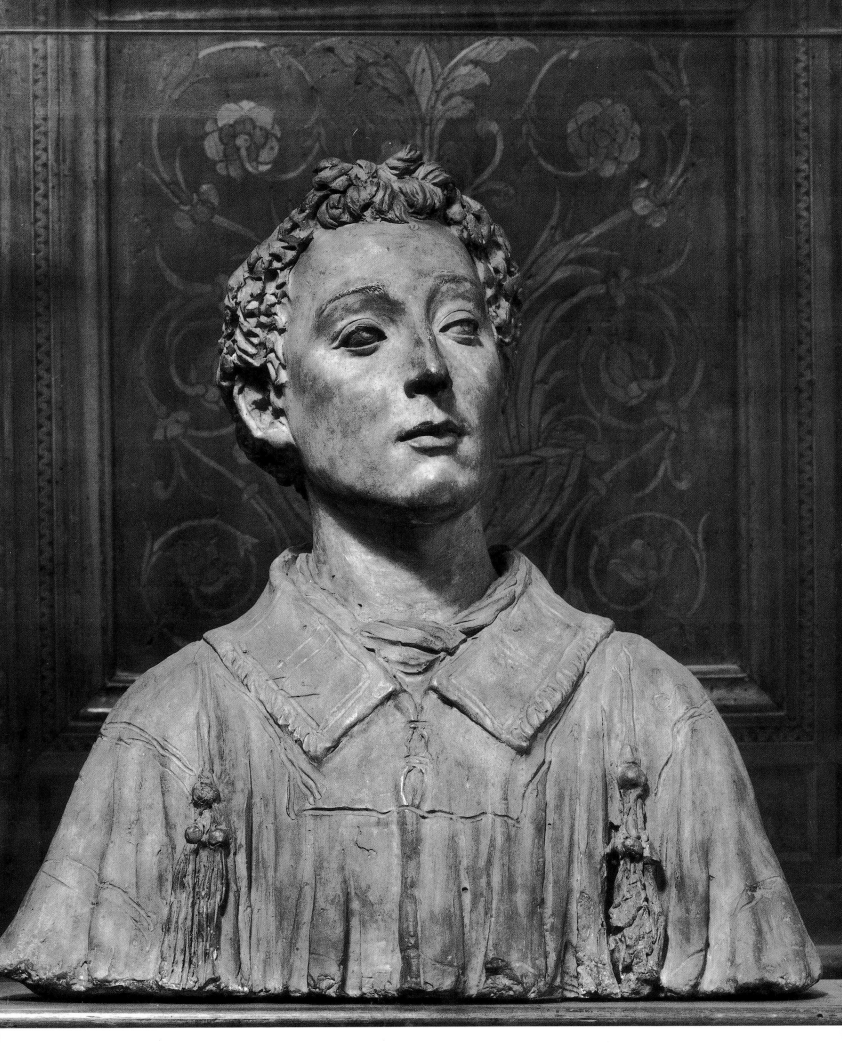

87 Donatello. *Bust of St. Leonard*. c. 1435. Old Sacristy, San Lorenzo, Florence

OPPOSITE:
86 Donatello. *The Annunciation* (Cavalcanti Tabernacle) (detail: Mary). c. 1435. Santa Croce, Florence

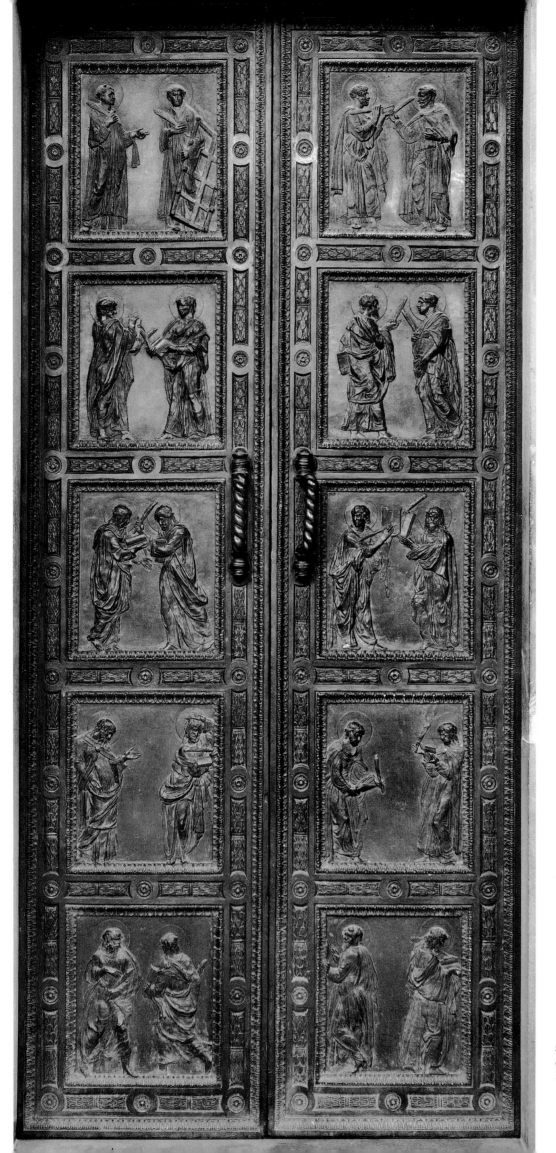

88 Donatello. Martyrs Door.
c. 1435. Old Sacristy, San Lorenzo,
Florence

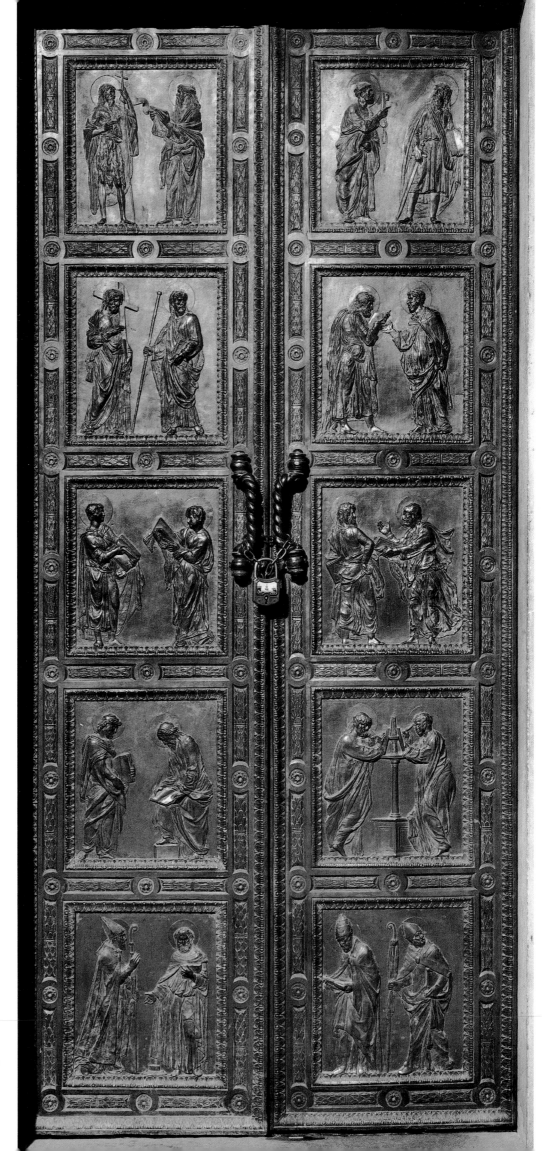

89 Donatello. Apostles Door.
c. 1435. Old Sacristy, San Lorenzo,
Florence

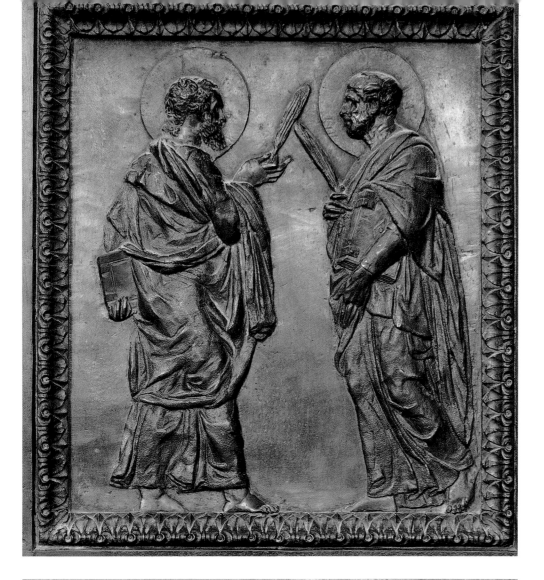

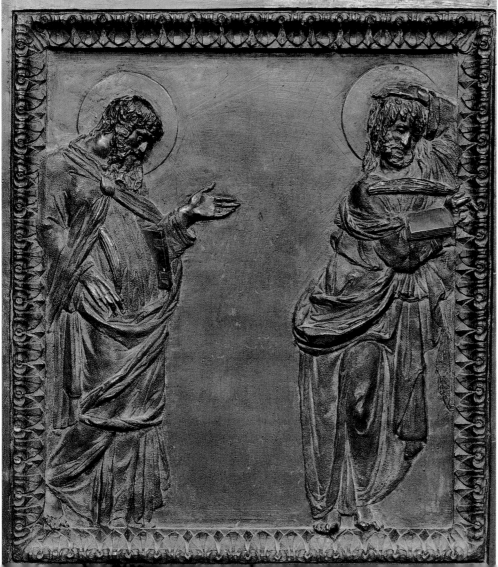

90　Donatello. Martyrs Door (details).
c. 1435. Old Sacristy, San Lorenzo,
Florence

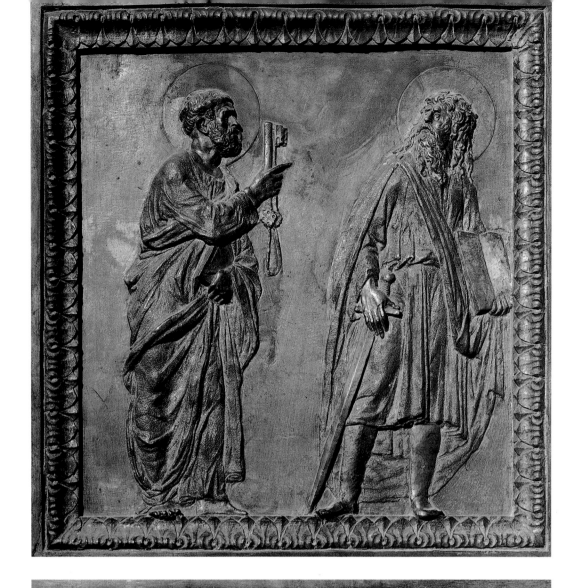

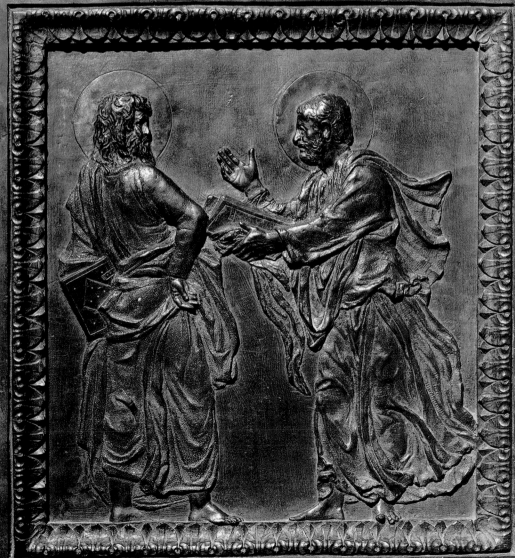

91 Donatello. Apostles Door (details).
c. 1435. Old Sacristy, San Lorenzo,
Florence

OVERLEAF LEFT:
92 Donatello. *Sts. Stephen and
Lawrence*. c. 1435. Old Sacristy,
San Lorenzo, Florence

OVERLEAF, RIGHT:
93 Donatello. *Sts. Cosmas and
Damian*. c. 1435. Old Sacristy, San
Lorenzo, Florence

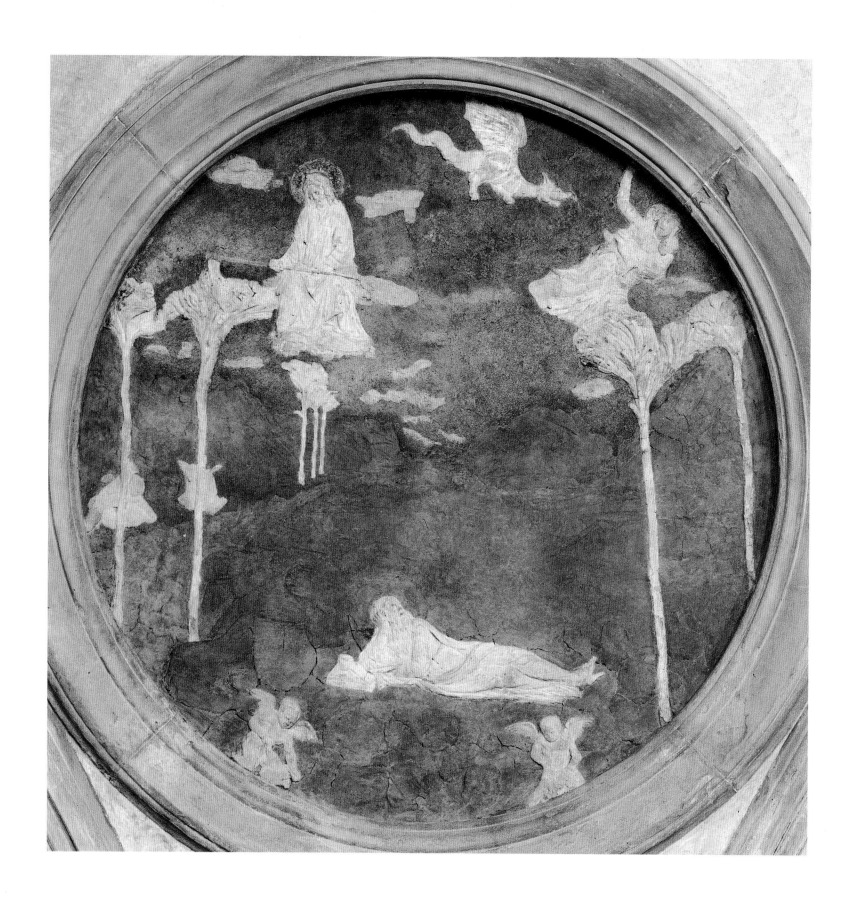

94 Donatello. *St. John on Patmos.* c. 1435. Old Sacristy, San Lorenzo, Florence

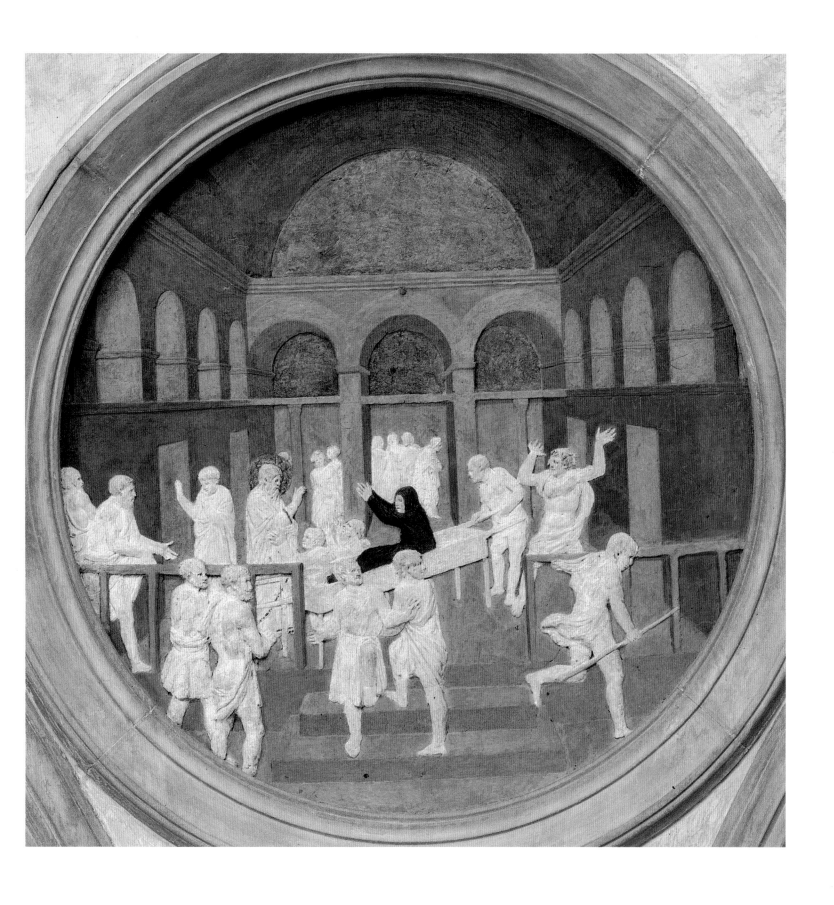

95 Donatello. *Awakening of Drusiana*. c. 1435. Old Sacristy, San Lorenzo, Florence

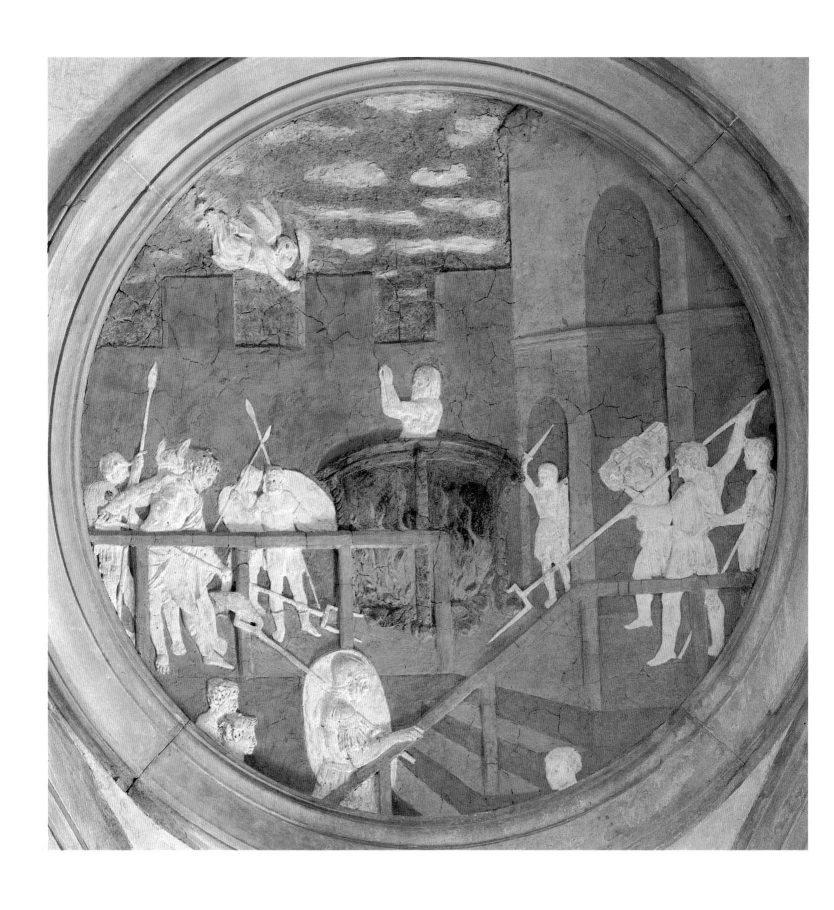

96 Donatello. *The Martyrdom of St. John*. c. 1435. Old Sacristy, San Lorenzo, Florence

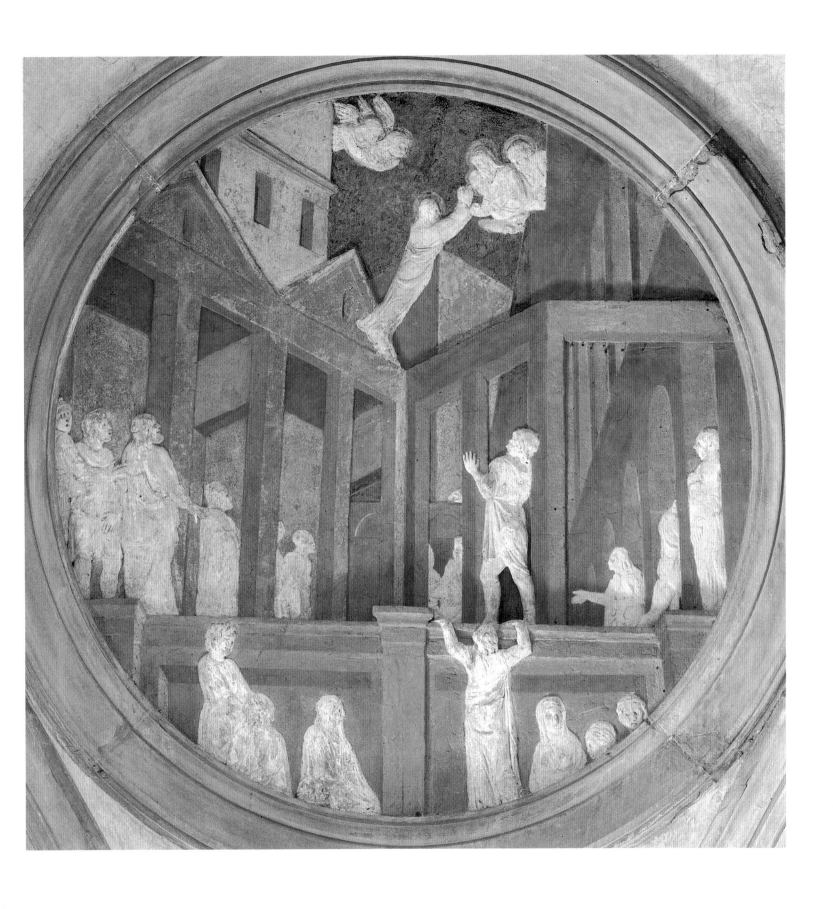

97 Donatello. *The Ascension of St. John.* c. 1435. Old Sacristy, San Lorenzo, Florence

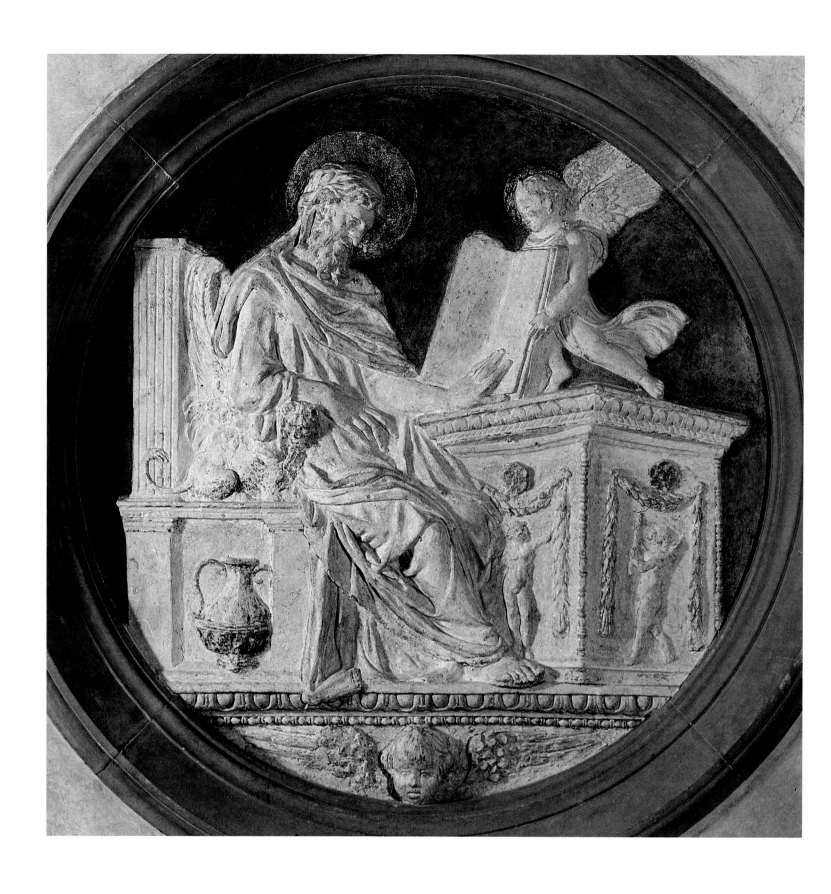

98 Donatello. *St. Matthew*. c. 1435. Old Sacristy, San Lorenzo, Florence

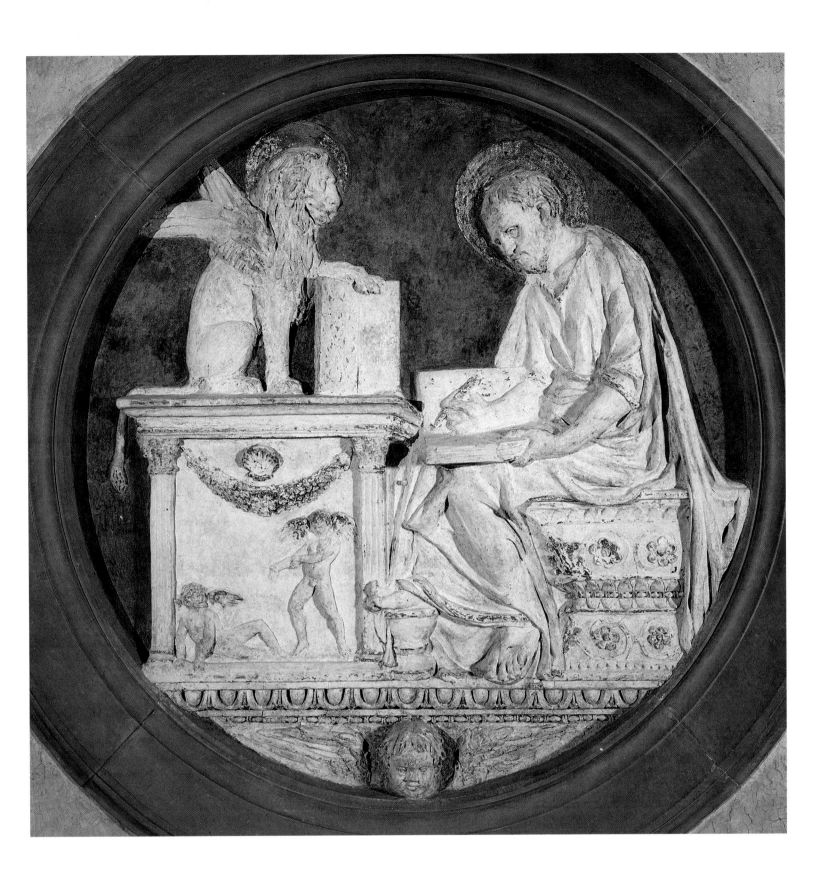

99 Donatello. *St. Mark.* c. 1435. Old Sacristy, San Lorenzo, Florence

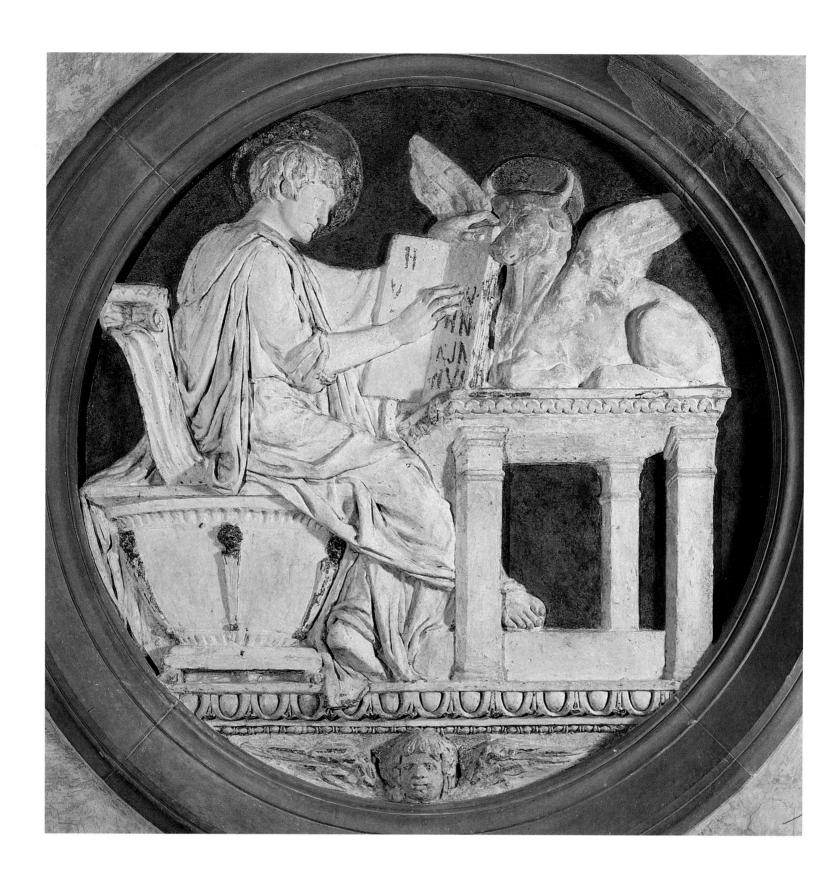

100 Donatello. *St. Luke*. c. 1435. Old Sacristy, San Lorenzo, Florence

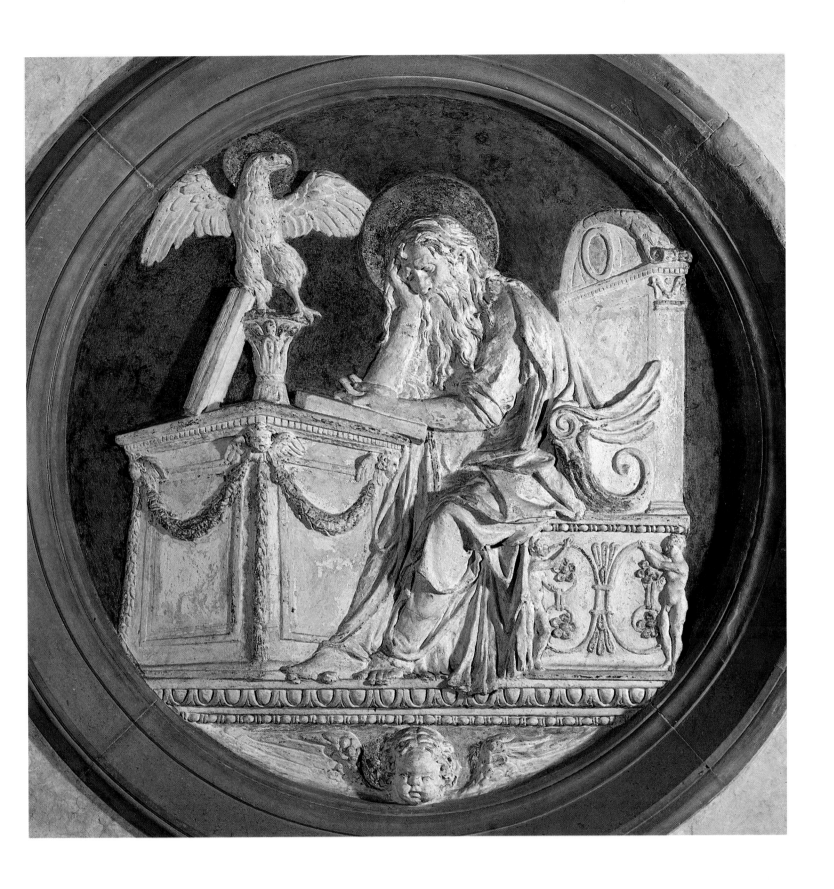

101 Donatello. *St. John the Evangelist*. c. 1435. Old Sacristy, San Lorenzo, Florence

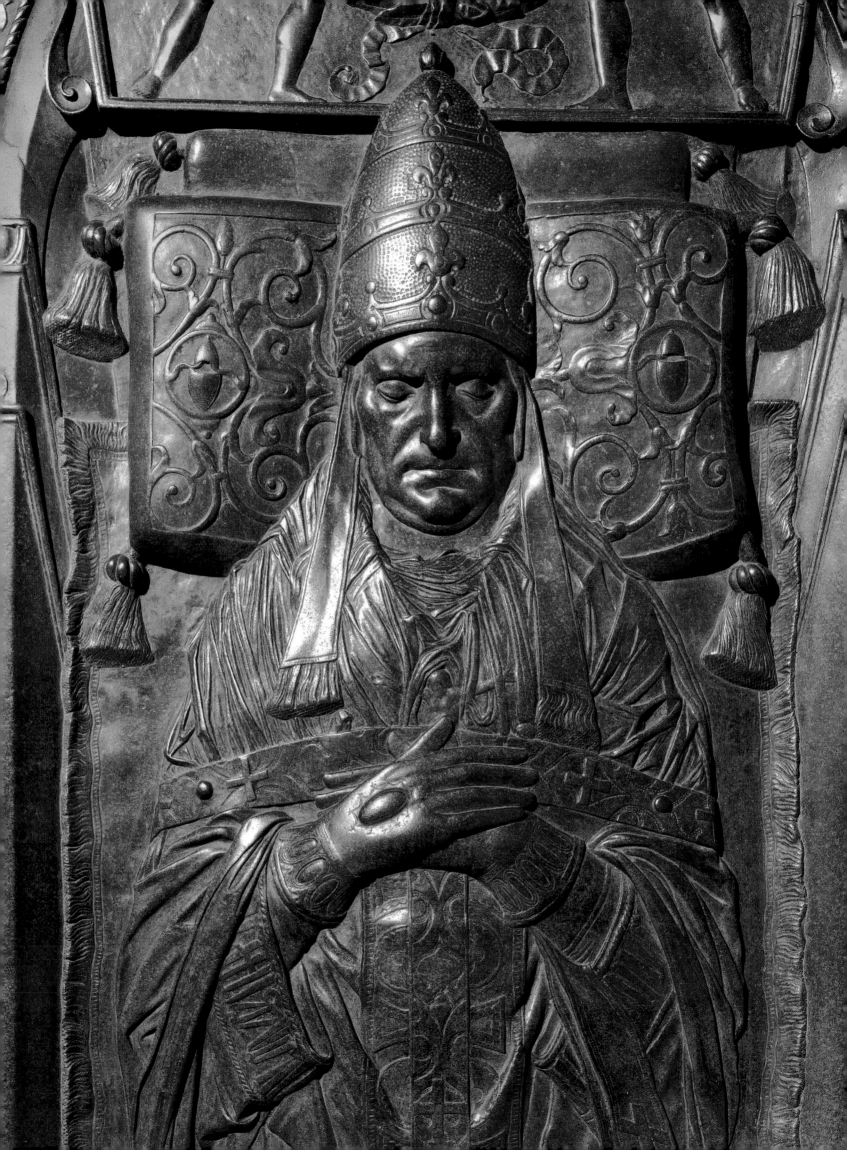

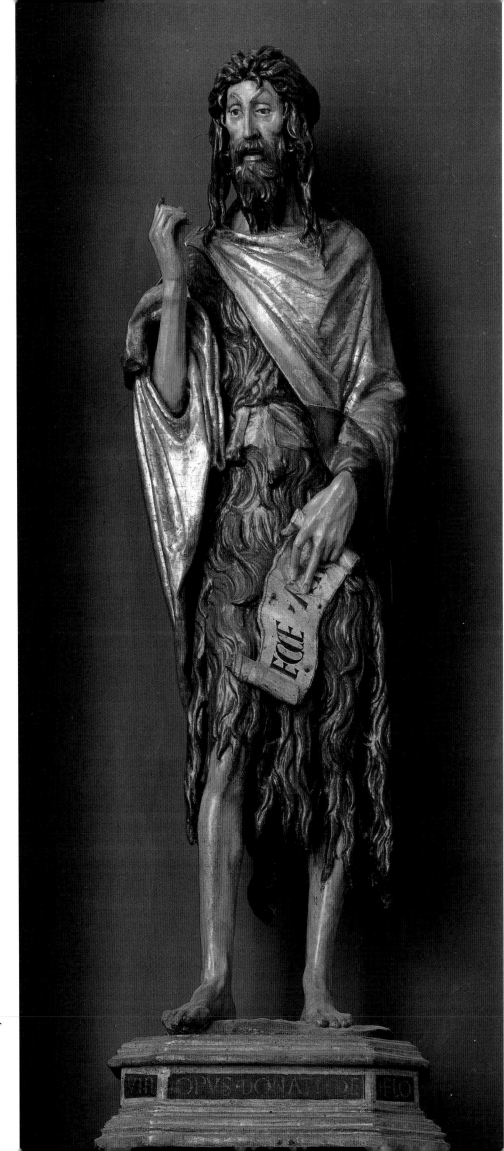

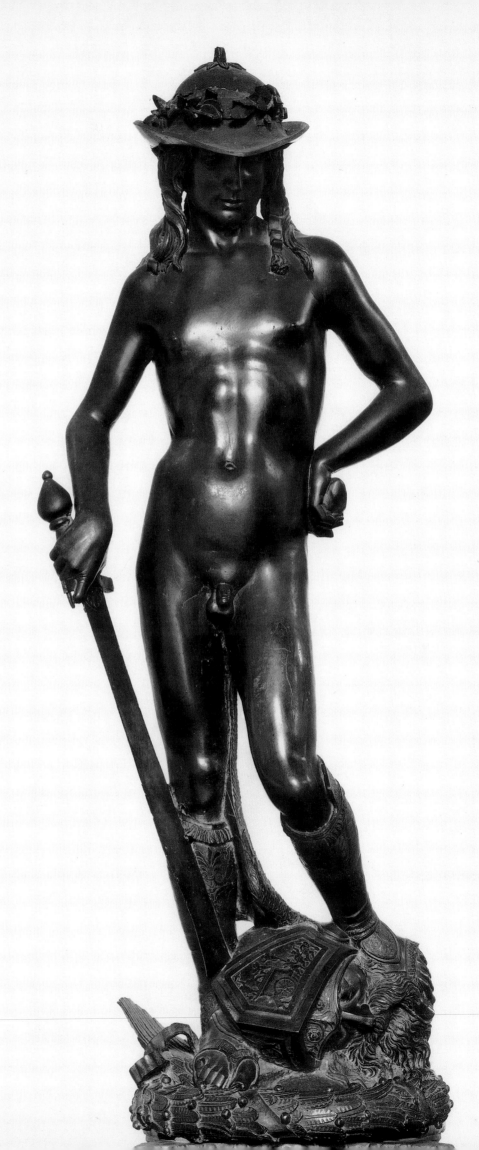

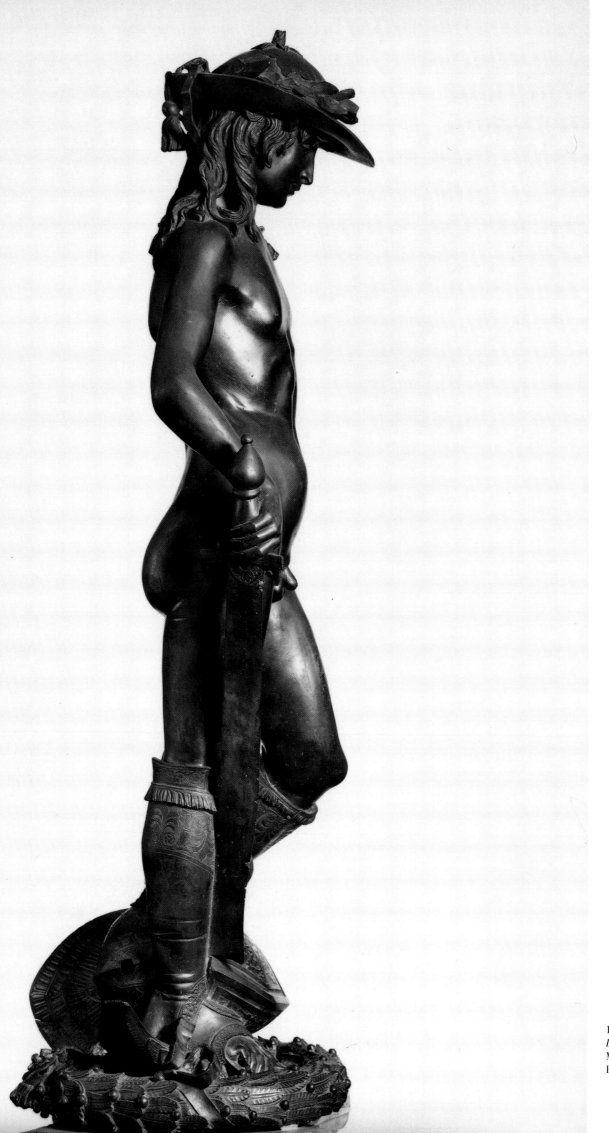

106, 107 Donatello.
David. c. 1444–46.
Museo Nazionale del
Bargello, Florence

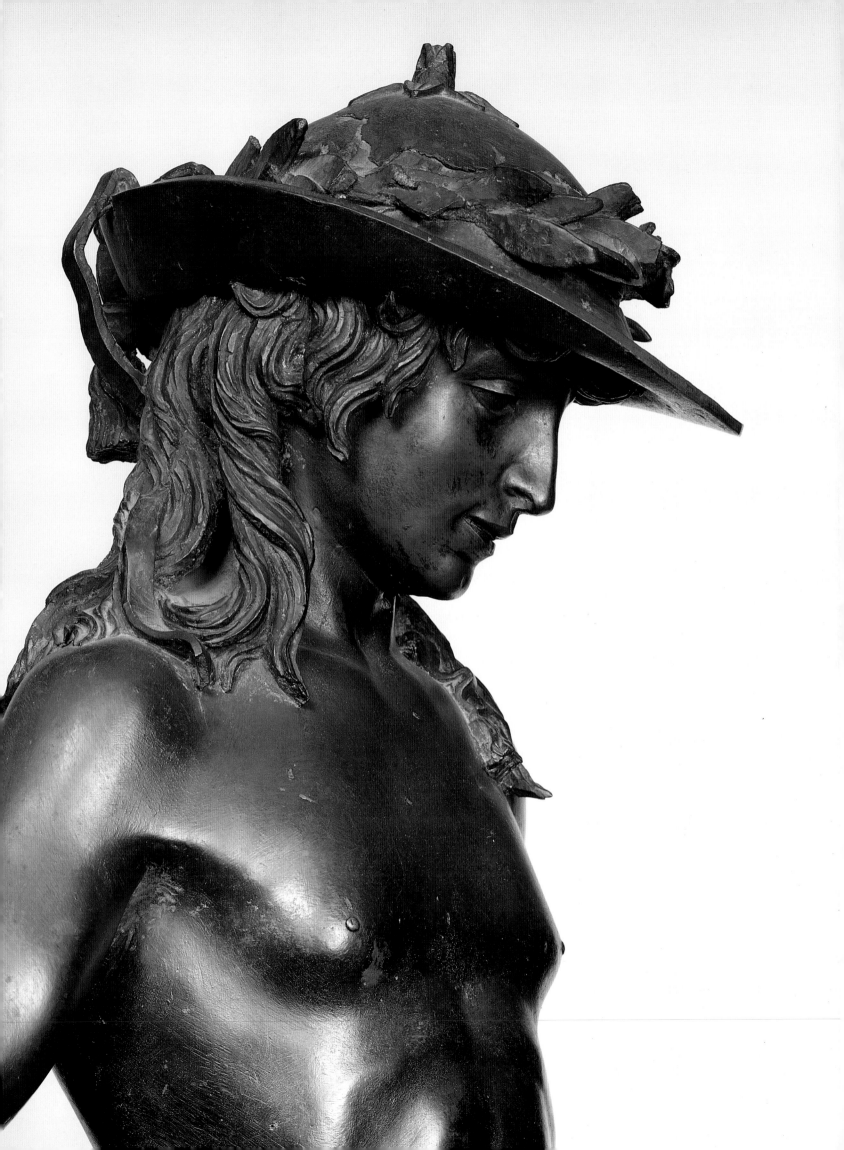

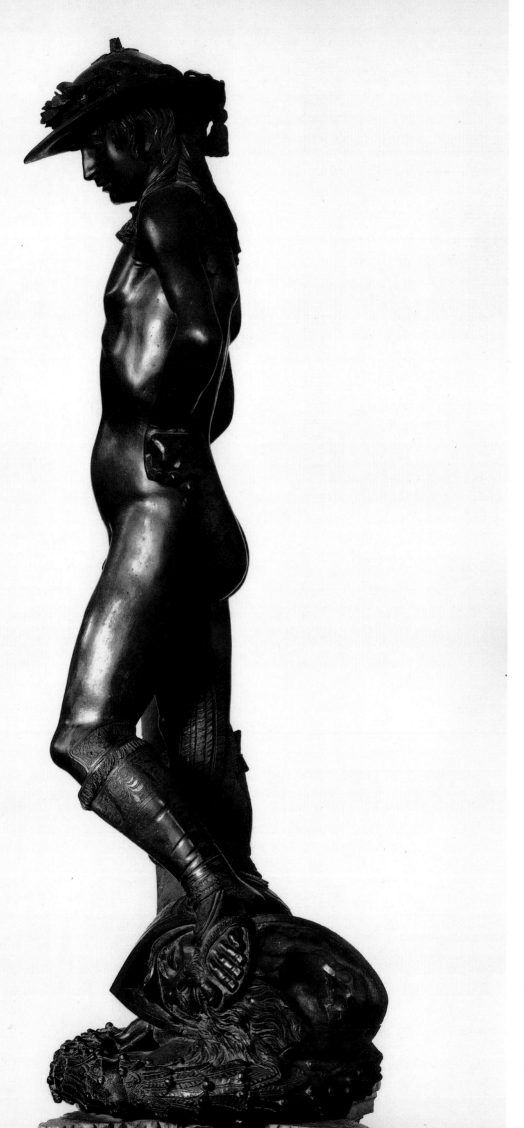

108, 109 Donatello.
David. c. 1444–46.
Museo Nazionale del
Bargello, Florence

109 detail: head of
Goliath

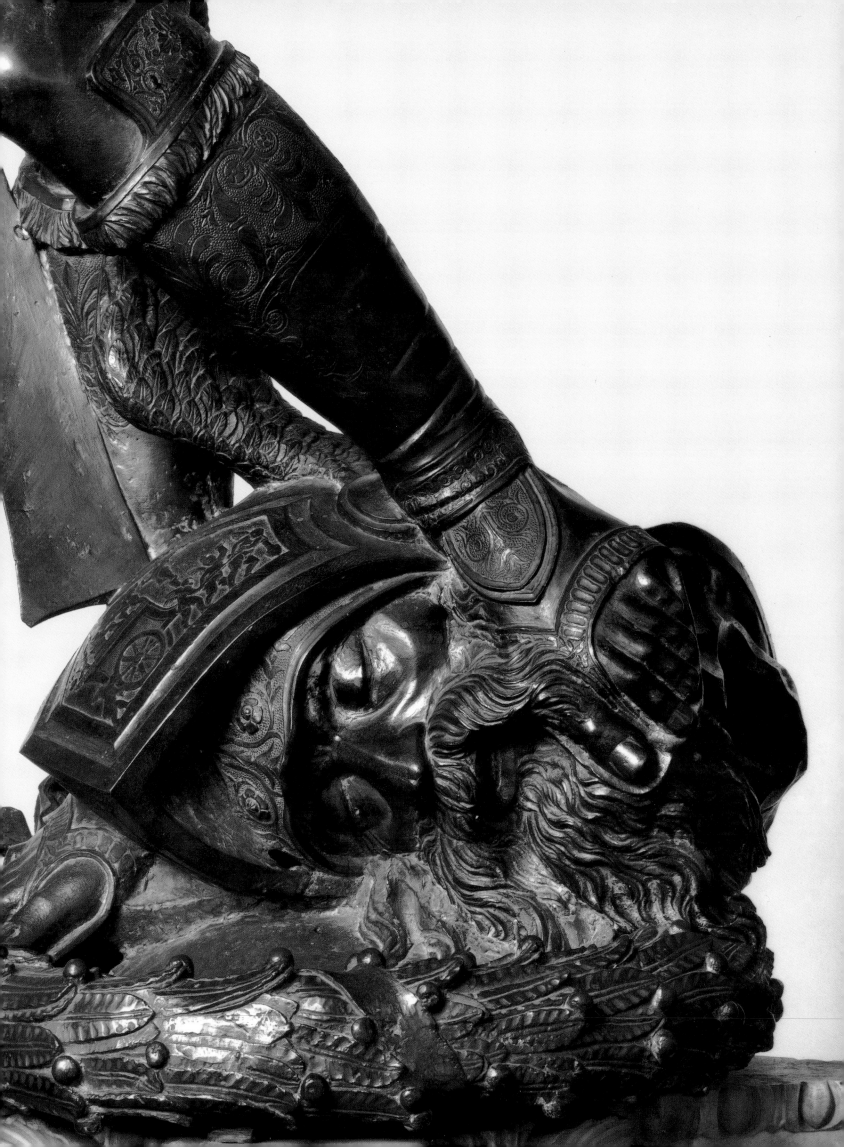

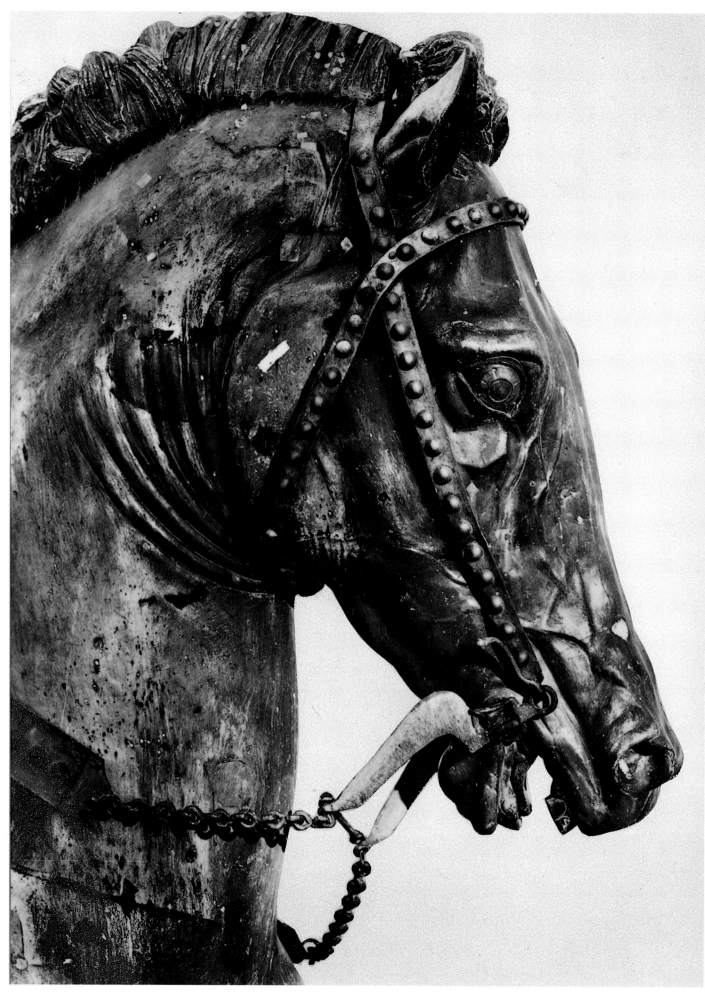

110, 111 Donatello. Equestrian Monument of Gattamelata. 1444–53. Piazza del Santo, Padua
110 detail: head of the horse

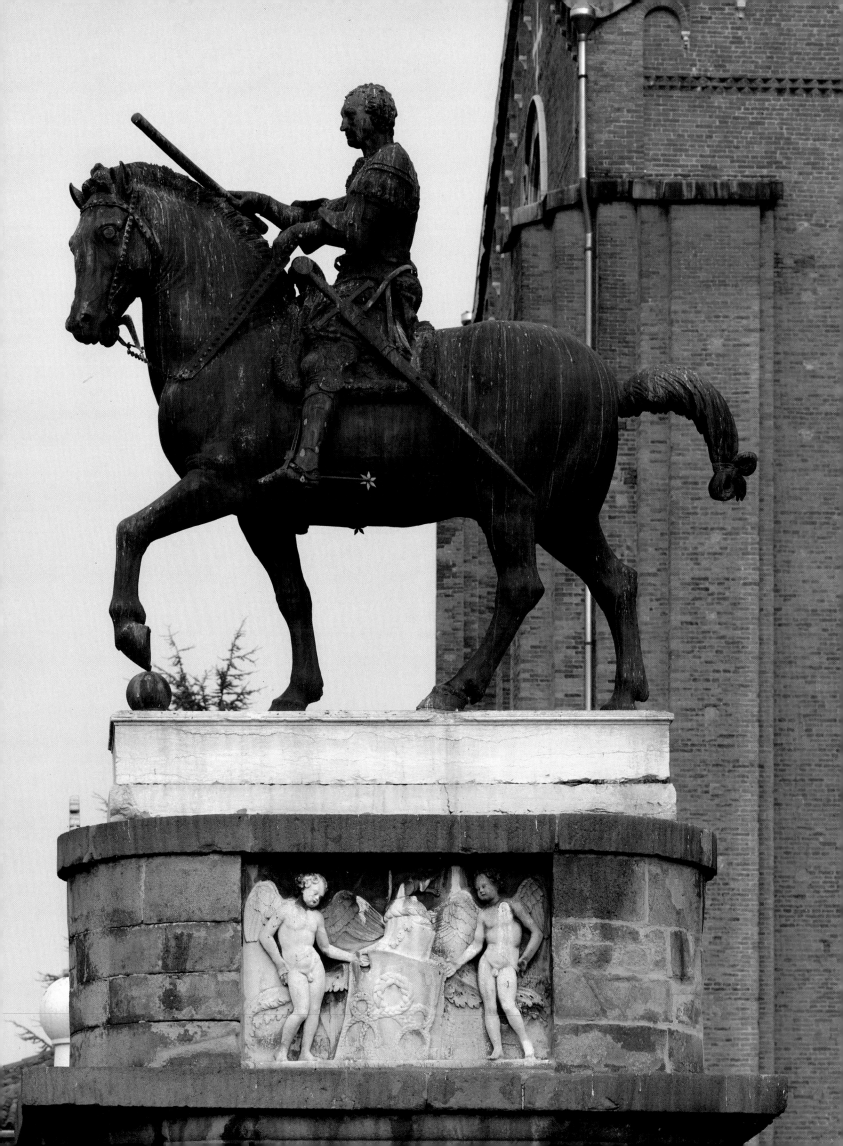

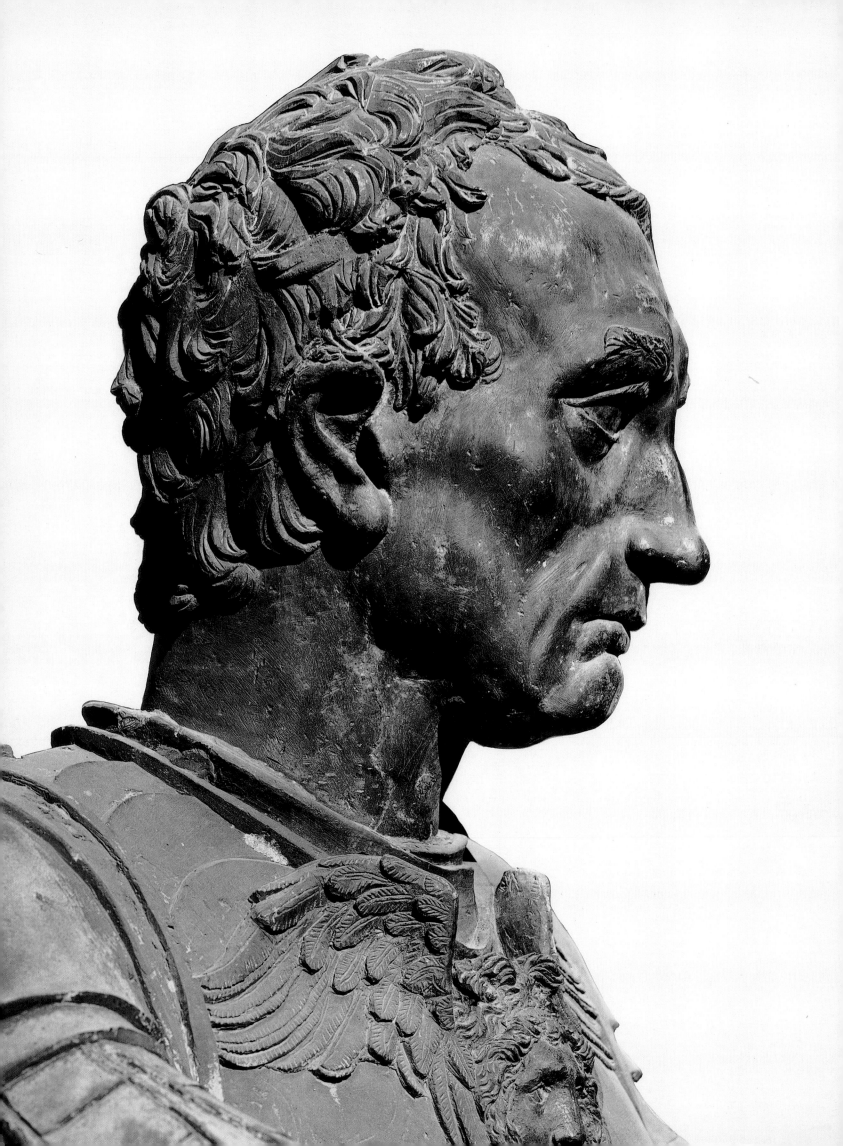

112, 113 Donatello. Equestrian Monument of Gattamelata. 1444–53. Piazza del Santo, Padua

113 detail: tunic

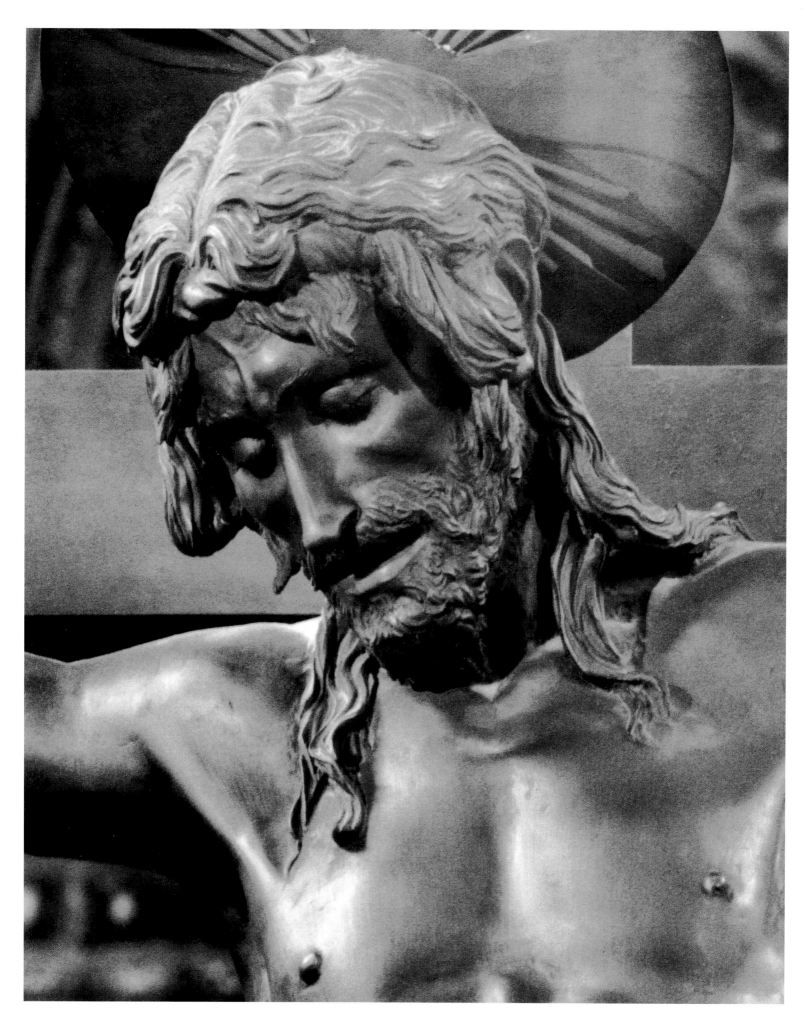

114 Donatello. *Crucifix* (detail). 1444–49. Basilica del Santo, Padua

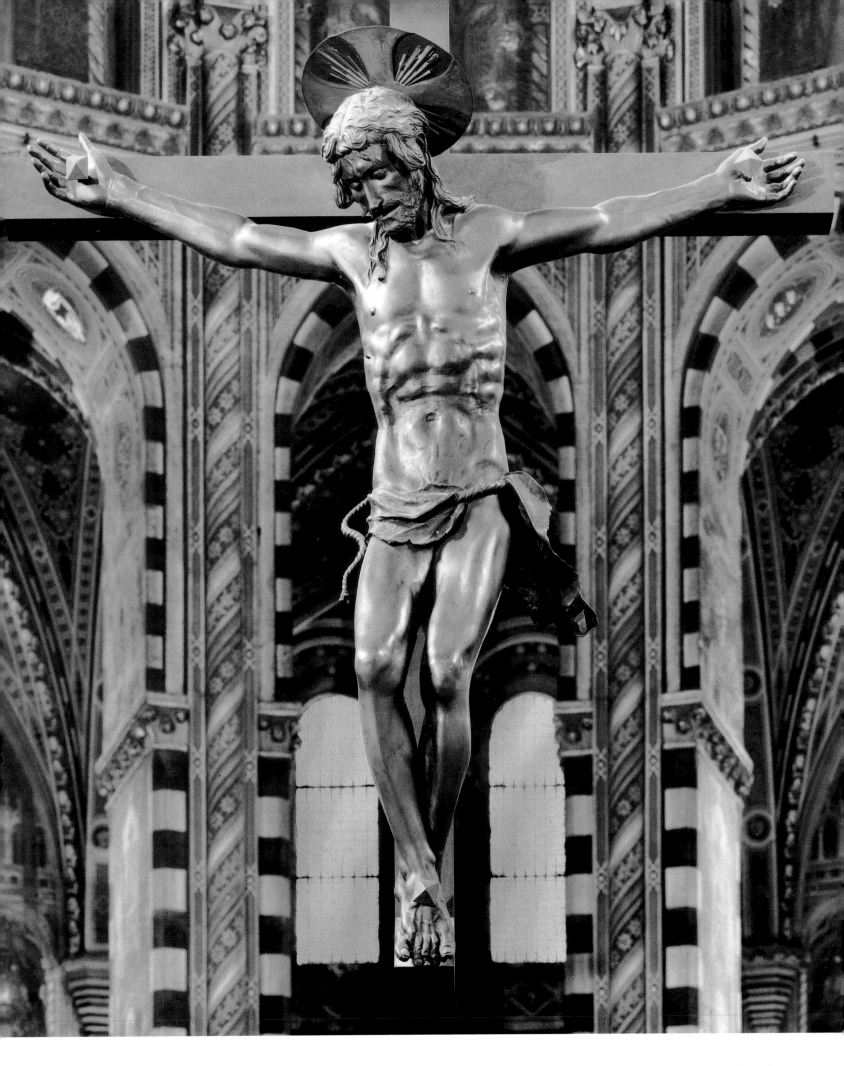

115 Donatello. *Crucifix*. 1444–49. Basilica del Santo, Padua

116, 117 Donatello. *Madonna and Child Between St. Francis and St. Anthony.* 1446–50.
Basilica del Santo, Padua

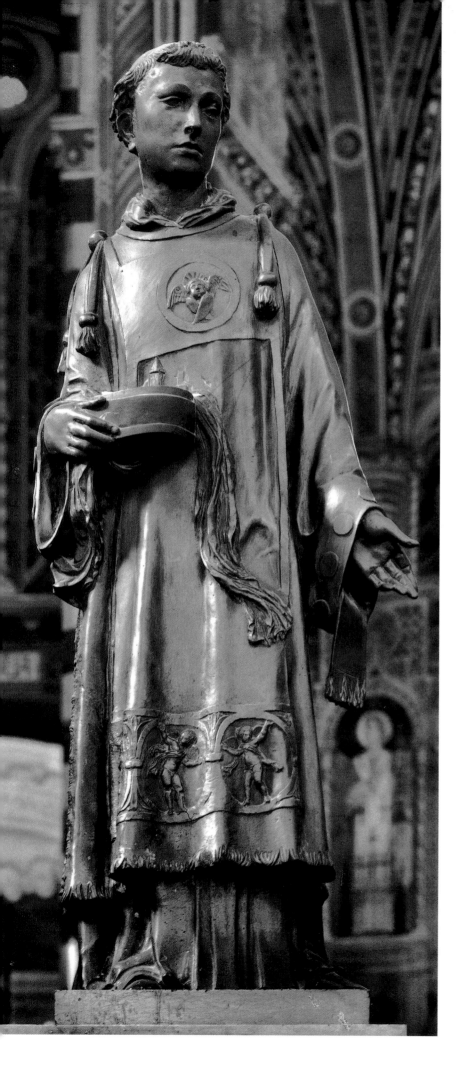
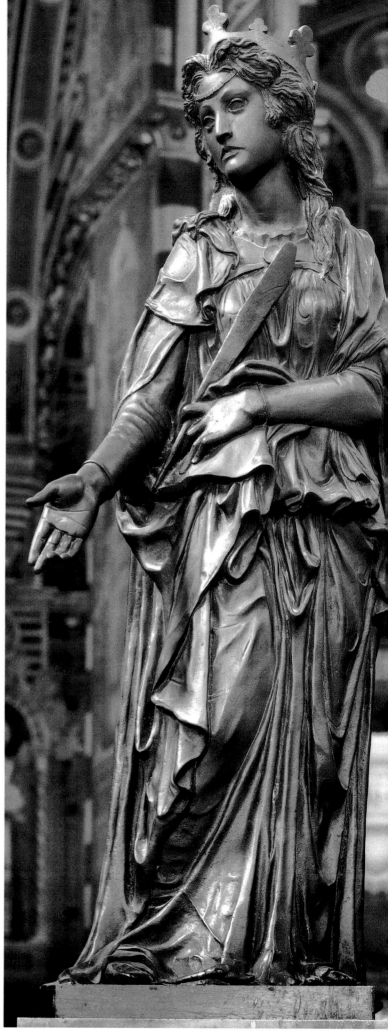

118 Donatello. *St. Daniel and St. Justina*. 1446–50. Basilica del Santo, Padua

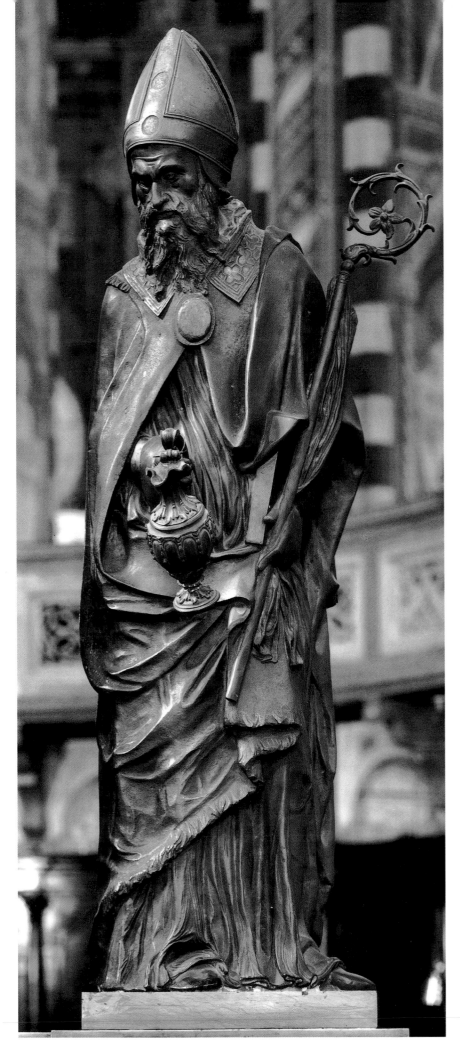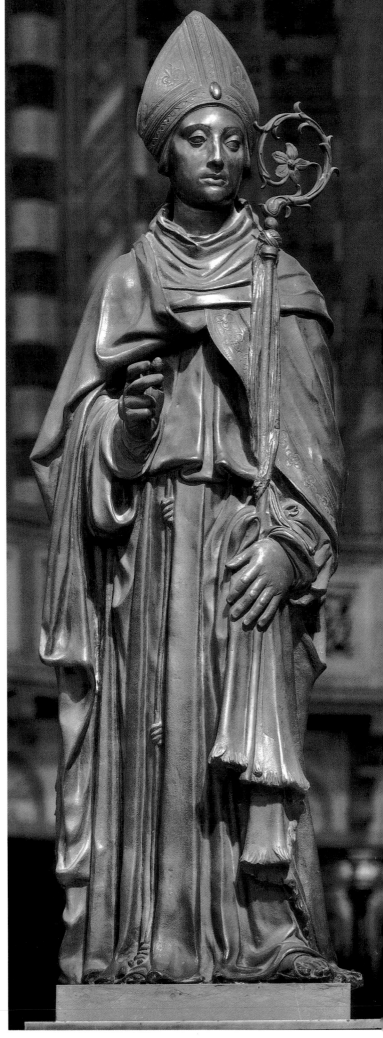

119 Donatello. *St. Prosdocimus and St. Louis of Toulouse*. 1446–50. Basilica del Santo, Padua

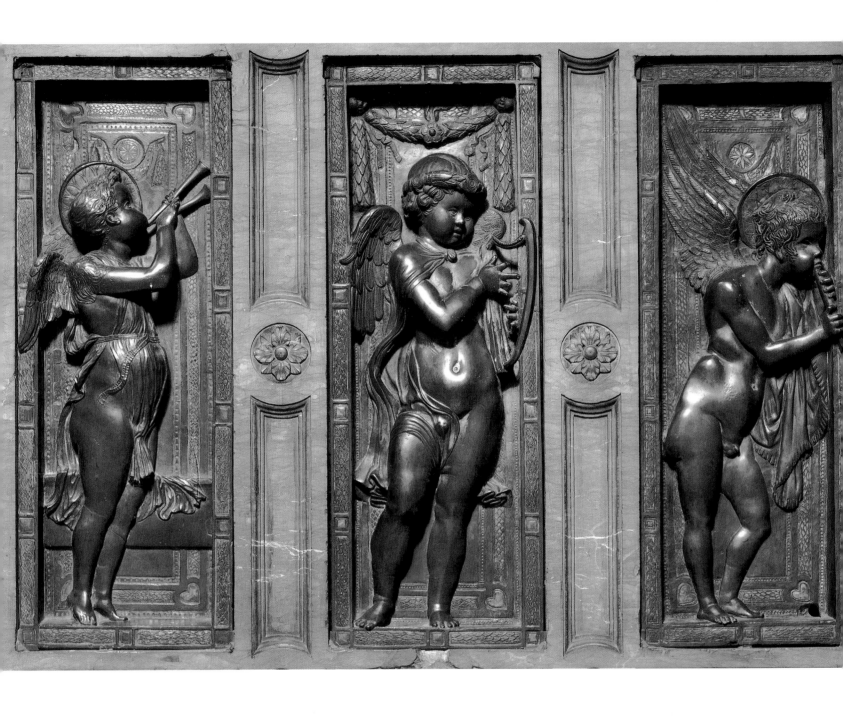

120 Donatello. *Musical Putti*. 1446–50. Basilica del Santo, Padua

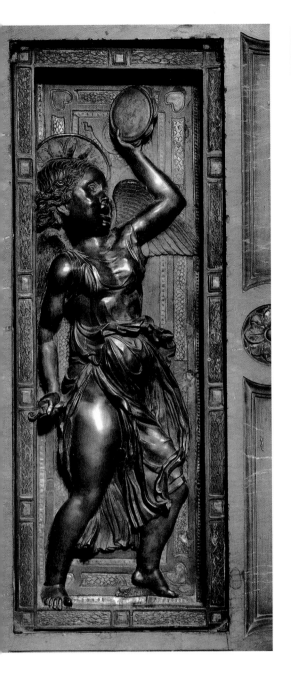

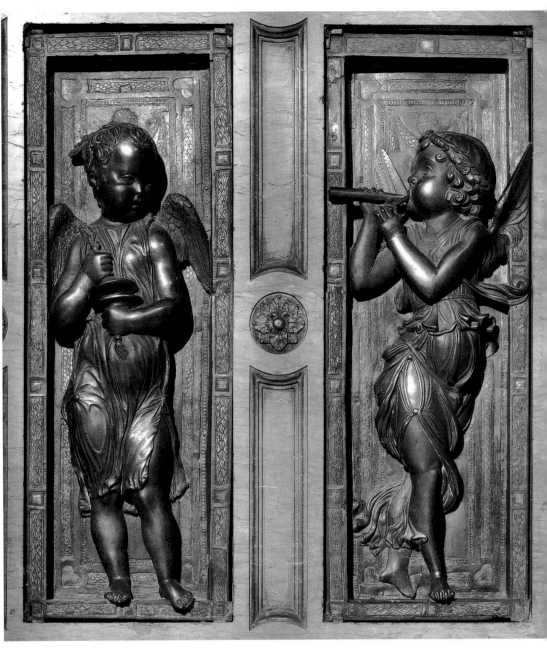

121 Donatello. *Musical Putti*. 1446–50. Basilica del Santo, Padua

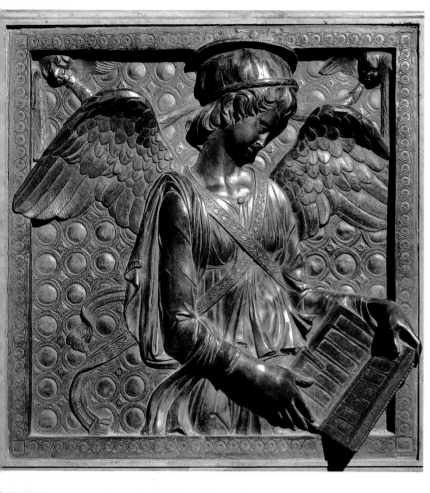
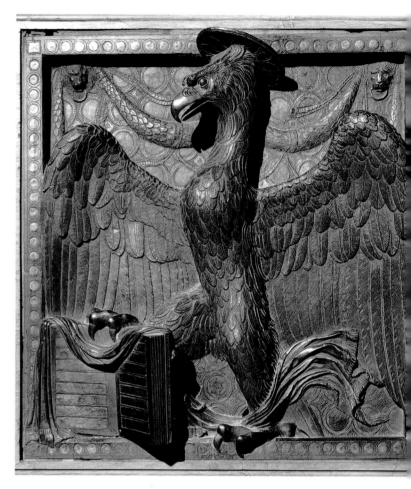
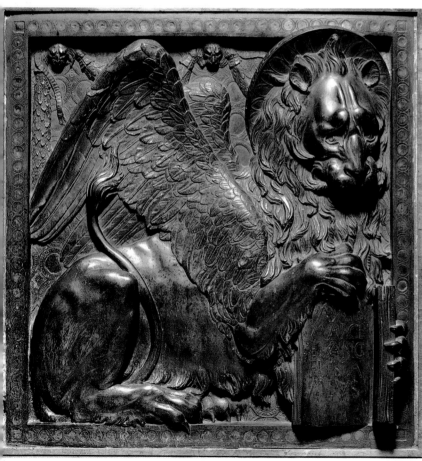
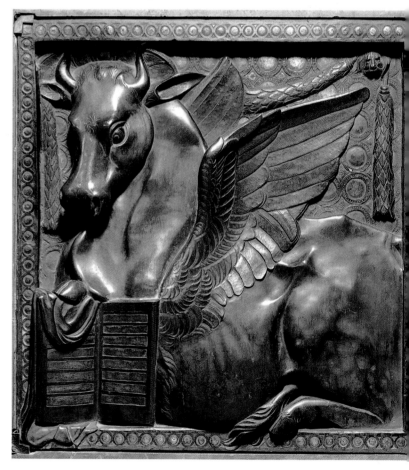

122 Donatello. *Symbols of the Evangelists.* 1446–50. Basilica del Santo, Padua

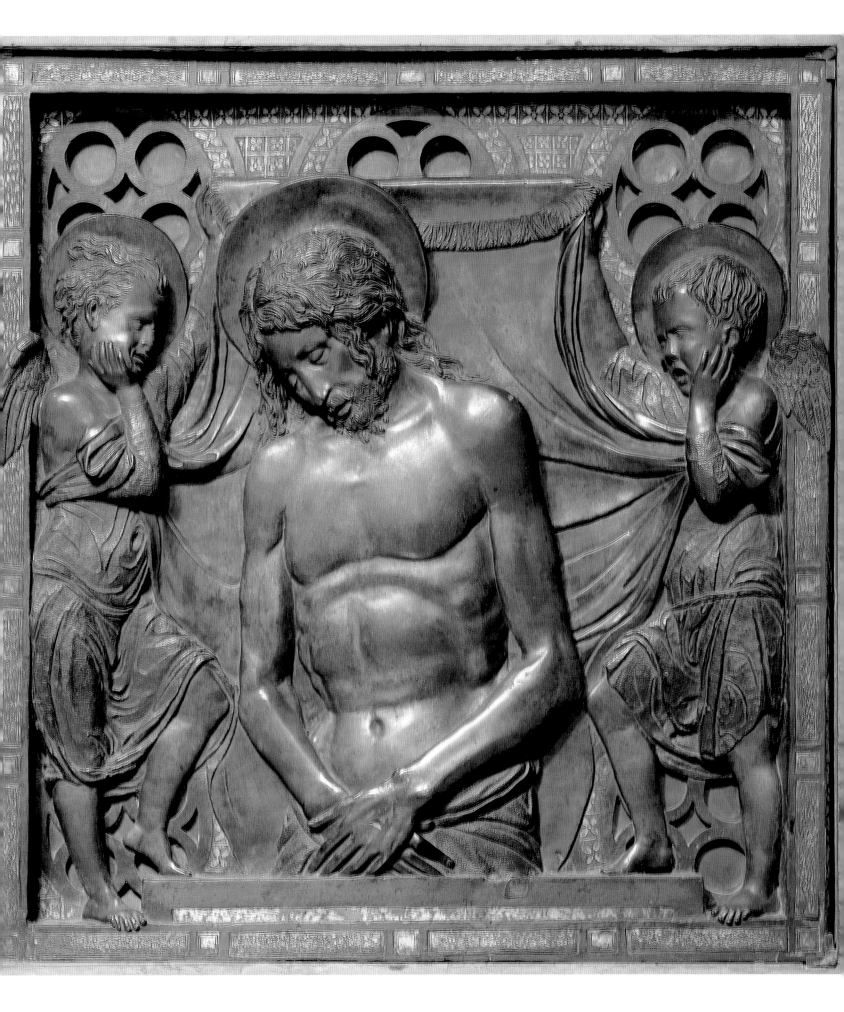

123 Donatello. *Pietà*. 1446–50. Basilica del Santo, Padua

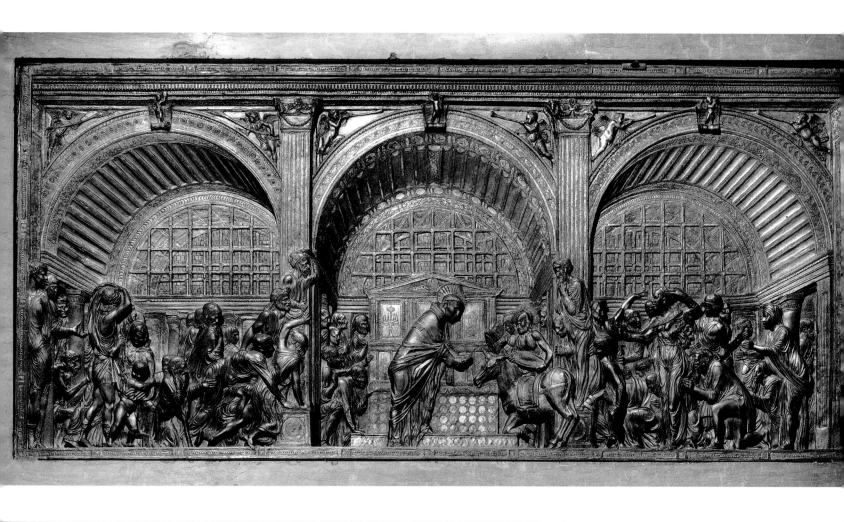

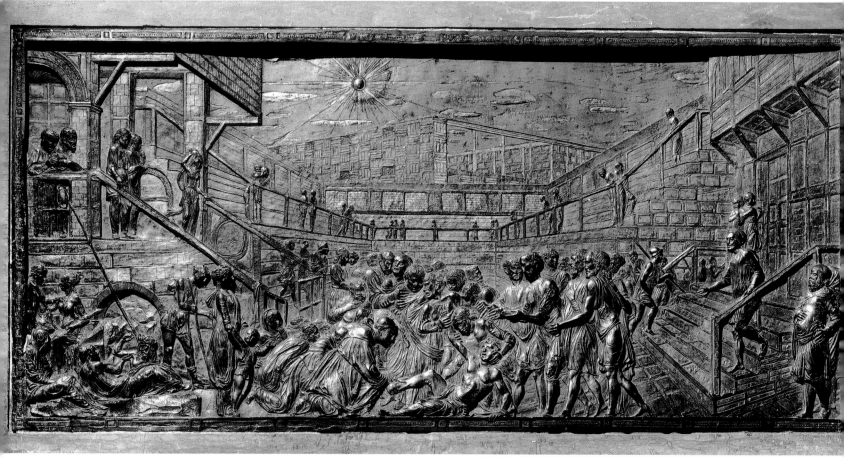

124 Donatello. *The Miracles of St. Anthony.* 1446–50. Basilica del Santo, Padua
ABOVE: *The Miracle of the Host*
BELOW: *The Healing of the Hotheaded Youth*

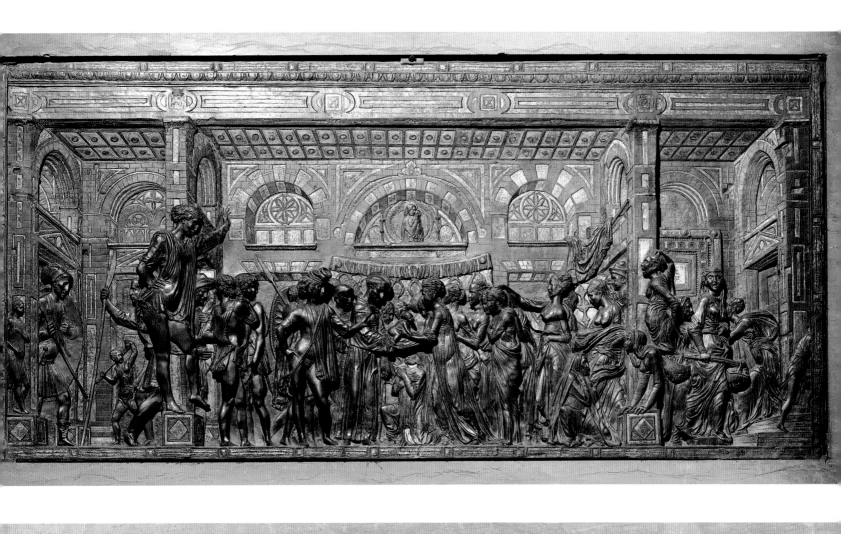

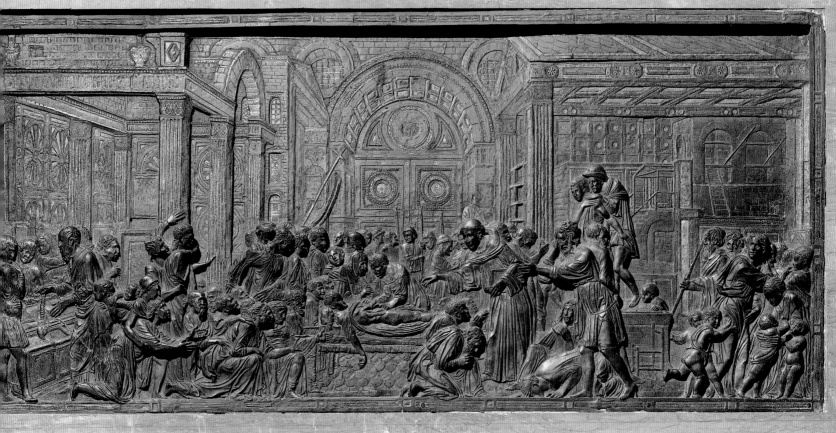

125 Donatello. *The Miracles of St. Anthony.* 1446–50. Basilica del Santo, Padua
ABOVE: *The Miracle of the Infant*
BELOW: *The Miracle of the Miser*

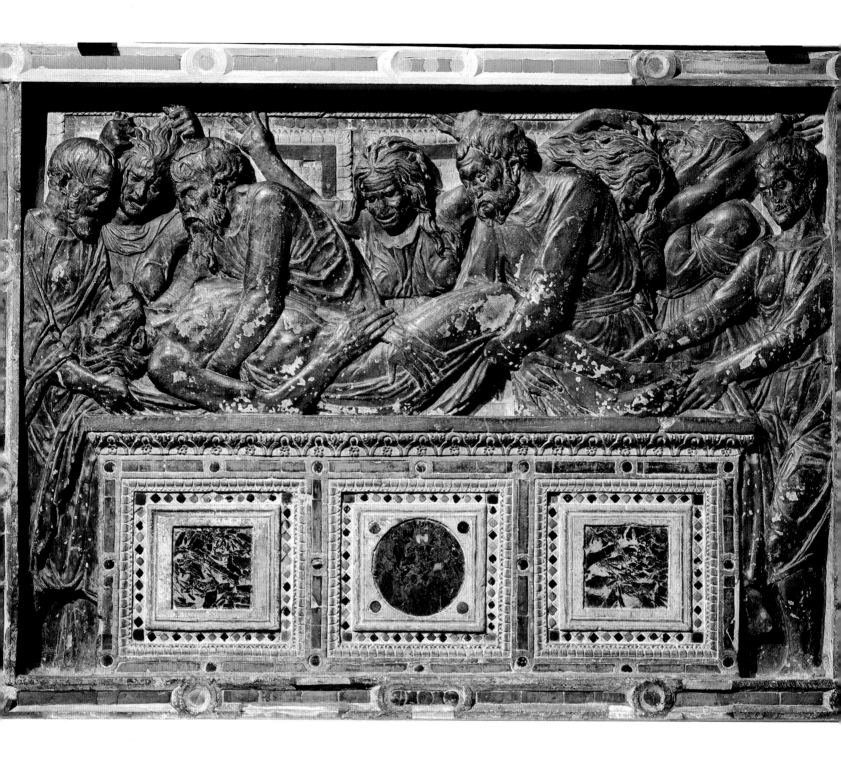

126 Donatello. *Entombment of Christ*. 1446–50. Basilica del Santo, Padua

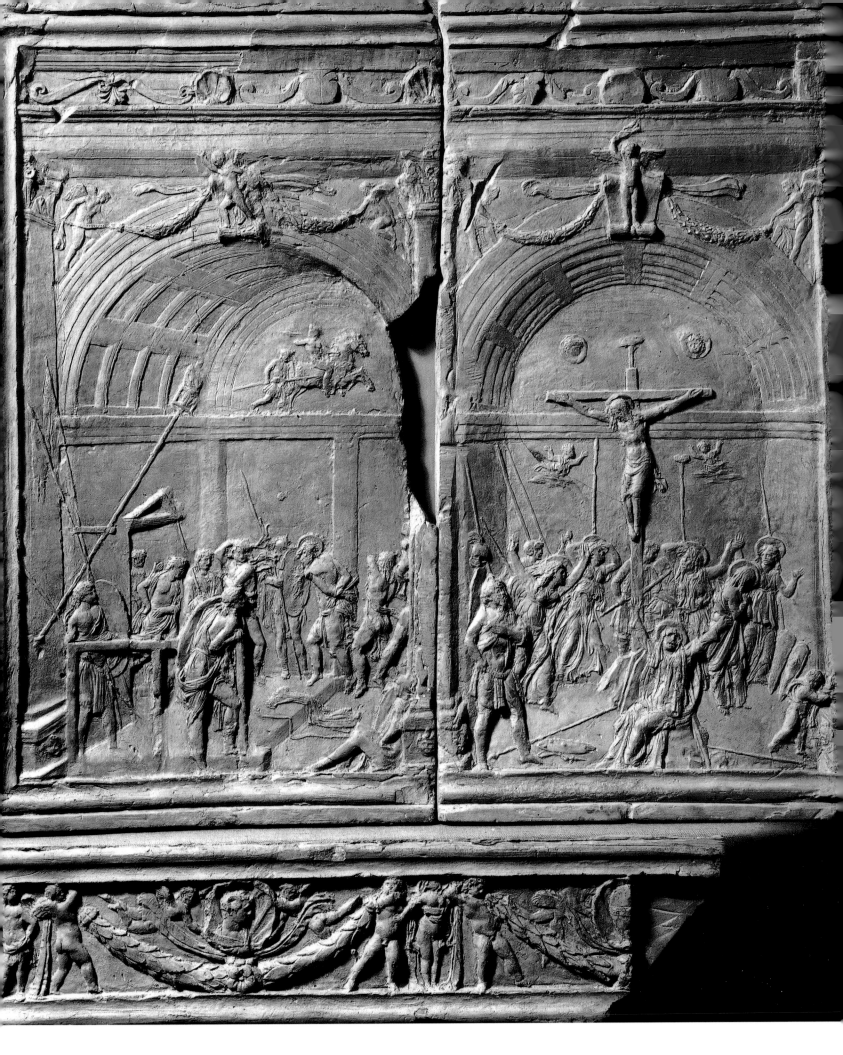

127 Donatello. *The Flagellation and Crucifixion of Christ* ("Forzori Altar"). c. 1445–47.
Victoria and Albert Museum, London

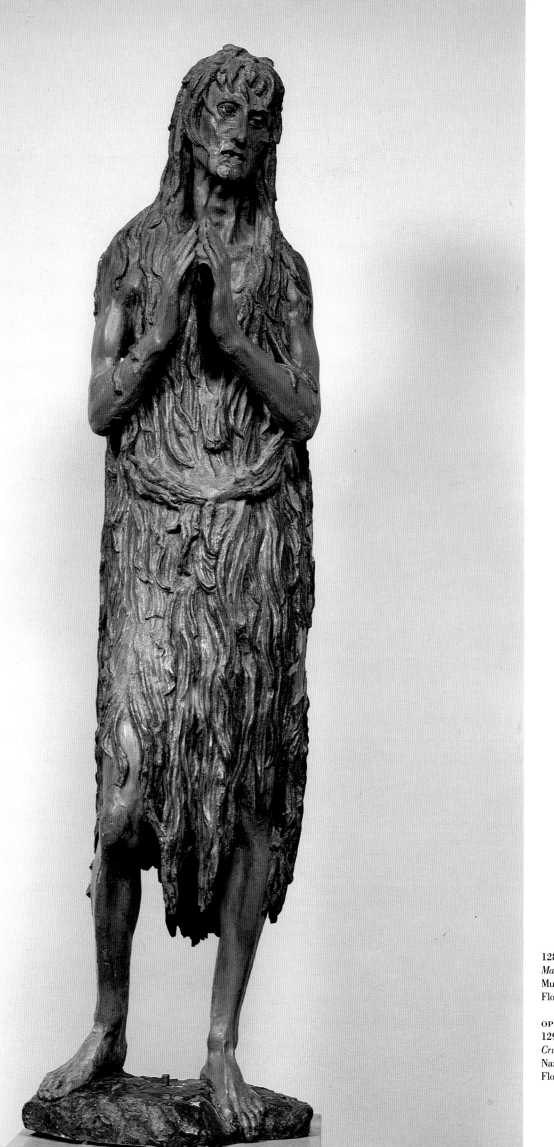

128 Donatello. *Mary Magdalene*. c. 1453–55. Museo dell'Opera del Duomo, Florence

OPPOSITE:
129 Donatello. *The Crucifixion*. c. 1455. Museo Nazionale del Bargello, Florence

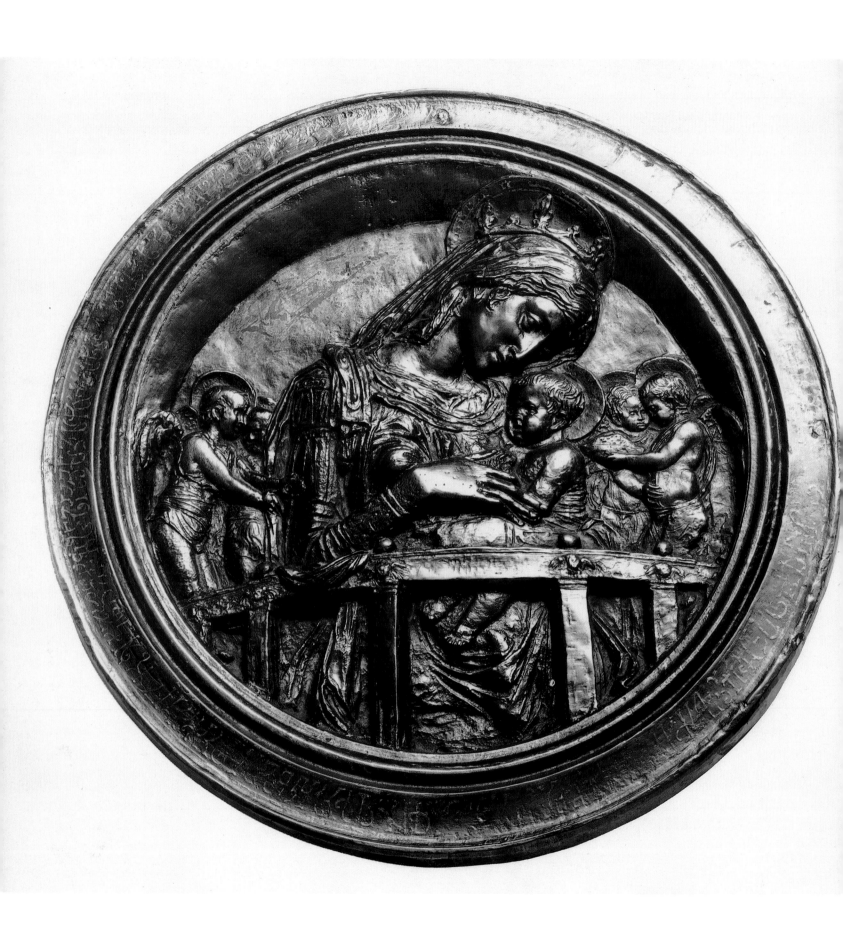

130 Donatello. *"Chellini Madonna."* 1456. Victoria and Albert Museum, London

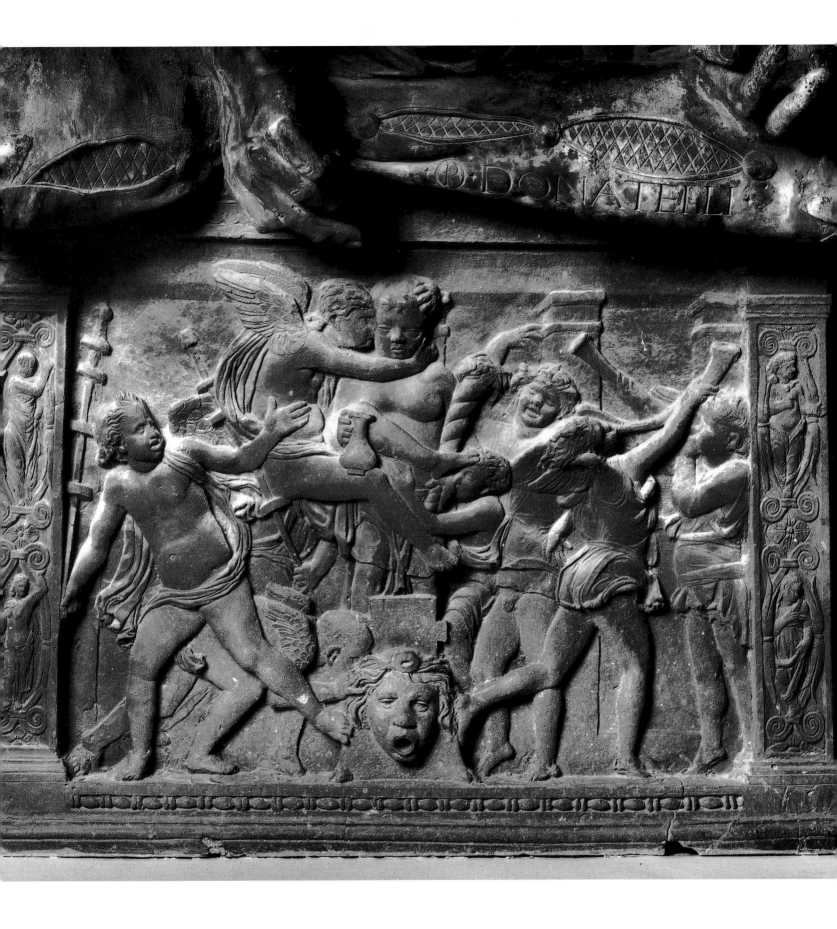

131 Donatello. *Judith and Holofernes* (detail: base relief, before restoration). c. 1456–57. Palazzo Vecchio, Florence

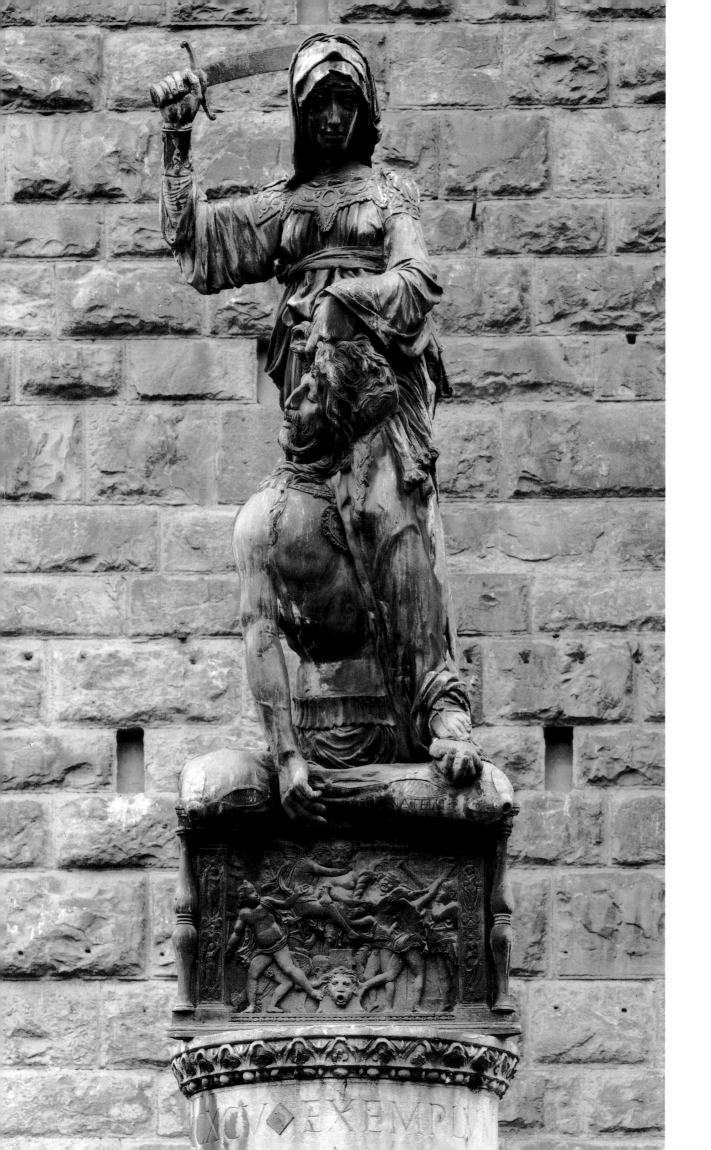

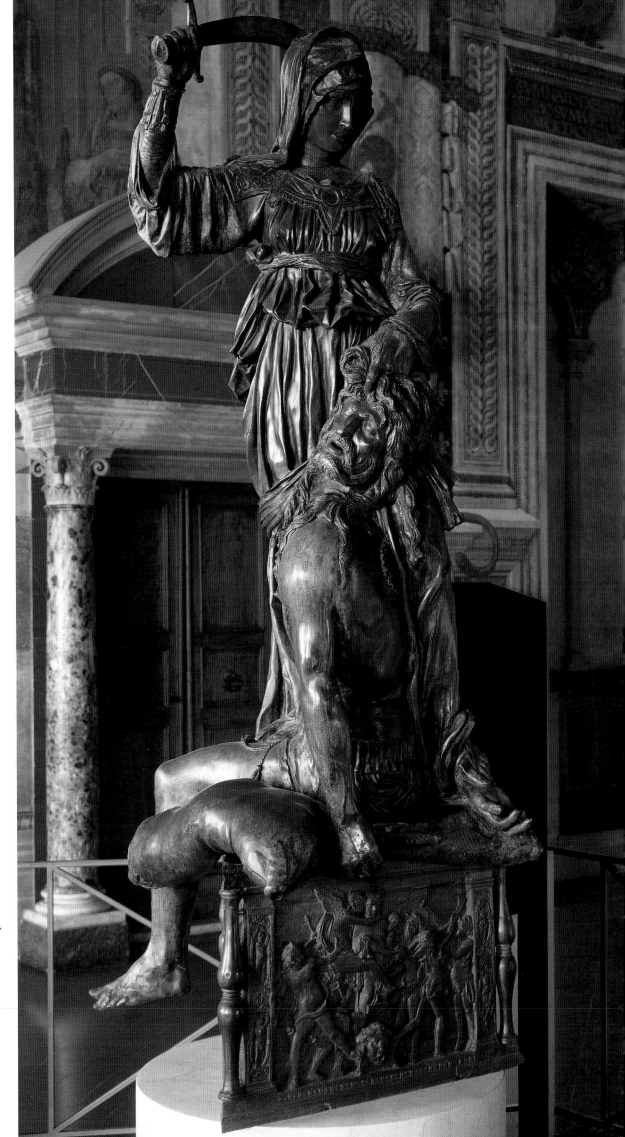

OPPOSITE, RIGHT AND OVERLEAF,
LEFT AND RIGHT:
132–35 Donatello. *Judith and
Holofernes.* c. 1456–57. Palazzo Vecchio,
Florence

132 Location before 1980

133 After restoration

134 detail: head of Judith (before
restoration)

135 detail: head of Holofernes (before
restoration)

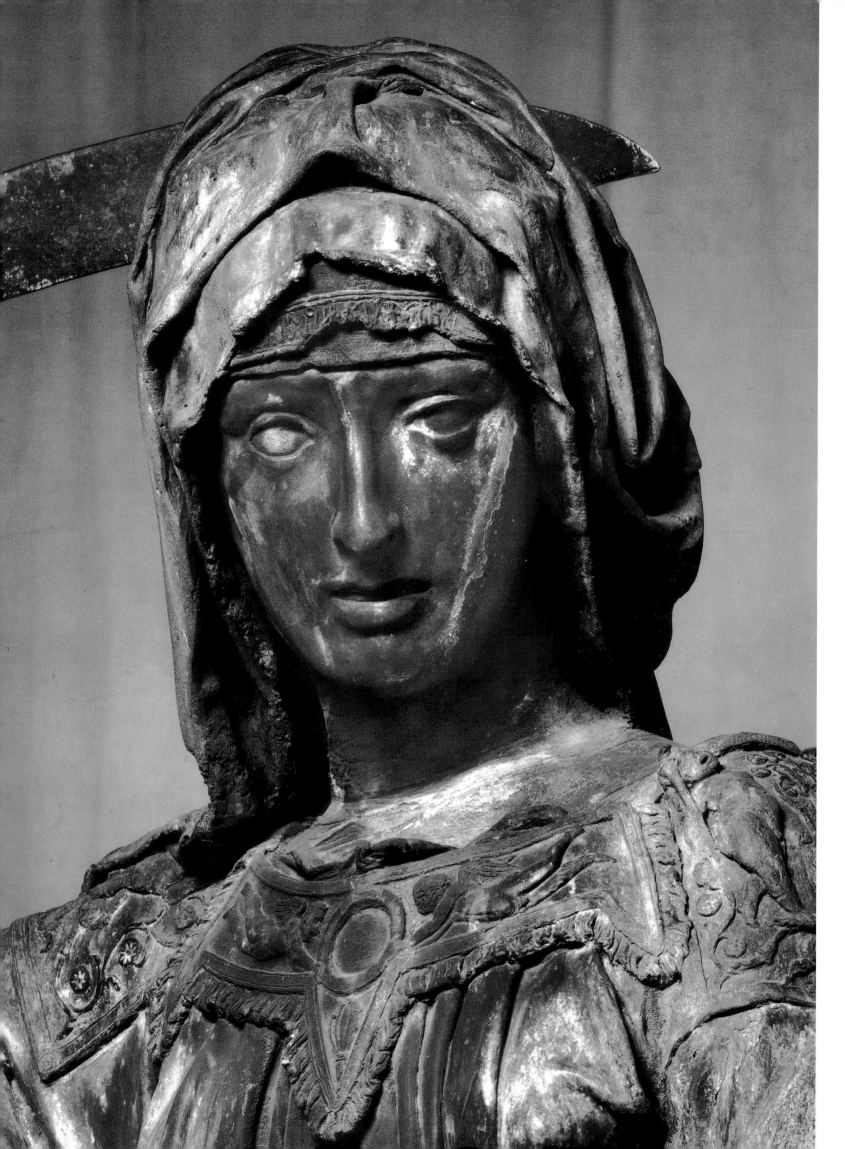

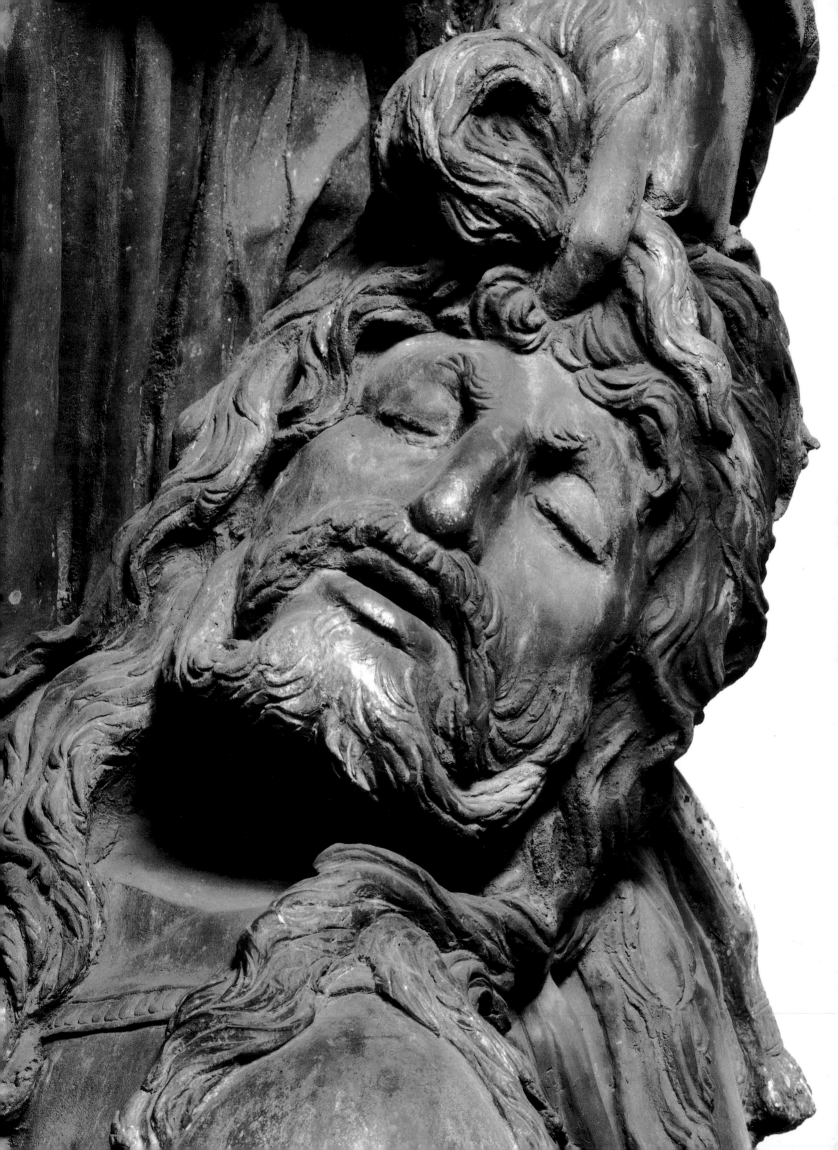

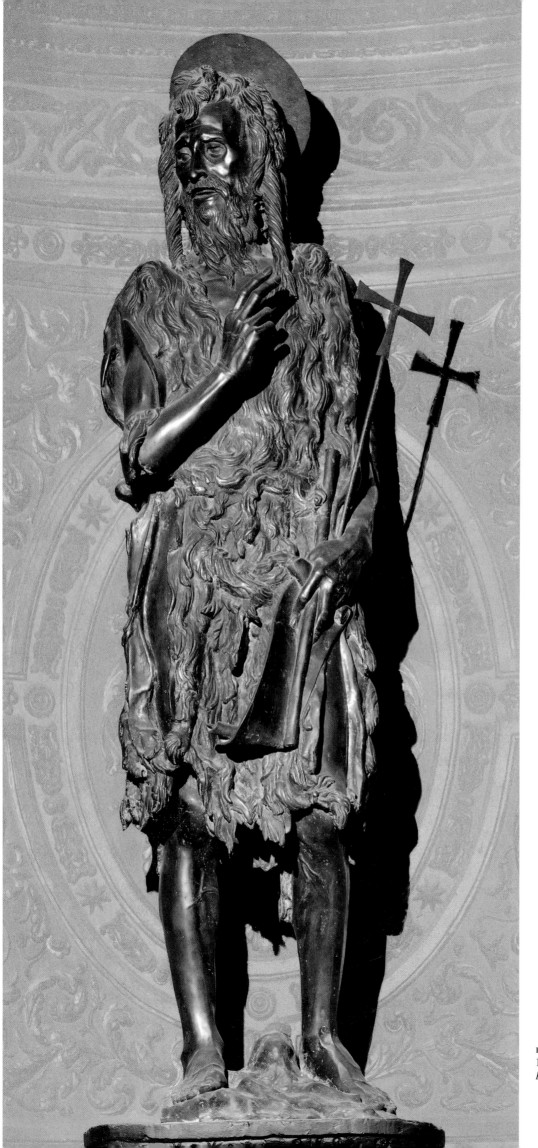

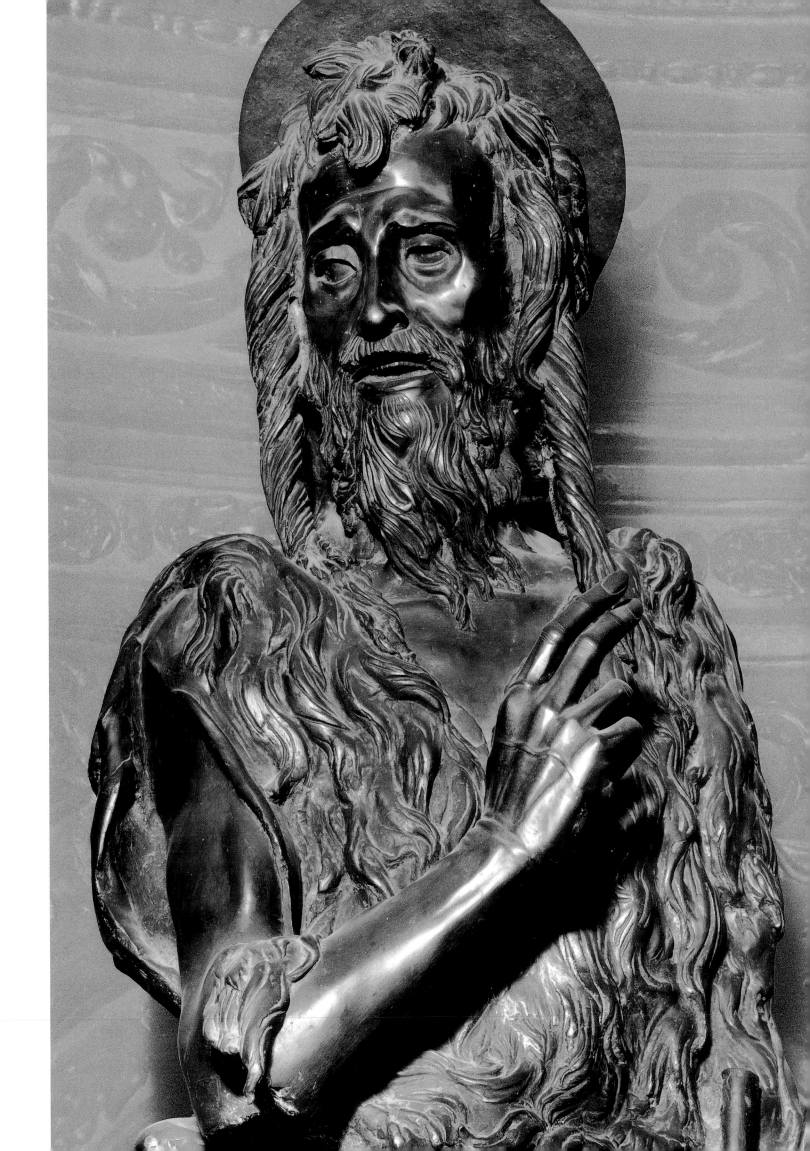

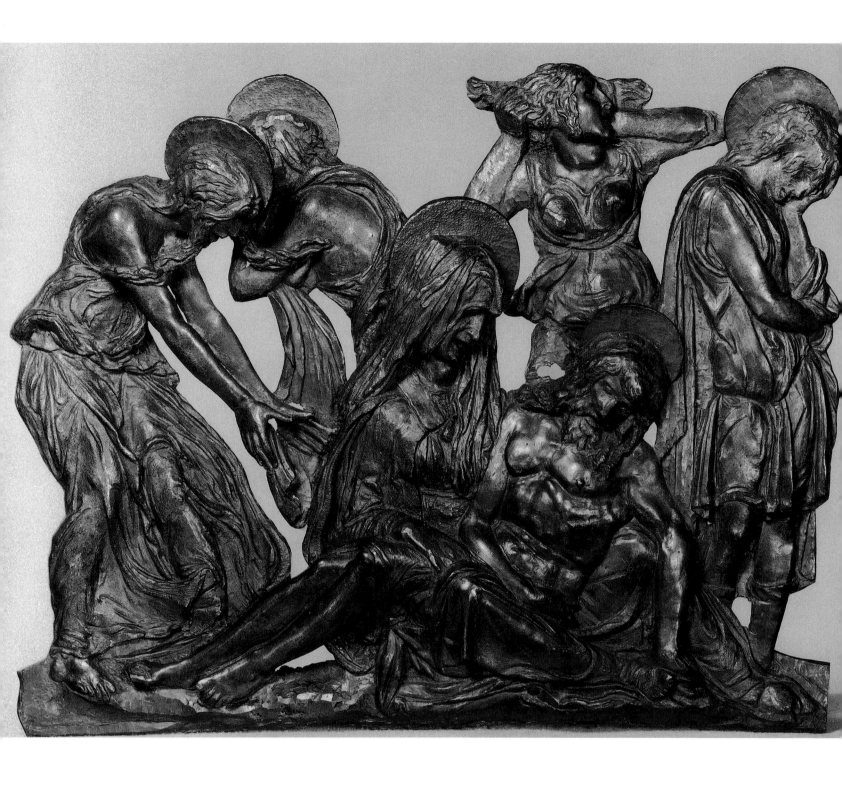

138 Donatello. *Lamentation of Christ*. c. 1460. Victoria and Albert Museum, London

139 Donatello. *Christ Praying on the Mount of Olives*. c. 1461–66. Passion Pulpit, San Lorenzo, Florence

OVERLEAF, LEFT:
140 Donatello. Passion Pulpit. c. 1461–66. San Lorenzo, Florence

OVERLEAF, RIGHT:
141 Donatello. Ascension Pulpit. c. 1461–66. San Lorenzo, Florence

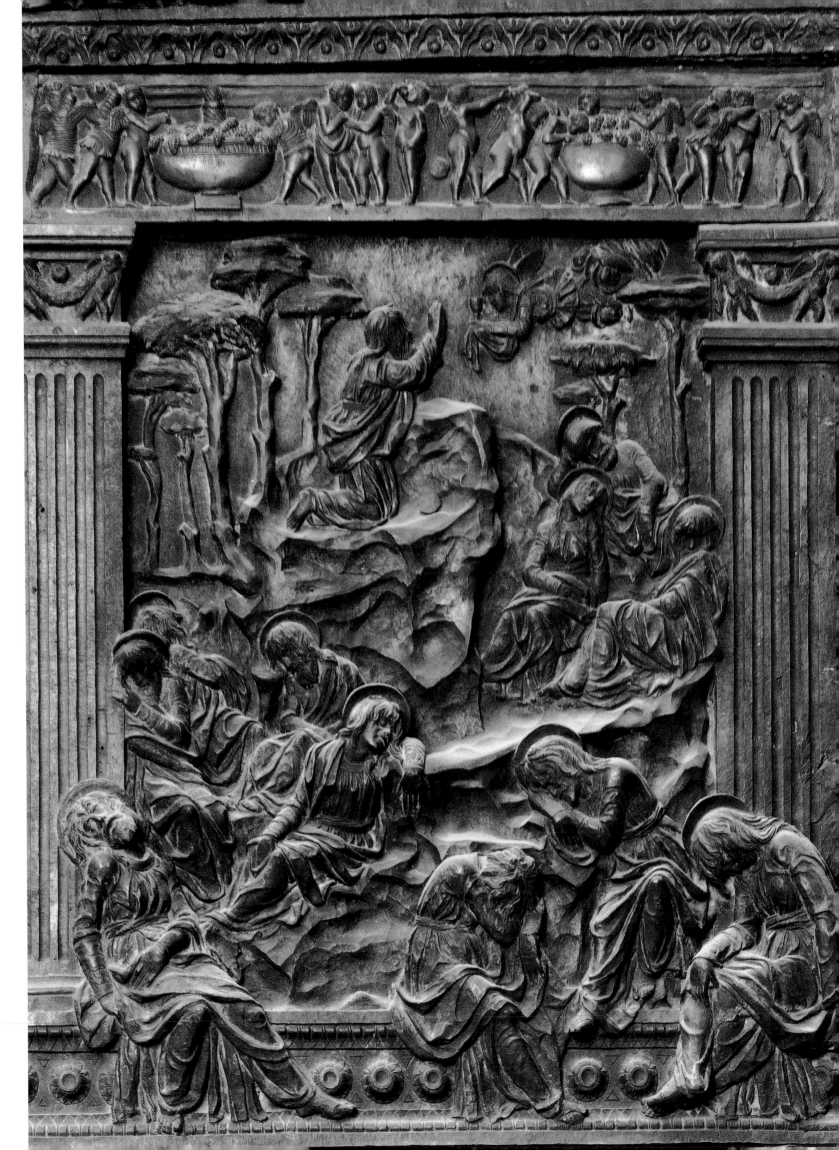

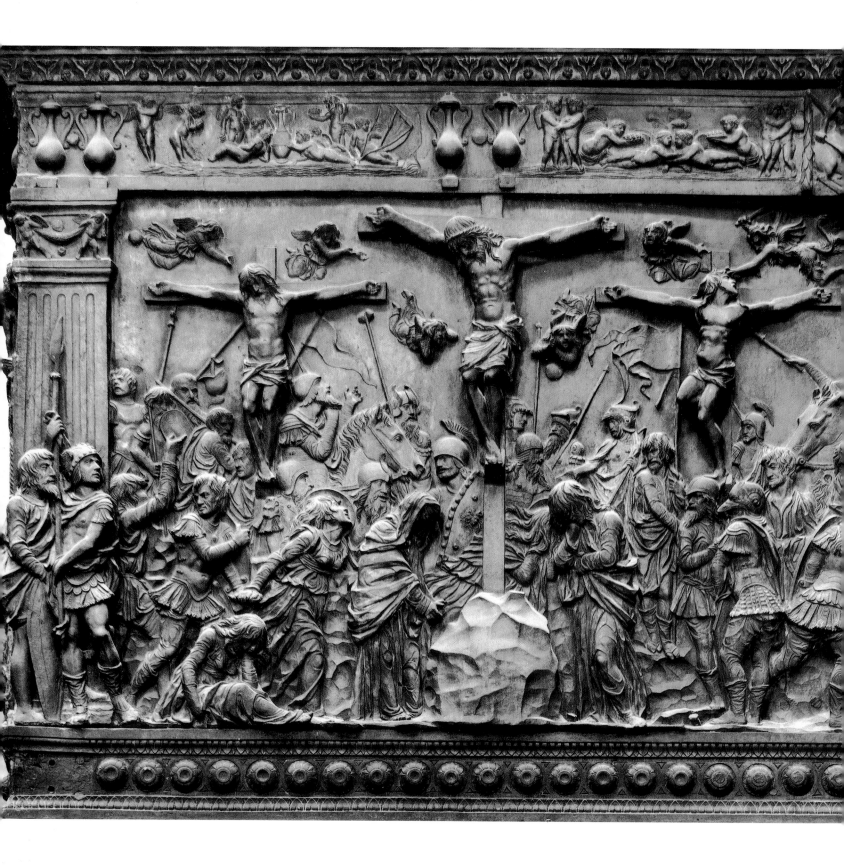

142 Donatello. *Crucifixion*. c. 1461–66. Passion Pulpit, San Lorenzo, Florence

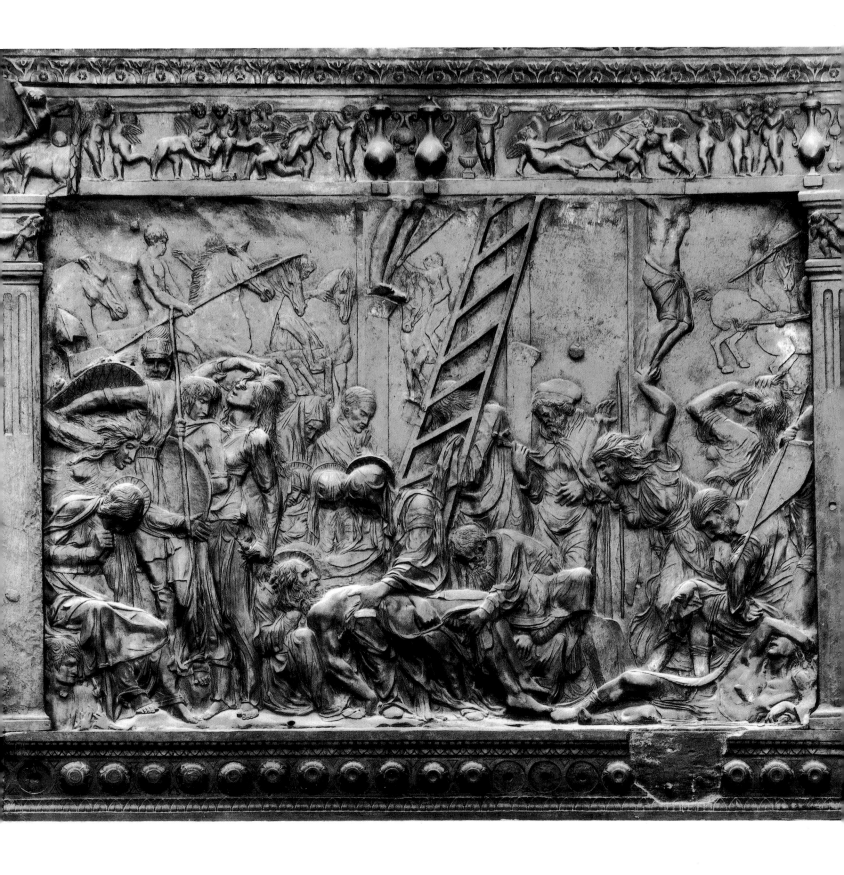

143 Donatello. *Lamentation*. c. 1461–66. Passion Pulpit, San Lorenzo, Florence

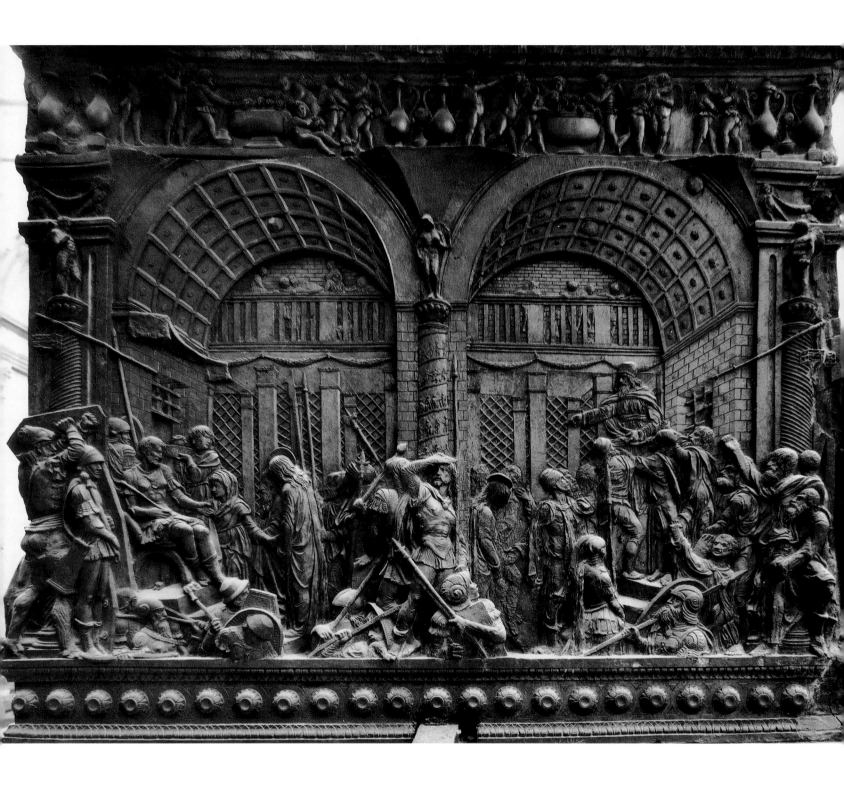

144 Donatello. *Christ Before Pilate and Caiaphas*. c. 1461–66. Passion Pulpit, San Lorenzo,
Florence

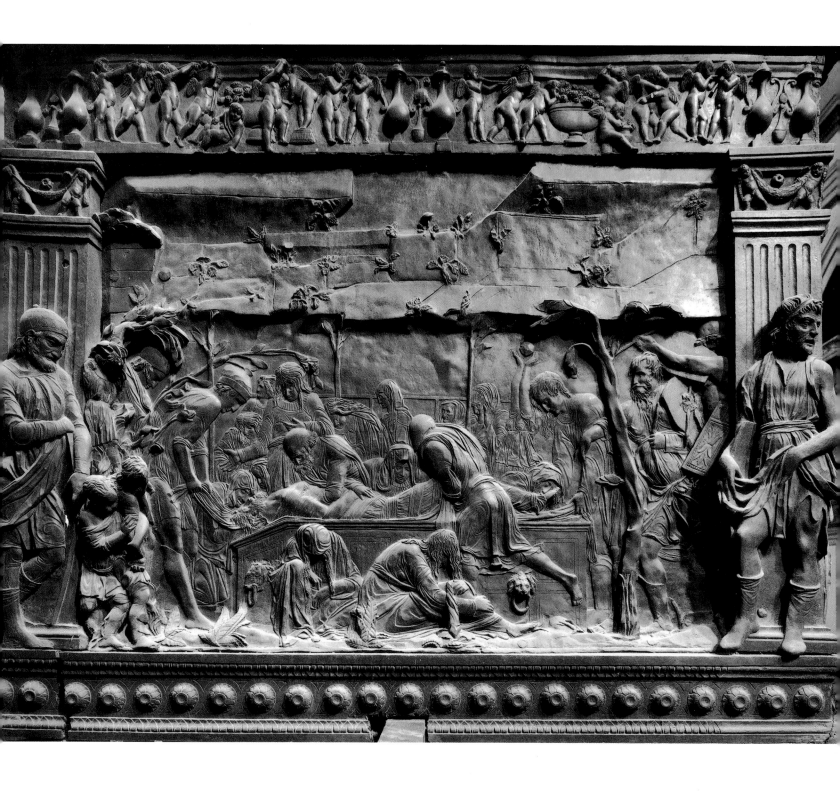

145 Donatello. *The Entombment*. c. 1461–66. Passion Pulpit, San Lorenzo, Florence

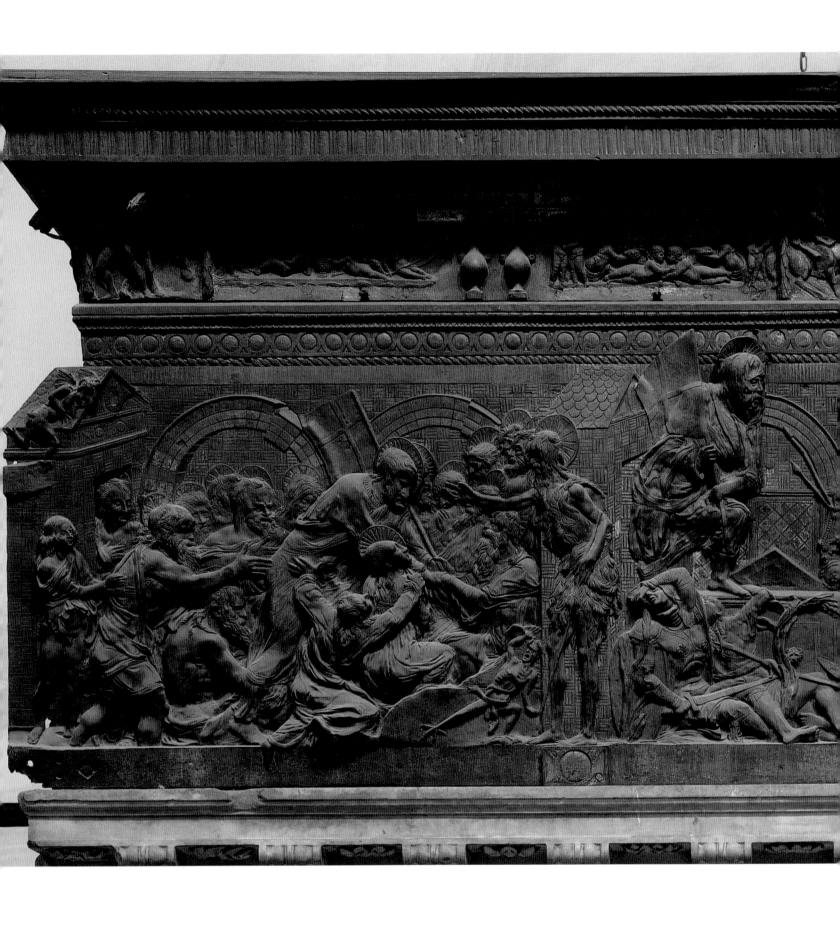

146, 147 Donatello. *Christ in Purgatory, Resurrection and Ascension.* c. 1461–66. Ascension
Pulpit, San Lorenzo, Florence

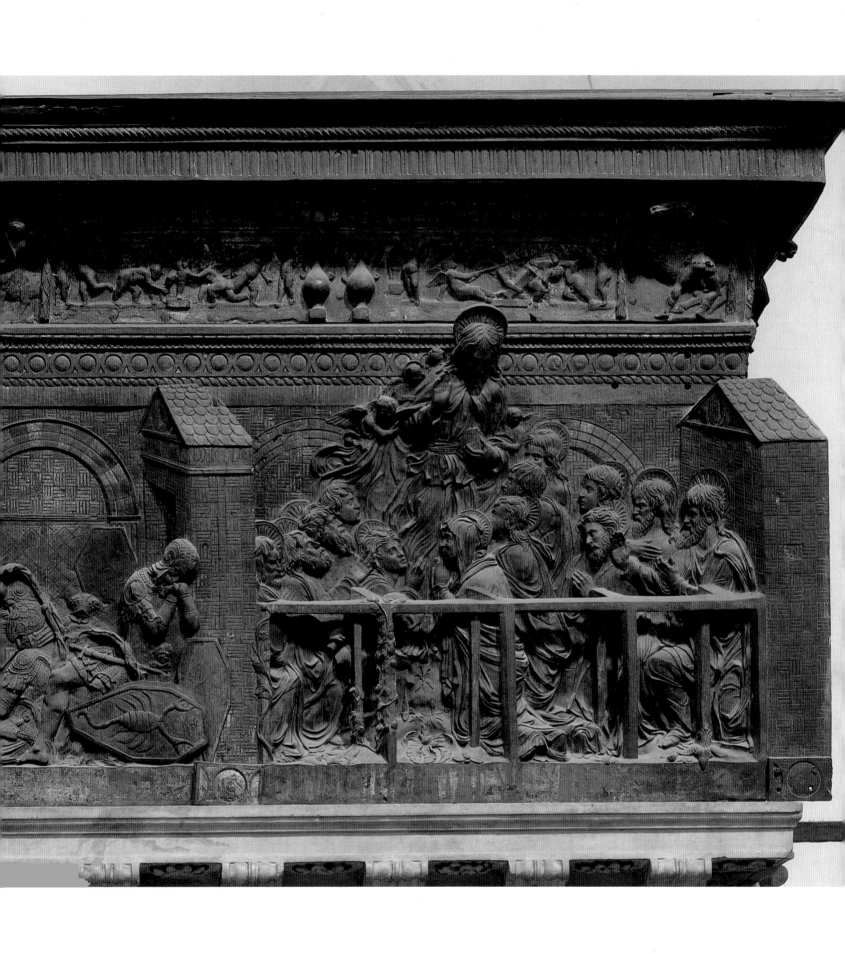

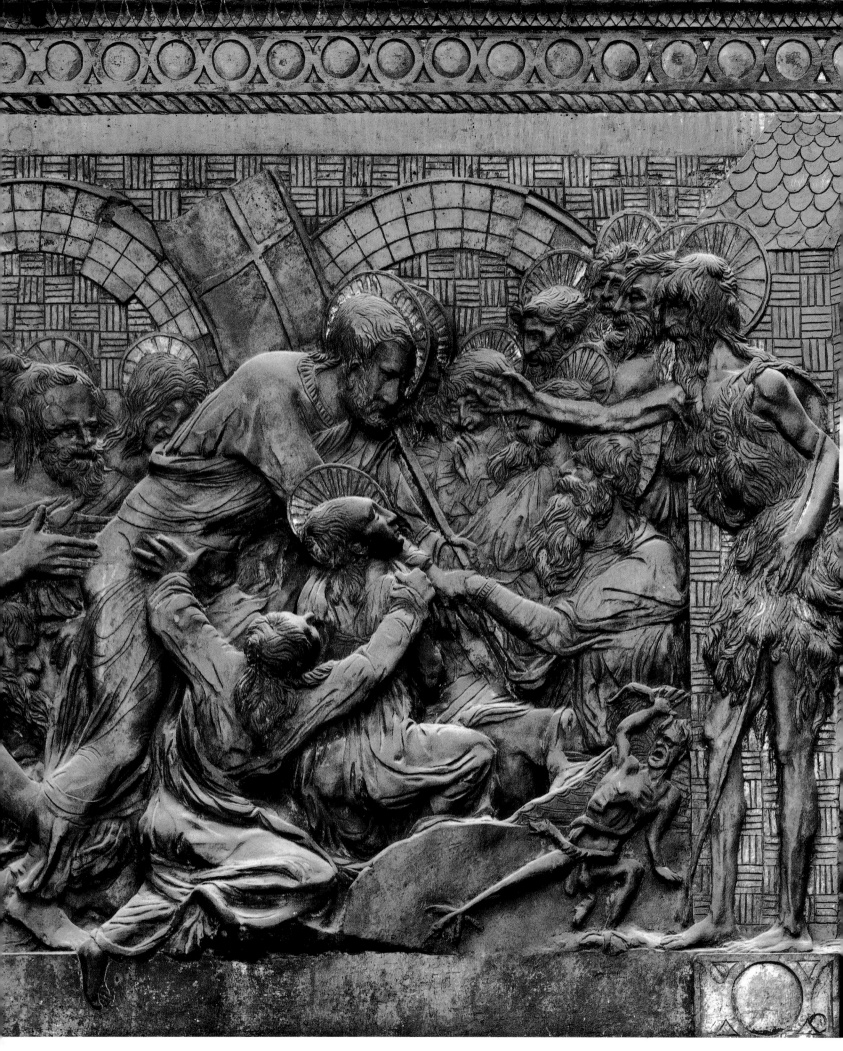

148 Donatello. *Christ in Purgatory*. c. 1461–66. Ascension Pulpit, San Lorenzo, Florence

OPPOSITE:
149 Donatello. *The Resurrection* (detail: Christ). c. 1461–66. Ascension Pulpit, San Lorenzo,
Florence

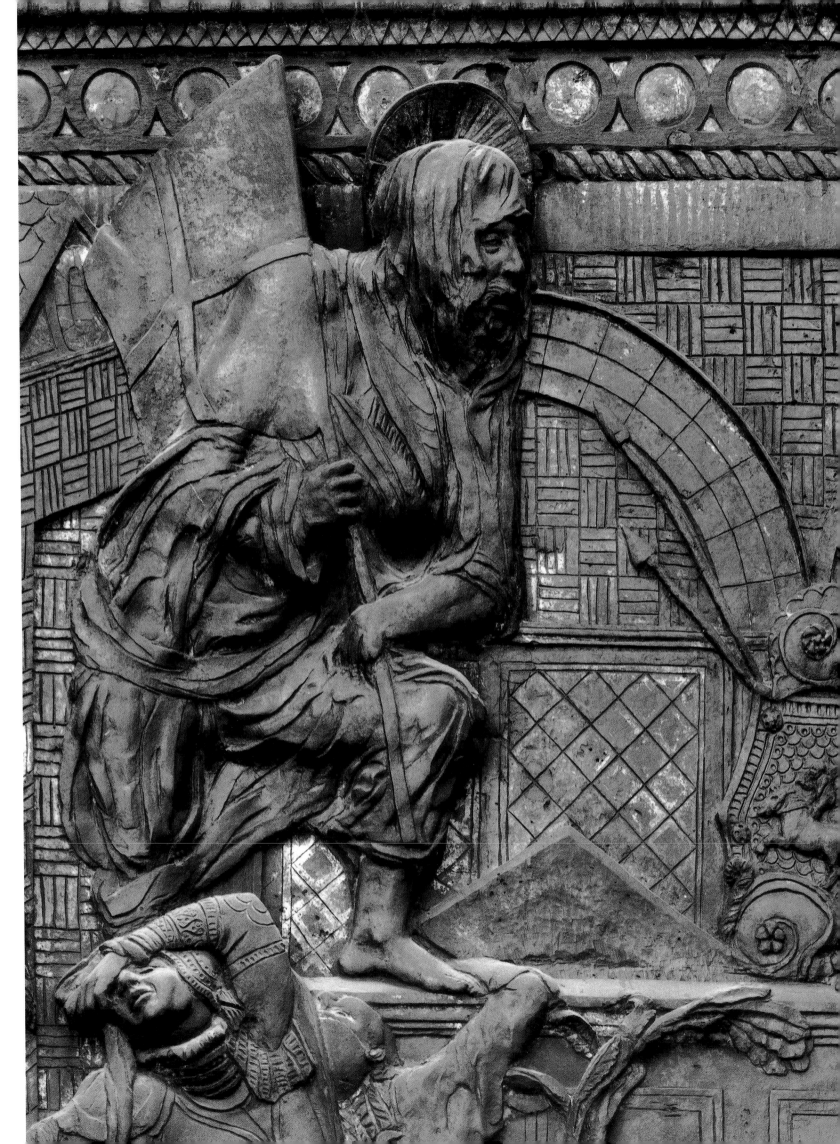

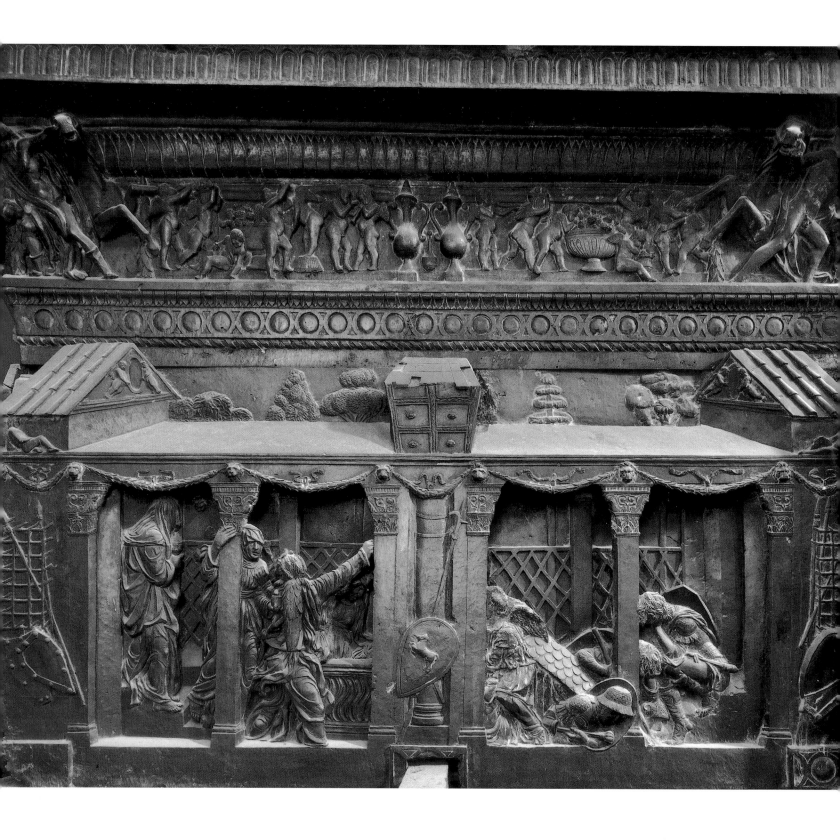

150, 151 Donatello. *The Three Women at the Tomb.* c. 1461–66. Ascension Pulpit, San Lorenzo, Florence

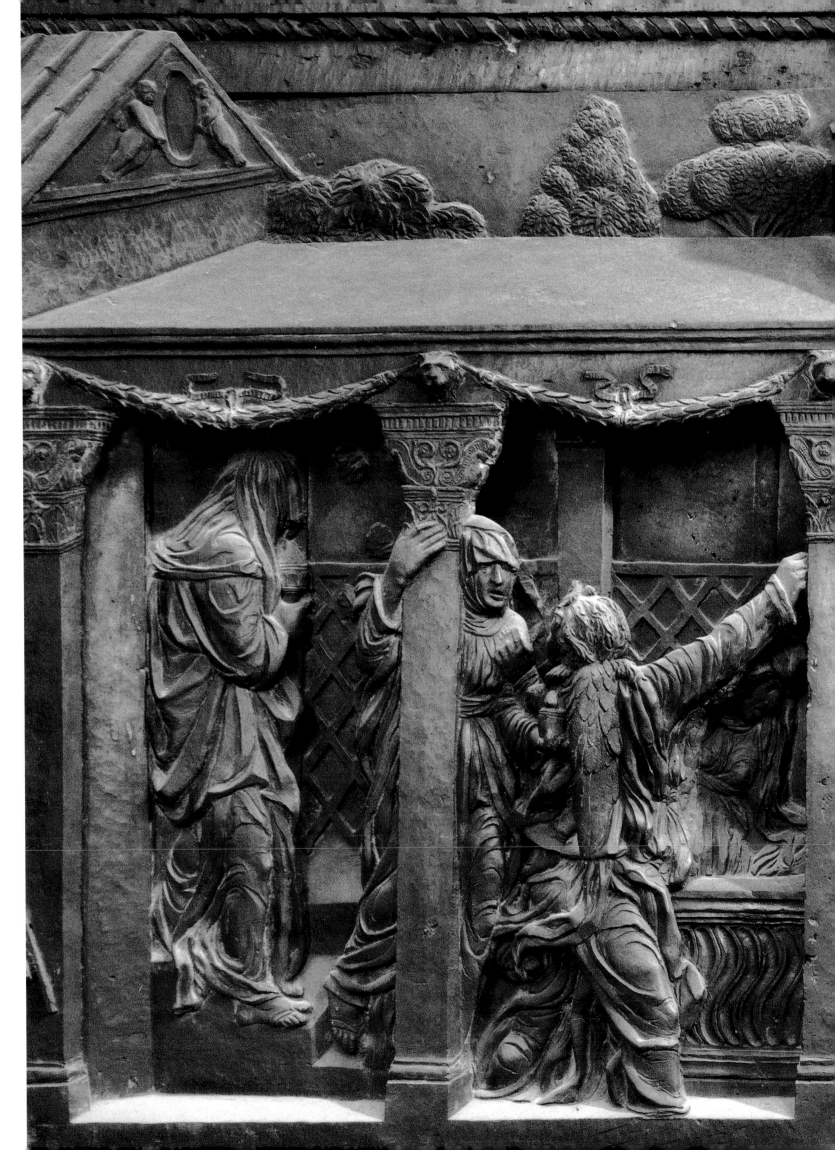

152 Donatello. *Pentacost.* c. 1461–66. Ascension Pulpit, San Lorenzo, Florence

OPPOSITE:
153 Donatello. *The Martyrdom of St. Lawrence.* c. 1461–66. Ascension Pulpit, San Lorenzo,
Florence

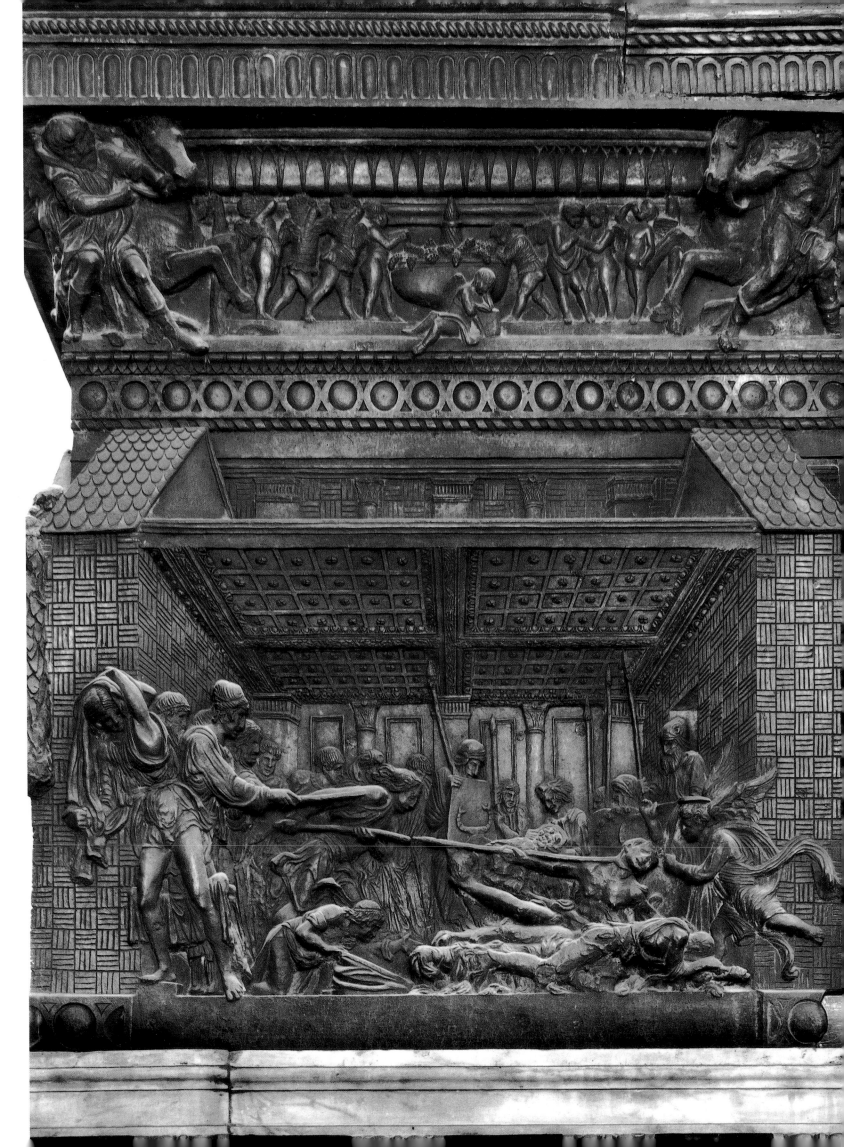

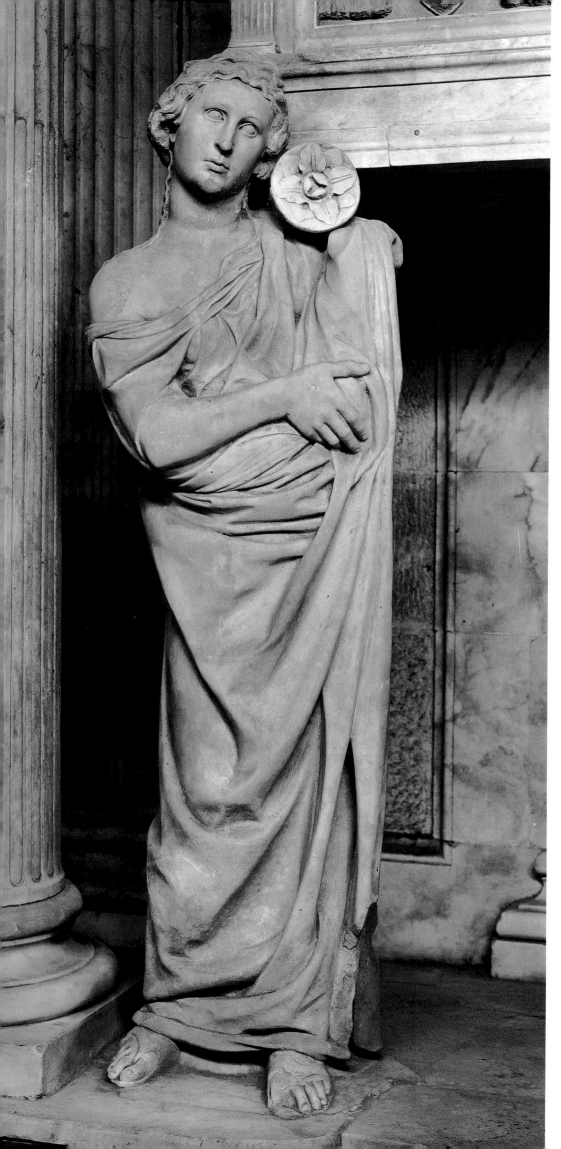

154, 155 Michelozzo. Tomb of Cardinal
Rinaldo Brancacci (details: bearer
figures). c. 1426–33. Sant'Angelo a Nilo,
Naples

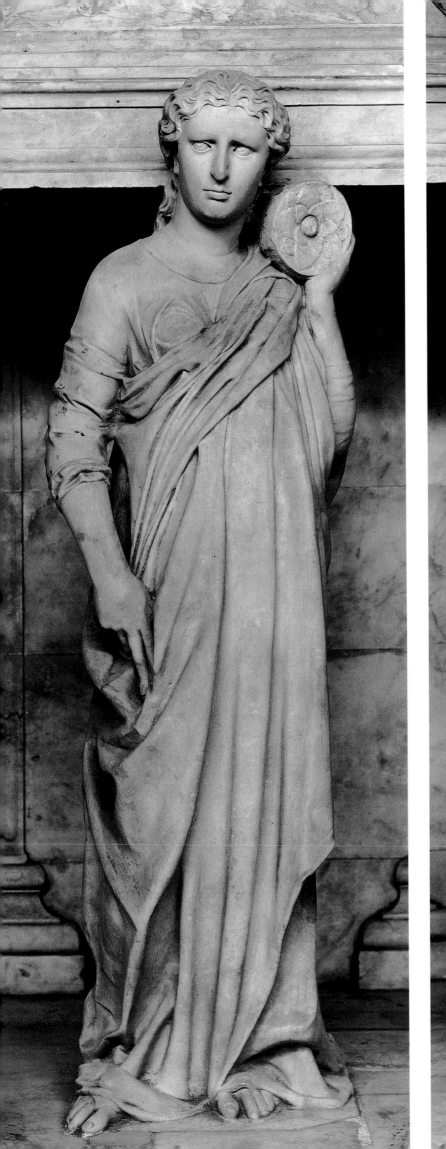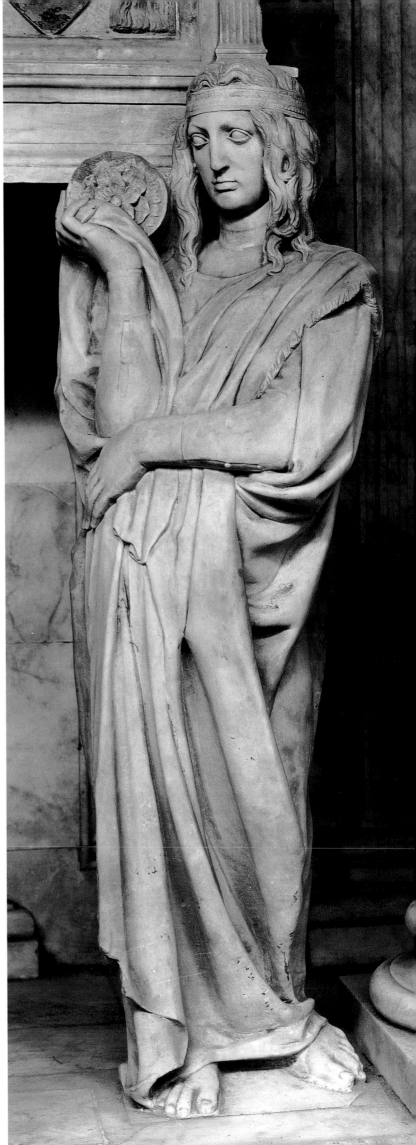

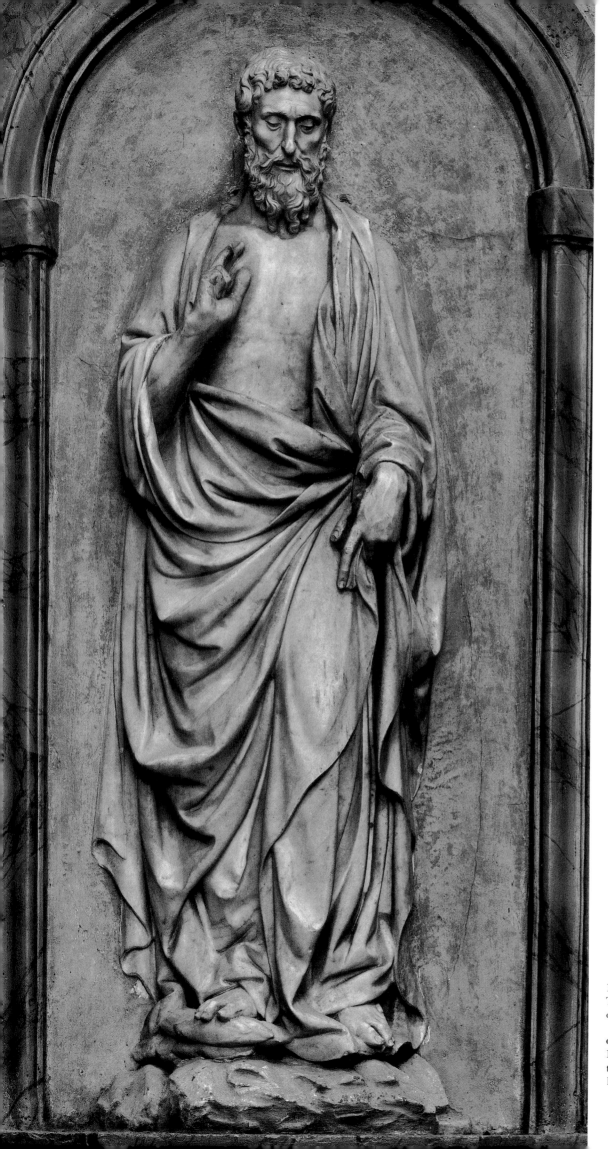

156 Michelozzo. *Christ*, from the
Tomb of Bartolomeo Aragazzi.
c. 1427–38. Duomo, Montepulciano

OPPOSITE:
157 Michelozzo. *Candelabrum Bearers*, from
the Tomb of Bartolomeo Aragazzi. c. 1427–38.
Duomo, Montepulciano

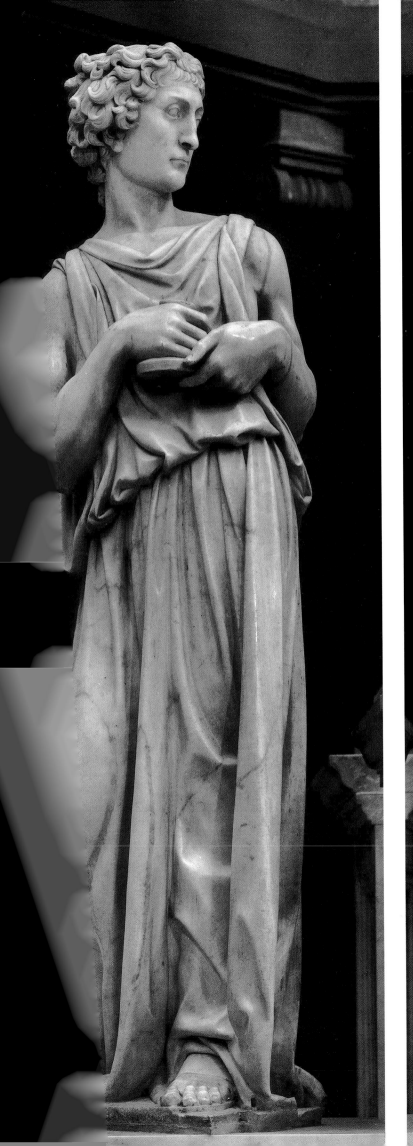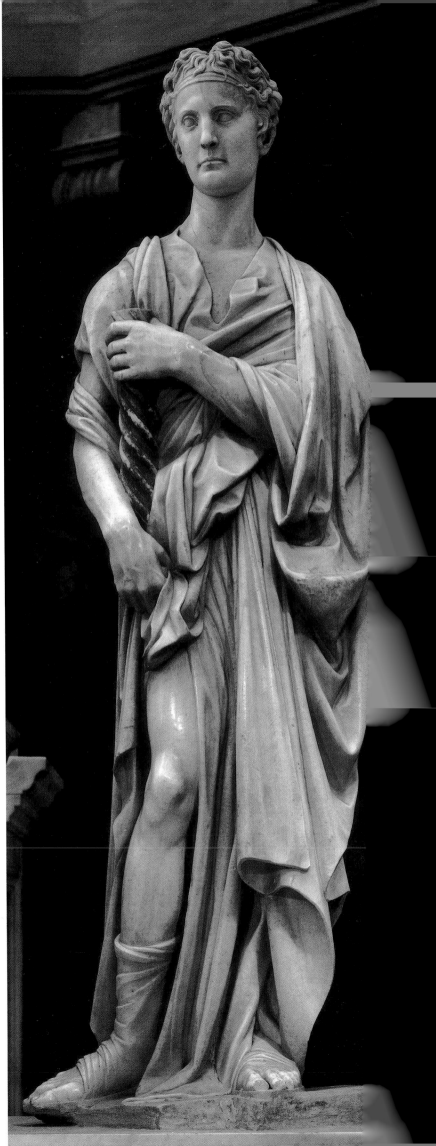

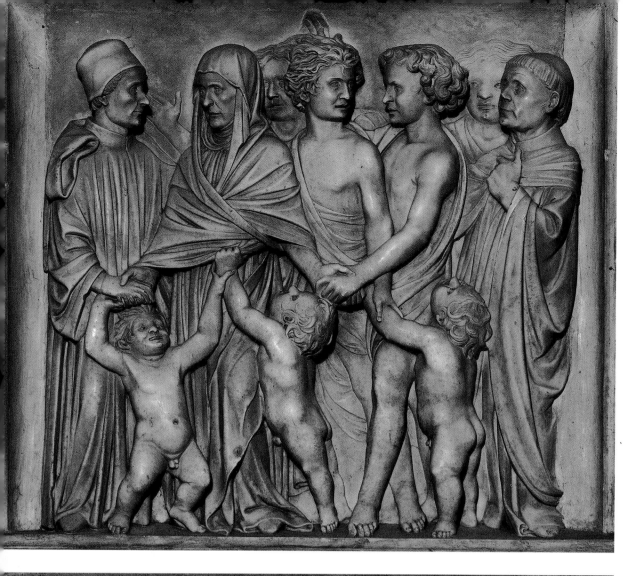

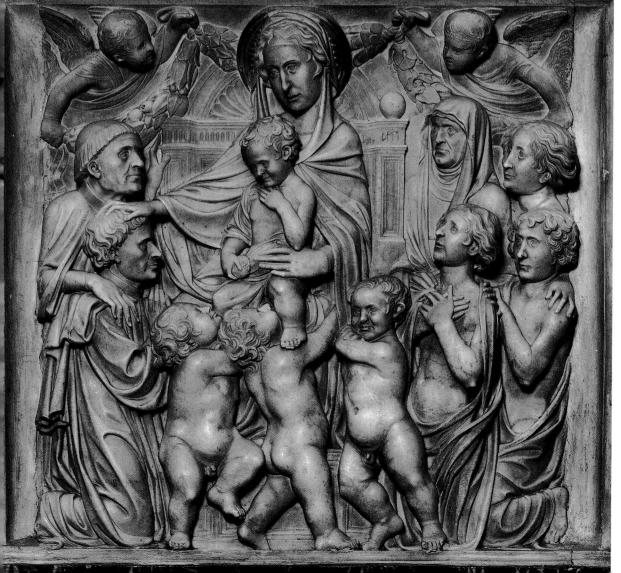

158 Michelozzo. Reliefs from the
Tomb of Bartolomeo Aragazzi.
ABOVE: Bartolomeo Aragazzi being
greeted by members of his family (?)
BELOW: the Aragazzi family before
the enthroned Madonna. c. 1427–38.
Duomo, Montepulciano

OPPOSITE:
159 Michelozzo. *Madonna and Child*.
c. 1435–40. Museo Nazionale del Bargello,
Florence

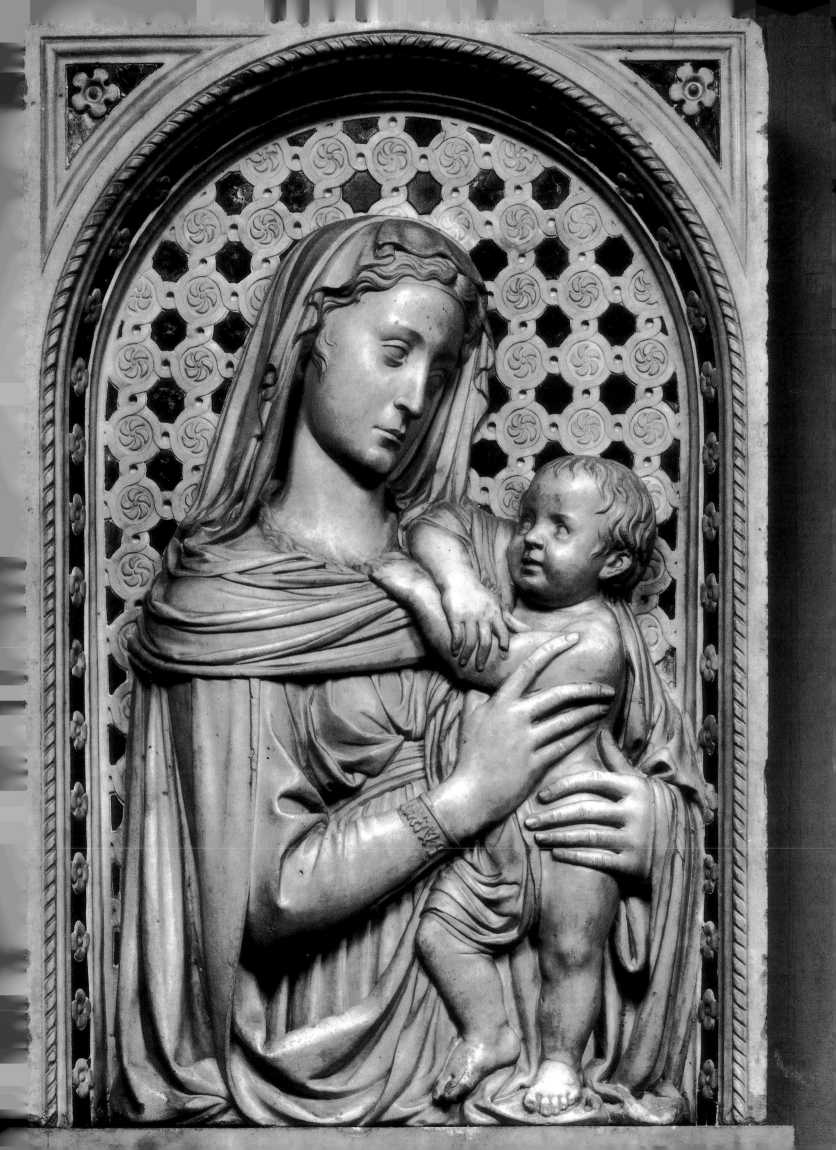

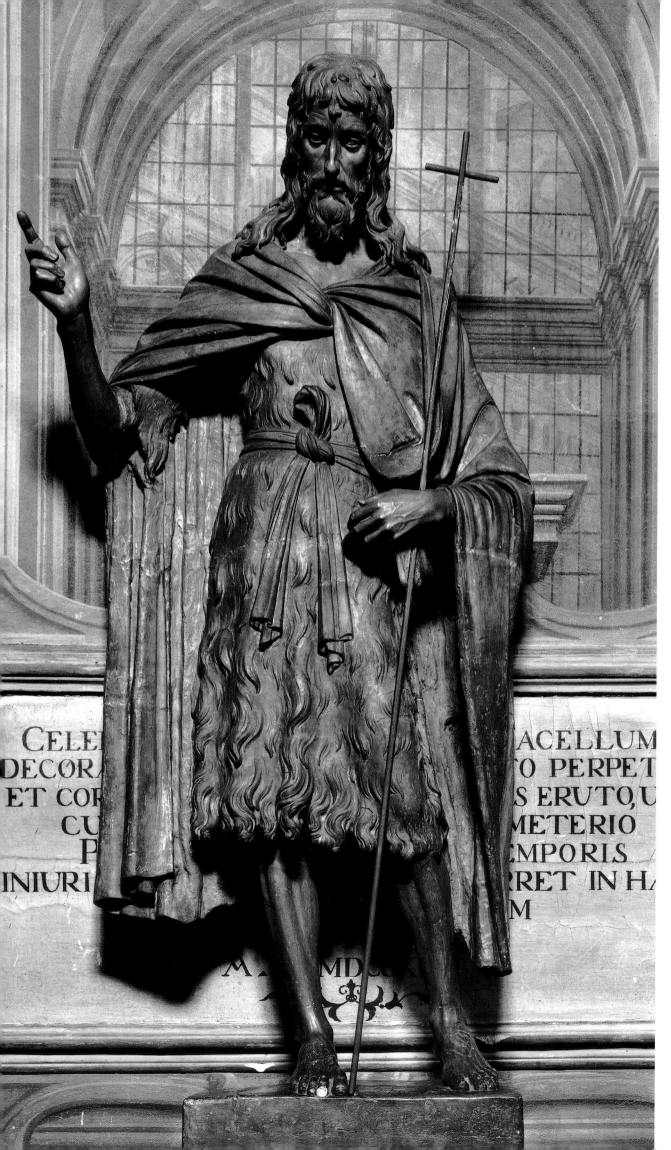

160 Michelozzo. *St. John the Baptist*. c. 1444. Santissima Annunziata, Florence

OPPOSITE:
161 Michelozzo. *St. John the Baptist*. 1452–53. Museo dell'Opera del Duomo, Florence

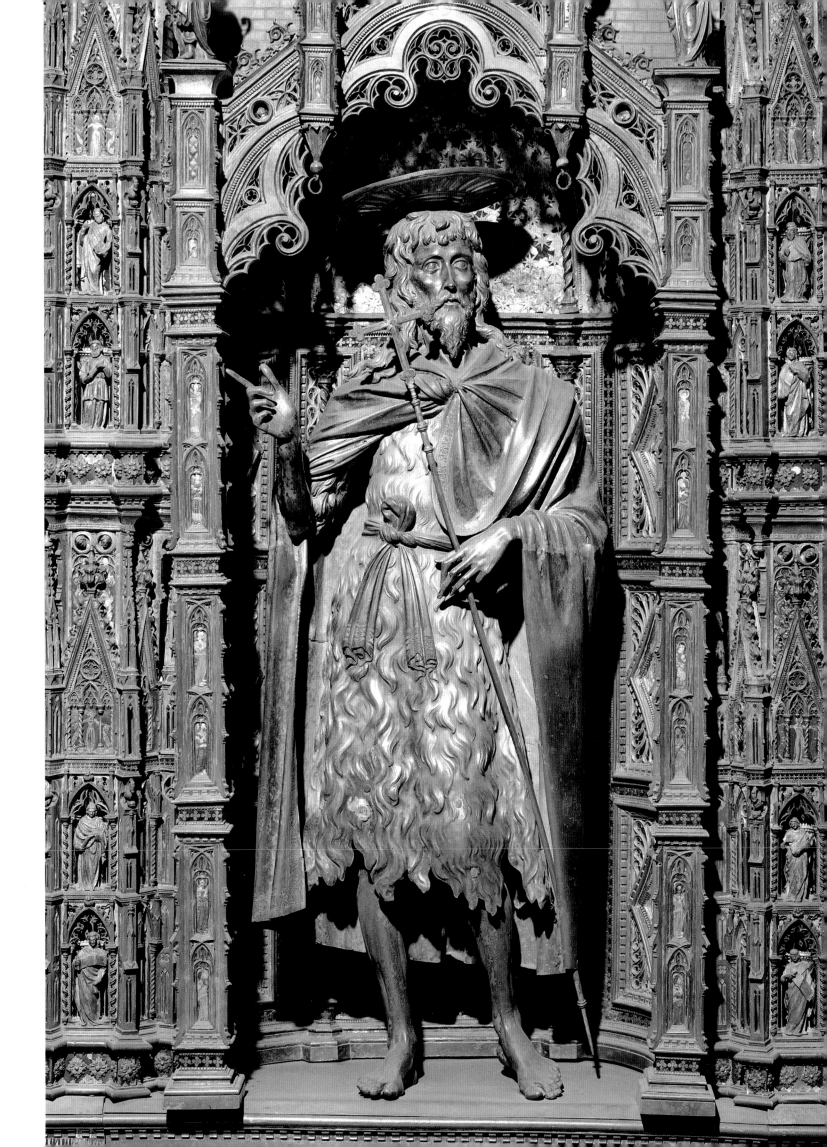

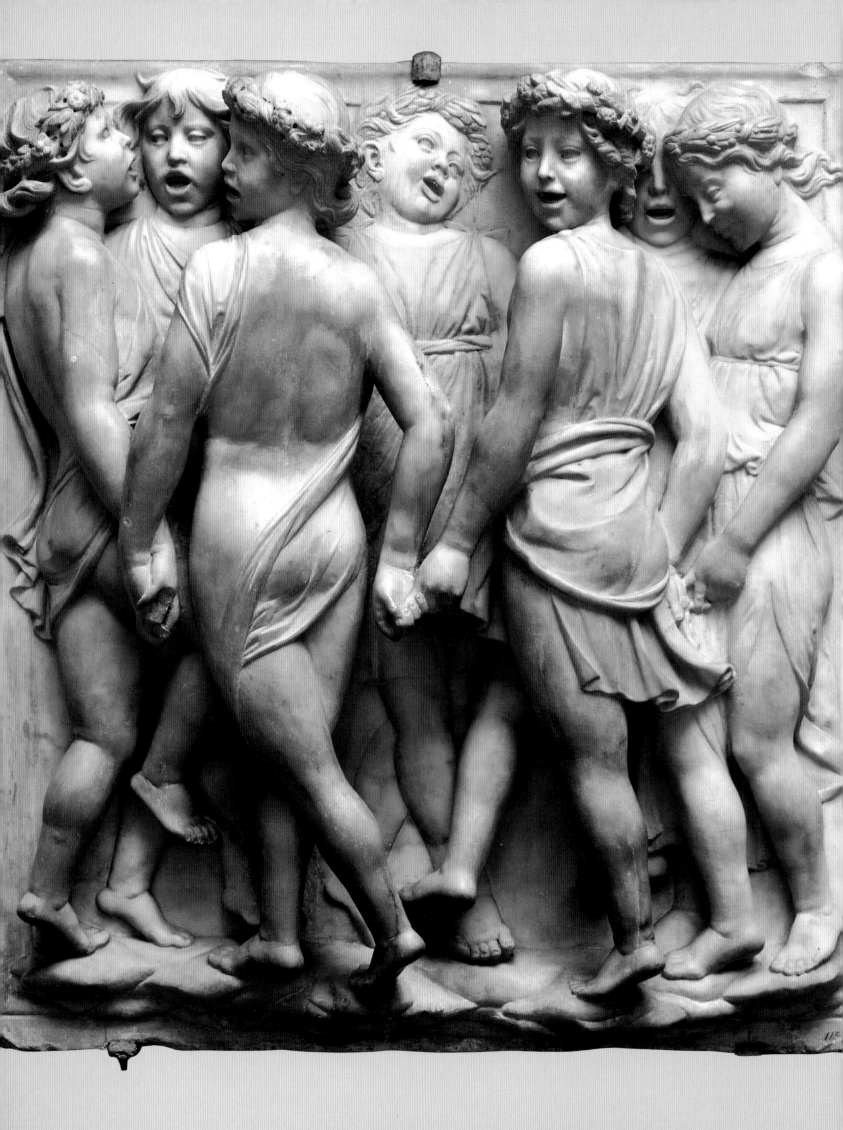

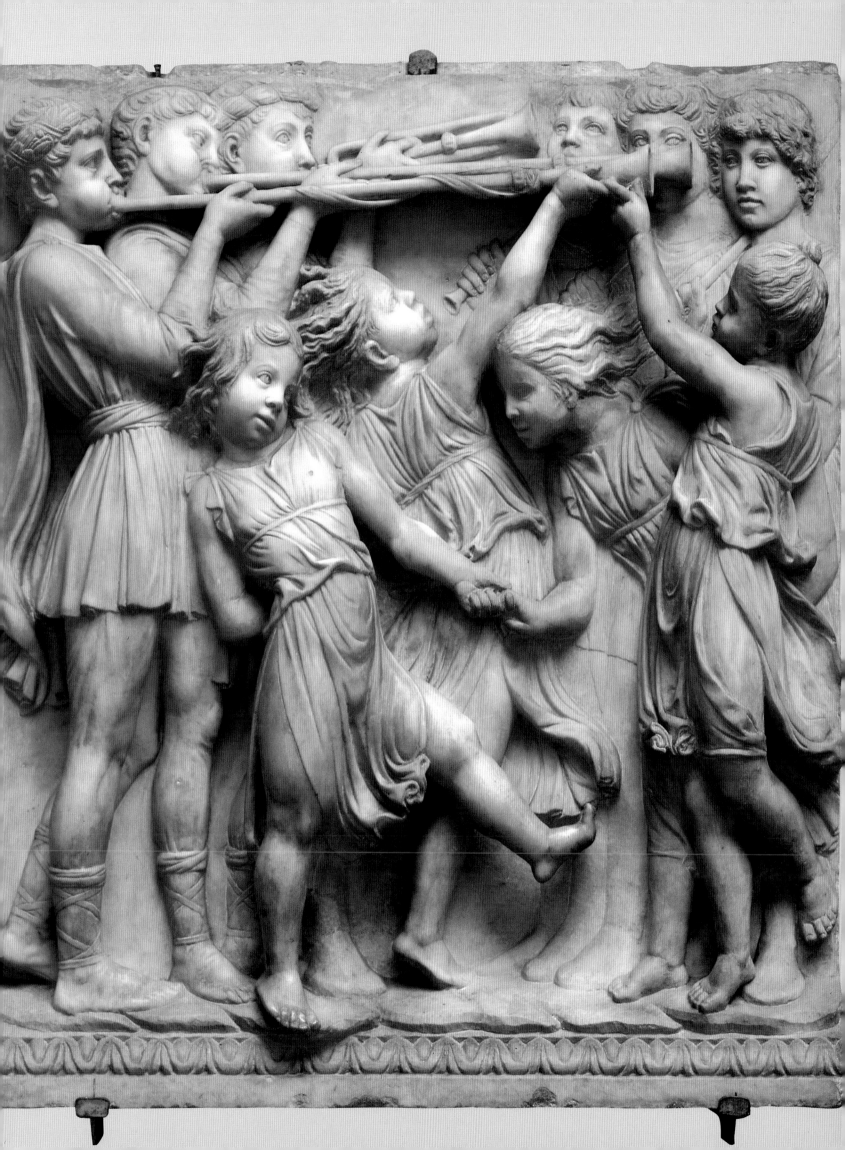

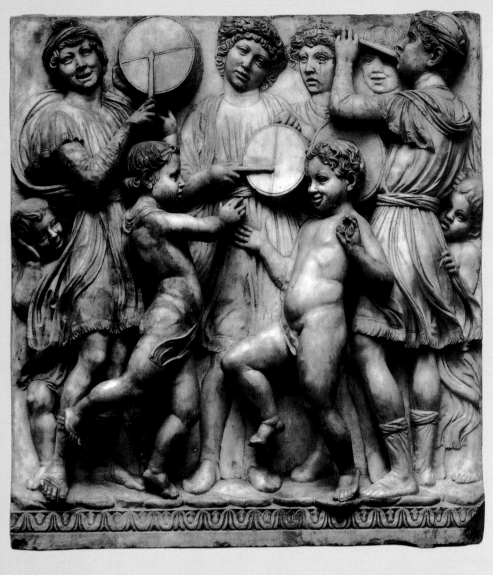
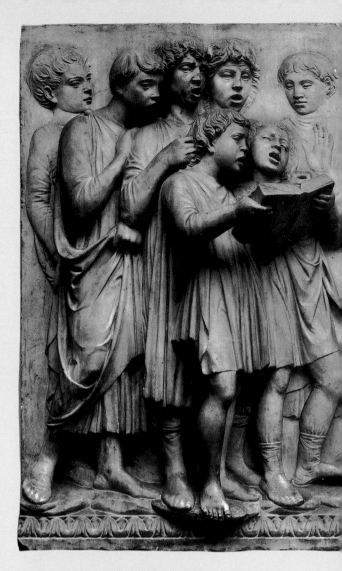
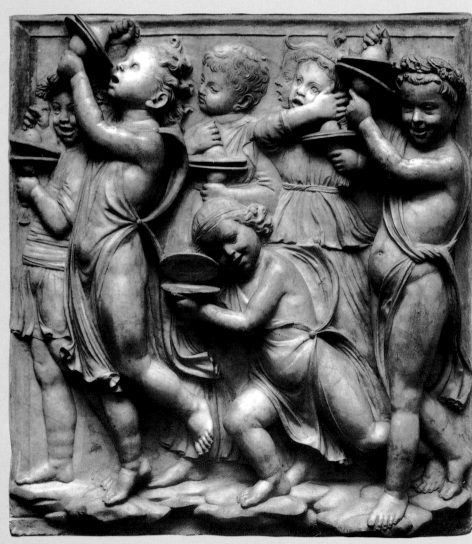
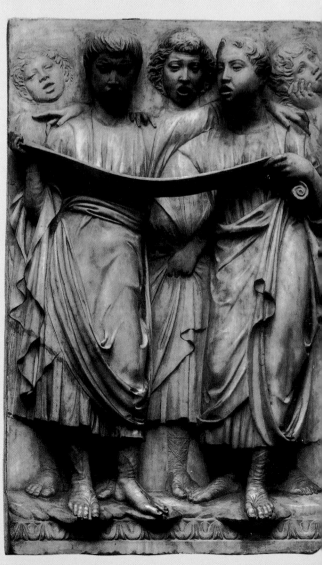

165 Luca della Robbia. Reliefs from the Campanile of the Cathedral. ABOVE: *"Philosophy"*; BELOW: *"Grammar."* 1437–39. Museo dell'Opera del Duomo, Florence

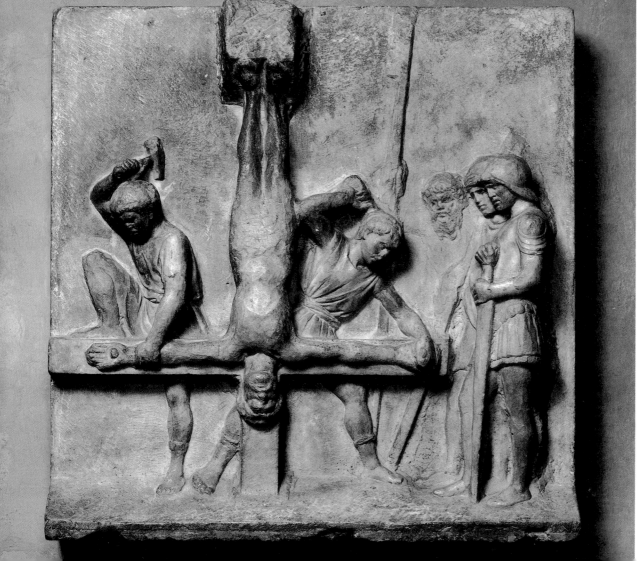

166 Luca della Robbia.
ABOVE: *The Release of St.
Peter*; BELOW: *The Crucifixion
of St. Peter*. 1439. Museo
Nazionale del Bargello,
Florence

OPPOSITE:
167 Luca della Robbia.
Tabernacle of the Sacrament.
1441–42. Santa Maria, Peretola

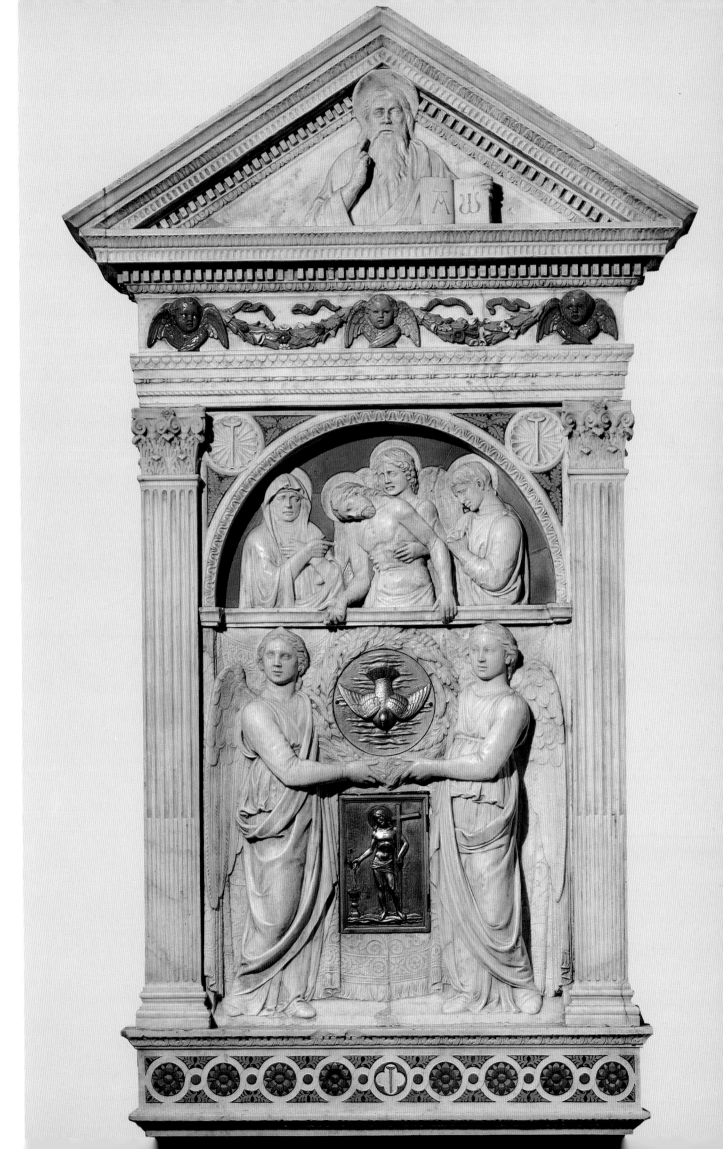

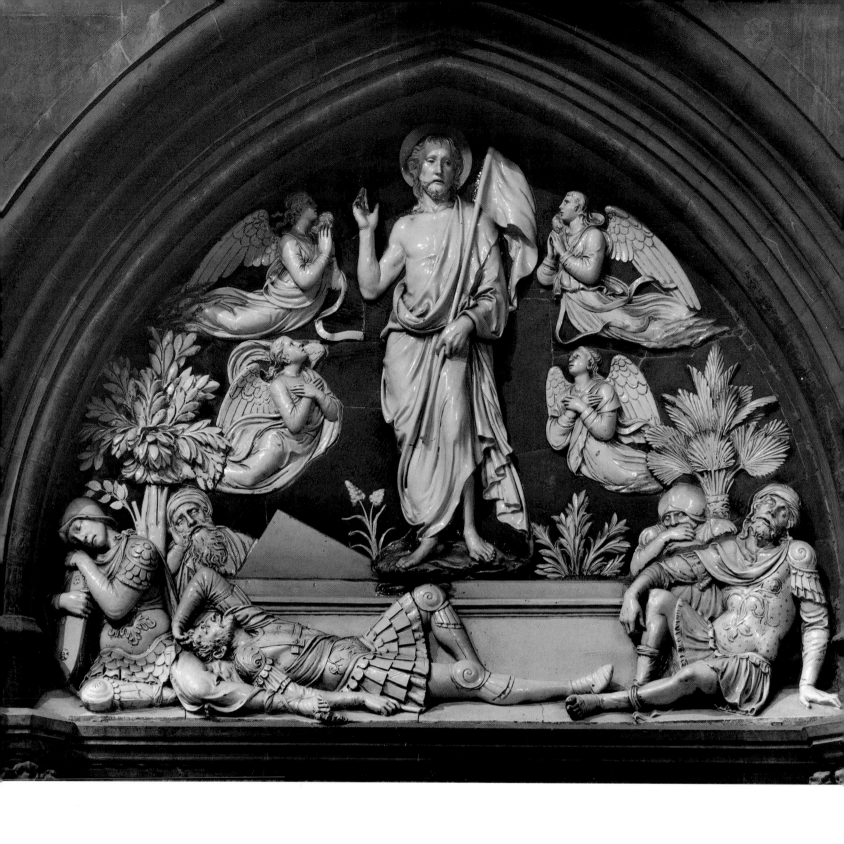

168 Luca della Robbia. *The Resurrection*. 1442–45. North Sacristy Door, Duomo, Florence

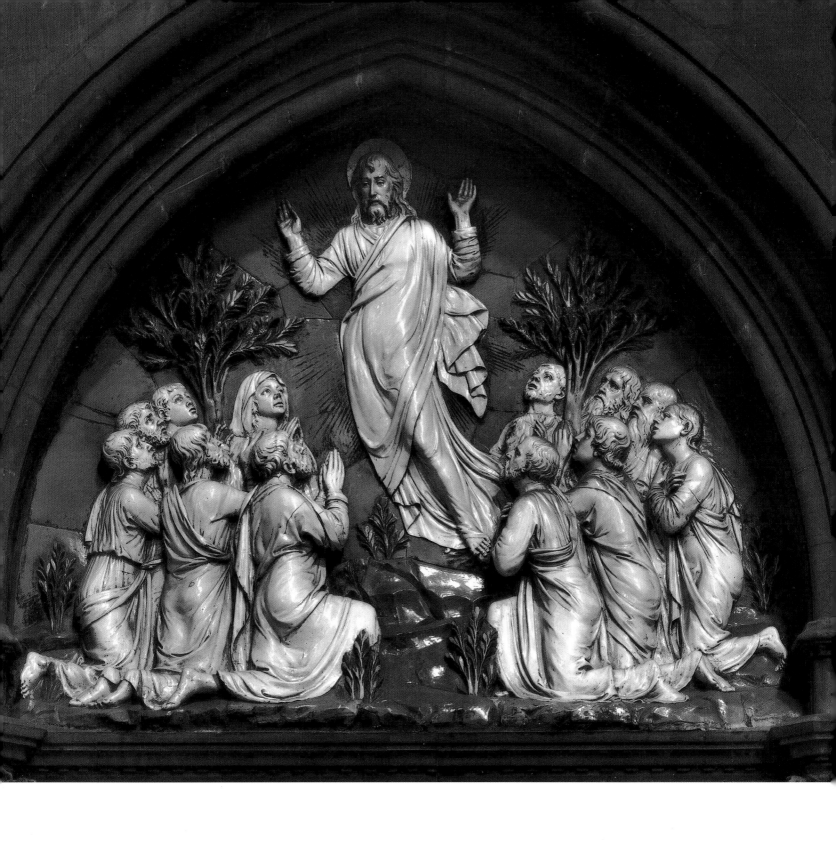

169 Luca della Robbia. *The Ascension*. 1446–51. South Sacristy Door, Duomo, Florence

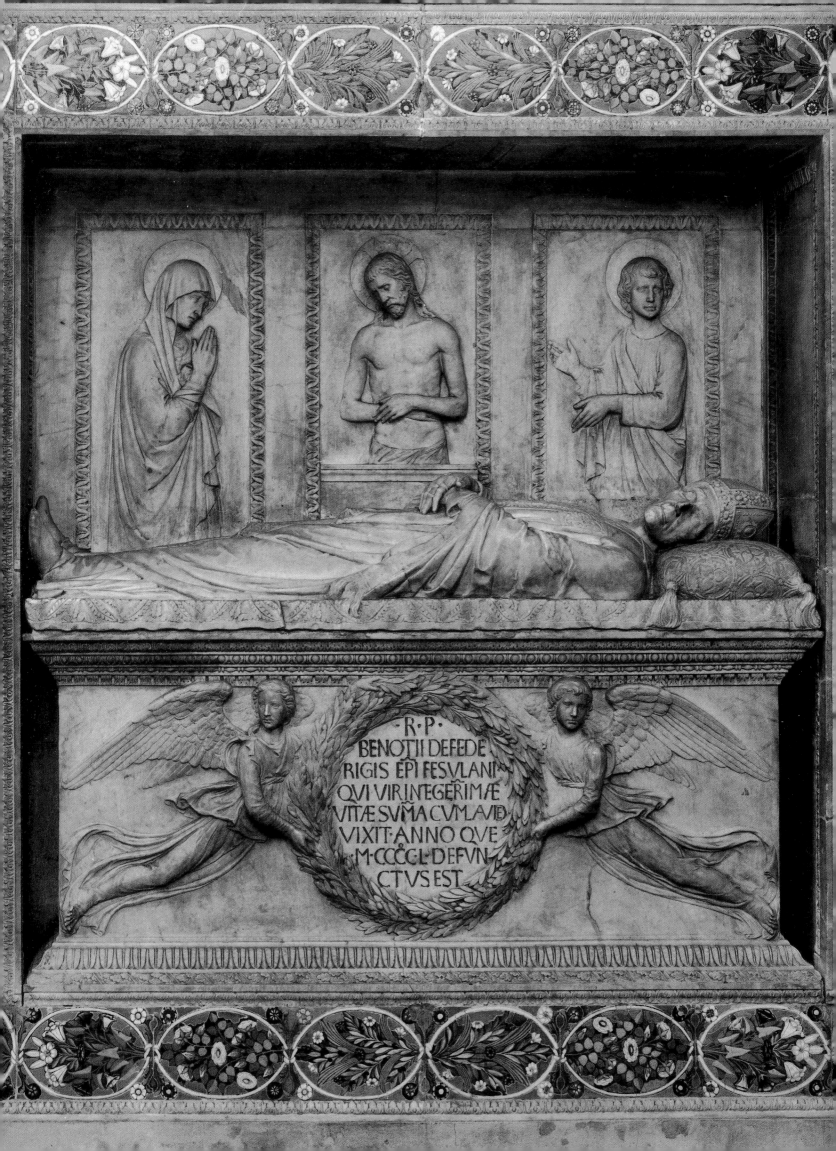

·R·P·
BENOTII DE FEDE
RIGIS EPÎ FESVLANI
QVI VIR INTEGERIMÆ
VITÆ SVMA CVM LAVDE
VIXIT ANNO QVE
M·CCCCL· DEFVN
CTVS EST

171 Luca della Robbia. Ceiling decorations in the Chapel of the Cardinal of Portugal. 1461–62.
San Miniato al Monte, Florence

OPPOSITE:
170 Luca della Robbia. Tomb of Bishop Benozzo Federighi. 1454–56. Santa Trinità, Florence

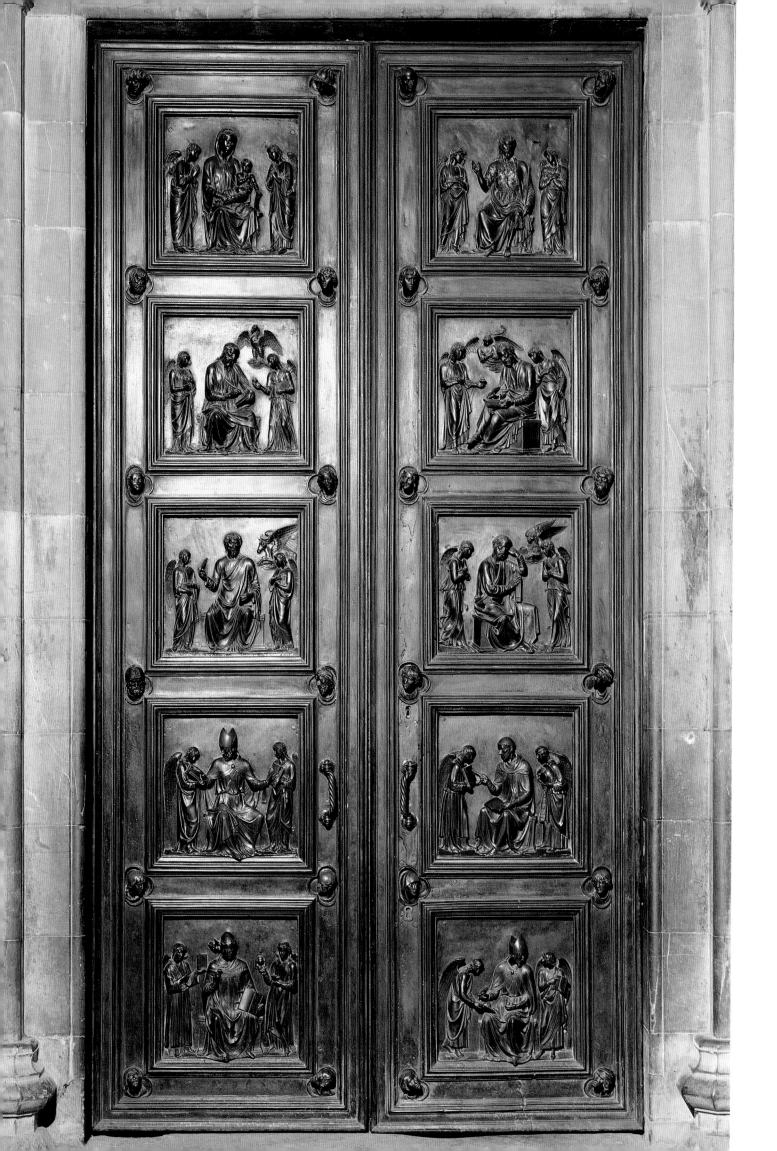

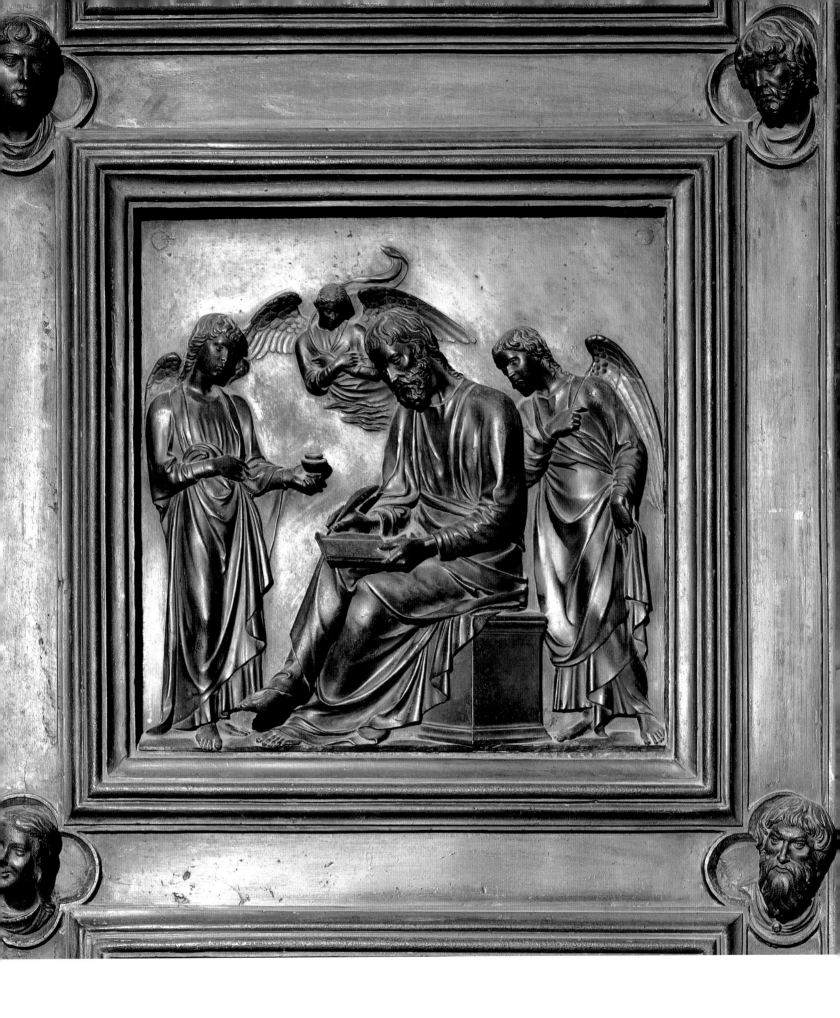

172, 173 Luca della Robbia. Sacristy Door. 1464–68. Duomo, Florence

173 detail: St. Matthew

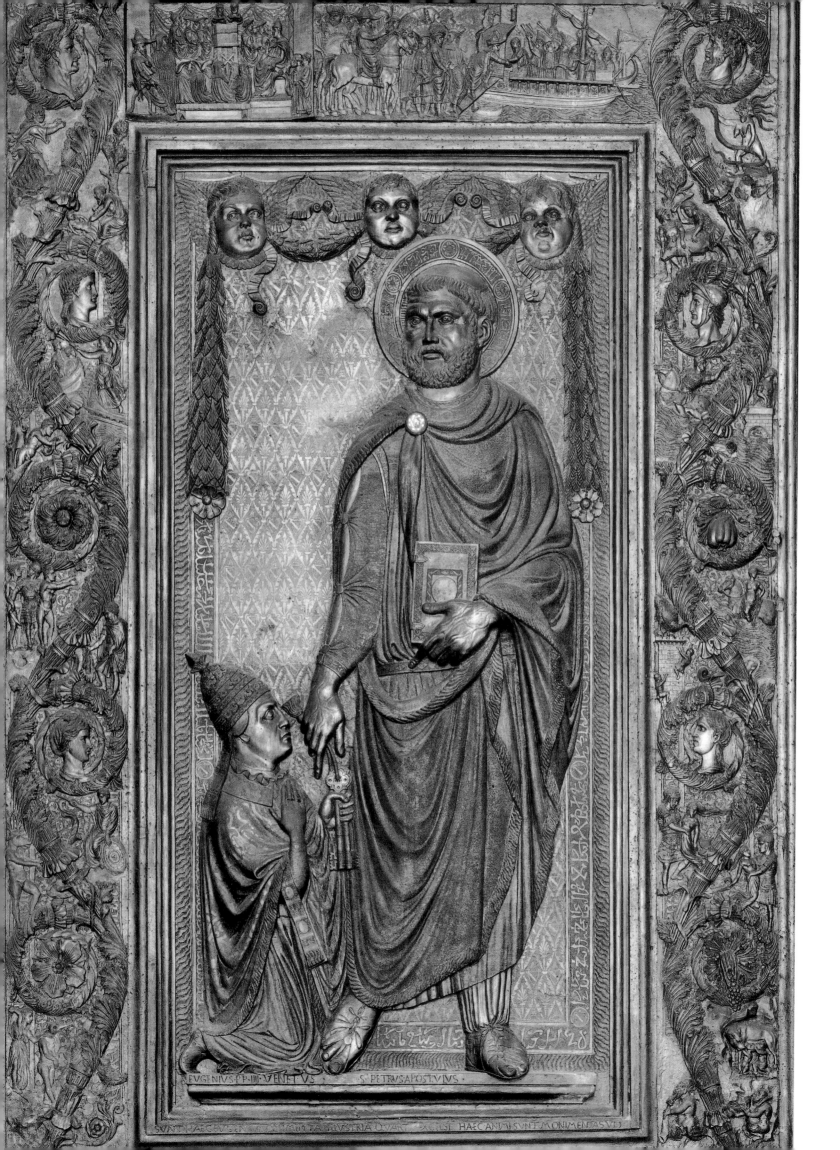

EVGENIVS·PP·IIII·VENETVS S·PETRVS·APOSTVLVS

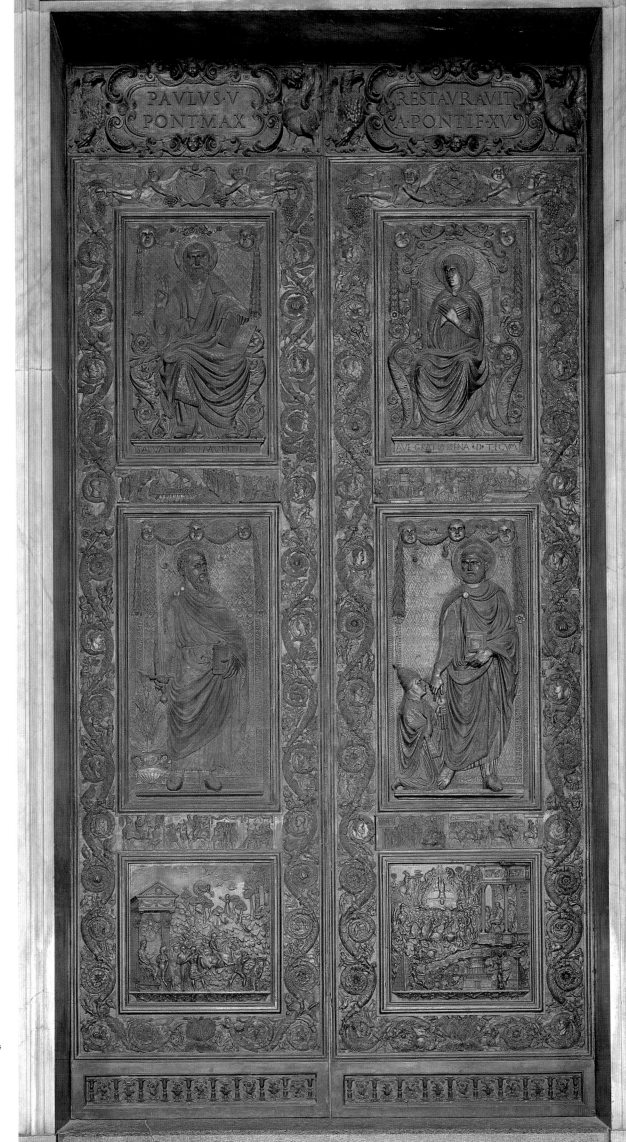

174 detail: St. Peter and Pope
Eugenius IV

174, 175 Filarete. Bronze Doors
for the Main Portal of St. Peter's.
1433–45. St. Peter's, Rome

176 Filarete. Bronze Doors for the Main Portal of St. Peter's (detail: the Conviction and Beheading
of St. Paul).
1433–45. St. Peter's, Rome

177 Filarete. Bronze Doors for the Main Portal of St. Peter's (detail: the Conviction and Crucifixion of St. Peter). 1433–45. St. Peter's, Rome

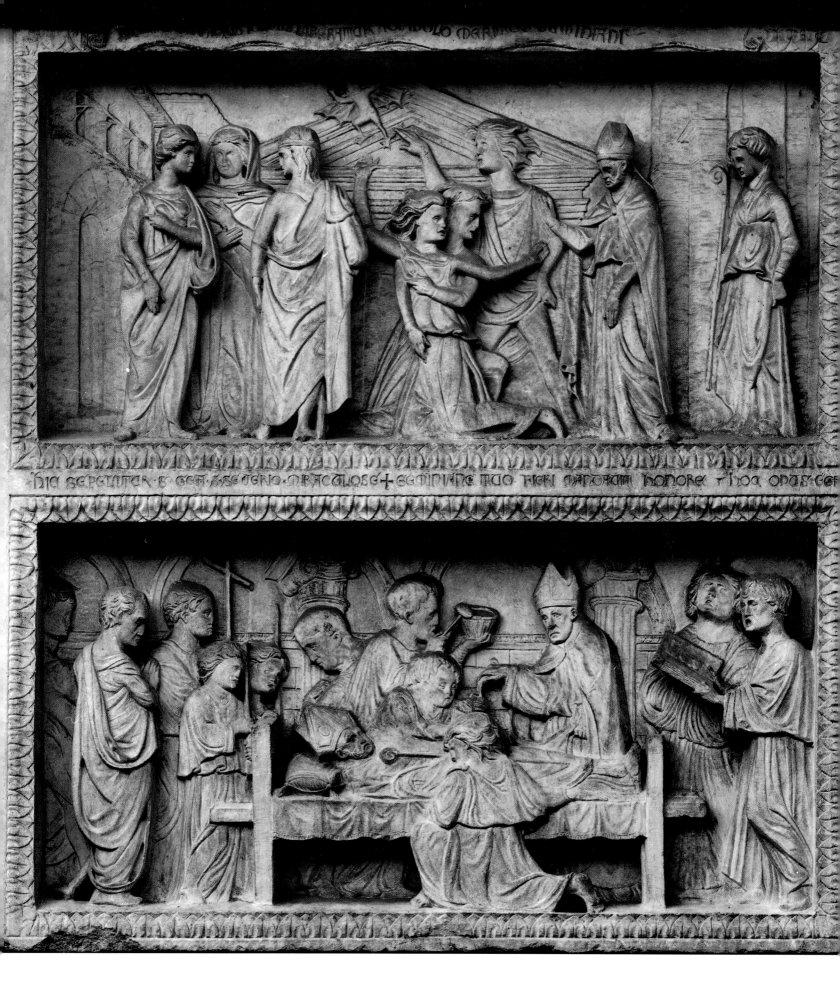

178, 179 Agostino di Duccio. *Scenes from the Life of St. Geminianus.* 1442. Duomo, Modena

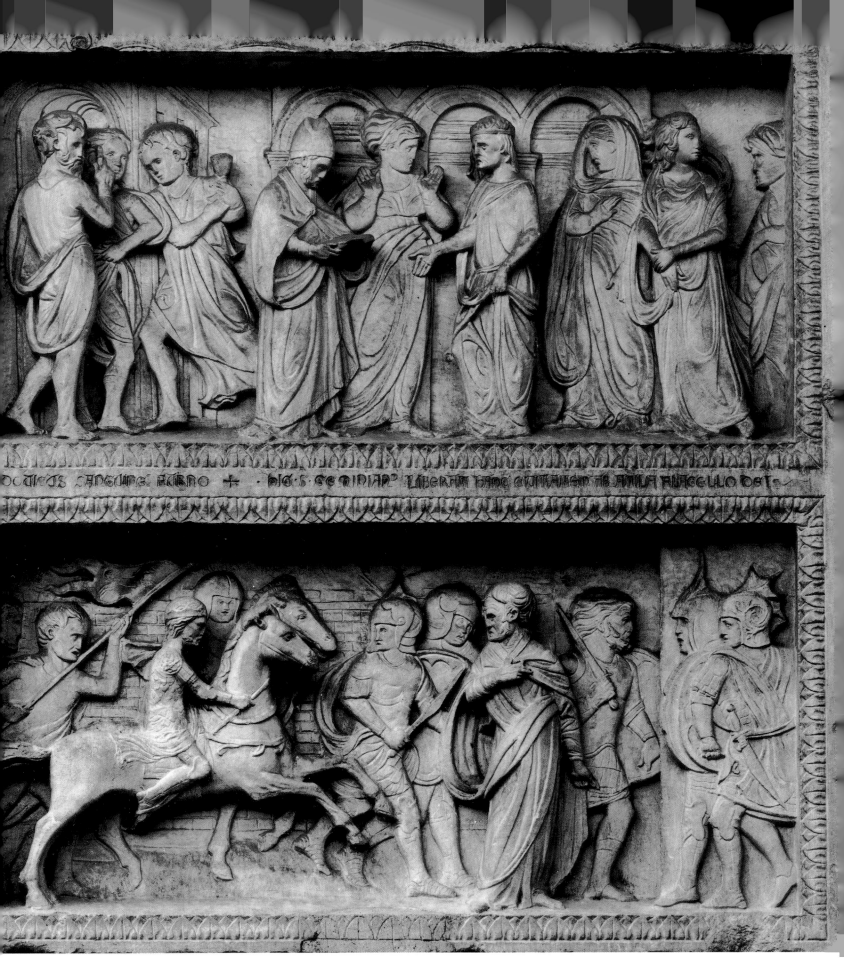

OOLICOS CANCOLPES BARRO + DIG S GGDIDIAD LIBERAT DANC GVITATIED AB ATILA FLAGGLLO DGI

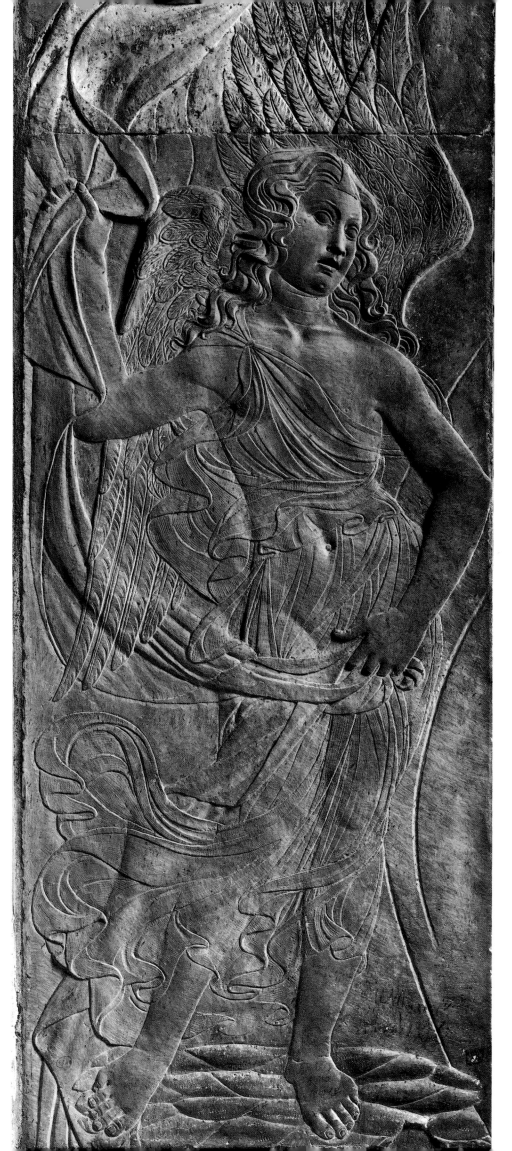

180 Agostino di Duccio. *Angel Holding a Curtain*. c. 1450–57. Chapel of St. Sigismund, San Francesco (Tempio Malatestiano), Rimini

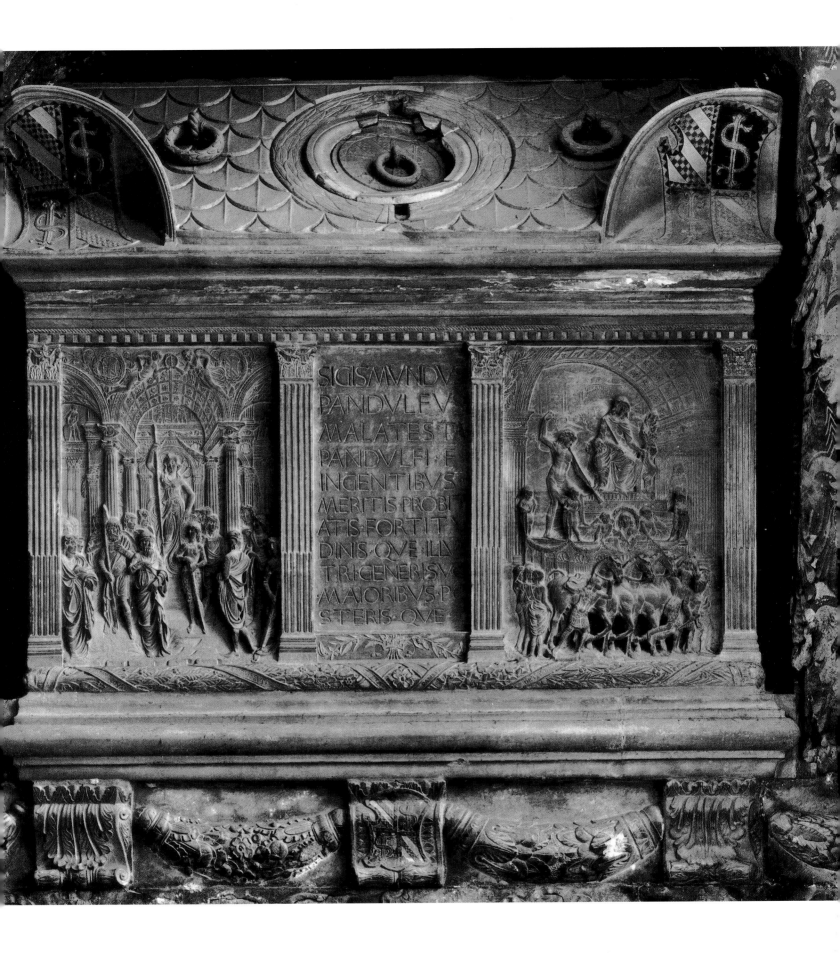

The inscription on the tomb reads:

SIGISMVNDV
PANDVLFV
MALATEST
PANDVLFI F
INGENTIBVS
MERITIS PROB
ATIS FORTIT
DINIS QVE ILL
TRI GENERIS M
MAIORIBVS P
STERIS QVE

181 Agostino di Duccio. Shrine of the Antenati. c. 1450–57. Chapel of the Virgin dell'Acqua, San Francesco (Tempio Malatestiano), Rimini

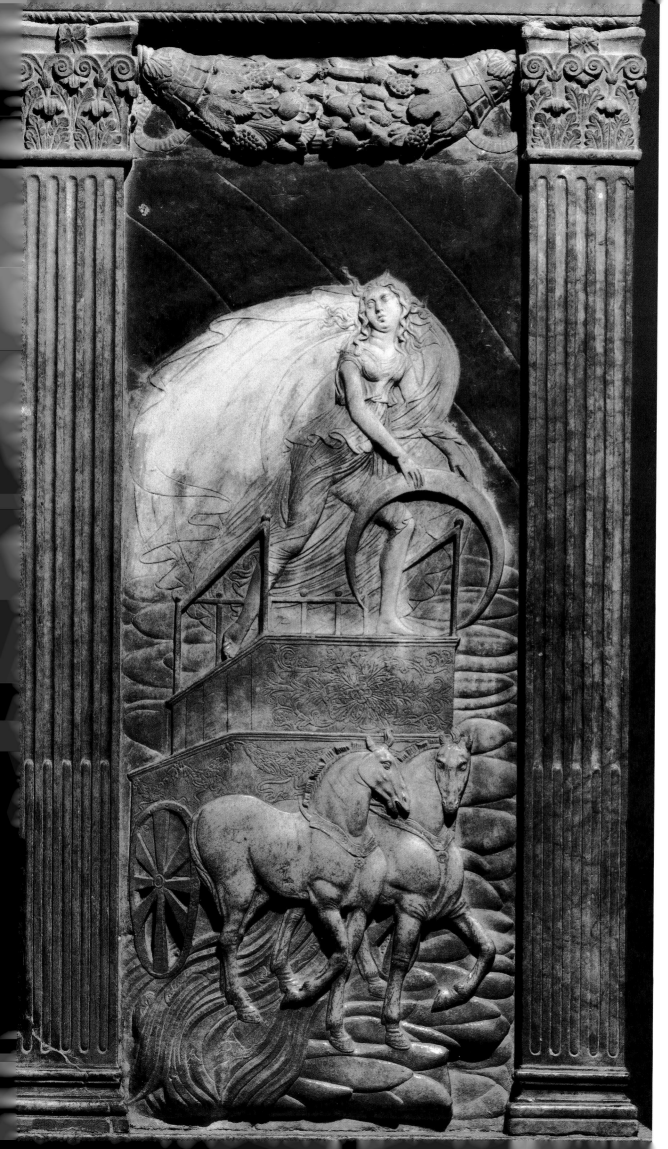

182 Agostino di Duccio.
Luna. c. 1450–57. Chapel
of the Planets, San
Francesco (Tempio
Malatestiano), Rimini

OPPOSITE:
183 Agostino di Duccio.
Sporting and Dancing Putti.
c. 1450–57. Chapel of the
Playing Children, San
Francesco (Tempio
Malatestiano), Rimini

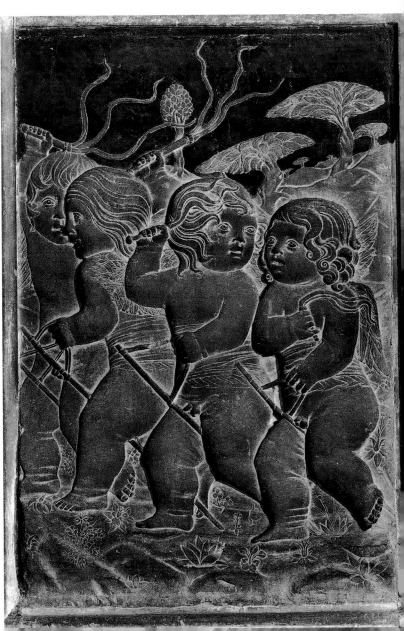

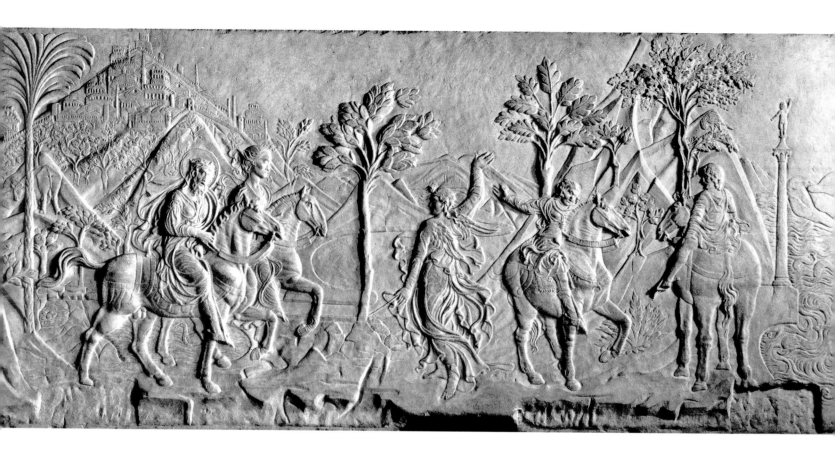

184 Agostino di Duccio. *St. Sigismund Encounters an Angel on His Way to Agaunum.* c. 1450–57.
Castello Sforzesco, Milan

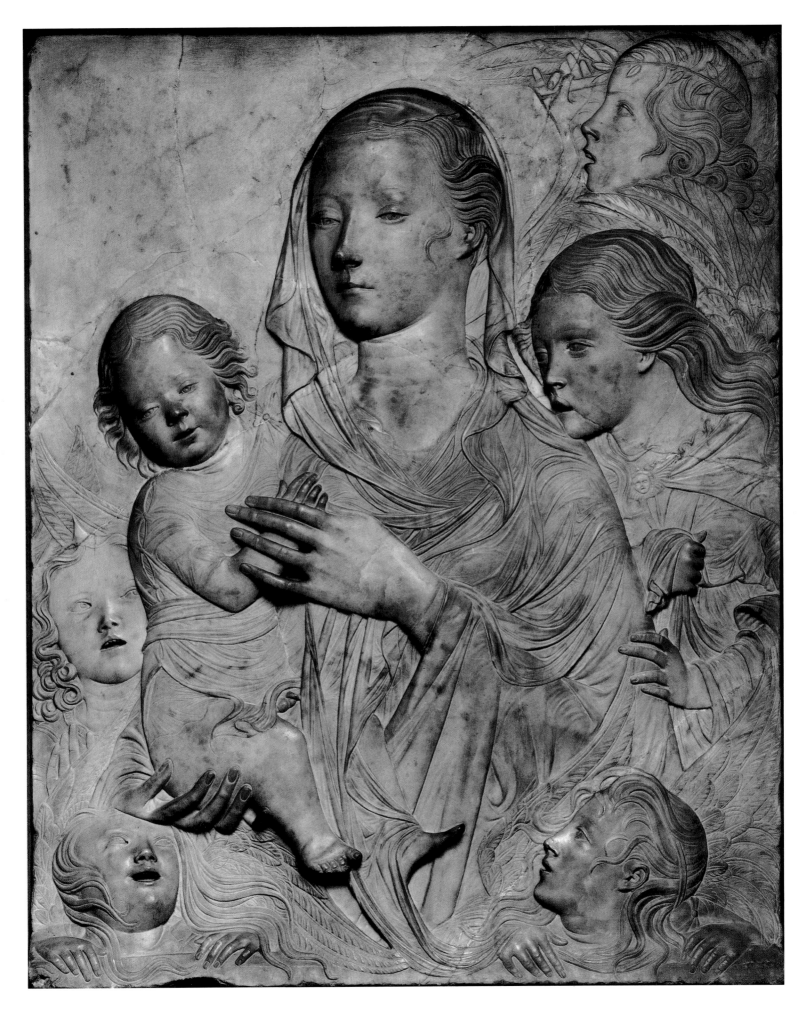

185 Agostino di Duccio. *Madonna and Child with Angels.* c. 1463–70. Museo Nazionale del Bargello, Florence

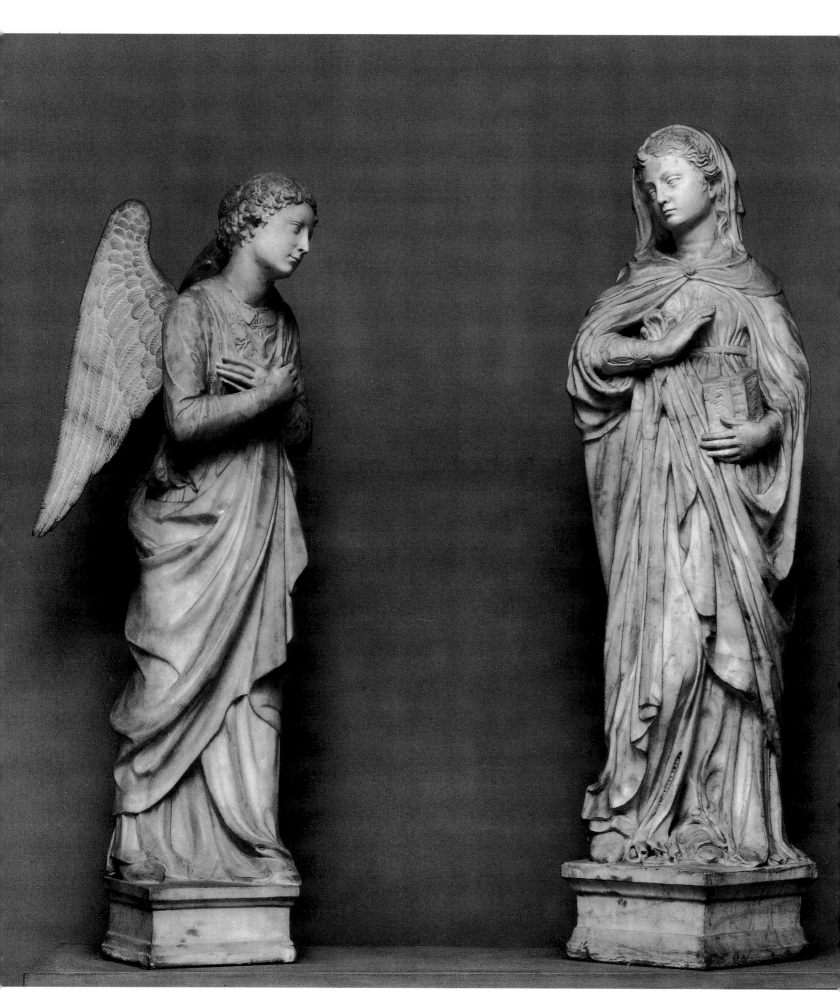

186 Bernardo Rossellino. *The Annunciation*. c. 1447. Museo della Collegiata, Empoli

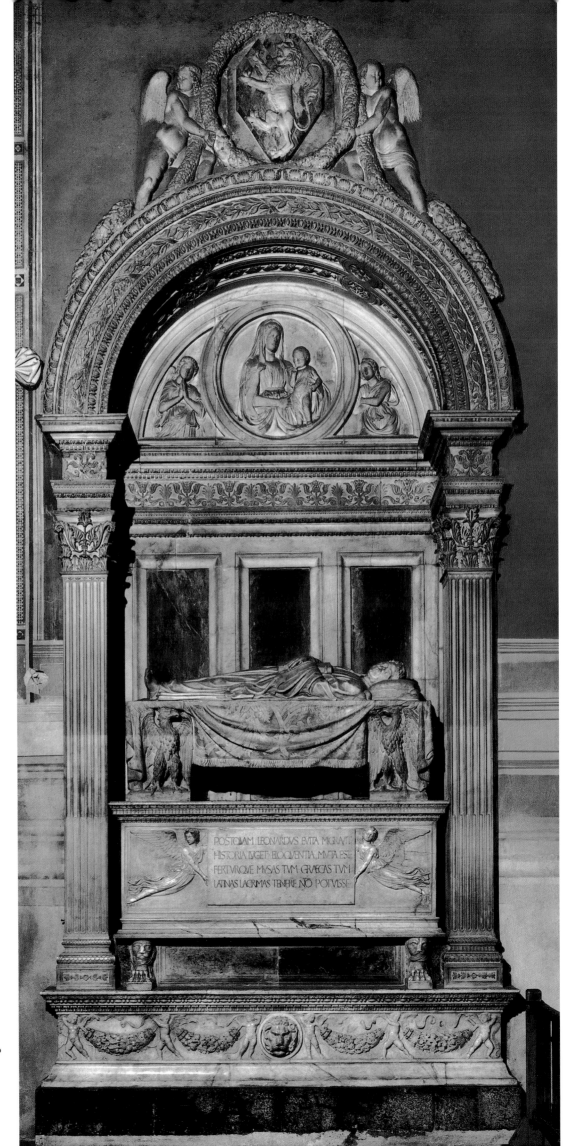

POSTQVAM·LEONARDVS·E·VITA·MIGRAVIT·
HISTORIA·LVGET·ELOQVENTIA·MVTA·EST·
FERTVRQVE·MVSAS·TVM·GRAECAS·TVM·
LATINAS·LACRIMAS·TENERE·NÕ·POTVISSE

187　Bernardo Rossellino. Tomb
of Leonardo Bruni. 1448–50.
Santa Croce, Florence

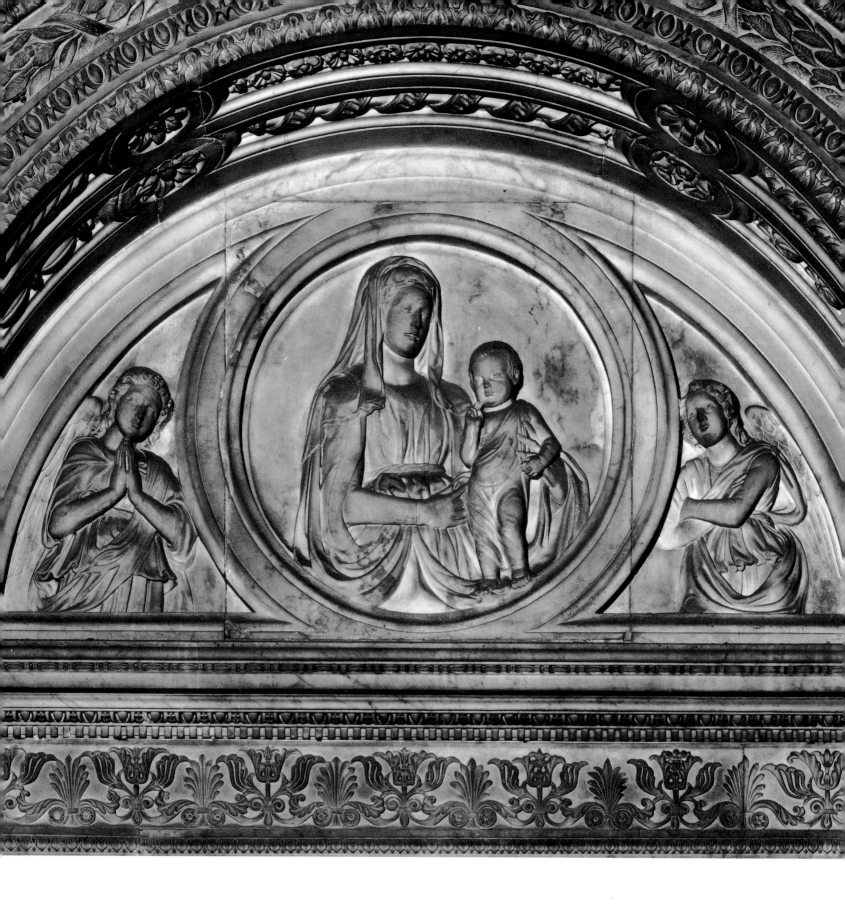

188 Bernardo Rossellino. Tomb of Leonardo Bruni (detail: Madonna and Child). 1448–50. Santa
Croce, Florence

OPPOSITE:
189 Bernardo Rossellino. Tomb of Leonardo Bruni (detail). 1448–50. Santa Croce, Florence

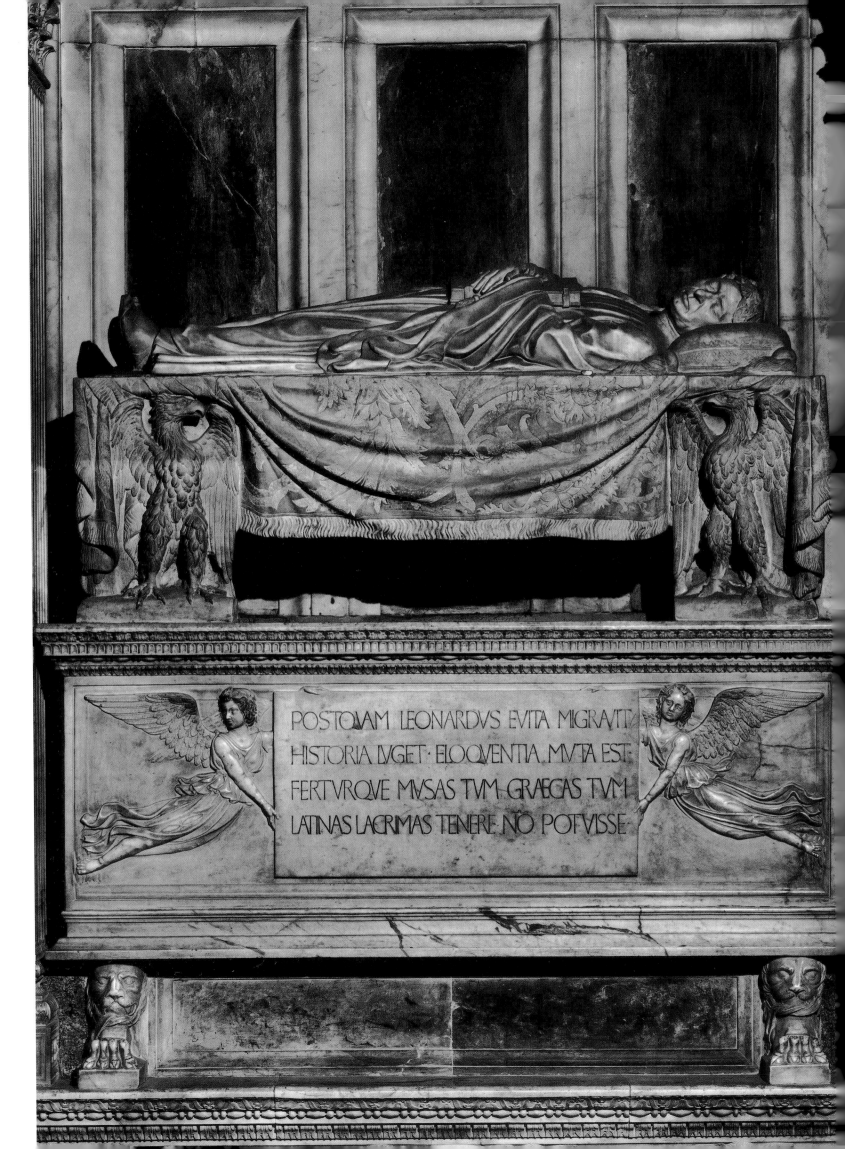

POSTQVAM LEONARDVS EVITA MIGRAVIT
HISTORIA LVGET · ELOQVENTIA · MVTA EST ·
FERTVRQVE MVSAS TVM · GRAECAS TVM ·
LATINAS LACRIMAS TENERE NŌ POTVISSE

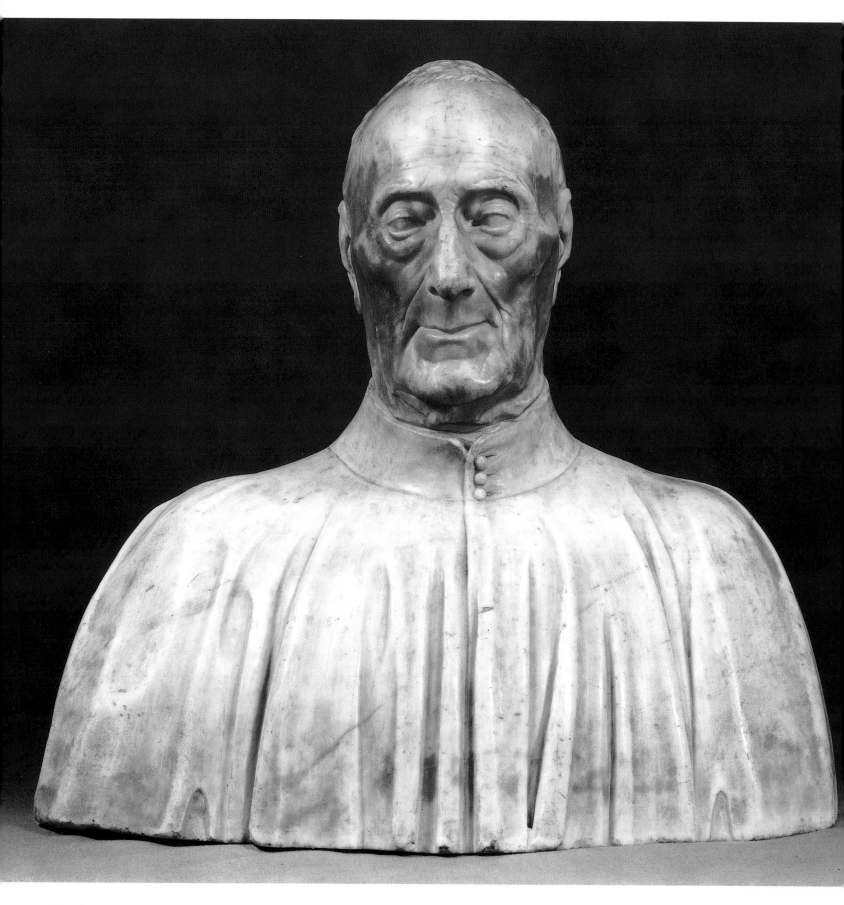

190 Antonio Rossellino. *Bust of Giovanni Chellini*. 1456. Victoria and Albert Museum, London

OPPOSITE:
191 Antonio Rossellino. *Madonna and Child*. c. 1460–61. Kunsthistorisches Museum, Vienna

OVERLEAF, LEFT AND RIGHT:
192, 193 Antonio Rossellino. Tomb of the Cardinal of Portugal. 1461–66. San Miniato al Monte, Florence

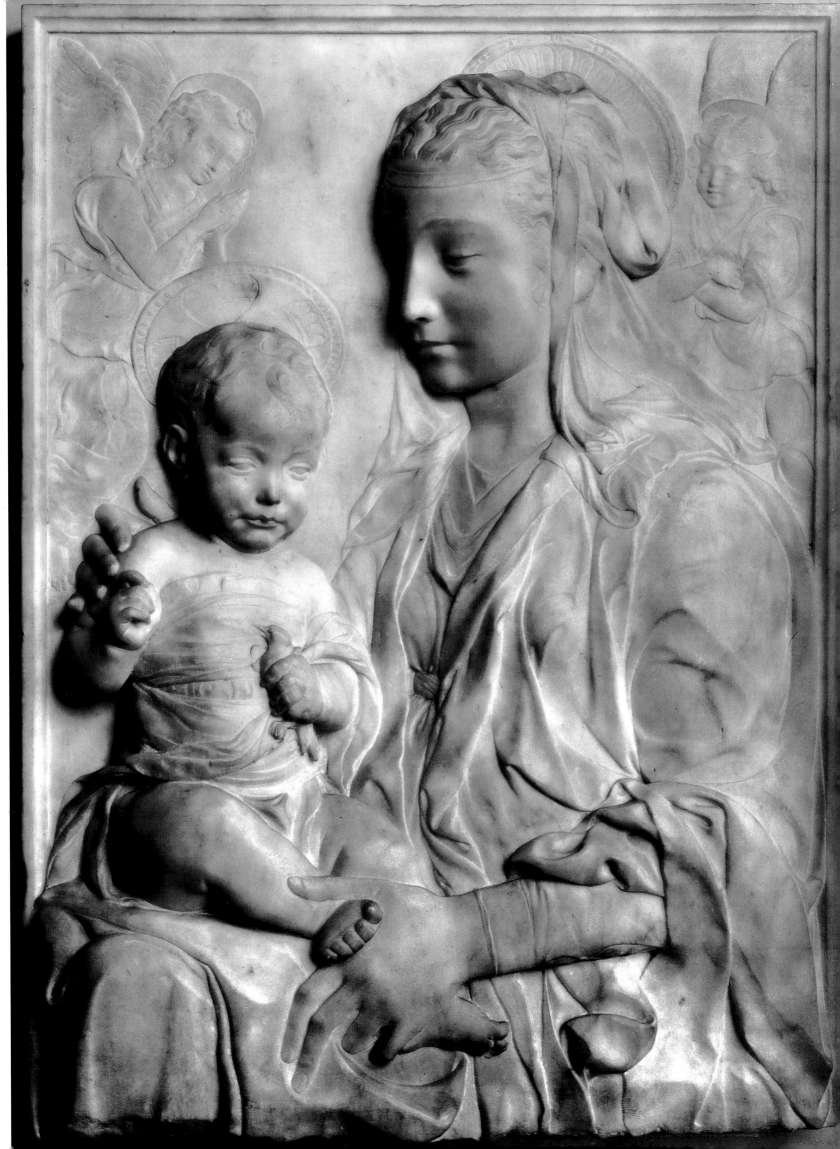

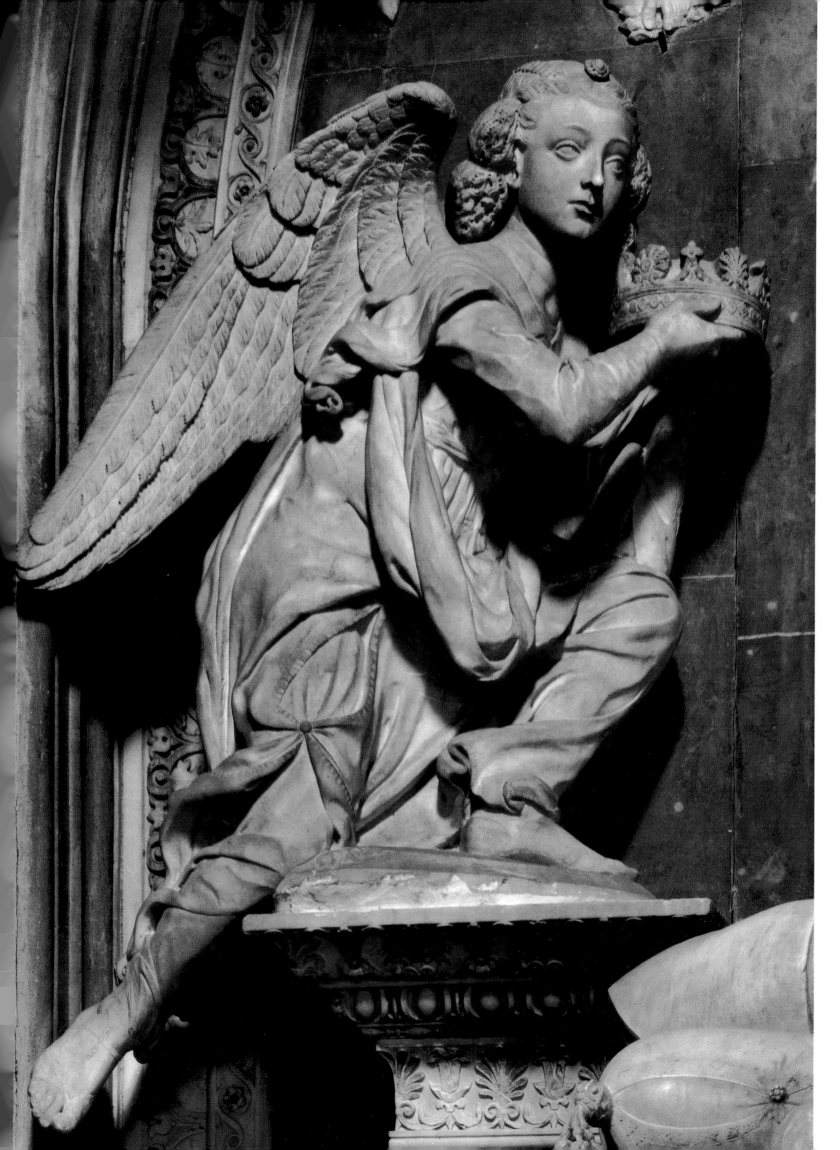

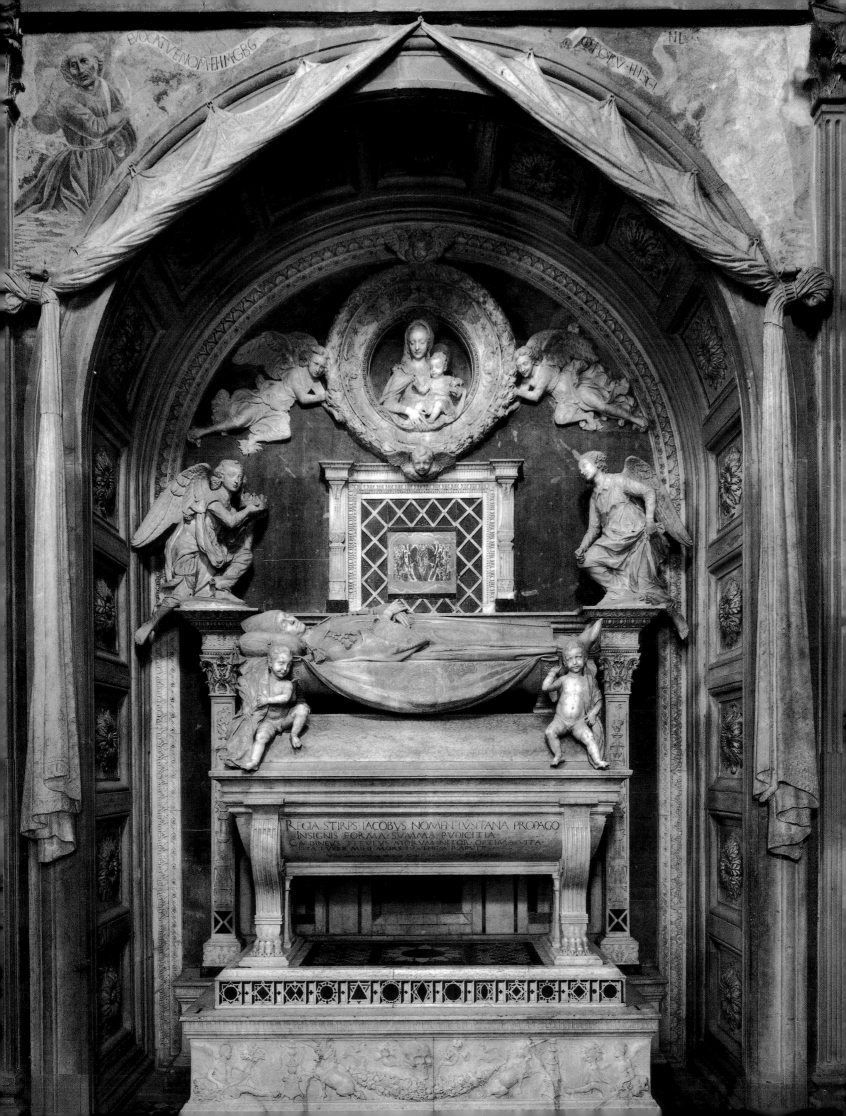

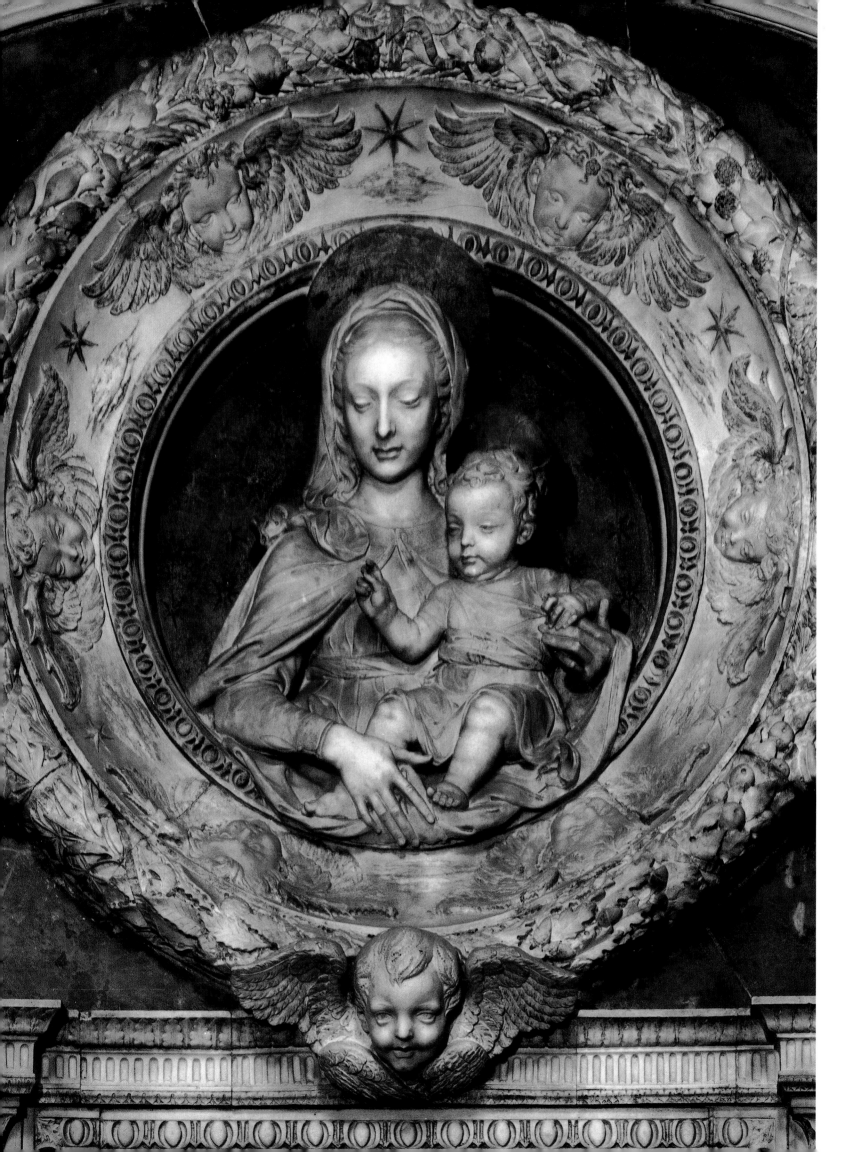

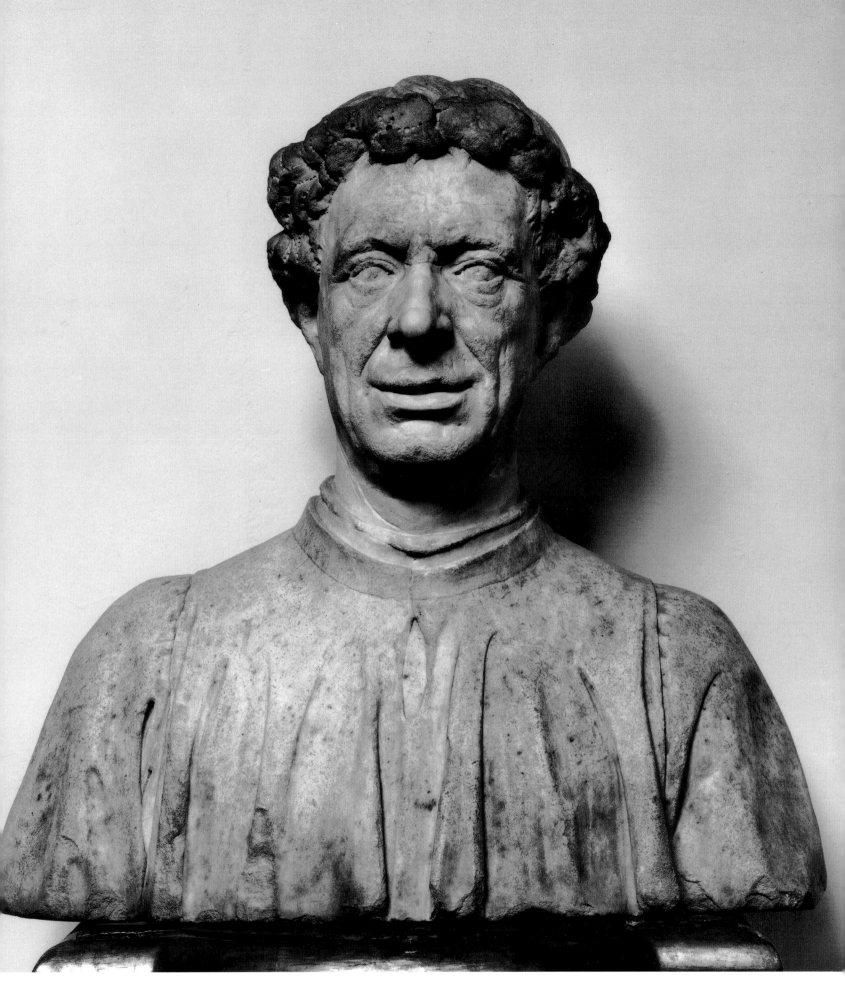

195 Antonio Rossellino. *Bust of Matteo Palmieri*. 1468. Museo Nazionale del Bargello, Florence

OPPOSITE:
194 Antonio Rossellino. Tomb of the Cardinal of Portugal (detail: *Madonna* tondo). 1461–66. San Miniato al Monte, Florence

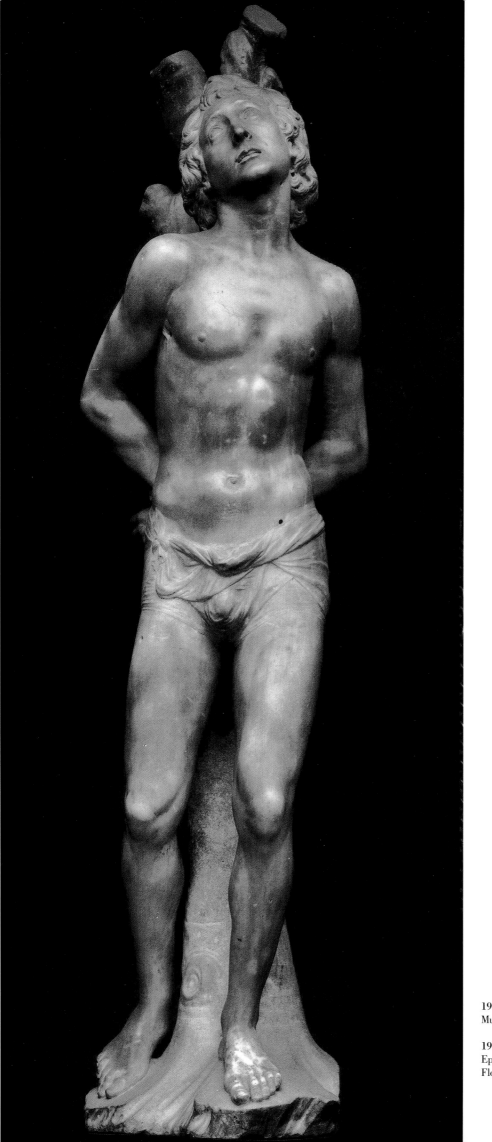

196 Antonio Rossellino. *St. Sebastian*. c. 1475.
Museo della Collegiata, Empoli

197 Antonio Rossellino. *Madonna* relief, from the
Epitaph of the Nori Family. c. 1475. Santa Croce,
Florence

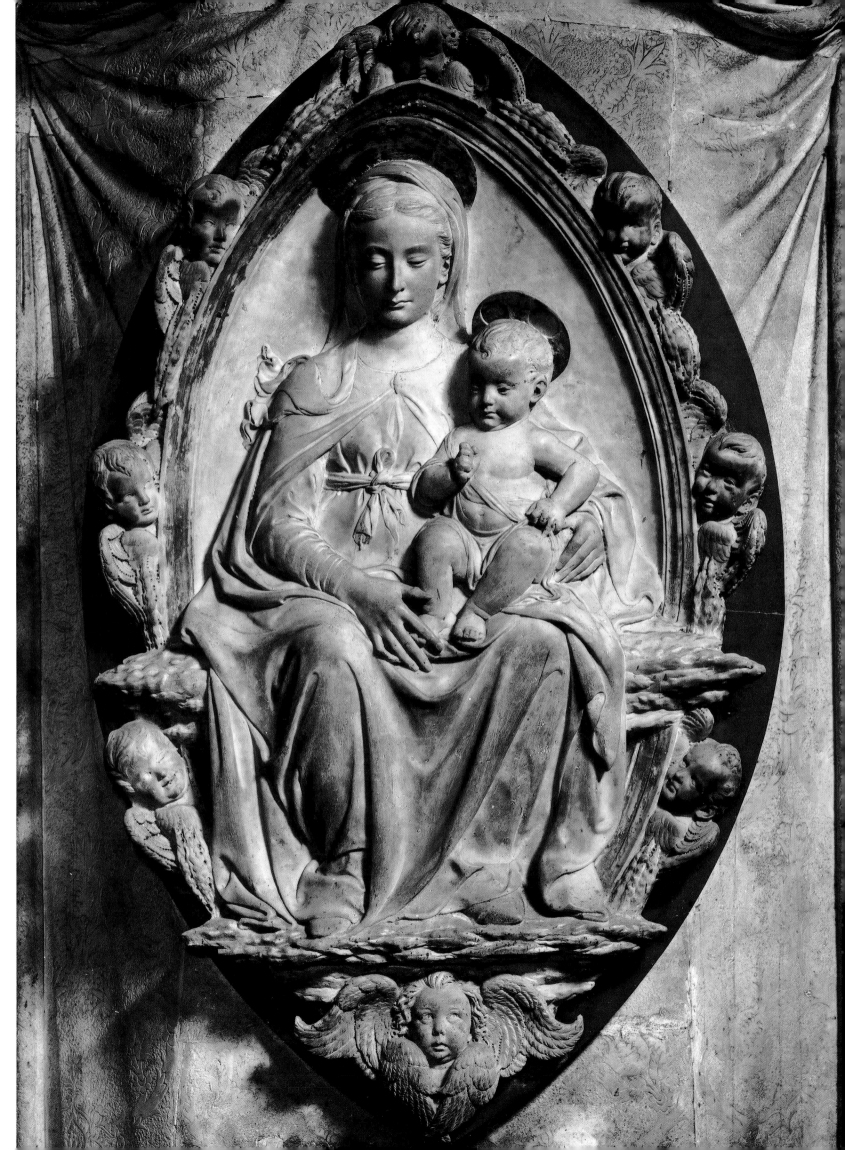

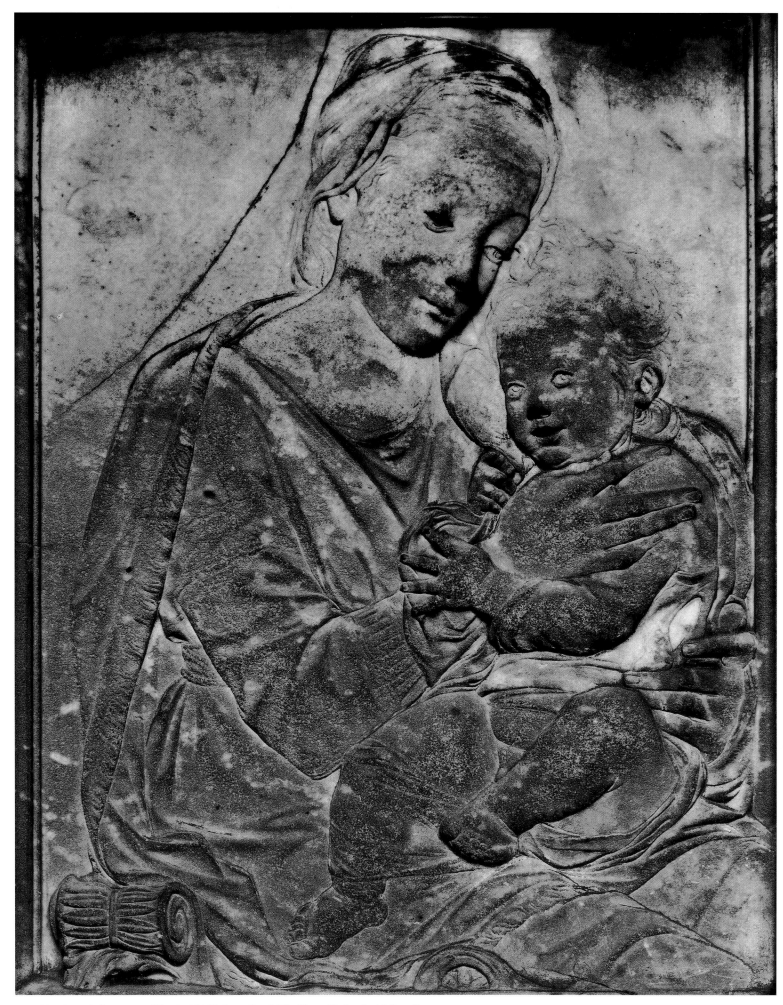

198 Desiderio da Settignano. *"Panciatichi Madonna."* c. 1453. Museo Nazionale del Bargello,
Florence

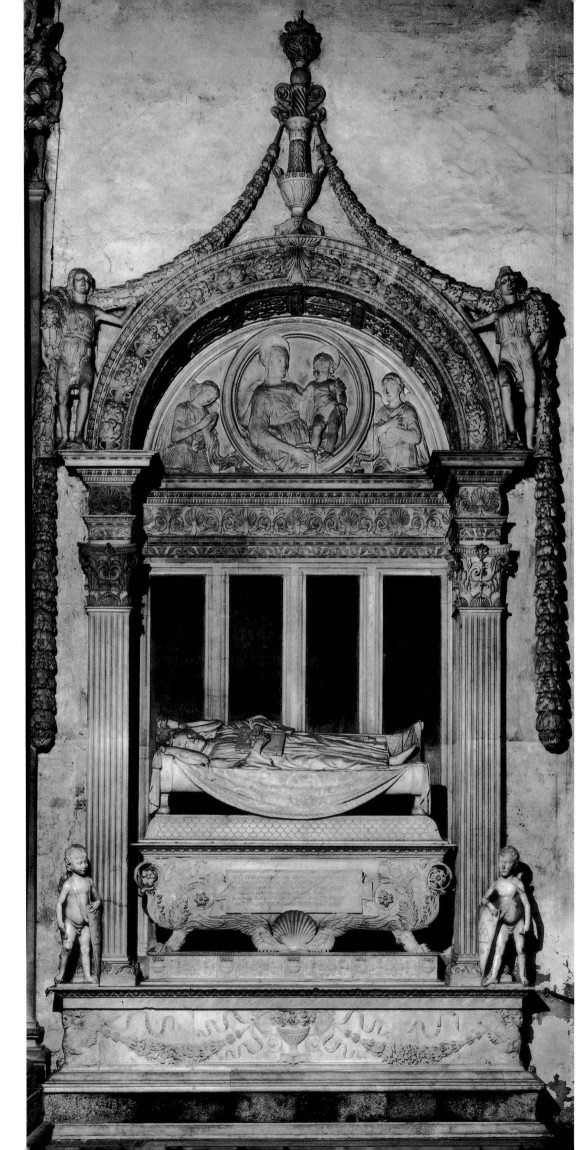

199 Desiderio da Settignano.
Tomb of Carlo Marsuppini.
c. 1453–54. Santa Croce, Florence

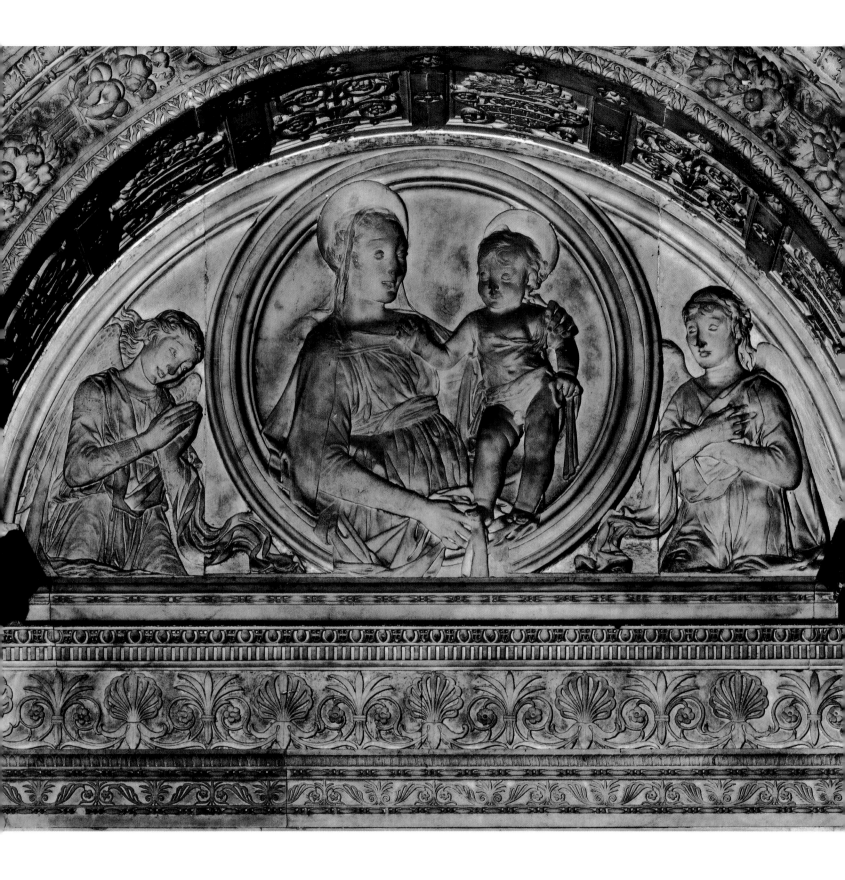

200 Desiderio da Settignano. Tomb of Carlo Marsuppini (detail: *Madonna* tondo). c. 1453–54.
Santa Croce, Florence

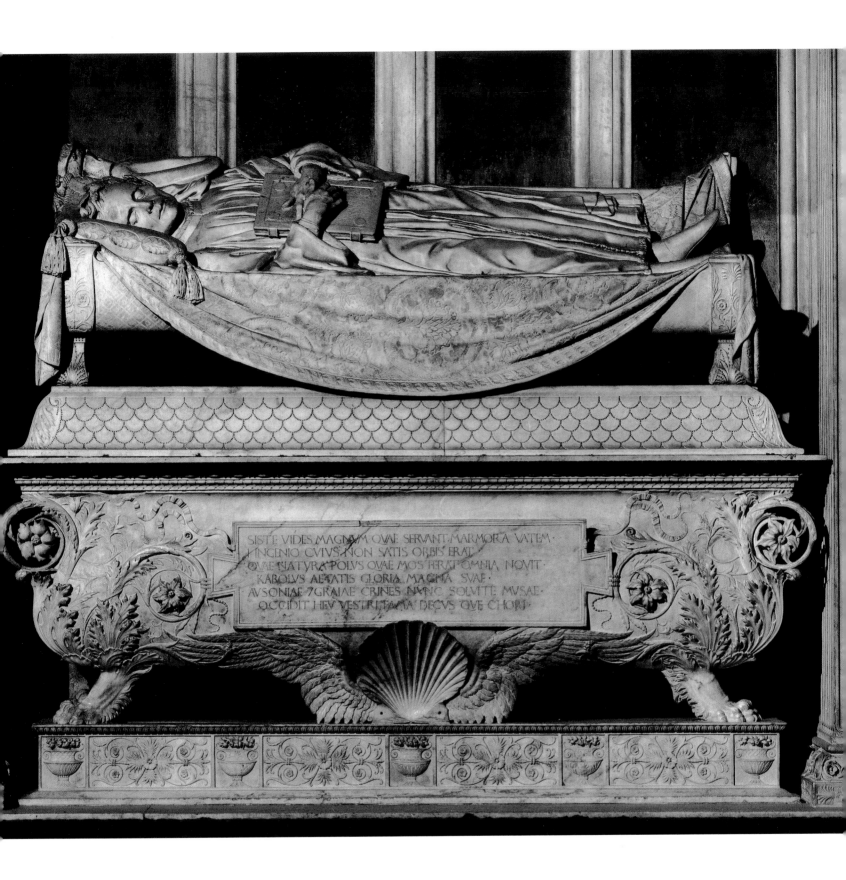

201 Desiderio da Settignano. Tomb of Carlo Marsuppini (detail). c. 1453–54. Santa Croce, Florence

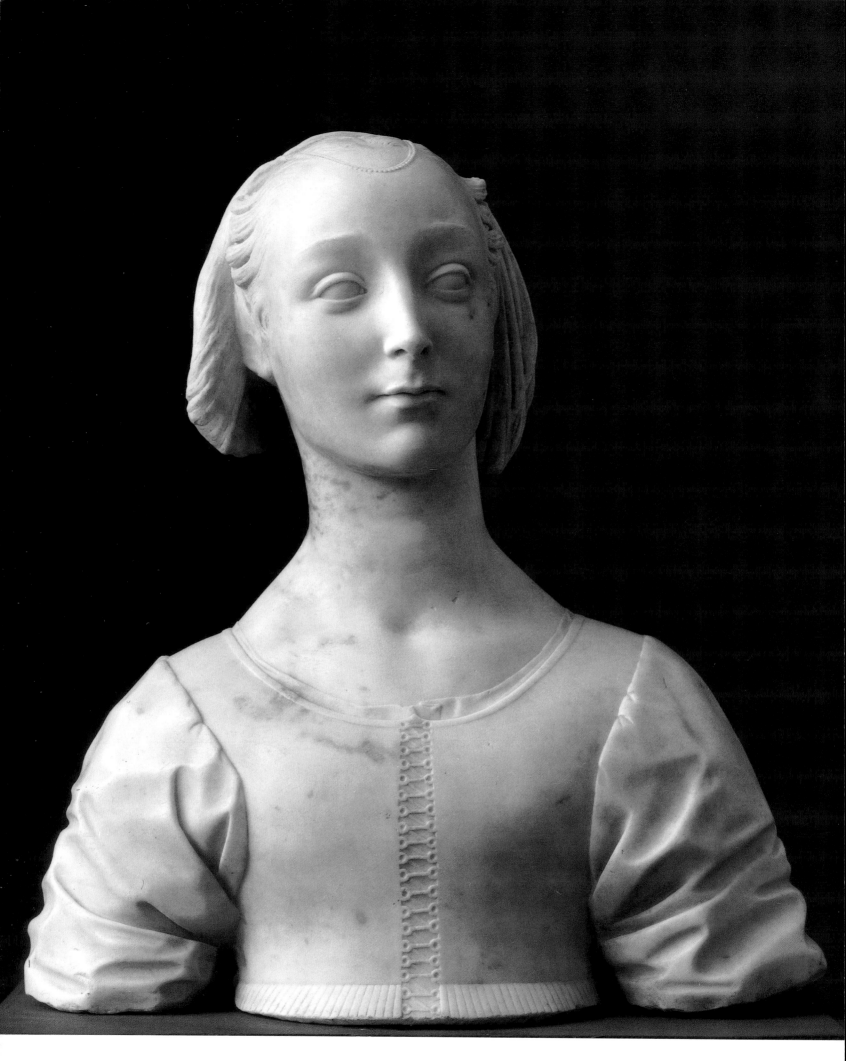

202 Desiderio da Settignano. *"Marietta Strozzi."* c. 1455. Staatliche Museen, Berlin-Dahlem

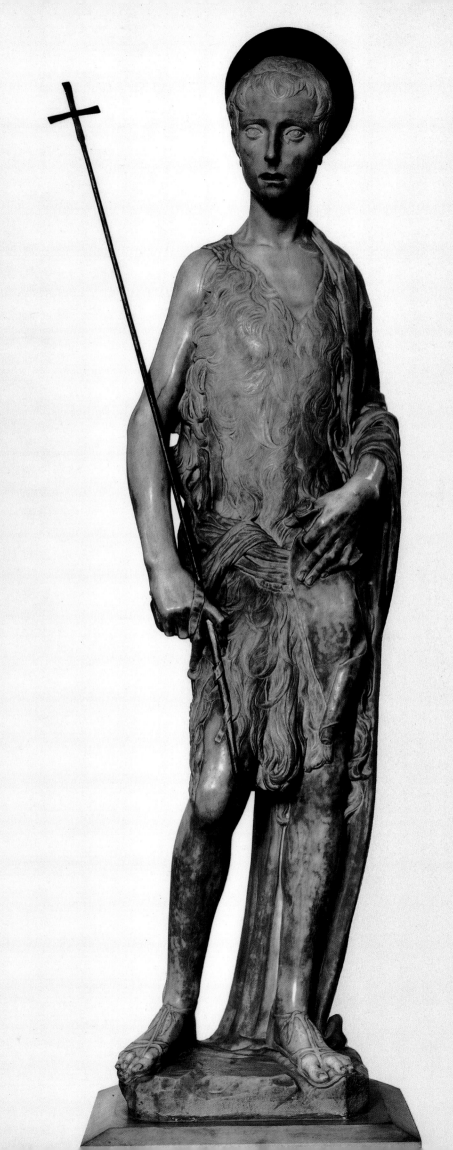

203 Desiderio da Settignano.
St. John the Baptist ("Giovannino Martelli"). c. 1458–60. Museo Nazionale del Bargello, Florence

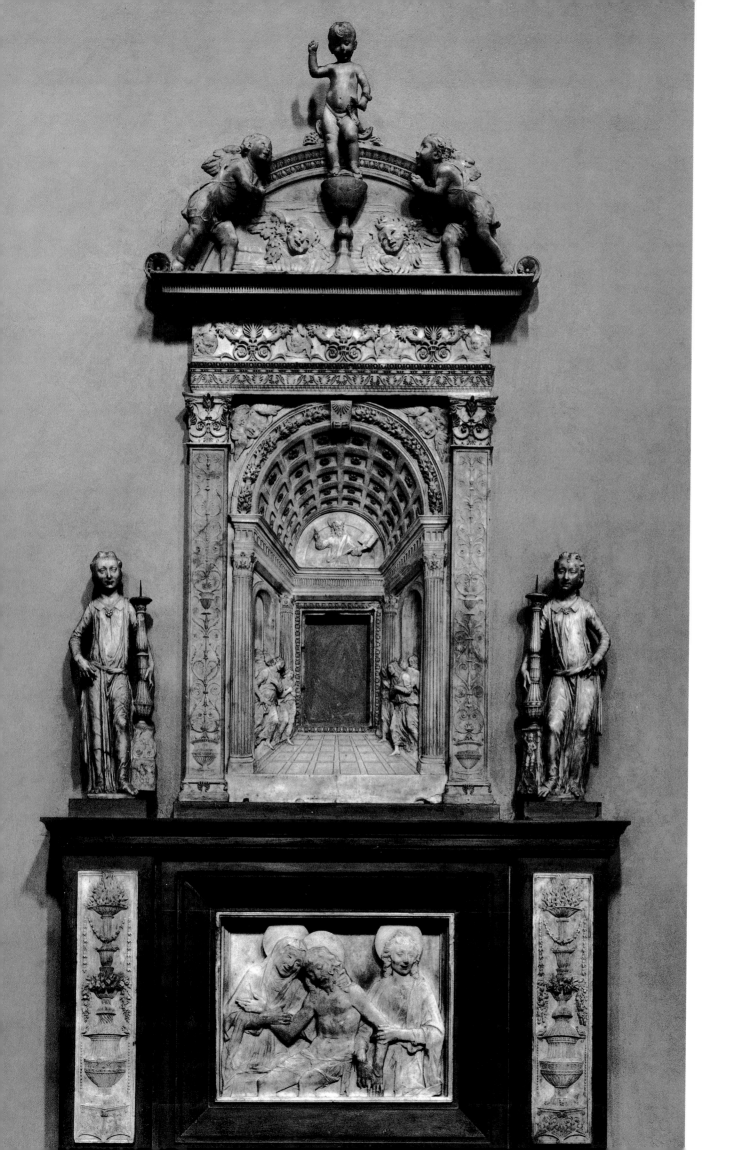

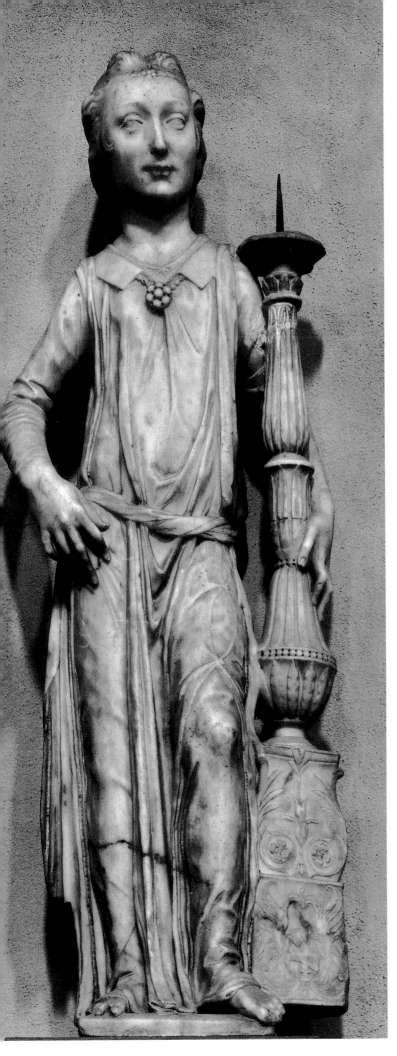
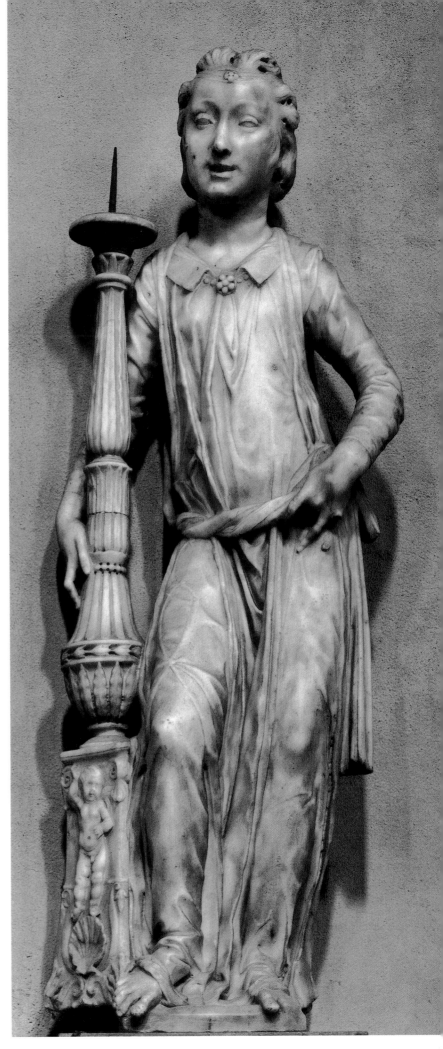

OPPOSITE AND ABOVE:
204, 205 Desiderio da Settignano. Tabernacle of the Sacrament. c. 1460–62. San Lorenzo, Florence

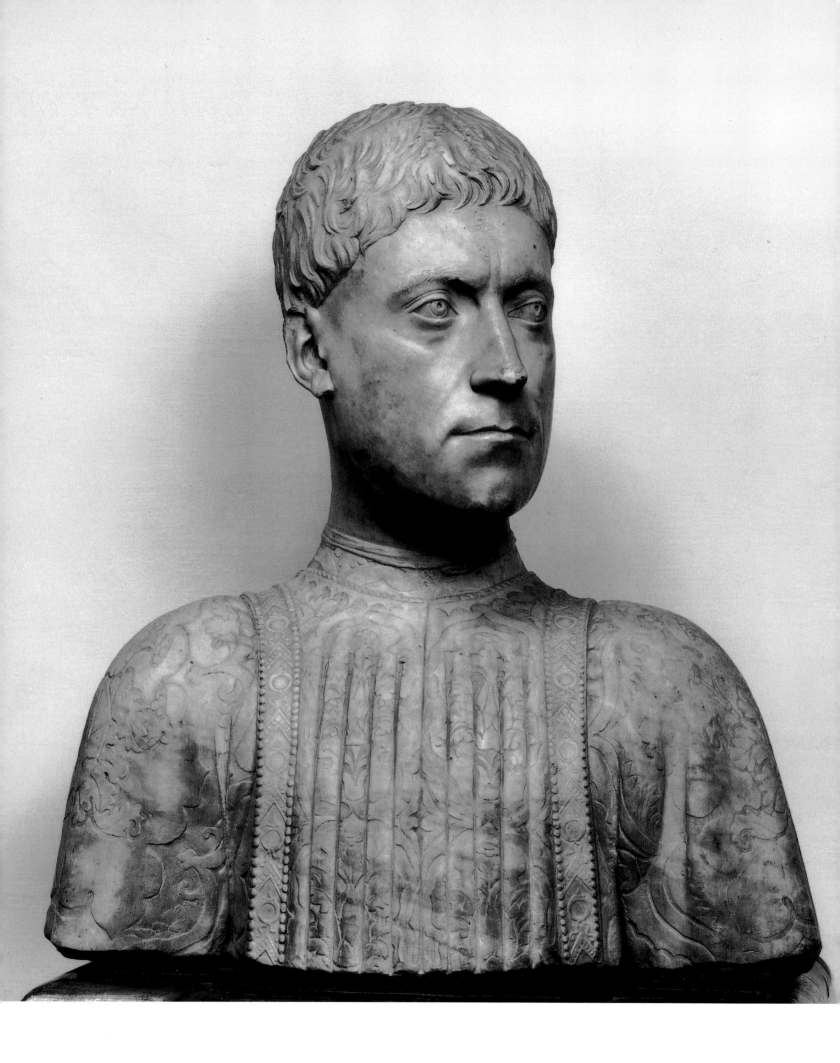

206 Mino da Fiesole. *Bust of Piero de' Medici.* c. 1455–60. Museo Nazionale del Bargello, Florence

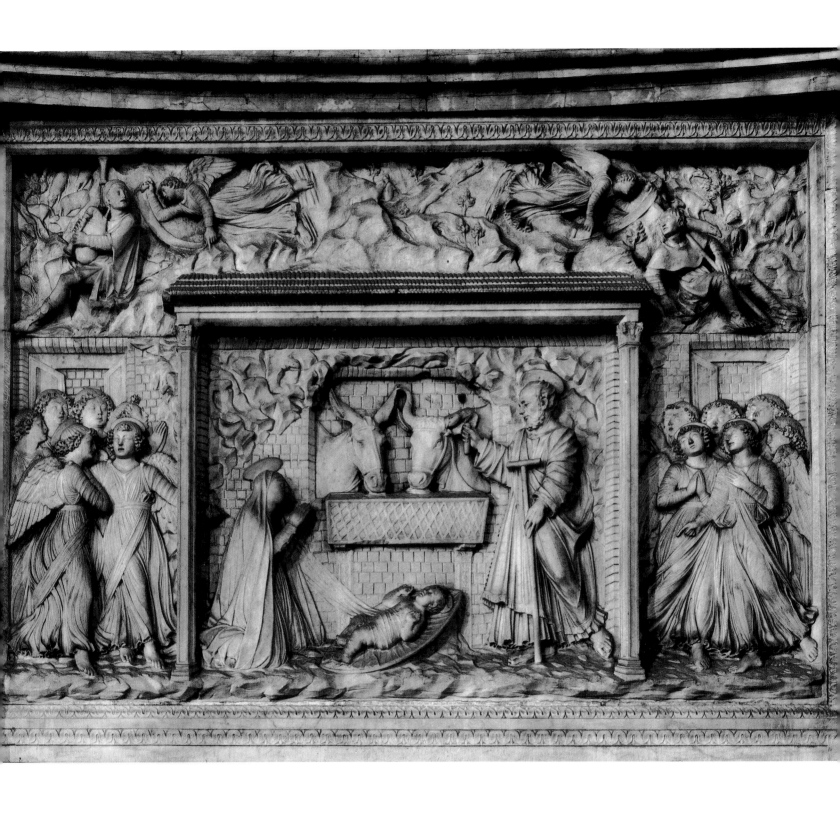

207 Mino da Fiesole. *Nativity*. Relief from the former ciborium over the High Altar. c. 1461–63. Santa Maria Maggiore, Rome

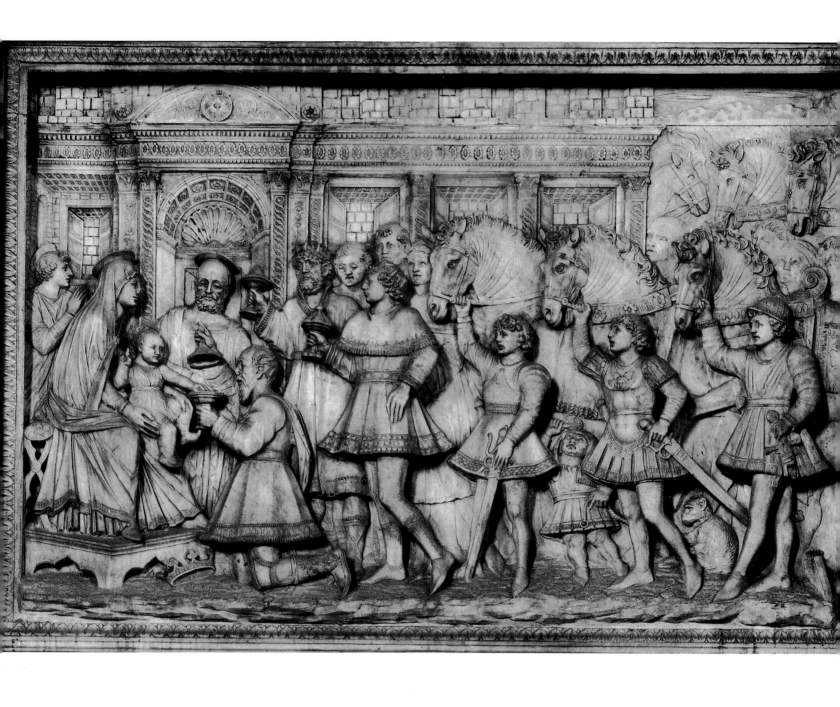

208, 209 Mino da Fiesole. Reliefs from the former ciborium over the High Altar.
c. 1461–63. Santa Maria Maggiore, Rome
208 *Adoration of the Magi*
209 ABOVE: *The Assumption of the Virgin*; BELOW: *Miracle of the Snow*

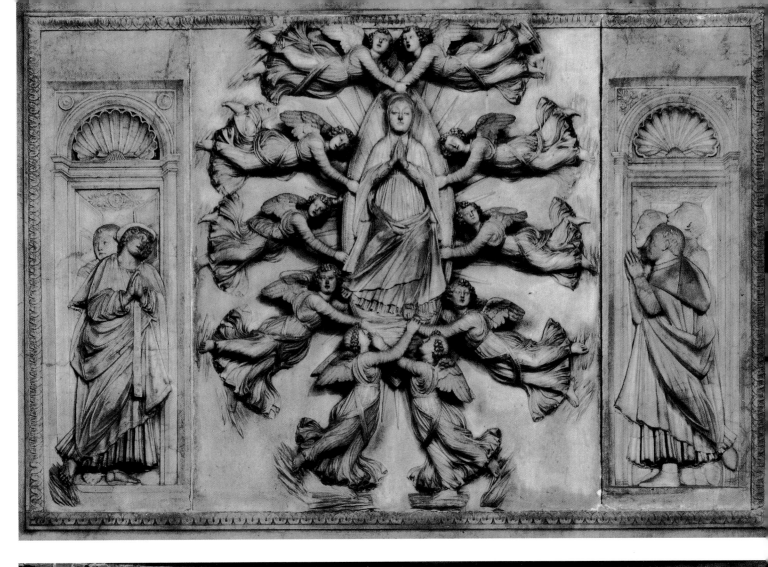

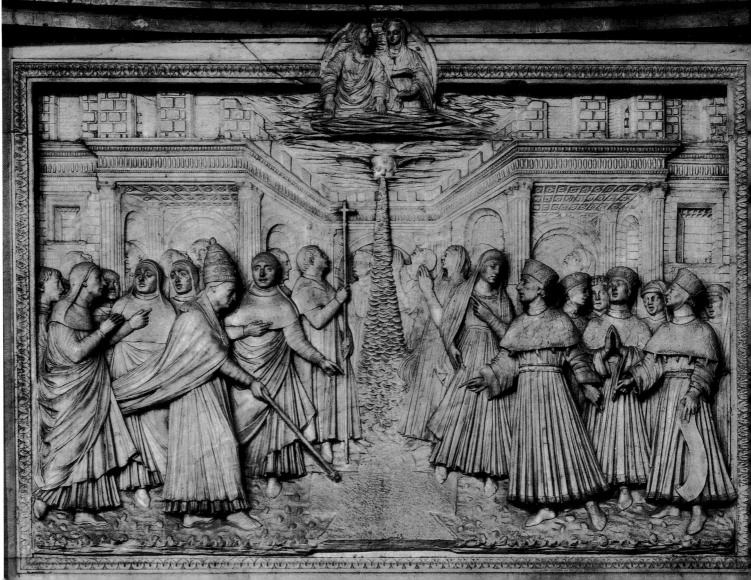

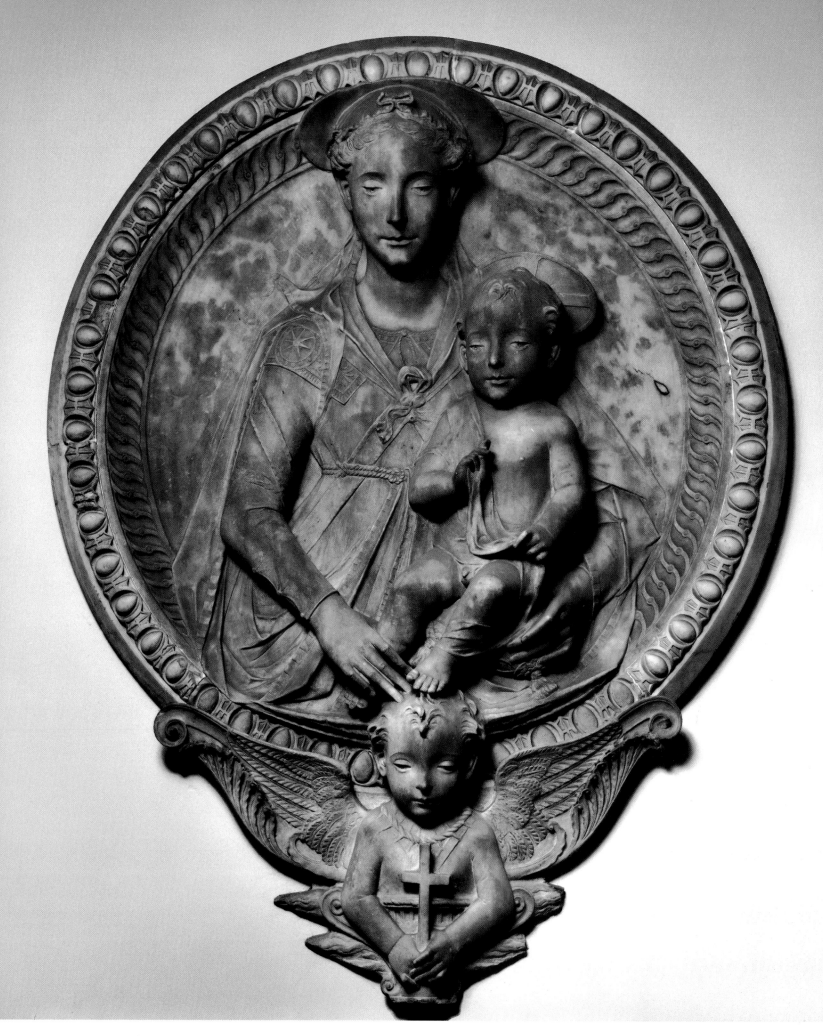

210 Mino da Fiesole. *Madonna and Child.* c. 1470–75. Museo Nazionale del Bargello, Florence

OPPOSITE:
211 Mino da Fiesole. *Charity,* from the Tomb of Pope Paul II. c. 1475–77. St. Peter's, Rome (now in the Fabbrica di San Pietro)

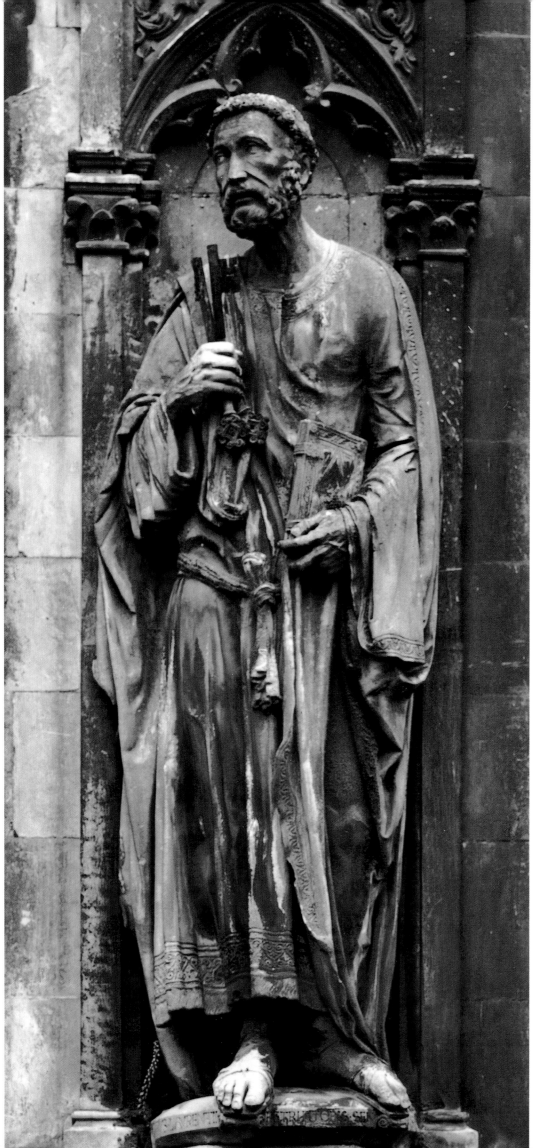

212 Vecchietta. *St. Peter*. 1460–62.
Loggia della Mercatanzia, Siena

OPPOSITE:
213 Vecchietta. *The Resurrected
Christ*. 1467–72. High Altar
Ciborium, Duomo, Siena

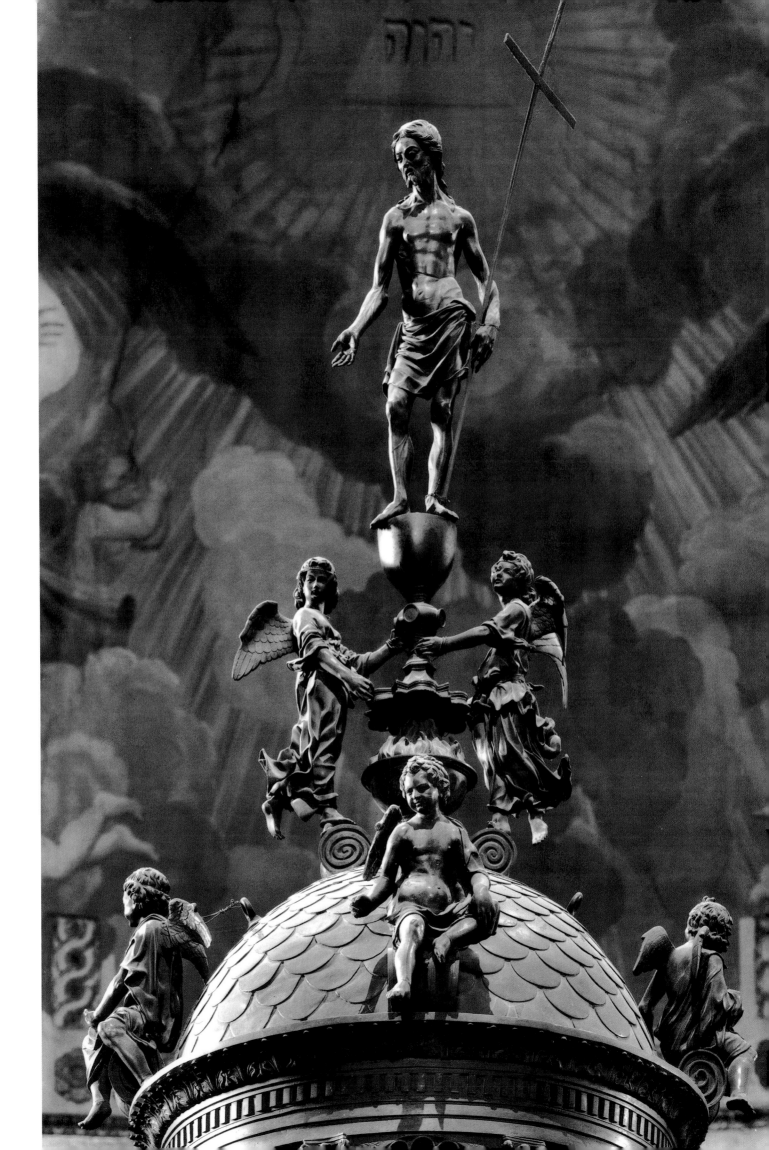

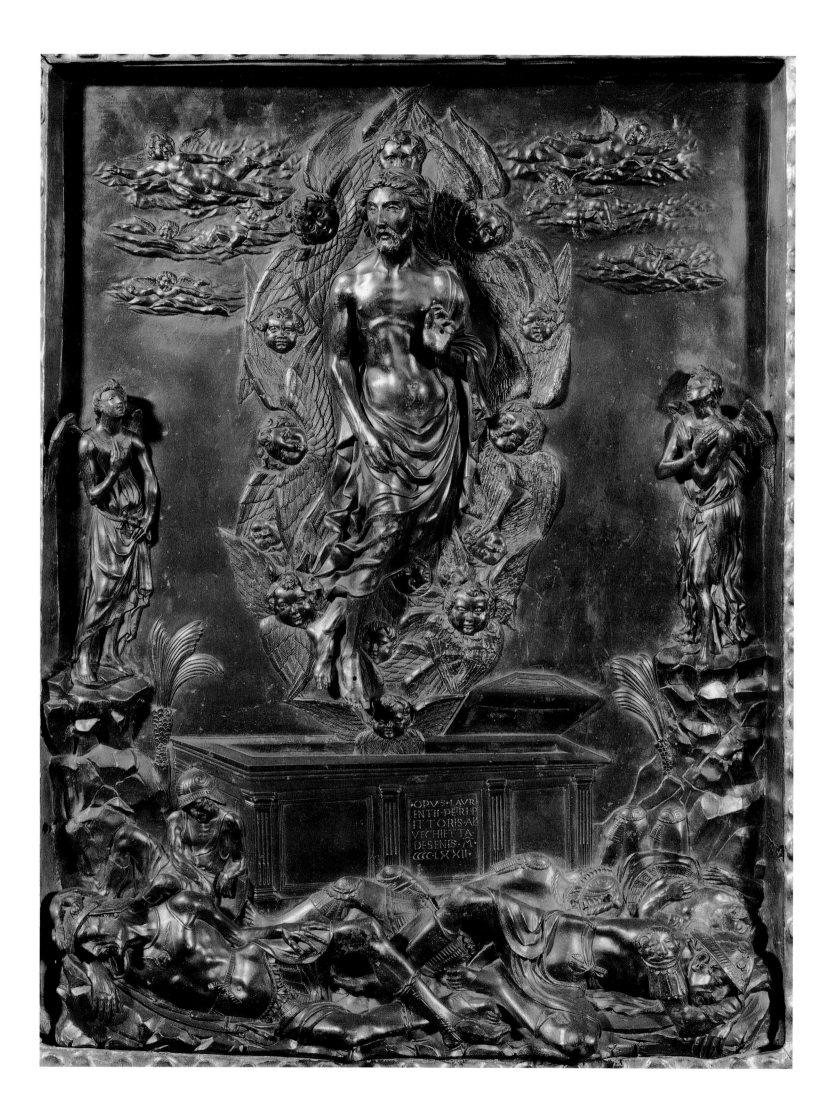

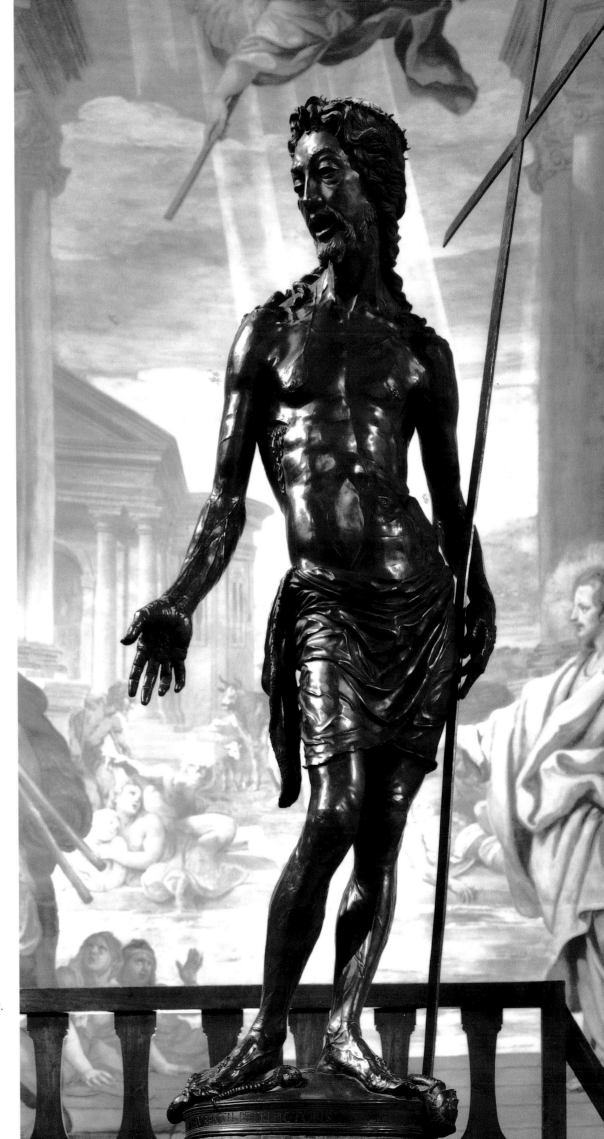

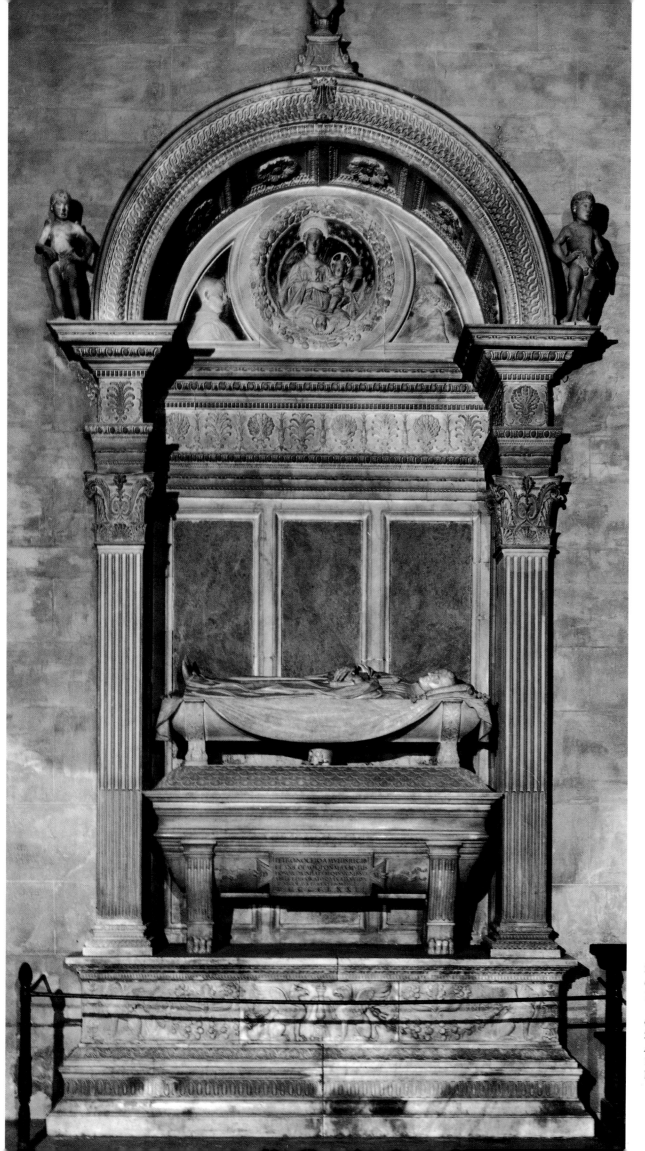

216 Civitali. Tomb
of Pietro da Noceto.
1472. Duomo, Lucca

OPPOSITE:
217 Civitali.
Adoring Angel.
1473–77. Duomo,
Lucca

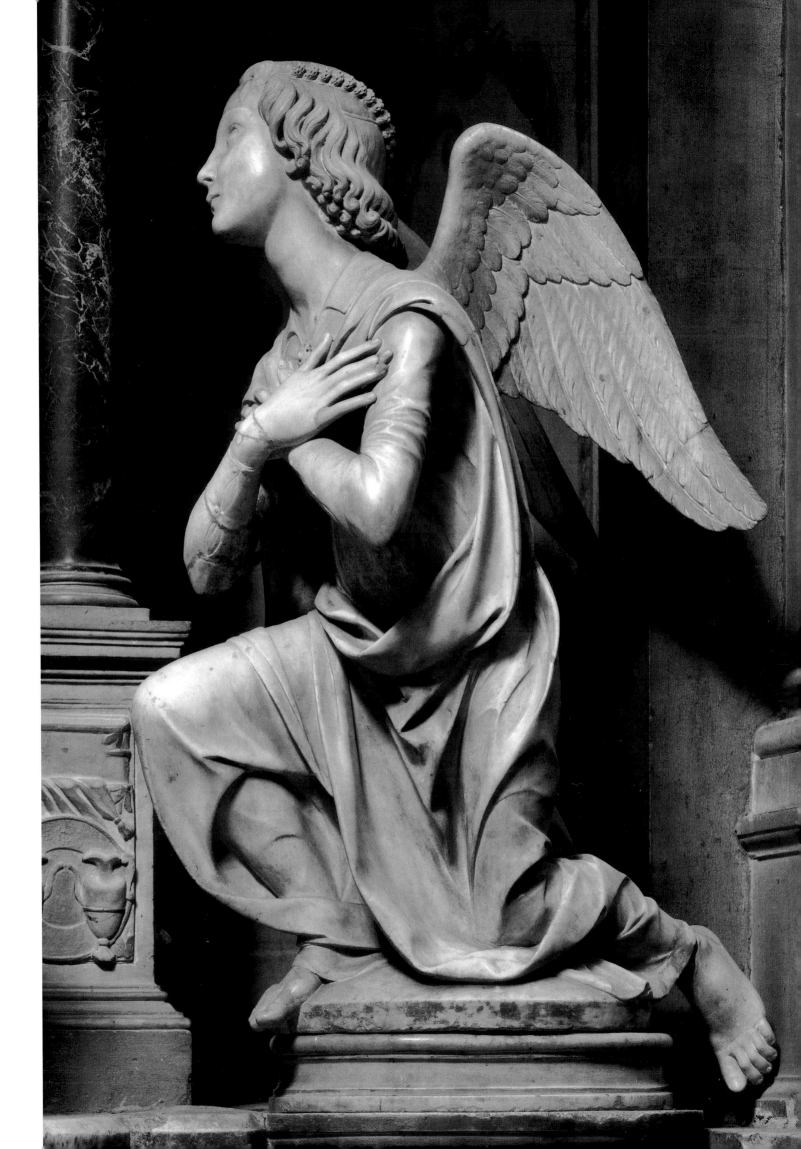

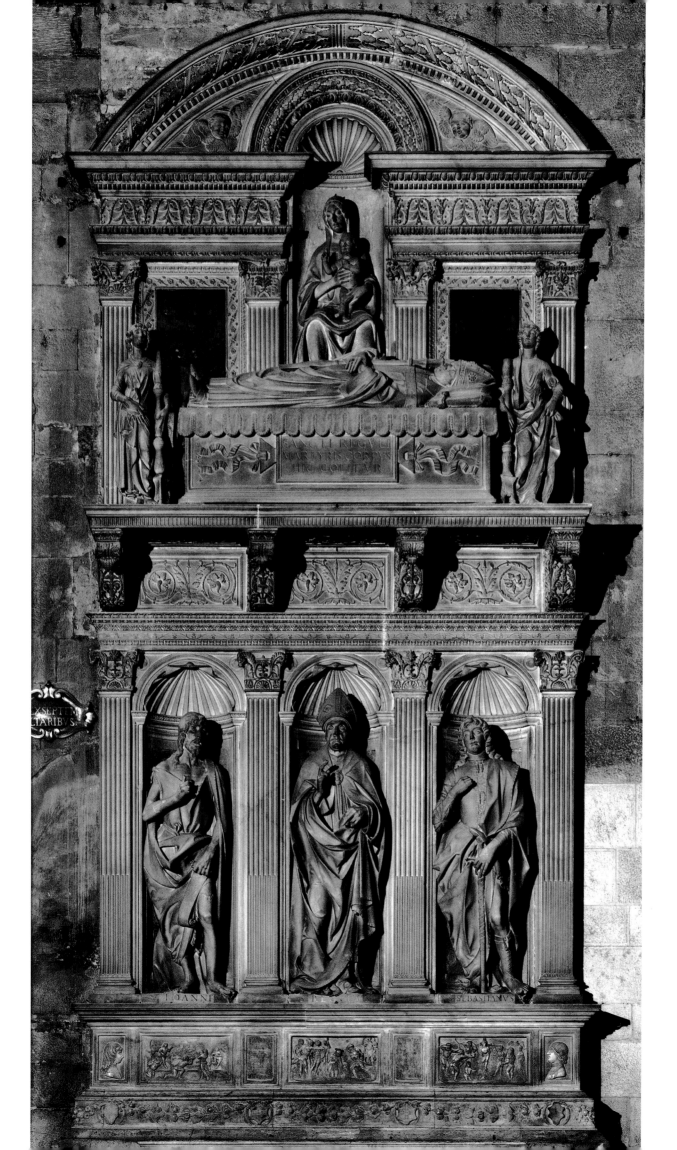

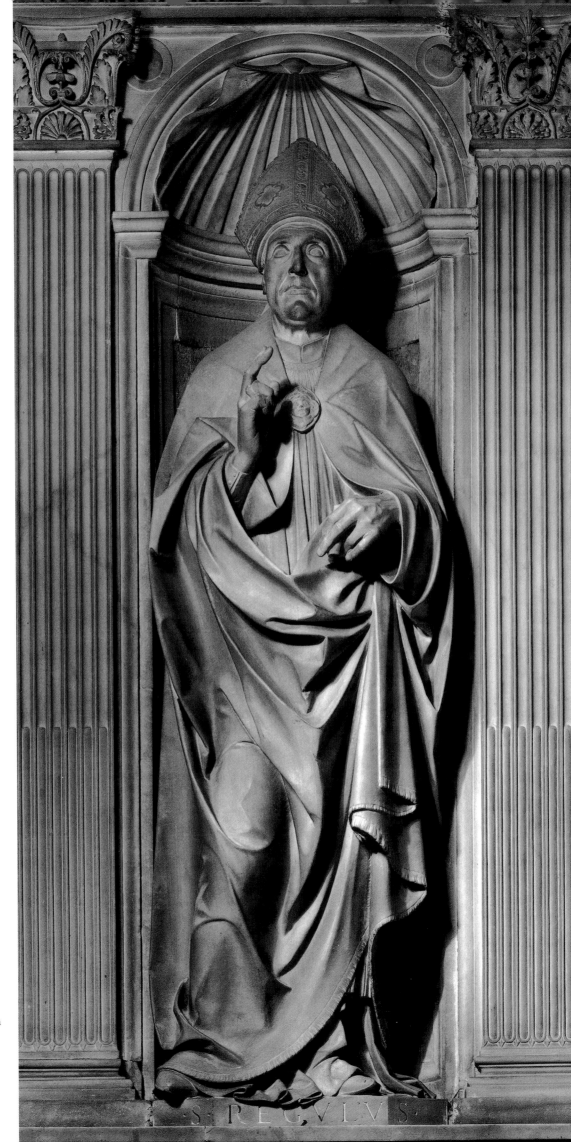

· S · R E G V L V S ·

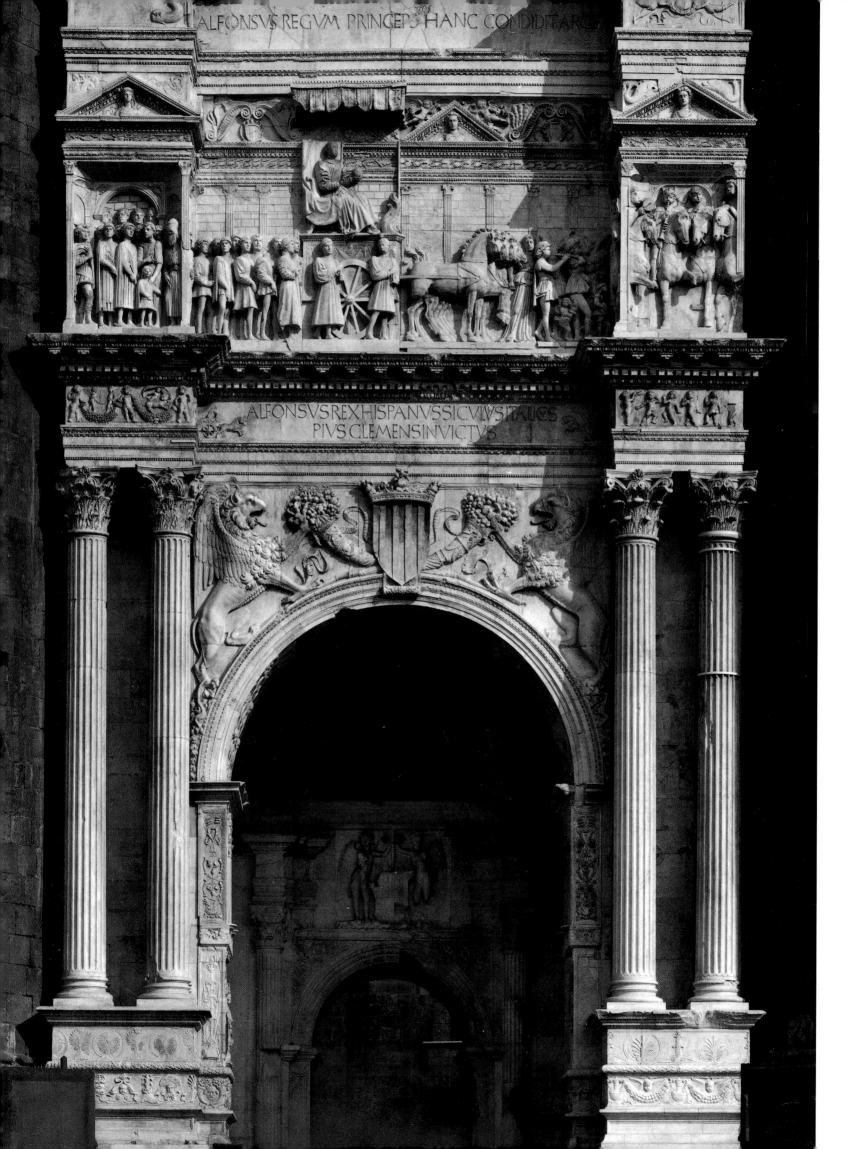

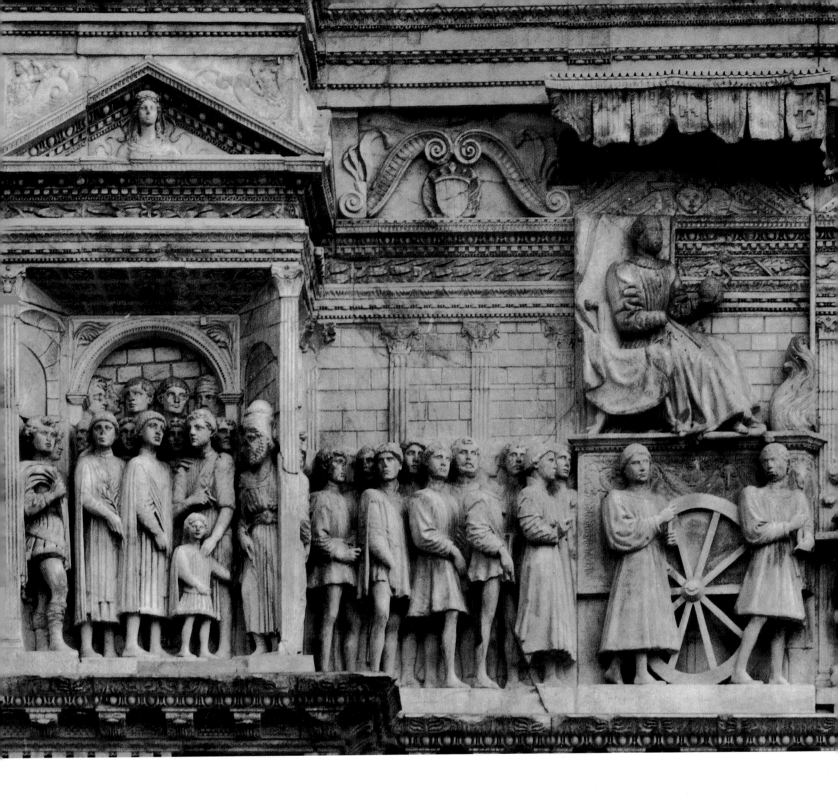

OPPOSITE AND ABOVE:
220, 221 Francesco Laurana et
al. Triumphal Arch of Alfonso I.
c. 1452–71. Castelnuovo, Naples

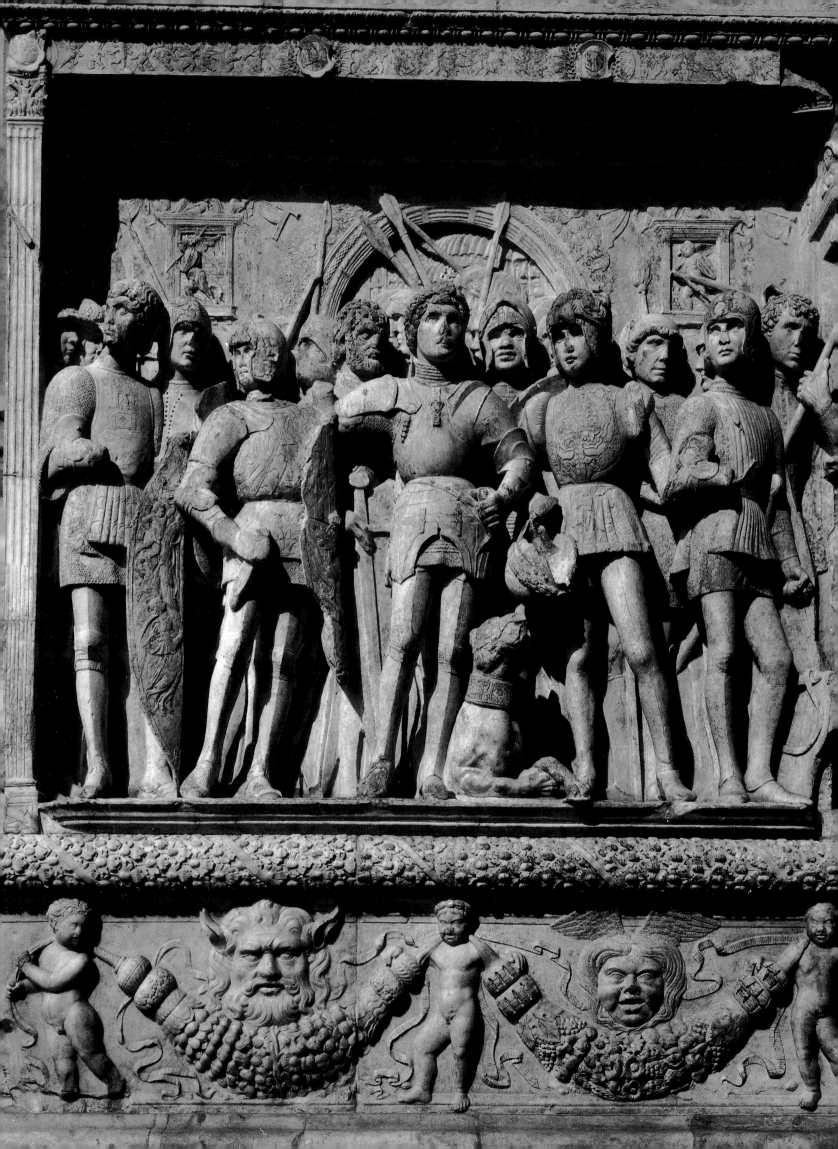

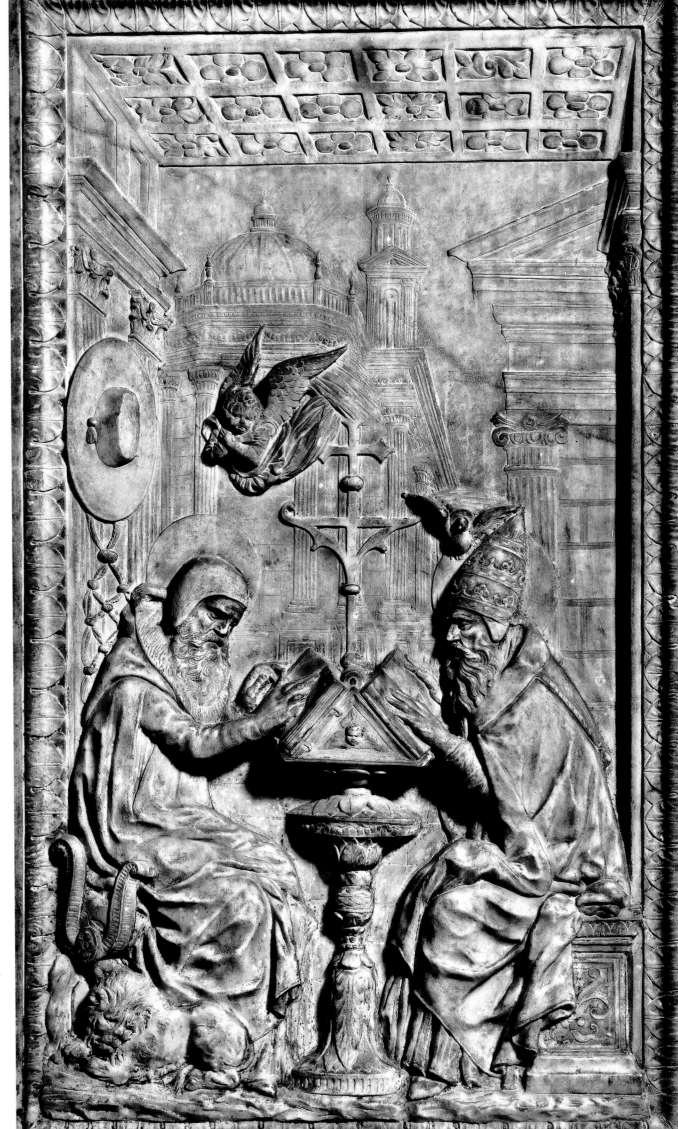

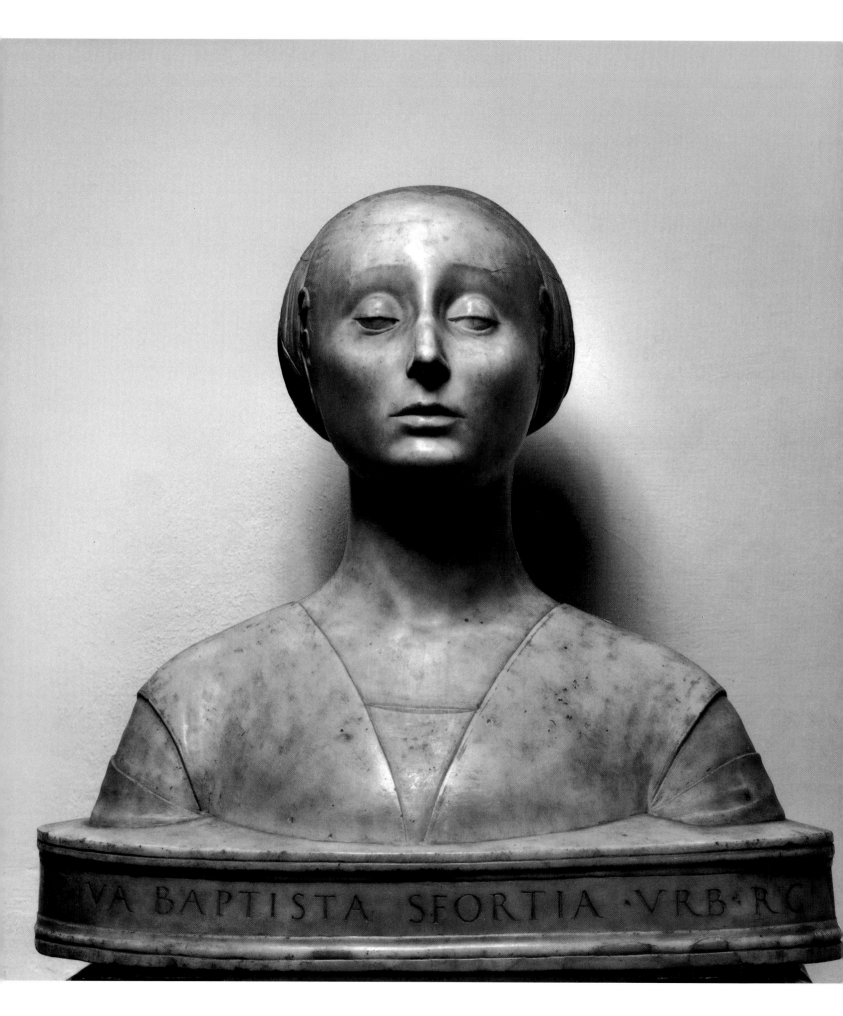

224 Francesco Laurana. *Bust of Battista Sforza*. c. 1475. Museo Nazionale del Bargello, Florence

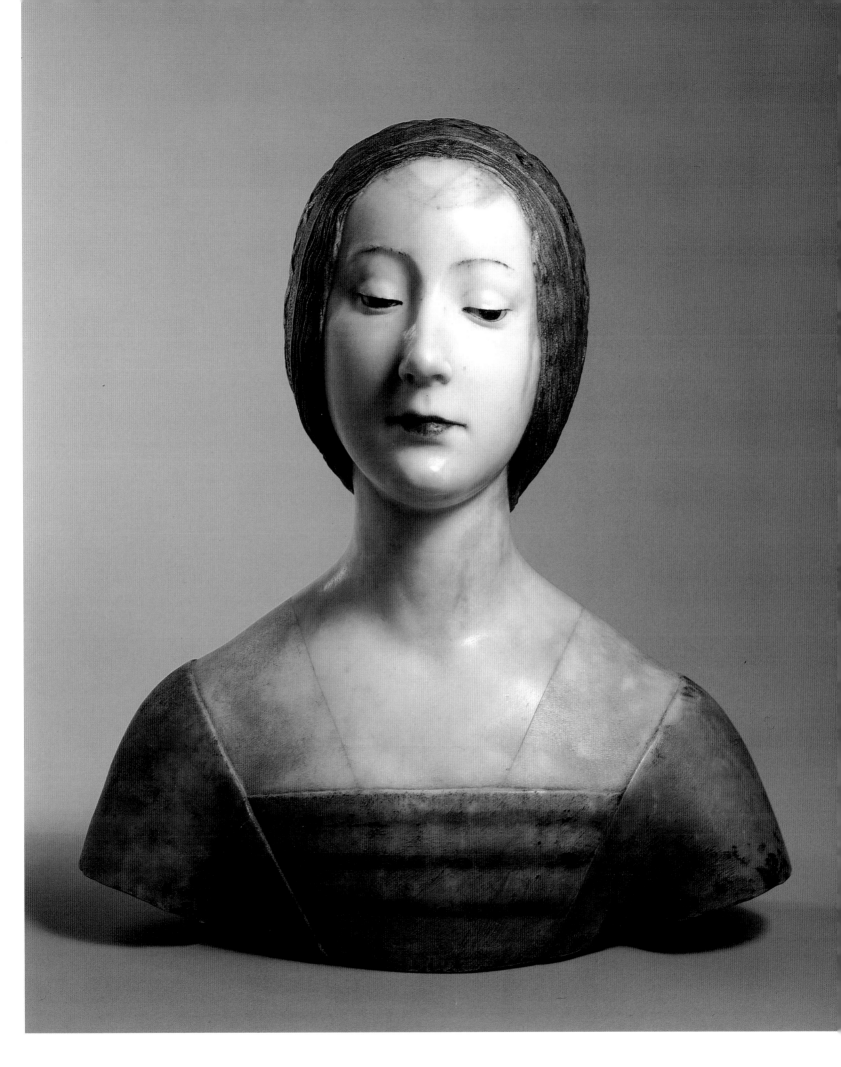

225 Francesco Laurana. *Bust of Isabella of Aragon (?).* c. 1490. Kunsthistorisches Museum, Vienna

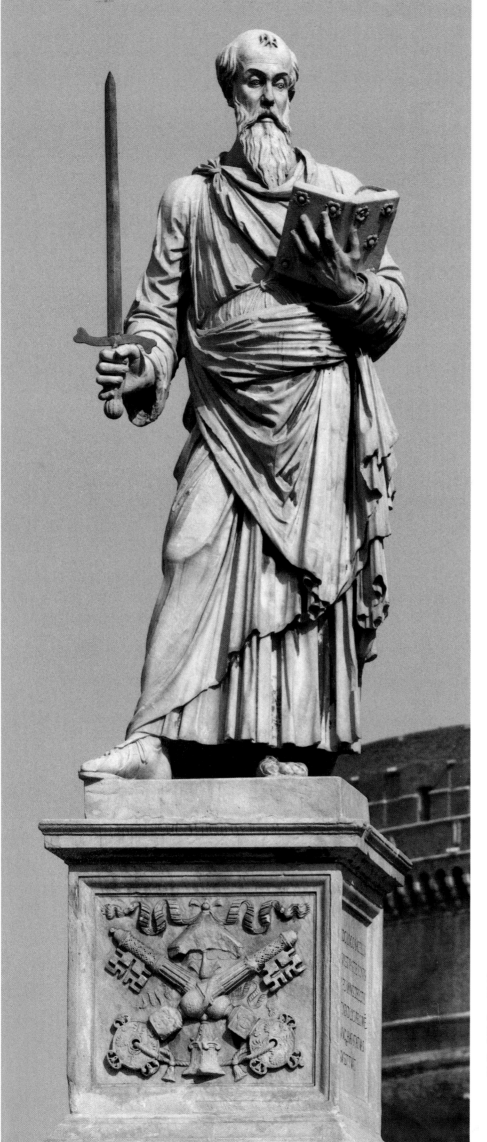

226 Paolo Romano. *St. Paul*. 1463–64.
Ponte Sant'Angelo, Rome

OPPOSITE:
227 Giovanni Dalmata. *Hope*, from the
Tomb of Pope Paul II. c. 1475–77.
St. Peter's, Rome (now in the Fabbrica di San
Pietro)

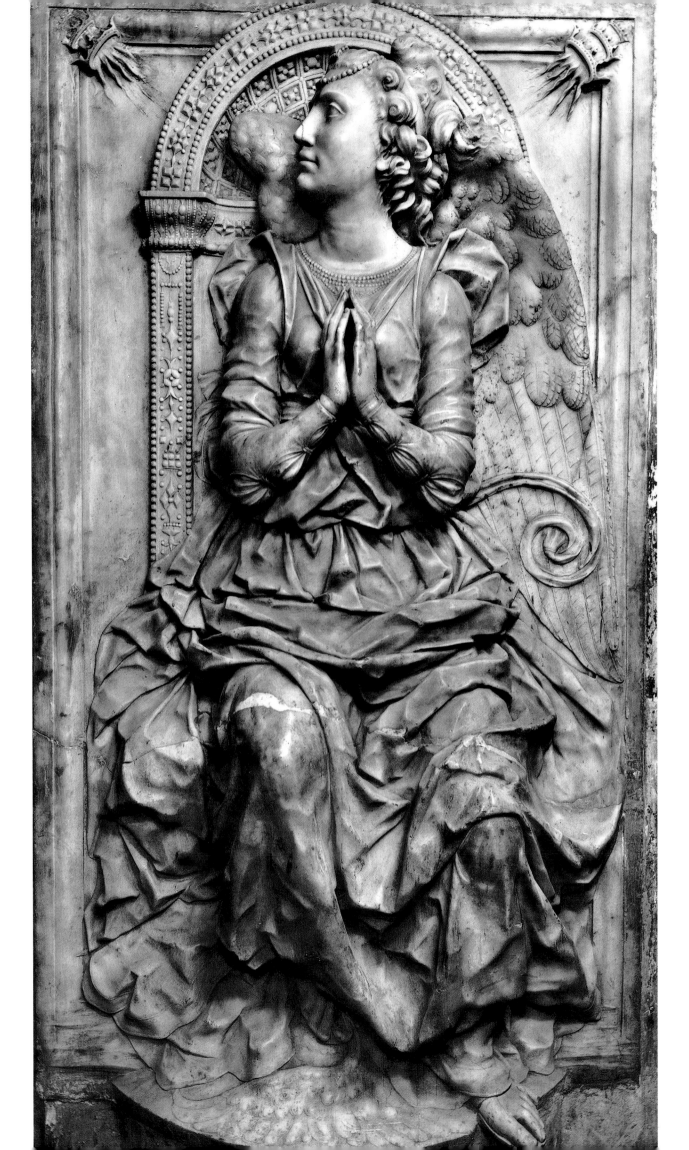

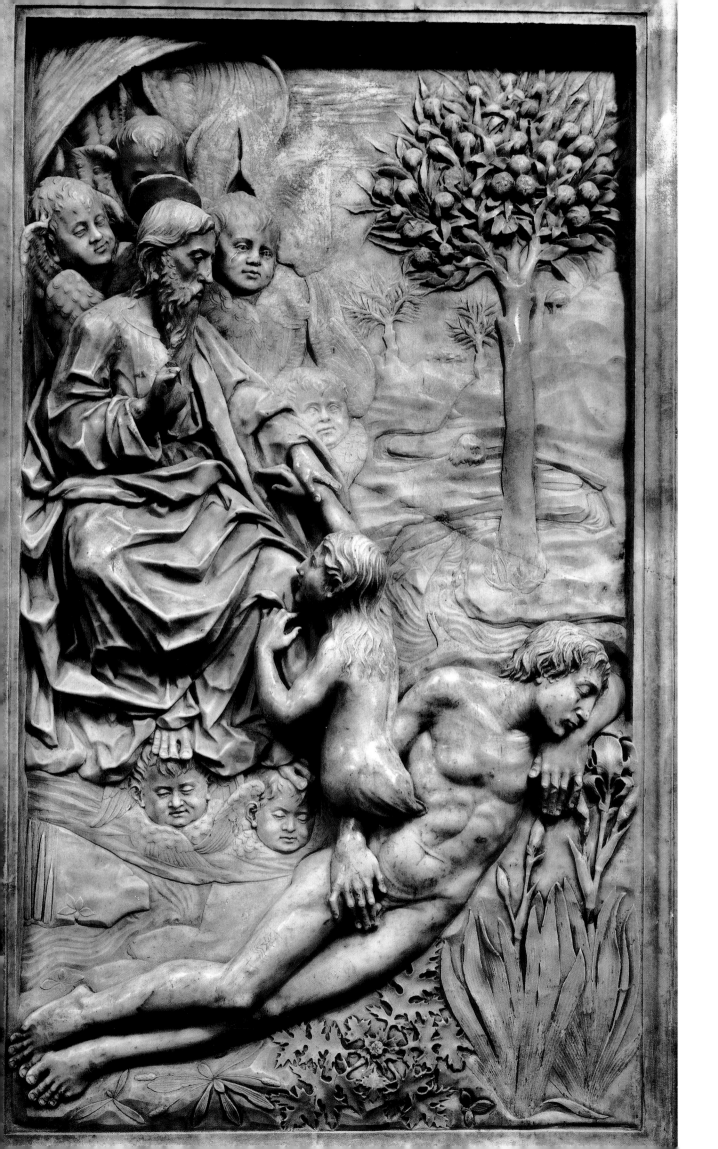

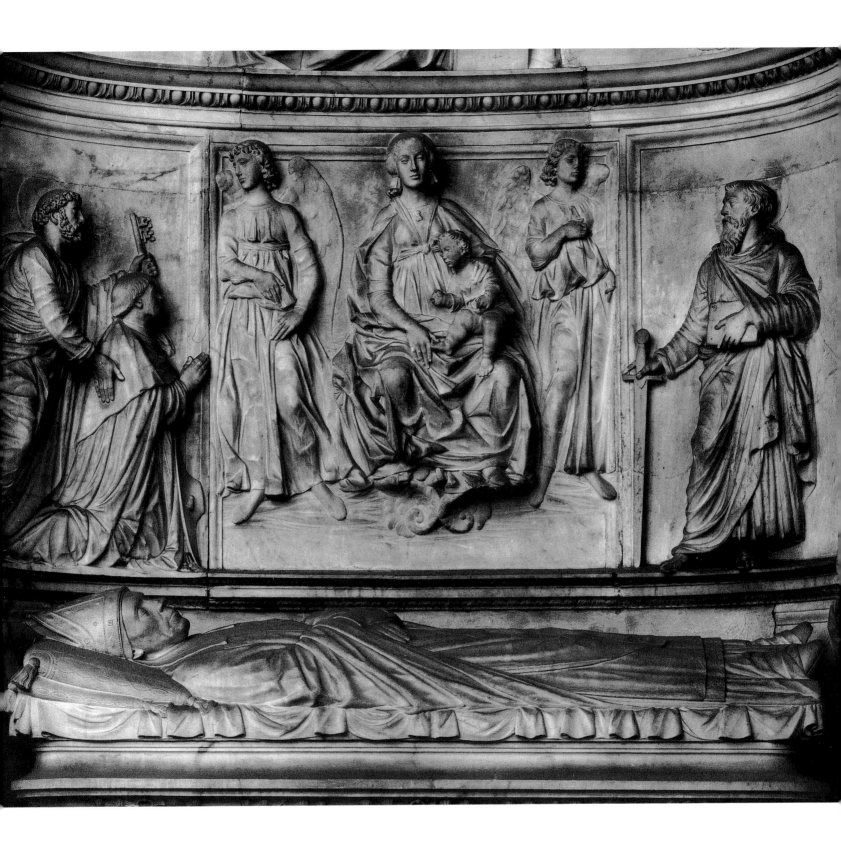

OPPOSITE:
228 Giovanni Dalmata. *Creation of Eve*, from the Tomb of Pope Paul II. c. 1475–77. St. Peter's, Rome (now in the Fabbrica di San Pietro)

ABOVE:
229 Giovanni Dalmata and Andrea Bregno. Tomb of Cardinal Roverella (detail). After 1476. San Clemente, Rome

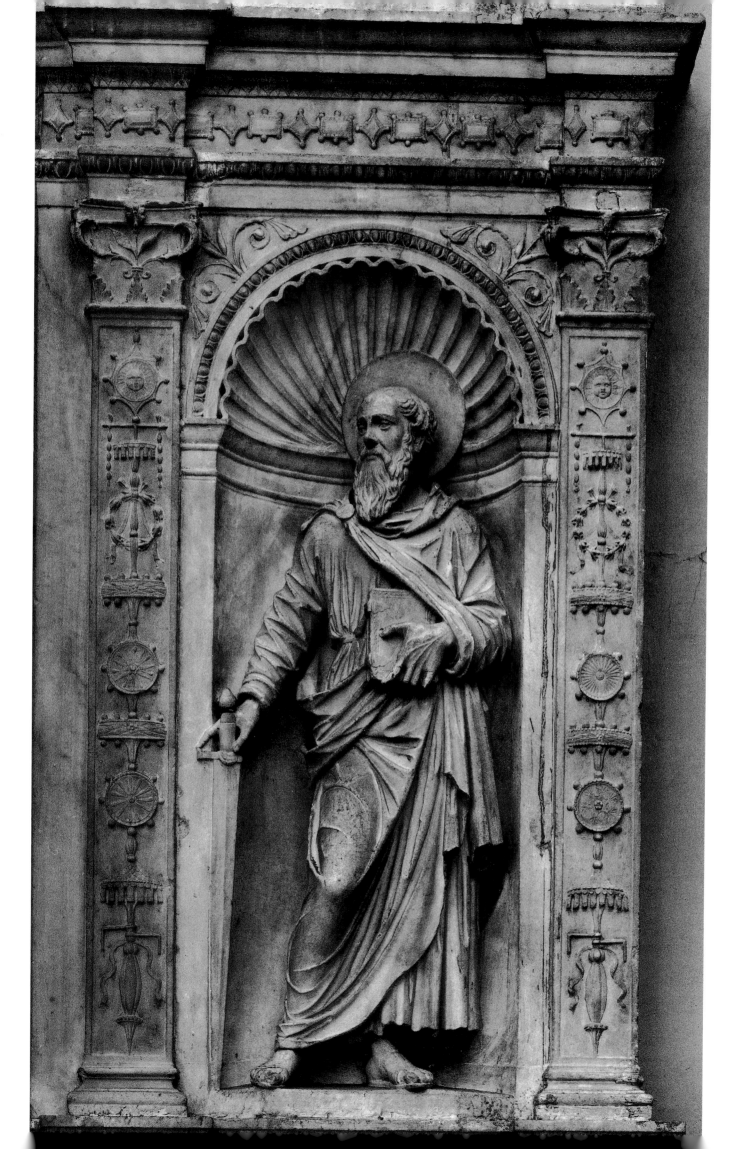

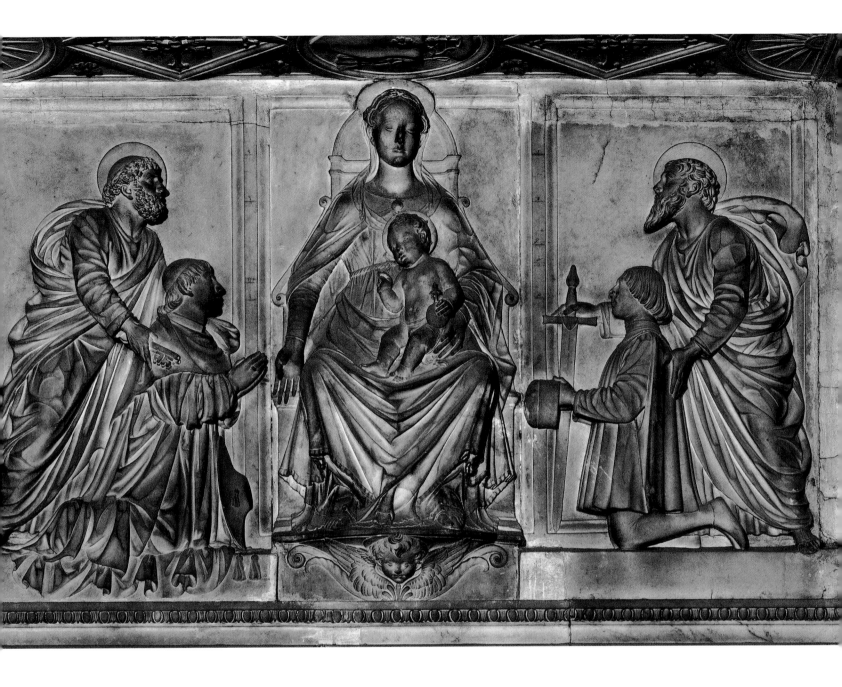

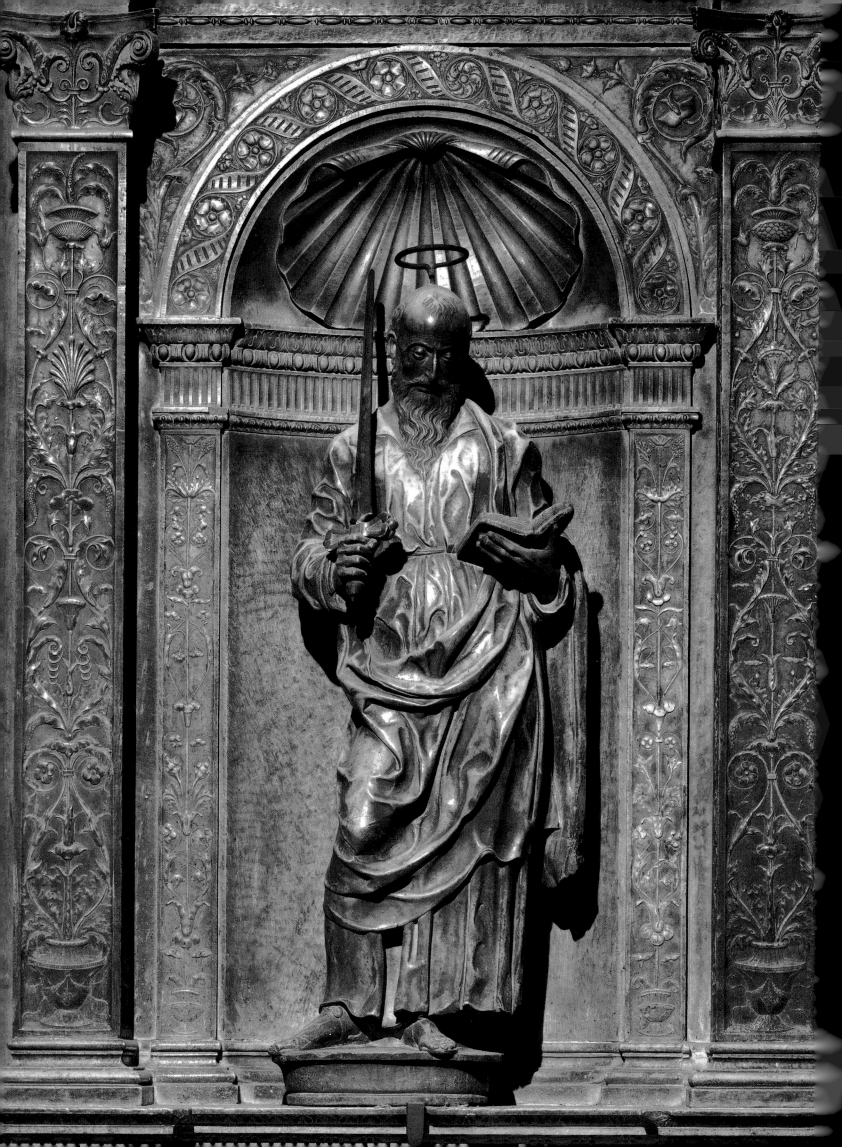

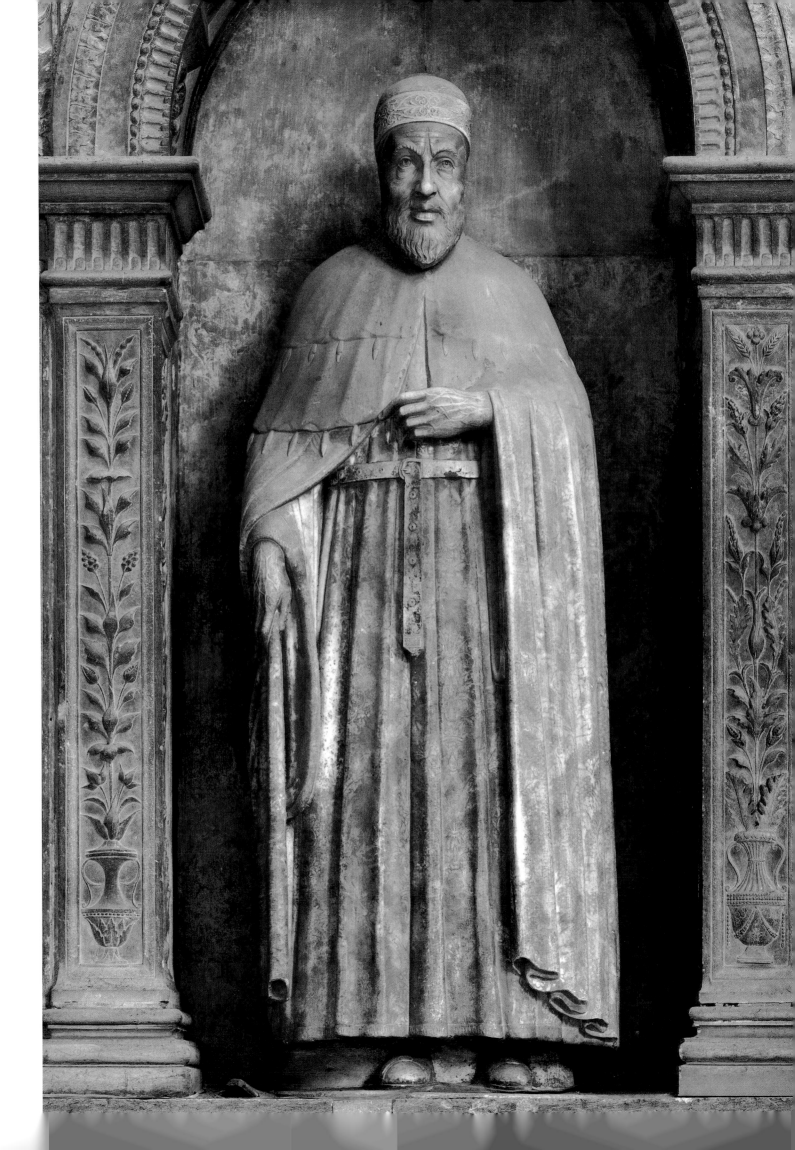

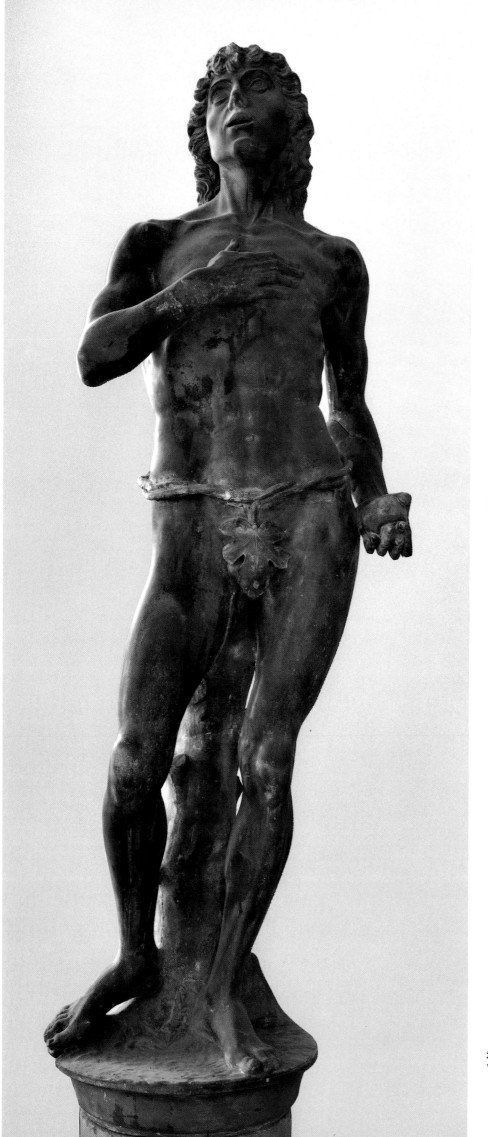

234 Rizzo. *Adam.* c. 1483. Palazzo Ducale,
Venice

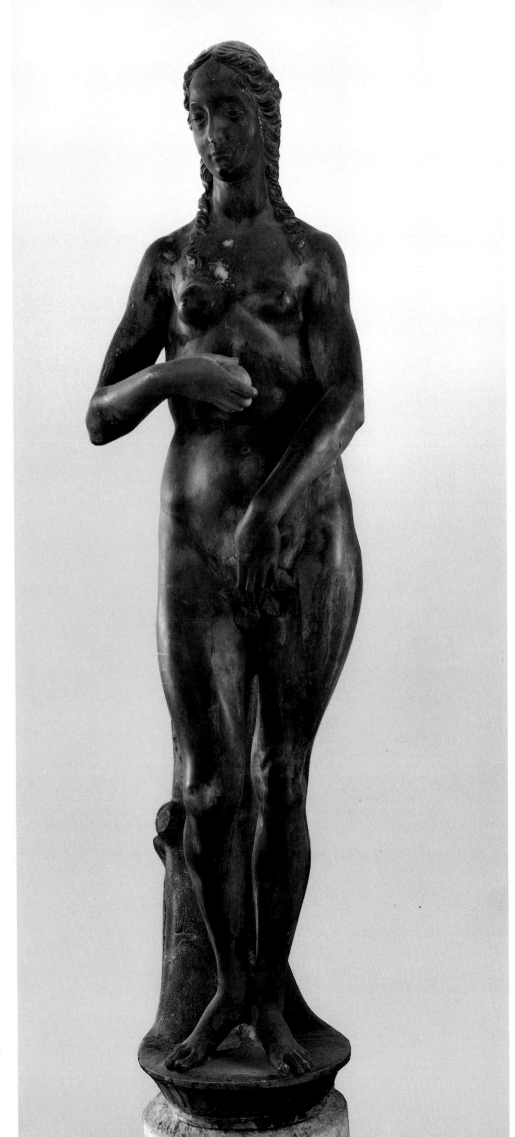

235 Rizzo. *Eve.* c. 1483. Palazzo Ducale, Venice

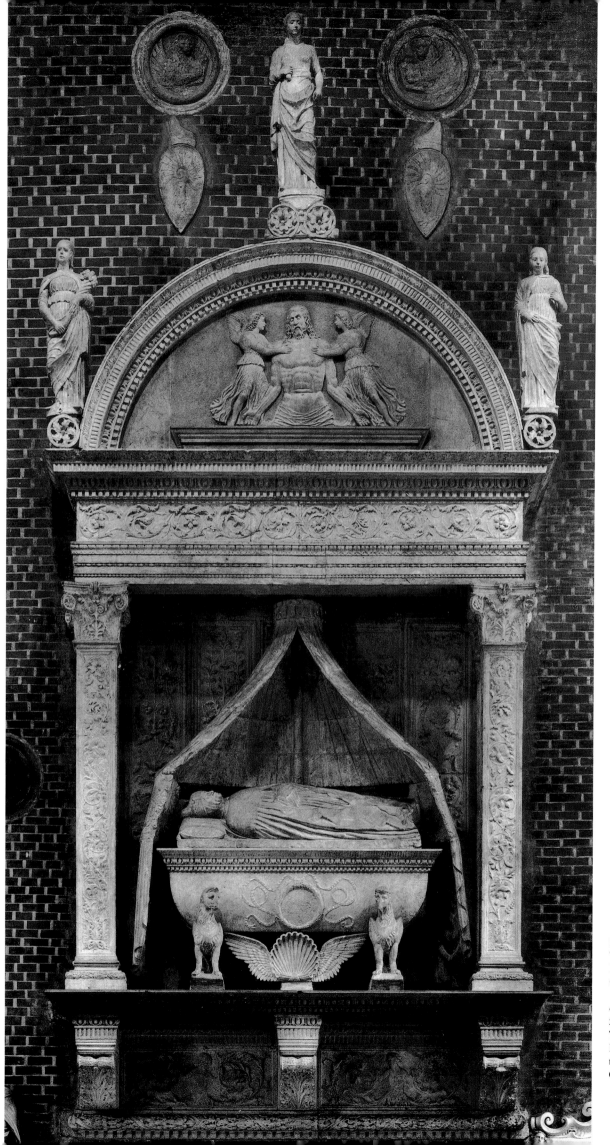

236 Pietro Lombardo.
Tomb of Doge Pasquale
Malipiero. c. 1470. Santi
Giovanni e Paolo, Venice

OPPOSITE:
237 Pietro Lombardo.
Tomb of Doge Pietro
Mocenigo (detail: statue of
the Doge). 1476–81. Santi
Giovanni e Paolo, Venice

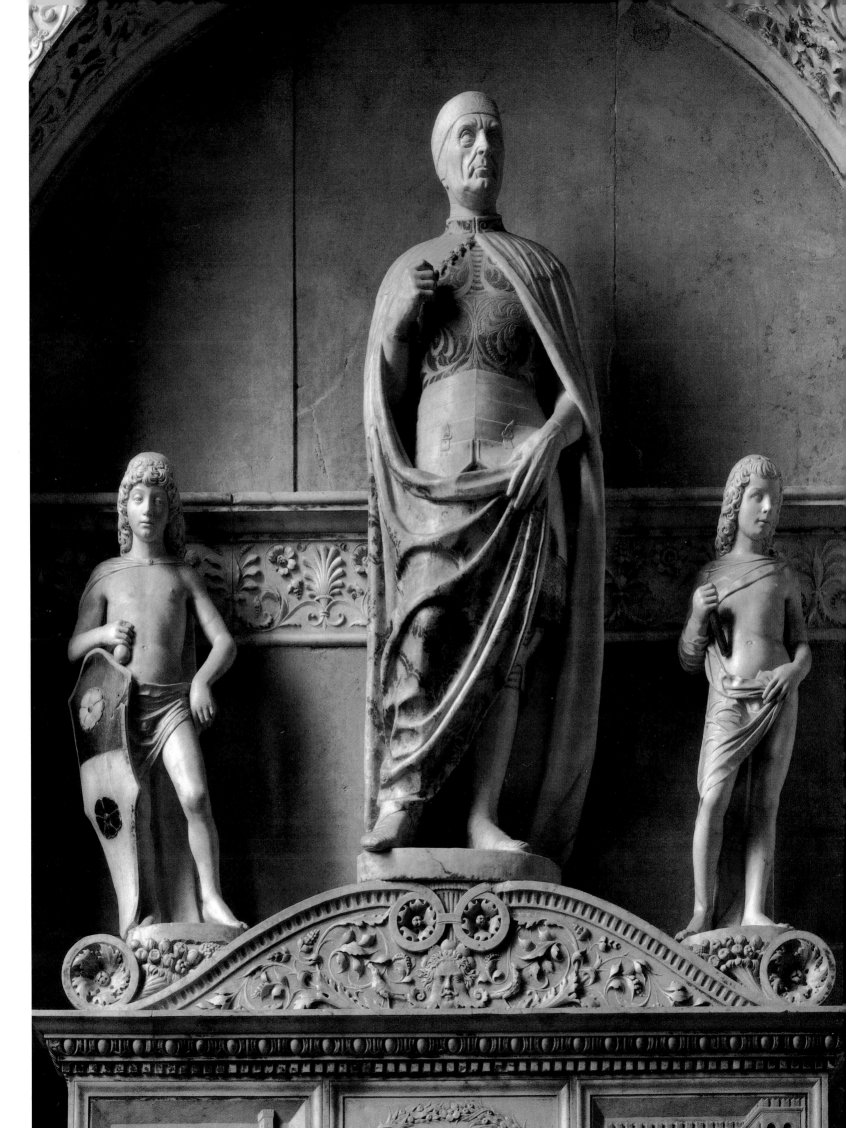

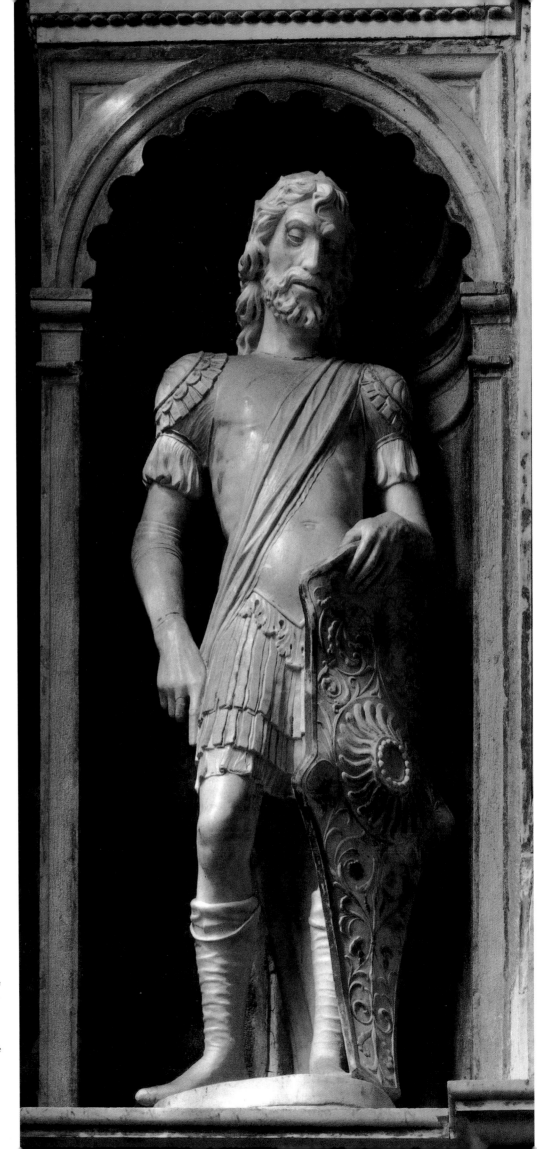

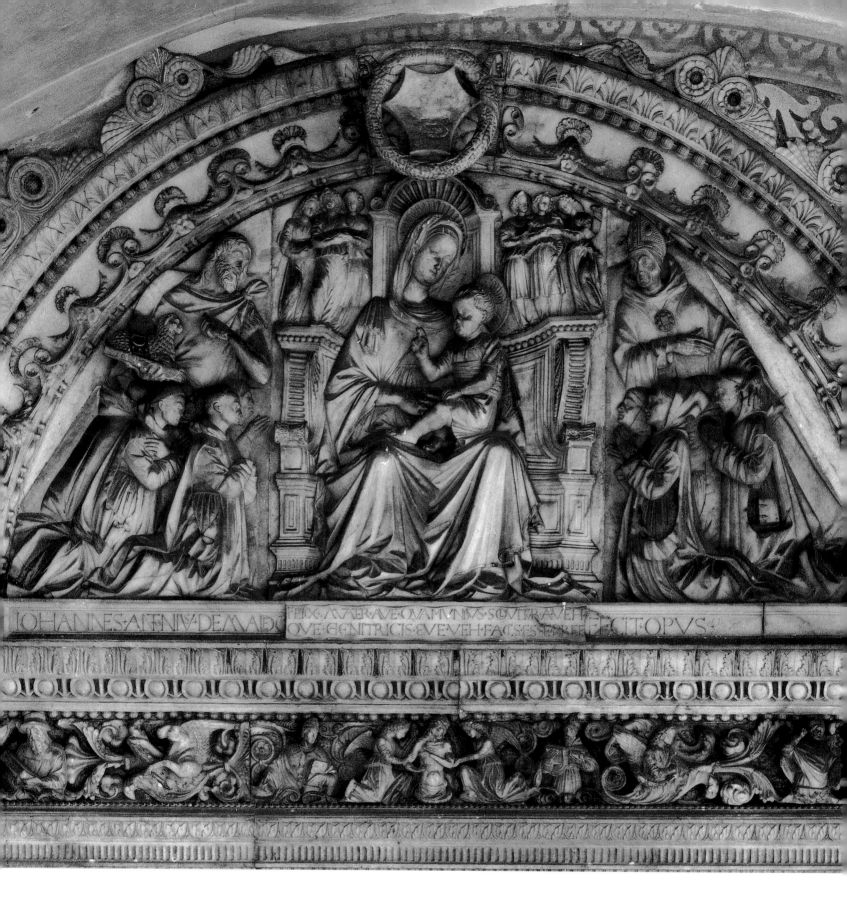

240 Amadeo. *Madonna and Child Enthroned.* c. 1467. Front Cloisters, Certosa di Pavia

241 Amadeo. Tomb of Medea Colleoni. c. 1470–75. Colleoni Chapel, Bergamo

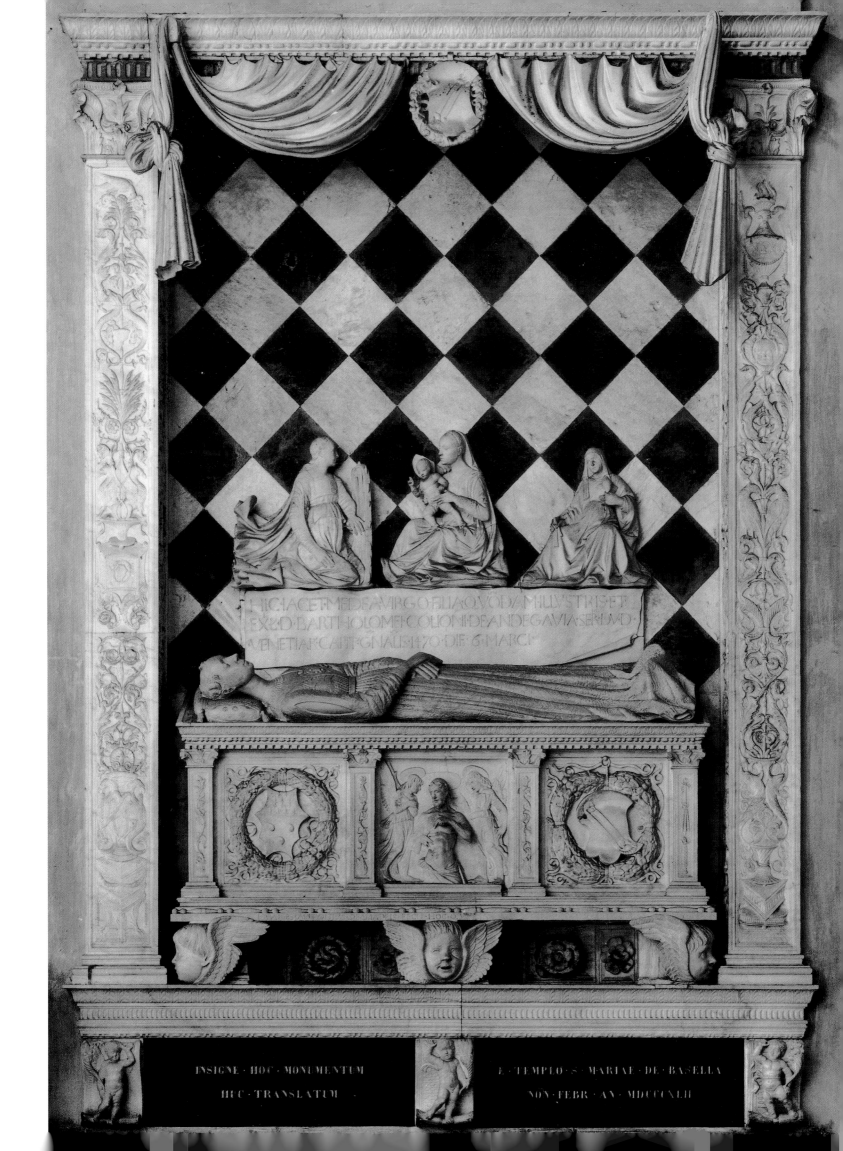

HIC IACET MEDEA VIRGO ELIA QVODAM ILLVSTRIS ET
EXED BARTHOLOMEI COLIONI DE ANDEGAVIA SERDMD
VENETIAR CAP GNALIS 1470 DIE 6 MARCI

INSIGNE · HOC · MONUMENTUM E · TEMPLO · S · MARIAE · DE · BASELLA

HUC · TRANSLATUM NON · FEBR · AN · MDCCCXLII

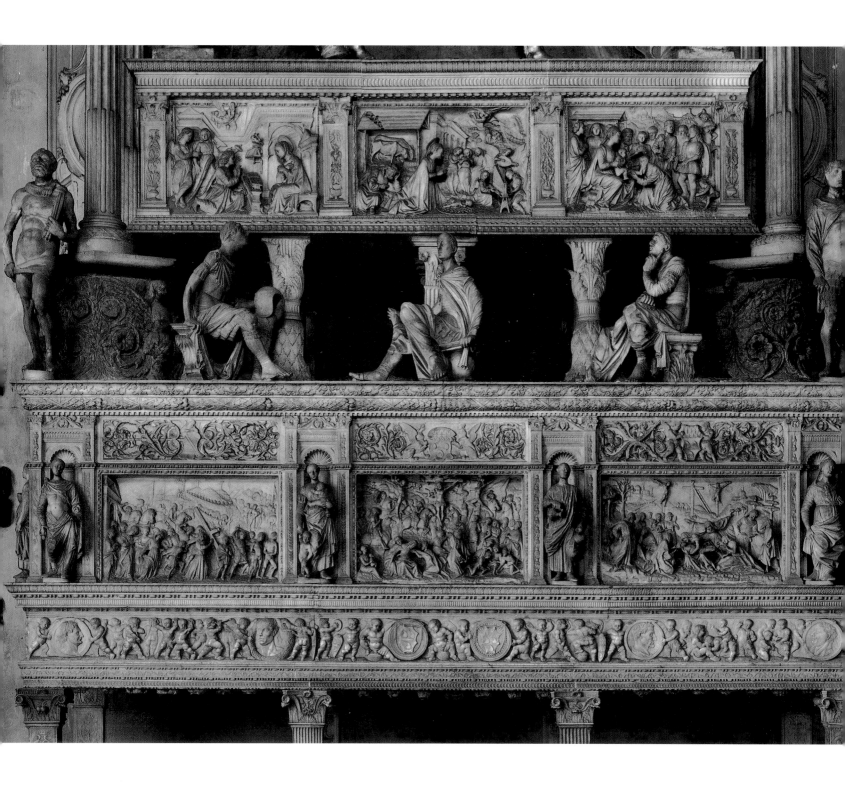

242 Amadeo. Tomb of Bartolommeo Colleoni. c. 1470–76. Colleoni Chapel, Bergamo

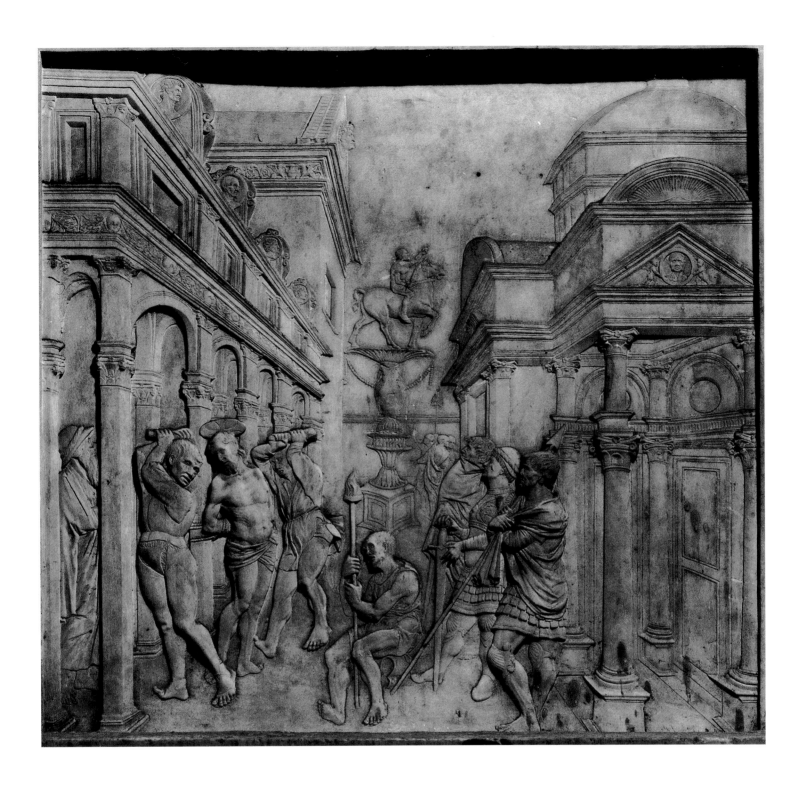

243 Amadeo. Tomb of Bartolommeo Colleoni (detail: Flagellation of Christ). c. 1470–6. Colleoni
Chapel, Bergamo

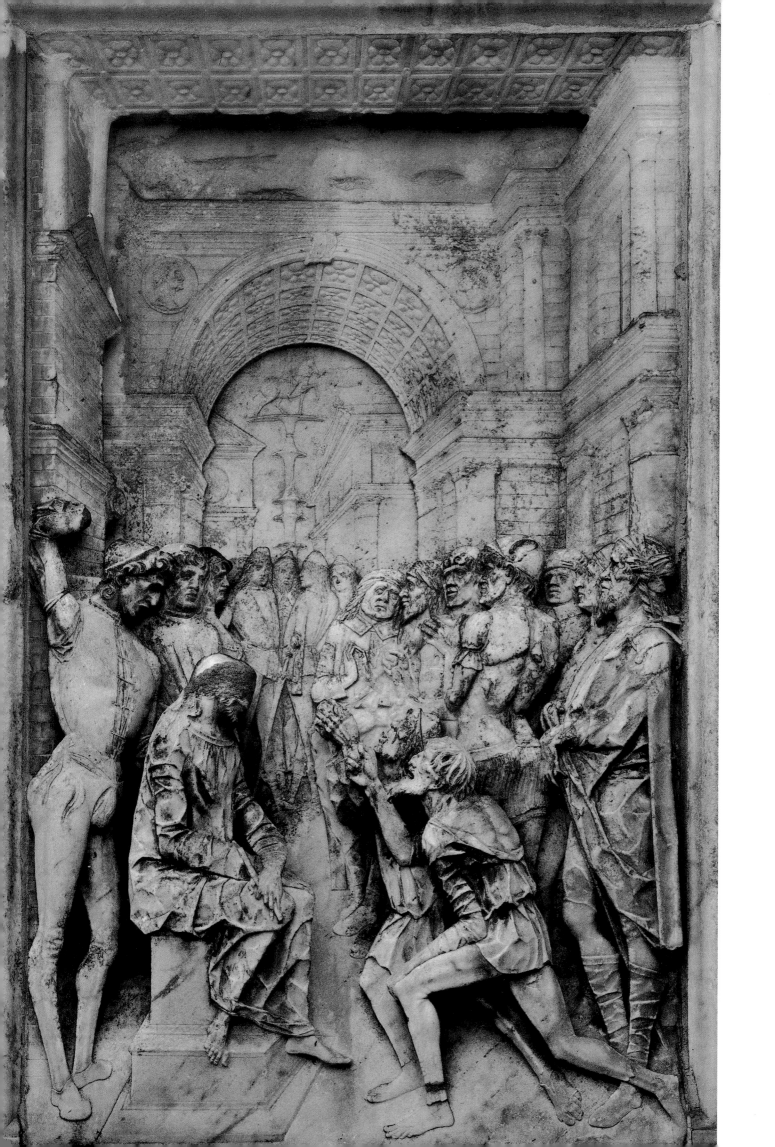

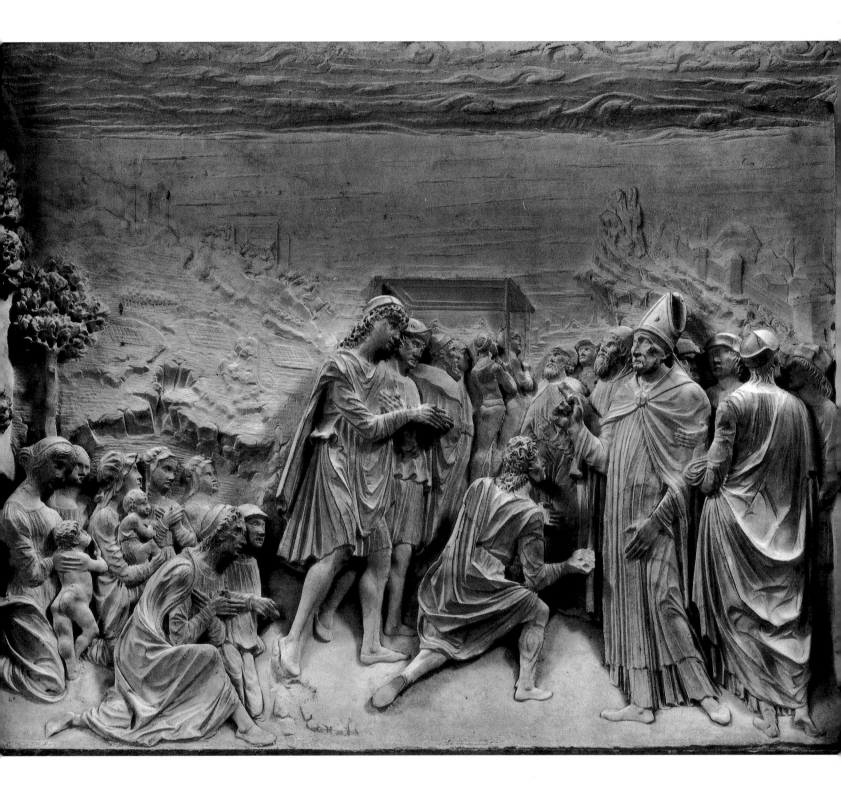

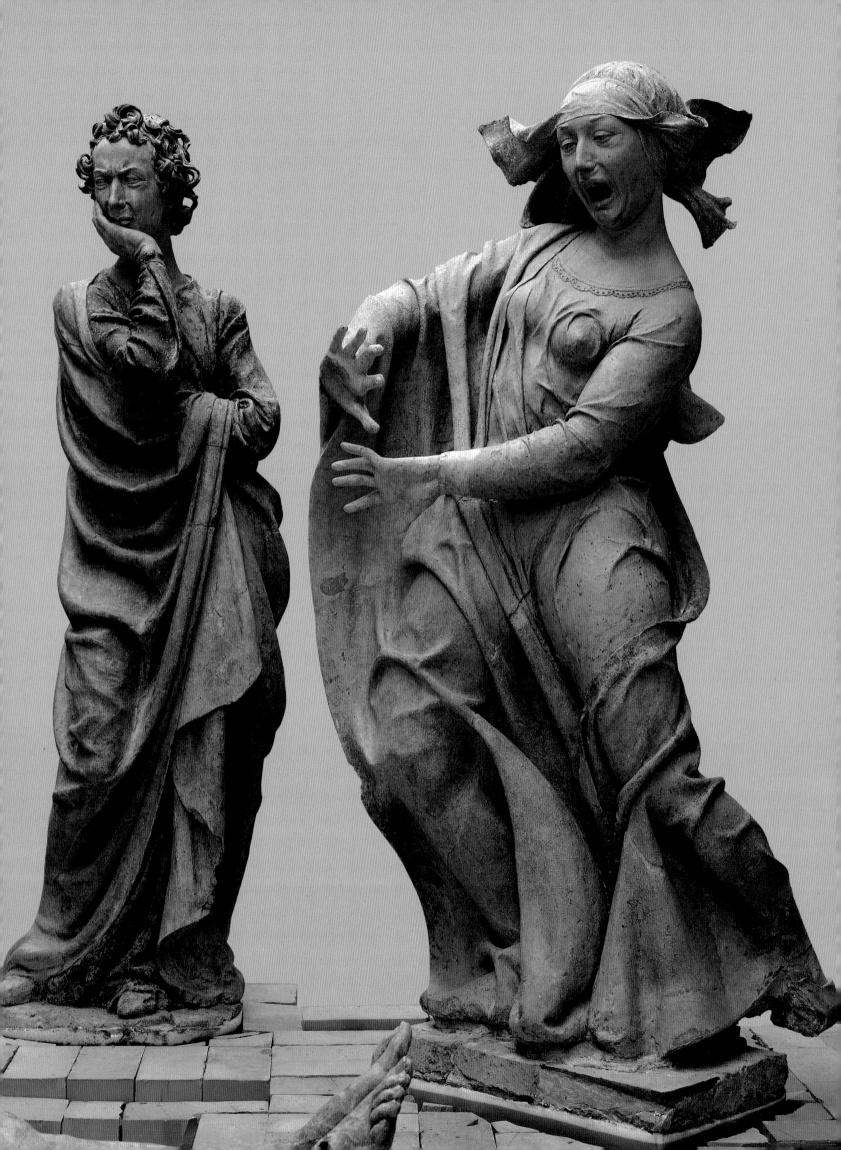

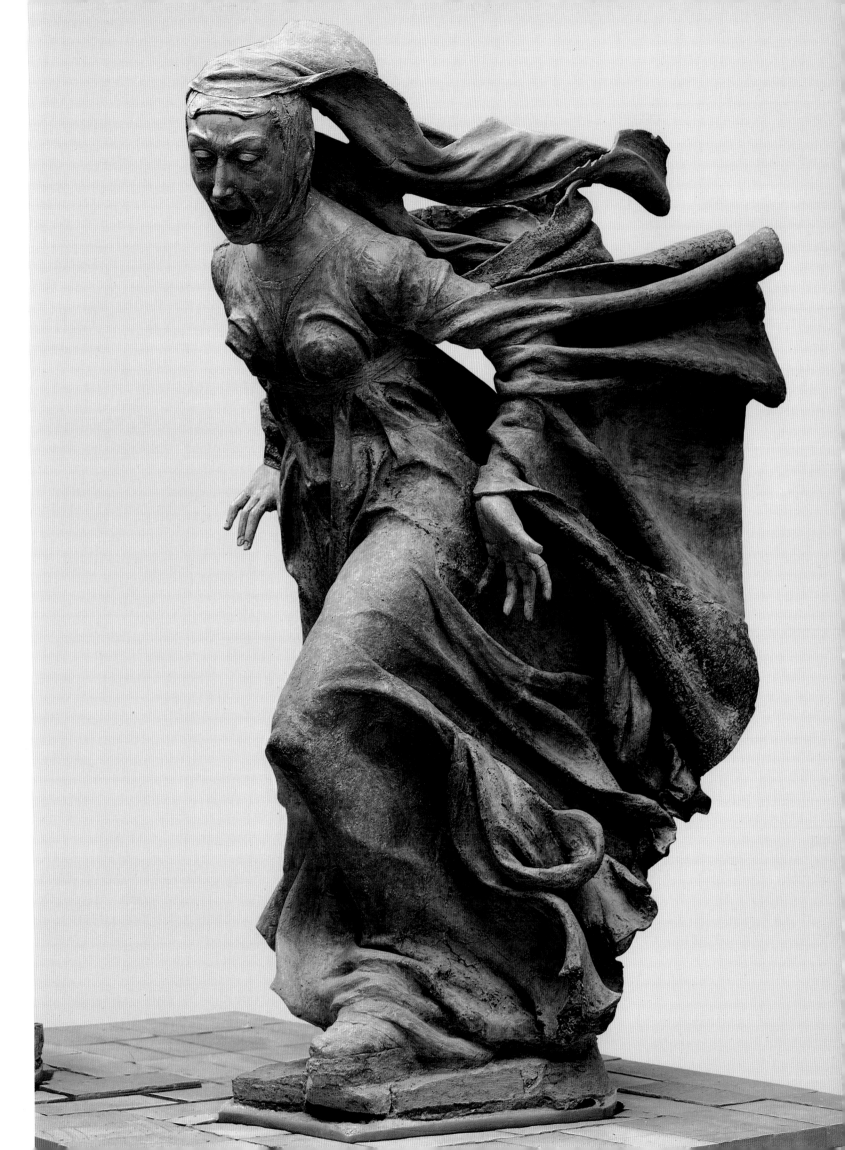

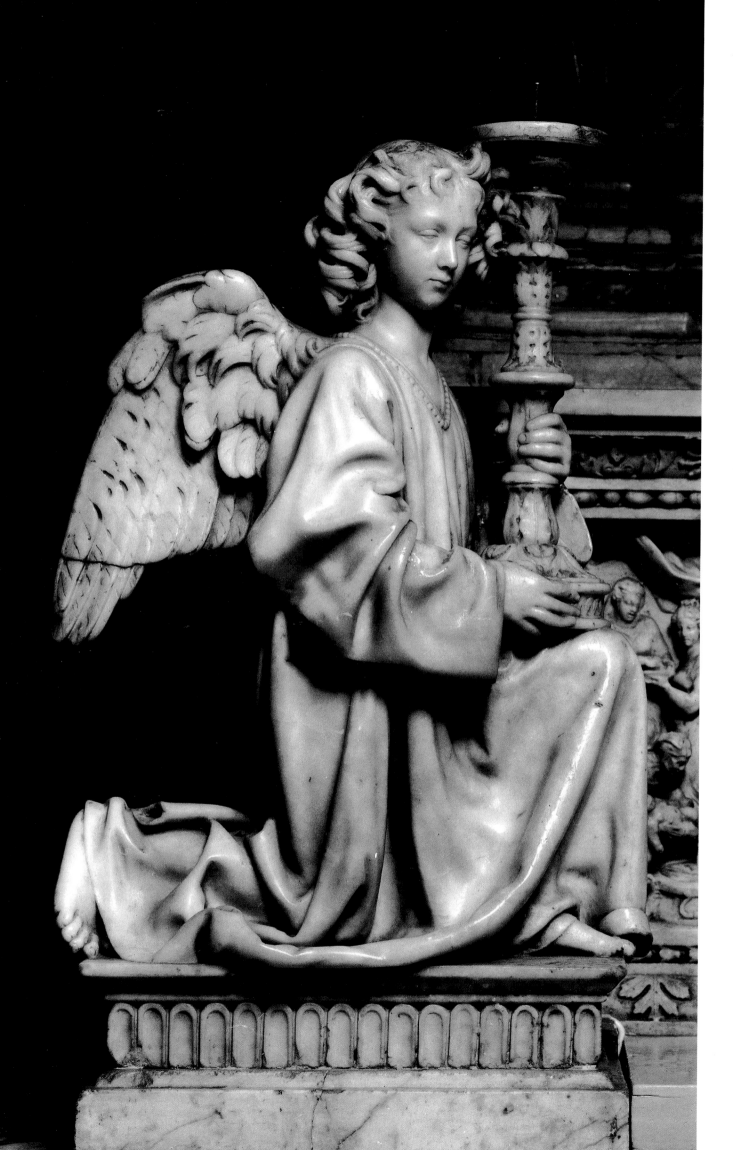

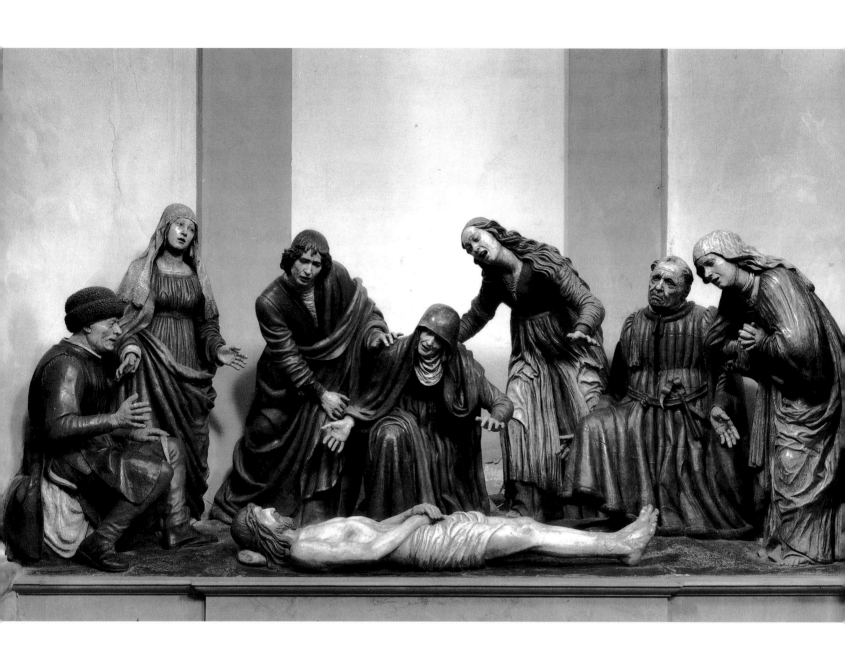

250 Mazzoni. *Lamentation*. c. 1485. San Giovanni Battista, Modena

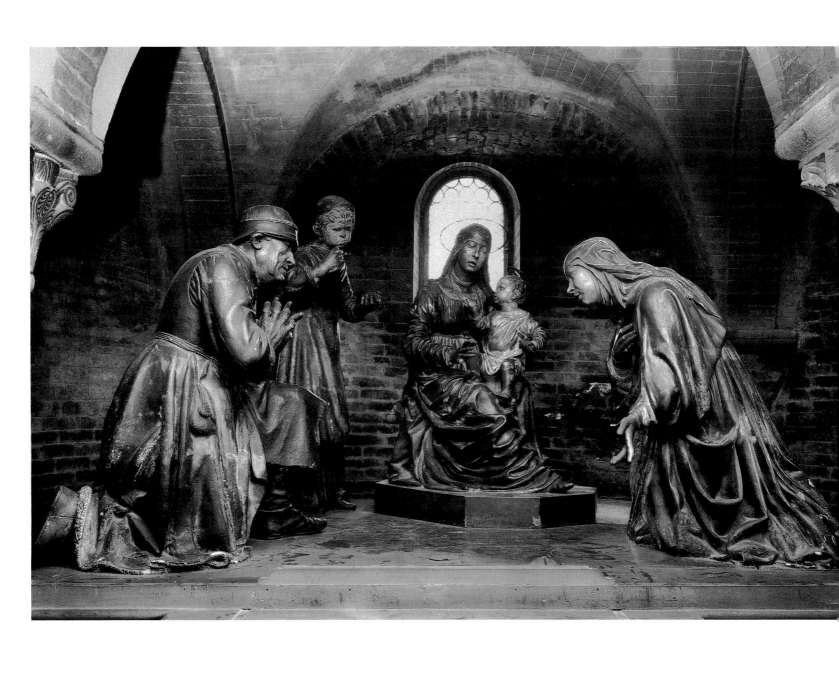

251 Mazzoni. *Adoration of the Child*. c. 1485–89. Crypt, Duomo, Modena

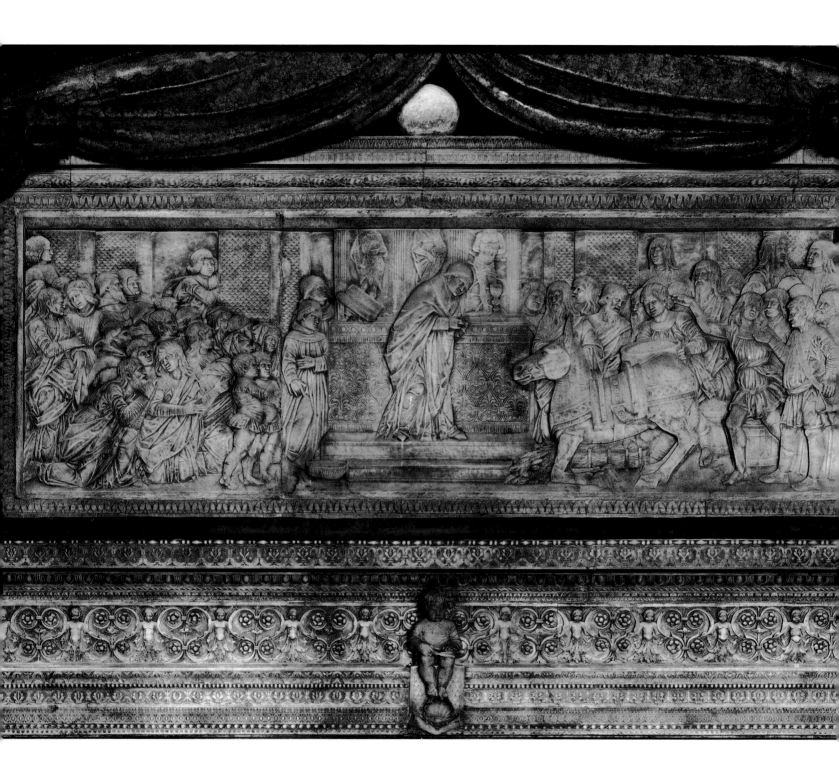

252 Bellano. *Miracle of the Host.* 1469–73. Basilica del Santo, Padua

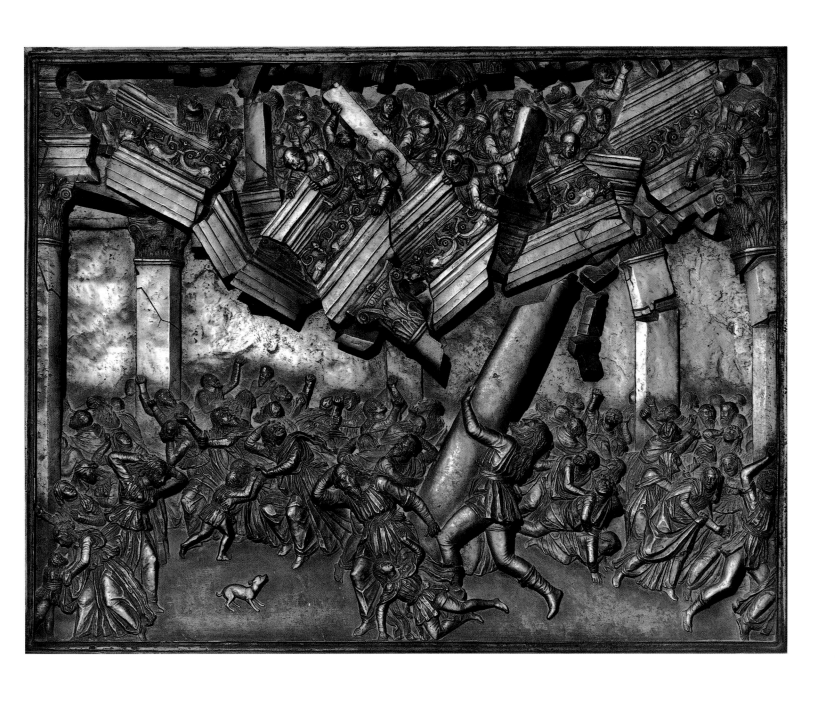

253 Bellano. *Samson Destroying the Temple of the Philistines.* 1484–90. Basilica del Santo, Padua

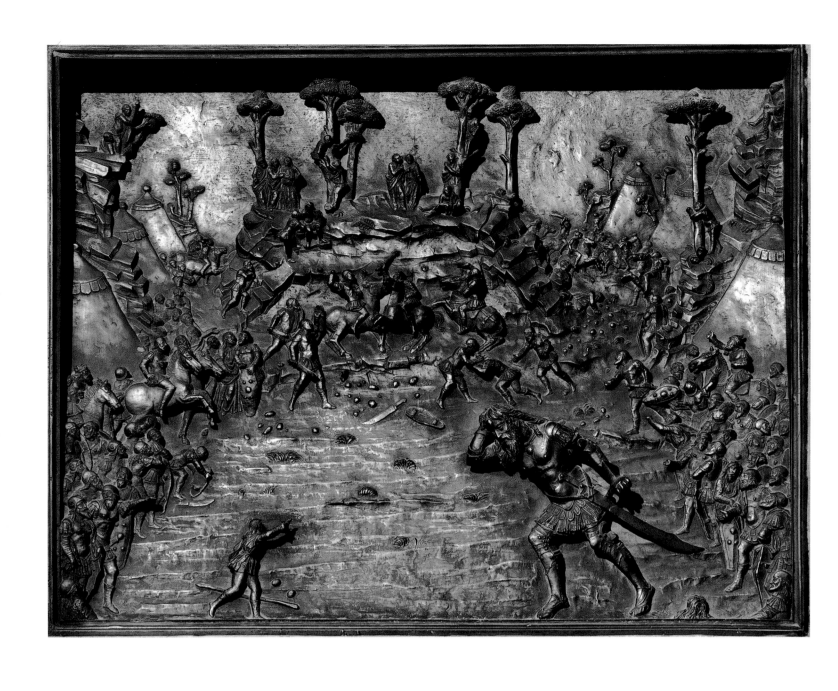

254 Bellano. *David Slaying Goliath*. 1484–90. Basilica del Santo, Padua

OPPOSITE:
255 Bellano. *Madonna and Child Enthroned Between St. Francis and St. Peter Martyr*,
from the Tomb of Pietro Roccabonella. 1492–98. San Francesco, Padua

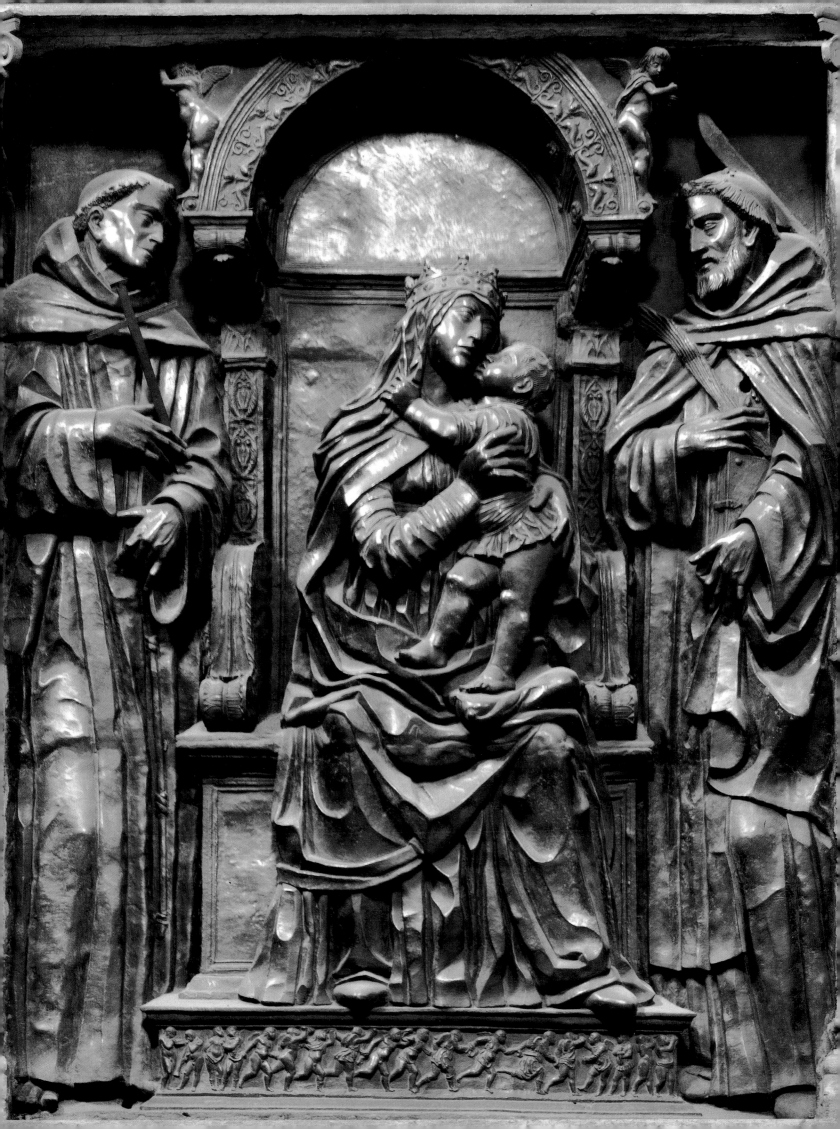

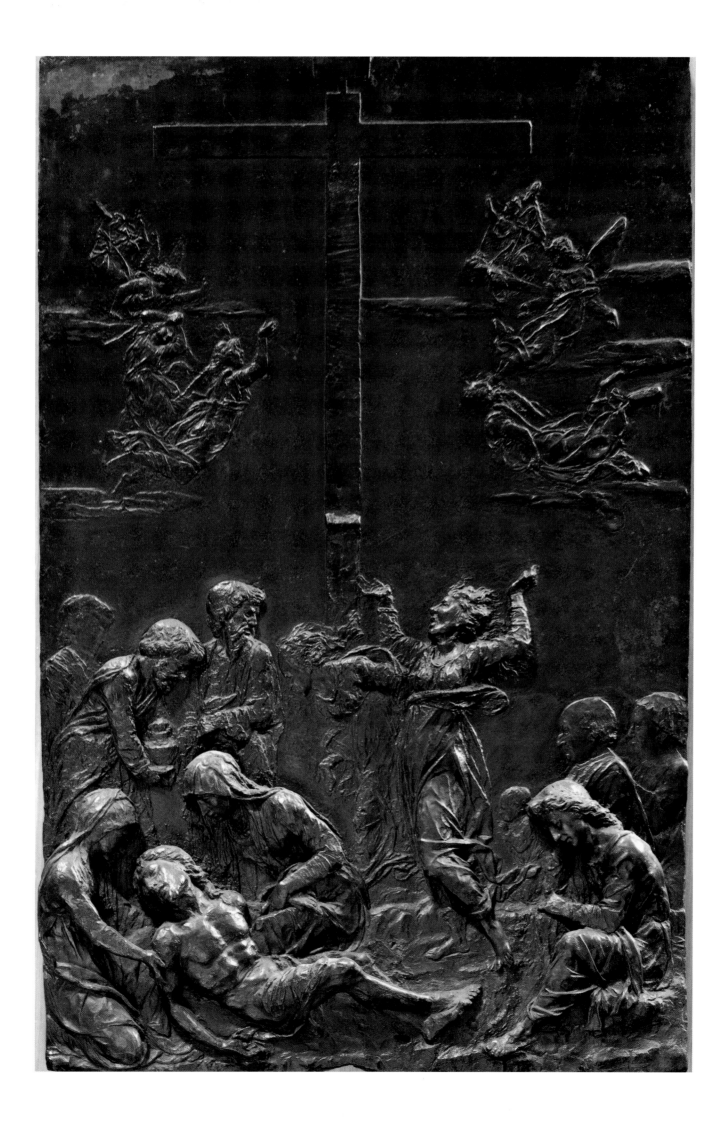

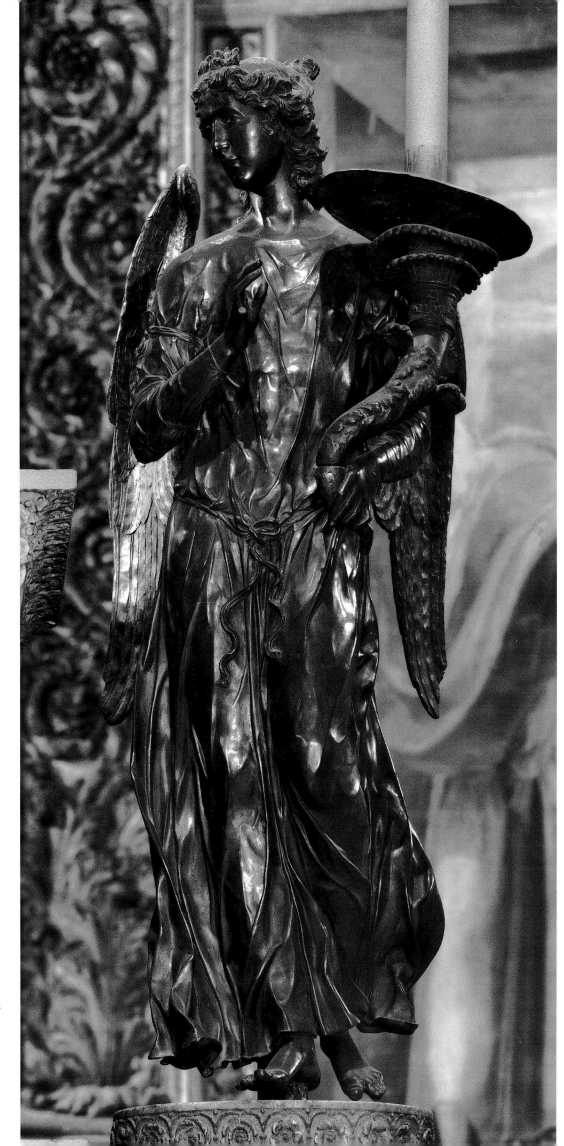

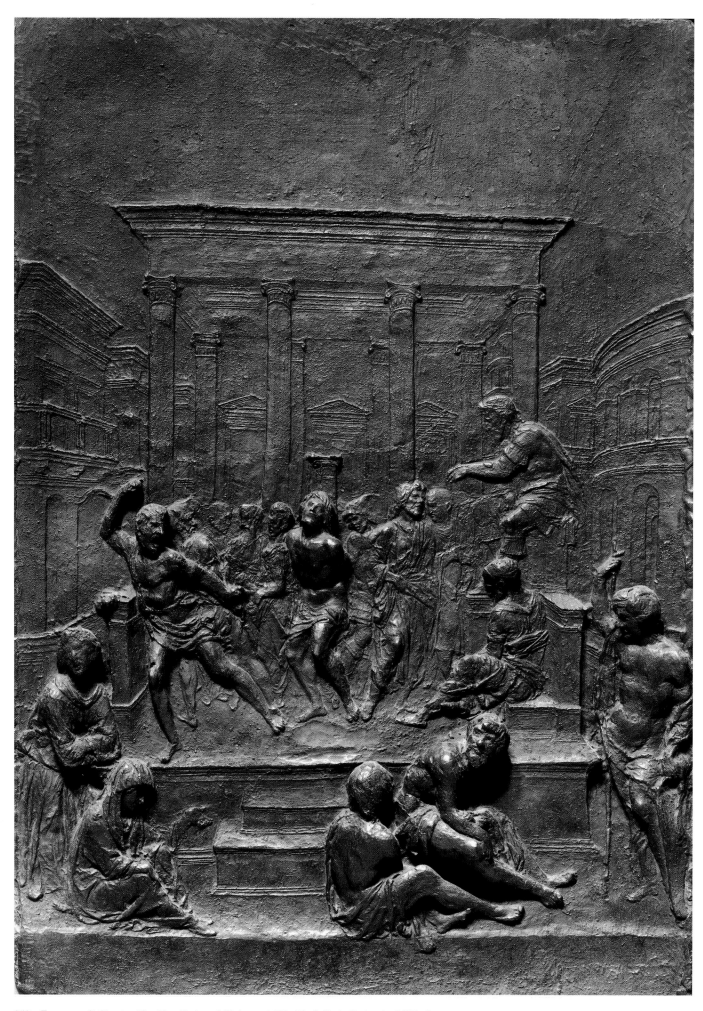

258 Francesco di Giorgio. *The Flagellation of Christ.* c. 1490–95. Galleria Nazionale dell'Umbria, Perugia

OPPOSITE:
259 Antonio del Pollaiuolo. *Hercules and Anteaus.* c. 1470. Museo Nazionale del Bargello, Florence

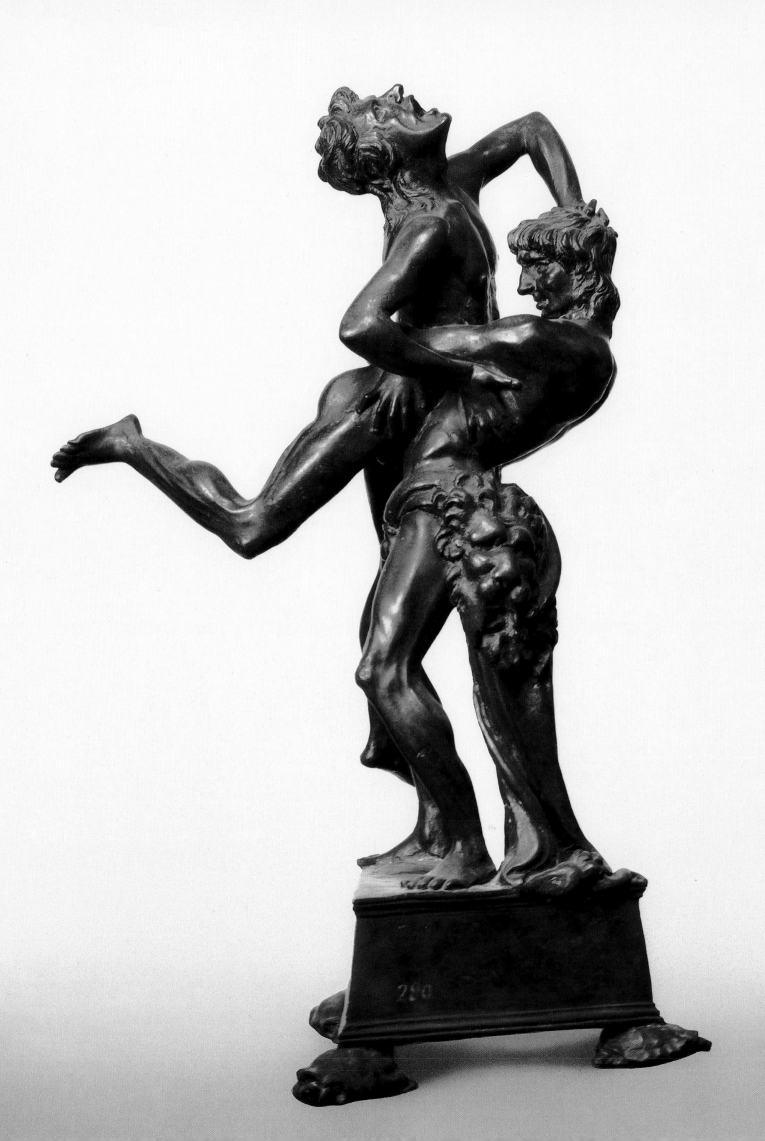

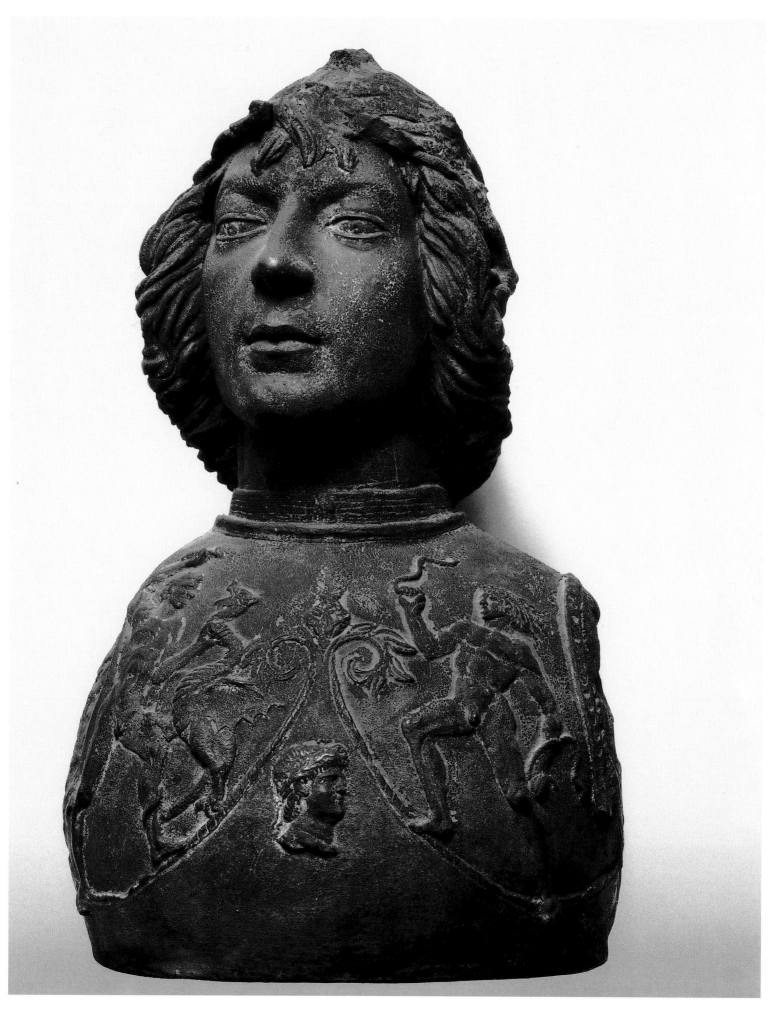

260 Antonio del Pollaiuolo. *Bust of a Warrior*. c. 1475–80. Museo Nazionale del Bargello, Florence

OPPOSITE:
261 Antonio del Pollaiuolo. Tomb of Pope Sixtus IV (detail). 1484–93. Tesoro, St. Peter's, Rome

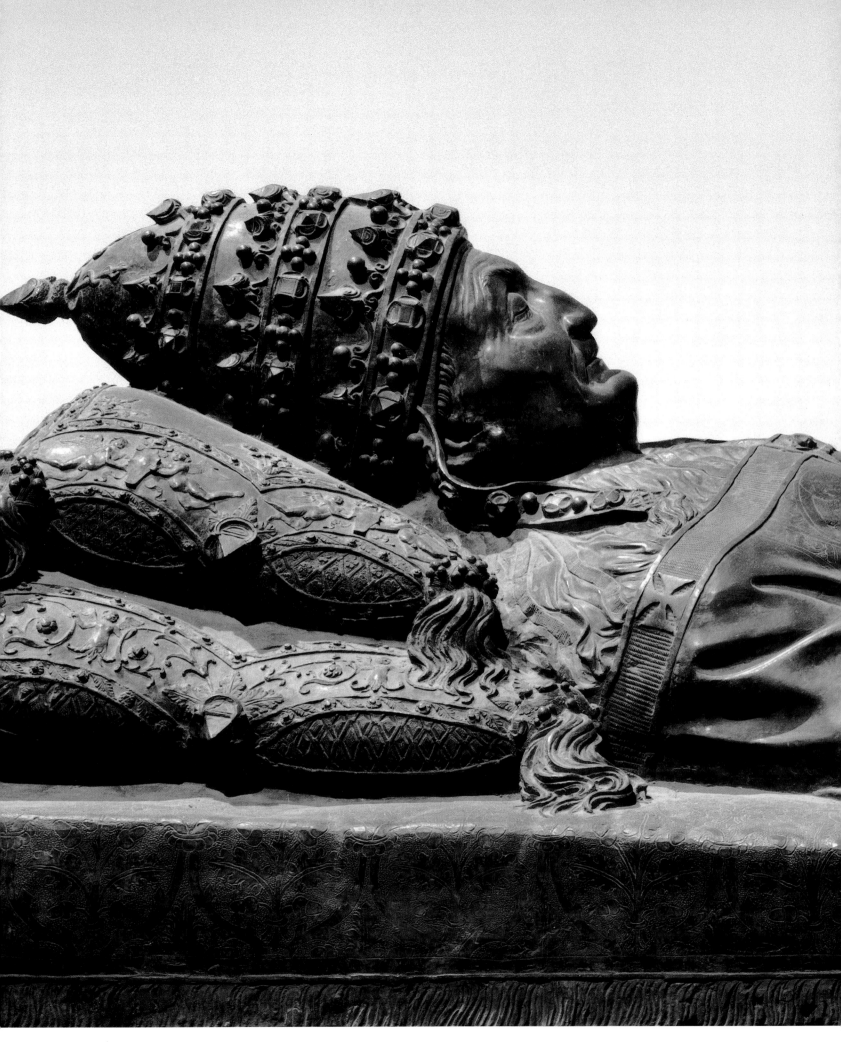

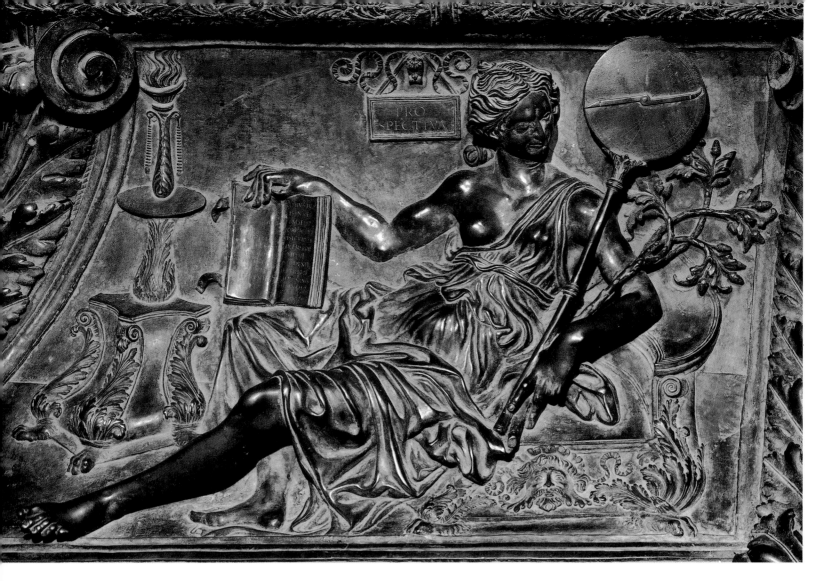

INNOCENTIVS VII
ANVENSIS PONT OPT
VIXIT ANNOS II LXI

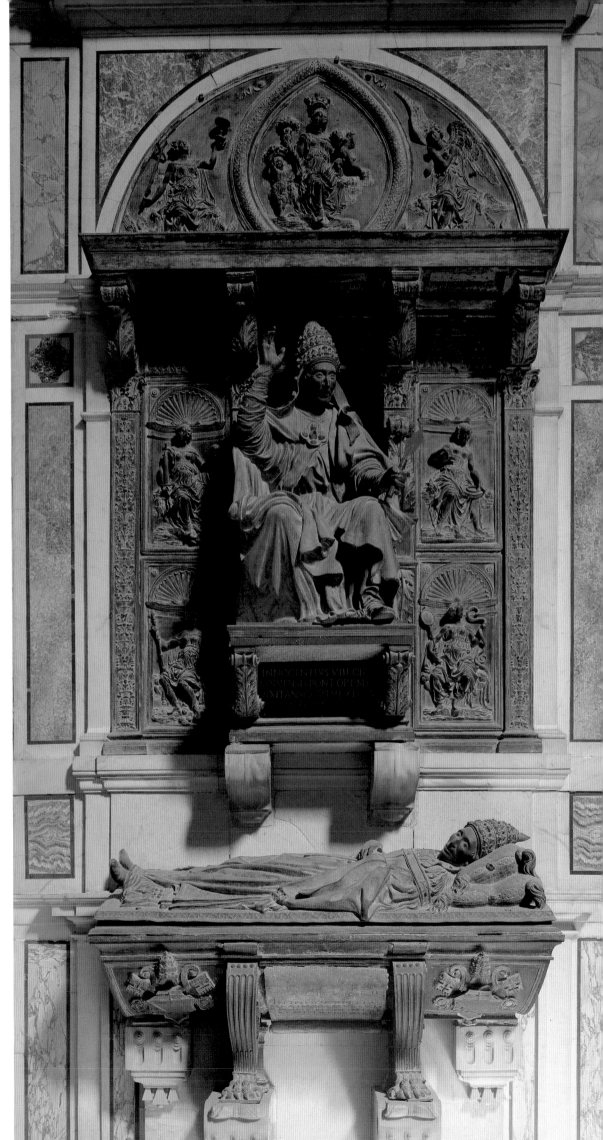

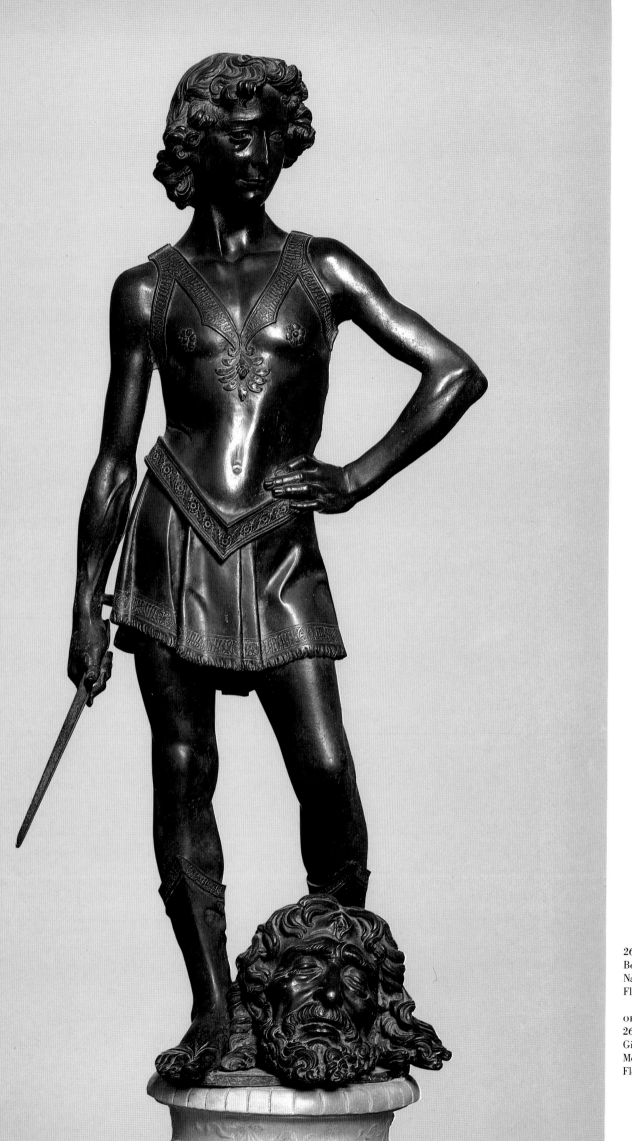

266 Verrocchio. *David*.
Before 1469. Museo
Nazionale del Bargello,
Florence

OPPOSITE:
267 Verrocchio. Tomb of
Giovanni and Piero de'
Medici. 1472. San Lorenzo,
Florence

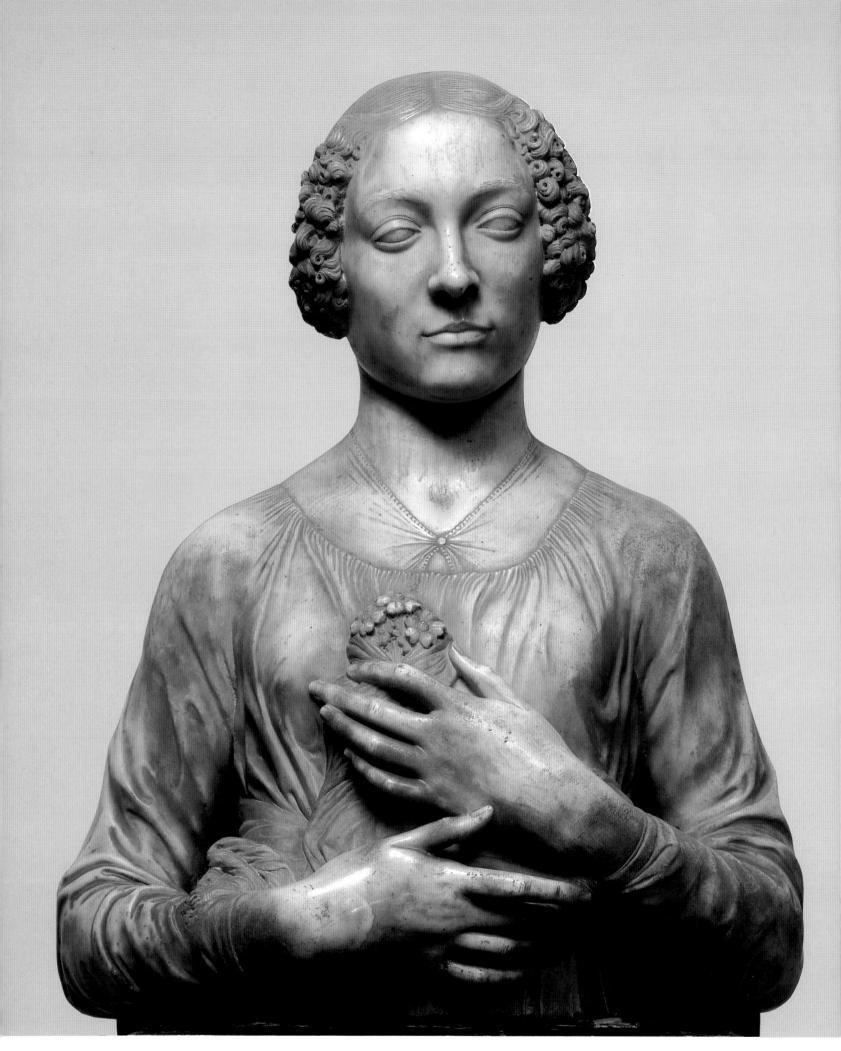

268 Verrocchio. *Woman with Posy*. c. 1475. Museo Nazionale del Bargello, Florence

OPPOSITE:
269 Verrocchio. *Christ and the Doubting Thomas*. 1467–83. Orsanmichele, Florence

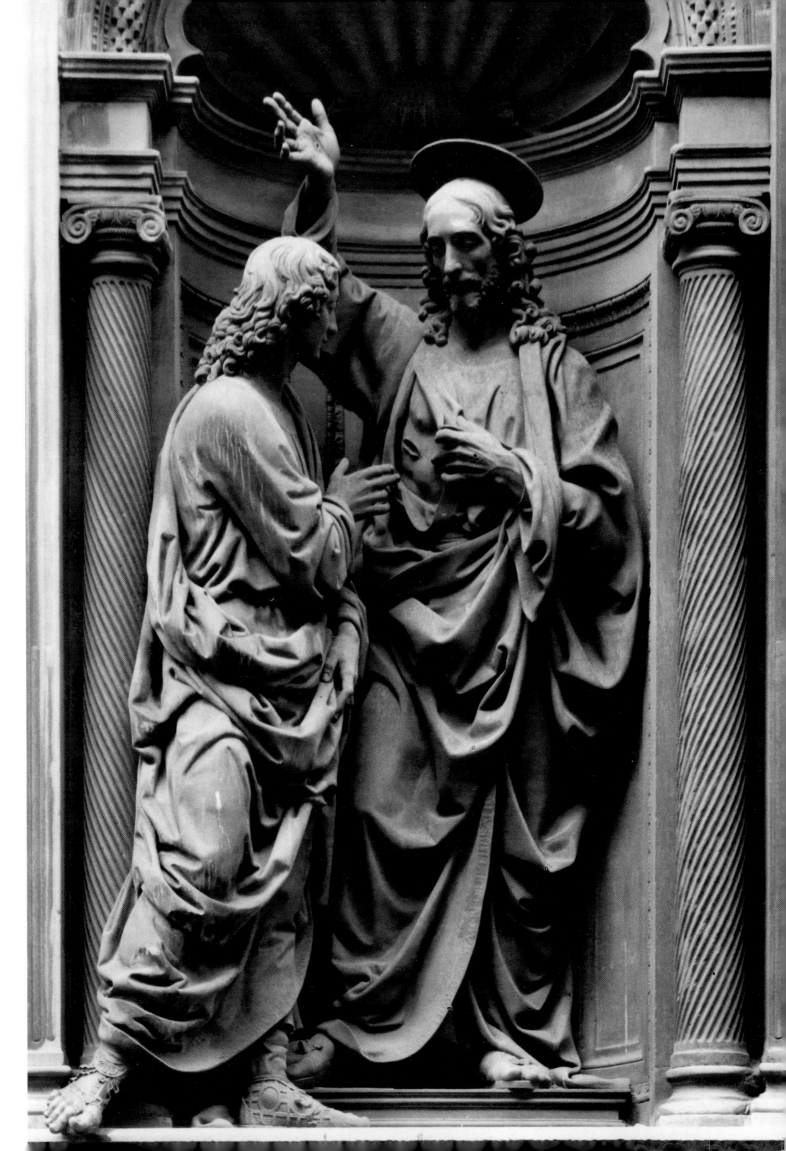

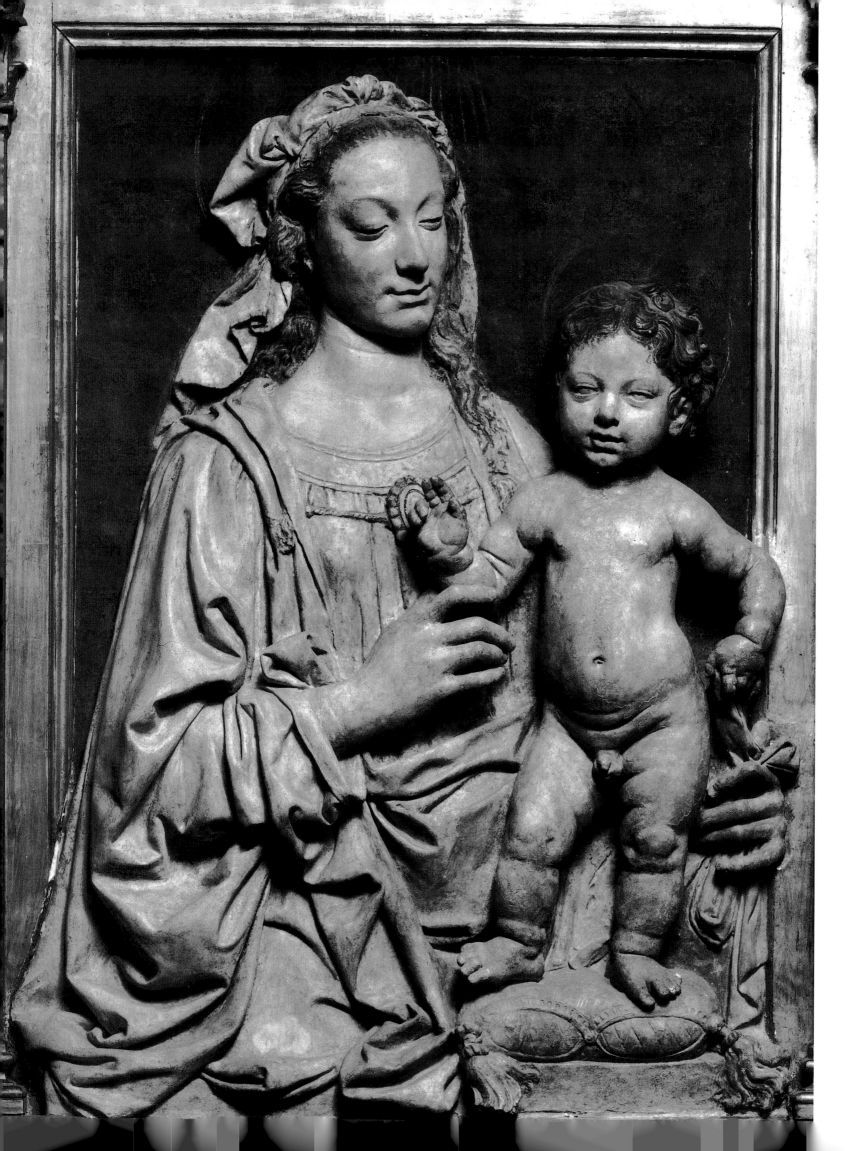

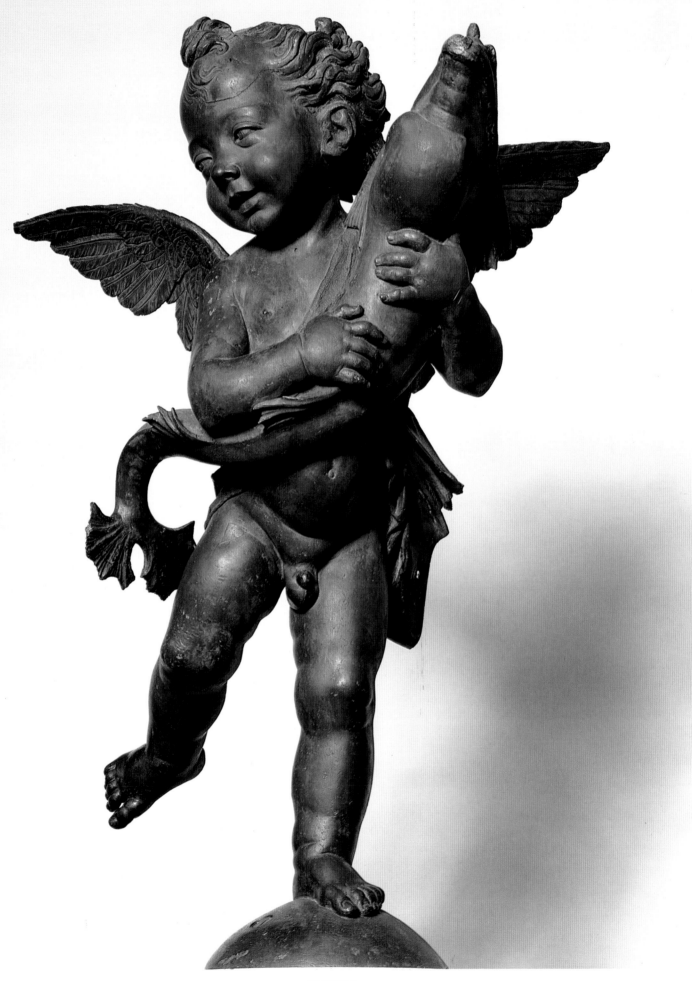

OPPOSITE:
270 Verrocchio. *Madonna and Child.* c. 1480. Museo Nazionale del Bargello, Florence

ABOVE:
271 Verrocchio. *Putto with Dolphin.* c. 1480. Palazzo Vecchio, Florence

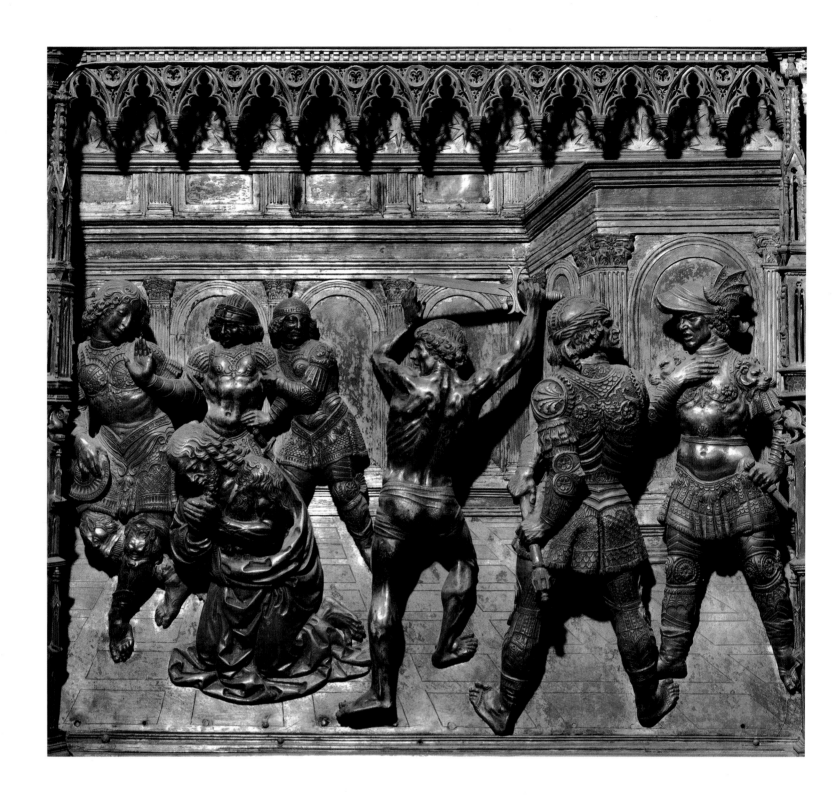

272 Verrocchio. *Beheading of St. John the Baptist*. 1478–80. Museo dell'Opera del Duomo,
Florence

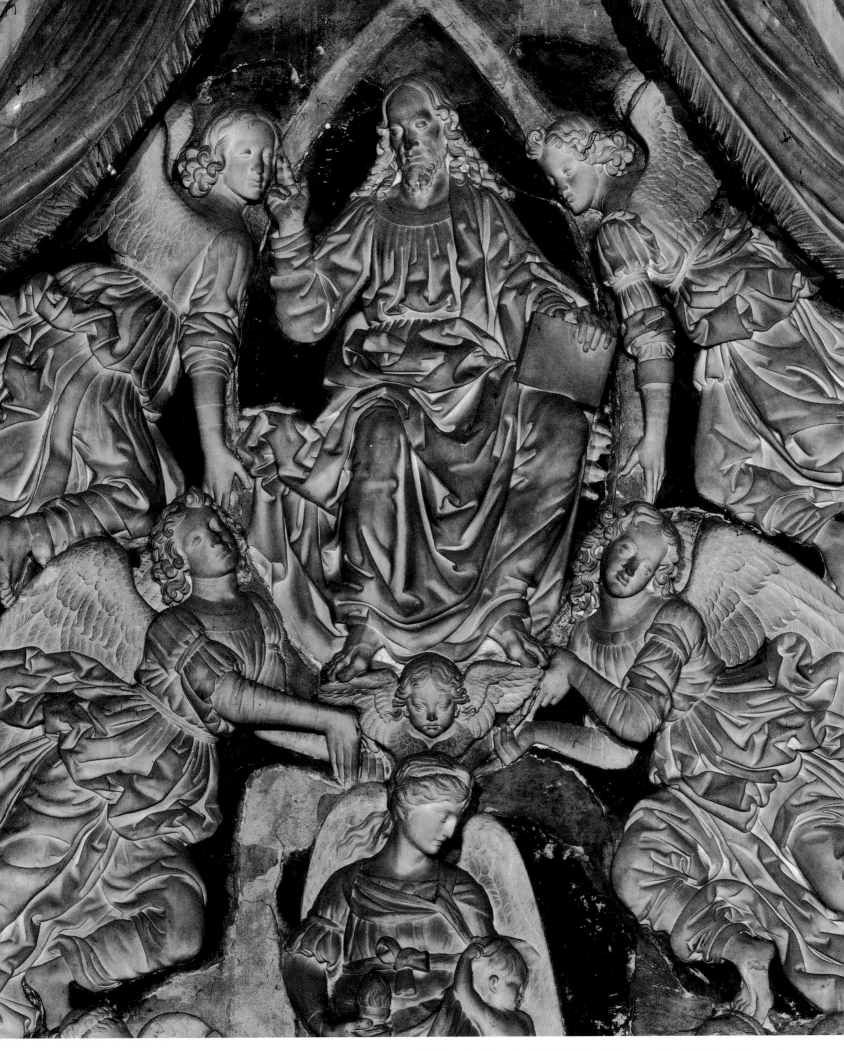

273 Verrocchio. Cenotaph of Cardinal Niccolò Forteguerri (detail: *Charity*, below center, by Lorenzo Lotti). 1476–88. Duomo, Pistoia

274 Verrocchio. *Angel.* c. 1480. Louvre, Paris

275 Verrocchio. *Angel.* c. 1480. Louvre, Paris

OVERLEAF, LEFT AND RIGHT:
276, 277 Verrocchio. Equestrian Monument of Bartolommeo Colleoni. 1479–88 (96). Campo Santi Giovanni e Paolo, Venice

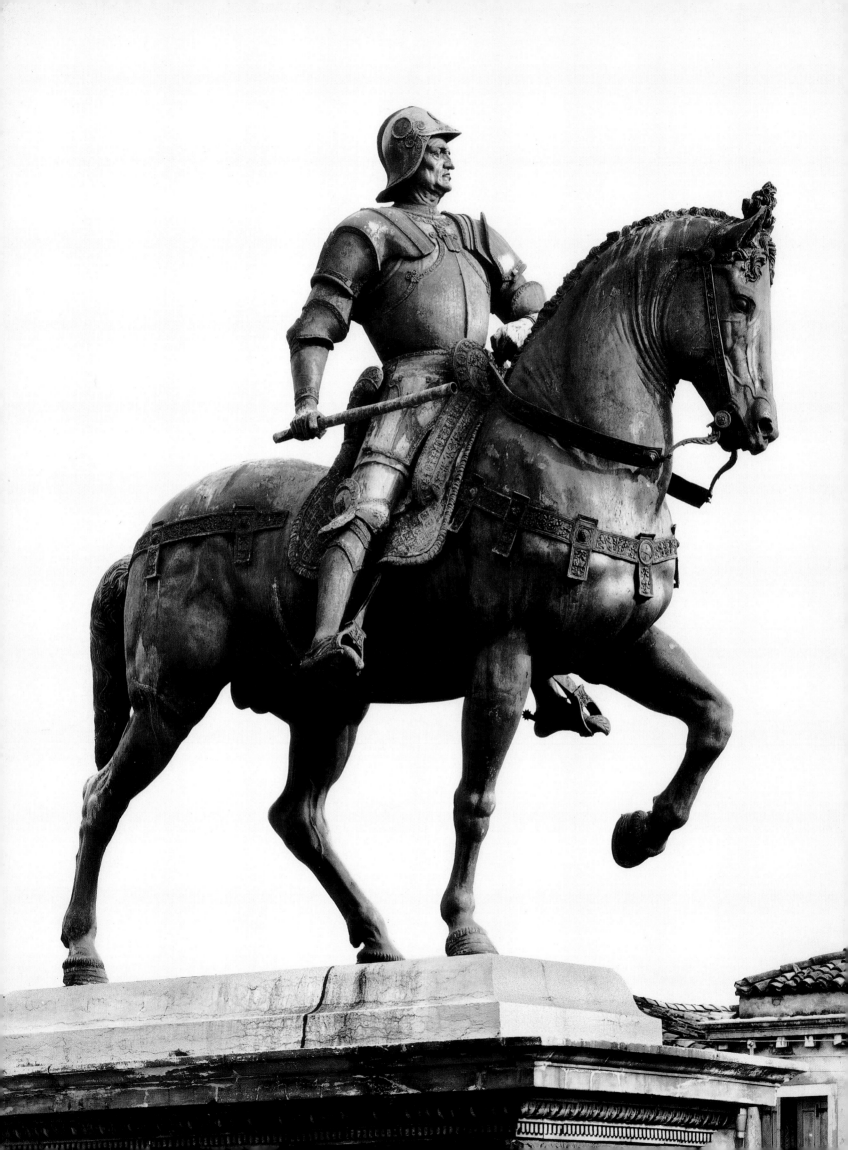

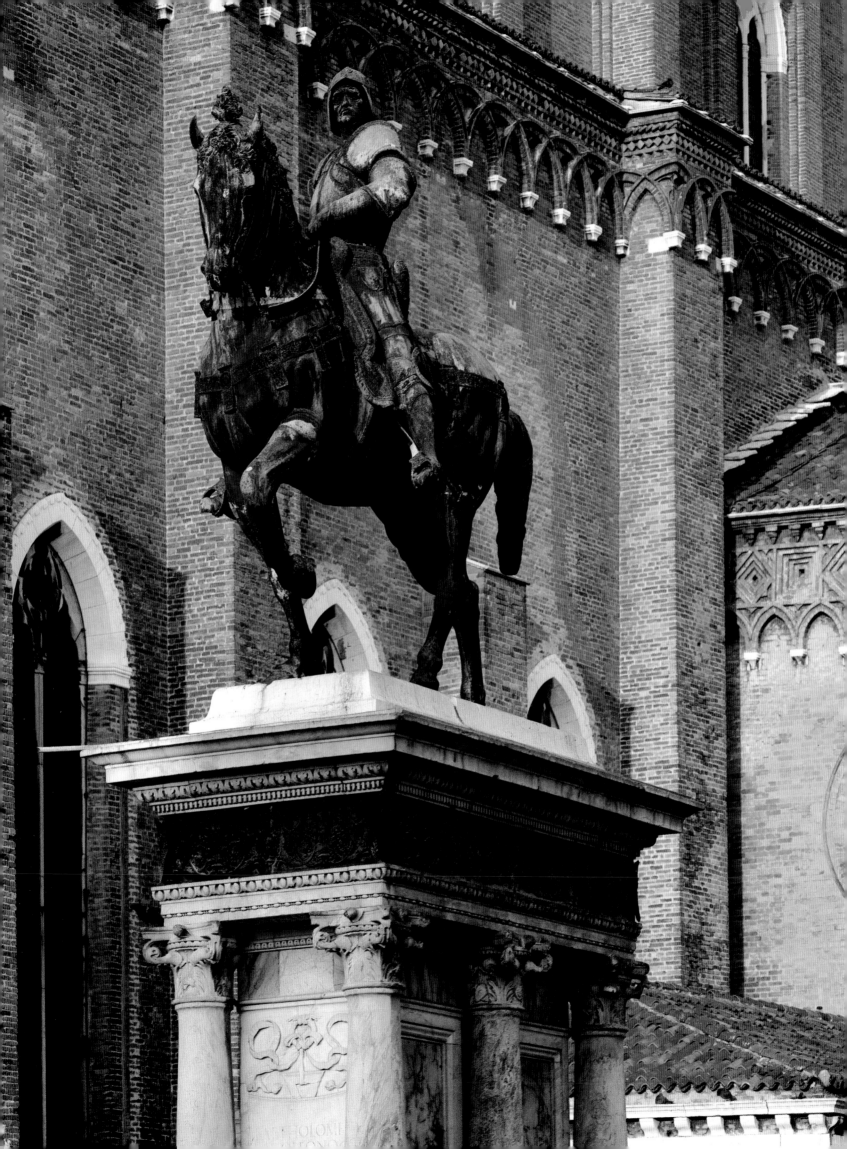

278 Bertoldo di Giovanni. *Bellerophon and Pegasus*. c. 1480–85. Kunsthistorisches Museum,
Vienna

279 Bertoldo di Giovanni. *Battle Relief.* c. 1485–90. Museo Nazionale del Bargello, Florence

280 Bertoldo di Giovanni. *The Crucifixion*. c. 1485–90. Museo Nazionale del Bargello, Florence

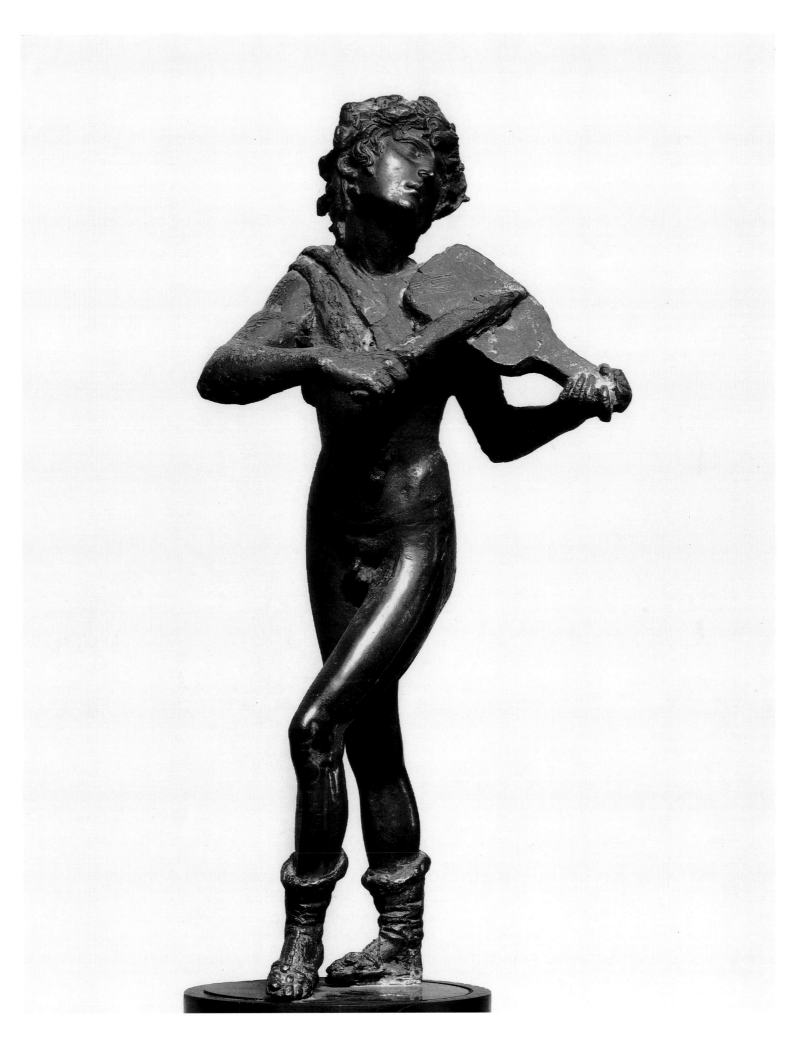

281 Bertoldo di Giovanni. *Apollo or Orpheus (?)*. c. 1485–90. Museo Nazionale del Bargello, Florence

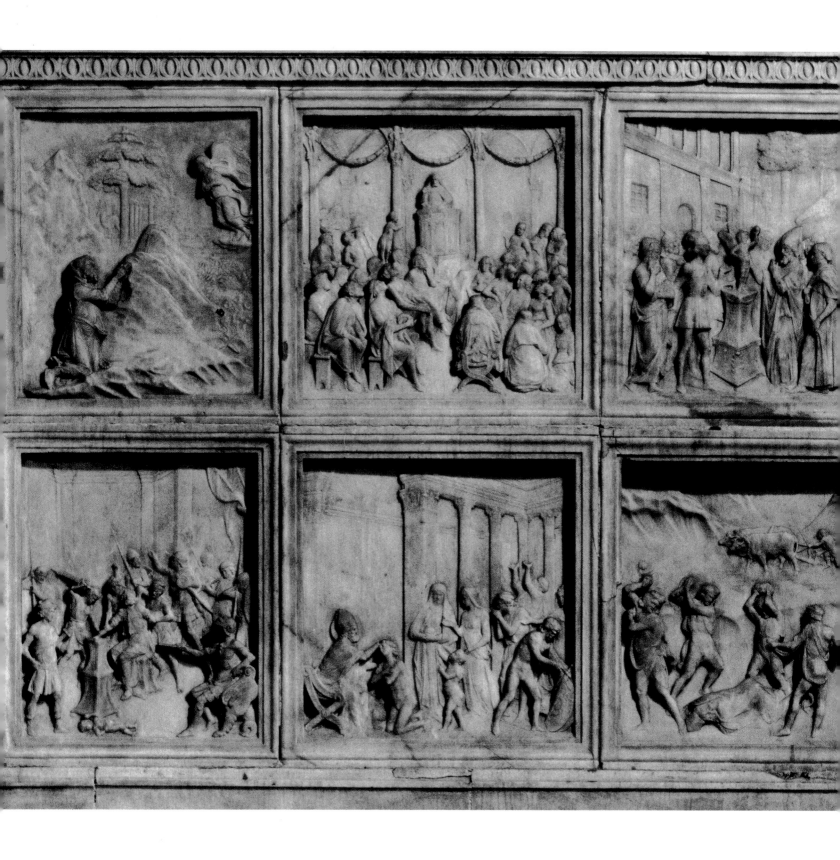

282 Benedetto da Maiano. *Scenes from the Life of St. Sabinus*. 1468–71. Shrine of St. Sabinus, Duomo, Faenza

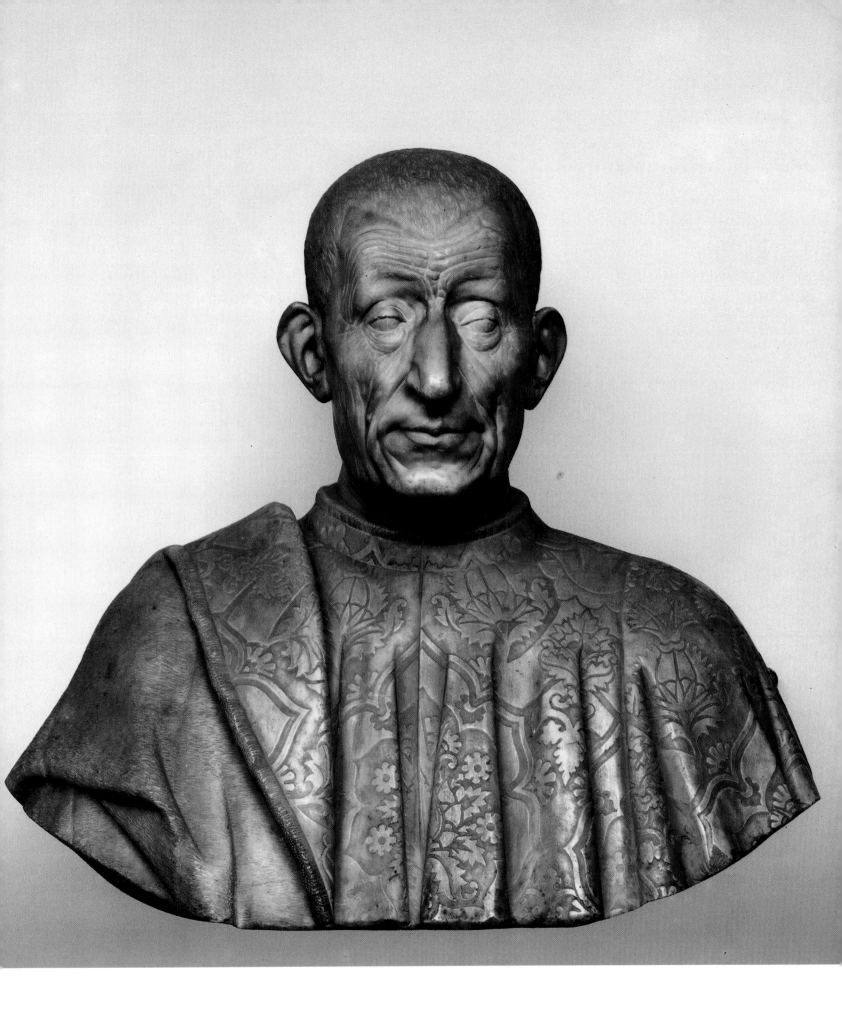

283 Benedetto da Maiano. *Bust of Pietro Mellini*. 1474. Museo Nazionale del Bargello, Florence

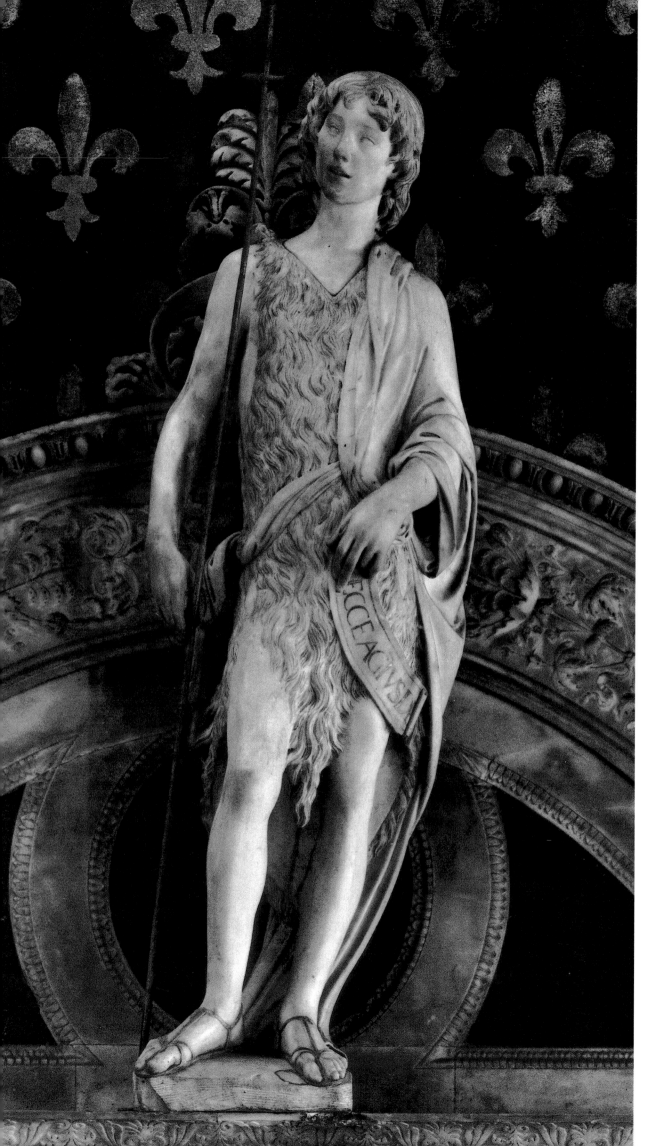

284 Benedetto da Maiano.
St. John the Baptist. 1476–81.
Palazzo Vecchio, Florence

OPPOSITE:
285 Benedetto da Maiano.
Justice. 1476–81. Palazzo
Vecchio, Florence

286, 287 Benedetto da Maiano. Pulpit. c. 1480–85. Santa Croce, Florence

286 detail: Stigmatization of St. Francis

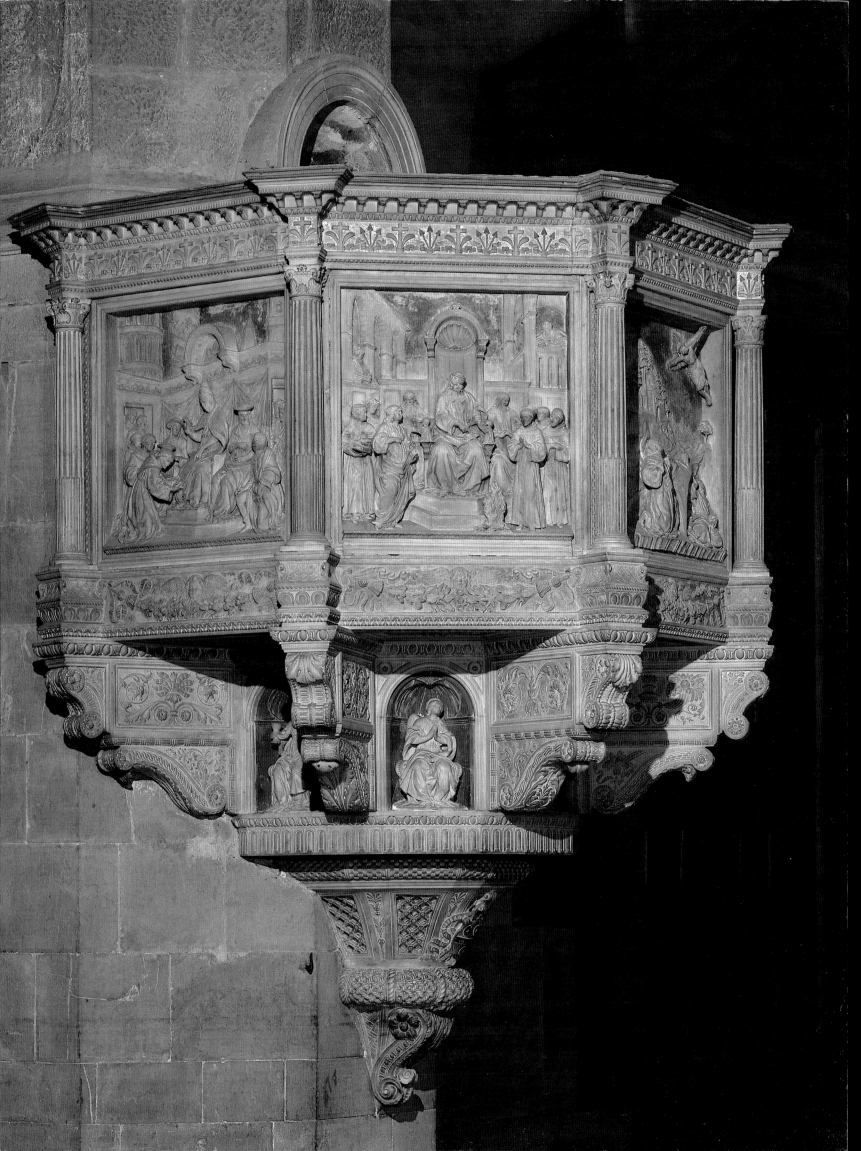

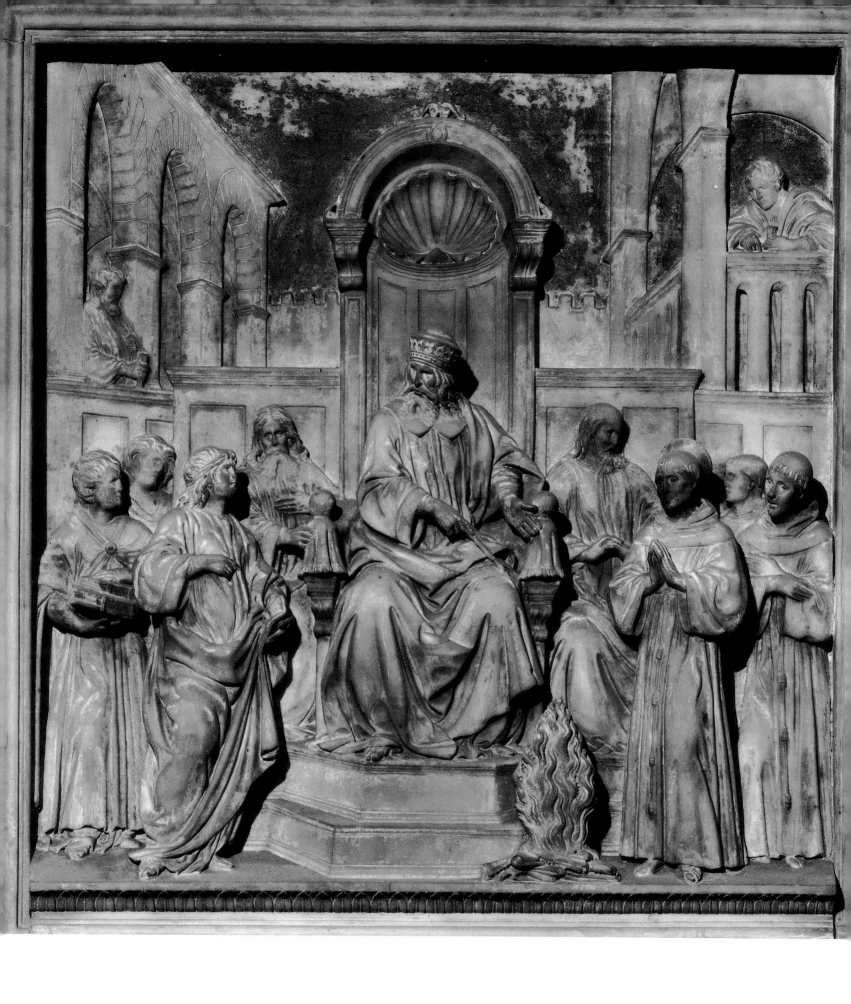

288 Benedetto da Maiano. Pulpit (detail: Ordeal by Fire Before the Sultan). c. 1480–85. Santa
Croce, Florence

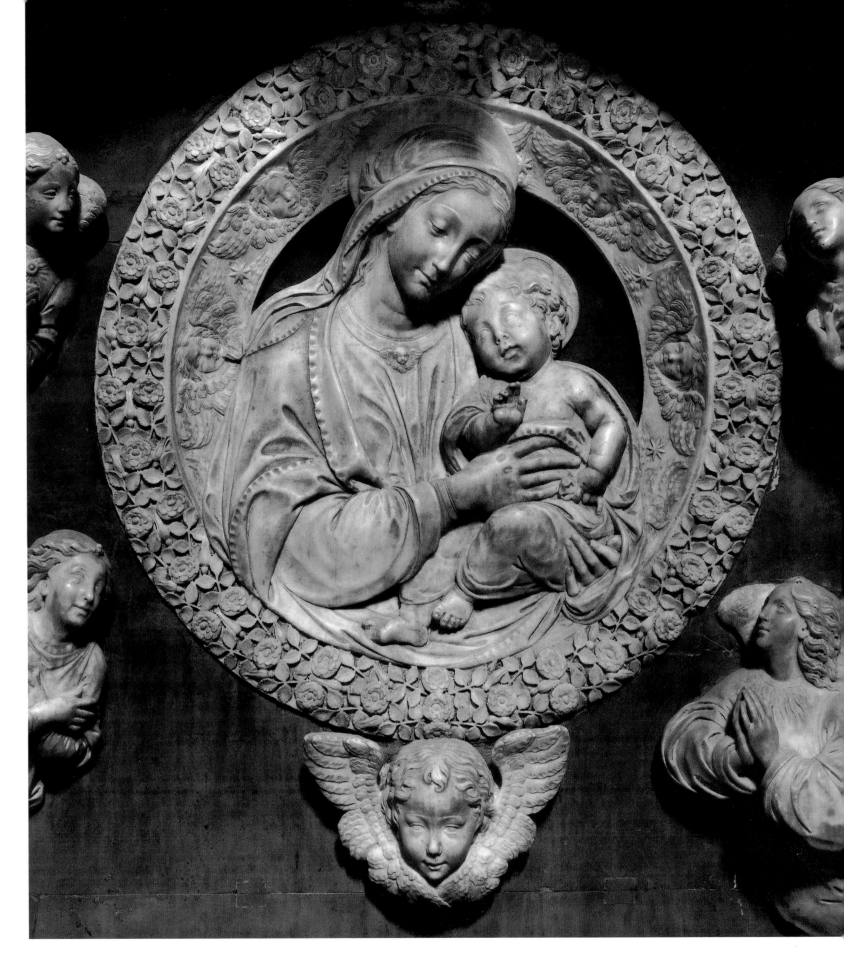

289 Benedetto da Maiano. *Madonna and Child*, from the Tomb of Filippo Strozzi. 1491–95. Santa Maria Novella, Florence

OVERLEAF, LEFT:
290 Benedetto da Maiano. *Coronation of Ferrante I of Aragon*. c. 1494. Museo Nazionale del Bargello, Florence

OVERLEAF, RIGHT:
291 Benedetto da Maiano. *Madonna and Child*. c. 1497. Oratory of the Misericordia, Florence

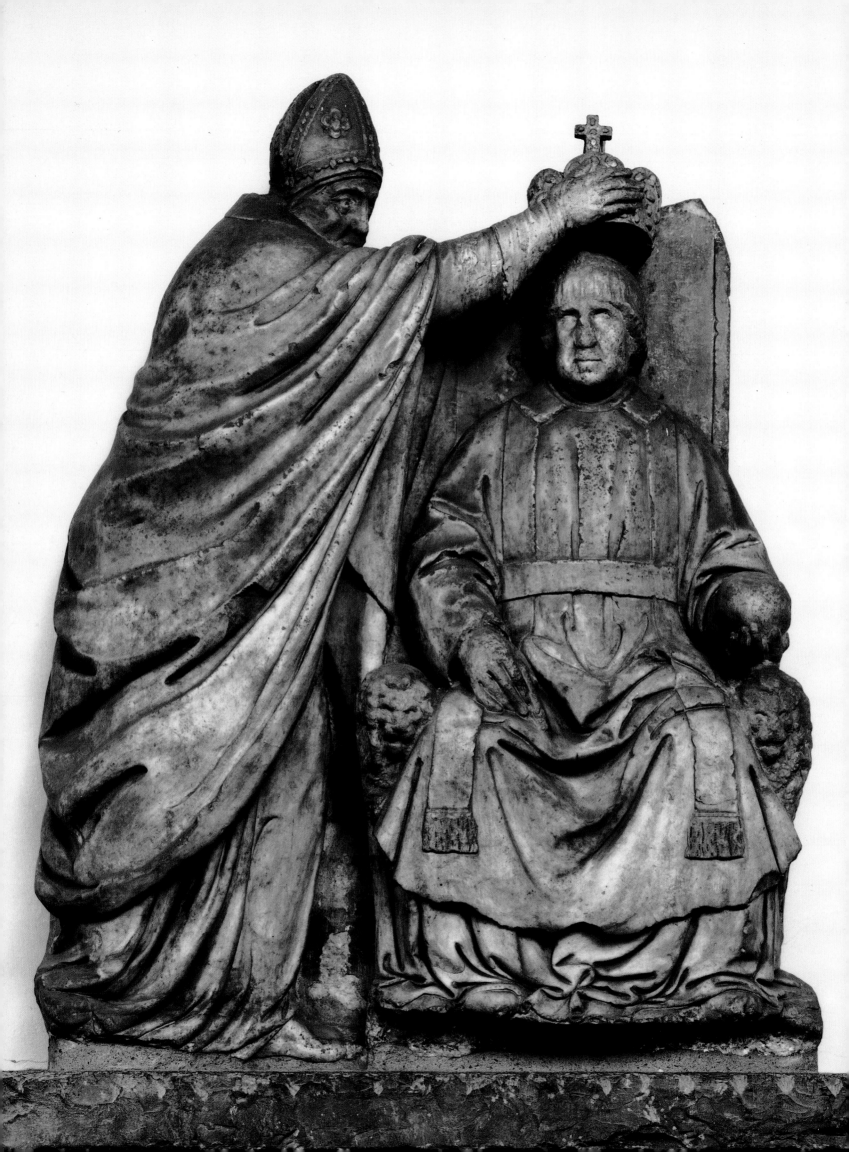

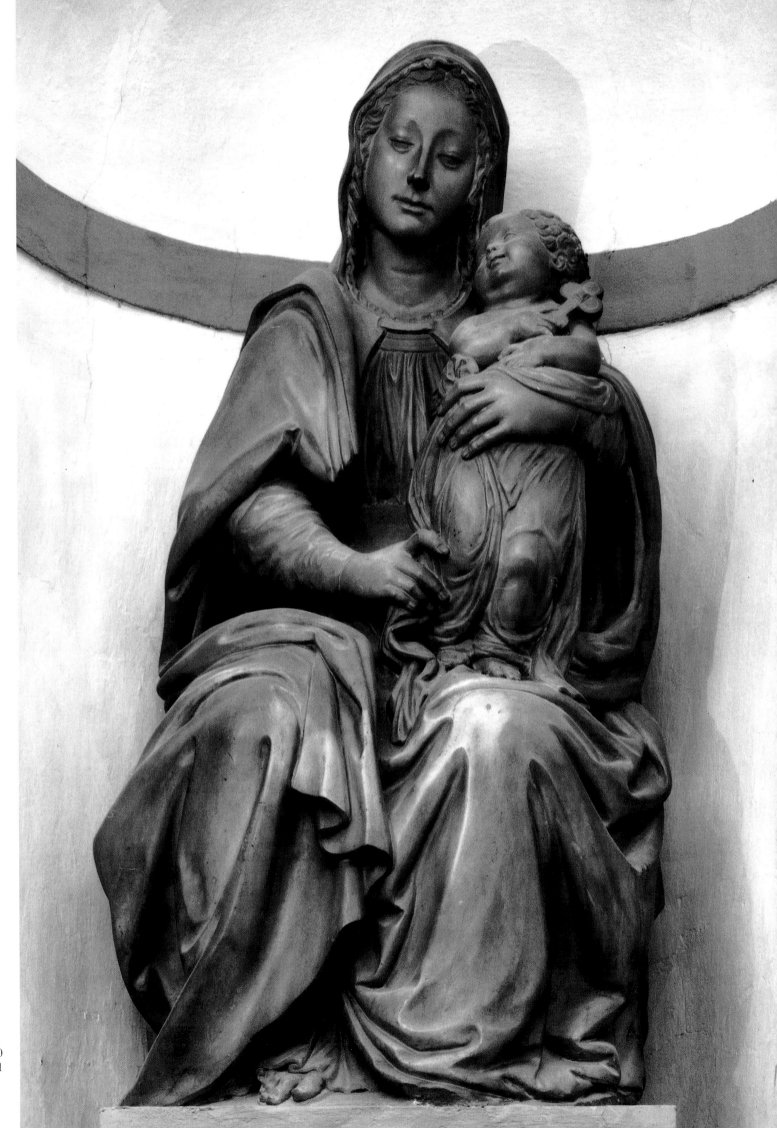

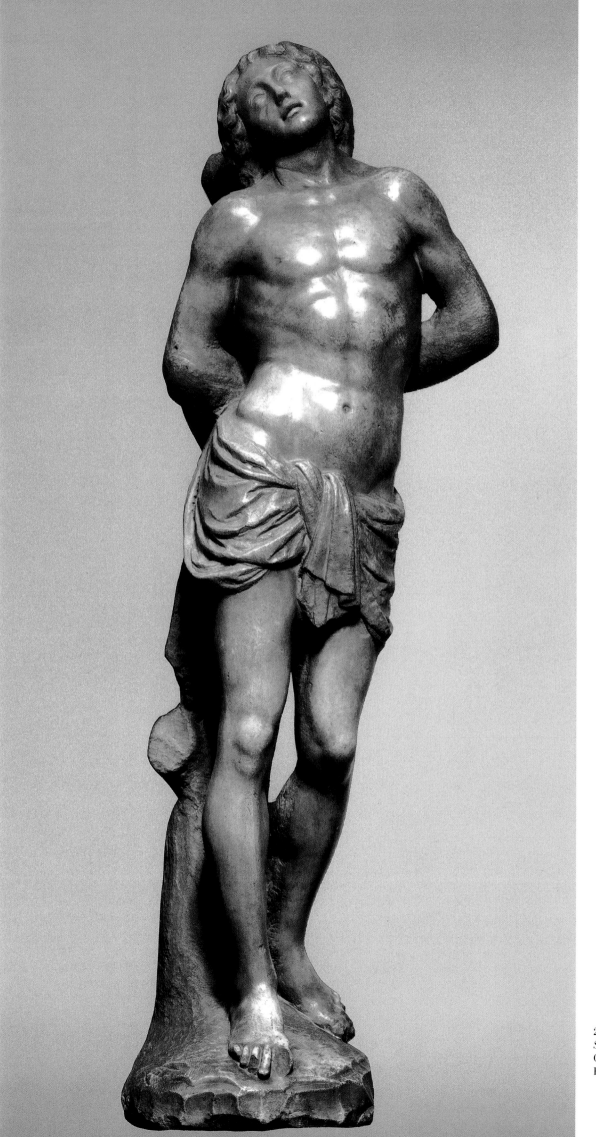

292 Benedetto da Maiano.
St. Sebastian. c. 1497.
Oratory of the Misericordia,
Florence

Documentation

Brunelleschi
(1377–1446)

Filippo Brunelleschi was born in Florence in 1377, the son of the notary Ser Brunellesco di Lippo Lapi and his wife Giuliana degli Spini. He attained his greatest renown as an architect, yet it was only relatively late in his career that he created the structures that justify his being called the founder of Renaissance architecture. In his early years he devoted himself principally to sculpture, as he had been trained as a goldsmith. He pledged himself to the Arte della Seta, the guild that included the city's goldsmiths, on December 18, 1398; however, it was not until July 2, 1404, that he attained full membership in the guild. In the meantime, during the years 1399–1400, we know that Brunelleschi collaborated on a silver altarpiece for the cathedral in Pistoia, and in 1401 he entered the competition for the second bronze door for the Baptistry in Florence. We are told by his early biographer Antonio Manetti (c. 1485) that once the contract for the Baptistry door had been awarded to Ghiberti, Brunelleschi set out for Rome with his friend Donatello to study the sculpture of antiquity. Once there, however, he devoted even more attention to ancient buildings and their construction. This would have been about 1403–4, although it is possible that Brunelleschi had visited Rome even earlier, before 1401.

Due to gaps in the record, it is impossible to form a clear picture of his activities between 1401 and 1418—in which year the competition for the dome of the Cathedral of Florence was announced. We must assume that his studies in perspective, which Manetti describes in such detail, date from this period. Documents from the years 1401, 1412, and 1417 attest that even during these years Brunelleschi was consulted as an architect, or at least as an expert in architectural matters. But at the same time he was working as a sculptor. On October 9, 1415, he and Donatello were presented with partial payment for the small marble figure covered with gilt lead that was to serve as a model for the buttress sculptures on the choir of the Cathedral of Florence. Another probable work from this period is the wooden statue of St. Mary Magdalene destined for Santo Spirito. It was mentioned as early as 1420, but was destroyed by fire in 1471. The wooden *Crucifix* from Santa Maria Novella, on the other hand, was probably executed later, during the 1420s.

Even after 1419, when building projects like the Cathedral dome, the forecourt of the Ospedale degli Innocenti, San Lorenzo, Santo Spirito, Santa Maria degli Angeli, the Pazzi Chapel, and fortifications in various Tuscan towns would seem to have kept him fully occupied, Brunelleschi was still asked to design sculpture, even though he did not execute it himself. For example, we know of designs or models for a tabernacle in San Jacopo in Campo Corbolini (executed in 1427, now lost); for the washbasins in the two sacristies in the Florence cathedral (from 1432, carried out by Buggiano and completed in 1445); for the reliquary of St. Zenobius (1432, although it was Ghiberti who was awarded the contract); and for the chancel of Santa Maria Novella (1443, completed by Buggiano in 1448).

Brunelleschi died on April 15, 1446. The Arte della Lana decided to honor him with burial in the Cathedral, and his adopted son Buggiano executed the busts adorning his tomb. The tomb's inscription, composed by the poet Carlo Marsuppini, lauds Brunelleschi primarily as the builder of the Cathedral dome. Brunelleschi had counted among his friends Donatello, Alberti, Niccolò Niccoli, Cosimo de' Medici, Ambrogio Traversari, and Toscanelli.

Alberti [1436]; Ghiberti [c. 1447]; Manetti [c. 1485]; Manetti [c. 1495]; Billi [1516–20]; *Il Codice Magliabechiano* [1537–42]; Gelli [c. 1550]; Vasari [1550, 1568]; Baldinucci [1681–1728]; Fabriczy 1892; Marquand, "Note," 1914; Sanpaolesi [1948]; Sanpaolesi 1953; Ragghianti, "Aenigmata," 1954; Krautheimer 1956 (1982); Pope-Hennessy 1958 (1985); Seymour 1966; Lisner 1970; Janson 1973; Battisti [1976]; Micheletti and Paolucci 1977; Paolucci 1977; Ragghianti 1977; Bozzoni and Carbonara 1977–78; *Filippo Brunelleschi* 1980; Parronchi, "Crocifissi," 1980; Fehl 1982; Gai 1984.

1, 2
The Sacrifice of Isaac

1401–2. Bronze, gilt, 17¾ × 15″ (45 × 38 cm.).
Museo Nazionale del Bargello, Florence

For the story of the creation of this relief, see page 354.

While the trial reliefs presented by the five other artists in the 1401 competition have been lost, those of Ghiberti and Brunelleschi are preserved. The latter was mounted on the back of the altar in the Old Sacristy of San Lorenzo, presumably about 1430. It subsequently found its way into the Uffizi, and in 1859 it was placed in the Bargello. Brunelleschi's relief consists of seven separate castings (Micheletti and Paolucci 1977). The

figures, the animals, the altar, and the shrubbery are gilt. It is probable that the shape and even the number of figures were prescribed in addition to the subject matter.

In its composition and its narrative style, Brunelleschi's relief is unlike Ghiberti's (plate 5). He has arranged his rock formations and figures in such a way as to contrast with the quatrefoil framework. Horizontals and verticals dominate the composition instead of diagonals, so that one concentrates solely on the relationships between the individual groups of figures. The work thus represents a new manner of pictorial composition, indeed a new pictorial concept, with the arrangement of the work independent of the surrounding frame. The centering of the composition and its division into parallel pictorial planes constitute a distinct break with tradition. Furthermore, the postures of the secondary figures are more strongly varied than those in Ghiberti's relief.

The seated figure on the right has bent down to dip his cup in the small stream from which the mule drinks so thirstily. But his movement has been arrested, and he gazes upward, visibly entranced by the momentous event taking place above him. This figure has been conceived with striking virtuosity, but beyond that it represents an early example of a type of which the Early Renaissance was inordinately fond, namely, the secondary figure calculated to direct one's glance from the periphery to the center of the picture or the focus of the action. By contrast, the groom seated across from him on the left is completely preoccupied. We cannot be sure that he is, in fact, removing a thorn from his foot, but as early as 1485 or so, Manetti was convinced that this is how he is to be interpreted. The direct antecedent of this figure was surely the Capitoline *Spinario* (*Boy Removing a Thorn*), which stood before the Lateran Palace in the Middle Ages and was one of Rome's most famous ancient monuments. Undoubtedly, Brunelleschi knew the work from personal observation, which would suggest that he had been to Rome before 1401.

The central event, like the actions of the two grooms in the foreground, is dramatized in a very specific and intense manner unusual for the period. Abraham advances on the bound Isaac in a rage. He has seized him by the throat with his left hand, pressing his chin upward with his extended thumb. With his right hand he has already placed the point of his knife against the victim's throat. At this precise moment he is prevented from plunging it in by the angel, who firmly grasps his wrist and draws his attention to the ram that is to be sacrificed in place of Isaac. The drama is concentrated in the center, in the powerful grip of the hands so effectively framed by the faces of Isaac and Abraham. Brunelleschi's articulation of the true climax of the event is more skillful than Ghiberti's and is more immediate and moving. Despite the Gothic touches, both in the construction of the relief and in the drapery, this immediacy is something distinctly new with Brunelleschi, a quality that Donatello would adopt in his own pictorial reliefs a short time later. The tiny scene on the front of the altar is not fully explained. According to Marquand ("Note," 1914), it depicts Abraham with the Virgin. Between them sits the rescued Isaac, here understood as a forerunner of Christ.

3
Crucifix

c. 1425. Wood, polychrome, 66⅞″ high (170 cm.). Santa Maria Novella, Florence

As early as about 1485 Manetti attributed this *Crucifix* to Brunelleschi. At that time it hung in the east transept of Santa Maria Novella. Later—toward the end of the sixteenth century—it was moved to the Gondi Chapel in the church. It is spoken of in an anecdote fleetingly referred to in the *Libro di Antonio Billi* (1516–20) and later elaborated on by Vasari (1550), according to which Brunelleschi and Donatello engaged in a friendly competition to see which of them could produce the better crucifix. Vasari has no doubts about the outcome, for he insists that Donatello, in his *Crucifix* in Santa Croce, depicts a crucified peasant, whereas Brunelleschi truly portrays the son of God—*il quale fu delicatissimo ed in tutte le parti il più perfetto uomo che nascesse giammai* (who was of utmost delicacy and in his entire physique the most perfect man ever born).

The story may well be spurious, yet in telling it Vasari succeeds in capturing the difference—from the point of view of *convenientia*, that is, the manner of portraying a given subject matter—between the two crucifixes. Brunelleschi has clearly underplayed the sense of physical weight in his work and suppressed any sign of exhaustion. Christ is arrayed against the cross more elegantly. His arms, in span the precise length of his figure, are more horizontal. Various writers have suggested that here Brunelleschi was consciously applying the Vitruvian schema of the *homo quadratus*. However, this is unlikely, especially since the figure of Christ is not extended to its full height. Moreover, its long legs are disproportionately powerful compared to its long, thin arms (whereas in Donatello's *Crucifix*, plate 40, the legs appear to be underproportioned). Brunelleschi has taken particular care with the joints in his figure, its bones and sinews. In contrast to the frontality of the outstretched arms, the torso and thighs twist well to the side. In this it is reminiscent of painted crucifixes from the Trecento and appears slightly forced—in large part thanks to the way the feet have been twisted so as to face each other.

The proportions of this *Crucifix* from Santa Maria Novella and its emphasis on anatomical detail would suggest that it was executed somewhat later than Donatello's version in Santa Croce. The period 1410–15, to which some have ascribed it (Fabriczy 1892; Lisner 1970), seems too early. Sometime closer to 1425 appears most likely, judging not only from its anatomical accuracy but also from its resemblance—already noted by Lisner ("Michelozzo," 1968)—to the Crucifixion in Masaccio's *Trinity* fresco in Santa Maria Novella from about 1426–28. The most obvious of these are the nearly rectangular torso, the sharp, bony shoulders, the high, trapezoidal chest, the way the left hip is turned out, and the inward twisting of the feet.

The *Crucifix* was restored in 1977. Its polychrome surface is original (Paolucci 1977); however, its loincloth has been lost. As was sometimes the case with even earlier Tuscan crucifixes, the garment was apparently made of fabric impregnated with plaster (Lisner 1970).

Ghiberti
(1378/81–1455)

Lorenzo Ghiberti was born in Florence in either 1378 or 1381. The ages given for him in his tax declarations from 1427 and 1442 enable us to posit either year for his birthdate. It is also uncertain whether Lorenzo was, in fact, the son of Cione Paltami Ghiberti or of the goldsmith Bartolo di Michele, known as Bartoluccio, the man his mother lived with after separating from her husband, and whom she married once she was widowed. While in his early years he signed himself simply "Lorenzo," and he appears in documents as "Lorenzo di Bartolo" or "Lorenzo di Bartoluccio" from the year 1422 on—presumably to squelch any doubts about his legitimacy—he preferred to use the full name "Lorenzo di Cione di Ser Buonaccorso Ghiberti."

Ghiberti was trained as a goldsmith in Bartoluccio's workshop. It is obvious that he managed to learn the principles of painting at the same time, for in the year 1400, as he himself relates in his *Commentarii*, he went with a fellow painter to Pesaro, where he completed various paintings—no longer extant—in the castle of the Malatestas. Even so, he was clearly back in Florence by 1401, when the Arte di Calimala announced a competition for the East Door (the present-day North Door) of the Baptistry. Winning out over the six other entrants, he was awarded this highly prestigious commission. In 1403, when the contract for the door was drawn up, his workshop was still under the direction of his stepfather, Bartoluccio. It was not until 1409 that Lorenzo became a member of the Arte della Seta.

While at work on this first bronze door (1404–24), he also served with Brunelleschi as an adviser on the construction of the Cathedral of Florence, providing both a model for its dome and designs for several of its stained-glass windows. Also during this same period he executed statues of St. John and St. Matthew for Orsanmichele, two bronze reliefs for the baptismal font in Siena, and various pieces of jewelry that are no longer preserved, including a tiara for Pope Martin V. In about 1415, Lorenzo married Marsilia, the daughter of the wool carder Bartolomeo di Luca. They had two sons, Tommaso in 1417 and Vittorio in 1418. The latter was to take over the workshop after his father's death.

Lorenzo was in Venice in late 1424, and in about 1430 he visited Rome. From 1425 to 1447 he worked on his second bronze door, the so-called *Gates of Paradise*. At the same time he managed to produce the bronze statue of St. Stephen for Orsanmichele, the Shrine of Sts. Protus, Hyacinth, and Nemesius for the Monastery of Santa Maria degli Angeli, the Tomb of Leonardo Dati in Santa Maria Novella, and the Shrine of St. Zenobius in the cathedral in Florence. He also continued to be involved with the construction of the Cathedral itself until 1436. In 1429, together with Brunelleschi, he was commissioned to prepare a model of the entire edifice. In 1435 and 1436 he submitted designs for the decoration of the choir and for the lantern atop the dome, and in 1441–43 he executed additional window designs.

At the age of seventy, after completing the reliefs for the second bronze door, he stopped working as an artist almost entirely. Instead—from 1447 on (Krautheimer 1982)—he devoted himself increasingly to the writing of his *Commentarii*, a treatise still unfinished at his death. In addition to numerous excerpts from ancient authors and his observations on the art of antiquity and art theory, it includes an overview of post-classical art history and even a brief autobiography—the first one we have by an artist. Ghiberti was fascinated with classical art not only as an artist and writer, but also as a collector. The last work definitely attributable to Ghiberti is the small bronze door for a tabernacle in the Church of San Egidio, from 1450. Ghiberti made his will on November 26, 1455, and died only a few days later, on December 1. He was buried in Santa Croce.

Ghiberti [c. 1447]; Manetti [c. 1485]; Vasari [1550, 1568]; Baldinucci [1681–1728]; Rumohr 1827–31; Milanesi 1854–56; Brockhaus 1902; Doren 1906; Poggi 1909 (1988); Bacci 1929; Kauffmann 1929; Krautheimer 1937; Planiscig, *Ghiberti, 1940*; Valentiner 1940; Schlosser 1941; Lotz 1948; Wundram 1952; Pope-Hennessy 1955 (1985); Krautheimer 1956 (1982); Wundram 1963; Brunetti 1966; Zervas 1976; *Lorenzo Ghiberti* 1978; Morselli 1978; *Ghiberti* 1979; Paoletti 1979; Clark 1980; Euler-Künsemüller 1980; *Lorenzo Ghiberti nel suo tempo* 1980; Pope-Hennessy, "Centenary," 1980; Kreytenberg 1981; *L'Oro del Ghiberti* 1985; Perrig 1987; Kecks 1988.

4, 5
The Sacrifice of Isaac

1401–2. Bronze, gilt, 17¾ × 15″ (45 × 38 cm.). Museo Nazionale de Bargello, Florence

For the story of the origin of this relief, see below.

Ghiberti's relief was first preserved in the guild hall of the Arte di Calimala. In 1792 it was moved, together with Brunelleschi's competing one, to the Uffizi. It was placed in the Bargello in 1859. The work is essentially a single casting. Krautheimer (1982) relates that the figure of Isaac, along with Abraham's left hand and the small section of rock below it, were the only pieces added to the original cast. The relief weighs 18.5 kilograms, which makes it considerably lighter than Brunelleschi's, at 25.5 kilograms. Technical advantages such as these may well have influenced the jury in favor of Ghiberti.

In the composition of his relief, Ghiberti is much more dependent on the quatrefoil outline than Brunelleschi is—or for that matter than was Andrea Pisano in the first Baptistry door, as Pope-Hennessy ("Centenary," 1980) quite rightly observes. Having taken into account the quatrefoil's prominent lobes, Ghiberti arranges the main axes by diagonals. However, the placement of the pairs of figures side by side essentially in the foreground is still somewhat indebted to the reliefs of Andrea Pisano, as is the treatment of the outcropping of rock. Ghiberti's forms are more tightly integrated, to be sure, and his details much more specific. His rocky terrain is laid out more elegantly, his figures convey greater movement and balance each other more gracefully.

One recognizes in the superb nude figure of Isaac not only a thorough study of antiquity but also a new appreciation for the beauty of the naked human form. In its narrative style, the relief continues to be indebted to the Giottesque tradition. This is especially evident in the two grooms standing to the side, who look at each other in dismay as one of them discreetly points toward the sacrificial scene. Their presence, although not the manner of their portrayal, is called for by the Biblical narrative. However, accompanying figures like these, providing commentary on the central event, are a standard fixture in the narrative repertoire from Giotto onward. In Brunelleschi's relief their dramatic value is markedly different.

All in all, Ghiberti is reserved in portraying his sacrifice scene so that he has not compromised the statuesque loveliness of his figures or the flow of curves dominating his composition. This is evident in the figure of Abraham, who has taken hold of the bound Isaac from behind and is pointing his knife at the victim's throat with his right hand, yet whose body, from head to foot, describes a curve in the opposite direction. In this way the Abraham figure fits nicely against the ridge of rock running up through the center and also provides a curving line leading to the upper right semicircle of the frame with its approaching angel, on whom the young Isaac has fixed his gaze. The connection between the figures is established not so much through violent contact or even touching as through their complementary postures and their respective glances. Like the handling of the drapery, this formal elegance, the dominance of the "exquisite curve" (Schlosser 1941), and the corresponding sublimation of the dramatic climax reveal an indebtedness to the International Gothic style that is typical of Ghiberti's early period.

6–11; figs. 1, 2
North Door of the Florence Baptistry

1404–24. Bronze, partially gilt, 15′ × 8′3″ (without frame) (457 × 251 cm.). Baptistry, Florence

Andrea Pisano had created the Baptistry's first bronze door, the South Door (fig. 2), between 1330 and 1336. Shortly afterward—as early as 1338/39 (Krautheimer 1982)—it was decided that a second door should be created to match. However, it was not until sixty years later that this task was accomplished. To determine the artist best suited to the project, the Arte di Calimala, the guild responsible for the Baptistry, announced a competition in 1401. According to Ghiberti's account, seven artists took part: Simone di Colle Val d'Elsa, Niccolò d'Arezzo, Jacopo della Quercia, Francesco di Valdambrino, Niccolò di Pietro Lamberti, Brunelleschi, and Ghiberti himself. Each was required to submit a sample relief depicting the Sacrifice of Isaac, and all of them—or at least so we are told by Ghiberti, writing in about 1477—managed to do so within the year. As the subject matter of this trial relief would suggest, the door was originally supposed to present scenes from the Old Testament and not from the life of Christ, which is what Ghiberti, the winner of the competition, ultimately supplied. When the guild agreed to this change in program, it also decided to mount the doors on the Baptistry's east side instead of the north, that is, in its main portal. The sample relief from the competition was to be saved for use in another door—a third—made up of Old Testament scenes.

Following the scheme of Pisano's existing door, Ghiberti's is divided into twenty-eight tall rectangular panels within which the figural scenes are further enclosed in quatrefoil frames. Smaller quatrefoils, each containing the head of one of the prophets—among them a self-portrait of Ghiberti—stand at the intersections of the panels. The sequence of New Testament scenes (fig. 1) begins on the left of the third row from the bottom with the Annunciation and continues upward across both doors, ending in the upper right-hand corner with the Miracle of Pentecost. As in Pisano's door, the eight lower panels contain solitary figures. The bottom row presents the four Church Fathers, the row above the four Evangelists. Surrounding the whole is an exquisite frieze of flowers and foliage teeming with little animals, one that eloquently attests to the profound fascination with plant life that is especially typical of Ghiberti and, following his example, of the art of the Early Renaissance generally. Above the depictions of the Nativity and the Adoration, the door bears the inscription OPUS LAURENTII FLORENTINI.

The contract with Ghiberti and his stepfather Bartolo di Michele was drawn up on November 23, 1403. Three reliefs—for which the payment was to be 200 florins apiece—were to be completed each year, but as it turned out it took the artist twenty years, from 1404 to 1424, to produce the twenty-eight reliefs. The completed doors were installed in the east portal of the Baptistry on April 19, 1424, and were only moved to the north portal after Ghiberti had finished his second set.

Nothing is known of the progress of the work itself. However, as might be expected, given the length of the project, it is possible to trace the artist's stylistic development from panel to panel, and this suggests that the reliefs were by and large produced in narrative order (Wundram 1952; Krautheimer 1982). From the earliest ones (The Annunciation, plate 7; Nativity; Adoration of the Magi, etc.) to the latest (Christ Bearing the Cross; The Resurrection, plate 10; The Miracle of Pentecost) one notes an increasing variety and density in his composition. His narrative style becomes more dramatic, his treatment of space more illusionistic. Little by little he abandons the use of diagonals in arranging his figures, instead favoring groupings that fill the entire plane of the relief yet are more three-dimensional. In the late reliefs, even his architectural backdrops tend to be parallel to the relief surface rather than being set at an angle.

It is clear that the very last panels to be completed were those depicting the Church Fathers and the Evangelists, for in them the figure increasingly comes into its own vis-à-vis the drapery. The thrones and lecterns also begin to reveal hints of a kind of perspective not found in Ghiberti heretofore and to rely on a new use of flat relief. Despite these obvious changes through the years, the artist still clings to the Gothic figural canon in all his reliefs for this first door and persists in arranging his compositions in deference to the quatrefoil frame. This is especially true of the scenes with smaller numbers of figures that lack architectural backdrops (Baptism of Christ, fig. 6; Temptation of Christ; Crucifixion).

7
The Annunciation

Bronze, partially gilt, 15⅜″ square quatrefoil (39 cm.). North Door, Baptistry, Florence

All of the purely architectonic backdrops in the reliefs of the North Door—like those on the door by Andrea Pisano—rise up

Christ Bearing the Cross	Crucifixion	The Resurrection (plate 10)	Pentecost
Christ on the Mount of Olives	The Arrest	The Flagellation (plate 9)	Christ Before Pilate
The Transfiguration	The Awakening of Lazarus	The Entry into Jerusalem	The Last Supper
The Baptism of Christ (fig. 6)	The Temptation of Christ	The Cleansing of the Temple (plate 8)	The Storm at Sea
The Annunciation (plate 7)	The Nativity	The Adoration of the Magi	The Twelve-year-old Christ in the Temple
St. John the Evangelist	St. Matthew (plate 11)	St. Luke	St. Mark
St. Augustine	St. Jerome	St. Gregory the Great	St. Ambrose

1 North Door, Baptistry, Florence. Pictorial program (after Krautheimer)

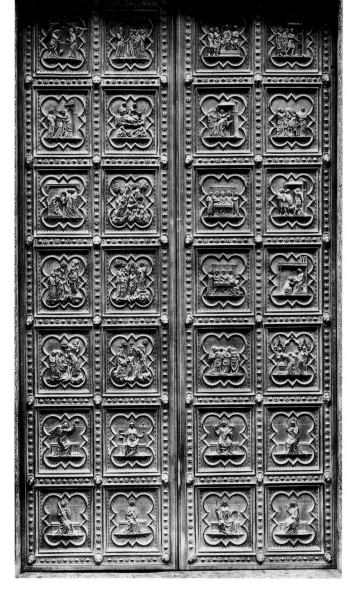

2 Andrea Pisano. Bronze Door. South Portal, Baptistry, Florence

from a narrow shelf supported by small consoles. Such is the case with the aedicula serving as a backdrop for Mary in the first of the series, depicting the Annunciation. The Virgin is visibly startled and raises her arm as though to protect herself from the angel approaching from the left, his right hand raised in salutation. Yet her curving posture is one of elegance and calm. The import of the scene is underscored by an additional motif: the half-figure of God the Father emerges from the clouds above, sending earthward the dove of the Holy Spirit. The graceful curves of the two main figures and the diagonal scheme underlying the entire composition are subtly attuned to the quatrefoil border. The slanted placement and blocklike isolation of the architecture still echo the practice of Andrea Pisano. Already in the third relief, however, with the Adoration of the Magi, one

notes that the architecture is more subtly detailed as it recedes, also more closely linked to both the figural groupings and the background surface.

8
Christ Driving the Moneychangers from the Temple

Bronze, partially gilt, 15⅜″ square quatrefoil (39 cm.).
North Door, Baptistry, Florence

This scene presents a degree of drama and density of composition wholly new to Ghiberti. Christ throws his whole body into the violent gesture with which he clears the dealers out of the temple. Other innovations are the way the figures are uniformly disposed across the breadth of the relief, the way they appear in

355

layers, one behind the other, the way the entire grouping seems self-contained, thanks to the central figure with his back to us, and—not least—the manner in which the architecure has been placed well behind the group of figures so that it serves as a backdrop for the entire scene. The figures and the arrangement of the space in which they move seem more independent of the confines of the Gothic border than they are in the earliest reliefs for the door. Undoubtedly this is a response to revolutionary changes in the concept of the relief and of the scene that Donatello introduced in his *St. George* relief (see plate 50).

9; fig. 3
The Flagellation of Christ
Bronze, partially gilt, 15⅜″ square quatrefoil (39 cm.).
North Door, Baptistry, Florence

Compared to the earlier scenes, this carefully balanced composition reveals a greater clarity and concentration, a new subtlety in the gradation of the relief. It is significant that the base shelf projects further forward than the one in the *Annunciation* relief. A delicate portico rises from the base, rendered in perspective and made up of two rows of fluted columns with Composite and vaguely Corinthian capitals. Christ is bound to the center column in the front. The bodies of the men to his left and right twist dramatically as they draw back to strike him.

3 Ghiberti. Studies for a *Flagellation of Christ*. Albertina, Vienna

While the rectangular front of the portico forms a distinct contrast to the quatrefoil frame, the curving bodies and expansive gestures of the two flagellants are carefully plotted so as to reflect its form.

Toward the center, however, the extreme violence of their movement is balanced and reassimilated into the architecture of columns by two additional figures. Each of them—one soldier points at Christ with his left hand while the other fixes him with his gaze—is positioned between two of the outer columns, although it is not altogether clear whether they stand in front of them or behind them. Here as well, the architecture serves only as a framework, providing form and stability to the arrangement of figures. A drawing in the Albertina that is ascribed to Ghiberti (fig. 3) and is, therefore, the only sketch to survive by a sculptor from the first half of the fifteenth century, presents five preparatory studies for the pair of flagellants. These make it clear that the left-hand figure was originally meant to be balanced on the right by a figure seen mainly from the back.

10
The Resurrection

Bronze, partially gilt, 15⅜″ square quatrefoil (39 cm.).
North Door, Baptistry, Florence

Like all of the late reliefs on the North Door, this one is no longer composed in accordance with the diagonal axes of the quatrefoil frame, but relies instead on a system of verticals and horizontals that emphasizes pictorial symmetry. Sleeping soldiers have been placed in front of the sarcophagus to provide foreground interest. Like the composition of the *Crucifixion* relief, the central figure of Christ hovering above the sarcophagus appears to be placed somewhat behind the foreground figures and seems slightly smaller. There is more contrast in the surface textures than in the earlier reliefs, gradations in the rocky terrain are more pronounced, and the vegetation is richer. The rock formations and the bushes or trees appear to be increasingly independent of the figures; they have become separate compositional elements serving to structure the space. This is especially true on the left side of the relief, where the more two-dimensional treatment of the rocks and plants lends a certain depth to the landscape.

11
St. Matthew

Bronze, partially gilt, 15⅜″ square quatrefoil (39 cm.).
North Door, Baptistry, Florence

The seated Evangelist has turned so as to listen to the angel, his traditional symbol. With his left hand he balances a book on a writing desk; in his right hand, which rests on his thigh, he holds a quill pen. His posture, the distinct emphasis on his upper body as opposed to his legs, and the hand resting on the thigh are clear borrowings from Donatello's *St. John* (plate 46), completed in 1415, who also once held a quill pen in his right hand. The angel's wafting cloak, so full of movement given the restful pose of the figure itself, is a motif that Ghiberti may well have taken from Donatello's *St. George* relief (plate 50). The way the figures

and the writing desk seem to fade into the background is similar to the technique employed in the reliefs of the Storm at Sea and the Transfiguration from the same door. The softness in the drapery also conforms to these reliefs and somewhat more to Ghiberti's *St. Matthew* and *St. Stephen* (plates 13 right, 18) than to his *St. John* (plate 12), which would indicate that the *St. Matthew* relief, along with the remaining reliefs in the bottom two rows, was executed between 1420 and 1424.

12, 13 left; fig. 4
St. John the Baptist

1413–16. Bronze, 8′4⅜″ high (255 cm.). Orsanmichele, Florence

For the Arte di Calimala, which had commissioned him to create the second bronze door for the Baptistry in 1403, Ghiberti also executed the statue of St. John the Baptist for Orsanmichele between 1413 and 1416. It was the first large statue in bronze to be erected in Florence, and Ghiberti was required to cover the cost of casting it himself (Baldinucci 1681–1728). He placed his signature along the hem of the Baptist's robe: OPUS LAURENTII.

In this statue, more than in any other work, Ghiberti approaches the International Gothic style. He reveals himself to be equally far removed from both the ostentatious physicality of the statues of Giovanni d'Ambrogio or Niccolò di Pietro Lamberti (fig. 4), still rooted in the tradition of the Trecento, and the innovative and far more subtle statuary of the early Donatello, whose *St. Mark* for Orsanmichele had just been completed in about 1413 (plate 44). The strictly frontal composition of the *St. John* figure, the sideways thrust of its hips, the relaxed placement of its hands on either side, the polygonal base—all of these are still in accord with the older tradition. The collar formed by excess fabric in the robe and the prominent, sharply defined curving folds are more strongly emphasized than in most Florentine statues of this period. All that one sees of the body beneath the drapery is the free leg, extended to the front, which serves to underscore the bending of the hips. Of the supporting leg, which appears to be extremely short compared to the free one, we see nothing but the foot. Since the drapery virtually nullifies the body beneath it, the head takes on a special importance, further heightened by the wild luxuriousness of the hair.

13 right
St. Matthew

1419–22. Bronze, 8′10¼″ high (270 cm.). Orsanmichele, Florence

Ghiberti was given the commission for a bronze statue of St. Matthew for the niche of the Arte del Cambio on Orsanmichele on July 21, 1419. The work was completed in 1422. Along the hem of its robe it bears the inscription OPUS UNIVERSITATIS CANSORUM FLORENTIAE ANNO MCCCCXX (the date 1420 designates the completion of the wax model). Ghiberti also designed the tabernacle architecture, the construction of which was begun in May 1422, but the work was carried out by the stonemasons Jacopo di Corso and Giovanni di Niccolò.

4 Niccolò di Pietro Lamberti. *St. Luke*. Museo Nazionale de Bargello, Florence

The niche and its figure clearly show Ghiberti moving away from the formulas of the International Gothic style, taking his bearings instead from the architecture and sculpture of Donatello. Unlike his *St. John*, created roughly eight years before (plate 12), the statue of St. Matthew is clearly conceived from the body outward. The robe, although still full of Gothic reminiscences, is arranged accordingly and no longer enfolds the body in virtually independent, sumptuous drapery. Thanks to the reduced amount of fabric and the relative tautness of its folds, the figure itself is more physical, its posture more clearly perceived. This innovation, not to mention the twisting of the figure in its niche, the way the right hand is poised in front of the body, and the interplay between this suspended hand and the searching gaze above it, is inconceivable without the examples of Donatello's *St. Mark*, *St. John*, and *St. George*. Even the rectangular plinth is a borrowing from the latter work (plate 48).

The architecture of the niche reveals a blend of Gothic and

Early Renaissance forms characteristic of Ghiberti at this period. Compared to the older, Gothic niches set into Orsanmichele, his rectangular frame surrounding the pointed arch of the niche itself, his triangular gable resting on the cornice above it, and his more sparing use of ornamental plant forms and classical decor are distinct innovations. A flat scallop-shell calotte and fluted pilasters with Corinthian capitals adorn the niche's interior. The coat of arms of the Arte del Cambio is set into the gable, which is flanked by two female finial figures. These were executed sometime after 1422 and are generally thought to be by Michelozzo (*Lorenzo Ghiberti* 1978), although Kreytenberg (1981) prefers to attribute them to Ciuffagni. The niche's rectangular frame, shell calotte, fluted pilasters, and overall classical feeling would suggest that in designing it for his *St. Matthew*, Ghiberti drew heavily on the example of Donatello's *St. Louis* tabernacle (fig. 28), while simplifying its array of classical forms and subjecting them to a veneer of Gothicism that is typical of him.

14, 15; figs. 5, 6
St. John the Baptist Before Herod; Baptism of Christ

c. 1424–27. Bronze, gilt, 24⅜ × 23⅝″ (62 × 60 cm.); 24⅜ × 24¾″ (62 × 63 cm.). Font, Baptistry, Siena

The idea of erecting a new font (fig. 5) in the Siena Baptistry was first broached in 1414. In the following years some of the most illustrious Tuscan sculptors were to work on its ornamental statues and reliefs. A team of stonemasons was commissioned to do the marble work in May 1416. Between June 1416 and May 1417, Ghiberti was called to Siena three times to advise in the planning of the font. Above all he is responsible for the idea of placing gilt bronze reliefs on the basin's six sides. Two of these, with scenes from the life of the Baptist, were executed by Ghiberti himself. He was given the contract for them on May 21, 1417.

Commissions for the remaining four had been awarded in the previous month: two to Jacopo della Quercia, and two to Turino di Sano and his son Giovanni. Ghiberti was given a deadline of ten months apiece for his two reliefs, but he failed to deliver them in time. It was not until June 1425, after the Sienese had threatened to annul his contract, that Ghiberti finally sent one of his reliefs for their approval. Then on August 2, 1425, he informed the Operai of the cathedral in Siena that the second relief was also finished (meaning that the casting was completed). Both were dispatched to Siena for final review in early March 1427, and their chiseling and gilding were accomplished immediately afterward, from April to October. On November 15, 1427, after a dispute about payment had been settled, they were transported to Siena for good.

In the original contract from 1417 it was indicated that Ghiberti would also be commissioned to do the six bronze statuettes for the corners of the font, but these were ultimately entrusted to Donatello, Giovanni di Turino, and Goro di Ser Neroccio (see page 390). Of the two reliefs Ghiberti produced for the font, the one depicting St. John the Baptist before Herod (Luke 3:19) is clearly the first one he completed. Even so, it is unlikely that it was executed as early as 1420, as Krautheimer

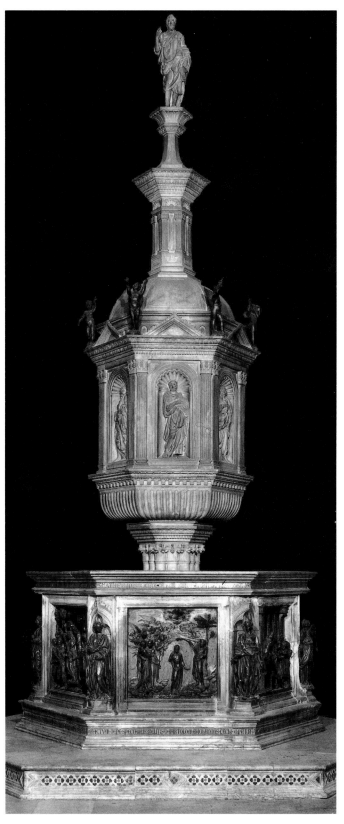

5 Baptismal Font, Baptistry, Siena

otherwise Ghiberti would hardly have postponed sending it to Siena until June 1425.

Its figures are all compressed into the foreground, in front of

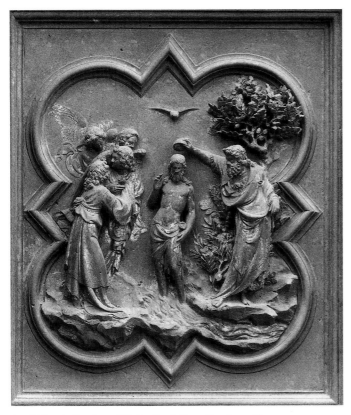

6 Ghiberti. *Baptism of Christ*. North Door, Baptistry, Florence

achieved by a gradation from almost full three-dimensionality to bas-relief and by letting the figures fade into the background surface with its suggestion of clouds. In his rudimentary use of *rilievo schiacciato* (squashed relief), he is undoubtedly imitating the early reliefs of Donatello (the *St. George* relief and the *Salome* relief in Siena). The strong physiognomies of his angels and their distinctly classical hairstyles further confirm this indebtedness. However, Ghiberti is clearly making use of new methods of modeling in only a limited way. As before, the play of curves created by the elegant poses of his figures, wholly independent of the picture's rectangular shape, constitutes the underlying framework of his composition.

16
Tomb of Leonardo Dati

c. 1426–27. Bronze, 90⅛ × 34½″ (229 × 87.5 cm.). Santa Maria Novella, Florence

Leonardo Dati, master of theology and from 1414 on minister general of the Dominican Order, died on March 16, 1425. It is not known when Ghiberti began work on the bronze effigy for his tomb. In any case, it was completed by the summer of 1427, for it is clear from Ghiberti's tax declaration of July 9, 1427, that at that point the monks of Santa Maria Novella still owed him 10 florins for it. It was originally installed in the monks' choir, but was moved to the Rucellai Chapel in 1956.

The deceased is depicted in the habit of the Dominicans. His hands are crossed above a book, and in his right he holds a small staff. There is an almost complete absence of ornament. The sole decoration is on the pillow, but it—like the features of the face—has been badly worn away. In his *Commentarii*, Ghiberti stresses that one of the special things about this work was that he had sculpted the head of the deceased *al naturale*—presumably from a death mask. He goes on to say that the bronze was in low relief and that there was an inscription panel at its foot.

These are not the only noteworthy features of the work, if one compares it to earlier tomb effigies from the fifteenth century. The extreme simplicity of the work, its rectangular frame, and the manner in which the figure appears to stand so solidly on the bottom of the frame are all without precedent. Compared to it, the two marble tomb effigies Ghiberti designed for Santa Croce, those of Lodovico degli Obizi (d. 1424) and Bartolomeo Valori (d. 1427), seem relatively old-fashioned. The twisting of Dati's head to the side and the crossing of his hands above his stomach are features common enough in older Florentine examples, yet here the hands and face have been modeled with a far greater degree of delicacy and expressiveness than tradition demanded. The low relief and the classical-style epitaph at the bottom of the slab are also found in Donatello's tomb effigy of Bishop Pecci in Siena (plate 72).

17
Shrine of Sts. Protus, Hyacinth, and Nemesius

c. 1427–28. Bronze, 22 × 41¾ × 15⅜″ (56 × 106 × 39 cm.). Museo Nazionale del Bargello, Florence

Baptist, surrounded by a tight ring of soldiers, stands before the thrones of the royal couple, one hand raised against them in accusation, the other pointing imploringly toward heaven. Herodias has lifted her right hand to her breast—as though wishing to protest her innocence—and in so doing has turned toward Herod. With a lordly gesture, the latter commands that his accuser be led away, and the soldier in the center, who has placed his hand on John, is just about to obey.

The jutting of the slanted dais out of the relief frame and the details of the palace architecture have parallels in the later reliefs from Ghiberti's first Baptistry door. However, the figures here are considerably different. Their physiognomies are noticeably stronger and coarser, with emphasis on the cheekbones and eyebrows. Their hair is styled in a more classical manner. Moreover, their expressions have a gravity about them that is nowhere evident to this degree in the reliefs of the North Door. This, as well as the distinctly martial faces of the heads thrust up between the arcades, suggests that Ghiberti was influenced—at least during the period when he was chiseling the relief (April to October 1427)—by Donatello's *Salome* relief for Siena (plate 68).

The relief depicting the Baptism of Christ is surely the one that was cast in the summer of 1425 (plate 15). A comparison with the *Baptism* relief on the North Door of the Baptistry (fig. 6) makes it especially apparent how greatly Ghiberti's development in these years was influenced by Donatello. Here, more emphatically than in Ghiberti's early work, the relief is perceived as a *picture* and an actual space. There is now a definite depth corresponding to the breadth of the figural composition. It is

Florence's Camaldolese monastery, Santa Maria degli Angeli, acquired the relics of Sts. Protus, Hyacinth, and Nemesius in 1422. Cosimo de' Medici and his brother Lorenzo—apparently at the urging of Ambrogio Traversari—commissioned this bronze shrine in which to house them, and the relics were placed inside it in 1428. It is by no means certain that Ghiberti began work on the shrine as early as 1425, as Krautheimer (1982) suggests. From the tax declaration of July 9, 1427, we see that the shrine was then still in Ghiberti's workshop and that he was still owed 65 of the 200 florins agreed upon as the total price for it. An inscription originally on the base of the shrine, but no longer there, has been passed down to us by Vasari (1568) and others. It told of the ceremonial dedication of the shrine and interment of the relics in 1428. The shrine was removed from the monastery in about 1800, and in 1814—missing its back wall— it came into the hands of the Florence museum administration. In 1878 it was placed in the Bargello. It was restored in 1947.

The shrine's chief decoration is on the front, where two hovering angels hold a wreath of olive branches inside of which is a Latin inscription referring to the relics. The strongly classical character of the whole design and its individual details is striking. The basic heraldic motif—angels, inspired by classical Victories, presenting a wreath—had been used by Donatello, although in a quite different manner, on the base of his *St. Louis* tabernacle (fig. 28). This is the first time Ghiberti clothed his angels not in the traditional manner, with tunic and pallium, but rather *all'antica*, that is to say, in sleeveless, double-belted, peploslike garments resembling those worn by the princess in Donatello's *St. George* relief and by the angels in his Brancacci relief. Another Donatello touch, one that first appears in his *Sibyl* (plate 62) from the Porta della Mandorla, is the headband these angels wear.

Ghiberti makes up for the loss of richness in the movement of the drapery, owing to these more close-fitting garments, by using long stoles that decoratively reflect the curves of the figures. The figures have been greatly elongated to adapt to the narrow rectangle of the shrine's front wall. Although they display a certain amount of gradation from high to low relief, they do not actually fade into the background surface, and there is no illusion of space in the overall composition. Like the figures, the inscription is presented in the classical manner. Ghiberti explicitly refers to it in his *Commentarii*. Two scrolling vines adorn the lid of the shrine, while each of the ends has a tall, oval shield framed by a wreath of palm branches and bearing the Medici coat of arms.

18; fig. 7
St. Stephen

1427–29. Bronze, 90½" high (230 cm.). Orsanmichele, Florence

On April 2, 1425, the Arte della Lana decided to replace the century-old marble figure of St. Stephen in their niche on Orsanmichele with a new statue in bronze. However, nothing had been done by 1427, for in that year the commission charged with overseeing the contract was reappointed. A short time later, however, in February 1429, the completed statue was placed in

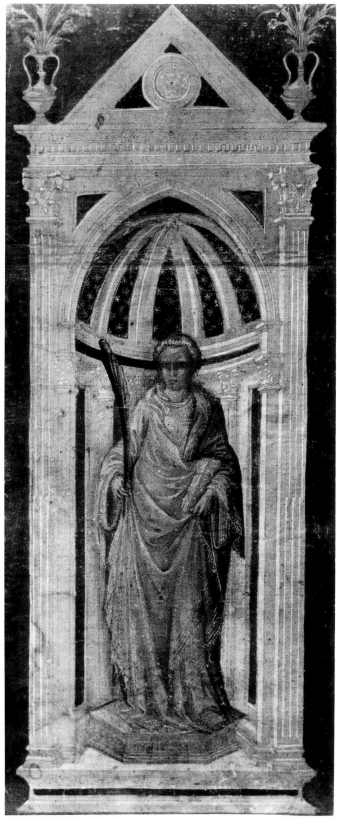

7 Ghiberti workshop. Presentation drawing for *St. Stephen*. Louvre, Paris

its tabernacle. The tabernacle architecture itself is the original design from the Trecento.

The statue of St. Stephen has little of the expansive movement and pathos of the earlier *St. Matthew* (plate 13 right). Drapery,

structured according to traditional Gothic formulas, has reasserted itself, although here it is no longer wholly independent of the body as it was in Ghiberti's early period. The pose of the figure is relaxed and untroubled, yet for all its restraint, both in gestures and drapery motifs, it fills the depth of its niche more emphatically than the *St. John* and *St. Matthew* do theirs. The knee and foot of the free leg press straight ahead, just as the eyes gaze fixedly forward. In the earlier statues this leg was placed to the side at a diagonal. The figure's depth is further emphasized by the manner in which the right forearm reaches forward into space—it is likely that the right hand once held the palm branch of a martyr—and by the slant of a book locked in the curve of the left arm. This tendency toward full three-dimensionality was something Donatello had developed a short time before in his *St. George*, his *St. Louis*, and his Campanile statues.

When working out the physiognomy of *St. Stephen*, most remarkable for its emphasis on the protruding brow, it is likely that Ghiberti referred to classical models. A drawing from Ghiberti's workshop, preserved in the Louvre (fig. 7), represents an early stage in the planning for the figure and its tabernacle. It depicts the statue in a Renaissance tabernacle and was obviously intended to be submitted to the guild commissioning the work (Kauffmann 1929).

19–24; fig. 8
East Door of the Florence Baptistry

1425–52. Bronze, gilt, 16′8″ × 9′5″ (with frame) (506 × 287 cm.). Baptistry, Florence

With the bronze door he completed in 1424 (plate 6), Ghiberti clearly fulfilled the expectations of his patrons to their complete satisfaction, for only a short time later the Arte di Calimala commissioned him to produce still another Baptistry door. The contract was concluded on January 2, 1425. Even earlier, presumably in the summer of 1424, the humanist and chancellor of the Florentine republic Leonardo Bruni had drawn up a pictorial program for the new door that provided for twenty scenes from the Old Testament and eight prophet figures. In a letter to Niccolò da Uzzano and the other members of the commission charged with overseeing the work, Bruni lists the events he had selected in some detail and adds that in choosing them he was concerned that the scenes be both *illustri* and *significanti*. The former, he explains, are such that delight the eye with the variety of their design (*varietà di disegno*), while the latter occupy the mind and are highly memorable (*che abbino importanza degna di memoria*).

Following the pattern of the two earlier Baptistry doors, Bruni's design for the new one still called for twenty-eight panels—twenty scenes and eight single figures—but this scheme was soon abandoned. Even at the start of the work, which Krautheimer (1982) places in 1428–29, the number of panels was reduced to twenty-four, a division that is still preserved on the back of the door. A short time later—about 1429–30, according to Krautheimer (1982), but the precise timing is uncertain—there was a second change of plan in which the large number of panels originally called for was reduced to ten large-format square reliefs. Altogether, this final and truly innovative

Eve				Adam	
Ezekiel (?)	*Adam and Eve* / The Creation of Adam / The Creation of Eve / The Fall / The Expulsion from Paradise (plate 20)	Jeremiah (?)	Prophetess	*Cain and Abel* / The Primeval Parents Before their Hut / Abel Watching his Sheep / Cain Plowing his Field / Cain and Abel Sacrificing / Cain Killing Abel / God the Father Calling Cain to Account (plate 21)	Job (?)
Elijah (?)	*Noah* / The Emergence from the Ark / Noah's Sacrifice in Gratitude / Noah's Drunkenness	Jonah	Hannah (?)	*Abraham* / Abraham Encountering the Three Angels / The Sacrifice of Isaac	Samson
Prophet	*Jacob and Esau* / Rebecca Praying to God / Rebecca in Childbed / Esau Selling his Birthright to Jacob / Isaac Sending Esau on the Hunt / Jacob Bringing Back a Ram / Isaac Giving his Blessing to Jacob (plate 22)	Rachel (?)	Prophet	*Joseph* / Joseph Being Sold by his Brothers / The Gathering of the Grain / The Discovery of the Silver Cup / Joseph Reveals Himself to his Brothers (plate 23)	Prophet
Miriam	*Moses* / Moses Receiving the Tablets of the Law / Israel on Mount Sinai	Aaron	Joshua	*Joshua* / The Israelites Crossing the Jordan / The Erection of the Stone Marker / The Fall of Jericho	Gideon (?)
Judith	*David* / David Slaying Goliath / The Entry into Jerusalem	Nathan (?)	Daniel (?)	*The Meeting Between Solomon and the Queen of Sheba* (plate 24)	Bileam (?)
Noah				Puarphara	

8 Pictorial program of the East Door (after Krautheimer)

scheme proved to be much more concentrated and imposing.

Nothing is known about the progress of the work until 1437. On April 3 of that year (Krautheimer 1982) the casting of the ten reliefs and of twenty-four portions of the figural frames was completed, and Ghiberti, his son Vittorio (?), and Michelozzo could begin their chasing. A document from July 4, 1439, reveals that at that point two of the reliefs (*Cain and Abel, Jacob and Esau*) were completely finished, a third (*Moses*) virtually done, and a fourth (*Joseph*) half-finished, while a fifth (*Solomon*) was barely begun. The chiseling of the entire set of reliefs was completed in August 1447; however, their gilding was only begun in April 1452. The door was finished in June 1452, or twenty-seven years after it was commissioned (plate 19). Taking

into account its extraordinary beauty (*stante la sua bellezza*), the consuls of the guild decided, on July 13 of that year, to install the door not on the north side of the Baptistry—as originally planned—but rather on its east side in the place of honor, opposite the facade of the Cathedral.

The doorway itself is framed by a splendid festoon, completed by Vittorio Ghiberti in 1462, consisting of bunches of flowers, leaves, and fruits with animals nesting among them. The reliefs run in sequence from upper left to lower right. They are framed by borders interrupted by niches sheltering figures of prophets, sibyls, and Old Testament heros (for their identification see fig. 8). Between these niches and at the four corners of each door are men's heads set in circular medallions. The two heads in the center at eye level are portraits of Ghiberti and his son Vittorio. Next to these, across both doors, runs the inscription LAURENTII CIONIS DE GHIBERTIS MIRA ARTE FABRICATUM.

The borders are highly decorative, of course, but in addition, both in their proportions and their pictorial program, they are precisely keyed to the reliefs themselves. Since they set off the five panels of each door as a group, one has an initial impression of two great vertical bands of reliefs, with the structural framework supporting them clearly visible. The pictorial reliefs and their setting are balanced in such a way as to present a single grandiose statement. The clarity and power of this arrangement result from the decision to have only ten reliefs—square ones— on the two doors. How this decision was reached we do not know, for it is nowhere documented, but it was primarily an artistic one and must have been influenced by the new pictorial concept and relief style represented by Donatello's *St. George* relief from 1417.

We can see from the last reliefs of his first door and the two in Siena that Ghiberti had gradually incorporated these innovations in his own work. It is perfectly plausible, then, that it was Ghiberti himself who chose to abandon the scheme of the two older Baptistry doors, which by about 1425–30 had become wholly outmoded, and convinced his patrons to go along with his new one. A reference in his *Commentarii* (II, 22) would seem to suggest as much. In Ghiberti's account, he stresses that the door's scenic reliefs are extremely rich with figures (*molto copiose di figure*) and that in them he had done his best to imitate nature (*imitare la natura quanto a me fosse possibile*). He proudly points out that some of the reliefs contain upwards of a hundred figures and that all of these figures and the architectural settings in which they are placed are modeled in accordance with the laws of perspective (*colla ragione, che l'occhio li misura*). He also takes pains to note that a single panel (*quadro*) frequently incorporates a number of different scenes (*effetti*). This permitted him not only to accommodate a large number of figures (*copia*) in each panel, but also to present a total of twenty-four Old Testament events even after reducing the number of reliefs to ten.

The practice he boasts of was outmoded, however. It had been superseded by a new concept of the picture as an illusion of reality with a single point of view. Ghiberti had clearly become aware of this himself, for the abundance of juxtaposed *effetti*, so characteristic of the first six reliefs, is distinctly reduced in the final four. As a result, these last ones seem more focused and, with their increasing use of bas-relief, provide a greater illusion of spatial depth. It seems clear that these panels, like those of

the North Door, were created essentially in narrative sequence. It is difficult to believe that the lower reliefs were the first ones completed, as Pope-Hennessy suggests ("Centenary," 1980).

Ghiberti ends his account of his work on the door with the comment: *E la più singolare opera ch'io abbia prodotta* (It is the most splendid work I ever created). According to Vasari (1550), it was Michelangelo who first referred to the door as the Gates of Paradise. The door's reliefs were cleaned in 1946–48 and are now (since 1979) being completely restored.

20
Creation of Adam and Eve, the Fall, and the Expulsion from Paradise

Bronze, gilt, 31½″ square (80 cm.). East Door, Baptistry, Florence

Four *effetti*, which according to Leonardo Bruni's scheme were to have been presented in three panels, are here compressed into one: the creation of Adam in the left foreground, the creation of Eve in the center, in the left background the Fall, and in the right foreground Adam and Eve being expelled from paradise (Genesis 1:27–31; 2:7–25; 3:1–24). (The latter scene also includes the figure of God the Father surrounded by angels in heaven, to whom the banished Eve gazes upward in sorrow.) This relief, like the following three from this door, is structured according to a triangular scheme that fully exploits the height of the square panel.

Following tradition, Ghiberti does not hesitate to place one pictorial motif above another, but at the same time he improves on that tradition in that he models the upper portions of the composition in flatter relief so that they appear to be behind the lower ones. The figures of the foreground, executed virtually in three dimensions, occupy a relatively narrow strip of ground. Everything behind these figures still has something of a theatrical backdrop. Particular emphasis is given to the figural groupings in the foreground corners. The overall composition relies for the most part on the figures alone, and on the elegant series of curves linking them together. The figures themselves continue to be exquisitely posed. Because of inconsistencies in the landscape, the space as a whole does not seem fully integrated.

21
Cain and Abel

Bronze, gilt, 31½″ square (80 cm.). East Door, Baptistry, Florence

This story (Genesis 4:1–15), which Bruni would have limited to the fratricide alone, is also expanded into several different scenes. In the upper left Adam and Eve are seated with their two sons before a straw hut. In the middle ground Abel watches over his flock of sheep, while in the left foreground Cain is plowing his field. In the upper right, at the top of the hill, Cain and Abel present their offerings. Below, Abel is slain by his brother, and in the lower right Cain is called to account for his deed by God.

As in the first relief, the separate *effetti* are distributed across the entire pictorial plane, but here the separate events are more clearly set off from each other by landscape forms. In their

arrangement, however, the artist appears to have paid little attention to narrative order. Typically, moreover, Ghiberti has brought the genre scene of Cain plowing his field to the foreground, while underplaying the dramatic climax of the tale—the killing of Abel.

22
The Story of Jacob and Esau

Bronze, gilt, 31½″ square (80 cm.). East Door, Baptistry, Florence

Bruni's program called for the blessing of Jacob, but in this relief as well, Ghiberti has drawn out the narrative with the inclusion of several disconnected episodes (Genesis 25:19–34; 27:1–29). Secondary genre scenes are again given a prominence equal to that of the primary encounter. In the upper right, on the roof of the huge arcade that dominates the background, Rebecca is seen praying to God. To the left, in the background, she lies in childbed. In the center of the arcade, Esau sells his birthright to Jacob. In the center foreground Isaac sends Esau out to hunt game. The young man sets out with his bow to the right in the background, while behind him Jacob hands his mother the kid she requested. The decisive event in the narrative, Jacob's triumph over Esau as he wins his father's blessing by trickery, takes place in the right foreground.

For the first time, Ghiberti here creates a large architectural backdrop. In its individual forms—arcaded columns, pilasters, Corinthian capitals, classical entablature—the structure is indebted to the architecture of Brunelleschi or the architectural drawings of Donatello. Ghiberti also borrows from the latter in his attempt at a consistent, monumental illusion of space, apparent in his perspective treatment of both the architecture and the floor. Even so, the structure remains a backdrop; it is not perceived as being truly three-dimensional. The action takes place essentially in front of it, not inside it.

23
The Story of Joseph

Bronze, gilt, 31½″ square (80 cm.). East Door, Baptistry, Florence

The beginning of the story is presented in the upper right, where Joseph is sold by his brothers to the Midianite traders (Genesis 37:23–28; 41:46–49; 44:1–15). Bags of grain are being collected in the right-hand middle distance, inside the large circular structure. In the left foreground Joseph discovers his silver cup in his brothers' baggage. And finally above this, in the middle distance at the left, Joseph reveals his identity to his brothers.

By juxtaposing two very different structures in the middle ground, Ghiberti here creates a more complex space than that found in his earlier reliefs. In other ways as well his composition reveals a tighter structure and seems more self-contained. He provides the background with a greater degree of scenic, three-dimensional interest and relates it to the foreground more logically. This is achieved in part thanks to the uncommonly large number of figures, especially secondary ones, which he dis-

tributes in loose groupings through the whole breadth and depth of his picture. In so doing, Ghiberti achieves "a new relationship between figural scale and picture space" (Wundram 1952).

24
Solomon and the Queen of Sheba

Bronze, gilt, 31½″ square (80 cm.). East Door, Baptistry, Florence

This last of the door's reliefs does without multiple *effetti*. In his depiction of the festive ceremony, Ghiberti concentrates instead on unity and comprehensibility. The encounter between Solomon and the Queen of Sheba (I Kings 10:1–2) takes place before a basilicalike structure rendered with central perspective and flanked by palace façades. Each is accompanied by a large retinue, and dense groupings of these courtiers fill the space from the foreground to the middle distance. Ghiberti has managed to create a more logical perspective space than ever before. And even though the architecture does not really absorb the figures, remaining essentially a backdrop, the figural groupings relate to the overall space most convincingly. It is worth noting that the foreground, middle distance, and background of the relief are clearly set off from one another, and that the crucial event is now relegated to the middle distance, while the foreground figures basically serve to introduce it, leading the eye to the two monarchs in the center.

Concentric composition of this kind is new for Ghiberti. The inspiration for it and for the monumental architectural prospect may have been Donatello's reliefs from the 1430s, especially the *Drusiana* relief in the Old Sacristy of San Lorenzo (plate 95).

Krautheimer (1982) theorizes that the choice of this subject matter for the relief relates to the coming together of the Greek and Roman churches for the deliberations of the Union Synod in Florence. This is a tempting but altogether hypothetical assumption, wholly unsupported by the dates in question: the decree of union was published on July 6, 1439, while the relief had already been cast at the latest in 1437.

25
Shrine of St. Zenobius

1434–42. Bronze, 25 × 74¾ × 25″ (63.5 × 190 × 63.5 cm.). Cathedral, Florence

In 1428 it was decided to place the bones of St. Zenobius in a new shrine in the easternmost chapel of the Duomo. A competition was announced in February 1432, and in March of the same year Ghiberti was entrusted with the creation of the reliquary. After the artist had failed to complete the work within the three-and-a-half-year deadline agreed upon, the contract with him was annulled in April 1437. Two years later, however—on April 18, 1439—it was renewed. By that time the two side reliefs may well have been cast, and Ghiberti pledged to complete the shrine within a period of ten months. Even so, the record of payments to him as late as August 1442 suggests that work on the reliquary continued until that date.

The long rectangular bronze shrine is adorned on the front and sides with scenes of St. Zenobius's miracles. In the center

the saint revives the child of a pilgrim woman during a religious procession. On the left, he revives another child, this one run over by an ox cart. And on the right, he brings back to life the messenger from St. Ambrose, who had suffered a fall in the mountains. In the side reliefs, presumably cast as early as 1434, the pictorial space is still quite narrow and wholly restricted to the foreground. The clifflike crags with their projecting peaks still resemble the ones in the earliest reliefs for the East Door of the Baptistry.

Within the uniform flatness of the front relief, however, Ghiberti displays a sovereign assurance in the delineation of a vast illusionistic space beyond anything he achieved on the door. Moreover, there is a new suppleness about these figures, and they are integrated into large groupings with a greater degree of naturalness. All of this makes the assumption that the front relief was executed as early as 1437—or even before (Krautheimer 1982; Pope-Hennessy, "Centenary," 1980)—considerably suspect. More likely, it was not undertaken until 1439, which means that we must consider it Ghiberti's last narrative relief.

On the back of the *Zenobius* reliquary, Ghiberti simply reworked his design from the front of the Shrine of Sts. Protus, Hyacinth, and Nemesius (see plate 17). As before, the central motif is a wreath of leaves framing an inscription in classical capitals. This one, referring to the relics of the saint, was composed by Leonardo Bruni. In place of the two single angels from the earlier shrine, Ghiberti here creates opposing groupings of three, one behind the other. These hold the wreath upright as before and point to the inscription within.

26; fig. 9
Tabernacle Door

1450. Bronze, gilt, 13⅜ × 7⅞″ (34 × 20 cm.). Sant'Egidio (Ospedale di Santa Maria Nuova), Florence

This small bronze door depicting God the Father was created for the marble tabernacle that Bernardo Rossellino had executed in 1449–50 for the Church of Sant'Egidio (fig. 9). Ghiberti received payment for it in 1450, and it is thus his last documented work. It was restored in 1978–79.

The Lord, enthroned on a bank of clouds and holding an open book in his left hand, raises his right hand in benediction. He wears a belted tunic and cloak, a stole, and a conical hat similar to one he wears in some of the reliefs—for example the one depicting Adam and Eve (plate 20)—from the East Door of the Baptistry.

It is unusual for the Lord to be portrayed alone, without a retinue of angels. In this case his posture, gestures, face, and

9 Bernardo Rossellino. Tabernacle of the Sacrament. San Egidio (Ospedale di Santa Maria Nuova), Florence

insignia alone serve to communicate his majesty. The rigid, frontal disposition of the figure, carried through to include the strictly orthogonal extension of the hand and forearm, is also remarkable for it is nowhere seen in Ghiberti's previous works.

Jacopo della Quercia
(1374?–1438)

Jacopo della Quercia was born in Siena, presumably in 1374. The son of the sculptor and goldsmith Piero d'Angelo and his wife Maddalena, he was to become the most important Sienese sculptor of the Early Renaissance. Nothing is known about his activities until 1401, the year in which he entered the competition for the second bronze door for the Baptistry in Florence. Among the works that have been attributed to him from this early period are the *Madonna* from the Piccolomini Altar in the

cathedral in Siena (Carli, "Primizia," 1949), the *Annunciation* group in Florence's cathedral museum (Brunetti 1951), and the tomb effigy of San Aniello Abbate in the cathedral in Lucca (Kosegarten 1968).

His first documented work, from 1406, is the *Madonna* for the Silvestri Chapel in the cathedral in Ferrara. He had been given the commission for it in 1403 and was still receiving payments as late as 1408 (Rondelli 1964; 1982). It is likely that a short time later he began work on the Tomb of Ilaria del Carretto in the cathedral in Lucca, a project that probably occupied him until well after 1410. In December 1408 the city of Siena commissioned him to create the *Fonte Gaia*. Work on this major undertaking began in 1414 and lasted until October 1419.

During these same years, Quercia paid repeated visits to Lucca as well, where in 1416, together with Giovanni da Imola, he created the two tomb effigies for the Trenta Chapel in San Frediano. In 1417 he was commissioned to produce two of the bronze reliefs for the new font in the Siena Baptistry, but ultimately he completed only one of them, in 1428–30. About this same time, he created the marble ciborium for the font. In 1421 Quercia received payment for the *Annunciation* group — painted in polychrome by Martino di Bartolomeo in 1426 — that he had created for the Collegiata di San Gimignano. In 1422 he completed the marble altar for the Trenta Chapel in San Frediano in Lucca. His statue of an Apostle for Lucca's cathedral may have been executed a short time before. Although he has also been credited with the console heads on the exterior of that cathedral (Klotz 1967), it is doubtful that they are his work.

In March 1425 he was given the contract for the main portal of San Petronio in Bologna, and in the following years he spent considerable time in that city, with briefer trips to Milan, Venice, and Verona in search of marble. He and his assistants worked on the portal until 1437, but it was still unfinished at his death. He had also been asked in 1433 to produce six statues for Siena's Loggia della Mercanzia, but he never got to them. About 1435 he was commissioned to do the sculptures for the Sebastian Altar that Cardinal Casini had donated to Siena's cathedral, and the fragment of a lunette from this project, showing the cardinal kneeling before the Madonna, is still preserved in the cathedral museum. In the same year Quercia was elected chief architect of the cathedral. He made his will on October 3, and died on October 20, 1438. He was buried in the transept of Sant' Agostino in Siena.

Vasari [1550, 1568]; Cornelius 1896; Schubring, *Plastik*, 1907; Longhi 1926; Lányi 1927–28; Bacci 1929; De Francovich 1929; Nicco 1934; Carli, "Primizia," 1949; Brunetti 1951; Carli 1951; Brunetti 1952; Krautheimer 1952; Pope-Hennessy 1955 (1985); Beck 1962; Morisani 1962; Beck 1963; Rondelli 1964; Beck, "Jacopo," 1965; Hanson 1965; Wundram 1965; Matteucci 1966; Klotz 1967; Kosegarten 1968; Seymour, "Fatto," 1968; Freytag 1969; Beck, *Jacopo*, 1970; Del Bravo 1970; Seymour, *Jacopo*, 1973; *Jacopo della Quercia nell'arte* 1975; Lisner 1976; Bellosi 1977; Bisogni 1977; *Jacopo della Quercia* 1977; Krautheimer 1977; Lisner, "Skulpturen," 1977; Paoletti 1979; Paoli 1980; Gnudi 1981; Rondelli 1982; Bellosi 1983; Beck, "Reflections," 1985; List-Freytag 1985; List-Freytag 1986; Beck and Amendola 1988.

27; fig. 10
Tomb of Ilaria del Carretto

c. 1408. Marble, 26¼ × 96⅛ × 34⅝" (66.5 × 244 × 88 cm.). Cathedral, Lucca

10 Jacopo della Quercia. Tomb of Ilaria del Carretto. Cathedral, Lucca

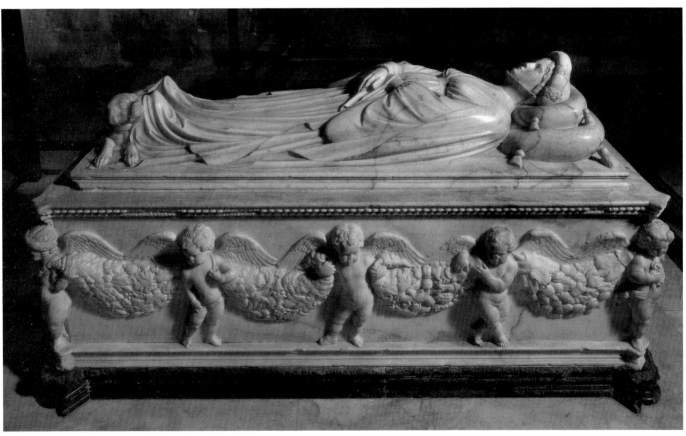

11 Jacopo della Quercia. Presentation drawing for the *Fonte Gaia* in Siena (left side). The Metropolitan Museum of Art, New York

Ilaria del Carretto, who died on December 8, 1405, was the second wife of Paolo Guinigi, Lucca's ruler at the time. Guinigi married yet again in 1407, and since we know that Quercia was in Ferrara from 1406 to 1408, the commission for the tomb may have been given to him before 1406. It was definitely not completed before 1408. After the expulsion of the Guinigi family in 1430, the tomb, originally in the Monastery of San Francesco, was disassembled. Over the course of the centuries it was repeatedly moved. In 1888–89 it was reassembled in the cathedral's north transept. The plate set into the head end of the sarcophagus, bearing the coats of arms of the Guinigi and del Carretto families, was only discovered in 1911. Quercia was first identified as the creator of the tomb by Vasari (1550).

The figure of the deceased is laid out on top of a relatively tall

sarcophagus adorned with putti carrying garlands. At her feet, as a symbol of fidelity, lies a little dog looking up at his mistress. The young woman is dressed in accordance with prevailing French fashion in a high-belted gown with wide sleeves and cowl collar. She is crowned with a circlet ornamented with flowers. The work's almost obsessively smooth finish does full justice to the fashionable elegance of her dress. The putti on the sides of the sarcophagus have not been given the same high, formal polish (fig. 10). These cherubs are borrowed from the sarcophagus sculpture of antiquity, and their varied, dancelike poses seem out of place given the weight of the fruit garlands and the rigid, heraldic repetition of these garlands and the putti's wings.

Ever since Longhi (1926), any number of writers have called

12 Jacopo della Quercia. Presentation drawing for the *Fonte Gaia* in Siena (right side). Victoria and Albert Museum, London

attention to the differences in style between the tomb's individual elements. It would appear that at the very least the frieze of putti and the effigy itself were executed at different times. It is also noteworthy that the slab beneath the effigy is considerably smaller than the base of the sarcophagus. Moreover, the wings of the two flanking putti are not continued across the panel bearing the coat of arms on the head end, although they are on the foot. The ornament on the cornice above the coat of arms is not the same as that of the other three sides. All of this would suggest that the 1889 reconstruction does not reflect the tomb's original design. It is quite possible that portions of various different monuments were incorporated into the present one (List-Freytag 1986).

The putti, which are executed in a different finish, all have distinctly chubby bodies and wear somewhat sorrowful expressions. They were probably not created before the 1420s. The effigy of the deceased, however, is clearly of an earlier date. It is still closely related to the Ferrara *Madonna* of 1406, as the drapery especially reveals. Thus it is impossible that the figure represents Jacopa de' Trinci, the fourth wife of Paolo Guinigi, as List-Freytag has suggested (1985), for she died in 1422. Although we can no longer form any clear notion of the monument's original appearance, it is clear that in general Quercia patterned the work after French examples, of which he may have had firsthand knowledge (Kosegarten 1968).

28, 29; figs. 11–13
Wisdom and Rea Silvia, from the Fonte Gaia

c. 1409–20. Marble, 53⅛″ high (135 cm.); 65″ high (165 cm.). Palazzo Pubblico, Siena

On December 15, 1408, the city of Siena commissioned Quercia to replace an older fountain on the Piazza del Campo with a new one. According to the contract, the sculptor was to produce a detailed sketch of his design on a wall of the council chamber in the Palazzo Pubblico. A new agreement was negotiated as early as January 22, 1409. This one provided for a higher fee and called for a new design, this time to be submitted on parchment. The commission was modified yet a third time in January 1415, and a revised version of the contract agreed upon on December 11 and 22, 1416. Whether or not Quercia had actually begun to work on portions of the fountain in 1409 is uncertain. In any case, the greater part of the work was accomplished between 1414, when he purchased marble for it, and 1419. The final payment was made on October 20, 1419, although Quercia was still engaged on the monument as late as 1420. His fountain, which had become badly weathered (fig. 13), was replaced by a copy in 1868, and in 1904 the original elements—at least those still surviving—were set up in the loggia of the Palazzo Pubblico. The head of *Justice* had been replaced in the sixteenth century; the lower portion of *Rea Silvia* was reworked in 1743.

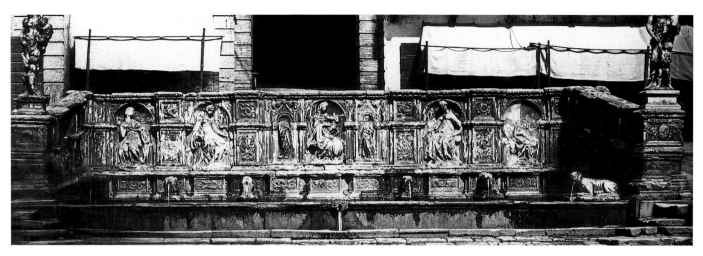

13 Jacopo della Quercia. *Fonte Gaia*. Piazza del Campo, Siena (photograph from 1858)

The fountain wall, its inner surface richly adorned with niches for figures and pilasters, forms an open trapezoid. The central niche is given over to a *Madonna and Child*. It is the only niche flanked by tabernacles containing smaller figures of praying angels and is thus set apart from the rest. The remaining ones contain enthroned figures of the Virtues and two scenes from Genesis. To the right of the central niche are the *Creation of Adam*, *Wisdom* (plate 28), *Hope, Fortitude,* and *Prudence;* to the left, *Justice, Charity, Temperance, Faith,* and the *Expulsion from Paradise*. The front ends of the side walls serve as pedestals for two freestanding female figures with children. These are usually identified as Rea Silvia (plate 29), the mother of Romulus and Remus, and Acca Larentia, their nursemaid. These would have been fitting allusions to Siena's ancient Roman origins.

The fountain presents a mixture of architectural and decorative motifs from the Gothic Trecento and the nascent Renaissance. The round arches of the niches are the most obvious signs of the new spirit. Quercia may have patterned them and the figures of the Virtues beneath them on the statues of the Evangelists created a few years earlier for the façade of the cathedral in Florence. His *Wisdom*, for example (plate 28), twists sideways on her throne and supports a book on her thigh, her cloak almost wholly obscuring the base of her throne. She is obviously influenced by Donatello's figure of St. John (plate 46). Donatello may, in fact, have been the inspiration behind a number of advances apparent in Quercia's fountain, innovations that take him far beyond the style of his Ferrara *Madonna* and his Ilaria del Carretto. He now stresses the motif of torsion in his figures as well as an abundance of drapery dominated by large curving folds. His voluminous drapery is nevertheless set off by the voluptuous limbs of his nudes and seminudes.

Directly related to the planning of the fountain are two ink drawings, one in the Victoria and Albert Museum in London (fig. 12), the other in the Metropolitan Museum in New York (fig. 11). The one in England was first published by Lányi (1927–28), the one in America by Krautheimer (1952). Both are only fragments—the center section is missing—and they differ sharply from the completed work. There is no indication of either the *Hope* or the *Charity,* for example, although possibly these were depicted on the missing center sheet. Also, the angel of the

Annunciation and the Virgin receiving him fill the niches ultimately given to the *Creation of Adam* and the *Expulsion from Paradise*. Moreover, the figures in the drawing display all the elements of the International Gothic tradition and have little in common with the ones actually executed. For all these reasons, the sketches are generally associated with the contract from 1409 (Hanson 1965; Seymour, "Fatto," 1968) and are attributed to either Quercia himself or his workshop. The two standing female figures in the drawing are expressly characterized as women living in the wilderness, for their clothing is scanty and ragged. Hence it is more likely that they are meant to be Rea Silvia and Eve (List-Freytag 1985) than Charity and Liberality (Bisogni 1977).

30; fig. 14
Altar Retable (Trenta Altar)

1416–22. Marble, 14'5" × 10'6⅜" (439 × 321 cm.). Trenta Chapel, San Frediano, Lucca

On February 28, 1412, Lorenzo Trenta, one of the wealthiest merchants of Lucca, was given permission to renovate the chapel consecrated to Sts. Richard and Jerome and St. Ursula in San Frediano and use it as a burial place for himself and his family. Quercia, together with his assistant Giovanni da Imola, was actively involved in the resulting redecoration of the chapel from 1413 on. The tomb slabs for Lorenzo Trenta and his wife were completed in 1416, the marble altar clearly six years later, for it bears the inscription HOC OPUS/FECIT JACOBUS MAGISTRI PETRI DE SENIS/1422. In 1625, when the altar was reworked in the new Baroque style, it was trimmed somewhat on either side, where the coats of arms of the Trenta family and the Arte della Seta had stood. The Baroque additions were removed in 1883, and in 1947 the retable was restored.

The five-part marble retable (fig. 14) conforms in its overall layout to the altar created by Tommaso Pisano for San Francesco in Pisa or the one by Dalle Masegne for San Francesco in Bologna. The center niche accommodates the Madonna enthroned (plate 30). She is flanked by Sts. Ursula and Lawrence on the left and Sts. Jerome and Richard on the right. The

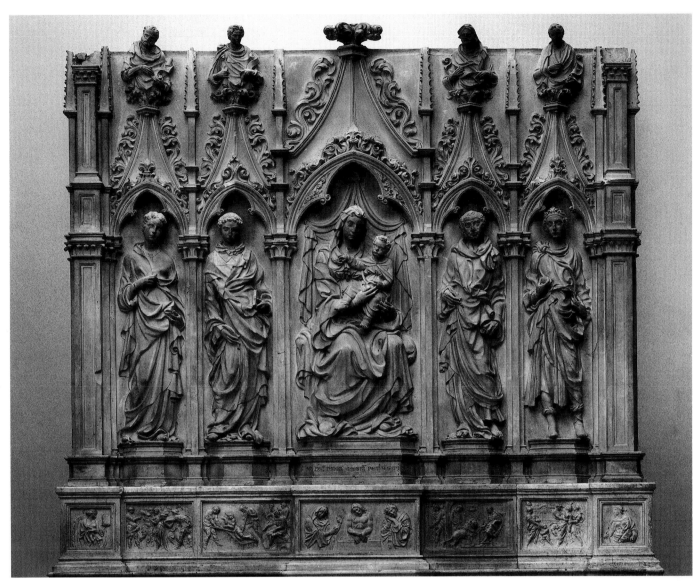

14 Jacopo della Quercia. Trenta Altar. San Frediano, Lucca

predella presents a Pietà in the center and four flanking scenes relating to the saints standing directly above them. Ursula and Lawrence are depicted in their martyrdoms, Jerome is removing a thorn from a lion's paw, and a madwoman is shown being healed at the grave of St. Richard. The frieze is completed by busts of St. Catherine of Alexandria (left) and St. Ursula (right). Half-figures of prophets are poised atop the gables of the side taberna-cles, while the figure crowning the center one—surely there at one time—is no longer present.

Gothic elements still dominate the overall structure and decor of the retable; however, the abundance of drapery in the saints' figures, the clear delineation of their bodies beneath, and even their physiognomies betray the influence of Donatello. The face of *St. Jerome*, for example, is similar to that of Donatello's beardless prophet on the Campanile in Florence, while *St. Richard* bears a distinct resemblance to Donatello's *St. Louis* (see fig. 28). The same influence is apparent in the partial employ-ment of *rilievo schiacciato* in the reliefs of the predella.

31, 32

Madonna and Child with Saints; Scenes from Genesis

1425–37. Red and white marble. Madonna, 70⅞″ high (180 cm.); each of the pilaster reliefs, 39 × 36¼″ (99 × 92 cm.). Main Portal, San Petronio, Bologna

The idea of ornamenting this portal with sculpture originated with the papal legate and then governor of Bologna, Louis Aleman, archbishop of Arles. A contract between the Fabbrica di San Petronio and Quercia was signed on March 28, 1425, and Quercia requested a period of two years in which to complete the work. The sketch on which the contract was based, no longer extant, provided for the following sculptural program: fourteen scenes from the Old Testament on the two side pilasters, twenty-eight half-figures of prophets in the jamb, two lions flanking the portal, three scenes from the boyhood of Christ in the architrave, statues of Sts. Peter and Paul against the side pilasters, an Ascension in the gable, a crucifix crowning the gable, and a

Madonna and Child in the tympanum, flanked by statues of St. Petronius and Pope Martin V with Louis Aleman kneeling beside him.

In 1428, after the Bolognese had rebelled against papal rule, it was decided to replace the statues of the pope and his legate, which were probably not yet completed in any case, with a figure of St. Ambrose. However, the latter figure was not executed until much later. In the meantime the number of scenes from the Old Testament (plate 32) had been reduced to ten, while the number of scenes from the boyhood of Christ was raised to five. The modified design for the portal, which Quercia submitted presumably in August/September 1428 (Beck, *Jacopo*, 1970)—although Gnudi (1981) dates it as early as 1425–26—survives in a sketch for the façade of San Petronio drawn by Peruzzi in 1522.

Although there were major interruptions, Quercia worked on the portal from 1425 to 1437 with the help of eight assistants. Yet at the time of his death only the lower section (including the architrave) and the *Madonna* and *St. Petronius* were finished. In 1442 the sculptor's brother and heir was commissioned to complete the work. The actual carving of the remaining works was to be entrusted to Antonio da Briosco of Milan, but none of it was done. Only in 1510, at which time the portal was heightened somewhat and moved forward, were the statue of St. Ambrose (the work of Domenico da Varignana) and the prophet figures on the inner face of the arch finally set in place, while the gable remained unfinished.

In its overall design and in the individual forms of its pedestals, pilasters, columns, and capitals, the architecture of the portal conforms to the Trecento Gothic spirit. The idea of decorating the pilasters with scenic reliefs is also a medieval one. There is not a trace of the more restrained, classical architectural forms beginning to be seen in the buildings of Brunelleschi and in the sculptural architecture of Donatello. Its carefully balanced proportions, which were singled out for special praise in the contract from 1425, are the portal's only nod to the spirit of the Early Renaissance. The subsequent change in the number of reliefs in the architrave and on the pilasters may well have been made—as in the case of Ghiberti's East Door for the Baptistry—as part of a continuing effort to achieve an ideal balance.

To judge from the restricted space of the Genesis reliefs (plate 32)—the crowding of the figures and the old-fashioned way the ground juts out beyond the bottom frame—these would appear to have been created *before* the architrave reliefs, which, like the reliefs on Donatello's Prato pulpit (fig. 31), are framed by fluted pilasters and reveal a more highly developed sense of space. A payment made on December 24, 1429, for marble for the pilaster reliefs suggests that Quercia began to work on them in that year. The architrave reliefs were completed in 1434 at the latest, for in that year the statue of St. Petronius was set up in the tympanum. The tympanum's *Madonna and Child*, however (plate 31), was executed before August 1428, for the Madonna's head inclines toward her right, and the body of the Christ Child twists in the same direction, both of them acknowledging the papal legate originally meant to be kneeling beside them.

There is a question concerning the extent to which Quercia himself participated in the creation of the portal. The *Madonna*, the *St. Petronius*, and the first five Genesis scenes are definitely

to be attributed to him, however. Compared to his earlier Madonna figures from the *Fonta Gaia* and the Trenta Altar (plate 30), this one from the portal is not only more concise in its construction and more balanced in its proportions, but also—despite the fullness of the drapery—more forceful in its corporeality and its gestures.

Yet it is the reliefs of the left-hand pilaster (plate 32) that must be included among Quercia's most important creations. Although working in a comparatively small format and deliberately confining himself to a cramped pictorial space, he has here created figures that are both profoundly physical and expressive of great narrative pathos, qualities that would in time make a profound impression on Michelangelo. The left-hand pilaster presents the following scenes: the Creation of Adam; the Creation of Eve; the Fall; the Expulsion from Paradise; and the Penance of the Primal Ancestors. The right-hand pilaster includes: Cain and Abel Making Sacrifice; Cain Slaying Abel; Noah Leaving the Ark; Noah's Drunkenness; and the Sacrifice of Isaac. Reading from the left, the lintel reliefs present: the Nativity; the Adoration of the Magi; the Presentation in the Temple; the Massacre of the Innocents; and the Flight into Egypt.

33
The Annunciation to Zacharias

1428–30. Bronze, gilt, 23⅝" square (60 cm.). Font, Baptistry, Siena

For the story of the construction of the font, see page 358.

Of the two reliefs that Quercia was to have created according to the contract of April 16, 1417, one was assigned to Donatello in 1423. Only after all the other artists had delivered their reliefs—that is to say, after 1427—did Quercia finally complete his own. The final payment for it was made on July 31, 1430, and it is presumed that Quercia had started work on it in 1428 (Beck, *Jacopo*, 1970). It depicts the annunciation of the birth of the Baptist to Zacharias (Luke 1:8–20). But here, contrary to the Biblical narrative and iconographic tradition, a number of awe-struck bystanders are in attendance, lending the scene—in accordance with the Quattrocento's ideal of the *storia*—greater visual variety. This narrative fullness, the types and gestures of the figures, even the layout of the pictorial space, with views through rounded arches into spaces further back filled with still more figures—all derive from Donatello. Quercia clearly patterned them, along with the classical ashlar masonry, after Donatello's *Salome* relief (plate 68). His masonry is admittedly more massive, more compact, less varied in design and less delicate in its surface detail than Donatello's, yet in itself it is perfectly appropriate to the space portrayed.

In 1429–30 Quercia also created the marble tabernacle that crowns the font (fig. 5). He had received the commission for it in June 1427. Its combination of classical forms—niches between fluted pilasters with Corinthian capitals—is reminiscent of the base of Donatello's Coscia tomb (plate 64). The niches shelter five prophet figures, and a statue of the Baptist stands atop the tabernacle. The marble block from which it was carved was delivered on April 14, 1428.

Nanni di Banco
(1370/75–1421)

Nanni was born in Florence, the son of the stonemason Antonio di Banco. The year was probably about 1370/75 (Wundram 1969), although some scholars have suggested a later date. The earliest documentary reference to him is from February 2, 1405. On that date he was admitted into the Arte dei Maestri di Pietra e Legname. On December 31, 1407, he and his father were paid for work on the archivolts of the Porta della Mandorla, one of the two north portals of the Duomo in Florence. The work in question clearly included the vines, the small nude figures, and the half-figures of angels on the left side of the portal (Wundram 1969). A short time later, in January 1408, Antonio and Nanni were commissioned to produce a prophet figure for one of the buttresses of the Duomo, a work that Nanni completed by December of that year. The same month, he was also charged with the execution of one of the four statues of the Evangelists for the façade of the Cathedral, and he received his final payment for that commission in February 1413.

In June 1414 came the contract for the large gable relief on the Porta della Mandorla, on which he worked for over seven years. In addition to these clearly documented works, three of the statues of saints in the niches of Orsanmichele—*St. Philip*, the *Four Crowned Martyrs*, and *St. Eligius*—must be attributed to Nanni. The precise dates of their creation are unknown, but he must have executed them between 1412 and 1418. Also in 1418 Nanni was engaged, along with Donatello, in the creation of the model for the dome of the Cathedral that Brunelleschi had designed.

Besides working as a sculptor, Nanni di Banco also held a number of public offices. Between 1412 and 1419, for example, he was elected several times as one of the consuls of the stonemasons' guild. In 1414 he served for six months as *podestà* (mayor) of the Montagna Fiorentina, and for six months in 1416 he was *podestà* of Castelfranco di Sopra. Nanni drew up his last will on February 9, 1421. Three days later he is listed as already deceased.

Vasari [1550, 1568]; Pachaly 1907; Poggi 1909 (1988); Wulff 1913; Lányi 1936; Planiscig 1946; Valentiner 1949; Vaccarino [1950]; Pope-Hennessy 1955 (1985); Einem 1962; Wundram 1962; Wundram 1965; Lisner 1967; Brunetti, "Riadattamenti," 1968; Wundram 1968; Becherucci and Brunetti [1969–70]; Wundram 1969; Herzner, "Bemerkungen," 1973; Munman 1980; Bergstein 1987; Horster 1987; Bergstein 1988.

34; fig. 15
Isaiah

1408. Marble, 76″ high (193 cm.). Cathedral, Florence

On January 24, 1408, the Operai del Duomo decided to commission Antonio di Banco and his son Nanni to create a statue of the prophet Isaiah some 3¼ braccia (190 centimeters) tall. The work was completed by December of that year, and the record of the final payment on December 15, 1408, makes it clear that Nanni alone was responsible for it. Like Donatello's marble *David*, it was intended to adorn one of the buttresses of the choir, but if it ever did so, it was only for a short time. Lányi (1936) first identified the figure of a young prophet standing in the right aisle of the Duomo as Nanni's *Isaiah*.

The statue is still heavily indebted to the Gothic ideal in the gentle curve flowing upward through the figure from the left foot to the left shoulder, a line subtly emphasized by the long, curving folds in the lower part of the drapery. The calligraphic reverses of the hem of the garment and the weightless scroll are also traditional motifs. Altogether new, by contrast, is the emphasis on the body beneath the drapery, which clings to the free leg like thin, wet fabric. This quite pronounced physicality—apparent not only in the free leg but also in the protruding right hip, the way the left shoulder thrusts forward to form an angle, the thick neck and squared forehead—is unquestionably part of a new trend in early Quattrocento sculpture, the revival of the art of antiquity. That the prophet wears his hair short instead of in a mass of curls is yet another classical touch. However, the manner in which the arms hang down at the sides is still rooted in the

15 Nanni di Bartolo (?). *Prophet.* Museo dell'Opera del Duomo, Florence

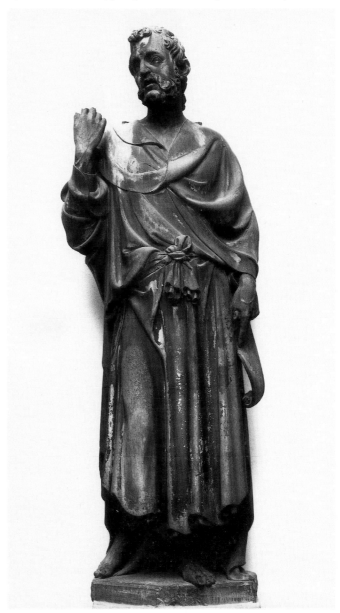

Gothic tradition. Like the forceful thrust of the right hand, it is not really a functional motif but one adopted for the sake of the composition and is, therefore, empty of meaning.

These formulaic touches in the overall construction of the figure, in its gestures and drapery, are equally visible in the angels of the left-hand archivolts of the Porta della Mandorla, in the *St. Philip* (plate 36), and in the *Four Crowned Martyrs* (plate 37). An extreme emphasis on the body is found in these figures as well, even in the modeling of facial details. Wundram (1968, 1969) chose to attribute this statue to Donatello, but the above-mentioned combination of stylistic elements is wholly inconsistent with his early work (Lisner 1967; Poeschke 1971). His starting point in ascribing this figure to Donatello and—equally unconvincingly—identifying instead the prophet with one raised hand (fig. 15) as Nanni's *Isaiah* was, in fact, the relative shape of their pedestals. He found that the pointed base of the previously unidentified prophet is suited to the buttresses of the Cathedral choir. However, this is not a decisive argument and can be easily disproved by a glance at Donatello's irregular pedestals for his Campanile prophets, which bear no particular relation to the niches for which they were carved.

35; fig. 16
St. Luke

1408–13. Marble, 81⅝″ high (207.5 cm.). Museo dell'Opera del Duomo, Florence

While the sculptural ornamentation of the buttresses and the Porta della Mandorla was in progress, the Duomo's overseers also began once again to concern themselves with its façade. As early as 1405, Niccolò di Pietro Lamberti and Giovanni d'Ambrogio are recorded as receiving payment for the delivery of four blocks of marble for the figures of the Evangelists to be set in the niches flanking the main portal. Yet it was not until December 19, 1408, that Nanni di Banco, Donatello, and Niccolò di Pietro Lamberti were commissioned to each create one of these figures. The contract for the fourth figure was to be awarded to the one whose statue was found to be most pleasing. But before the three had managed to complete their work, the final figure was entrusted to still another sculptor, Bernardo Ciuffagni.

To judge from the width and height of the marble blocks, it must have been intended from the start that these were to be monumental *seated* figures, unusual for the time but possibly owing to the considerable width of the niches in question. While Niccolò di Pietro Lamberti, Ciuffagni, and Donatello did not complete their statues until 1415, Nanni's *St. Luke* had been finished in 1413. Nanni received his first payment for it on June 12, 1410, his last on February 16, 1413, yet it would appear that he only began to devote himself to the completion of the *St. Luke* figure in June 1412 (Wundram 1969). The statue stood on the façade of the Duomo until 1587 (for the original placement of all four of the Evangelist figures, see Munman 1980 and fig. 16). It was then placed inside the Cathedral, where it stood until it was moved to the Museo dell'Opera del Duomo in 1936.

Nanni's Evangelist is dressed in a belted undergarment and cloak. His left hand cradles an open book, while his right rests on his upper thigh. The somewhat forced placement of this right hand and the stiff angle of the arm are both motifs obviously borrowed from Donatello's *David*. The same can be said of the tentative tilt of the torso, the elongated neck, and the regular oval

16 Bernardino Poccetti. Façade of the Duomo in Florence before 1587 (detail). Museo dell'Opera del Duomo, Florence

of the face with its close-cropped hair. His head is held high as though he were gazing off into the distance, yet his eyes are cast down—focused not so much on the book as on the viewer standing below.

Nanni's use of a hand loosely holding an open book in front of the body and the manner in which he has his figure look out beyond that possible focus—another typical Donatello motif—are derived from the *St. Mark* from Orsanmichele (plate 45). This tells us that the latter work must have been virtually finished by the time Nanni finally began to work on his *St. Luke* in the summer of 1412. Despite the expansive gestures, the front of the figure remains relatively flat. The interplay between the body and its drapery is not completely in harmony with such limited depth. The large cloak covers the bent arms and legs only loosely. As a result, there is no opportunity for the sort of contrast between taut folds of drapery and more relaxed ones that provides a figure with genuine depth and reveals its body structure.

36; fig. 17
St. Philip

c. 1413–14. Marble, 75¼″ high (191 cm.). Orsanmichele, Florence

The statue of St. Philip and its tabernacle were donated to Orsanmichele by the Arte dei Calzolai. There are no surviving documents relating to the creation of the figure. It was not until the sixteenth century that it was identified as the work of Nanni di Banco (Billi 1516–20; *Il Codice Magliabechiano* 1537–42; Vasari 1550), but modern scholars have never contested that attribution.

The figure of the youthful saint stands on a rectangular base with beveled corners. This in itself is a departure from the Gothic tradition and its polygonal bases. He is dressed in a belted undergarment and a large cloak draped loosely across his shoulders. His left hand holds a book propped against his hip, but the book itself is covered by his cloak. With his right hand he lifts the cloak across his free leg, which is set forward and slightly bent. His gaze follows the direction of this forward knee and hand, and this motif alone reveals that the figure was patterned after the *St. Mark* of Donatello (plate 45). The latter work also served as a model not only for the greater depth of this *St. Philip*—the figure stands at an angle, so that a severe frontality is avoided—but also for the rich treatment of the drapery, including details like the free-falling folds in front of the weight-bearing leg or the triangle of folds framing the hand placed in front of the body.

A number of awkwardnesses in the figure's construction make it perfectly clear that Nanni was the borrower: one notes, for example, how the feet are placed perfectly in line, each on one of the corners of the base; how the overabundance of drapery tends to obscure the standing pose; how the figure and its base seem to have been designed with no consideration of the niche in which they were to stand, so that the base ended up off center. To settle what has been called "the most important question of all about the relationship between Donatello and Nanni di Banco" (Wundram 1969), all of these details show that the *St. Philip* was created not *before* the *St. Mark* but rather *after* it, that is to say

17 Nanni di Banco. Tabernacle of St. Philip (gable relief). Orsanmichele, Florence

after 1413, presumably very shortly afterward, however, since its similarity to the *St. Mark* is obviously quite close.

The half-figure of Christ in the gable of the tabernacle is also the work of Nanni (fig. 17). To judge from the absence of a quatrefoil frame, the figure must have been executed later than the one above the *Four Crowned Martyrs* yet not before Donatello's *St. George* tabernacle, that is, not before 1417.

37
Four Crowned Martyrs

c. 1414–16. Marble, 72″ high (183 cm.). Orsanmichele, Florence

The four crowned martyrs—that is to say, Castorius, Claudius, Symphorianus, and Nicostratus—were the patron saints of the Arte dei Maestri di Pietra e Legname, whose coat of arms embellishes the base of the tabernacle. There are no documents telling us just when the guild donated the tabernacle with the four figures or who created it; however, Nanni di Banco is credited with the work in the source literature from the sixteenth century (Albertini 1510; Billi 1516–20; Vasari 1550), and modern scholarship tends to accept this attribution. One possible indication of the date of the work is the purchase of marble on behalf of the guild, presumably for the tabernacle, on September 12, 1415 (Bergstein 1988).

This is the first time that multiple figures came to be housed in a single niche, an innovation occasioned by the guild's multiple patronage. The tabernacle of the *Four Crowned Martyrs* is accordingly larger than any of the previous niches on Orsanmichele. The martyrs stand close together on a semicircular base, seemingly conversing among themselves. The four figures have been accommodated in the space of the niche with great skill. According to Vasari (1550), Donatello was said to have lent Nanni a hand in the planning of the work. The individual figures reveal a clear indebtedness to draped figures from antiquity (cf. Horster 1987). The unusual motif of the cloth hung on the wall of the niche behind the figures is undoubtedly borrowed from classical reliefs as well (Horster 1987).

While the two right-hand figures were carved from a single block, the two on the left were conceived as individual statues. The first to be completed was probably the second from the left. Its pronounced and graceful *contrapposto* suggests that it was conceived as a solitary figure, with little thought as to how it would fit in with the group as a whole. Moreover, it closely resembles Nanni's *Isaiah* from 1408 (plate 34). The posture of the remaining figures is more balanced and relaxed, and their drapery is longer and fuller. It is, therefore, unlikely that they were carved before the *St. Philip*, that is to say, before 1413. Most probably they were done about 1414–15. The crockets on the gable would tend to confirm such a date, for as Paatz (1940–54) already noted, they are similar to those on the Porta della Mandorla. The gable relief, however, depicting Christ giving benediction, may well be of an earlier date than that of the *St. Philip* tabernacle.

The relief on the base presents the four saints engaged in crafts represented in the guild: a mason building a wall, a stonecutter working with a drill on a twisted column, an architect plotting a capital with a compass, and a sculptor carving a putto. Unlike the corresponding panel on Donatello's *St. George* tabernacle, this one is still modeled in half-relief in traditional Trecento style (cf. pages 17–18). The suggestion that Nanni's sculptor represents the new type of Renaissance artist as opposed to a mere craftsman (Einem 1962) is most unconvincing, as is Bergstein's claim (1987) that Nanni filled this base relief and the statues themselves with autobiographical details.

38
St. Eligius

c. 1417–18. Marble, 75¼″ high (191 cm.). Orsanmichele, Florence

Like the preceding sculpture, there are no surviving documents relating to the tabernacle and figure of St. Eligius, the patron saint of the Arte dei Maniscalchi. It is first identified as a work by Nanni di Banco in the *Codice Magliabechiano* (1537–42), and modern scholarship has generally accepted the attribution. There has been considerable debate, however, about the dating of the statue. A number of writers (Kauffman 1935; Planiscig 1946; Herzner, "Bemerkungen," 1973) see it as the first of the statues that Nanni executed for Orsanmichele; others (most recently Wundram, 1969, who proposes the date 1417–18) consider it the last, a work completed just before the gable relief of the Porta della Mandorla.

The saint wears the mitre and pluvial. In his left hand he holds

a book, in his right a broken bishop's crozier. His right foot and right shoulder are drawn back slightly, while his free leg—clearly visible beneath his robe—and left shoulder press slightly forward. Attention is thus drawn to the left side of the body, and accordingly it is to the left that the saint's eyes gaze off into the distance. Like the figure's pose and its stern gaze, its proportions—more slender than in other statues of Nanni's—its compactness, and the deliberate development of the front of the body in the interest of a more fully three-dimensional effect are all reminiscent of Donatello's *St. George* (plate 48).

All of these features lead us to assume that the work was executed after 1416, and the tabernacle's gable relief tends to confirm such a dating. In it, the figure of Christ giving benediction blends into the relief background more than do the relief figures from Nanni's other tabernacles, which suggests the influence of Donatello's *rilievo schiacciato*, more specifically, his gable relief for the *St. George* tabernacle. The same influence is less apparent in the relief below the figure of St. Eligius, however. Here the saint is depicted shoeing a horse possessed by the devil. He has removed the shoe from the animal's left foreleg, while a groom restrains it, and the devil, in the form of a woman, looks on. The figures are crowded closer together and overlap more than those in the lower relief from the *Four Crowned Martyrs*, but there is no appreciable difference in the way they merge with the background.

39; fig. 18
The Assumption of the Virgin

1414–21. Marble. Porta della Mandorla, Duomo, Florence

The commission for this relief in the gable of the Porta della Mandorla was given to Nanni on June 19, 1414. A first payment is dated May 28, 1415; however, regular payments only began in 1418. The carving of six of the ten blocks comprising the relief, each presenting a single figure, had been completed by October 12, 1418. When Nanni died in February 1421, the relief was still unfinished, but there cannot have been much left to do, for eleven months later it was set in place above the Cathedral portal. Two ornamental heads by Donatello (plate 62), one of a prophet, the other of a sibyl, were added to the gable in May 1422, and the placement of an older statue of a prophet on the summit of the gable (fig. 18) in 1423 brought the work to completion.

The relief is Nanni's most important work. In this *Assumption*, the Virgin, seated inside a mandorla, is being borne aloft by angels. She extends her girdle to St. Thomas, who kneels at the lower left and raises his hands to receive it. Balancing Thomas on the right is a bear climbing an oak tree to feast on honey—an obvious borrowing from Andrea Pisano's relief of Adam and Eve on the Campanile. The Virgin's girdle, the *sacra cintola*, appeared as a relic in Prato in the Middle Ages, which explains why the motif is frequently tied to the theme of the Assumption in Tuscan art of the fourteenth and fifteenth centuries. An older example of this is the relief of the Assumption of the Virgin on Orcagna's tabernacle for Orsanmichele, which dates from 1359.

Even though the girdle itself is no longer preserved in Nanni's relief—originally it took the form of a silk band, then from 1435 on a copper one—Mary's gesture of presentation and Thomas's

gratitude are eloquent enough. The gesture of handing the garment to him also introduces a welcome sense of movement into the Virgin's seated pose, so that it forms a lively counterpoint to the rigid form of the mandorla. By the same token, the billowing robes of the angels, some of whom are actually supporting the mandorla, others providing a musical accompaniment to the scene, contrast nicely with the mandorla and the straight lines of the steep gable. The Virgin wears a crown. Her throne, which is flanked by cherubs, is only suggested; her full and richly draped cloak almost completely obscures it. Some (for example, Wundram 1969) have seen in the movement of this seated Virgin and the ample robes of all of the figures the influence of Quercia. In fact, Vasari (1550) was convinced that Quercia had executed the relief. However, Nanni goes well beyond the Sienese sculptor both in the fullness of his drapery and the liveliness of his gestures.

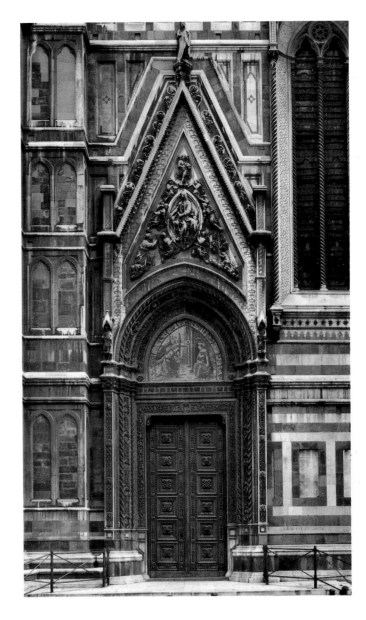

18 Porta della Mandorla, Duomo, Florence

Donatello
(1386–1466)

Donato di Niccolò di Betto Bardi, called Donatello, was born in Florence, but it is not certain just when, probably in 1386. Unlike Brunelleschi and Alberti, who were his friends, he came from a very humble background. His father was a wool carder who lived in the diocese of San Piero in Gattolini. The first documentary mention of Donatello is from 1401, when he was involved in a violent altercation in Prato. The trip to Rome that Manetti (c. 1485) claims Donatello took with Brunelleschi in his early years could have taken place in 1403–4. There is evidence that between 1404 and 1407 Donatello served as an assistant in the workshop of Ghiberti, who at that time was at work on his first bronze door for the Baptistery of Florence. In 1406 Donatello was commissioned to do two small statues of prophets for the Porta della Mandorla.

His first known work is the marble *David* (1408–9) for one of the buttresses of the Duomo. From this time on he had considerable influence on the sculptural adornment of both the Cathedral and Orsanmichele. He created the *St. John the Evangelist* for the Cathedral façade (1408–15), the *St. Mark, St. George,* and *St. Louis* for Orsanmichele (1411–c. 1422), and the statues of prophets for the Campanile (1416–36). Meanwhile Donatello worked during the 1420s, together with Michelozzo, on the Tomb of Pope John XXIII (Baldassare Coscia), the Tomb of Cardinal Brancacci in Naples, and the exterior pulpit of the Prato Cathedral. This same fruitful decade saw the completion of the reliquary bust of St. Rossore as well as the *Herod* relief and statuettes of the Virtues for the font in Siena's Baptistery.

It is documented that Donatello sojourned in Rome in 1432–

33. In late December 1432 the Operai of the Prato Cathedral sent for him, insisting that he finish the exterior pulpit that he had begun for them in 1428 but left unfinished. He finally completed it in 1438. During this same period Donatello worked on the decoration of the Old Sacristy at San Lorenzo and the *Cantoria* for the Duomo in Florence. In October 1434 he received payment for a design for the *Coronation of the Virgin* window in the Duomo. In 1437 he was commissioned to create the bronze doors for the two Cathedral sacristies, but these he never executed. From 1444 to 1453 Donatello was chiefly engaged in Padua, where he took up permanent residence beginning in 1446/47. Presumably it was the commission for the equestrian monument to the Gattamelata that caused him to take such a step. The monument was completed as early as 1450 and was finally unveiled in 1453. While in Padua, Donatello also executed a bronze *Crucifix* as well as the high altar for the Church of Sant'Antonio. Commissions for Ferrara, Mantua, and Modena, planned for the years 1450–51, were never carried out.

On his return to Florence, it would appear that Donatello soon found himself with too few contracts. He created works of great importance in these years, to be sure, such as the wooden *Mary Magdalene* and the bronze *Judith and Holofernes*. But by 1457, already seventy years of age, he had left for Siena, where he hoped to produce a pair of bronze doors for the cathedral. Unfortunately, these never advanced beyond the planning stage; however, he did create a bronze figure of St. John the Baptist for the cathedral. He was back in Florence as early as 1459. Presumably it was Cosimo de' Medici who had lured him back, entrusting him with two bronze pulpits for San Lorenzo. Donatello died on December 13, 1466, this last commission uncompleted. He was laid to rest in San Lorenzo, near the tomb of his friend and patron Cosimo de' Medici, but the precise location of his tomb is unknown.

Donatello, who created sculptures in stone, clay, bronze, and wood, was unquestionably the most important sculptor of the Early Renaissance. He enjoyed close ties to humanists like Alberti and Poggio and was admired for his knowledge of antiquities. His work had enormous influence on the creations of his contemporaries as well as the two generations of artists to follow. But it appears that contemporaries were just as intrigued by his *person* as by his *work*, for a number of amusing anecdotes about him were in circulation even during his lifetime. Stripped of their stock rhetorical embellishment, these stories, combined with the documentary source material, provide us with an uncommonly colorful portrait of an artistic personality, one altogether without parallel in the period. They tell us that Donatello was easily excitable and constantly hatching new plans—often as not for hilarious practical jokes.

His personal needs were modest. He was extremely generous but was possessed of a sharp tongue and a devastating wit. He could be uncompromising with patrons whose ideas failed to mesh with his own, and those who did manage to tie him to a contract frequently had to wait for a long time for the works they had commissioned. Yet Donatello was by no means a slow worker. On the contrary, he obviously worked with uncommon speed and was completely engaged in all that he did. This is but one of the qualities that set him apart from the traditional type of

artist and serves to explain the astonishing quantity and variety of his work.

Alberti [1435, 1436]; Filarete [c. 1451–64]; Manetti [c. 1485]; Vespasiano da Bisticci [c. 1485]; Manetti [c. 1495]; Albertini [1510]; Billi [1516–20]; *Il Codice Magliabechiano* [1537–42]; Gelli [c. 1550]; Vasari [1550, 1568]; Bocchi [1571]; Burckhardt 1855 (1879); Semper 1870; Semper 1875; Müntz [1885]; Bode 1886; Schmarsow 1886; Milanesi 1887; Semper 1887; Tschudi 1887; Semrau 1891; Bode 1892–1905; Gloria 1895; Vöge 1896; Boito 1897; Schmarsow, "Statuen," 1897; Fabriczy, "Hl. Ludwig," 1900; Bode 1901; Bode, *Bildhauer*, 1902 (1921); Burger 1904; Schottmüller 1904; Burger, "Donatello," 1907; Schubring, *Donatello*, 1907; Meyer 1908; Corwegh 1909; Poggi 1909 (1988); Cruttwell 1911; Schubring 1919; De Francovich 1929; Colasanti [1930]; Lányi 1932–33; Kauffmann 1935; Lányi, "Problemi," 1939; Planiscig 1939; Band 1937–40; Valentiner 1940; Poggi, Planiscig, and Bearzi [1949]; Pope-Hennessy, *Ascension*, 1949; Bearzi 1951; Morisani 1952; Siebenhüner 1954; Janson 1957; Martinelli 1957–58; Gosebruch, "Kapitelle," 1958; Gosebruch, *Reiterdenkmal*, 1958; Lisner, "Büste," 1958; Lisner 1958–59; Pope-Hennessy 1958 (1985); Kauffman 1959; Lavin 1959; Pope-Hennessy, "Donatello Problems," 1959; Previtali 1961; Corti and Hartt 1962; Lightbown 1962; Lisner 1962; Castelfranco 1963; Grassi 1963; Martinelli 1963; Janson 1964; Marchini 1966; Romanini 1966; Seymour 1966; Carli 1967; Lisner 1967; Schlegel 1967; Wundram 1967; *Donatello e il suo tempo* 1968; Gosebruch 1968; Huse 1968; Seymour, "Aspects," 1968; Wundram 1968; White 1969; Wundram 1969; Herzner 1971; Herzner, "Kanzeln," 1972; Hartt [1973]; Herzner 1973; Rosenauer 1975; Herzner 1976; Pope-Hennessy 1976; Radcliffe and Avery 1976; Caplow 1977; Herzner 1978; Becherucci 1979; Herzner, "Regesti," 1979; Herzner 1980; Lightbown 1980; Parronchi, *Donatello*, 1980; Poeschke 1980; Greenhalgh 1982; Herzner 1982; Rosenauer 1982; Herzner 1983; Bennett and Wilkins 1984; *Italian Renaissance Sculpture in the Time of Donatello* 1985; *Omaggio a Donatello* 1985; *Donatello e i suoi* 1986; *Donatello e la Sagrestia Vecchia* 1986; Trudzinski 1986; *Donatello e il restauro della Giuditta* 1988; Herzner 1988; *Donatello-Studien* 1989.

40
Crucifix

c. 1407–8. Wood, polychrome, 66⅛ × 68⅛" (168 × 173 cm.). Santa Croce, Florence

There are no documents relating to the wooden *Crucifix* in Santa Croce. It is first mentioned and identified as the work of Donatello by Albertini (1510). His attribution has never been questioned by modern scholars with the exception of Lányi (1932–33) and Parronchi (1976). Their only disagreement has been the problem of its dating. Most recent scholarship tends to include the *Crucifix* among Donatello's very earliest works. Presumably it was created even before the marble *David* from 1408–9.

In its time, this *Crucifix* represented a wholly new artistic concept. Obeying the laws of gravity, the lifeless torso tips slightly to the side, forming a curve that culminates in the bowed head. Pain and exhaustion are evident in the facial features and in the ragged strands of hair virtually glued to the face. By introducing this combination of physical weight and obvious suffering into the subject matter, the young Donatello committed what even the sixteenth century still considered an impropriety, a breach of *convenientia* (see pages 37f.). It would be false, however, to label his work mere naturalism. The expression of exhaustion is all the more effective in that the crucified body appears to be well formed, athletic, and strong, displaying no signs of weakness or torture.

The figure's proportions are quite different from those of Brunelleschi's *Crucifix* in Santa Maria Novella (plate 3). Here the

arms and torso are emphasized more strongly than the legs. The thin fabric of the loincloth lies tight against the thighs. The curling line of its hem and the curve of the fold below the hips are standard Gothic motifs. The taut outline of the body is also a borrowing from the Trecento. Reminiscences such as these—no longer so apparent in the marble *David* from 1408–9—support our dating the *Crucifix* to 1407–8. Further confirmation is provided by the way the left knee presses through the loincloth so prominently, a motif that Nanni di Banco adopted in even more exaggerated form in his *Isaiah* (plate 34) from 1408, also by the fact that Nanni obviously used Donatello's *Crucifix* as a model in his *Man of Sorrows* of about 1408 for the Porta della Mandorla.

Donatello carved the front half of the skull and the arms out of separate pieces of wood. The latter are hinged and could be lowered against the sides of the body in accordance with the requirements of the Good Friday liturgy. The polychrome surface, cleaned during restoration in 1974, is the original.

41–43
David

1408–9. Marble, 75¼″ high (191 cm.). Museo Nazionale del Bargello, Florence.

On February 20, 1408, Donatello was given the commission for a statue of the prophet David (*figure david profete*) that was to crown one of the buttresses on the choir of the Duomo in Florence. Nanni di Banco had been given a similar contract a short time before. A total of twelve such prophet statues was planned for the choir buttresses, but they were never completed. Donatello received 100 florins for his work, the final installment of which was paid on June 13, 1409. His statue, however, like Nanni's, was never placed in the spot for which it was intended, as it had meanwhile been determined that it was too small for such a height (see page 27). Donatello's *David* stayed in the Duomo workshops for a few years and in July 1416 was moved to the Palazzo Vecchio. At that time the sculptor was paid an additional 5 florins for adapting the statue and making some minor alterations to it. Somewhat by accident, then, the Old Testament hero was given a place of honor in the city hall as a symbol of political freedom and provided with an inscription (no longer preserved, but recorded in 1592 by Laurentius Schrader) that read PRO PATRIA FORTITER DIMICANTIBUS ETIAM ADVERSUS TERRIBILISSIMOS HOSTES DII PRAESTANT AUXILIUM.

Donatello's statue must have seemed especially well suited to this new role inasmuch as the sculptor presents the *prophet* David solely as the youth who has triumphed over Goliath. Wearing a close-fitting jerkin and a large cloak, he towers proudly above Goliath's severed head, which lies between his feet. His own head is wreathed with ivy. His right hand, extended in front of his body, was once connected by a strap to the sling draped across the head of his victim. One senses in this boyish figure a tremendous self-assurance and feistiness. These are expressed not only by its external attributes, but also in every detail of its pose. To the sculpture of the time, such individualized characterization and the presentation through form and gesture of a specific moment in a subject's life were something wholly new. The boy's stance is wary, yet there is a relaxed, circling movement in the torso and the arms. At the same time the torso

stretches upward, its extension culminating in the proudly held head. The right hand hangs loose, while the left one is brazenly propped against a hip. It is only when viewed from directly in front and from not too great a height that the interplay of movement in the figure achieves its full effect (plate 41).

Another innovation in this figure is the distinct emphasis on the body, which appears to be peeling off its covering cloak. Its clothed portions are played off against its bare ones, its close-fitting garments against the cloak wrapped loosely about the waist. Clothing details like seams, fringes, and the tiniest of folds are given greater prominence than was usual in the sculpture of the period. The same fascination with textures is apparent in the head of Goliath, with its lined face and soft locks of hair (plate 43). Here, employing *rilievo schiacciato*, Donatello achieves a degree of subtlety in differentiating between the facial features and the masses of hair that was unavailable to him before 1416. Therefore, it is quite possible that in his documented reworking of the statue in 1416 he concentrated primarily on the head of Goliath.

Donatello scholars had never doubted that this marble *David* in the Bargello was the statue from 1408–9 intended for one of the choir buttresses. But in 1968 Wundram questioned whether this sculpture was not, in fact, a later *David*, one for which a block of marble was purchased in 1412 but that Donatello quite possibly never got around to. To complete his argument, Wundram suggests that the figure identified here as the *Isaiah* of Nanni di Banco (plate 34) is really Donatello's buttress statue of David from 1408–9. Those interested in the ensuing discussion are referred to the scholarly literature. In the present context, it is enough to say that arguments in favor of identifying this marble *David* in the Bargello with the buttress figure from 1408–9 are more persuasive. In style, it is clearly earlier than the *St. Mark* from 1411–13. Furthermore, its height of 191 centimeters conforms to the 3¼ braccia (190 centimeters) specifically called for in the contract of February 1408. And, lastly, the side view of the figure is not developed as it would have to have been if it had been meant to stand alone in the hall of the Palazzo Pubblico from the start. Its whole bearing seems most appropriate to an elevated setting.

44, 45; figs. 19, 20
St. Mark

1411–13. Marble, 92⅞″ high (236 cm.). Orsanmichele (now in the Museo dell'Opificio), Florence

The Arte dei Linaiuoli commissioned Donatello to produce a statue of St. Mark for its niche on Orsanmichele on April 3, 1411. The figure was to be set in place by November 1, 1412. Accordingly, when the stonemasons Perfetto di Giovanni and Albizzo di Piero were contracted to create a tabernacle to house the figure on April 24, 1411, they were given eighteen months to complete the job. Even so, a document from April 29, 1413, makes it clear that at that point there was still work to be done on both the figure and the niche. A short time later, however—surely before the close of the year 1413, and not after 1415, as has been suggested (Wundram 1969)—the *St. Mark* figure must have been completed.

In it Donatello created a totally new type of niche figure that

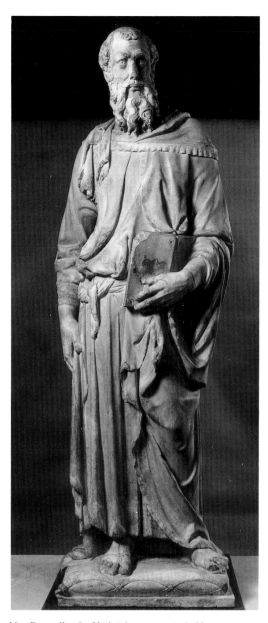

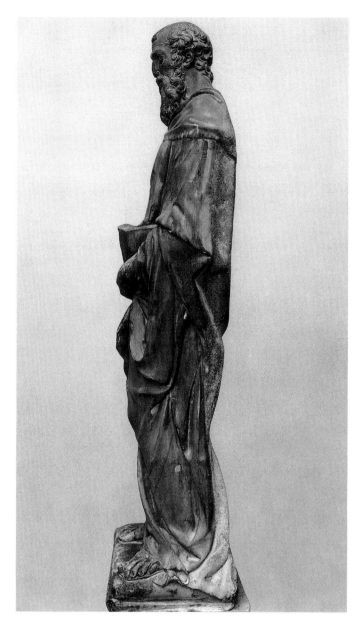

19 Donatello. *St. Mark* (after restoration). Museo dell'Opificio, Florence

20 Donatello. *St. Mark*. Orsanmichele, Florence

would set a standard for the future. Although precisely attuned to its architectural setting and the restrictions that setting imposed, it displays complete freedom of movement. It differs radically from all of the earlier statues of Florence and from those of his contemporaries. Its *contrapposto* is more clearly articulated and subtler in its effect, incorporating a wide variety of contrasting movement. Although seeming to turn in on itself, with its carefully plotted movement and depth, it easily commands the space of the niche. To be sure, it has this effect only when set in the spot for which it was intended (plate 44).

Fully conscious of its ultimate setting, Donatello developed only the front of the statue, utilizing the depth of the block of marble to the fullest while leaving the back largely undeveloped and extremely flat (fig. 20). He went still further, providing visual correctives so that the proportions would be maintained once the figure was set in place. In so doing, he created a new

pictorial cohesion between figure and tabernacle that suggests more than a casual interest in the perspective studies that his friend Brunelleschi was engaged in at the time. Vasari (1550) makes much of this *St. Mark* figure and Donatello's precise calculation of its effect in its ultimate setting. He relates that for lack of *guidizio* the consuls of the Arte dei Linaiuoli expressed disappointment when they first saw the statue standing on the floor of Donatello's workshop, but were highly satisfied once the figure had been placed in its niche and could have the effect Donatello intended (cf. pages 19f.).

Along with these innovations in the figure's design, one must acknowledge its definite physicality, the emphasis on the body beneath the robes. The body's physical strength stands in distinct contrast to the utterly passive hang of much of the drapery. At the same time, this drapery is more carefully developed as fabric than before, an interest underscored by the fact that the

figure stands on a rectangular cushion rather than the customary polygonal base. Precise characterization is even more apparent in the Evangelist's facial features, whose taut and rounded forms nevertheless reveal a vestige of traditional, Gothic sensibility that completely disappears from Donatello's work after 1415. The statue was recently cleaned and is now in the Museo dell'Opificio.

46, 47; figs. 21, 22
St. John the Evangelist

1408–15. Marble, 85⅝" high (210 cm.). Museo dell'Opera del Duomo, Florence

The contract for this *St. John* was awarded to Donatello on December 19, 1408. The first payment was made on August 12, 1412, the last on October 8, 1415. By the latter date the statue

had already been set in place on the façade of the Duomo (see page 372 for the other Evangelist figures). It remained in its original location, the niche immediately to the right of the main portal, until the old Cathedral façade was torn down in 1587. It was then moved inside the building, and in 1936 it was placed in the Museo dell'Opera del Duomo.

The seated Evangelist is dressed in a belted undergarment and has a large cloak loosely draped about his shoulders and knees. His left hand, clutching a small sponge, rests on a book; his right lies on his thigh and apparently once held a metal pen. The stolid torso and the heavy and relatively passive hands project a distinct tranquility, yet the positions of the legs and head are filled with tension. It is characteristic of the young Donatello that even a seated figure such as this is governed by a definite *contrapposto*, the calves angled in one direction, the head turning in the other. The twist of the head is very slight, but

21 Ciuffagni. *St. Matthew.* Museo dell'Opera del Duomo, Florence

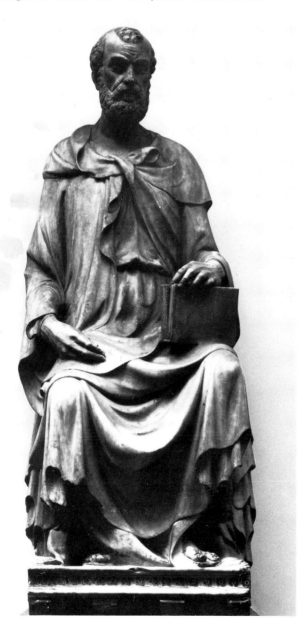

22 Donatello. *St. John.* Museo dell'Opera del Duomo, Florence

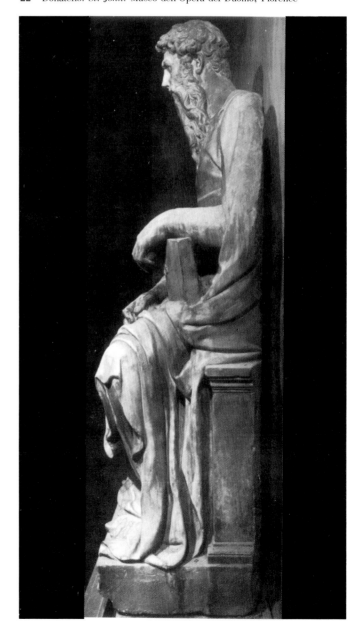

it is uncommonly expressive, its effect heightened by the way the eyes gaze off into the distance beneath furrowed brows and a shock of hair falls onto the forehead. Critics have frequently pointed out the similarity between this head and that of Michelangelo's *Moses*. They both turn aside as though with a start, and both wear a frown suggestive of intense concentration. But the similarity is only very general. Another work that *is* definitely patterned after Donatello's statue is the figure of St. Matthew created for the Cathedral façade at about this same time by Bernardo Ciuffagni (fig. 21).

A number of elements make it clear that Donatello's *St. John* was not completed until 1412–15, and surely *after* his *St. Mark*. The contrasting movements are further clarified, the direction of the gaze more focused—attributes that already anticipate his *St. George*. The lower portions of the drapery are executed with a new freedom; also the hair is textured with little lines, giving it a woolly softness not yet apparent in the *St. Mark*. For these reasons it seems incorrect to date this figure *before* the *St. Mark*, as Janson (1957) and Wundram (1969) attempt to do.

Here, too, Donatello has obviously taken into account the fact that his statue was destined for a niche placed above eye level. He has the figure bend slightly forward and concentrates all detail on the front, wresting from the marble block all the depth he could for this single aspect (fig. 22). One also notes how he has manipulated the proportions of the figure, compensating for any foreshortening they would suffer when viewed from below by lengthening the upper part of the body and the head considerably. No other sculptor of the time was so skillful in applying this sort of "optical corrective" (Seymour 1966).

Even more than the marble *David* and the *St. Mark*, the *St. John* shows Donatello to be unrivaled both in the freedom with which he plotted his statues relative to their architectural settings and in his concern for the specific effects they would have once set in their destined locations. This also explains why Donatello's early statues seem least suited for display in settings other than those for which they were originally intended. A drawing of the Duomo's façade made before 1587 (fig. 16) and a miniature in the Biblioteca Laurenziana's *Codex Edili 151* show the *St. John* statue and the other Evangelist figures occupying relatively spacious round-arched niches with scallop-shell calottes, the form and ornamentation of which are probably of a later date than the statues themselves.

48–50; figs. 23, 24
St. George

c. 1416–17. Marble, 82¼″ high (209 cm.); bas-relief, 15⅜ × 47¼″ (39 × 120 cm.). Museo Nazionale del Bargello, Florence

This statue was removed from Orsanmichele in 1892 and placed in the Bargello; the bas-relief followed in 1976. The only surviving document relating to the figure of St. George and its tabernacle (Wundram, "Albizzo," 1960) tells us that the marble for the base of the tabernacle was purchased by the Arte dei Corazzai e Spadai in February 1417. It would appear, then, that work on the relief had not yet begun at that point, whereas the statue may well have been completed. The saint stands with his feet solidly planted on a rectangular plinth. He holds a narrow shield in front

of him and gazes off into the distance. He wears classical armor and a cloak, but his head is uncovered. (If there ever was a helmet placed on his head—as Janson [1957] assumes—it was probably only on special ceremonial occasions.)

Renaissance writers from Filarete (c. 1451–64) to Bocchi (1571) found more to praise in this statue than in any other work by Donatello. They were especially struck by its amazing vitality and its moving revelation of the subject's essential nature. Although there is a great deal in its construction and gestures that is still reminiscent of his *St. Mark* and *St. John*, it displays a greater roundness (see fig. 23) than Donatello's earlier niche statues do. In his conception of the figure he took into account its ultimate placement as much as before. The work is more fully developed as a three-dimensional figure than the *St. Mark*, so that the spatial counterpoint between the statue and its niche is considerably greater (cf. pages 20f.).

23 Donatello. *St. George*. Museo Nazionale del Bargello, Florence

24 Donatello. Tabernacle of St. George (gable relief). Orsanmichele, Florence

It is virtually impossible to know to what extent Donatello influenced the planning of the niche architecture. It is similar to the older Gothic tabernacles on Orsanmichele, although simpler in its decorative forms and more austere in its overall design. This could be an indication that Donatello did have a hand in it. The fact that the original niche also had a smooth, unornamented interior suggests his involvement as well, for he would have known that his statue would be more effective against a plain background.

What is certain, however, is that Donatello executed the reliefs in the gable and on the base of the tabernacle for his *St. George*. The gable relief (fig. 24) is the first fully consistent bas-relief from the Quattrocento. It depicts Christ holding a book against the lower edge of the gable frame with his left hand while raising his right hand in benediction. He is looking down at the saint in the niche below so that his blessing is clearly directed toward him. A glance at the other tabernacles of Orsanmichele will show how novel this arrangement is. The treatment of the gable area as a framed opening with the figure looming through it is equally innovative, to say nothing of the uniformity of this *rilievo schiacciato*. Although Lányi ("Rilievi," 1935) claimed that this relief was definitely a work by Donatello, a claim that had not been fully appreciated by earlier scholars, his attribution has more recently (Wundram 1969)—and quite unjustly—been called into question.

The far more famous bas-relief from the *St. George* tabernacle (plate 50) dates from about 1417 and was presumably executed even before the relief in the gable. In its spacious perspective arrangement, its believable scenery, and its use of extremely flat relief, it demonstrates what changes Donatello was bringing to the art of relief at a time when Ghiberti was still working in a decidedly Gothic style on the panels for his first bronze door, and when Nanni di Banco, Donatello's contemporary, was carving the

bas-relief for the *Four Crowned Martyrs* niche on Orsanmichele (see pages 22f.). His innovations would have tremendous influence on the further development of Renaissance art. Admittedly, in the *St. George* relief the new relationship between the figures and the space of the relief is not yet fully articulated. The figures have been confined to the foreground so that they appear in a friezelike row. Of course, the extremely horizontal format of the base may be in part to blame, a difficult shape in which to create a scene of this sort.

51–58; figs. 25–27
Five Prophets

Beardless Prophet. 1416–18. Marble, 74¾″ high (190 cm.)
Pensieroso. 1418–20. Marble, 76″ high (193 cm.)
Abraham. 1421. Marble, 74″ high (188 cm.)
Zuccone. 1423–26. Marble, 76¾″ high (195 cm.)
Jeremiah. 1427–36. Marble, 75¼″ high (191 cm.)
Museo dell'Opera del Duomo, Florence

Once the statues of the Evangelists had been completed for the façade of the Duomo, it was decided to proceed with the sculptural program for the Campanile. Eight statues of prophets, Old Testament kings, and sibyls had already been carved by Andrea Pisano and his workshop in the fourteenth century and placed in the second-story niches on the tower's west and south sides.

25 Campanile from the west, Duomo, Florence

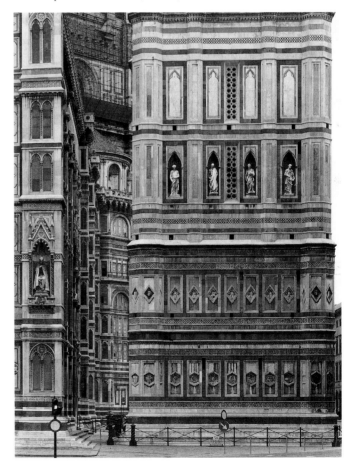

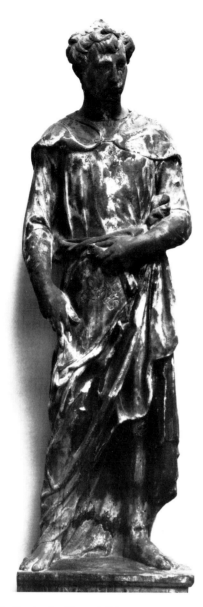

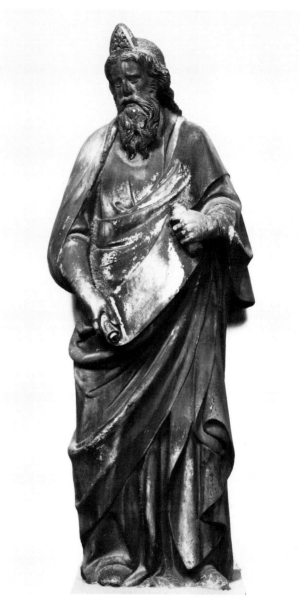

26 *St. John the Baptist (?)*. Museo dell'Opera del Duomo, Florence 27 Andrea Pisano. *Prophet*. Museo dell'Opera del Duomo, Florence

Beginning in 1415, Donatello was to oversee the completion of the cycle. He was given a contract for two additional figures on December 5, 1415, and payments for them began on March 11, 1416. The final payment for one of the two was made on December 19, 1418. An advance against the second was paid only four days later, and the final payment for this one is dated July 24, 1420. On March 10, 1421, Donatello received a contract, together with his assistant Nanni di Bartolo, for a third figure, an Abraham, and they received their last payment for this work on November 6, 1421. All three of these figures were placed on the Campanile's east side.

Between 1423 and 1436 Donatello was paid for two additional prophet figures, one of which was completed in 1426. The other, from 1434–36, is definitely referred to as Habakkuk. These two were intended for the north side of the Campanile, but in 1464 they were installed on the west side (fig. 25), replacing two of Andrea Pisano's figures—*King David* and *King Solomon*. The

prophet statues by Donatello were moved to the Museo dell'Opera del Duomo in 1936.

Thanks to the researches of Lányi ("Statue," 1935) and further investigations by Janson (1957), it now seems clear which payments relate to which figures. Even so, there is still a question about which of these statues was the last to be completed. A further statue, portraying a youthful St. John the Baptist (fig. 26), does not belong in the Donatello *oeuvre*, as Lányi recognized. To be sure it bears the signature DONATELLO, but like the signatures on the other statues this one is of a later date (possibly from 1464).

Donatello's earliest prophet figure, from 1416–18, is the so-called *Beardless Prophet* (plates 51 left, 52). It is the most similar in posture and gestures to the older Campanile statues by Andrea Pisano (fig. 27) inasmuch as it too gazes downward and holds an open scroll at a diagonal across its body. Donatello puts his own characteristic stamp on this inherited form, however, in

that his prophet steps forward with one leg while pointing most dramatically at the open scroll. The cloak draping his figure is quite large. It spills down across the plinth in front of the feet and has been flung back in a wide fold across the left shoulder. These particular drapery motifs are echoed somewhat in the later statue of St. Louis (plate 61), although the amount of excess fabric is not so great as in that figure in bronze. Even so, Donatello here emphasizes the contrast between the human form and the fullness of the drapery, concealing it more sharply than in his earliest works. As a result, our attention is drawn especially to the head, undoubtedly modeled after portrait heads of antiquity, and the hands.

The next figure to be completed after the *Beardless Prophet* is the so-called *Pensieroso* (plates 51 right, 53), from 1418–20. This figure also bends his head forward, gazing down at the ground below, but here Donatello abandons the conventional motif of the scroll unrolled across the body. Instead, he evokes the prophet's inner nature in an innovative and very moving way. The attribute of the scroll is now only secondary; the prophet clutches it in his left hand like an arbitrary wad of drapery, while supporting his chin with his right. He is portrayed as a judicious man sunk deep in thought, yet Donatello stresses his physical strength as never before. His head is massive, its furrowed brow deliberately tilted to catch the light.

His robe is made of a very heavy fabric that bunches into complex folds, with almost no sign of the soft and curving draping formerly employed. The complexity, irregularity, and quite intentional variety of the drapery design are only one indication of a new and dramatic angularity in Donatello's work, part of a new boldness and self-confidence. Other signs of it are evident in the left hand holding tight to the scroll, the right hand supporting the chin with the index finger extended, the pointed accentuation of the elbows, and the forward placement of the naked foot beyond the right front corner of the plinth. Forceful details such as these were not yet so evident in the *Beardless Prophet*.

Similar to the *Pensieroso* in this regard is the *Abraham*, from 1421 (plates 54, 55). Within the narrow limitations of the marble block, Donatello has depicted the sacrifice of Isaac as an event of high drama, a proper *storia*, and in so doing has created, albeit under more difficult conditions, his own version of the competition reliefs of Ghiberti and Brunelleschi. He shows Abraham violently taking hold of Isaac, bound and cowering at his feet, pulling him upward by the hair while pressing one leg planted on a bundle of wood against the boy's shoulder blade. Isaac can only respond with a look of utter helplessness and abandonment to his fate. Startled by the angel's calling to him, Abraham has already forgotten what his hands are doing. The one holding the knife has relaxed its grip, so that the blade begins to slide quite harmlessly across Isaac's naked shoulder. The manner in which Donatello telescopes these successive moments from the event into this single work anticipates his narrative approach in his *Herod* relief in Siena. For this reason alone, not to mention the quality of its execution, it is difficult to understand why certain critics have chosen to credit Nanni di Bartolo, who shared the commission with Donatello, with a major hand in the work.

The culminating figures in the series Donatello created for the Campanile are the two prophets executed between 1423 and 1436, *Zuccone* (plate 56) and *Jeremiah* (plates 57, 58). These two niche figures are closer to freestanding statues than any before. And with their bared limbs, forceful gestures, and earnest expressions they project a new depth of pathos (cf. page 21). It is clear that the figure executed in 1423–26 was not the *Jeremiah* but the *Zuccone*, for the unusual motif of the hand resting against a strap crossing the thigh was immediately taken up by various other artists, notably Jacopo della Quercia in the relief he created for the baptismal font in Siena in 1428–30 (plate 33). Furthermore, specific details of drapery and posture in the middle and right-hand supporting figures from Donatello's own Brancacci tomb (plate 155), which was begun in 1426, are obviously borrowed from the *Zuccone*, just as he was to copy the motif of the shoulder button holding together the prophet's undergarment in the *Assumption* relief for the Naples monument (plate 70). Also worth noting is the fact that in the *Jeremiah*, who is not wearing an undergarment but only a richly folded cloak, the nude body is more exposed than in the other one of the pair. All of this confirms that the *Jeremiah* is the later figure, begun in 1427 but only finished in 1436. This is the figure referred to in the documents as Habakkuk. Janson (1957) judges the inscription GEMIA on the open scroll to be a later addition. Rosenauer (1982) attempts to prove that Michelozzo had a hand in the carving of the figure, while Herzner (1983) makes a similar case for the involvement of Nanni di Bartolo.

59
The "Pazzi Madonna"

c. 1417–18. Marble, 29¼ × 27¼" (74.5 × 69.5 cm.). Staatliche Museen, Berlin-Dahlem

It is not altogether certain that this relief, pieced together from numerous fragments and acquired for the Berlin museum by Wilhelm von Bode in 1886, did, in fact, belong to the Pazzi and that it was removed from the Palazzo Pazzi in Florence. It is also unclear whether the *"Pazzi Madonna"* is one of the *Madonna* reliefs mentioned as being works of Donatello's in the Medici inventory of 1492 as well as in Vasari (1550) and Bocchi and Cinelli (1677).

There are numerous plaster copies of the *"Pazzi Madonna,"* which attests to the great popularity of the work in the fifteenth century. It stands at the beginning of the magnificent series of half-figure *Madonna* reliefs that runs through the sculpture of the Quattrocento as a sort of leitmotiv. Reliefs of this kind were created for private devotions. Presenting his figures in profile and close-up, Donatello brilliantly succeeds in capturing a sense of tenderness and intimacy uniting Mother and Child. Yet he wholly avoids the cloying sweetness frequently imposed on the idyll of mother and infant later in the century. The Madonna's monumental size, together with her severely classical profile, elevate the scene to an altogether higher plane. For all the gentleness with which she embraces the child and that he returns by nuzzling his face against hers, their intimacy is nevertheless imbued with a degree of sacred gravity that lifts it out of the ordinary. Both Masaccio and the early Michelangelo would emulate this quality in their own depictions of the Madonna.

In order to enhance the effect of the figures themselves, Donatello has eliminated all ornament and decoration. The

windowlike frame through which the Madonna rises has been kept severely plain. The perspective of its inner face reveals that the relief was meant to be mounted above eye level so that it would be seen from below. Once again we note the careful attention to the position of the viewer that distinguishes Donatello's statues from the second decade of the century. There are also definite analogies to the gable relief from the *St. George* tabernacle (fig. 24), as Kauffmann (1935) observes, primarily in the way the figure appears to break out of the frame and in certain of the drapery motifs.

Kauffmann proposes a date of about 1418 for the relief, which seems more credible than the one first advanced by Bode (1886), namely, the early 1420s, which has been generally accepted ever since. Janson (1957) dates the *"Pazzi Madonna"* to roughly 1422, basing his assumption on a comparison of the treatment of its faces and hair with the heads executed in that year for the Porta della Mandorla (plate 62). However, if one does, in fact, make such a comparison, one only notes how different this work is from the heads in question—or for that matter from the Campanile statues that Donatello began in 1418—which suggests that they were not produced at the same time at all. As compared with the statues executed after 1418, the surface treatment is here considerably softer and smoother, more concerned with a blending of forms than with contrasts; the lines are more rounded, the gestures more restrained.

60
Marzocco

1418–20. Sandstone, 53¼″ high (135.5 cm.). Museo Nazionale del Bargello, Florence

Pope Martin V sojourned in Florence in 1419–20, residing in the Monastery of Santa Maria Novella. For the staircase leading from the monastery's larger cloister to the papal apartment, Donatello created this lion holding the coat of arms of the city of Florence. About 1812 it was placed in the Palazzo Vecchio, and in 1885 it was moved to the Bargello.

Any number of armorial lions of this basic type could be seen in Florence as early as the fourteenth century. However, Donatello's *Marzocco* is related to its precursors in only a very general way. It differs from them primarily in its extraordinary size and its eloquent expression and gestures. Although extremely compact, this lion's pose has none of the axial rigidity of the traditional heraldic beast. One is struck by the insignificance of the coat of arms, which has become an almost incidental attribute held up by a sinewy paw. The massive head, modeled on lions' heads from classical sarcophagi, towers high above it. It is also unusual for heraldic beasts of this type to look to the side as this one does, an innovation that lends him an air of great vigilance. This twist of the head and fixed distant gaze are familiar from Donatello's early statues, while the lion's expressive physiognomy and the strong grasp of his right paw have parallels in the figures of the Pensieroso and Abraham.

61; fig. 28
St. Louis of Toulouse

c. 1418–20. Bronze, gilt, 8′8¾″ high (266 cm.). Museo dell'Opera di Santa Croce, Florence

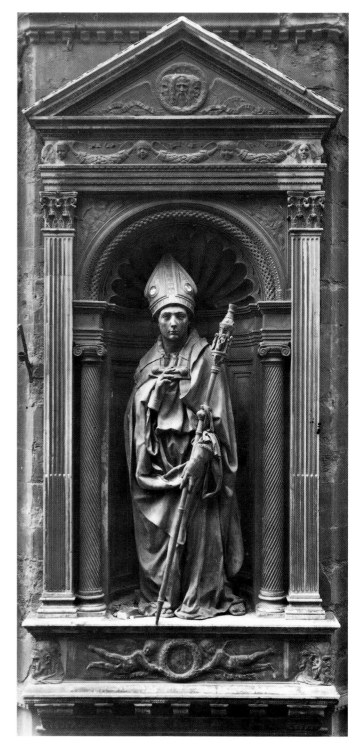

28 Donatello. *St. Louis of Toulouse*. Orsanmichele, Florence (photograph from 1945)

At the beginning of the fifteenth century, the Guelph party was still a powerful force, and it was able to spend lavishly on its niche for Orsanmichele. It provided not only a fully gilt bronze statue of its patron saint, St. Louis of Toulouse, but also an especially ambitious tabernacle in which to shelter him. We do not know when Donatello was given the commission for both statue and tabernacle, but it may be—as Fabriczy ("Hl. Ludwig," 1900) proposed—that it was even before February 1418.

From the single document relating to the execution of the work we learn that on May 14 and 19 of 1423 the Guelph party advanced the sum of 300 florins for the statue's completion. Since there is no mention of Donatello in this connection, it is quite possible—as Janson (1957) assumes—that the payment recorded was for the statue's gilding. By 1460 the Guelph party had become insignificant and found itself forced to sell its tabernacle. In a document relating to the sale, from January 14, 1460, there is mention of the fact that the tabernacle had been created "about 1422." The statue of St. Louis had already been removed some time before. Presumably, it had even then come into the possession of the Franciscans at Santa Croce. In 1903 it was moved from the church's main portal to the refectory (the present-day museum).

The saint is dressed in a Franciscan habit over which is a broad pluvial. The habit and his bare feet show him to be a mendicant monk, while the large mitre and pectoral reveal his bishop's rank. Donatello deliberately emphasizes the inherent conflict in the saint's dual identity. The vestments are clearly too large for the figure, so that his right hand appears to grope its way out from the cloak to give benediction. In his left hand he loosely holds a crozier adorned with putti bearing coats of arms. He is not meant to impress us with his insignia; on the contrary, he seems to be detached from it, allowing it to lean at a casual angle in front of him. His melancholy expression is a further comment on the discrepancy between his office and his person. Renaissance writers were fully appreciative of this ambiguity in the depiction of the saint, as we see from the anecdote handed down to us by Gelli (c. 1550) and Vasari (1550), which dwells on it at some length.

The figure is made up of a number of separate castings. The hand raised in benediction, for example, is actually only a glove set into the drapery. There is more excess fabric and a greater irregularity in its draping than in Donatello's earlier statues. Here he makes a greater distinction between the clothed body and the covering garments. The latter, with their sacklike cut, are not unlike those worn by the *Pensieroso* (plate 51 right) and the other Campanile statues carved after him. The way the left hand holds the crozier between its index and middle fingers also prefigures the sinewy grip found in the later works from that series. (The young Masaccio pirated this typical Donatello motif as early as 1422 in his triptych for San Giovenale.) On the other hand, certain details of the drapery, such as the way it piles up around the feet and is tossed back across the left shoulder, hearken back to the *Beardless Prophet* (plate 51 left).

The statue of St. Louis stands in its niche with no intervening plinth, for the figure and its tabernacle were conceived as a unit. Unfortunately, the only photograph to give some indication of the intended effect, from 1945 (fig. 28), was shot from too high an angle so that the figure appears to be virtually drowning in its drapery. Here, for the first time, Donatello had an opportunity to design a tabernacle to complement his figure in accordance with his own ideas. The imposing base and double frame for the round-arched niche fill almost the entire width of the pillar. The aedicula also extends vertically across more of the pillar's surface than any of the earlier tabernacles for Orsanmichele. And none of these had displayed such a variety of ornament or clear architectonic design. None were so obviously patterned after the architecture of antiquity. Donatello's niche is classical, not only in its overall form but also in its details: the paneling and scallop-shell calotte of its interior, the twisted half-columns, the fluted pilasters, the imposing entablature, the triangular pediment, the three-faced head in its gable, and the masks at the corners of its base. Any of these details could well have been borrowed from any number of Florentine buildings from the so-called Protorenaissance, especially the Baptistry. But in designing his tabernacle, Donatello could only have combined them as he did after a thorough study of ancient monuments.

The Guelph party coat of arms originally filled the wreath medallion supported by putti on the base. A counterpart to this heraldic motif is the head with three faces in the gable, a definite borrowing from classical architecture. Here, of course, it is to be understood as the Trinity. Another detail worth noting is the mat of cordage that serves as padding between the upper row of consoles and the base. This is a fine example of how the search for a new variety in decorative forms leads to a heightened appreciation for the qualities of specific materials. As it happens, all of the tabernacle's ornamental details are highly original, as is this one. For this reason alone—quite apart from the fact that the figure and its architectural setting have been designed as a unit—one wonders how anyone could attribute the *St. Louis* tabernacle to Michelozzo, as some writers have attempted to do. This would seem to be especially misguided inasmuch as Michelozzo's known creations in the field of architectural ornament, at least until well into the 1440s, are wholly derivative. It is equally unlikely that Brunelleschi had any decisive influence on the tabernacle, if only in view of its rich and varied decoration. It is highly probable, however, that Ghiberti was already familiar with the *St. Louis* tabernacle when he designed the niche for his *St. Matthew* (plate 13 right) in 1422, and that he drew on it for ideas. Still another indication that the tabernacle was in existence by 1422 is the fact that the masks on the corners of the base bear a distinct affinity to the heads Donatello created in that year for the Porta della Mandorla (plate 62).

62
Prophet and Sibyl

1422. Marble, 25¼" high (64 cm.). Porta della Mandorla, Duomo, Florence

On May 13, 1422, Donatello was given a payment of 6 florins for these two relief busts, which had already been installed on the Porta della Mandorla. The relevant document speaks of two "heads of prophets"; however, to judge from the hairdo of the one on the right it is clearly female and, therefore, to be thought of as a sibyl (Lányi, "Rilievi," 1935). Each of them holds one hand flat against his or her breast, and by this gesture alone, despite the only fragmentary format, is characterized as an awed witness to the Virgin's assumption into heaven. Their profiles are strongly classical in feeling. One is struck by both the vividness of their portrayal and the deliberate variety in the treatment of their hair, both of which are typical of Donatello at this time. It is also worth noting that each of them wears a headband, a costume detail that was to become a virtual Donatello trademark that he used again and again. These faces are more convincingly three-dimensional than the masks on the base of the *St. Louis* tabernacle (fig. 28). Their tresses and locks of hair are much more

sharply detailed, their headbands cut deeper into the mass of the hair. All of this suggests that the tabernacle masks are of a somewhat earlier date than the heads from the Porta della Mandorla.

63–65; fig. 29
Tomb of Pope John XXIII (Baldassare Coscia)

c. 1421–27. Marble and bronze, partially painted and gilt, length of the bronze figure, 83⅞″ (213 cm.). Baptistry, Florence

Baldassare Coscia became pope in 1410 but was deposed by the Council of Constance in 1415. He died in Florence on December 23, 1419. Shortly before, he had willed a number of relics to the Florence Baptistry and requested that his executors—including Giovanni d'Averardo de' Medici and Niccolò da Uzzano—designate one of the churches of Florence as his final resting place. He himself had obviously already thought of the Baptistry for his tomb.

29 Pietro di Niccolo Lamberti and Giovanni di Martino da Fiesole. Tomb of Doge Tommaso Mocenigo. Santi Giovanni e Paolo, Venice

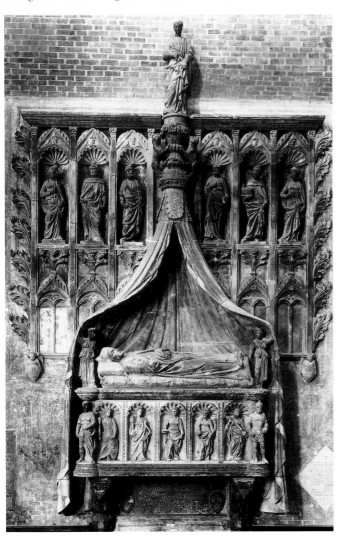

Just when the commission for the tomb was awarded is unknown. However, the records of the Arte di Calimala reveal that his executors met with representatives of the guild on January 9, 1421, to discuss the possibility of erecting a monument in the Baptistry and that work on the monument was underway in 1424. In January 1427 the Opera del Duomo sold to one of the executors four slabs of marble required for the tomb, and in July of that year Michelozzo explains in his tax declaration that the monument, on which he was working with Donatello, was as yet unfinished, but that the two of them had already received 600 of the total of 800 florins agreed upon.

The Arte di Calimala had refused to authorize the erection of a separate tomb chapel for the deceased pope, for that would have compromised the Baptistry's architecture. A chapel of sorts was nonetheless created, for Donatello was clever enough to fit his monument between two of the colossal columns set in front of the Baptistry wall. In so doing he integrated his wall tomb into the existing architecture in a manner that was altogether new; the Trecento had not produced anything remotely like it. The monument rises in several stories above a base whose Attic molding matches that of the bases of the adjacent granite columns. The bottom story consists of three niches containing figures of Faith, Hope, and Charity. Above these, on deeply projecting consoles, rests the actual sarcophagus. Between the consoles are the coats of arms of the papacy and the Coscia family.

On the front of the sarcophagus two naked putti hold open a large scroll with an inscription detailing the name and death date of the deceased. This is the first monumental inscription from the Renaissance to take the form of an inscription from antiquity. According to Del Migliore (1684), Pope Martin V is said to have expressed displeasure with the wording of the scroll (QUONDAM PAPA). If this is true, he was doubtless equally unhappy about the inclusion of the papal coat of arms among the three displayed between the consoles, and the fact that the one on the left, a Coscia family crest, is crowned by a tiara.

The sarcophagus functions simultaneously as the monumental base for an ornate deathbed, on which the figure of the deceased, in bronze, is laid out in his religious vestments. On the back wall, behind the deathbed, there is a repeat of the three-part vertical division from the niche story and the row of consoles. The top story of the structure itself, which is essentially rectangular, consists of a semicircular tympanum framing a Madonna beneath a deeply projecting entablature. The true culmination of the whole, however, is a marble curtain, partially gilt and ornamented with a colorful border, that hangs down from the underside of the wall cornice and is caught at the sides by brackets affixed to the granite columns.

The monument's architecture and figures complement each other perfectly. Janson (1957) attributes the architectural elements to Michelozzo, but there is no good reason for doing so. They are altogether typical of Donatello's pictorial architecture from the 1420s and have close parallels to both the *St. Louis* tabernacle (fig. 28) and the Prato pulpit (fig. 31). This is not to suggest that Donatello had no help in the *execution* of the monument. Of the figures created by other hands, the Madonna and Child, somewhat abandoned in the tympanum, turn out to be the least successful. The Cardinal Virtues (plate 64), however, with their greater movement, their more elaborate drapery, and their varied poses within identical niches, are of a perfectly

respectable quality. Of the three, the least convincing is the *Faith*, in the niche to the left. She is shorter and heavier than the other two, and she displays less movement—quite apart from the fact that her pose seems somewhat awkward. The face of this Faith, especially, is very similar to those in Michelozzo's later works (see the Aragazzi tomb monument, plates 156–58). Both Gelli (c. 1550) and Vasari (1550) singled out this figure as Michelozzo's work. It is quite likely that the same sculptor carved the other two Virtues as well, although undoubtedly they are based on Donatello designs.

Among Donatello's own contributions to the monument are the putti, who with wry smiles hold open the scroll presenting the inscription on the front of the sarcophagus. Unlike the ones on the base of the *St. Louis* tabernacle, these putti, although in very flat relief, are set out in front of the background surface. They seem wholly independent of the framing elements of the tomb architecture, and thus, although only secondary figures with a subservient heraldic function, they take on a character of their own. Another work created by Donatello himself is the figure of the deceased pope (plate 65). This gilt bronze figure dominates the monument due to its size and central position, not to mention its rich color.

Donatello had various reasons for placing the figure of the deceased on a ceremonial bed rather than on the sarcophagus itself, as was customary heretofore. For one thing, it was necessary to provide a major accent in the center, given the monument's extremely vertical orientation. Moreover, the additional element of the raised bed contributed further to what was already a delightful variety of forms in the overall design. And, lastly, the figure is much more visible this way. The recumbent pope occupies the entire length of the bier. While his face and body are tilted toward the viewer, his legs lie flat against the coverlet, so that the tips of his slippers assume special prominence. The helpless angles of these slippered feet serve to make it painfully clear that this is a body robbed of life. The placement of the hands and the fleshy face are also highly realistic. The distinct outline and sharp features of this countenance suggest that the figure was executed in the early 1420s.

Despite Janson's arguments (1957), it is difficult to imagine the Coscia figure as being later than the *St. Rossore* (plate 66). It is still too close in feeling to the *St. Louis* and the early Campanile statues. Since we know that discussions regarding the eventual placement of the monument occurred in January 1421, there is no reason to doubt that work on the tomb began in that same year. This seems all the more likely inasmuch as the Tomb of Doge Tommaso Mocenigo, in Santi Giovanni e Paolo in Venice (fig. 29), and in which Fiocco (1927/28) discerned the definite influence of this Coscia monument, bears a date of 1423. Clearly the Florentine sculptors who created the Venice monument were well versed in the newest developments in sculpture in their native city and already familiar with the overall design for the Coscia tomb.

66, 67
Reliquary Bust of St. Rossore

c. 1424–25. Bronze, gilt, 22″ high (56 cm.). Museo Nazionale di San Matteo, Pisa

The Ognissanti, Florence's Umiliati monastery, came into possession of the relics of St. Rossore in 1422. It is not known just when the monks commissioned Donatello to create a reliquary for them. All we know is that the work was completed before July 1427, for at that time Donatello was still owed a balance of 30 florins. After the dissolution of the Umiliati monastery in the sixteenth century, the reliquary was moved to Pisa, where it was housed in the Church of San Stefano dei Cavalieri until 1977, when it was placed in the museum.

St. Rossore, according to legend a warrior saint who suffered martyrdom under Diocletian, is here portrayed wearing armor and a cloak. In its strict axiality, Donatello's portrait is not unlike earlier reliquary busts. What makes it unusual is the definite tilt of the head, which lends a certain inwardness to its gaze. Equally striking is the restless animation of its facial features. With these, Donatello endows the bust—within the limitations imposed by its function—with a distinctly individual character, which is developed as fully as that of a standard portrait bust. Since 1939 (Lányi, "Problemi") it has frequently been assumed that the round collar is a later addition, but there is no real justification for this. A bit of clothing in a soft fabric is definitely called for, if only for the sake of the bust's formal unity, between the metal collar and the bearded chin.

The vibrant physiognomy, the close-cropped hair lying in wispy curls, the embellishment of the surface with the subtlest differences in texture—all of these suggest that the reliquary bust of St. Rossore was created at the same time as the *Herod* relief for Siena, that is, about 1425. It is certainly later than the *St. Louis* and also later than the figure of Baldassare Coscia, whose physiognomy does not yet reveal this degree of animation from within.

68, 69
The Feast of Herod

c. 1425. Bronze, gilt, 28⅝″ square (60 cm.). Font, Baptistry, Siena

For information on the font in general, see page 358.

On April 16, 1417, Jacopo della Quercia agreed to produce two bronze reliefs for the Baptistry font. Ultimately, however, one of these was entrusted to Donatello instead. We do not know the exact date, but it must have been in May 1423 at the latest. The modeling of the work, at least, appears to have been completed in the summer of 1425. In March of that year, the Sienese had warned the sculptor that they were about to demand the return of the advance they had paid him in 1423. Since they did not follow through with this threat, we must assume that they were satisfied that the work was getting done. The finished relief was delivered on April 13, 1427.

This relief is unquestionably one of the most important sculptures of the Early Renaissance. It is the earliest example of a picture conceived as a unified perspective space, and it set a new standard for pictorial narrative. Instead of simply calling the work the Feast of Herod or the Dance of Salome, the payment record from October 8, 1427 (Bacci 1929), specifies the precise moment depicted: *quando fu recata la testa di san giovanni a la mensa de' Re* (just as the head of St. John was brought to the table of the king). This momentous event is indeed the subject of the

scene, and it dominates the foreground, holding all of the participants immediately spellbound.

To have captured so movingly this decisive moment and the general reaction to it, and to have imbued it with such intense animation was itself a considerable artistic accomplishment on Donatello's part. But he went even further, determined to achieve in his pictorial narrative the greatest possible range of action and characterization—the *varietas* that would become from this point on one of the declared objectives of Early Renaissance art. Variety in the portrayal of a given event is precisely what Alberti was soon to demand in his treatise on painting of 1435. He was not so taken with Donatello's intensity of expression, a quality equally striking in the figures of this Siena relief and one characteristic of the sculptor's early work in general. Alberti clearly advocated greater restraint in this regard.

The palace architecture, with its massive pillared arcades and ashlar masonry, is obviously inspired by classical buildings. Although monumental in its effect, its surface articulation is highly varied, ornate, and full of detail. To achieve this, Donatello included all manner of structural details from classical architecture, even signs of deterioration in the masonry. The scene's perspective arrangement—especially apparent in the floor paving and the progressively smaller arches of the background arcades—follows the general rules of one-point perspective discovered by Brunelleschi and described in great detail by Alberti. It has often been noted that Donatello fails to apply them with absolute rigor, however, for his straight lines fail to converge in a single vanishing point. This "inconsistency" does not necessarily indicate that Donatello was somehow inept; more likely it was intentional so that his interior would not seem too rigid and schematic. See also pages 22f.

70
The Assumption of the Virgin

c. 1425–26. Marble, 21 × 30¾″ (53.5 × 78 cm.). Tomb of Cardinal Rinaldo Brancacci, Sant'Angelo a Nilo, Naples

Regarding the tomb itself, see page 407.

The subject matter of this relief is uncommon enough for a tomb monument, but the manner in which it is depicted is altogether unprecedented. Instead of facing forward in triumph as she is borne aloft by angels, this Virgin is turned to the side and sunk in fervent prayer. Another striking innovation is that the traditional mandorla is presented not as a rigid frame but rather as a coalescence of the clouds themselves, a boundary of genuine substance that sets off the silent and motionless Madonna in a zone of absolute calm, while the rest of the relief teems with whirling motion. All around her, angels in turbulent flight penetrate the clouds to lift the mandorla, reaching into it as though into cotton wadding, and form a second aureole around it with their outstretched arms.

Despite this ecstatic movement, the arrangement of the figures is controlled and virtually symmetrical: three angels fly in from either side, while a seventh supports the mandorla from below, rather like an Atlas figure, and with his head provides the Virgin with a sort of footstool. A number of smaller cherubs are visible in the spaces between the large angels, although they are nearly swallowed up by the roiling vapors. In fact, the movements of all of the figures are closely intertwined with those of the clouds. The angels appear to be anything but solemn, in part owing to the new style of clothing Donatello has provided for them. They all wear lightweight, airy shifts that leave their arms and shoulders bare and either hug the body or follow its movement in flamelike curves. They resemble the undergarment secured by a button at the shoulder that is worn by the *Zuccone* (plate 56), and they are obviously the inspiration for the angels' garments on Ghiberti's shrine for Sts. Protus, Hyacinth, and Nemesius (plate 17). Accordingly, the *terminus ante quem* for this *Assumption* relief would have to be 1428. Everything about the work appears to confirm this—especially the way the frame pushes up against the figures on every side, inviting comparison with the front of the sarcophagus from the Coscia monument (plate 63) and the London relief of the Ascension (plate 71).

71
The Ascension and Delivery of the Keys to St. Peter

c. 1426–27, Marble, 16 × 45″ (40.6 × 114.3 cm.). Victoria and Albert Museum, London

This relief, acquired by the Victoria and Albert Museum in 1860, is undoubtedly a work that appears in the Medici inventory of 1492. Christ, seated on a bank of clouds and surrounded by small angels and a cloud mandorla, holds out the keys to the approaching Peter with his left hand, while giving him a blessing with his right. The rest of the Apostles stand in tight rows on either side, commenting with excited gestures on the scene before them. The Virgin kneels in the center foreground, gazing upward as though transfixed. The figures of the Virgin, Christ, and Peter constitute a distinct pyramidal grouping. Two angels in the left-hand middle distance serve as additional silent witnesses to the scene. Peter's fervent acceptance of the keys is beautifully expressed. Christ's imminent ascent is obvious, both in that he appears to be slipping upward out of his seat, so that he is forced to bend down to hand the keys to Peter, and because the suggestion of a mandorla is cut off at the top by the frame. Behind the figures a landscape of mountain ranges and lines of trees stretches off into the distance, with the city of Jerusalem just visible on the horizon to the left.

The uniformly atmospheric rippling of the background, the veil-like consistency of the clouds and the mandorla, the way the frame of the relief crowds the figural composition from above and below, the animated gestures and faces, the prominent gathering of drapery folds wrapping vertically or diagonally around the bodies—all of these indicate that this relief was created at roughly the same time as the one of the Assumption of the Virgin in Naples (plate 70), that is, about 1426–27. As for Donatello's combining the transfer of the keys with the Ascension, Kauffmann (1935) catalogues similar practices in earlier depictions from Florence, and he also notes that the two events were compressed into one in a religious play presented in Florence's Piazza del Carmine in 1439.

The original function of this relief is not known; however, its extremely horizontal format and the fact that it was intended to be viewed from below would indicate that it was conceived as a predella. It is possible, as Pope-Hennessy suggests (*Ascension* 1949), that it was part of an altar, never completed, for the

Brancacci Chapel in Santa Maria del Carmine in Florence. Similarities between this relief and the figural style of Masaccio would tend to support that explanation.

72
Tomb Slab of Bishop Giovanni Pecci

c. 1426. Bronze, 97¼ × 34⅝" (247 × 88 cm.). Duomo, Siena

Giovanni Pecci, the bishop of Grosseto and an apostolic notary, died on March 1, 1426. His tomb slab, signed by Donatello, consists of three separate castings, and despite its uniform bas-relief it is uncommonly complex in its design. With a deft manipulation of perspective, the sculptor has achieved startlingly illusionistic effects. The basin-shaped bier cradling the deceased rests upon a rectangular slab, which is cut off at the foot by a scroll held open by two putti. Donatello has accounted for the viewer's position by presenting the lower rim of the bier and the soles of the dead man's feet as though seen from a low angle. Asymmetries in the pose of the recumbent figure and the splaying of the feet pointing up in the air underscore the impression of lifelessness, much as in the figure of Baldassare Coscia (plate 65).

Nonetheless, the figure is by no means naturalistic in its overall conception. Its effect is softened somewhat in that the hands have been raised so that they lie above the breast rather than the abdomen, as was traditional on earlier effigies. This gives the figure a wholly unnaturalistic expression of absolute calm and inner composure—one that Donatello re-created in his later Tomb Slab of Pope Martin V (plate 102). Originally, both the bier and the fabrics were richly adorned with chiseled designs, but most of these have been worn away. The pillow, for example, was embellished with stars—the first time the family emblem of the deceased was utilized in this way. The inscription is especially beautiful. One of the sculptor's illusionistic tricks was to have his signature appear to be half-obscured as the putti unroll their scroll.

In some respects, the Pecci effigy still seems closely related to the one of Baldassare Coscia. In certain details, however, such as its expression of intense calm, it goes well beyond the Coscia likeness. The illusionism of this work and the sudden appearance of perspective in it place it in close proximity to the *Herod* relief in Siena (plate 68). Its classical inscription is of the same general type as that of the Coscia monument (plate 65), although it is more exquisitely drawn; the widths of its letters are more varied, and there is a livelier rhythm to the whole. Janson (1957) dates the effigy to the end of the 1420s, assuming a relatively late dating for the Coscia tomb. It seems more likely that the work was executed immediately after the bishop's death.

73; fig. 30
"Niccolò da Uzzano"

c. 1425–30. Terra-cotta, painted, 18⅛" high (46 cm.). Museo Nazionale del Bargello, Florence

Granted that the first scholarly mention of this bust is relatively late, from 1745, and that there is no certainty that it is, in fact, a

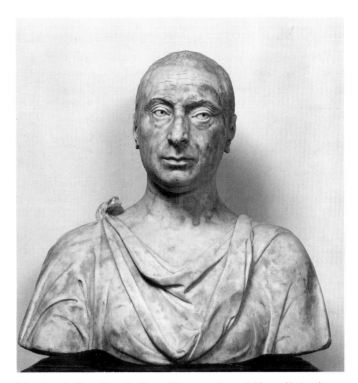

30 Antonio Rossellino (?). *Bust of Francesco Sassetti*. Museo Nazionale del Bargello, Florence

portrait of Niccolò da Uzzano or even a work of Donatello's, it was highly admired in the late nineteenth and early twentieth centuries as one of the sculptor's masterpieces. Only recently have art historians begun seriously to question the attribution of this work to Donatello, even to doubt that the bust really dates from the first half of the fifteenth century. Their arguments do not seem convincing. It makes no sense to date the bust to the late Quattrocento or even to the sixteenth or seventeenth centuries. The bust was cleaned in 1984–85, and it now seems highly likely that it is indeed the work of Donatello, presumably from the late 1420s. This makes it the first true portrait bust in the history of modern art.

Unquestionably, the work is patterned after portrait busts from antiquity. The form itself is classical, of course, and so is the close-cropped hair, which serves to emphasize the shape of the face and skull; also classical is the draping of the bust in such a way as to leave the base of the neck exposed. We encounter such classical draping again in Mino da Fiesole's later busts of Alessio di Luca and Diotisalvi Neroni (Staatliche Museen, Berlin-Dahlem; Louvre, Paris) and in the bust of Francesco Sassetti (fig. 30), which is probably the work of Antonio Rossellino, although Pope-Hennessy (*Study* 1980) prefers to attribute it to the early Verrocchio.

The "*Uzzano*" bust is altogether unlike classical precedents in its horizontal termination at the base and its angular outline. It reveals Donatello's signature in various ways: in the extreme twisting of the head to the side, with the eyes fixed on a point far in the distance, and in its juxtaposition of frontality and torsion, calm and motion, general and specific. All of these would suggest that it was created about 1430. Also suggestive of this date are the affecting forms and the animation of the features, which are especially deserving of mention in that the portrait

was evidently based on a casting. Yet Donatello was clearly not content with merely copying from life. Specific details have been accentuated in the interest of contrast and more lively expression. To appreciate this fully, it is necessary to view the bust straight from the front and not at an angle. During its recent cleaning, the earlier mounting of the work has been corrected, so that the shoulders are now drawn somewhat further back. This makes it even more apparent that the bust was originally intended to be placed above eye level, a feature it shares with countless portrait busts from the later Quattrocento.

74
Statuettes of Faith and Hope

1428–29, Bronze, gilt, 20½" high (52 cm.). Font, Baptistry, Siena

For the creation of the font itself, see page 358.

The contract of May 21, 1417, anticipated that Ghiberti would execute six bronze statuettes that were to stand in the corner tabernacles between the font reliefs. For unknown reasons, however, they were later assigned to other artists. The next mention of them is in May 1427, when Donatello inquired of the Sienese about the identities of the figures still missing. Then between September 1428 and April 1429 various payments were made for two figures—doubtless *Faith* and *Hope*. At about this same time, Giovanni di Turino was at work on the statuettes of Charity, Prudence, and Justice, which he completed in 1431. The *Fortitude* was only commissioned from Goro di Ser Neroccio on October 25, 1428, yet he also delivered his finished work in 1431.

The *Faith* wears a long undergarment and a large cloak with complex folds. Her hair is restrained by a headband. In her left hand she holds a chalice, her traditional attribute, and it is obvious that in her right, which is extended downward, she once held a cross-shaped staff, of which only a fragment of the shaft remains (Janson 1957). The winged *Hope*, on the other hand, whose right wing is missing, has let her cloak slip off her shoulders and wears a small round cap. She steps forward, turning, and lifts her hands and her gaze toward heaven. It is thus made manifest that Hope rises above itself, while the attributes of Faith are composure and assurance.

Unlike the statuettes of Giovanni di Turino and Goro di Ser Neroccio, which are altogether neutral in this respect, Donatello's figures truly express what it is they are meant to symbolize. They also differ from the former in the fact that they stand more freely in their confining niches. Turned to the side, and full of movement, they make the most of their positions at the corners of the font. It is important to note certain aspects of their dress. Donatello had already given a headband like the one holding back the hair of the *Faith* to his *Sibyl* for the Porta della Mandorla (plate 62), and the completely bare arms of the *Hope* can be traced back to the *Zuccone* (plate 56) as well as to the angels of the Brancacci relief (plate 70). Ghiberti made use of similar costume details when carving the angels on his shrine for Sts. Protus, Hyacinth, and Nemesius (plate 17).

75
Putti

c. 1429. Bronze, 14⅛" high (36 cm.). Font, Baptistry, Siena (now Staatliche Museen, Berlin-Dahlem)

On June 20, 1427, it was decided to change the original design for the Siena font and erect a marble tabernacle above its center. Among the tabernacle's ornaments were to be bronze putti standing atop its six corners. The first mention of these figures is from April 1429, at which time Donatello received money for wax required for the creation of *fanciulini innudi* (nude infants). Three of the six were executed by Donatello, the other three by Giovanni di Turino. Only two of each set are still in place. Donatello's third putto can be seen in Berlin's Staatliche Museen, which acquired it in 1902 (plate 75 top).

Donatello's winged *fanciulini*, shown making music and dancing, stand delicately balanced on shells encircled with wreaths. These shells are deliberately placed with the convex side up, so that the figures' poses seem all the more precarious. These are the first Renaissance putti to stand by themselves, performing no specific function. They neither carry garlands, unfurl scrolls, nor hold coats of arms. Instead, they are allowed to be utterly carefree, to revel in their own delightful existence. The charm of the naked body in joyous motion has here become a subject for art for the first time since antiquity. As finial figures, the small Sienese putti are not yet freestanding statues in the true sense, but to a certain extent they prepare the way for them.

76, 77; fig. 31
Exterior Pulpit

1428–38. Marble and bronze. Reliefs, 29 × 31⅛" (73.5 × 79 cm.); capital, 35⅜" high (90 cm.). Duomo and Museo dell'Opera del Duomo, Prato

This pulpit replaced an earlier one on the right-hand corner of Prato's cathedral façade. It was used for the display of the Duomo's most illustrious relic, the *sacra cintola* (Virgin's girdle). Donatello and Michelozzo were commissioned to create the pulpit on July 14, 1428. The contract specified that they were both to adhere to the model submitted, but in fact they failed to do so in certain respects (see pages 34f.). A first payment was received in July 1428. Work on the project was clearly suspended for a time in 1432–33, for between December 1432 and April 1433 the Duomo's Operai dispatched Pagno di Lapo to Rome, where he was to track down Donatello and his *compagno* (presumably Michelozzo) and bring them back to finish their work. The pulpit's bronze capital was cast on December 9, 1433, and a few months later, on May 27, 1434, a revised contract was agreed upon that guaranteed Donatello 25 florins for each of the parapet reliefs he executed himself. The reliefs were installed in July 1438, and a final payment followed on September 17 of that year. They were placed in the cathedral's Museo dell'Opera in 1972.

The round box of the pulpit is supported by a wreath of consoles projecting outward from a flaring base. The base, in turn, rests on a bronze capital that crowns a pilaster against the corner of the cathedral façade. Pairs of small pilasters divide the

31 Donatello and Michelozzo. Exterior Pulpit. Duomo, Prato

work of the pulpit is apparently earlier. The bottom part especially, up to and including the architrave, shows a great similarity to both the Coscia monument (plate 63) and the *St. Louis* tabernacle (fig. 28), which leads one to suppose that the work had proceeded at least to this point in the late 1420s.

The superb bronze capital (plate 77 below) was also completed after Donatello's stay in Rome. Although Michelozzo oversaw its casting, it can only have been designed and modeled by Donatello himself. It is by far the most beautiful, richly constructed capital from the whole of the Quattrocento. In type it goes back to the classical calyx volute capitals of the Castel Sant'Angelo. With its numerous small figures, volutes, fluttering ribbons, palmettes, tendrils, and rosettes, it presents such a variety of motifs, organized with an eye to symmetry but no concern for tectonics, that it seems a virtual catalogue of the decorative repertoire available to Donatello at this time. The overall quality of invention and modeling is so splendid that the capital must be Donatello's own work, and not—as Janson (1957) proposes—Michelozzo's. It is no longer possible to determine whether there ever was a matching capital on the cathedral's side wall, as Vasari (1550) implies, and as must have been called for in the plan.

78
Tomb Slab of Giovanni Crivelli

c. 1432–33. Marble, 92½ × 34⅝″ (235 × 88 cm.). Santa Maria in Aracoeli, Rome

Giovanni Crivelli, archdeacon of Aquileia, canon of Milan, and papal scriptor and abbreviator, died at the end of July 1432. His tomb slab, signed by Donatello, must have been created a short time later, before the sculptor left Rome to return to Florence in April 1433—probably before he carved the *Sacrament* tabernacle for St. Peter's as well.

The slab is very badly worn so that much of its original detail is no longer visible. The archdeacon stands in a niche with his head tilted to the side and his hands crossed at the waist. The niche, decorated with fluted pilasters, entablature, and scallop-shell calotte, is topped by a coat of arms in a medallion supported by two angels. A number of traditional elements—the inscription around the edge, the candelabrum motif—may possibly be explained by Donatello's having been expressly admonished to follow the example of earlier Roman tomb slabs. The fact that he does not employ the perspective illusionism so evident in the Pecci slab (plate 72) should not—as Janson (1957) claims—be thought of as a step backward. In virtually all of Donatello's work from the 1430s, he abandons such perspective *coup d'oeil* in the interest of pictorial consistency. The stark outline of the figure and the simple forms of its separate bits of clothing, especially the large almuce that closely frames the face and almost forms a square at the top, are evidence of this same aesthetic decision. It is clear from the relatively large number of Roman tomb slabs patterned after the Crivelli monument in the following decades that its special qualities were immediately recognized and admired.

parapet into seven sections, each presenting a group of gaily dancing putti. This unusual subject matter, which has nothing to do with the heraldic decor originally envisioned, may well have presented itself to Donatello while he was at work on the *Cantoria* for the cathedral in Florence (plate 84), which occupied him during this same period. In these years he became increasingly fascinated with putti as a theme in themselves. No longer are they mere decor; they now become the central subject matter. Their costumes are mostly those worn by the angels from the *Sacrament* tabernacle in Rome (plate 79), but here, owing to their ecstatic movements, there is a greater emphasis on nudity. One is also struck by the faces of these infants, which seem much older than they should be.

In both these respects, the Prato putti are similar to those of the *Cantoria*. Like the putti reliefs, the intervening pilasters with their varied capitals and the concluding cornice above them were undoubtedly only executed after 1433—that is to say, after Donatello's sojourn in Rome. The overall architectonic frame-

79, 80
Tabernacle of the Sacrament

c. 1432–33. Marble, 88⅝ × 47¼″ (225 × 120 cm.). Tesoro, St. Peter's, Rome

Mentioned by Vasari in 1550 and only rediscovered in 1886 by Schmarsow, this tabernacle hangs in the Chapel of the Beneficiati, which is now part of the Tesoro di San Pietro. Presumably it was originally mounted near the high altar of Old St. Peter's (Janson 1957). The bronze door that once belonged to it has been lost.

Most likely the tabernacle was created during Donatello's sojourn in Rome in 1432–33. It is the first wall tabernacle to employ nothing but Early Renaissance forms. It is also the earliest example of a new relationship between structure and figural decor that becomes apparent in Donatello's sculptural architecture from this period. An already elaborate structure, consisting of a richly articulated base, staggered pairs of pilasters, and a high attic story, is further enriched by the addition of a variety of figures. A grouping of three angels stands in front of the pilasters on either side, gazing in adoration at the sacrament. At one time there was surely a pictorial counterpart to these on the tabernacle's miniature door.

The figures upstage the tabernacle's architecture with an unprecedented freedom. The same thing occurs on the attic front, where two angels gracefully hold aside a curtain, permitting us to see an exquisite bas-relief of the Entombment of Christ. Two old men—Joseph of Arimathea and Nicodemus—are placing the body in the sarcophagus. The Virgin kneels behind it, bending over the deceased in mourning. These three main figures are quiet and restrained. Those further back, however, give vent to their anguish and despair in wildly violent gestures. Angels even adorn the outer pilasters, twisting with difficulty in order to face toward the center. These are similar to a number of the putti on the Prato pulpit, as are their shiftlike garments slit down the side.

The tabernacle's uncommonly elaborate architectural forms are rendered even more complex by a wealth of ornamental motifs, which reveal Donatello's increasing interest in the rich variety of architectural decor from antiquity. In these years he added considerably to the repertoire of ornament he had commanded in the 1420s, when his range of motifs was, in fact, relatively limited and much the same as Brunelleschi's. We now find for the first time vases with foliage candelabra, for example, soffit festoons, and round medallions with radial patterns. Also new are the Corinthian capitals with highly stylized acanthus leaves, which would continue to be a favorite design for capitals until the close of the century. Ultimately, the Roman tabernacle marks not only a new style of architectural ornament in the work of Donatello, but the beginning of a definite predilection for highly varied building decor that is characteristic of the Quattrocento in general.

81
The Feast of Herod

c. 1433–34. Marble, 19⅝ × 28¼″ (50 × 71.5 cm.). Musée Wicar, Lille

This relief, which came to Lille from the collection of Jean-Baptiste Wicar in 1834, is most likely one of the Donatello works listed in the Medici inventory of 1492. It is probably his subtlest work in marble, a bas-relief filled with exquisite nuances and delicately contrasting values. It is also an exemplary instance of a *storia*, as the Early Renaissance understood the term. In its narrative style and the design of its pictorial space it is, nevertheless, quite unlike Donatello's works from the 1420s. He depicts the same moment that he had chosen for his *Herod* relief in Siena (plate 68). Here, however, the palace architecture is larger and considerably more complex. A staircase leading up at an angle, pillared halls and arcades, and a loggia decorated in classical style complete with figural reliefs are blended into a vast perspective prospect. The figures are not only smaller than those of the Siena relief, by comparison, but also more convincingly integrated into the spaces formed by the architecture.

Donatello does not distinguish as sharply as before between the actions of the figures in the foreground and the architectural backdrop. Moreover, his narrative tone is much more restrained. A woman sits on a bench in the immediate foreground, her back to the viewer. As she draws back in horror, we are permitted to see beyond her, where a servant is presenting the head of John the Baptist to Herod, seated at a table. In this instance one hardly notices Herod or the servant at first glance, while in the Siena relief everything leads the eye straight to them. The presentation of the head is handled much more discreetly. For example, the others seated at the banquet table and the bystanders to the right of Salome, who continues to whirl in her dance, respond with silent horror, whereas in the Siena relief the same occurence causes them to leap to their feet and gesticulate wildly. Earlier, the sculptor felt it necessary to highlight the dramatic climax, but in the Lille relief he is less concerned with drama than with unity of composition, so that his narrative style is more measured, his staging more restrained.

The Lille relief cannot have been part of an altar, a tabernacle, or a font. It was apparently created as an independent work meant to serve as an example of *storia*, an artistic showpiece as it were. Since 1935 (Kauffmann), it has repeatedly been pointed out that it conforms for the most part, both in its spatial construction and its narrative fullness, to the prescriptions given by Alberti in his 1435 treatise on painting. This does not mean to imply that Donatello was inspired by Alberti's writing. The opposite is more likely, for in principle the rules Alberti laid down were already prefigured, by and large, in the *Herod* relief in Siena. It was first suggested by Bode (1901) that Donatello carved the Lille relief shortly after his Roman sojourn of 1432–33, and both the style of its figures and their costumes, still close to those of the sacrament tabernacle in Rome, would seem to bear him out.

82–84; fig. 32
Cantoria

1433–38. Marble, 11′5″ × 18′8⅜″ (348 × 570 cm.). Museo dell'Opera del Duomo, Florence

Donatello was only given the commission for this singers' gallery in 1433; however, Luca della Robbia had been working on a

companion one since 1431 (see fig. 45). A first installment was paid to Donatello on November 19, 1433, and on October 30, 1438, we are told that the pulpit was "nearly finished." On October 12, 1439, Donatello was provided with 300 pounds of bronze for one of the two heads that were to be mounted in the circular depressions between the pulpit's consoles. The completed work was originally placed above the door to the south sacristy of the Duomo. In 1688 it was partially dismantled, and at the end of the nineteenth century it was moved to the Museo dell'Opera del Duomo. While the documents refer to Luca della Robbia's work expressly as an organ pulpit (*perghamo degli orghani*), they do not specify the purpose of Donatello's. Yet there can be no doubt that it was to serve as a gallery for singers and musicians.

Five tall consoles support the body of the pulpit, the front of which is sectioned off by pairs of freestanding columns. A train of playful putti weaves through the resulting gallery. Wearing only the scantiest of clothing, they leap, stagger, spin, and fling their arms and legs about with abandon as they make their merry way across a floor strewn with leaves and flowers. Some of them are linked together by wreaths held in their hands. Nearly all of the ones on the front of the gallery are dancers. The only exception is the putto on the far right, who is playing a trumpet. The same instrument appears on the side reliefs as well, while two of the putti in the spaces between the consoles can be seen playing a drum and tambourine, respectively, and the remaining two help themselves to fruit from a tall vase. These last two scenes, as Corwegh (1909) has demonstrated, are largely copied from classical reliefs.

It is only on the front of the balustrade that all the putti are clothed, however minimally. In the side reliefs and in those below, their garments are either reduced to mere strips of fabric or abandoned altogether. This is the first occurrence of this degree of nudity — and of such joyous abandon — in a decorative object intended for a church, for none of the ancillary putti on the *St. Louis* tabernacle (fig. 28), the Coscia monument (plate 63), or the Sienese font come anywhere close to it. The thesis advanced by Janson (1957), according to which one ought to distinguish between specifically Christian motifs in the upper portion of the gallery and specifically heathen ones in the lower, is nevertheless unconvincing.

The *Cantoria* reliefs are not of uniform quality. Those on the bottom and sides were obviously entrusted to assistants, although Donatello was definitely responsible for the design of all of them. The left half of the front of the gallery was probably the first to be completed. The movements of the figures in this section are not so wild, and — as Janson (1957) quite rightly points out — do not contrast so dramatically with the sober line of columns as those of the right half. Moreover, the putti on the left side are still quite similar in their proportions, chubbiness, and innocence to those of the Prato pulpit (plate 76).

Sixteenth-century writers took note of the fact that in the execution of these figures a great deal is only sketchily suggested. They tended to stress this quality as a virtue, insisting that this was Donatello's way of dealing with the height of his finished work from the floor and poor lighting in the Cathedral crossing. His roughly worked figures seem more lively, Vasari insists (1550), than those in the carefully polished gallery reliefs of Luca della Robbia. Much of this animation comes from the

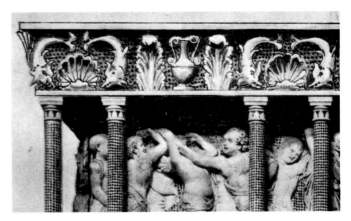

32 Donatello. *Cantoria*. Reconstruction of the original entablature according to G. Kauffmann (1959); illustration after Janson (1963)

distinct contrast between the dancing figures and their ordered architectural setting. There is no longer a definite framework to contain the figures, as in Luca della Robbia's companion piece. Abandoning the traditional concept of the frame, as he so obviously does in the *Cantoria*, Donatello flew in the face of tradition. Manetti (c. 1485) was still convinced that Donatello lacked a proper understanding of the *quadro*, that is, the order imposed on sculpture by its architectural setting. Donatello's contemporaries were nevertheless quick to follow his lead.

The sculptor releases his figures from the framing architecture to an even greater degree in the *Cantoria* than he had in his Roman *Sacrament* tabernacle or the Prato pulpit. The closest parallel in this regard is his Cavalcanti tabernacle (plate 85). Other features common to these two works are the quantity and variety of classical decor and the increasing independence of the decorative elements from the structure itself. His architectural designs become more and more three-dimensional, while his decorations tend toward mere surface pattern. A further case in point is his use of mosaics on the *Cantoria*'s columns and on the background surface of its reliefs. The top molding of the gallery's balustrade is a nineteenth-century reconstruction. The original cornice consisted of a frieze of dolphins, shells, leaves, and vases (Kauffmann 1959; fig. 32) that was clearly inspired by a classical frieze still preserved in the Pantheon. The two bronze heads mentioned in 1439 — surely gilt, or at least meant to be — have been lost. The ones that Corwegh (1909) identified as belonging to the *Cantoria*, which were then set into the tondi between the consoles around 1930, are definitely not the work of Donatello.

85, 86
The Annunciation (Cavalcanti Tabernacle)

c. 1435. Limestone, partially gilt, 13′9¼″ × 8′1⅝″ (420 × 248 cm.). Santa Croce, Florence

Albertini (1510) first referred to this *Annunciation* tabernacle with the coat of arms of the Cavalcanti family on its base as a work by Donatello. Vasari (1550), who praises it in some detail, mistakenly includes it among the sculptor's early works. Its

present location in the right-hand side aisle of the church is very probably the site for which it was intended (Janson 1957).

Kauffmann (1935) finds a precedent for the way the Annunciation is presented on the tabernacle, as an interior scene with kneeling angel and standing Virgin, in earlier paintings from Florence. However, a detailed comparison of the paintings he describes and Donatello's depiction reveals them to be wholly unrelated. Donatello's presentation is altogether original; he captures a single moment in the encounter with unprecedented immediacy, linking his two figures together despite the distance between them. The angel approaches Mary on bended knee, leaning well forward and extending his neck. His right hand, raised in greeting, stays close to his body, and the respectful hesitancy expressed in this gesture is underscored by the deferential placement of his left arm. The Virgin's response is equally full of nuance. She draws back from the angel in surprise, at the same time turning her head and body toward him. In gestures each of the figures reveals a similar combination of approach, withdrawal, and hesitation, and it is only in the meeting of their eyes that true contact is achieved. The animation of the scene is enhanced by the way the framing pilasters cut across the figures. It appears that the angel is moving out from behind the one on the left, the Virgin taking refuge behind the one on the right. Nevertheless, the illusionistic effect is not as pronounced as in Donatello's earlier works. The tone of his presentation here is somewhat calmer, more serene.

No other Annunciation grouping from the Quattrocento, either earlier or later, displays such subtlety in the use of gestural language. And nowhere, not even in earlier works by Donatello himself, does one encounter such fullness, complexity, and transparency in the drapery, beneath which, even at the slightest movement, portions of the figures' bodies are clearly revealed. Here is a perfect example of what Vasari (1550) extolled as *cercare lo ignudo*, making the body visible beneath its covering.

The astonishing richness of the decoration, both on the wall behind the figures and especially on the surrounding architecture, is also typical of this stage in Donatello's career. We first note a change in his use of architectural decor during his Roman sojourn of 1432–33, most notably in the *Sacrament* tabernacle for St. Peter's (plate 79). Here he goes a step further. This aedicula breaks new ground not only in its architecture, with a receding, concave base and a segmented gable crowned with putti, but also in the density of its applied decoration, its wealth of new ornamental motifs—pilasters covered with scales, capitals formed of masks, bases made up of volutes and lions' feet, arabesques, rows of identical palmettes—and the added richness of that decor thanks to the partial gilding of its gray stone. A further remarkable feature of these decorations is the way individual motifs appear to have been combined solely for the sake of contrast. One notes, for example, the ram's head shields freely applied to the base. Tschudi (1887) was the first to point out that Donatello could only have created this style of architectural decoration following his Roman sojourn in 1432–33. Janson (1957) ignores that observation and dates the work to before 1432. He also argues, equally unconvincingly, that the figures were not created with this architectural framework in mind, that because of their supposed similarity to the bronze putti from the Siena font they must have been created in the late 1420s.

87
Bust of St. Leonard

c. 1435. Terra-cotta, 19⅝″ high (50 cm.). Old Sacristy, San Lorenzo, Florence

The first mention of this bust is from the eighteenth century (Richa 1754–62). At that time it stood above the door of the Old Sacristy in San Lorenzo. According to Moreni (1813; 1816–17), it was originally placed in the Neroni Chapel, which was completed in 1457, and is, in fact, a portrayal of St. Leonard, to whom that chapel is dedicated. Moreni's theories are not free of contradictions, however, for he also maintains that Donatello created the bust in 1457, yet it is certain that the sculptor did not produce this work at such a late date. His attribution of the bust to Donatello, universally accepted in the older literature, was first questioned by Janson (1957) and subsequently by Lisner ("Büste," 1958), Schlegel (1967), and others. These scholars prefer to ascribe the work to Desiderio da Settignano, basing their judgment on a comparison with that sculptor's bust of "Marietta Strozzi" (plate 202) and the figures supporting the garland in his Marsuppini tomb monument (plate 199).

Their arguments are unconvincing. The whole conception of the bust, its blend of statuesque gravity and spontaneity of expression, is altogether typical of Donatello. Moreover, specific details—the slight turn and brazen lift of the head, the subtle characterization of a specific individual, the precise and animated modeling of the facial features, the sure but sketchy treatment of the dalmatic and the hair—all of these reveal the hand of Donatello beyond all doubt. In style, it most closely resembles his works from the Old Sacristy. It is seldom recognized that this bust, like the one of "Uzzano," must be viewed from directly in front and somewhat below, for it was quite obviously meant to be placed in an elevated position. One must also be aware that this is the first bust of a saint that was not intended to serve as a reliquary, which makes it the prototype for the terra-cotta busts of saints often placed in the sacristies of Florence in the later Quattrocento.

88–101; fig. 33
Sculptural Decoration of the Old Sacristy

c. 1435. Doors. Bronze, 92½ × 42⅞″ (235 × 109 cm.); Reliefs above the doors. Stucco, 84⅝ × 70⅞″ without frame (215 × 180 cm.); Tondi. Stucco, 84⅝″ in diameter without frame (215 cm.). San Lorenzo, Florence

The Old Sacristy was erected by Brunelleschi between 1422 and 1428 as part of the rebuilding of San Lorenzo, which had begun in 1419. It was donated by Giovanni d'Averardo Bicci, the father of Cosimo the Elder, who died in 1429 and was interred, as was his wife Piccarda (d. 1434), in a sarcophagus beneath the sacristy table. The building is one of the outstanding architectural monuments from the Early Renaissance, not only because of its innovative and harmonious proportions but also because of its unified sculptural ornament. The latter, created by Donatello, was planned to take the place of traditional wall frescoes. For the first time, a structure and its decoration were coordinated in a manner typical of the Early Renaissance (fig. 33).

There are no documents relating to Donatello's contributions

to the ornamentation of the structure, but early writers like Filarete (c. 1451–64), Antonio Manetti (c. 1485), Vespasiano da Bisticci (c. 1485), and others were well aware that they were his. Nevertheless, we still do not know for certain just when Donatello created these bronze doors and stucco reliefs. Most more recent scholars (Kauffmann 1935; Janson 1957; Pope-Hennessy [1985]) date them to the end of the 1430s. However, there is considerable evidence that the bronze doors, at least, may already have been completed about 1434–35 (Poeschke 1980). The aediculae that Donatello designed as frames for the doors leading to the adjacent choir rooms—later criticized by Manetti (c. 1485)—were doubtless constructed even a few years before that, shortly after the basic structure of the sacristy had been completed.

The architectural frame for these small doorways is uncommonly elaborate, and up to this time bronze doors had never been used in interior settings. It was not until 1437—and probably in imitation of these two from the Old Sacristy—that similar ones were commissioned for the sacristy doors in the Cathedral of Florence. Each of the portals contains a pair of doors of five panels each. These are framed by moldings ornamented with soffit designs based on classical examples. One pair consists of portrayals of martyrs (in the top panels Stephen and Lawrence, Cosmas and Damian); the other of portraits of the Apostles (with the addition of St. John the Baptist), the Evangelists, and the Church Fathers (plates 88–91). Each of the panels presents two figures, some of them deeply absorbed in their writing, but most engaged in lively conversation. This consistent pairing of figures, the almost complete lack of spatial illusion in the panels, and the deliberately restricted subject matter help to insure the unified effect of the two doors. In the figures themselves, however, there is as much variation as possible. The sculptor has here selected a basic subject matter, namely, theological argument, and varied it so as to achieve an array of postures and gestures in his figures in a manner that is altogether new. Equally unprecedented is the range of human emotion he portrays, the degree of passion apparent in these disputes.

Contemporaries were inclined to fault Donatello for overstepping the bounds of propriety, for in depictions of saints a certain dignity and *gravitas* were expected (see pages 37f.). We therefore find Alberti insisting in his 1435 treatise on painting that when portraying philosophers engaged in argument one must not present them as "combatants"—a passage that Filarete (c. 1451–64) later cites with express reference to Donatello's sacristy doors. Luca della Robbia was clearly inspired by these doors from the Old Sacristy when carving his reliefs for the Campanile between 1437 and 1439, in which Plato is seen debating with Aristotle (plate 165 above). Numerous later artists also drew on them when portraying figures engaged in debating and writing (Signorelli in Loreto; Raphael in the Stanza della Segnatura; Bandinelli in his choir screens in the Florence cathedral).

The wall sections above the portal aediculae are almost completely given over to partially colored stucco reliefs inside wide frames (plates 92, 93). In analogy to the panels of the bronze doors below, each of these reliefs presents two martyrs. The one on the left portrays Stephen and Lawrence (the patron saint of San Lorenzo), the one on the right Cosmas and Damian (the patrons of Cosimo the Elder). The frames, also of stucco, are

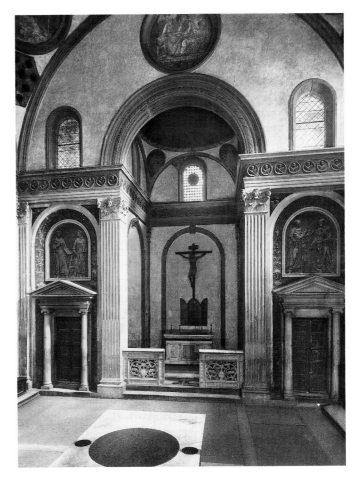

33 Choir wall of the Old Sacristy, San Lorenzo, Florence

ornamented with plants rising out of vases like candelabra—a motif that only begins to appear in Donatello's work after his stay in Rome. His use of stucco for these reliefs was also undoubtedly inspired by classical examples he had encountered in the Eternal City.

The eight tondi higher up on the walls and on the pendentives (plates 94–101) are also filled with stucco reliefs. They alternate portraits of all four of the Evangelists with scenes from the life of St. John. The latter include his vision on Patmos, his awakening of Drusiana, his martyrdom, and his ascension into heaven. John the Evangelist, the patron saint of the sacristy's donor, Giovanni d'Averardo Bicci, is given further prominence in that his portrait appears above the choir arch. All four of the Evangelists are pictured sitting on thrones at splendidly ornamented tables, meditating, writing, and reading. The vigorous movements in their various poses are suggestive of their intense concentration. Their respective symbols appear on the tables in front of them, three of the four serving as supports for books. Each of these traditional symbols is highly individualized and provides a lively contrast to the Evangelist he serves. The decoration on the thrones and tables is highly unusual and varied. The Evangelists' garments are full, soft, and clinging, and spill in broad folds across the furniture and onto the floor, as in the Cavalcanti *Annunciation* (see plate 85).

Since the reliefs on the vertical walls must be viewed at an angle, they are restricted to larger figures in a limited space.

However, the pendentive reliefs with scenes from the life of St. John are tilted toward the viewer and can, therefore, present more complex settings filled with numerous figures. Even more than the *Herod* relief in Lille, these tondi reveal Donatello's predilection for spaciousness in his relief compositions from the 1430s. This is most apparent in the one depicting the awakening of Drusiana (plate 95). Never before had the sculptor created such a self-contained, symmetrical, and monumental space — and he never would again. The miracle of the dead woman being brought back to life takes place in the center of a large barrel-vaulted and arcaded hall, while the foreground, set off by a horizontal railing, presents a flight of steps leading up into the hall and various bystanders reacting with amazement. With this clear and logical space, Donatello managed to establish a pictorial precedent that Renaissance artists for some time to come would consider ideal. Ghiberti's relief of Solomon and the Queen of Sheba (plate 24) and Raphael's famous fresco of the School of Athens are both indebted in their use of space to this relief of the Drusiana story.

The original coloring of these stucco reliefs has been uncovered only recently (1984–89), as has that of the terra-cotta medallions in the entablature frieze. The latter, like the ram's head shields with Medici coats of arms that appear below the pendentive reliefs, must have been a part of Donatello's original design as well.

102; fig. 34
Tomb Slab of Pope Martin V

c. 1435–45. Bronze, 9'4⅝" × 4'⅞" (256 × 124 cm.). San Giovanni in Laterano, Rome

Pope Martin V, of the Colonna family, died on February 20, 1431. Shortly after his arrival in Rome he had ordered the restoration of the Lateran, and it was his express wish that he be interred before its high altar. In churches north of the Alps, it had been the tradition since the Middle Ages to reserve this prime location for tombs of major benefactors. Until the nineteenth century, when the Confessio was installed, the Tomb of Martin V stood slightly elevated above the floor of the nave.

The sides of this relatively low marble tomb are adorned with mosaics and reliefs of putti bearing the Colonna coat of arms. However, its chief artistic attraction is the bronze slab with an effigy of the pope that forms its top. The slab was transported from Florence to Rome in April 1445 (Esch 1978). Vasari (1568) mistakenly attributes it to a certain Simone, supposedly a brother of Donatello's, insisting that Donatello himself had at most assisted his brother in the modeling of the work. Milanesi (Vasari and Milanesi 1878) identified the artist as the Florentine goldsmith Simone di Giovanni Ghini. But Semrau (1890) subsequently argued that it was Donatello himself who had made the major contribution to the effigy. Although most scholars have failed to agree with him (Janson, for example, 1957), Semrau is most likely correct (Pope-Hennessy [1985], Poeschke 1980), for the work is of such high quality that it cannot be the work of a mere Donatello follower. This is true despite the somewhat rough and awkward chiseling of the bronze in a number of areas, most of which may well have been delegated to an assistant.

Many scholars have noted the differences between this work and the Tomb Slab of Bishop Pecci (plate 72) from roughly ten years before, but few have adequately explained them in the light of Donatello's artistic development. Here the frame around the effigy of the deceased is larger and less cramped. It surrounds a

34 Donatello. Tomb Slab of Pope Martin V. San Giovanni in Laterano, Rome

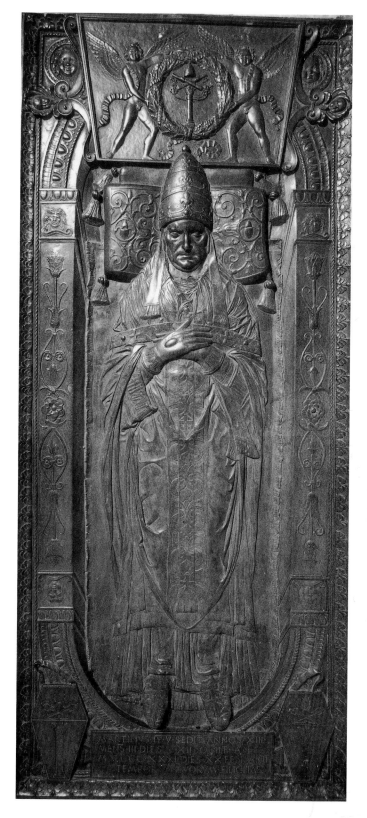

tub-shaped depression in which the figure rests on a carpet. The concentric forms of the figure itself and its surrounding border produce a monumental unity of solemnity and calm. The pope's pose is suggestive of absolute inwardness. His hands lie across his breast, his right thumb pointing, as though quite by accident, at the image of the crucified Christ half hidden in the embroidery of his fanon. His features—unlike those of the Coscia pope (plate 65)—express a profound animation even in death. This figure's complete independence of the frame, its self-contained and peaceful attitude, the coats of arms and inscription panels applied as deliberate contrast to the border, the finely creased folds of the chasuble, and all of the decorative details—ram's head shields, arabesques, volutes, and rows of palmettes—have close parallels in the Cavalcanti tabernacle and other works of Donatello's after the mid-1430s. Later papal figures such as those on the tombs of Pius II (fig. 67) and Sixtus IV (fig. 82) still reveal artistic borrowings from this one. The Northern medieval tradition of placing a benefactor's tomb before the high altar was followed once again in Florence when Cosimo de' Medici was interred in San Lorenzo. The phrase TEMPORUM SUORUM FELICITAS in the inscription honoring the deceased goes back to Roman imperial coins.

103
St. John the Baptist

1438. Wood, polychrome, 55½" high (141 cm.). Santa Maria dei Frari, Venice

This statue, once numbered among the works Donatello executed after his Paduan period (Vasari 1550), was restored in 1972. In the process the original polychrome surface was cleaned, along with a signature already known. The restorers also discovered a previously unsuspected date: MCCCCXXXVIII (Wolters 1974). In 1436, two years before that date, the Florentines residing in Venice had been granted space to set up an altar in the Frari church. This statue of the Baptist may well have been intended for it. It is one of Donatello's three sculptures in wood, along with the *Crucifix* in Santa Croce and the *Mary Magdalene* in Florence's Museo dell'Opera del Duomo (plates 40, 128).

The Baptist, wearing a gilt cloak over his shirt of animal hides, gazing down at an angle with his right hand raised and his left holding open a scroll, seems much more communicative than the bronze figure from Donatello's late years in Siena (plate 136). Donatello deliberately abandoned the cloak in the latter work, although it is included in his portrayal of the Baptist on the right-hand bronze door of the Old Sacristy (plate 89). Another feature common to this wooden figure and the small bronze relief is the way the hide and the saint's hair are rendered in uniformly soft, flowing lines. The motif of a portion of the hair being caught up so as to form a protruberance above the forehead and ears can be seen in a number of the Apostles and Evangelists from the earlier bronze door.

104
"Amor-Atys"

c. 1440. Bronze, 41" high (104 cm.). Museo Nazionale del Bargello, Florence

Vasari (1568) first mentioned and identified this sculpture as a work by Donatello. At that time it stood in the Casa Doni in Florence, where Cinelli (Bocchi and Cinelli 1677) managed to see it, although he mistook it for a work from antiquity. In 1778 it found its way to the Uffizi, and in 1865 to the Bargello.

This laughing putto, his hair tied by a cord so as to form a pointed tuft above his forehead, has wings on both his back and his feet. He also sports the small tail of a satyr. For clothing, he makes do with a pair of breeches that only covers his legs and is held up by a broad belt ornamented in the back with poppy heads. A snake writhes trustingly at his feet. His left foot is placed slightly forward, with only the heel touching the ground. From this unbalanced stance, the figure builds upward in angular movements to culminate in the raised arms and upward gaze.

Even today, despite a great deal of scholarly speculation, it is unclear just what the figure should be called. In addition to "Cupid" and "Amor-Atys," countless other names have been suggested. There was no agreement even among the writers of the sixteenth and seventeenth centuries. Its various attributes—breeches, wings on the back and feet, a snake, a satyr's tail, poppyheads, a hair cord with flowers—cannot be associated exclusively with any particular classical deity, and it is not even certain that the figure is meant to depict one. Many scholars have suggested that at one time the putto held something in his hands, but this too is unclear. His gracefully posed hands and fingers are not formed as though they are meant to grasp anything.

The most recent conjecture (Buddensieg 1986), to the effect that the hands once supported a second snake, is no more convincing than earlier ones, for it is difficult to imagine Donatello overorchestrating, as it were, employing two identical attributes. For all the giddy movement in the boy's pose, it is also carefully balanced, and at one time he may well have carried something on his head, especially since there is an uncommonly large hole in the crown. The decidedly classical feeling of this winged figure, its cheerful air, precarious stance, delight in self-display, and the execution of its details suggest that it was created at nearly the same time as the bronze *David*.

105–9
David

c. 1444–46. Bronze, 62¼" high (158 cm.). Museo Nazionale del Bargello, Florence

There are no documents relating to this bronze *David*. It is first mentioned in a report of the marriage of Lorenzo de' Medici to Clarice Orsini in the year 1469. At that time the figure stood in the Palazzo Medici, in the center of the courtyard, a spot for which one assumes it was originally intended. In 1495, after the Medici had been banished, it was moved, together with the *Judith*, to the Palazzo Vecchio, where until 1555 it occupied a position similar to its former one in the center of the cortile. It was then moved to one of the cortile's wall niches until at some later date it ended up in the Uffizi, and in 1880 it was placed in the Bargello.

The statue is one of the most famous of Donatello's works and of the Early Renaissance in general. Michelangelo created a bronze *David* patterned after it in 1501, at the behest of the

Maréchal de Gié (Pierre de Rohan), but the work has since been lost. The youthful David, wearing only a hat and leather leggings with sandals, stands calmly above the head of Goliath. His bearing and gestures are fully self-contained, reflecting the circular form of the base on which he stands. This is the first freestanding statue since antiquity that is intended to be seen from every angle. Donatello's earlier marble *David* (plate 41) fails to qualify for such an honor, as it was meant to stand against a buttress. Although subtle, the differences between this *David* and the sculptor's earlier one are fundamental. In this figure Donatello concentrates not so much on the young warrior's bravery as on his physical beauty—an attribute expressly mentioned in the Bible—and his almost narcissistic delight in himself. He holds a small stone in his left hand and a large sword in his right with utter casualness, so that they appear to be only incidental attributes. They are unmistakable, nevertheless, and, together with the head of Goliath, prevent the figure from becoming a mere idyll, a bucolic reverie.

These attributes provide a distinct contrast to the figure's charming, indolent pose and its pronounced nudity, so that the statue has an aspect of subtle drama missing in classical figures similarly conceived. The theme of David and Goliath thus takes on a whole new dimension. It is no more correct to interpret the nude *David* as a symbol of Christian humility (Kauffmann 1935) than it is to make of him some sort of political statement (Janson 1978). It seems equally misguided to relate him to Mercury, an interpretation first attempted by Lányi and taken up once again more recently (Parronchi, "Mercurio," 1980; Pope-Hennessy 1984).

The fact that the figure is fully developed in the round indicates that it was intended to be freestanding from the start. And from the distinct emphasis given to four cardinal points of view one suspects that the spot in the center of the square courtyard of the Palazzo Medici was the site for which it was conceived. It is likely that the statue's position there was somewhat elevated, for the report from 1469 speaks of its "beautiful column." The richly ornamented marble base that Vasari (1550) tells us was created for the bronze *David* by Desiderio da Settignano has not survived (but see Passavant 1981).

Closely tied to the question of the statue's original location is that of its dating. Over the last hundred years scholars have suggested dates for the work from as early as 1430 to as late as 1457. Kauffmann (1935) is the most outspoken champion of the later date, while among the more recent scholars Janson (1957; 1978) argues most strongly for the earlier one. One would think it impossible to reconcile the bronze *David* with Donatello's late statues. They no longer have this quiet, unforced pathos, and nowhere in the later years does he create a pose as delightfully free yet perfectly balanced as this one. But the bronze *David* is equally far removed from the sculptor's early works in the genre. It does not incorporate the surrounding space as they do, nor is it so blatant in its expressiveness. Its calm self-possession, balanced ponderation, exquisite proportions, and restrained emotion are all qualities of what must be thought of as Donatello's classical phase, culminating in the works he produced in Padua. The most likely date for the *David* is thus sometime just before his final move to Padua, or 1444–46. This suggests that he created the statue when work on the Palazzo Medici was just beginning. See also pages 41f.

110–13; figs. 35, 36
Equestrian Monument of Erasmo da Narni, called Gattamelata

1444–53. Bronze, 36′9″ high with base (1120 cm.); statue, 11′11¾″ high (340 cm.). Piazza del Santo, Padua

Donatello's presence in Padua is first documented in January 1444. In the following ten years he would execute in that city the Gattamelata monument and the bronze *Crucifix* and high altar for the Santo. His move to Padua was presumably occasioned by the commission for an equestrian statue of the condottiere of the Venetian republic, Erasmo da Narni, known as Gattamelata. The condottiere had died in January 1443, and it is likely that the family of the deceased—with the consent of the doge, of course—contracted for his monument. At least it was they who paid for it. It is uncertain whether Donatello had taken up residence in Padua as early as the beginning of 1444, for work on the equestrian statue is only documented from 1447 on. At that point the masonry work on its pedestal and the casting of individual sections was already underway. In 1453 the work was appraised and installed. It had probably been completed as early as 1450. The upper part of the base bears the signature OPUS DONATELLI FLO.

Noted military commanders had been honored in Italy with equestrian portraits, either painted or sculpted, since the fourteenth century. In northern Italy, as opposed to Tuscany, such equestrian likenesses were at first always associated with tomb monuments. Examples of these are the tombs of the Scaligeri in Santa Maria Antica and the Tomb of Cortesia Sarego in Santa Anastasia, all in Verona. However, at the same time that Donatello was working on the *Gattamelata*—between 1444 and 1451—the bronze equestrian portrait of Niccolò III d'Este was created, also as a fully independent piazza monument, in Ferrara. Until its destruction in 1796, that statue stood atop the Arco del Cavallo, which was probably designed by Alberti and still survives. The arch served to tie the work to the front of the ducal palace.

Donatello's work, the actual prototype for all subsequent equestrian statues, surpassed these earlier examples both in size and in monumental grandeur. It was set up in the square in front of the Basilica del Santo as a freestanding monument that could be seen from every direction. Donatello surely modeled his work after equestrian monuments from antiquity, such as the *Regisole* in Pavia, destroyed in 1796, or the famous statue of Marcus Aurelius, which in the fifteenth century stood in front of Rome's Lateran church. However, the effect of the *Gattamelata*, which dominates the entire square in which it stands, is considerably greater than that of these ancient examples, owing not only to its unusually tall pedestal but also to the figure's authoritative bearing. His baton is no mere attribute; he holds it aloft in command, laying claim to all the space before him.

As always, Donatello here combines a definite *storia* with his *statua*, creating a sense of action that belies the calm equilibrium of his figure. Avoiding emotionalism, and with the greatest economy of expressive means, the sculptor successfully portrays the general as a superior commander. The contrasting motif of the horse stepping on a cannonball further enhances the characterization. A heroic dimension is added by the fact that the general does not ride into battle wearing a helmet, as was

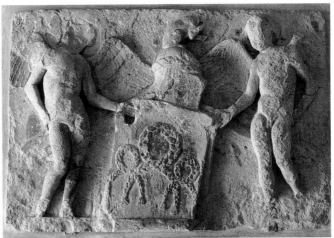

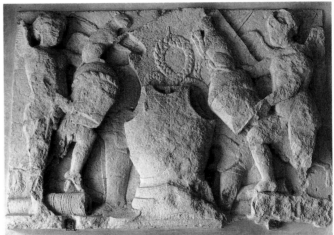

36 Donatello. Reliefs on the base of the Gattamelata monument.
Museum, Basilica del Santo, Padua

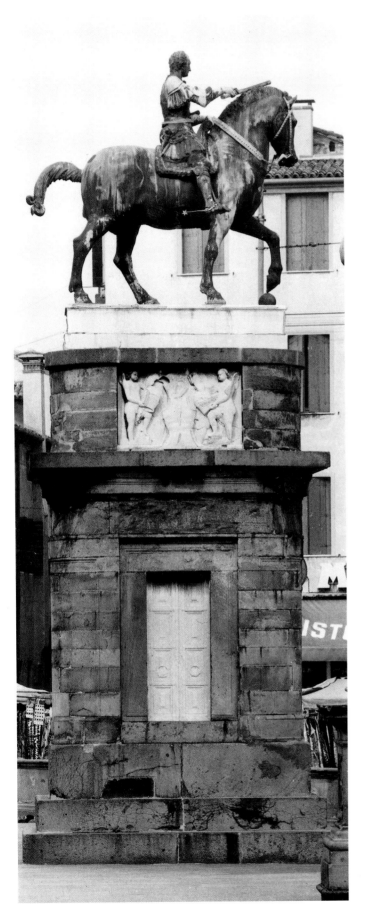

35 Donatello. Equestrian Monument of Gattamelata. Piazza del Santo,
Padua

customary in the fifteenth century, but bareheaded, like the
leaders of antiquity.

The *Gattamelata*'s features are extraordinarily lifelike, but it
is impossible for us to know whether they constitute an actual
portrait. One must not take too literally the *compromesso* from
1453, which states that the equestrian image was made *ad
similitudinem*, or so as to reflect the true appearance of the
condottiere. By no means did Donatello stick to the truth when
modeling his subject's armor, for example. Instead of mirroring
the contemporary fashion, he devised a type of armor all his own
that was patterned to a great extent after examples from antiq-
uity. Classical touches helped to give his *Gattamelata* monu-
ment an unprecedented *magnificenza*, one that notable later
examples of the genre such as the statues of Louis XIV and the
Great Elector, Friedrich Wilhelm, still sought to emulate.

Donatello designed the base for the monument as well. In the
upper part are two reliefs. In one a pair of mourning angels
points to the coat of arms of the deceased, while in the other a
second pair displays his battle armor. The badly weathered
originals were replaced by copies in 1854 and are now preserved
in the Santo museum (fig. 36). The lower section of the pedestal
has two mock portals of marble. These were based on the doors
to Hades portrayed on classical sarcophagi and serve to under-

score the monument's tomblike aspect. The structure may, in fact, have been conceived as a tomb, but this is not certain. There is reason to think so in that the payment record from 1447 refers to the pedestal as the *pilastro della sepoltura*. Also, we discover that the condottiere's widow only commissioned a conventional tomb in the Santo in 1456—some years after the completion of Donatello's monument. See also page 43.

114, 115
Crucifix

1444–49, Bronze, 70⅞ × 65⅜″ (180 × 166 cm.). Basilica del Santo, Padua

The first mention of this *Crucifix* is from January 24, 1444. It would seem that it was then ready to be cast, for on that date Donatello was supplied with 46 pounds of iron. The actual completion of the work appears to have been delayed for over five years, however, for it was not until June 23, 1449, that the sculptor received the final payment for it. With this bronze *Crucifix*, presumably intended for the choir screen installed in the Santo in 1443–44 (Kauffmann 1935), Donatello created what was in its time a wholly new and idealized portrait of the Savior. Here there is no longer a trace of the crude realism and "peasantlike" form of his early wooden *Crucifix* in Santa Croce (plate 40). Nor does this work emulate the forced posture and exaggerated sinewiness of Brunelleschi's version in Santa Maria Novella (plate 3).

A perfect balance pervades this figure down to its fingertips, lending it a weightlessness wholly lacking in earlier crucifixes from the Quattrocento. The legs are more powerfully formed, held closer together, and filled with a greater upward movement than those of older crucifixes. As a result, the slender torso stretching upward from the hips, and the gently outstretched arms appear to float effortlessly above them. Obviously designed to be placed at a considerable height, the figure regally commands the space below and to the front. In its overall bearing, it combines grace and dignity, animation and calm, frailty and strength. Its physical details are highly individualized, yet conform to the ideal of harmonious proportions. Any hint of death and exhaustion is confined to the bowed head and face, and even here it is rather restrained. Only from the open mouth and the vein prominently descending across the brow does one sense the suffering endured. Otherwise the expression is one of complete inwardness. This effect is underscored by the considerable mass of hair that hangs down in broad locks over the forehead and partially obscures the face.

Donatello created his Savior as a nude. The present loincloth is a Baroque addition. The original one cannot have been much larger than this, however, or it would have considerably lessened the overall effect of the figure, which relies to a great extent on the prominent knees and thighs. One suspects that it was similar to the brief loincloth on the crucifix that St. Francis carries on the Santo altar (plate 116; Janson 1957) or to those frequently encountered in painted crucifixes from northern Italy a short time later (for example, Mantegna's predella from the San Zeno altar). One of the obvious imitations of this Paduan *Crucifix* is the wooden one in San Niccolò Oltrarno in Florence, first attributed

to Michelozzo by Lisner ("Michelozzo," 1968). Michelangelo's *Crucifix* for Santo Spirito also borrows something of the quiet radiance of this Donatello masterpiece.

116–26; figs. 37–40
Statues and Reliefs from the former High Altar in the Santo

1446–50. Bronze, partially inlaid with gold and silver: *St. Francis.* 57⅞″ high (147 cm.); *St. Louis of Toulouse.* 64⅝″ high (164 cm.); *St. Prosdocimus.* 64⅛″ high (163 cm.); *St. Anthony of Padua.* 57⅛″ high (145 cm.); *St. Daniel.* 60¼″ high (153 cm.); *St. Justina.* 60⅝″ high (154 cm.); *Madonna and Child Enthroned.* 62⅝″ high (159 cm.); 12 reliefs with angels. 22⅞ × 8¼″ (58 × 21 cm.); 4 reliefs with the symbols of the Evangelists. 23½″ square (59.8 cm.); 4 reliefs depicting the Miracles of St. Anthony. 22½ × 48⅜″ (57 × 123 cm.); *Pietà.* 22⅞ × 22″ (58 × 56 cm.). *Entombment of Christ.* Limestone with polychrome inlays, 54⅜ × 74″ (138 × 188 cm.). Basilica del Santo, Padua

After the equestrian statue of the Gattamelata, the second major work Donatello produced in Padua was the high altar for the Santo, created in a brief four years. Francesco Tergola had donated 1,500 lire for a new high altar on April 13, 1446. In all of the documents the altar is referred to as a *pala* or an *anchona*. The work must have been commissioned from Donatello a short time afterward. He received a first payment for it on February 11, 1447. Between 1446–47 and 1448 he first produced several reliefs—the one depicting the miser was the last of them—and then the statues. By June 13, 1448, St. Anthony's feast day, they were already sufficiently complete to be temporarily installed in the church. Those portions still missing at that time—the fram-

37 High Altar, Basilica del Santo, Padua

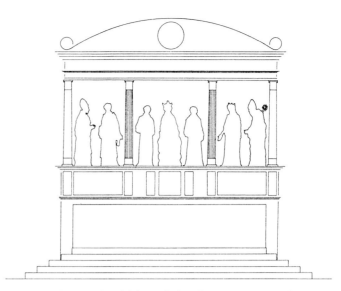

38 High Altar, Basilica del Santo, Padua. Reconstruction according to Janson (1957)

39 High Altar, Basilica del Santo, Padua. Reconstruction according to White (1969)

ing architecture, the *Pietà* relief in the center of the predella, and the *Entombment* for the back of the altar—were executed in the following year. The documents relate that Nicolò Pizolo, Urbano da Cortona, Giovanni da Pisa, Antonio Chellini, and Francesco del Valente assisted in the creation of the reliefs of angels and Evangelists for the predella. The casting of the bronze reliefs and statues was entrusted to Andrea dalle Caldiere, who had also cast the *Gattamelata* and the Santo *Crucifix*. Nicolò da Firenze and two additional assistants produced the framing structure.

40 High Altar, Basilica del Santo, Padua. Reconstruction according to Poeschke (1980)

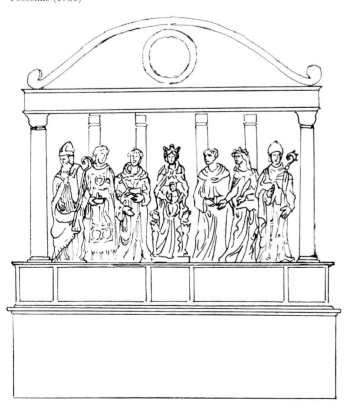

Donatello's altar was dismantled to make way for a new one by Girolamo Campagna in 1579. In 1895, however, as part of the Donatello renaissance of the late nineteenth century, Camillo Boito undertook to "restore" the work to its present form (fig. 37). Through the years since Boito's highly idiosyncratic reconstruction, a number of scholars have tried to determine the original form of the altar (figs. 38–40) by studying the documents relating to payments as well as a brief description of the work by Marcantonio Michiel (1521–43). They disagree on both the original arrangement of the statues and reliefs and the architectural form of the altar itself. Since none of the framing elements from the old altar survive, we are reduced to pure speculation.

Of the seven statues (plates 116–19), the *Madonna and Child Enthroned* surely stood in the center. She has risen from her throne and steps forward slightly to present her infant. She holds the Child at a relatively low angle, as would have been appropriate given her elevated position. The Madonna was flanked by Franciscan and Paduan saints (see fig. 40). St. Francis himself stood immediately to her left, St. Anthony to her right. Next came Sts. Daniel and Justina, each pointing toward the Mother and Child. St. Prosdocimus completed the line on the left, St. Louis on the right. The former offers the sacrament of baptism, the latter raises his hand in benediction. Both turned away from the rest of the group to face the viewer directly. The slight variation in the size of the figures tends to confirm this arrangement.

The predella was composed of twenty-one bronze reliefs, twelve with angels playing musical instruments (see plates 120, 121), four with the symbols of the Evangelists (plate 122), a Pietà (plate 123), and four depicting the Miracles of St. Anthony (plates 124, 125). Of these, the ones based on St. Anthony's miracles are of especially high quality. Specifically, they depict: the Miracle of the Host (a heretic is convinced of the presence of Christ in the wafer when he sees a donkey that has been starved for three days ignore the hay placed before it and kneel down before the Host); the Miracle of the Infant (a newborn attests to the innocence of his mother, who has been accused of adultery); the Healing of the Hotheaded Youth (a young man has hacked off one of his feet in a rage, but St. Anthony manages to reattach it);

the Miracle of the Miser (at a miser's funeral the saint gives a sermon on Luke 12:34 — "where your treasure is, there will your heart be also" — and the miser's heart is, in fact, discovered not in his body on the bier but in his money chest).

The architectural prospects in these scenes are even more imposing than those of Donatello's earlier reliefs, and their figural compositions, presenting the varied reactions of a host of onlookers, are astonishingly varied. The autonomous spaces characteristic of the sculptor's reliefs from the 1430s have again been abandoned, for the most part, as he concentrates his attention on the responses of his figures. The focal events are no longer placed well back in the picture space, as was still the case in the *Herod* relief in Lille or the *Awakening of Drusiana* (plates 81, 95). They now take place almost exclusively in the foreground, the figures upstaging what is in every case a three-part architectural backdrop. These figures react to the miracles taking place before their eyes with more animated gestures and in more agitated, crowded groupings than any Donatello had created before.

The miracles of the Host and the Infant, unlike the other two, are designed to be seen from below and may well have been placed on the back side of the altar. The large relief carved from Istrian limestone and depicting the Entombment of Christ (plate 126) would also have been on the back. In its extremely restricted space, its compressed planes, the distinct angularity of its figural silhouettes, and the harsh expressiveness of its gestures, it already anticipates Donatello's late style (Gosebruch 1968).

If one considers the possible dimensions of a Quattrocento altar and the different sizes of the statues as well as their specific gestures — not to mention the subsequent imitations of Donatello's altar, both painted and sculpted — it seems most likely, contrary to the reconstructions by Janson (1957), White (1969), and others, that the figures were packed close together on either side of the Madonna, with no space between them (fig. 40). As for the reconstruction of the predella, one has to bear in mind that it was not originally intended to house the sacrament, and that therefore the *Pietà* relief could not have been a part of it. This latter relief was added only after the temporary installation of 1448 and must have occasioned a different arrangement of the predella reliefs already completed (Poeschke 1980).

Donatello's self-contained grouping of the statues inside an aedicula was a drastic innovation that inspired no direct imitations. It did, however, have an influence on the relief sculpture and painting of the period, for example, on Nicolò Pizolo's Ovetari altar for Padua's Eremitani church and Mantegna's altar in San Zeno in Verona.

127

The Flagellation and Crucifixion of Christ ("Forzori Altar")

c. 1445–47. Terra-cotta, 21½ × 22¾″ without predella (54.6 × 57.8 cm.). Victoria and Albert Museum, London

This relief was purchased for the South Kensington Museum in 1861, and since that time most scholars have attributed it to Donatello, dating it to his final years. Only Janson (1957) and Pope-Hennessy (1964) have chosen to think of it as the work of one of Donatello's followers. It has recently been cleaned, and since then Radcliffe (1989) has once again suggested that the work may well be by Donatello. The restorers discovered that the relief is a casting from a wax model — presumably the model for an altar. The wooden frame was added later and the predella partially replaced so that the coat of arms that appears on the right side, which Bode (1892–1905) thought belonged to the Forzori family, cannot be clearly identified. Noting the central perspective of the right-hand interior, Schottmüller (1904) deduced that the relief was originally in three sections, the missing one surely portraying either the Entombment or the Ascension of Christ.

Since the two scenes from the Passion are placed in matching architectural settings, namely, large, barrel-vaulted halls separated by pilasters supporting a common entablature, it does seem likely that these were portions of an altar design. For the sake of uniformity, the artist has defied all tradition and even placed the Crucifixion indoors. The Flagellation is depicted in the left-hand panel. Christ's torture has been placed well back in the hall, while the foreground is occupied by soldiers — one of whom even stands outside the railing that forms a boundary in the front — who direct our gaze to the central event. The Crucifixion scene is arranged in a similar way. The cross, surrounded by mourners, rises up in the center of the hall, while in the foreground the Virgin, isolated, laments on a rock with outstretched arms.

As Pope-Hennessy has pointed out, the monumental architecture of this relief is not unlike that of the *Miracle of the Host* in Padua (plate 124 above). Compared to the figures, it here seems even larger and more spacious. While this would suggest that the relief was created before Donatello's sojourn in Padua (Pope-Hennessy 1964), its figural style and architectural decor are very similar to the works he produced in that city. His placement of the foreground figures on the bottom border of the relief also conforms to his practice in the Paduan reliefs. The odd combination of motifs from different levels of reality in the lunette of the Flagellation scene, where a man on horseback charges forward accompanied by a foot soldier, bears a particular affinity to the relief of the healing of the enraged youth (plate 124 below). For this reason, it would appear that the London relief was executed just before the Santo altar (Radcliffe 1989).

128

Mary Magdalene

c. 1453–55. Wood, polychrome, 74″ high (188 cm.). Museo dell'Opera del Duomo, Florence

This statue is first mentioned in the year 1500. Until 1966 it stood in the Baptistry in Florence, but it is not at all certain that this was its original location. It was restored after the flood in November 1966, at which time its original polychrome painting came to light. The figure was then placed in the Museo dell' Opera del Duomo.

Albertini (1510) was the first to identify the work as Don-

atello's. Despite recent arguments against a late dating for the statue (Strom 1980), it must be numbered among his post-Paduan works. The artist has deliberately avoided all semblance of ideal beauty and sublimated expression. Instead, his figure projects, with frightening immediacy, a deep spiritual pathos. Lank strands of hair and ragged hides are all that clothe the fragile body. Her step is hesitant, and she meekly lifts her hands in a gesture of prayer. But the penitent's self-flagellating nature is most vividly expressed in the taut throat and hollowed face with its exhausted, staring eyes.

A statue of the Magdalene in the Collegiata in Empoli, patterned after this one and dated 1455, assures us that Donatello's figure was created sometime before this. Numerous other portrayals of the Magdalene in the sculpture and painting of Florence from the second half of the fifteenth century are also influenced by this late work of Donatello's.

129
The Crucifixion

c. 1455. Bronze, with gold and silver inlay, 38⅛ × 28¾″ (97 × 73 cm.). Museo Nazionale del Bargello, Florence

This relief is most likely the one Vasari (1568) speaks of as a *passione di Nostro Signore, con gran numero di figure* by Donatello, which in the sixteenth century was located in the private apartment of Duke Cosimo I. In 1784 and 1825 it is listed in the inventories of the Uffizi, and after 1865 it was moved to the Bargello. The attribution to Donatello has been questioned repeatedly in this century, most forcefully by Janson (1957), although Pope-Hennessy (1975) continues to argue that it is indeed the master's work.

For the sculpture of the time, this portrayal of the Crucifixion contains an unusually large number of figures. Symmetrically placed crosses tower above the landscape and the assembled crowd. Hovering angels hold out chalices to catch the blood from Christ's wounds. The Virgin is seated in the foreground, her back to the cross, wringing her hands and gazing at the ground in despair. St. John stands to the right, equally mute and motionless, sunk in his sadness. In deliberate contrast to the stillness and isolation of these principals, the rest of the onlookers are full of movement. Two of the soldiers have flung themselves to the ground in terror, covering their faces with their hands. Possibly they are reacting to the ominous darkening of the sky that is suggested in the thickening clouds.

In the variety and density of its array of figures, its highly expressive gestures, the unusual freedom in its selection of motifs, and the affecting angularity of its figural silhouettes, this relief anticipates those on the pulpits in San Lorenzo. However, the spaciousness of the scene, the landscape forms, the modeling of the figures, and the ornamentation are still close to the St. Anthony reliefs in Padua. Pope-Hennessy (1975) dates this Bargello relief to 1453–56, and for the above reasons this seems most plausible. Perhaps this is the Donatello *tavola di bronzo* mentioned by Piero de' Medici in a letter of September 12, 1454.

130
Madonna and Child ("Chellini Madonna")

1456. Bronze, partially gilt, 11¼″ diameter (28.5 cm.). Victoria and Albert Museum, London

This bronze plate, discovered and purchased for the Victoria and Albert Museum by Pope-Hennessy (1976), was presumably brought to England sometime in the mid-eighteenth century. Donatello presented the work to Giovanni Chellini on August 27, 1456, in gratitude for medical treatment he had received from him. Chellini himself recorded the gift in his *Libro debitori creditori e ricordanze* (Janson 1964), adding that the plate's relief was hollowed out on the back in such a way that one could make casts from it in molten glass. This is indeed the case, for the back is a precise negative of the casting mold.

The small tondo is dominated by a half-figure of the Madonna, who is seated behind a balustrade. She cradles her infant against her breast and bends her head toward him. The Child is quite small compared to his mother, and for that reason the sense of intimacy and shelter is even more pronounced. The four angels visible behind her are equally underproportioned. One of them points toward the Christ Child while another gazes at something—it is not clear what—in a bowl he holds in his hands. Unlike other Florentine Madonnas of the period, this one wears a crown on top of her veil, a motif that may have been adopted from the northern Italian tradition.

The *"Chellini Madonna"* is Donatello's only documented Madonna relief. It is altogether typical of his late work in its intensity of feeling, the dense crowding of its figures, the angularity of the Madonna's silhouette, her more slender form, and her less abundant drapery. One can see the influence of this work already in the *"Madonna del Perdono"* on the Siena Duomo, which was produced in Donatello's workshop about 1457.

131–35
Judith and Holofernes

c. 1456–57. Bronze, partially gilt, 92⅞″ high with base (236 cm.); base relief, 17⅛ × 22½″ (43.5 × 57 cm.). Palazzo Vecchio, Florence

Donatello returned to Florence from Padua in 1453. In the years immediately following, he executed three statues that typify his late style, the most important of which is this *Judith and Holofernes* group. On the cushion it bears the signature OPUS DONATELLI FLO., and it was probably created in 1456–57. We cannot know for certain where the group was originally meant to be placed. Presumably it was intended for the Palazzo Medici (Herzner 1980), although most recently it has been argued that the commission came from Siena (Natali 1988). In 1464, or shortly after its completion, it is mentioned for the first time in a condolence letter to Piero de' Medici on the occasion of Cosimo the Elder's death. At that time it stood in the Palazzo Medici, and on its pedestal was the double inscription: REGNA CADUNT LUXU SURGENT VIRTUTIBUS URBES CAESA VIDES HUMILI COLLA SU-

PERBA MANU. SALUS PUBLICA. PETRUS MEDICES COS. FI. LIBER-
TATI SIMUL ET FORTITUDINI HANC MULIERIS STATUAM QUO CIVES
INVICTO CONSTANTIQUE ANIMO AD REM PUB. REDDERENT DEDI-
CAVIT. In October 1495, after the Medici had been expelled, the
statue was removed from the garden of the Palazzo Medici and
installed in front of the Palazzo Vecchio on the spot where
Michelangelo's *David* came to stand in 1504. On its new pedestal
the inscription read: EXEMPLUM. SAL. PUB. CIVES. POS. MCCC-
CXCV. It was restored in 1986–88 and subsequently placed in
the Palazzo Vecchio's Sala dei Gigli.

The group is composed of eleven separate castings and was
obviously meant to stand atop a fountain. A possible connection
between that placement and the work's subject matter is provided
in the fact that the springs of Bethulia were walled up by
Holofernes and only began to flow again after Judith had com-
mitted her grisly deed. As a statue intended to be freestanding,
the Judith group is part of the series Donatello began with his
bronze *David* and the *Gattamelata*. However, as a double figure
of complex design, and also in its blending of *statua* and *storia*, it
is subject to different laws than those earlier works. The sculptor
has chosen the moment when Judith overwhelms Holofernes, the
Assyrian general who had laid siege to Bethulia on behalf of
Nebuchadnezzar, on his couch. "Stepping close to the bed she
grasped his hair. 'Now give me strength, O Lord, God of Israel,'
she said" (Judith 13:7–8).

Not only do these figures represent the first monumental
portrayal of this subject matter; they are also unique in the way
they strike at the inherent conflict in the scene. For precisely this
reason, the Judith group stands as an important precursor of the
wrestling groups popular in the Cinquecento. As a statue, it is,
however, more stringently compact than these. It is also more
pictorial, its front view clearly more fully developed than those of
the back and sides. The hierarchy between the two figures is
clearly established, despite their complex intertwining. A defi-
nite contrast is set up between the upper and lower sections,
between the delicate yet menacing silhouette of the triumphant
Judith and the powerlessness and physical weight of the van-
quished Holofernes. The work gives monumental expression to
the deed itself and the instant of its execution; the momentary
takes the form of a lasting admonition. It would, therefore, be
mistaken to define too precisely a single stage in this conflict.
Donatello's narrative realism, despite the variety and subtlety of
his details, is not that specific.

It is typical of Donatello's late figural style that the *Judith*
figure displays no gestures developing freely in space. Her
movements are labored, angular, and mechanical. One notes not
only her raised arm and the garment belted tightly around her
slender body, but also the way she appears to cling to her victim
for support. Her deed has been dictated by external forces; it
does not rise out of her own inner strength. Judith, therefore,
appears to be the tool of a higher will, and this is what makes her
such a potent symbol of humility. Her facial expression is wholly
appropriate; her gaze is directed at her victim, to be sure, but
seemingly focuses beyond him as though she were lost in
thought.

The triangular base provides a formal analogy to the group-
ing's angular silhouette. In deliberate contrast to the event
depicted above, it presents a gay bacchanal. A number of putti
have abandoned themselves to harvesting grapes, making wine,

and the unrestrained enjoyment of their vintage. Their carousing
is directly related to the figures above; it is by no means coinci-
dental that the fingers of Holofernes's left hand, falling down so
visibly past the cushion, are pointing at the statue of Bacchus in
the center of the pedestal relief, which the putti caress and
around which they frolic (plate 131).

136, 137; fig. 41
St. John the Baptist

c. 1456–57. Bronze, 72⅞" high (185 cm.). Duomo, Siena

This statue was delivered to Siena in three sections in the fall of
1457. The seams run parallel to either end of the Baptist's staff.
At that time the right arm was still missing, and it was only
delivered to the director of the Opera del Duomo in 1474
(Herzner 1971). Obviously the arm had been created only a
short time before and is therefore not the work of Donatello
(Janson 1957; Poeschke 1980). The staff held with a scroll in the
left hand is topped by a cross that was added at a later date.

In its composition as a statue and in its austere characteriza-
tion of the religious ascetic, the *Baptist* is closely related to

41 Francesco di Giorgio. *St. John the Baptist*. Pinacoteca, Siena

Donatello's tortured *Magdalene* (plate 128). The figure describes a tall rectangular shape as though in a fixed frame. Each of its movements is strained, including the slight turning of the head to the side and the subdued emotions in the face. The costume and pose suggest nothing of the Baptist's forceful eloquence and commanding manner, only stubborn perseverance. The body wears no cloak, only an animal hide full of twisted and tangled tufts of hair. Wide and ragged locks frame the face. The sculptor has carefully contrasted the high polish and exquisite detail of the *Baptist*'s bare limbs with the rough and confusing tangle of his hair and the animal hide.

The right forearm, added later, does not entirely fit and can, therefore, be misleading. Donatello undoubtedly had in mind a more horizontal gesture than this diagonal one, for it is not that the Baptist is giving his blessing—in that case his gaze would follow the direction indicated by the hand. Instead, he is pointing at someone perceived to be behind him, that is, Christ, as he does, for example, in the wooden *St. John* by Francesco di Giorgio in Siena's Pinacoteca (fig. 41).

138
Lamentation of Christ

c. 1460. Bronze, 12⅞ × 15¾″ (32.6 × 40 cm.). Victoria and Albert Museum, London

This relief was acquired by the Victoria and Albert Museum in 1863. Although there is no mention of it in contemporary documents or in the writings of the early authors, it is definitely considered to be the work of Donatello himself. It was not meant to have the form of a silhouette; the group of figures has simply been sawed out of a larger panel that was presumably ruined in the casting (Middeldorf 1936). The work portrays the dead Christ surrounded by mourners. Kneeling on the ground, the Virgin cradles his body in her lap. Three women behind her wail uncontrollably, while to the right a grief-stricken John stands with his back to the others, sunk into himself.

As in the reliefs for the pulpits in San Lorenzo, the sculptor has paid little attention to uniform figural proportions, believable spatial groupings, or finished detail. On the contrary, he has seemingly thrown his figures together, so that portions of their limbs and bodies seem deformed. This is especially true of the Virgin and Christ, who appear to have been pieced together from figural fragments.

Their pathetic gestures, the roughness of their garments, and their masklike faces distorted by grief all reveal that the relief can only date from Donatello's late period and not, as Pope-Hennessy proposes ("Donatello Problems," 1959; 1964), from the late 1430s or early 1440s. Kauffmann (1935) and Janson (1957) consider the possibility that the London relief may have been related to the door for Siena's Duomo that Donatello began but failed to complete. However, this remains an open question.

139–53
Pulpit Reliefs

c. 1461–66. Passion Pulpit. Bronze, 4′5⅞″ × 9′2¼″ (137 × 280 cm.); Ascension Pulpit. Bronze, 4′3⅜″ × 9′7″ (123 × 292 cm.). San Lorenzo, Florence

Donatello had moved from Florence to Siena in 1457. Among the works he was commissioned to produce there was a pair of bronze doors for the Duomo. Clearly he must have quarreled with his employers, however, for in 1459 he returned to Florence. According to Vespasiano da Bisticci (c. 1485), the sculptor had difficulty finding work on his return. To help support him, Cosimo the Elder stepped in with a commission for two bronze pulpits for the Church of San Lorenzo. It may be that Vespasiano embroidered on the circumstances of this commission, but Cosimo the Elder was definitely the one who gave Donatello the job. This may have been in 1461, for in that year San Lorenzo's high altar was consecrated. The only sure date relating to the pulpits is June 15, 1465, which was discovered by Previtali (1961) on the relief of the martyrdom of St. Lawrence. All of the pulpit reliefs may well have been cast by that time.

The pulpits themselves were not completely finished at the time of Donatello's death. They were assembled temporarily for the first time in 1515, on the occasion of a visit to Florence by Pope Leo X. The reliefs must have been on display long before this, however, for we have Albertini's appreciation of them from 1510, and there are obvious borrowings from them by various artists. Two examples of this are the relief frieze from the Sassetti tombs in Santa Trinità and the Frick Collection's *Resurrection* relief by Vecchietta, which dates from 1472 (plate 214). The pulpits were first given permanent form in 1558 and 1565. They were then set up as we see them today between 1619 and 1637 (plates 140, 141).

In the fifteenth century it was uncommon for a church to have two pulpits. According to Albertini (1510), one was used when reading from the Epistles, the other from the Gospels. It has been suggested that in calling for a pair of pulpits Cosimo was attempting to revive some Early Christian or medieval tradition, but it may be that the deciding factor was a simple desire for symmetry. Their rectangular form was dictated by the crossing pillars on which they were originally meant to be mounted.

That the pulpits are paired is certainly unusual, but no more so than the fact that their reliefs are almost exclusively based on scenes from the Passion. Included on the south pulpit are: Christ on the Mount of Olives; Christ Appearing before Pilate and Caiaphas; the Crucifixion; the Lamentation; and the Entombment. On the north pulpit: the Three Marys at the Tomb; Christ in Purgatory; the Resurrection; the Ascension; Pentecost; the Martyrdom of St. Lawrence (the remaining reliefs are of wood and were added later). Around the tops of the pulpits are friezes of putti cavorting and making wine—lighthearted marginalia of the sort Donatello had earlier included on Goliath's helmet in his bronze *David* and in his *Judith* statue—as well as horse tamers and centaurs bearing shields. The shield on the north pulpit carries the signature OPUS DONATELLI FLO.

One is struck by the differences in the shape of the two pulpits and in the way the reliefs are mounted on them. Scholars have advanced a variety of arguments to explain these discrepancies. For example, Huse (1968) suggests that the south pulpit is composed of designs originally intended for the door of Siena's cathedral, while Herzner ("Kanzeln," 1972) attempts to show that the front plate on the north pulpit was originally meant for a tomb monument for Cosimo the Elder that was never completed. Becherucci (1979) argues that the front of the north pulpit was intended to be a part of San Lorenzo's high altar, a work that

Donatello began but never finished. Pope-Hennessy (1985) suggests that the sculptor worked on the project for an extended period of time—beginning on the south pulpit even before 1457—and that, therefore, such discrepancies are to be expected. None of these explanations is fully satisfactory, although surely there must have been some definite reason why the pulpits are so dissimilar.

Scholars also disagree about just how much of the work on these reliefs was done by Donatello himself. Obvious differences in their execution have led many writers to suspect that the master only produced a fraction of the whole, while the rest was delegated to his assistants. Yet those who make such assertions do not adequately distinguish between the reliefs' uneven execution and their uniformly superb conception. In their design, they are without question among the most important and moving religious works from the whole of the Quattrocento and thus can only have been conceived by Donatello himself. They are also quite typical of his late relief style. They reveal him to be less concerned with clearly composed pictorial unity than with intensity of expression in his figures. He concentrates on the inner feelings of the people involved in these events. The frame of his pictures becomes increasingly fragmented and is finally exploded altogether. In the scene on the Mount of Olives, for example (plate 139), the small figure of Christ raising his hands toward heaven in anguish looms above the summit of the mountain, while the contrasting figures of the Apostles appear in varied groupings across the mountain's slopes. The picture's frame is not an absolute boundary; the picture spills forward, seemingly overflowing its frame, as sleeping figures sit on the bottom edge and lean against the side pilasters.

Other reliefs on both of the pulpits show a similar disregard for the conventional, clearly circumscribed, pictorial form of the time. Another example is the *Resurrection* from the north pulpit, which forms with its neighboring scenes of Christ in Purgatory and the Ascension a friezelike continuum (plates 146, 147). Sections of wall projecting outward at right angles are all that separate this scene from the adjacent ones, and even these boundaries are anything but definite, for the soldiers sleeping fitfully at the foot of the sarcophagus and the figure of the Baptist from the scene in hell overlap them. Christ rises up out of his tomb still wrapped in his shroud, clutching his banner of conquest with both hands (plate 149). In another deliberate violation of the frame, his head and the banner extend across the pulpit's entablature. It is characteristic of the late Donatello that this Christ does not leap forth from his sarcophagus in radiant triumph over death. He appears to suffer from strain, exhaustion, and a certain heaviness, yet he projects a profound spirituality. In some of the pulpit reliefs, such as the *Mount of Olives* or the *Crucifixion*, the surface is less finished, the modeling of the figures more tentative, while others are smoother, with elegant outlines.

Vasari (1550) tells us that the reliefs were completed by Bertoldo, but this can only mean that he did the chiseling. Beginning with Semrau (1891), certain scholars have emphasized the contribution of Bellano as well, for he is mentioned as an assistant to Donatello in Florence in 1456 and was also apparently active there in 1463. However, both he and Bertoldo can only have had a hand in the finishing of the pulpit reliefs, not their design, as is obvious if one looks at their own documented works.

Michelozzo
(c. 1396–1472)

Michelozzo was born in Florence in about 1396, the son of the master tailor Bartolomeo di Gherardo, who had moved there from Burgundy and attained Florentine citizenship in 1376. The first documentary reference to the artist is from May 28, 1410, when he is mentioned as a die-cutter in the mint in Florence. Between 1417 and 1424 he assisted in Ghiberti's workshop, helping to create the latter's first bronze door for the Baptistry and the statue of St. Matthew for Orsanmichele. Since he obviously had considerable experience in the casting of bronze, other masters frequently asked for his assistance. Beginning in 1425 he worked for several years as a *socius* (partner) with Donatello. During this period the latter produced—with varying degrees of assistance from Michelozzo—the tombs of Baldassare Coscia (plates 63–65), Cardinal Brancacci, and Bartolomeo Aragazzi, as well as the exterior pulpit for the cathedral in Prato (fig. 31).

It is known that in 1428 Michelozzo was in Pisa, where he collaborated with Donatello and Pagno di Lapo on the Brancacci monument. In that same year he signed a contract for the Prato pulpit, and in 1430 he spent some time in Lucca, Padua, and Venice. By this time he was already closely associated with the Medici. In 1432 he sojourned in Montepulciano and also, presumably—together with Donatello—in Rome. However, he is documented to have been back in Prato in December 1433. Vasari (1550) relates that in 1433 Michelozzo went into exile in Venice with Cosimo the Elder, but we have no proof of this.

Beginning in 1437 he was once again employed for roughly five years in Ghiberti's workshop. In September of that year he also committed himself to completing, in a brief six months, the Aragazzi monument, commissioned roughly ten years earlier. In February 1446 he was given a contract—together with Luca della Robbia and Maso di Bartolomeo—for doors for the two sacristies in the Duomo in Florence; however, only one of these was actually completed many years later, and by Luca della Robbia alone. The silver statue of St. John the Baptist for the altar of the Florence Baptistry, the last of Michelozzo's documented sculptures, was executed in 1452–53.

Since the 1430s he had devoted himself increasingly to architecture, primarily in the employ of the Medici. He began working on San Marco in 1437, on Santissima Annunziata in 1444, on the Palazzo Medici in 1444, on Santa Croce about 1445, and on the lantern for the Duomo in 1446. He executed the Chapel of the Crucifix in San Miniato al Monte in 1447–48. We know very little about his activities in the last two decades of his life. In 1461 he journeyed to Ragusa (modern Dubrovnik), where he directed work on the city's fortifications. In 1464 he moved to Chios. In 1467 he returned to Italy and is known to have been in Florence again beginning in 1469. He died in 1472 and was buried in San Marco on October 7.

Vasari [1550, 1568]; Stegmann 1888; Wolff 1900; Burger 1904; Fabriczy 1904; Mather 1942; Janson 1957; Martinelli 1957–58; Pope-Hennessy 1958 (1985); Martinelli 1963; Lisner, "Michelozzo," 1968; Lisner 1970; Caplow 1977; Lightbown 1980; Poeschke 1980; Ferrara and Quinterio 1984; Beck, "Michelozzo," 1985; Beck 1987; Frosinini 1987.

154, 155; fig. 42
Tomb of Cardinal Rinaldo Brancacci

c. 1426–33. Marble, partially polychrome, 29′9″ × 12′8¼″ (907 × 387 cm.). Sant'Angelo a Nilo, Naples

We learn from Michelozzo's tax declaration of July 1427 that among the things he and Donatello were working on at that time was the Tomb of Cardinal Brancacci in Pisa. Rinaldo Brancacci, the nephew of Pope John XXIII, died on June 5, 1427, in Rome (the tomb inscription mistakenly gives the date of his last testament as the date of his death). A number of documents attest to the presence in Pisa of Donatello, Michelozzo, and Pagno di Lapo between April 1426 and August 1428, where they were engaged on the Brancacci monument. Thus it is obvious that the work had been commissioned while the cardinal was still alive. Just when it was completed and shipped to Naples is unknown, but it was probably sometime in the early 1430s (Caplow 1977). In the sixteenth century it was moved from the choir to the side chapel, where it stands today (fig. 42).

The sarcophagus, carried on the shoulders of three female figures and complete with an effigy of the deceased, is sheltered in an aedicula supported by columns and pilasters. The front of the sarcophagus is embellished with the cardinal's coat of arms and a relief depicting the Assumption of the Virgin. Behind the deceased, two angels hold up the ends of a curtain suspended from the aedicula's round arch. Above them, in the tympanum on the back wall, a half-figure of the Madonna and Child appears between St. John the Baptist and the Archangel Michael. God the Father gives his blessing from the oculus in the gable, which is flanked by two angels playing trumpets. Many of these motifs—especially the female figures supporting the sarcophagus—are obviously patterned after traditional Neapolitan tomb monuments from the Trecento, so it must be assumed that they had been expressly requested by their patron.

Even though the monument was created while Donatello and Michelozzo were collaborators, Donatello's contribution to it was relatively small. He provided only the relief of the Assumption (plate 70) and possibly the design of the supporting statues, although these were carved by Michelozzo. The latter probably

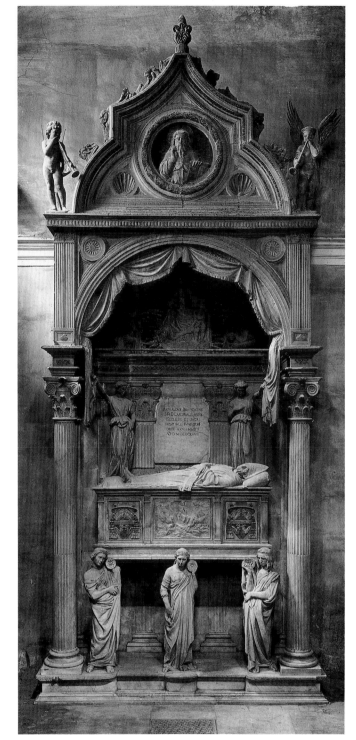

42 Michelozzo and Donatello. Tomb of Cardinal Rinaldo Brancacci. Sant'Angelo a Nilo, Naples

carved the figures of the cardinal and the female angels holding the curtain as well, while the figures in the tympanum and the gable are apparently the work of assistants, among them Pagno di Lapo.

In addition to the *Assumption* relief, the works especially worthy of mention are the female figures supporting the sarcophagus (plates 154, 155). Oddly enough, these are not clearly identified. In the setting of a tomb monument such as this it

would have been customary to have them represent Faith, Hope, and Charity, but they display none of the attributes of these Virtues. They bear the weight of the sarcophagus on movable volutes. The two outer ones turn in toward the one in the middle. In the positions of their arms and hands and in their clothing one notices many similarities to Donatello's Campanile prophets—especially the *Pensieroso*, the *Zuccone*, and the *Jeremiah* (plates 51 right, 56, 57).

To judge from its combination of heterogenous elements—Renaissance forms from antiquity such as fluted columns and pilasters, Composite capitals, etc., together with Gothic ones like the ogee arch of the gable—the monument's architecture is surely attributable to Michelozzo as well. This is the first appearance in the Early Renaissance of both the fluted column and the Composite capital. These, together with the paired pilasters above them, vaselike capitals reminiscent of the one from the Prato pulpit, and shell ornaments, were not a part of the available decorative repertoire of the 1420s and are only met with in the 1430s. We first encounter rosettes like these on Donatello's tabernacle for St. Peter's (plate 79), and the sunken shells in the entablature are borrowed from Donatello's *Cantoria* (plate 84).

156–58; figs. 43, 44
Statues and Reliefs from the Tomb of Bartolomeo Aragazzi

c. 1427–38. *Christ*. Marble, 72½″ high (184 cm.); *Candelabrum Bearers*. Marble, 68⅛″ high (173 cm.); reliefs. Marble, 29½ × 30¾″ (75 × 78 cm.). Duomo, Montepulciano

In the tax declaration of July 1427 already referred to,

Michelozzo speaks of a third tomb that he and Donatello were working on together, one for the humanist and papal secretary Bartolomeo Aragazzi (d. 1429). The latter wished to be commemorated in the Pieve di Santa Maria in his hometown of Montepulciano. It is true that the two sculptors acquired the marble for this monument in 1427, but that was all they accomplished. Apparently it was not until the 1430s that work began in earnest, and by then Michelozzo was wholly responsible for the commission; Donatello was no longer involved. A new contract was negotiated between Aragazzi's heirs and Michelozzo in 1437, with the latter promising to complete the tomb within six months. A year later, however, the work was still unfinished. A letter to Poggio Bracciolini from Leonardo Bruni discusses the transport of the tomb's component parts to Montepulciano, but unfortunately this document is undated.

The monument as such, which originally incorporated an altar, no longer survives. It was disassembled in the seventeenth century, when the church in which it had stood until that time, the Pieve di Santa Maria, was razed to make way for the present cathedral. Among its fragments preserved in Montepulciano's Duomo are the base, the figure of Aragazzi, the two reliefs from the front of the sarcophagus, the figure of the resurrected Christ (often mistakenly identified as St. Bartholomew), and two candelabrum bearers. Its bronze inscription is in the Archivio Vescovile, and two additional angels are in the collection of the Victoria and Albert Museum (figs. 43, 44).

These latter figures, in attitudes of worshipful adoration, surely flanked the relief of the resurrected Christ, which was mounted above the sarcophagus on the back wall of the tomb niche. Christ's right hand is raised in benediction, but he is clearly looking downward, originally toward the figure of the

43, 44 Michelozzo. *Angels*, from the Tomb of Bartolomeo Aragazzi in Montepulciano. Victoria and Albert Museum, London

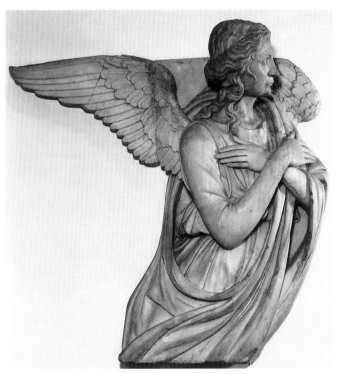
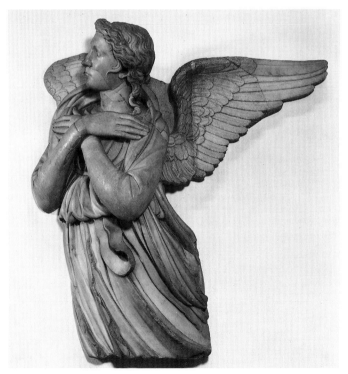

deceased. This Christ (plate 156) is unquestionably one of Michelozzo's masterpieces, a distinction it shares with the two candelabrum bearers (plate 157). These are sometimes referred to as angels, but they are not specifically characterized as such. Nor do they display the attributes of either the Virtues or the Liberal Arts, which others claim they are meant to represent. Presumably they stood to the right and left of the sarcophagus, possibly in front of the pilasters framing the tomb niche.

The one on the left wears a sleeveless, belted garment of the sort first seen on the angels from Donatello's Brancacci relief (plate 70) and holds the lower portion of a candelabrum in front of her breast. The one on the right, however, wears a gown, a cloak, and a headband. She is steadying with both hands a small, spiral column. There is a definite twist to each of their poses, their movements are angular, and their bodies quite muscular, all of which links them to the later prophets that Donatello created for the Campanile. There are other resemblances as well, such as their drapery, with clusters of taut folds contrasting with sections of loosely hanging fabric, or the way the corners of their mouths are drawn downward and their lips pressed tightly together, lending a suggestion of defiance to their expressions.

The two reliefs (plate 158) are clearly of inferior quality. In one, Bartolomeo Aragazzi is apparently being greeted by members of his family, and in the other he kneels with them before the Madonna and Child. In addition to their obvious borrowings from antiquity—for example, the use of the motif of the *dextrarum iunctio* (the clasping of hands, symbolizing concord) from classical marriage sarcophagi in the greeting scene—one notes the influence of Donatello's Prato pulpit and his *Cantoria*. The prematurely aged faces of these putti and young men are obviously borrowed from Donatello, as is the treatment of their hair, an indication, along with the style of the statues, that most of the work on this monument was accomplished in the 1430s.

159
Madonna and Child

c. 1435–40. Marble, with inlays of colored glass, 47¼ × 29⅞″ (120 × 76 cm.). Museo Nazionale del Bargello, Florence

The Bargello acquired this relief from a private collection at the beginning of the twentieth century. Bode (1892–1905) was the first to call attention to the work and to attribute it to Michelozzo. The majority of later writers have agreed with him, although Lightbown (1980) raises doubts about the relief's authenticity.

It reveals a number of similarities to other works of Michelozzo's, especially to the statues and reliefs from the Aragazzi tomb. Particularly telling details are the Madonna's facial type, her wavy hair with its loose strands falling across her cheeks, and the headband crossing her brow. Her ample drapery, rich in contrast and overlapping the bottom of the frame, has parallels in the tomb monument completed in 1438, especially the two candelabrum bearers (plate 157). There are but few similarities to the Coscia tomb, however, so that this Bargello relief would appear to date from the years 1435–40. This assumption is supported by the ornamentation of the round-arch niche as well as the inlays of glass, for colorfully decorated relief

backgrounds became increasingly common following the example of Donatello's *Cantoria*. There would seem to be no particular reason to date the Bargello relief as late as 1450, as Kecks (*Madonna* 1988) has recently chosen to do.

160
St. John the Baptist

c. 1444. Terra-cotta. Santissima Annunziata, Florence

This statue was discovered by Schmarsow (1886) in the lesser cloister of the Annunziata, and it was he who first ascribed the work to Michelozzo. There are no surviving documents relating to it. It cannot be the Michelozzo statue of the Baptist in the Annunziata that Vasari (1550) alludes to, for that one must have been considerably smaller. According to Lightbown (1980), the figure was created for the Chapel of St. John in the Annunziata, which was begun in 1444 at the behest of Messer Antonio di Michele di Forese da Rabatta. More than lifesize, it is hollowed out in the back, which would suggest that it was meant to stand either against a wall or in a niche.

The Baptist is dressed in a belted garment of hides and a cloak. One is immediately struck by his expansive gestures and the resulting uninterrupted fall of his cloak. He appears to be pointing at something with his right hand, and presumably his left hand originally held a cross (the present one is new). In his facial features and in the treatment of his hair and the animal hides, there are certain similarities to the *Baptist* in the tympanum from Sant'Agostino in Montepulciano. Even more obvious are the parallels to the statue of St. John that Michelozzo created in 1452 for the silver altar of the Baptistry in Florence (plate 161). There is no evidence that the figure was ever painted.

161
St. John the Baptist

1452–53. Silver, partially gilt, 23⅝″ high (60 cm.). Museo dell'Opera del Duomo, Florence

On April 13, 1452, the Arte di Calimala commissioned Michelozzo to create this statuette of the Baptist for the silver dossal of the Florence Baptistry. It was already finished and in place in the central niche of the altar by March 25, 1453, and is the only definitely documented piece of sculpture from Michelozzo's late period. In its posture and gestures, as well as in the form and treatment of its garments, it is essentially a repetition of the terra-cotta statue of the Baptist in Santissima Annunziata (plate 160), and it is possible that the guild expressly requested a *simile* of that earlier work. Here the right hand does not extend so far from the body, however, and the head does not tilt forward to the same degree—undoubtedly because the silver statuette was not intended to stand in such an elevated spot. In this later work, certain details like the hands and beard are also more delicately worked.

Luca della Robbia
(1399/1400–1482)

Luca della Robbia was born in Florence in either 1399 or 1400. His father was the wool merchant Simone di Marco della Robbia. Just who the young boy apprenticed with is unknown; however, Ghiberti and Michelozzo were decisive influences on his artistic development, as was Donatello. Schubring (1905) and Pope-Hennessy (1985) conjecture that Nanni di Banco was his teacher, but it would be extremely difficult to prove this, for the first works definitely attributed to the younger artist were not produced until 1431–32. The first documentary reference to him is from 1427, when his father lists him in his tax declaration as his third son. In that same year he was enrolled along with his two older brothers in the Arte della Lana. He was not inducted into the Arte dei Maestri di Pietra e Legname until September 1, 1432. In the years immediately following, Luca worked in marble as well as in clay and bronze. His specialty, however, was glazed terra-cotta reliefs, which he began to produce in the early 1440s at the latest, thereby founding a branch of sculpture that would prove to be extremely fertile over the next few decades.

His first documented work is the *Cantoria* that he executed for the Duomo in Florence between 1431/32 and 1438. In 1434 he collaborated with Donatello on a marble head for the Cathedral's cupola. It is unclear whether this work was ever completed and just where it was meant to be placed. In 1437–39 he executed five reliefs for the Campanile that complete the relief cycle begun by Andrea Pisano in the fourteenth century. In 1439 Luca was commissioned to produce a marble altar of St. Peter for one of the Duomo's choir chapels, but this work was never completed. He created the *Sacrament* tabernacle for the Church of San Egidio in the hospital of Santa Maria Nuova in Florence (now in Peretola) in 1441–42, and this is thought to represent his first use of glazed terra-cotta.

In the following years, he created the reliefs above the doors of the two Duomo sacristies (1442–51), the *Apostle* tondi for the Pazzi Chapel (after 1443), the coffered ceiling of the Tabernacle of the Crucifix in San Miniato al Monte (1447–48), two candelabrum-bearing angels in the Duomo (1448–51), the lunette above the portal of San Domenico in Urbino (1450), and two altars in Santa Maria in Impruneta (c. 1460)—all in glazed terra-cotta. Luca's last known sculpture in marble is the Tomb of Bishop Federighi in Florence's Santa Trinità, which he created in 1454–56. In 1461–62 he collaborated on the Chapel of the Cardinal of Portugal in San Miniato al Monte. In addition to the works already listed, Luca executed a great number of *Madonna* reliefs and splendid medallion coats of arms in glazed terra-cotta from the 1440s to the 1460s. The chief work from his late period is the bronze door for the north sacristy of the Duomo in Florence, a commission he had received as early as 1446 but which he only completed between 1464 and 1468.

Luca repeatedly served as consul in the sculptors' guild. In his last decade he appears to have withdrawn from all artistic activity. On February 19, 1471, he drew up his will, in which he bequeathed his workshop to his nephew Andrea—and with it his *ars superlucrativa* of glazed terra-cottas. Although he was once again asked to be consul on September 2 of that year, he declined, pleading ill health. However, in 1475 he once again put himself at the service of the guild. He died on February 20,

1482, and was buried in the Church of San Pier Maggiore. As early as 1436, Alberti had included him among the most distinguished artists of Florence of his time, along with Brunelleschi, Donatello, Ghiberti, and Masaccio. Vespasiano da Bisticci (c. 1485) relates that Luca, like Brunelleschi, Donatello, and Ghiberti, enjoyed a close association with the humanist Niccolò Niccoli.

Vasari [1550, 1568]; Reymond 1897; Bode, "Luca," 1902 (1921); Cruttwell 1902; Schubring 1905; Marquand, *Luca*, 1914; Horne 1915–16; Mather 1918; Planiscig, *Luca*, 1940; Pope-Hennessy 1958 (1985); Lisner 1960; Hartt, Corti, and Kennedy 1964; Parronchi 1964; Becherucci and Brunetti [1969–70]; Glasser and Corti 1969/70; Del Bravo 1973; Avery, "Luca," 1976; Gaborit 1980; Parronchi, "Croce," 1980; Pope-Hennessy, *Luca*, 1980; Bellosi 1981; Padoa Rizzo 1983; Mode 1986.

162–64; fig. 45
Cantoria

1431/32–38. Marble, 10′9⅛″ × 18′4⅜″ (328 × 560 cm.). Museo dell'Opera del Duomo, Florence

Just before the completion of the Duomo's cupola in the 1430s, the Cathedral Operai decided to undertake the sculptural adornment of the eastern crossing piers. They first commissioned the marble tribunes above the sacristy doors, which were to serve as balconies for the organ and for singers and instrumentalists. Shortly afterward, they contracted for the bronze doors for the two sacristies, and finally for the terra-cotta reliefs meant to be mounted above them. The first mention of the pulpit above the door to the north sacristy, which was entrusted to Luca della Robbia, is from April 9, 1432, at which time the work, then well underway, is expressly referred to as a *perghamo degli orghani*, or an organ pulpit. Luca had probably been given the contract for it in 1431, for on October 4 of that year he received a payment for marble.

This is the sculptor's first known commission; he was then either thirty-one or thirty-two. Another *Cantoria*, this one for the corresponding spot above the door to the south sacristy, was commissioned from Donatello in 1433 (plates 82–84). By August of 1434 Luca had completed four of the figural reliefs, two larger and two smaller ones—the latter for the tribune sides. He received his final payment for the work on August 28, 1438. The architectural portions of the *Cantoria* were executed by his assistants Caprino di Domenico di Giusto da Settignano and Nanni di Miniato detto Fora. Luca's *Cantoria* was removed in 1688, as was Donatello's as well, and they were only reassembled for display in the Museo dell'Opera del Duomo in 1891. Certain corrections to their reconstruction were undertaken in 1939 and 1954 (fig. 45).

There are ten figural reliefs on the balustrade of the tribune and between its consoles, and their subject matter reflects the original function of the work. They depict groups of boys and girls playing various musical instruments and singing and dancing in a literal illustration of Psalm 150, the opening words of which—*Laudate dominum in sanctis eius . . .* —appear on the

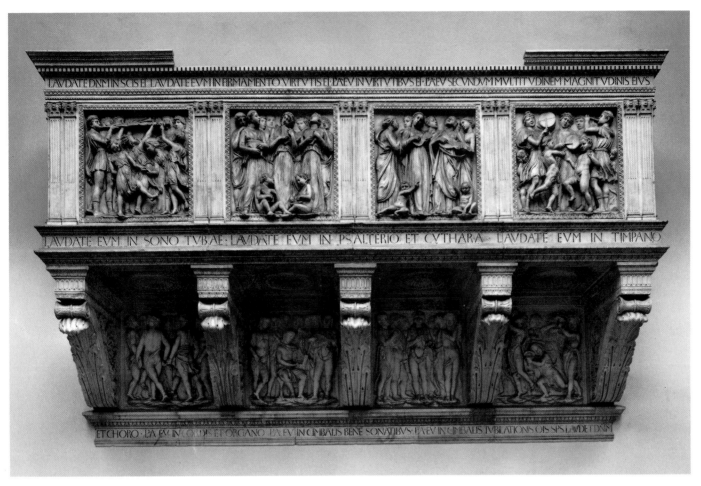

45 Luca della Robbia. *Cantoria*. Museo dell'Opera del Duomo, Florence

three entablatures in large capitals. The balustrade reliefs, slightly taller than they are wide, are separate pictorial entities, surrounded by a cymatium and framed by paired pilasters. Unlike Donatello, Luca chose to have the architecture of his tribune predominant, with figural reliefs applied to it in traditional frames. It is obvious that he patterned his framing system after that of the exterior pulpit in Prato, already apparent before 1432, especially in his use of paired pilasters (see fig. 31). One also notes the obvious influence of the Prato pulpit and of Donatello's own *Cantoria* on Luca's dancing boys, which are wearing either almost nothing at all or lightweight shifts slit up the sides.

In Luca's reliefs, however, there is a greater emphasis on objective details than in Donatello's *Cantoria*, and his narrative tone is altogether less hectic. The two reliefs in the center of the front and the ones on either end reveal the least influence from Donatello's pulpit, those at the corners and between the consoles the most. The former have a much more statuesque air about them; their groupings are not so dense. Most likely these are the ones mentioned as already completed in the document of 1434. The direct influence of classical models is also stronger in these than in the later ones, as various scholars, most recently Del Bravo (1973) and Pope-Hennessy (*Luca* 1980), have pointed out.

Schubring (1905) and Marquand (*Luca* 1914) both assumed

that the pulpit was originally painted, but there is no longer any evidence to justify such an assumption. According to Vasari (1568), a pair of bronze angels—also by Luca—once sat on the tribune's parapet. These are presumably the ones that are now in the collection of the Musée Jacquemart-André in Paris, which earlier writers frequently ascribed to Donatello, an attribution advanced once again more recently by Rosenauer (1987). Pope-Hennessy (*Luca* 1980) quite rightly points out their stylistic similarities to the dancing figures from Donatello's pulpit reliefs.

165
Reliefs with Portrayals of "Philosophy" and "Grammar"

1437–39. Marble, $32\frac{7}{8} \times 27\frac{1}{8}''$ (83.5 × 69 cm.); $32\frac{1}{8} \times 27''$ (81.5 × 68.5 cm.). Museo dell'Opera del Duomo, Florence

In the fourteenth century, Andrea Pisano and his workshop had created a total of twenty-one reliefs for the ground level of the Campanile in Florence. Luca completed this cycle with five additional reliefs for the tower's north side. These were moved to the Museo dell'Opera del Duomo in 1965. He was given the commission on May 30, 1437, and received his final payment on March 10, 1439. The original program for the cycle was encyclopedic in scope, moving from the creation of man through

depictions of the Mechanical and Liberal Arts, the Planets, the Virtues, and the Seven Sacraments. Accordingly, Luca's reliefs portray Tubal-cain (or Pythagoras) as a personification of astrology (?), Orpheus (?) to represent music (or poetry?), Euclid and Pythagoras (?) as representatives of geometry and arithmetic, Plato and Aristotle to personify philosophy, and Donatus (or Priscian) to signify grammar. There is some disagreement in the literature about the identification of these figures as well as the arts represented. Even Vasari (1568) found them confusing.

The relief depicting "Philosophy" presents two men engaged in heated debate. The younger of the two points dogmatically to a passage in the book he holds open before him, while the older one extends his hands imploringly as he seeks to convince his opponent. The vigor of their dispute is apparent even in the swirling of their cloaks. Since Luca never employs such forceful gestures in any of his other works, one has to assume, as Reymond did (1897), that for this pair of figures he drew on Donatello's reliefs for the bronze doors of the Old Sacristy (plates 88–91).

The "Grammar" relief is not unlike earlier portrayals of teaching, even though the professor is here seen in profile. It depicts a classroom with a half-opened bookcase on its back wall (this is not a door, to be interpreted symbolically as the gate to Hades, as some have attempted to do, but an *armarium*, or cupboard). The teacher—either Donatus or Priscian—is seated at his desk, his left hand raised to emphasize a point. Two pupils sit across from him. The one in the foreground has crossed his legs and is taking notes in a book held open on his knee. This figure was clearly patterned after the *St. Mark* in one of the tondi from the Old Sacristy (plate 99).

166
The Release of St. Peter; The Crucifixion of St. Peter

1439. Marble, 27⅛ × 30¾″ (69 × 78 cm.); 27⅛ × 26¾″ (69 × 68 cm.) Museo Nazionale del Bargello, Florence

The Operai of the Florence Duomo began to worry about altars for the choir chapels in 1435. While Ghiberti was at work on the Shrine of St. Zenobius for the chapel at the apex of the choir, commissions for the adjacent chapels dedicated to Sts. Peter and Paul were awarded to Donatello and Luca della Robbia on April 6 and 12, 1439. Donatello was already prepared with a wax model for the St. Paul altar by April 20, 1439, and Luca had progressed to the point of receiving payment by November 23. Although none of Donatello's work relating to this commission survives, we do have these two unfinished marble reliefs by Luca depicting St. Peter's release and crucifixion. Schubring (1905) postulated that they were intended to be mounted on the altar's ends, but this is unlikely. It is more probable they are two of the reliefs planned for the front of the altar. The altar would have been of the same type as those in the Baptistry and the choir chapel of the Old Sacristy of San Lorenzo.

The relief of the freeing of St. Peter is framed by two small columns with Composite capitals. Peter is moving quickly as he is led out of his cell by an angel but stops long enough to look back at his sleeping guards. Through the barred window in the background we see the angel discussing the escape with St. Peter. This portion of the composition is more traditional in form

(see, for example, the predella panel by Giovanni del Ponte in the Uffizi). The depiction of the cell as a cramped and gloomy room with thick masonry walls, the theatrical arrangement of the picture space, and the focus on the specific moment when Peter pauses in his flight are much more modern. Beset with conflicting emotions, Peter bears a certain resemblance to the figure of Mary in the Cavalcanti *Annunciation* (plate 85).

The *Crucifixion* relief has no framing columns, which suggests that it was intended to stand in the center of the altar front and be flanked on the right by an additional relief that would have included columns. Luca abandons the strictly symmetrical structure traditional in depictions of St. Peter's martyrdom. He has instead placed his cross somewhat to the left of center, balancing it with a group of armed soldiers on the right. He also eliminates all topographical references, the Roman landmarks and typical Roman vegetation common in earlier depictions of the scene. He concentrates instead on the Crucifixion itself, the driving of the nails and Peter's stoic submission. Pope-Hennessy (*Luca* 1980) points out similarities between this work and the predella panel by Jacopo di Cione, still strongly rooted in the Giotto tradition, in the Vatican Museums. It is more likely that Luca actually patterned his work after Masaccio's portrayal of the event on the predella of the Carmelite altar (Staatliche Museen, Berlin-Dahlem). All in all, the *Crucifixion* relief is not as nearly finished as the scene of St. Peter's escape.

167
Tabernacle of the Sacrament

1441–42. Marble, glazed terra-cotta, and bronze, 8′6⅜″ × 4′ (260 × 122 cm.). Santa Maria, Peretola

Luca created this tabernacle in 1441–42 for the choir chapel of the Church of San Egidio in the hospital of Santa Maria Nuova in Florence. We can no longer determine just when it found its way to the parish church of Peretola. After Donatello's tabernacle for St. Peter's, it is the second most important wall tabernacle from the Early Renaissance. The small bronze door was added in the late 1400s, while the bronze tondo with the dove of the Holy Spirit is a copy of the original, which is now in the Bargello. The latter is surrounded by a marble wreath supported by angels. The lunette above contains a *Pietà* in which the dead Christ is supported by an angel and mourned by Mary and John. His right hand hangs down across the molding, pointing at the tabernacle's opening and the sacrament housed within. The representation of the Trinity is completed by a half-figure of God the Father giving his blessing in the gable.

The overall architectural scheme of the work is largely patterned after Donatello's *St. Louis* tabernacle (fig. 28), as are specific details such as the fluted pilasters with Corinthian capitals, the fascia decoration, and the heads of cherubs in the frieze. A crutch, the symbol of the hospital of Santa Maria Nuova, appears on the concave rosette medallions in the spandrels and in a quatrefoil frame in the center of the base. Most of the tabernacle itself is carved of marble, while the ornamental elements in the friezes, the tympanum, and the spandrels are colored and glazed terra-cotta. Donatello had already experimented with mixed materials and colored decoration in his

Cavalcanti tabernacle and his *Cantoria*, but this is the first sculptural use, however limited, of the glazed terra-cotta that would become a specialty of the Robbia workshop.

168, 169
The Resurrection; The Ascension

1442–45; 1446–51. Terra-cotta, glazed, 6′6¾″ × 8′8⅛″ (200 × 265 cm.); 6′6¾″ × 8′6⅜″ (200 × 260 cm.). Duomo, Florence

The *Resurrection* relief "*in terra cotta invetriata*" (enameled terra-cotta) was commissioned on July 21, 1442, and was intended for the portal of the north sacristy of the Duomo. Luca received his final payment for it on February 26, 1445. On October 11, 1446, he was commissioned to create a relief of the Ascension to fill the corresponding arch above the door of the south sacristy. His contract specified the number of figures it was to contain and that it was to be in color and refers to a model to be kept in the Opera del Duomo until the lunette was finished. Luca was to complete the work within eight months, but he only received final payment for it on June 30, 1451.

The relief above the north door depicts the risen Christ standing on a tiny cloud above his sarcophagus. In his left hand he carries a banner, and his right hand is extended upward toward heaven. Adoring angels hover on either side, while sleeping soldiers are grouped around the open tomb. Those in the foreground, especially the one leaning against his shield, are clearly indebted to Ghiberti's *Resurrection* relief on his first door for the Baptistry (plate 10).

In the relief above the south door, the Virgin and the Apostles are crowded around the slight elevation from which Christ, his hands raised in farewell, has already begun his ascent. As opposed to the earlier relief, and in strict accordance with the contract from October 11, 1446, the earth is here depicted in brown and the trees are green, or "*suis coloris*," while there are no colors applied to the figures.

170; fig. 46
Tomb of Bishop Benozzo Federighi

1454–56. Marble and glazed terra-cotta, 8′5½″ square (257.5 cm.). Santa Trinità, Florence

Benozzo Federighi, the bishop of Fiesole, had died on July 27, 1450. His nephew, Federigo di Jacopo Federighi, commissioned Luca to create his tomb monument on May 2, 1454, and the sculptor worked on it until 1456. It was placed in the Church of San Pancrazio in 1459, but in 1809 it was moved to San Francesco di Paola and in 1896 to Santa Trinità. Before it was installed in San Pancrazio, Luca had been forced to bring a lawsuit against the bishop's nephew in order to receive payment for his work.

In its overall form, this monument is wholly without precedent in Florentine tomb sculpture. Set into a rectangular wall niche, it was originally supported by a base adorned with the Federighi coat of arms and two pairs of pilasters and crowned by a richly ornamented cornice (fig. 46). In its details, however, it is in-

debted to the Bruni monument in Santa Croce (plate 187). One notes especially the similarities in the boxlike sarcophagus with angels supporting an inscription on the front. These angels and their inscription medallion are, moreover, closely related to those of Ghiberti's *St. Zenobius* shrine (plate 25).

The back wall of the niche is divided into three vertical rectangular panels, just as in the Coscia and Bruni monuments. Here, however, the panels are filled with reliefs. The subject matter of these reliefs, the Pietà, is occasionally met with in Florentine tomb monuments from the fourteenth century (see the Baroncelli monument in Santa Croce, fig. 85, and the Tomb of Tedice Aliotti in Santa Maria Novella). Bishop Federighi's features were presumably modeled after a death mask. The frame of the niche, with the Federighi coat of arms in the upper corners, is inlaid with colorful majolica tiles with exquisite floral designs that Vasari (1568) singled out for particular praise. The idea of using pilasters placed against the wall below the niche was

46 Eighteenth-century drawing of the Federighi tomb. MS. Moreni, Sepoltuario Baldovinetti, Biblioteca Moreniana, Florence

borrowed a short time later by Bernardo Rossellino in his monument to Orlando de' Medici (d. 1455) in Santissima Annunziata.

171
Ceiling Decorations in the Chapel of the Cardinal of Portugal

1461–62. Terra-cotta, painted and glazed. San Miniato al Monte, Florence

Regarding the chapel itself, see page 422.

These ceiling decorations were planned as part of a unified design for the chapel, encompassing its sculpture and painting as well. Luca was given the contract for them on April 14, 1461, and payments to him are recorded until April 9, 1462. He had created ceilings in glazed terra-cotta for the Chapel of the Crucifix in San Miniato, for Piero de' Medici's studiolo in the Palazzo Medici, and for the cupola in the narthex of the Pazzi Chapel next to Santa Croce well before this time, in each case basing his designs in part on patterns from antiquity. His use of figural tondi as the main decorative elements in this instance is obviously inspired by the Old Sacristy of San Lorenzo and the Pazzi Chapel itself.

The center tondo presents the dove of the Holy Spirit surrounded by seven candlesticks symbolizing its gifts. The other four contain portrayals of the Cardinal Virtues: Prudence (with two faces, a mirror, and a serpent as attributes), Justice (with a sword and a sphere), Fortitude (in armor, with a mace and a shield bearing the Portuguese cardinal's coat of arms), and Temperance (with a ewer and a cup). The optical-illusion pattern of isometric cubes between the tondi was known in antiquity (Pope-Hennessy, *Luca*, 1980). This ceiling from the Chapel of the Cardinal of Portugal is one of the loveliest from the Early Renaissance and served as a pattern for the one in the Martini Chapel in San Giobbe in Venice.

172, 173
Sacristy Door

1464–68. Bronze, 13'5⅜" × 6'6¾" (410 × 220 cm.). Duomo, Florence

On March 27, 1437, Donatello was given a contract for the bronze doors for the two sacristies in the Cathedral of Florence. They were to be completed by 1439 and 1441, respectively. It is entirely possible that he was chosen for the task because of the pair of doors he had created for the Old Sacristy in San Lorenzo. Although he had submitted models of the doors as early as 1436, Donatello never did fulfill the commission. The Operai of the Cathedral were therefore obliged to alter their agreement with him on June 21 and July 1, 1445, and on February 28, 1446, they entrusted the north door to Michelozzo, Luca della Robbia, and Maso di Bartolomeo.

Their contract makes specific mention of a model the artists were to adhere to, but it cannot have been the one Donatello created in 1436. It also stipulates that the door was to be completed within three years. Again this was not to be. The framing elements had been cast as early as 1447, yet it was not until April 9, 1461, that Giovanni di Bartolomeo was asked to do the chasing and finishing work on them. A new contract was drawn up on August 4, 1464, and this time Luca was to complete the door by himself, which meant essentially creating its reliefs. All of these were done by October 1467, Verrocchio having overseen the casting of the last two. Luca continued receiving payments for his work until June 1475.

In its overall scheme and its figural program, Luca's door essentially complies with the stipulations made as early as 1446. Each wing was to be subdivided into five square panels, and these were to portray the Madonna and Child, St. John the Baptist, the Evangelists, and the Church Fathers, each of them flanked by angels. The 1446 contract also specified that each of the seated figures was to be framed by a tabernacle, but these were abandoned by the sculptor. He also failed to provide the requested damascening of the framing sections, with the exception of a small area on the right-hand door between the reliefs of St. Luke and St. Jerome. The postures and gestures of these saints and angels, as well as the arrangement of the door in general, reveal the influence of Donatello's doors and tondi for the Old Sacristy (see plates 88, 89), while the small quatrefoils framing heads of prophets at the corners of the reliefs are borrowed directly from Ghiberti's bronze Baptistry doors (plate 19).

Filarete
(c. 1400–c. 1469)

Antonio di Pietro Averlino, better known as Filarete, was born in Florence about 1400. He was a sculptor in bronze, an architect, and an architectural theorist. In proper humanist fashion, he chose a name of his own with which to sign his works, and this name, Filarete, is first encountered in the treatise on architecture that he wrote between about 1451 and 1464. It is highly likely that he began his artistic career in Ghiberti's workshop. In 1433 he was in Rome at the coronation of Emperor Sigismund.

Presumably it was in that same year that he was commissioned to create bronze doors for St. Peter's. This work, completed in 1445, is his best known contribution in the field of sculpture. During these years in Rome he also produced a bronze equestrian statuette—a copy of the equestrian statue of Marcus Aurelius—that he presented to Piero de' Medici in 1465. Now in Dresden's Albertina, this work can be considered the first small bronze from the Renaissance.

Two years after he had completed the doors for St. Peter's, Filarete was commissioned to create a tomb for Cardinal Antonio Chiavez in the Lateran. He completed only the design for that monument, however, for in 1448 he was accused of stealing religious relics and forced to leave Rome. Isaia da Pisa was left to execute his design for the tomb. In 1449 he was in Venice, and in that same year he created a processional cross, signed and dated by him, that is now in the cathedral in Bassano. In 1451 he accepted an invitation from Duke Francesco Sforza to come to Milan, where he provided the terra-cotta decorations for the tower of the Castello Sforzesco. He also collaborated on the building of Bergamo's cathedral and oversaw the construction of the Ospedale Maggiore in Milan—his chief architectural undertaking—the cornerstone of which was laid in 1457.

Along with these practical endeavors, he was engaged, presumably between 1451 and 1464, in the writing of the above-mentioned treatise on architecture. Composed like a novel, this work takes a fictional project, the designing of an ideal city called Sforzinda, as the basis for theoretical discussions on architecture. It also includes comments on fifteenth-century sculpture and sculptors. A bronze known to be from Filarete's Milan period is the equestrian statuette of Hector (Museu Arqueológico Nacional, Madrid), which bears the date 1456. In that same year the artist undertook a trip to Tuscany in order to study hospital buildings in Florence and Siena. Disagreements with Duke Francesco Sforza caused him to leave Milan in 1465. He first went to Florence, where he hoped for commissions from the Medici, but he soon moved on to Rome, where he died about 1469.

Filarete [c. 1451–64]; Vasari [1550, 1568]; Tschudi 1884; Müntz, *Histoire*, 1891; Sauer 1897; Gerola 1906; Lazzaroni and Muñoz 1908; Roeder 1947; Pope-Hennessy 1958 (1985); Spencer 1958; Tigler 1963; Keutner 1964; Middeldorf 1973; Seymour, "Reflections," 1973; Spencer 1973; Lord 1976; Nilgen 1978; Spencer 1978; Spencer 1979; Coppel 1987; Parlato 1988.

174–77
Doors for the Main Portal of St. Peter's

1433–45. Bronze, partially enameled, 20'7⅞" × 11'8⅞" (630 × 358 cm.) without the seventeenth-century additions. Narthex, St. Peter's, Rome

The *porta argentea* (silver door) of St. Peter's had been donated by Pope Honorius I in the seventh century and renovated by Pope Leo IV in 846. Pope Eugenius IV may well have decided to replace it with a pair of bronze doors after seeing Ghiberti's doors for the Baptistry in Florence, the first of which had been completed in 1424. It is not certain just when Filarete was given the commission, but it was probably in 1433, for Vasari (1568) relates that the sculptor took twelve years to complete it. We know that the doors were definitely finished by 1445, as they were installed in the main portal of St. Peter's on August 14 of that year. The date of their completion is also given on the doors themselves: ANTONIUS PETRI DE FLORENTIA FECIT MCCCCXLV and DIE ULTIMO IULII MCCCCXLV. Filarete's signature, without a date, is found in three additional places. Moreover, on the back of the door, near the bottom, there is a row of cheerful portraits of

the assistants who collaborated on the work, identified as Agniolus, Jacobus, Janellus, Passquinus, Joannes, and Varrus. When the doors were reinstalled under Pope Paul V in 1619, they were heightened by the addition of rectangular strips at both top and bottom. To what extent the bronze was originally gilt, if at all, is unclear. No traces of gold were discovered when the doors were restored in 1962.

The division of the doors into rectangular panels of different sizes is a direct borrowing from ancient designs, such as the bronze doors from the Pantheon and from San Giovanni in Laterano. The borders on the bottom and sides are ornamented with a scrolling garland also borrowed from antiquity, whereas the top one is filled with putti displaying coats of arms: on the right the papal emblem, on the left the coat of arms of Pope Eugenius IV.

The pictorial program of the panels relates specifically to the church and to the papacy in Rome (Nilgen 1978). In the upper left is Christ enthroned, his hand raised in benediction; to the right is Mary, likewise enthroned, turned toward Christ in reverence. St. Paul appears in the left-hand center panel, St. Peter, with Pope Eugenius IV kneeling at his feet and receiving the keys, on the right (plate 174). The smaller panels at the bottom relate to the Apostles above them: on the left is the judgment and beheading of St. Paul (plate 176), on the right the judgment and crucifixion of St. Peter (plate 177). These two scenes, with their large numbers of figures and wealth of detail, are obviously indebted to Ghiberti's panels for his *Gates of Paradise*, although they fail to display his compositional clarity. Filarete was more concerned with presenting a rich variety of detail. One notes especially an almost pedantic wealth of classical allusions, extending in the *St. Peter* relief to a detailed depiction of Roman topography. Here, in contrast to the medieval portrayals of the saint's martyrdom in the former atrium of the Old St. Peter's basilica, in San Francesco in Assisi, in San Piero a Grado, or on Giotto's Stefaneschi Altar—formerly the high altar in St. Peter's—ancillary details and simple requisites are given undue prominence.

Filarete does not confine his display of antiquarian knowledge to these lower reliefs. One notes, for example, the unusual costumes of the two Apostles, complete with barbarian trousers and chlamys, or the above-mentioned garland border, which is studded not only with all manner of animals but also with scenes from classical mythology—chiefly according to Ovid—and Roman history, and with classical profile portraits, most of them heads of emperors. Marginal details such as these, many of them altogether charming, make it clear that Filarete's talents were best suited to smaller forms. The same might be said of the miniature figural scenes inserted like a frieze between the panels. Depicting important events from the pontificate of Eugenius IV, these include: in the upper left, the pope receiving the Byzantine emperor John Palaeologus and the patriarch Joseph on their arrival in Ferrara; in the upper right, the meeting of the council in Florence and the homeward journey of the Byzantine emperor; in the lower left, the coronation of Emperor Sigismund and the triumphal procession of the pope and the emperor to Castel Sant'Angelo; in the lower right, the abbot Andreas, head of the Coptic church, receiving the decree of union from the pope in Florence in 1442 and subsequently making his ceremonial entry into Rome with his entourage.

Agostino di Duccio
(1418–c. 1481)

Agostino di Duccio was born in Florence in 1418, the son of a cloth weaver. Nothing is known about the period of his apprenticeship. The standing *Madonna and Child* in Santa Maria del Carmine in Florence may possibly be one of his early works (Rosenauer 1977). His first definite sculpture is the *Geminianus* relief on the Duomo in Modena, dated 1442. The previous year he and his brother had been fined a large sum of money for stealing silver in Santissima Annunziata and were banished from Florence. This clearly explains his presence in Modena. The statue of St. Geminianus in Modena's cathedral was created at the same time as the above-named relief.

Agostino and his brother are known to have been in Venice in 1446, and it is probable that while there he created some of the figures for the St. Peter altar in the Frari church (Stefanac, unpublished). Shortly afterward—in 1449 at the latest—Agostino went to Rimini, where until 1457 he supervised the sculptural decoration of the six chapels of the Tempio Malatestiano. His next stop was Perugia. The first mention of his presence there is from July 1457, in connection with the façade for the Oratory of St. Bernardino, which he completed by 1461. During this same period, between January and October of 1459, he created the *St. Lawrence* altar in San Domenico. Agostino is then documented in Perugia until May 1462, but in that same year he appears to have moved to Bologna, where in February 1463 he received payment for a wooden model for the façade of San Petronio.

In April 1463—for the first time in his career as a sculptor—he is documented in Florence. There he created a large statue (*uno gughante overo Erchole*) in terra-cotta for one of the choir buttresses of the Duomo. A second figure of similar size, in marble, was planned but never completed. The awkwardly shaped block for it was set aside in 1466, and it was not until roughly forty years later that Michelangelo created his *David* from it. In 1464 Agostino had enrolled in the Arte dei Maestri di Pietra e Legname, but obviously he failed to make his way in Florence as he left the city again in the early 1470s. He appears in Perugia once again in 1473. In that city he created the two most important sculptural works of his later years: the *Pietà* altar for the Duomo and the façade of the Oratory of the Maestà delle Volte, of which only fragments survive (Galleria Nazionale dell'Umbria, Perugia). The last mention of Agostino is from 1481, and it is possible that he died in that same year.

Vasari [1568]; Rossi 1875; Pointner 1909; Ricci [1924]; Mather 1948; Ravaioli 1951; Salmi 1951; Ragghianti 1955; Brandi 1956; Pope-Hennessy 1958 (1985); Seymour 1966; Janson 1970; Kühlenthal 1971; Rosenauer 1977; Mitchell 1978; Stefanac (unpublished).

178, 179
Relief with Scenes from the Life of St. Geminianus

1442. Marble. Duomo, Modena

This relief, which was installed on the outside of the cathedral choir in 1584, was originally part of an altar dedicated to St. Geminianus that had been donated by Lodovico Forni in 1442. It is the earliest surviving documented work by Agostino. On the frame between the two lower scenes are his signature and the date: AUGUSTINUS DE FLORENTIA F. 1442. Additional inscriptions give the name of the donor and the subject matter of the scenes. The reliefs present four events from the life of St. Geminianus, patron saint of the city of Modena. In the upper left, the saint frees the daughter of Emperor Jovianus from the devil. In the upper right, the emperor presents the saint with gifts in gratitude. In the lower left, St. Severus, the bishop of Ravenna, appears at the saint's deathbed. In the lower right, Attila's hordes are turned away from the city of Modena thanks to the intervention of its patron saint.

The framing of the relief, in the form of smooth fillets bordered by slender friezes of foliage, is patterned after Donatello's bronze doors for the Old Sacristy (plates 88–91). A number of the figures seem to be indebted to Donatello as well, especially in their facial features, their hairdos, and their voluminous yet transparent garments, reminiscent of works like the Cavalcanti tabernacle (plate 85). All of the scenes have elaborate, complex architectural backdrops, yet their spaces are largely reduced to the foreground—another similarity to the Cavalcanti tabernacle. One can already see in these garments a suggestion of Agostino's later characteristic penchant for large, rounded curves and calligraphic lines in his drapery.

180–183; fig. 47
Angel Holding a Curtain; Shrine of the Antenati; Luna; Sporting and Dancing Putti

c. 1450–57. Marble, partially painted and gilt. San Francesco (Tempio Malatestiano), Rimini

The carved decoration of the Tempio Malatestiano comprises the most ambitious sculptural ensemble from the Early Renaissance. It was created under the supervision of Agostino di Duccio, who is first mentioned as being in Rimini in 1449 and surely remained there until his departure for Perugia in 1457. It is no longer possible to determine conclusively just how much of this work he produced himself. However, his manner is everywhere apparent in the figural reliefs—with the exception of the Chapel of the Liberal Arts—so that it would appear that the greater part of it was at least based on his designs. The wording of two signatures found in the interior of the Tempio seems to confirm such an assumption, for there Agostino is named as the project's sculptor, Matteo de' Pasti its architect. According to Mitchell (1978), however, the Tempio's unusual pictorial program, which Pope Pius II expressly criticized as "pagan," was developed by Alberti. Using chiefly the writings of Macrobius (commentary on Cicero's *Somnium Scipionis* and *Saturnalia*), Alberti is said to have devised a Neoplatonic program incorporating Christian concepts.

The Church of San Francesco had been erected in the thirteenth century, and when Sigismondo Malatesta first decided to construct the Chapel of St. Sigismund he had no intention of redesigning the entire structure. The cornerstone for this chapel was laid on October 31, 1447, and its structural work was completed in 1449. By that time the masonry for the adjacent reliquary chamber and for the Isotta Chapel was already finished as well. The two pairs of elephants that serve as bases for the

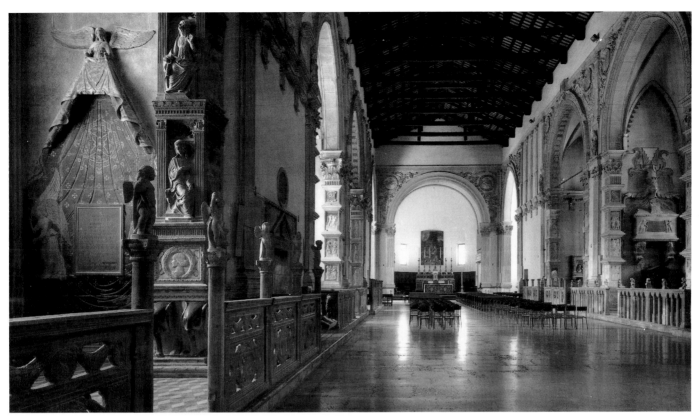

47 Interior, San Francesco (Tempio Malatestiano), Rimini

pilasters of the Chapel of St. Sigismund were set in place in October 1450, and the chapel was sufficiently complete by early 1452 that it could be consecrated on March 1 of that year. The Isotta Chapel must have been finished a short time later. As early as 1450, presumably—although Mitchell (1978) argues for 1453—Sigismondo Malatesta had come up with the plan to redesign San Francesco completely, and he entrusted the job to Leon Battista Alberti. The marble facing for two additional chapels, the Chapel of the Martyrs and the Chapel of the Playing Children, was begun in 1454, and in 1455 the marble was delivered for the last two chapels, the Chapel of the Planets and the Chapel of the Liberal Arts. Work on the structure came to a halt in 1461, so that the renovation remained incomplete at the time of Sigismondo's death in 1468.

Except for the works inside the Sigismund and Isotta chapels, Agostino's sculptural ornaments consist almost entirely of reliefs on the pillars at the entrance to each chapel and floral and heraldic motifs above and between the arches (fig. 47). The reliefs on the east and west walls of the Chapel of St. Sigismund may well be among Agostino's earliest works. Each of them employs the same motif: two angels standing on clouds hold open a curtain falling in sinuous folds from a baldachin supported by a third angel at the top. The angels are carved in a flat relief that is typical of Agostino during this period, and there is a special emphasis on the decorative effect of their drapery, which flutters about their bodies with airy elegance (plate 180). Figures like these were Agostino's strong point. When creating them he was greatly influenced by both classical sculpture—especially maenad reliefs of the neo-Attic type as established by Callimachus—and the contemporary art of northern Italy, which

was more decorative in its orientation than that of the Early Renaissance in Tuscany.

Of a somewhat later date than these angels in the Sigismund Chapel is the Shrine of the Antenati (plate 181) in the Chapel of the Virgin dell'Acqua. This is a splendid marble shrine that Sigismondo commissioned to glorify the Malatesta family. Of all the sculptural adornments of the Tempio, it is the only work documented to be by Agostino himself. On December 18, 1454, Pietro de Gennari informed Sigismondo that Agostino would finish the nearly completed sarcophagus as soon as he returned from Cesena.

The sarcophagus stands in a niche lined with a curtain. Its overall form is based on the Early Christian sarcophagi of Ravenna. Pilasters divide the front into three panels. In the center is the inscription SIGISMUNDUS PANDULFUS MALATESTA PANDULFI F. INGENTIBUS MERITIS PROBITATIS FORTITUDINIS QUE ILLUSTRI GENERI SUO MAIORIBUS POSTERIS QUE. The left-hand panel depicts the Temple of Minerva. The goddess stands atop a pedestal in the midst of splendid imaginary architecture. She is surrounded by a number of men dressed in armor or classical garments and representing the gens Malatesta. The right-hand panel presents a triumphal procession. A youth crowned with laurel (presumably Sigismondo) sits enthroned on a tall carriage, holding a scepter in his right hand and a branch in his left. Standing to his right is a naked man blowing on a trumpet and holding up his right hand. Four horses led by men in armor draw the carriage through a large triumphal arch. A number of Roman monuments are visible in the city looming up in the background, among them two commemorative columns, one topped by the figure of a pagan god, the other by an equestrian statue. One is

struck by the similarity between this city and those in the paintings of Mantegna. The numerous classical touches in the architectural backdrops of both reliefs are also like those in Mantegna's frescos in the Ovetari Chapel in Padua.

The pilaster reliefs from the Chapel of the Playing Children, however, which was begun in 1454, are obviously indebted to Donatello. They are filled with carefree putti playing, dancing, making music, and riding on dolphins (plate 183), and constitute the most varied depiction of children's games in Early Renaissance art. Such reliefs would have been unthinkable had not Donatello turned his attention to putti as a subject matter in themselves in his *Cantoria* and his exterior pulpit for the Duomo in Prato. The execution of these pilaster reliefs, like the sculptures in the other chapels, is of uneven quality, but they were undoubtedly created after Agostino's designs.

Among his last works in the Tempio are the reliefs in the Chapel of the Planets, for which the marble was delivered in 1455. They present the twelve signs of the zodiac and the seven planets: the Moon, Mercury, Venus, the Sun, Mars, Jupiter, and Saturn. One of the most impressive of these is the relief of the Moon, in which Luna, dressed in a fluttering cloak, is speeding through clouds in a carriage drawn by two horses (plate 182). She holds a crescent moon in her hands. A river teeming with fish can be seen flowing across the clouds beneath her carriage.

184
St. Sigismund Encounters an Angel on His Way to Agaunum

c. 1450–57. Marble, 32¼ × 49⅝″ (82 × 126 cm.). Castello Sforzesco, Milan

This relief, which in the seventeenth century belonged to the Scolca monastery (near Rimini) and found its way to Milan in 1812, was first attributed to Agostino by Yriarte (1882). It was presumably part of the decoration for the Chapel of St. Sigismund in the Tempio Malatestiano. According to Ricci (1924), it was originally mounted on the strip of wall between the tabernacle and the altar table, from which it was removed in 1581. Its provenance, subject matter, proportions, and style all tend to confirm that it was indeed created for the Sigismund Chapel.

Its foreground encounter takes place against the backdrop of a spacious landscape composed of a winding river, numerous trees, and conical hills, one of them topped by a large city. Sigismund and his wife are seen riding into the scene from the left, while to the right their sons turn back to look at an angel standing in the center. The angel has appeared to the royal couple in order to explain to the king how he can atone for having killed his son from his first marriage. On the far right stands a column topped by a pagan idol. Here the picture space is quite expansive, unlike those of the *Geminianus* relief, and the carving is uniformly flat. The relief's subtle gradations, its transparent drapery flowing in calligraphic lines, its conical mountains, and the Mantegnesque view of a city are all similar to the surviving reliefs in the Tempio Malatestiano.

185; fig. 48
Madonna and Child with Angels

c. 1463–70. Marble and pietra serena. Museo Nazionale del Bargello, Florence

This tabernacle with its adoring angels carved in pietra serena and the two marble putti holding aside a curtain was moved to the Bargello from the Ognissanti monastery. The relief of the Madonna, however, originally from Santa Maria del Carmine, had formerly been in the Opera del Duomo and was not meant to be part of the tabernacle. Rumohr (1827) first identified the

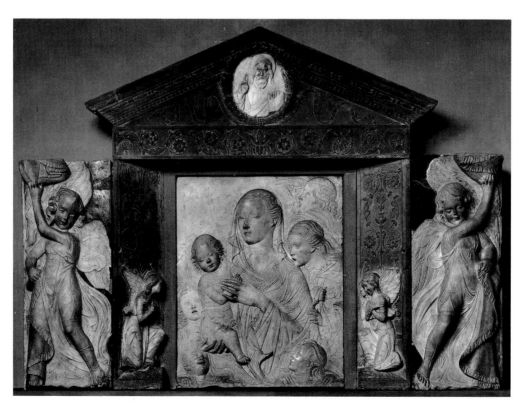

48 Agostino di Duccio. Tabernacle with *Madonna* relief. Museo Nazionale del Bargello, Florence

relief as the work of Agostino. Since 1909 (Pointner), scholars have generally dated the work to Agostino's sojourn in Florence between 1463 and roughly 1470. It is, in fact, closer in style to the reliefs of the Oratory of San Bernardino in Perugia—for example, in the complex forms of its drapery and the way the hair of the main figures is combed back over the ear—than to the ones in Rimini. Yet it is altogether more finely carved than the Perugia façade reliefs. The Madonna and Child are surrounded by angels (the upper left corner has been broken off and patched). The work bears a striking similarity to the *Madonna Auvillers* in the Louvre, which is also assumed to be the work of Agostino.

Bernardo Rossellino
(1407/10–1464)

The second of five sons of the stonemason Matteo Gamberelli, Bernardo Rossellino was born in Settignano in either 1407 or 1409/10. The name Rossellino was first applied to him in the sixteenth century. He was both a sculptor and an architect. He is first documented in 1433 in connection with contracts in Arezzo, where by 1435 he had completed the façade—including its figures—of the Oratory of the Misericordia, begun as early as 1375–77. In 1436–38 he received repeated payments for architectural and decorative work in the Badia and in the Cloister of the Campora in Florence. Between 1441 and 1444 he did masonry work on the Duomo in Florence. In 1446 he was commissioned to create a marble portal for the Sala del Concistoro in Siena's Palazzo Pubblico, and in the following year he was given the contract for an *Annunciation* group in the Oratory of the Annunziata in Empoli.

Beginning in roughly 1448 he was entrusted with the construction of the Palazzo Rucellai, the façade of which had been designed by Alberti. About this time he must have created his sculptural masterpiece, the monument to Leonardo Bruni in Santa Croce. Other works from these years are the *Sacrament* tabernacle in San Egidio (1449–50; fig. 9), for which Ghiberti supplied the small bronze door, and the tomb monument for Beata Villana in Santa Maria Novella (1451; fig. 49). By the end of December 1451, at the latest, Bernardo had settled for a few years in Rome, where he worked for Pope Nicolas V as *ingegniere in palazo*, overseeing his various building projects.

Between 1455 and 1458 Bernardo worked on the Tomb of Orlando de' Medici in the Santissima Annunziata in Florence, and from 1460 to 1463 he was employed as an architect in Pienza by Pope Pius II. On February 20, 1461, he was named chief architect of the Duomo in Florence. The last work he executed himself was the tomb for the doctor Giovanni Chellini in San Miniato al Tedesco, created in 1462–64. He submitted the design for a monument to Filippo Lazzari in Pistoia and was given a contract for the work in 1462, but he was unable to complete it. He died in September 1464 and was interred in the Church of San Pier Maggiore in Florence.

Billi [1516–20]; *Il Codice Magliabechiano* [1537–42]; Vasari [1550, 1568]; Bode 1892–1905; Fabriczy, "Jugendwerk," 1900; Fabriczy, "Neues," 1902; Burger 1904; Weinberger and Middeldorf 1928; Kennedy 1933; Planiscig, *Rossellino*, 1942; Mather 1948; Pope-Hennessy 1958 (1985); Hartt 1961; Markham 1963; Salmi 1977; Schulz, *Sculpture*, 1977; Cecchi 1985.

186
The Annunciation

c. 1447. Marble, 43½″ high (110.5 cm.); 45½″ high (115.5 cm.). Museo della Collegiata, Empoli

This group was commissioned in either 1444 or 1447—the latter date is more likely—by the Compagnia della Santissima Annunziata in Empoli for its Oratory of San Stefano degli Agostiniani. The work was evaluated by Ghiberti, who found the figures *belle, ben fatte e proporzionate*. As late as February 1458 the Compagnia still owed Rossellino 8 lire, as we learn from his tax declaration. The figures were moved to the museum in Empoli after World War II.

49 Bernardo Rossellino. Tomb of Beata Villana. Santa Maria Novella, Florence

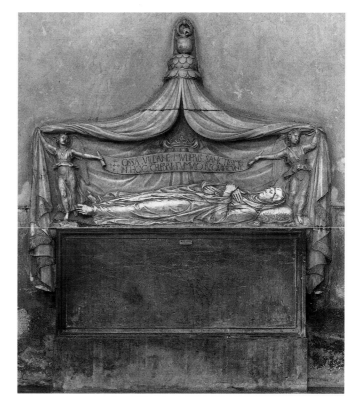

The *Annunciation* is Bernardo Rossellino's earliest surviving work, after the figures from the façade of the Misericordia in Arezzo, and it clearly reveals his indebtedness to Donatello. The evasive posture of the Mary figure, for example, and her left hand holding a book are definite borrowings from the Cavalcanti *Annunciation* (plates 85, 86). The same can be said of the angel, who bends slightly forward while folding his arms in front of his breast. In this figure, the pose and the relationship between the body and its drapery are not so clearly articulated as in the Madonna, which suggests that the angel was largely delegated to an assistant. Pope-Hennessy ("Altman Madonna," 1970) postulates that this assistant was Giovanni Rossellino, about whose sculptural abilities, however, nothing certain is known.

187–89
Tomb of Leonardo Bruni

c. 1448–50. White, red, and black marble, partially gilt, 23'5⅜" (715 cm.). Santa Croce, Florence

Leonardo Bruni, originally from Arezzo, was a prominent humanist and historian and chancellor of the Florentine republic. He died on March 9, 1444, at the age of seventy. At his funeral, which is described by Vespasiano da Bisticci (c. 1485), he was crowned with a laurel wreath by Giannozzo Manetti. No documents relating to the creation of his tomb monument have survived. It is first mentioned in 1458 in the diary of Luca Landucci, who mistakenly attributes the work to Donatello. However, the *Libro di Antonio Billi* (1516–20) names Bernardo Rossellino as its creator. Vasari does so as well in his *Vita* of Antonio Rossellino (1550), yet in his *Vita* of Verrocchio he insists that the Madonna in the lunette was the work of that sculptor.

The monument is now thought to be essentially the work of Bernardo Rossellino and to have been created in the late 1440s. Scholars disagree about the extent of any contribution to its design or execution by others, either Alberti (Stegmann and Geymüller 1885–1909), Desiderio da Settignano (Markham 1963), or Antonio Rossellino (Passavant 1969). The quality of its design as well as the originality and delicacy of its classical decor suggest that Alberti, with whom Bernardo collaborated in the late 1440s on the Palazzo Rucellai, had a hand in the conception of the monument.

Inspired by the wall monuments of Donatello and Michelozzo

(the Coscia tomb, the Brancacci tomb, the Aragazzi tomb), Bernardo created in his Bruni tomb a classic example of the wall niche tomb monument of the Early Renaissance. Its structure is both simpler and more unified than that of earlier examples. An arcade consisting of pilasters, entablature, and richly decorated archivolt provides a uniform frame for the niche, which houses the sarcophagus with an effigy of the deceased and—in the tympanum—a Madonna and Child flanked by angels. The later tomb monuments by Desiderio and Mino—and some by Andrea Bregno—continue to be largely indebted to this basic structure, even including the arrangement of the back wall.

The figure of the deceased is laid out above the sarcophagus on a deathbed supported by eagles. He is crowned with a laurel wreath, and his hands lie folded above a book. His face may well have been based on a death mask. Angels support a panel on the front of the sarcophagus containing the inscription POSTQUAM LEONARDUS E VITA MIGRAVIT / HISTORIA LUGET ELOQUENTIA MUTA EST / FERTURQUE MUSAS TUM GRAECAS TUM / LATINAS LACRIMAS TENERE NON POTUISSE. Crowning the arch is a wreath of oak leaves supported by putti and encircling the Bruni coat of arms. This heraldic motif is without classical precedent and is altogether too large, detracting from the otherwise carefully balanced proportions of the monument's architecture. Quite possibly it was not a part of the original design and was only added as an afterthought, as Stegmann (1885–1909) suspected. The execution of the monument is of uneven quality, yet to ascribe obvious differences in the carving to specific artists, as many have attempted to do (most recently Schulz, *Sculpture*, 1977), would seem to be futile.

The decor of the Bruni monument, although patterned after classical precedents, is of exceptional delicacy, variety, and originality. The scales on the double bases for the pilasters, the outlined flutings, the highly ornamental and stylized version of the Corinthian capital, and the lotus and palmette frieze of the entablature are decorative motifs never employed in the art of the Quattrocento before this time. They betray an understanding of the architectural ornament of antiquity otherwise encountered in this period around 1450 in the works of Alberti (the façades of the Palazzo Rucellai and the Tempio Malatestiano) and Michelozzo (Chapel of the Crucifix in San Miniato al Monte). One notes in the Bruni monument a tendency toward the stylization of foliage ornament into inorganic and virtually cutout forms. This tendency is carried even further by Desiderio, and there are parallels to this in Alberti as well.

Antonio Rossellino
(1427/28–c. 1479)

Antonio di Matteo di Domenico Gamberelli was born in Settignano, near Florence, in 1427 or 1428. As he was a younger brother of Bernardo Rossellino, it is likely that he trained in the latter's workshop. He worked exclusively in marble and in the 1460s and 1470s was the leading marble sculptor in Florence. Vasari (1550) praises his work not only for the extraordinary delicacy of its execution and its grace, but also for the three-

dimensional construction and roundness of his figures. These attributes were indeed striking if one compares them to the works of Desiderio and Mino, and they would soon have an influence on Verrocchio, Civitali, and Benedetto da Maiano.

Antonio is first mentioned as the recipient of payment for two entablature sections above the columns in the interior of San Lorenzo. In 1451 he was accepted into the Arte dei Maestri di

Pietra e Legname. In 1453 he, Desiderio da Settignano, and Giovanni di Pierone were asked to judge a pulpit created for Santa Maria Novella by Buggiano. His earliest known work is the marble bust of the physician Giovanni Chellini, dated 1456. In 1457–58 it appears that he collaborated on the tomb monument to Neri Capponi in Santo Spirito and the Shrine of Beato Marcolino in Forlì. Between 1461 and 1466 he created his masterpiece, the tomb of the Portuguese cardinal in San Miniato al Monte in Florence. In 1465–67 he and his brother collaborated on the monument to the law professor Filippo Lazzari in the cathedral at Pistoia, a work originally commissioned from his brother, Bernardo Rossellino, but only executed after his death. Antonio's signed bust of Matteo Palmieri is dated 1468.

In 1473 he received payment for three of the five reliefs for the inside pulpit of the Duomo in Prato, the remaining two reliefs having been provided by Mino da Fiesole. In the same year he was asked to evaluate the tomb monument to Pietro da Noceto, by Matteo Civitali, in the cathedral in Lucca. About this time he also undertook the sculptural decoration of the Piccolomini Chapel in Santa Anna dei Lombardi in Naples—including the Tomb of Mary of Aragon—which was completed by Benedetto da Maiano. In 1475 Antonio received payments relating to the monument to Bishop Lorenzo Roverella (d. 1464) in San Giorgio in Ferrara. His contribution to the work consisted only of the *Madonna* tondo and its flanking angels, while the remainder is by Ambrogio da Milano. It is possible that about this same time, namely 1475, Antonio created the statue of St. Sebastian in Empoli and the Nori epitaph in Santa Croce in Florence. In 1477 he was paid for the youthful *St. John the Baptist* (now in the Bargello) that originally stood above the portal of the Opera di San Giovanni.

In addition to these works known to be by him, some of them documented from relatively early in his career, a large number of *Madonna* reliefs have been attributed to Antonio. Chief among these are the ones in the Metropolitan Museum of Art and the Pierpont Morgan Library in New York and in the Kunsthistorisches Museum in Vienna. Another, in the Bode Museum in Berlin, was badly damaged in World War II. Antonio's death is not documented, but presumably he died of the plague in 1479.

Vasari [1550, 1568]; Baldinucci [1681–1728]; Burger 1904; Weinberger and Middeldorf 1928; Gottschalk 1930; Planiscig, *Rossellino*, 1942; Mather 1948; Pope-Hennessy, *Virgin*, 1949; Pope-Hennessy 1958 (1985); Pope-Hennessy, "Martelli David," 1959; Hartt 1961; Lightbown 1962; Hartt, Corti, and Kennedy 1964; Pope-Hennessy 1964; Pope-Hennessy, "Altman Madonna," 1970; Kaczmarzyk 1971; Schulz, *Sculpture*, 1977; Covi 1978; Beck, "Rossellino," 1980; Carl, "Document," 1983.

190
Bust of Giovanni Chellini

1456. Marble, 20⅛″ high (51.1 cm.). Victoria and Albert Museum, London

The Victoria and Albert Museum purchased this bust in Florence in 1860. At that time it was in the Palazzo Pazzi, where it had been since it was acquired from the Samminiati family in the eighteenth century. In the hollow in its base is the inscription MAGR. IOHANES. MAGRI. ANTONII. DE. STO. MINIATE DOCTOR

ARTIUM ET MEDICINE. MCCCCLVI. OPUS ANTONII. Giovanni Chellini (1372/77–1461), originally from San Miniato al Tedesco, taught philosophy at the University of Florence and was a prominent physician. The bust was first identified as his portrait by Weinberger and Middeldorf (1928). Donatello created a bronze plate for Giovanni Chellini in 1456 (plate 130). Chellini's tomb, in the Dominican Church of San Miniato al Tedesco, was executed between 1462 and 1464 by Antonio's brother, Bernardo.

The bust is Antonio's earliest known work. Strictly symmetrical in construction, it was designed to be viewed solely from the front. The chest section is abnormally large, relieved only by the vertical folds of the cloak. By contrast, facial wrinkles, furrows, and veins are reproduced in great detail. It is obvious that the sculptor based his work on a life mask (Pohl 1938), a common practice as the preparation of such masks was not unusual in the Early Renaissance. As early as 1395 Cennino Cennini provides a detailed description of the process. Another work similar to this Chellini bust is the portrait medallion on the tomb monument to Neri Capponi in Santo Spirito in Florence. Capponi died in 1457, and the medallion was likely based on a death mask. It is so similar that it too is generally attributed to Antonio Rossellino.

191
Madonna and Child

c. 1460–61. Marble, 27½ × 20½″ (69.5 × 52 cm.). Kunsthistorisches Museum, Vienna

First attributed to Rossellino by Ilg (1883), this relief was acquired from the Medici family collections in the seventeenth century and taken to Ambras Castle in the Tyrol. It was then moved to Vienna in 1880. Both Antonio Rossellino and Desiderio da Settignano seemed to favor this pictorial arrangement—the Madonna seated sideways holding the Child in her lap, almost completely filling the rectangular frame—for they both used it repeatedly. The Christ Child has raised his right hand and is clutching a bird in his left. In each of the upper corners is an angel posed in adoration. Their gestures are similar to those of the adoring angels of the Bruni and Marsuppini monuments (plates 188, 200). Their airy garments, however, held together with buttons, are most similar to ones worn by the angels on Desiderio's *Sacrament* tabernacle (plates 204, 205).

The Madonna's facial type and the way her wavy hair is combed back and secured by a headband are replicated in the young candelabrum bearers from that same work. Otherwise, the specific features of both the Madonna and the Child are unquestionably Antonio's work. Even so, one is struck by the almost uniformly flat execution of the relief and the Madonna's ample drapery, which is richly folded yet pressed flat against her body. These qualities set the Viennese relief apart from Antonio's other *Madonna* reliefs, in which the fabric appears to be thinner, the drapery flatter, and the limbs more prominent, with a definite alternation between low and high relief. For these reasons it is probably not a late work, as Planiscig (*Rossellino* 1942) and again more recently Kecks (*Madonna* 1988) have claimed, but rather one from his early years, when he was still

obviously close to Desiderio. Another factor supporting this assumption is the way the poses of the figures are adjusted to the relief's rectangular form, as a result of which the Madonna's knee and thigh do not appear to be attached to her body. Pope-Hennessy (1988) has also stressed the differences between this work and Antonio's other *Madonna* reliefs; however, his attribution of the piece to the early Verrocchio is unconvincing.

192–94
Tomb of the Cardinal of Portugal

1461–66. Marble. San Miniato al Monte, Florence

Prince Jacopo of Lusitania, the cardinal of Portugal, died in Florence on August 27, 1459, at the age of twenty-five. In accordance with his own wishes, he was buried in San Miniato al Monte. His uncle, King Alfons V of Portugal, commissioned his tomb chapel. In its decoration it is the most highly integrated and most splendid monument of its kind from the Early Renaissance. Antonio Manetti submitted the design for its architecture in June 1460. The structural work was completed between July 1460 and October 1461, the glazed terra-cottas for its ceiling in 1461–62 (plate 171), and its Cosmati-work floor in 1465. On September 12, 1466, the chapel was consecrated to St. James (the patron saint of the deceased), St. Eustache (patron of his titular church), and St. Vincent (the patron saint of Lisbon, where the cardinal served as archbishop). Its frescos were executed later, between October 1466 and March 1468.

The tomb monument, on the chapel's east wall, was completed between December 1461 and February 1466 by Antonio Rossellino and his assistants, one of whom was his older brother, Bernardo. It is Antonio's masterpiece. The older type of wall monument, introduced by Bernardo Rossellino and continued by Desiderio da Settignano and Mino da Fiesole, is here subjected to several decisive alterations. On the one hand, the structure of the tomb monument itself is integrated into the overall architecture of the chapel more closely than ever before, yet, on the other hand, its individual elements are handled with much greater freedom. Its structural arrangement is less compact; the placement and poses of its ornamental figures are not dictated to the same degree by the framing elements. This is especially apparent in the upper part, where one pair of angels flanking the *Madonna* tondo hovers freely in space while another balances on sections of entablature above the pilasters. They serve to lighten the lines of the architecture, as do the two mourning putti in front of the bier.

The figure of the deceased is laid out above the sarcophagus. His robe and pall are unusually plain, and by contrast his face and hands seem especially prominent. Vespasiano da Bisticci (c. 1485) informs us that these elements were modeled after plaster casts, and, in fact, it seems likely that Desiderio da Settignano produced the cardinal's death mask (Hartt, Corti, and Kennedy 1964). The sarcophagus, too, is severely plain, with none of the usual floral decor. It was patterned after an ancient porphyry sarcophagus discovered in Rome during the pontificate of Eugenius IV, which stood in front of the Pantheon until 1740, when it was incorporated into the tomb monument for Clement XII in the Lateran.

The decoration on the base of the monument is altogether unprecedented. On the front, two unicorns support a garland draped beneath a skull. These are flanked in turn by candelabra and seated spirits holding cornucopias. On the sides, however, are depictions of Mithras killing a bull and Eros speeding toward heaven in a chariot. These are surely copies of classical reliefs; in fact, the *Eros* relief was obviously patterned after the same cameo that the sculptor copied for a necklace ornament on his bronze bust of a young man in the Bargello.

Another of the innovations in this monument is its greater use of color, especially in its juxtaposition of marbles of different shades. Like the overall design of the work, this was widely imitated. A direct copy of the monument, although considerably less successful, is the tomb for Mary of Aragon (d. 1470) in the Piccolomini Chapel in Santa Anna dei Lombardi in Naples, which was begun by Antonio and his workshop and completed by Benedetto da Maiano.

195
Bust of Matteo Palmieri

1468. Marble, 23⅝″ high (60 cm.). Museo Nazionale del Bargello, Florence

This badly weathered marble bust, which stood until 1832 above the door of the Casa Palmieri in Florence in what is now called the Via di Pietrapiana, was acquired by the Bargello in 1890. It is signed and dated in the hollow in its base OPUS. ANTONII. GHAMBERELLI. MATHAEO. PALMERIO. SAL. AN. MCCCCLXVIII. It portrays the Florentine statesman and writer Matteo Palmieri (1406–1475), author of *Della vita civile*, among other works, at the age of sixty-two.

The differences between this bust and the one of Giovanni Chellini (plate 190) created twelve years earlier are considerable. To be sure, the Palmieri bust is also severely frontal and axial in its conception, but here the proportions have been adjusted so as to give more prominence to the head. The chest area is not so overwhelming and has been given a greater amount of interest. The features, full of energy and self-confidence, are prominent and true to life. The masklike rigidity that marks the Chellini bust has completely disappeared.

196
St. Sebastian

c. 1475. Marble. Museo della Collegiata, Empoli

This smaller-than-lifesize figure is part of a St. Sebastian Altar that was formerly in the Collegiata's Chapel of St. Sebastian in Empoli. There are no documentary references to the altar, but we do have assurances from as early as the sixteenth century that Antonio was the creator of the statue of Sebastian (*Libro di Antonio Billi* [1516–20]; *Il Codice Magliabechiano* [1537–42]; Vasari [1550]). Since 1864 (Cavalcaselle), the paintings of the related shrine have been attributed to Francesco Botticini. The two marble angels on its upper corners are from Antonio's workshop as well. In their placement and posture they correspond to the two kneeling angels from the Cardinal of Portugal monument (plates 192, 193).

The figure of St. Sebastian, bound to a tree trunk and clothed in only a narrow loincloth, is important inasmuch as it is Antonio's first nude. It is but one example of an increasing interest in the expressive potential of the naked human form on the part of Florentine artists beginning in the 1470s. In its careful rendering of anatomical details and its anguished pose, the figure bears a resemblance to nudes by Antonio del Pollaiuolo— for example, his painting of the *Martyrdom of St. Sebastian* from 1475, in London's National Gallery. There are also similarities to Antonio's marble statuette of a youthful St. John the Baptist in the Bargello, notably the emphasis on the transitory moment in the pose and the relative independence of the figure from its support, here a tree trunk, there a rock. Thus it seems implausible that the Empoli *Sebastian* figure could have been done in the period about 1460, as Weinberger and Middeldorf (1928) and Pope-Hennessy (1985) have proposed. More likely it dates from the 1470s, as Planiscig (*Rossellino* 1942) suspected some time ago, possibly as late as the mid-1470s.

197; fig. 50
Epitaph of the Nori Family

c. 1475. Marble. Santa Croce, Florence

The inscription on the base of the font informs us that Francesco Nori, who was murdered during the Pazzi conspiracy in 1478, had commissioned this monument to commemorate himself, his father, and his descendants. Since the Nori family tombs were located next to the first right-hand pier of the nave, the chapter obviously suggested that the relief of a seated Madonna and Child, surrounded by a mandorla and backed by a marble curtain, be combined with a font for holy water. A two-armed bronze candelabrum is mounted between the two.

The *Libro di Antonio Billi* (1516–20) gives Bernardo Rossellino as the work's creator; however, the sculpture is surely by Antonio, as Albertini (1510) had earlier indicated. The epitaph is generally thought to be one of Antonio's last works, for its smooth surface treatment and the rounded fullness of its limbs and drapery forms would seem to be the culmination of a tendency only hinted at in the *Ascension* relief that Antonio provided for the pulpit in the Duomo in Prato in 1473. On the other hand, Hartt (1964) argues—without compelling reasons—that the relief is a work from Antonio's early years.

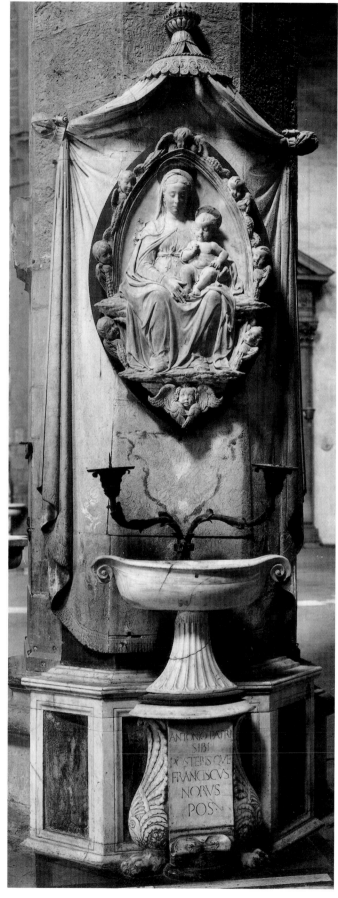

50 Antonio Rossellino. Epitaph of the Nori Family. Santa Croce, Florence

423

Desiderio da Settignano
(c. 1430–1464)

Desiderio was born sometime between 1428 and 1431 in Settignano, the son of Bartolomeo di Francesco detto Ferro and his wife Monna Andrea. In a tax declaration from 1451, his father relates that he is a stonemason and that his three sons, Francesco, Geri, and Desiderio, all work at the same trade. Desiderio appears to have settled in Florence in the 1440s. It is possible that he was engaged for a time in both Donatello's workshop and that of the Rossellino brothers. In 1453, together with Antonio Rossellino, he made an appraisal of Buggiano's reliefs for the pulpit in Santa Maria Novella. In the same year he was accepted into the Arte dei Maestri di Pietra e Legname. About this time he may have received the commission for the Marsuppini tomb in Santa Croce. A few years later, in 1456, Desiderio and his brother Geri bought a house in the diocese of San Pier Maggiore. In his own tax declaration from 1458 he explains that he and his brother operated a sculpture workshop next to the Ponte Santa Trinità.

In April 1461 he received payment for a design for the Chapel of the Madonna della Tavola in the cathedral at Orvieto. About this time he was also working on the sacrament tabernacle for San Lorenzo. Certain of his *Madonna* reliefs are mentioned in the diary of the painter Neri di Bicci in 1461 and 1464; however, it is no longer possible to identify them. The freestanding sacrament tabernacle that Albertini (1510) tells us he created for the Church of San Pier Maggiore is now in the National Gallery in Washington, D.C. According to Albertini, Desiderio also began the wooden statue of the Magdalene in Santa Trinità, which Vasari (1550) speaks of as having been completed by Benedetto da Maiano.

Although his documented works are few, the number attributed to him on the basis of their style is considerable. It is thought, for example, that among his earliest works are the cherubim medallions on the narthex entablature of the Pazzi Chapel. Also dating from early in his career are the *Madonna and Child* in the Galleria Sabauda in Turin and the relief of the young St. John the Baptist in the Bargello. Desiderio died as a young man, in January 1464, and was buried in San Pier Maggiore. His contemporary, Giovanni Santi, the father of Raphael, praised him as *il vago Desider si dolche e bello*.

Vasari [1550, 1568]; Ilg 1883; Stegmann and Geymüller 1885–1909; Bode 1888; Bode 1889; Bode, *Florentiner Bildhauer*, 1902 (1921); De Nicola 1917; Weinberger and Middeldorf 1928; Kennedy 1930; Middeldorf 1940; Planiscig, *Desiderio*, 1942; Planiscig 1948–49; Lisner, "Büste," 1958; Pope-Hennessy 1958 (1985); Cardellini 1962; Corti and Hartt 1962; Markham 1963; Negri Arnoldi 1964; Parronchi 1965; Negri Arnoldi 1967; Schlegel 1967; Spencer 1968; Wittkower 1971–72; Avery, "Beauregard," 1976; Middeldorf 1979; Passavant 1981; Herzner 1982; Strom 1982; Strom 1983; Beck 1984; Goldner 1989.

198; fig. 51
Madonna and Child ("Panciatichi Madonna")

c. 1453. Marble, 26¾ × 20⅞" (68 × 53 cm.). Museo Nazionale del Bargello, Florence

This relief, the surface of which is badly weathered, hung on the seventeenth-century Palazzo Panciatichi in the Via Cavour in Florence until 1917. To whom it belonged before that is un-

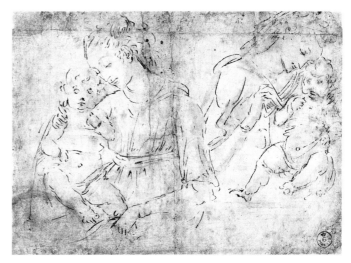

51 Desiderio da Settignano (?). Studies for a *Madonna and Child*. Uffizi, Florence

known. Since 1887 (Tschudi) it has been commonly attributed to Desiderio.

The Madonna is seated on a folding chair and holds her Child on her lap with both hands while he holds tight to her right wrist. This type of Madonna, who is portrayed down to the knees and with a suggestion of the chair on which she is seated, is also found in the painting of the period, for example, in works by Filippo Lippi. This is perhaps its first appearance in sculpture, for the relief's comparatively ample body forms, the intimacy it portrays between mother and child, the softness of its drapery, its gentle outlines and subtle sculptural details, suggest that it is an early work, from about 1453. Cardellini (1962) assumes an early date rather than a late one, as Pope-Hennessy ("Altman Madonna," 1970; 1985) suggests. De Nicola (1917) attempts to relate the relief to two drawings in the Uffizi (fig. 51). Although the connection is doubtful, it does seem more likely that the drawings were done by Desiderio than, as Weinberger and Middeldorf (1928) contend, by Antonio Rossellino.

199–201
Tomb of Carlo Marsuppini

c. 1453–54. White and red marble, 19′8¾″ × 11′8⅞″ (601 × 358 cm.). Santa Croce, Florence

Carlo Marsuppini, chancellor of the Florentine republic, died on April 24, 1453. His tomb monument was probably completed shortly after his death. There are no documents stating that Desiderio was its creator; however, Luca Landucci (1450–1516), Albertini (1510), Antonio Billi (1516–20), and Vasari (1550) have acknowledged that the work is his, and modern scholars have never questioned their attribution.

The immediate precedent for this monument, probably referred to expressly in the contract (no longer surviving), was the Tomb of Leonardo Bruni (plate 187). The Marsuppini monument is nevertheless more varied in its motifs. Putti with shields bearing coats of arms are placed before the framing pilasters,

and young men standing at the corners of the entablature hold aside two long festoons. These are suspended from a candelabrum at the top and form an elegant counterpoint to the niche's round arch. The figure of the deceased on his catafalque lies tilted somewhat to the side, so that he is easier to see. He is crowned with a laurel wreath, and his hands lie crossed on a book.

Like the Bruni monument, the lunette is almost completely filled with a tondo presenting a half-figure of the Madonna and the standing Child and a pair of adoring angels. These figures are relatively larger than those of the earlier monument and even overlap the tondo somewhat. Typical of Desiderio are the angularity of their silhouettes, the waferlike thinness of the relief, the pointed lines of the lower part of the faces and the hands, and the thin, crumpled drapery. All of these qualities are anticipated in the late works of Donatello, but here they are further developed into a separate style.

An aspect of the Marsuppini monument that Vasari (1550) specifically emphasizes is the variety and intricacy of its decoration, most apparent on the sarcophagus. The sarcophagus is of a new type, more decorative than the one in the Bruni monument (plate 189). It has curved lines, stands on lions' feet, and is ornamented on the corners with acanthus leaves, vines, blossoms, and fluttering ribbons, while the center boasts a *tabula ansata* with an inscription and—as a further ornamental motif—a winged scallop shell.

Both the form of this sarcophagus and its ornamental decor were copied repeatedly in the second half of the fifteenth century, especially in the tomb monuments for Roman prelates. The decoration of the base, with seated sphinxes at the corners, the entablature, and the arch of the monument are also particularly rich and original. On these, and on the capitals, the vegetal forms are highly stylized so that they appear as virtual cutouts—a tendency that was to become even stronger in Florence in the 1450s and 1460s. Also noteworthy are the frequent use of the drill and the fact that drill holes are left unworked. Traces of the original gilding and painting are still visible in a number of areas—especially on the pall. It is also possible to identify differences in the execution of individual portions of the monument, although any attempt to attribute these to specific collaborators—to Geri, for example, Desiderio's brother, or to the early Verrocchio—seems ill-advised.

202
Bust of a Woman ("Marietta Strozzi")

c. 1455. Marble, 20¾″ high (52.5 cm.). Staatliche Museen, Berlin-Dahlem

Waagen acquired this bust in Florence in 1842. Bode (1888) was the first to attribute it to Desiderio and later (1889) to identify it as the portrait of Marietta Strozzi that Vasari (1550) mentions in his *Vita* of this sculptor. His identification is by no means positive, however.

The work is certainly one of the earliest surviving female busts from the Quattrocento. The turning and slight lift of the head were obviously inspired by Donatello's bust of St. Leonard (plate 87). The young woman wears a relatively simple dress of the period. Her hairdo, with its braids secured on top with a

small kerchief, can be seen in Fra Filippo's Madonnas from the mid-1450s. The treatment of the mouth and eyes is typical of Desiderio. The somewhat distorted proportions of the head, neck, and shoulders, which tend to emphasize the neck, reveal it to be an early work and suggest a dating about 1455. Closely related to this Berlin bust is the so-called *"Giovinetta Morgan"* (Pierpont Morgan Library, New York), which is also held to be the work of Desiderio. Pope-Hennessy (1985) maintains that the *"Marietta Strozzi"* is not by Desiderio at all, but by Antonio Rossellino.

203
St. John the Baptist ("Giovannino Martelli")

c. 1458–60. Marble, 63″ high (160 cm.). Museo Nazionale del Bargello, Florence

This statue, which both the *Libro di Antonio Billi* (1516–20) and Vasari (1550) attribute to Donatello, remained in the possession of the Martelli family in Florence until 1912, when it was acquired by the Bargello. Lànyi (1932–33) was the first to question the traditional attribution. He convincingly ascribed the work to Desiderio, and Planiscig (1948–49), Pope-Hennessy (1985), and Cardellini (1962) have followed his lead. Janson (1957), however, continues to think of it as Donatello's.

In the Florence of the second half of the fifteenth century it became increasingly common for private houses to own busts or statues of the youthful St. John the Baptist. This statue in the Bargello is the earliest surviving work of this kind. The young saint is dressed in a loosely belted garment of hides, with only his left side protected by a cloak. In his right hand he holds a cross, in his left a scroll. Among the qualities that link the work to Desiderio are the angularity of its gestures, the slenderness and elongation of the torso, the soft, tufted treatment of the hide, the closely compressed folds of the fabric belt and the cloak, the half-open mouth, the bony structure of the hands, shoulders, and facial features, and the decorative ribbon wound around the cross and the boy's right hand.

The figure's ascetic appearance, here imposed—not altogether fittingly—onto a mere boy, may well have been influenced by the bronze *Baptist* (plate 136) that Donatello created for Siena about 1456–57. The same work may have inspired the emphatic contrast between these naked limbs and the swirling movement of the hide or the gesture of the left hand pressed against the body. The irregular base, suggestive of stony ground, is another feature reminiscent of Donatello's Sienese *Baptist* as well as his *Magdalene* (plate 128). All of this would suggest that the *"Giovannino Martelli"* was not created before the end of the 1450s. It is possible that a payment to Desiderio from Ruberto Martelli in 1460 had something to do with this work (Beck 1984).

204, 205
Tabernacle of the Sacrament

c. 1460–62. Marble, 95¼ × 34¼″ (242 × 87 cm.). San Lorenzo, Florence

On August 1, 1461—a few days before the consecration of the high altar in San Lorenzo—this tabernacle was installed in the

choir chapel of the church, yet it appears that work was still being done on it in 1462 (Spencer 1968). According to Beck (1984), it was placed on the high altar itself. However, since the reconstruction of the altar area by Burns (1979) reveals that the mass was celebrated from the altar *versus populum*, it is more likely that the tabernacle was mounted on the wall. In 1507 at the latest, it was moved to the Chapel of Sts. Cosmas and Damian, and in 1677 to the Neroni Chapel. It is referred to as the work of Desiderio by Albertini (1510), Billi (*Libro di Antonio Billi*, 1516–20), and Vasari (1550).

Its present form is a makeshift reconstruction from 1956. The original arrangement of its parts is not altogether clear; especially puzzling is the relationship of the *Pietà* relief to the remainder of the structure—if indeed it was part of it at all. The tabernacle is flanked by two boys supporting tall candelabra and crowned by the figure of the Christ Child standing on a chalice, with adoring angels on either side. The tabernacle opening—its door is now missing—is framed by a barrel-vaulted hall set between the pilasters of the aedicula. Adoring angels appear on either side of this hall.

Bernardo Rossellino had made use of a perspective interior such as this in his tabernacle for San Egidio from 1449–50 (fig. 9), but this one is much more grandiose. Mino da Fiesole and others would produce additional tabernacles of this type a short time later. The decor of this work, like that of the Marsuppini monument, is especially original and varied. Innovative motifs

and the manner in which specific ornaments are executed would appear to exclude the possibility that portions of the tabernacle were created before 1448, as Parronchi ("Tabernacolo," 1980) maintains. The figural silhouettes are even more angular than those of the Marsuppini tomb, and the relief figures still flatter. The garments are even thinner and less substantial, so that at times they appear to adhere to the body as though wet, and at others they have the look of crumpled paper.

The figure of the Christ Child on the tabernacle gable enjoyed great popularity in the Renaissance and was often copied. He once held a crown of thorns (part of which survives) and the nails for the cross in his left hand, while his right hand is raised in benediction. According to Vasari (1550), it was customary in the sixteenth century to place this figure on the high altar of San Lorenzo at Christmastime, substituting a copy by Baccio da Montelupo on the tabernacle itself. The present statuette is obviously the original one created by Desiderio, although Parronchi (1965) and Beck (1984) maintain that the original is in the Cleveland Museum of Art. The proportions of the work, the modeling of the body in general and its facial features, and the drill holes left in the crown of thorns are altogether typical of Desiderio's work on the rest of the tabernacle and elsewhere. In his Badia tondo (plate 210) Mino da Fiesole also combines the motif of the instruments of the passion with the depiction of the bambino. He does so in a somewhat different manner but was likely inspired by this statuette by Desiderio.

Mino da Fiesole
(1429–1484)

Mino di Giovanni di Mino was born in Papiano, in the Casentino, in 1429. The inaccurate designation "da Fiesole" was first employed by Vasari (1550). It is thought that the sculptor arrived in Florence in the mid-1440s, but we do not know in whose workshop he received his training. Artistically he is most indebted to Desiderio da Settignano, as Vasari (1550) was the first to point out. His earliest known works are the portrait busts of Piero de' Medici (1453?) in the Bargello and Niccolò Strozzi in Berlin-Dahlem (1454), the second of which was created in Rome. About 1455 Mino was clearly active in Naples, where he produced, among other works, the bust of Astorgio Manfredi, now in the National Gallery of Art in Washington, D.C. (Valentiner 1944 [1950]). Other certain works of his early period include busts of Alessio di Luca in Berlin-Dahlem (1456), executed in Florence, Giovanni de' Medici in the Bargello, and Rinaldo della Luna, also in the Bargello, which is dated 1461.

In 1463 Mino was again in Rome, where he collaborated on the benediction loggia of Pope Pius II and created the ciborium for the high altar in Santa Maria Maggiore. Back in Florence in 1464, he became a member of the Arte dei Maestri di Pietra e Legname in July. Desiderio da Settignano had died a few months before, leaving Antonio Rossellino and Mino as Florence's two leading sculptors. He was, therefore, given countless commissions over the next few years. In 1464 he created the bust of

Diotisalvi Neroni (Louvre, Paris), in 1464–66 the sculptural ornament of the Salutati Chapel in the cathedral in Fiesole, in 1464–70 the altar relief for the Neroni Chapel in San Lorenzo (now in the Badia), in 1465 a marble head for the cabinet frame in the north sacristy of the Duomo in Florence, shortly after 1466 the Giugni tomb in the Badia in Florence, and in 1467–71 the *Sacrament* tabernacle in the cathedral at Volterra. By 1473 he had also produced two reliefs for the pulpit in the cathedral in Prato and a wall tabernacle for the Church of San Pietro in Perugia.

After the death of Pope Paul II in 1471, Mino was commissioned to create his tomb monument in St. Peter's; however, it is clear that he did not undertake the project until the mid-1470s. Immediately before doing so he apparently executed, at the behest of Cardinal d'Estouteville, the *St. Jerome* altar in Santa Maria Maggiore in Rome. Fragments of that work are preserved in the storerooms of the Museo di Palazzo Venezia. The chief contributor to the Tomb of Pope Paul II was Giovanni Dalmata, with whom Mino also created the *Sacrament* tabernacle for San Marco. It is assumed that Mino collaborated with Andrea Bregno on the tomb for Cardinal Forteguerri (d. 1473) in Santa Cecilia in Trastevere, on the Tomb of Pietro Riario (d. 1474) in Santi Apostoli (fig. 66), and on the monument to Cristoforo della Rovere (d. 1478) in Santa Maria del Popolo. Mino's last work

from his second sojourn in Rome is the Tomb of Francesco Tornabuoni (d. 1480) in Santa Maria sopra Minerva.

There is as yet no detailed study of his stylistic development, especially during his Roman years. Early in this century a number of the Roman works bearing the signature OPUS MINI were mistakenly attributed to a "Mino del Reame," an artist introduced into the literature by Vasari (1550) but about whom nothing definite is known. In about 1480 Mino returned to Florence, where by 1481 he had completed the Tomb of Count Ugo in the Badia, a commission he had been awarded in 1469. His last work was a wall tabernacle for the Church of Sant' Ambrogio. He made his will on July 10, 1484, and died the following day.

Vasari [1550, 1568]; Angeli 1904; Burger 1904; Angeli 1905; Biasiotti 1918; Lange 1928; Middeldorf, Review of *Porträtbüsten*, 1938; Marrucchi 1939; Valentiner 1944 (1950); Langton-Douglas 1945; Langton-Douglas 1946; Mather 1948; Carrara 1956; Pope-Hennessy 1958 (1985); Corti and Hartt 1962; Lavin 1970; Sciolla, *Mino*, 1970; Negri Arnoldi, "Monumento," [1978]; Borsook 1981; Zander 1982–84; Haines 1983; Caglioti 1987; Pujmanova 1987.

206
Bust of Piero de' Medici

c. 1455–60. Marble, 21⅝" (55 cm.). Museo Nazionale del Bargello, Florence

This bust, included in the Medici inventory of 1492 and specifically mentioned by Vasari (1568), was rediscovered by Bode (1892–1905). It bears the inscription PETRUS COS. S. AETATIS ANNO XXXVII OPUS MINI SCULPTORIS. Piero de' Medici was Cosimo's oldest son and the father of Lorenzo the Magnificent. Since he was born in 1416, the inscription would imply that Mino created the bust in 1453; however, a number of scholars have questioned the authenticity of the inscription itself and suggested a later date for the work (Angeli 1905; Lange 1928).

Piero is portrayed wearing a sumptuous brocaded robe, the borders of which are ornamented with a diamond-ring emblem. The straight termination at the bottom and the turning of the head to the side had been prefigured in busts by Donatello ("*Niccolò da Uzzano*" and *St. Leonard*; plates 73, 87). If one compares this work with Mino's bust of Niccolò Strozzi in Berlin-Dahlem, which is signed and dated 1454, and with Antonio Rossellino's 1456 bust of Giovanni Chellini (plate 190), one notes how the shoulders and upper arms are here more clearly developed, like those of Desiderio's "*Marietta Strozzi*" (plate 202). The breast portion is no longer a uniformly rounded, compact form. The relation between head and shoulders is more convincing; they appear to be portions of a coherent anatomy. This is also the case in later busts by both Mino and Antonio. Thus it would seem more likely that the Piero bust was created after 1454, and not—as the inscription implies—in 1453.

207–9; fig. 52
Nativity; Adoration of the Magi; The Assumption of the Virgin; Miracle of the Snow

Reliefs from the former ciborium over the High Altar.
c. 1461–63. Marble. Santa Maria Maggiore, Rome

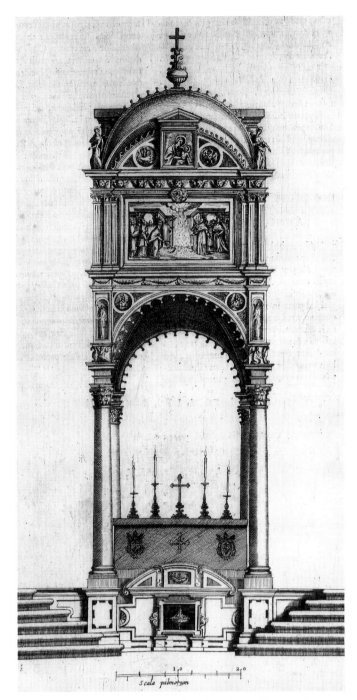

52 Former ciborium over the High Altar, Santa Maria Maggiore, Rome (after De Angelis, 1621)

The former ciborium over the high altar in Santa Maria Maggiore, replaced by the present one in 1747, was donated by Cardinal Guillaume d'Estouteville. Its original appearance can be seen in an engraving (fig. 52) and descriptions of it were noted by De Angelis (1621) and P. Giuseppe Bianchini shortly before it was demolished (reprinted in Sciolla, *Mino*, 1970). It was a boxlike marble structure, richly ornamented with niche figures and figural reliefs, resting on four porphyry columns and crowned with a cupola. Its four main reliefs, depicting the Nativity, the Adoration of the Magi, the Assumption of the Virgin, and the Miracle of the Snow, are now mounted in the apse of the church. Additional reliefs and statues from the ciborium

are preserved in the Aula Capitolare of Santa Maria Maggiore, and a *Madonna* relief, formerly in the Stroganoff Collection, is now in the Cleveland Museum of Art. According to Bianchini, the inscription that gave the name of the ciborium's donor included the date 1461 or 1463.

Scholars are divided over the attribution of the work. Some consider it to have been the creation of Mino da Fiesole, as Albertini (1510) relates; others follow Vasari (1550) in ascribing it to an as yet mysterious "Mino del Reame." Despite considerable differences in the execution of the reliefs, a number of features unmistakably reveal the designing hand of Mino da Fiesole: the construction of the figures, with emphasis on their silhouettes and a noticeable flattening of their forms near the edges, the thinness of the drapery despite their apparent stiffness, an obvious preference for an outward twisting of the free leg in standing figures, the design of the niches on either side of the *Assumption* relief, and certain details in the decoration throughout. The fact that the sense of space in the reliefs is unlike anything found in other Roman sculpture from the 1460s—or for that matter on Laurana's Triumphal Arch of Alfonso I in Naples—suggests that they are the work of a sculptor schooled, like Mino, in Florence. However, these figures are distinguished from those in Mino's later works by their shorter proportions; also, their garments, with their wide, bell-like shapes, are unlike those found in his sculptures after 1464. It therefore seems plausible that the ciborium dates from 1461–63.

210
Madonna and Child

c. 1470–75. Marble, 35⅜″ diameter (90 cm.). Museo Nazionale del Bargello, Florence

Until the nineteenth century, this tondo, first mentioned by Vasari (1550), hung above the main portal of the Badia. In its frontal orientation, the way it overlaps the medallion frame, and the fact that it was designed to be seen from below, Mino's half-figure of the Madonna resembles Antonio Rossellino's *Madonna* tondo on the Tomb of the Cardinal of Portugal (plate 193). The putto console is found in other works by Mino, including the *Sacrament* tabernacle in Santa Croce in Florence and the *Madonna* from the Tomb of Pietro Riario in Santi Apostoli in Rome (plate 231); however, the Badia tondo is unusual in that the putto is wearing a crown of thorns and holding a cross and his head serves the infant Christ as a footrest. The rigid frontality of the *Madonna* figure and the angularity of her silhouette have parallels in the reliefs of the Virtues on the Tomb of Pope Paul II. The unusual form of the console volutes overlaid with leaves also appears on the Riario tomb monument. On the other hand, Mino does not emphasize the body as strongly here as he does in the works he created after the mid-1470s. For this reason it seems reasonable to date the Badia tondo to the early half of the decade.

211
Charity, relief from the Tomb of Pope Paul II

c. 1475–77. Marble, 53⅞ × 30¾″ (137 × 78 cm.).
St. Peter's, Rome, now in the Fabbrica di San Pietro

For general information on the tomb, see page 438.

This relief is the center one of five reliefs on the base of the tomb and bears on the upper edge of its frame the signature OPUS MINI. In his *Vita* of Mino da Fiesole, Vasari (1550) attributes the Tomb of Pope Paul II to him, yet in his *Vita* of Paolo Romano he mentions it as the work of "Mino del Reame," which suggests that his knowledge of this latter sculptor was uncertain at best. The relief of Charity and other portions of the tomb are unquestionably the work of Mino da Fiesole. The figure's seated posture and its size in relation to the throne are similar to those in Mino's *Madonna* relief from the Tomb of Pietro Riario in Santi Apostoli (c. 1474; plate 231). However, the details are more finely executed here, especially those of the drapery, which appears to be extremely thin. In the *Charity*, moreover, Mino has given the body beneath the drapery a greater roundness than he had in earlier works.

It is unusual that the Virtues should be depicted as seated; in earlier tomb monuments from the Quattrocento they are always standing figures. Clearly they were patterned after the *Virtues*, now in the Uffizi, painted by Piero and Antonio del Pollaiuolo for the Mercanzia in Florence in 1469–70. Their frontal poses, their proportions relative to their thrones, and the very forms of the thrones themselves confirm this borrowing. Like Pollaiuolo's *Charity*, Mino's probably also once held a flame as an attribute in her right hand.

Vecchietta
(1410–1480)

Lorenzo di Pietro, known as Il Vecchietta, was born in Siena in 1410. He was a painter, wood-carver, sculptor in marble and bronze, and a builder of fortifications. It was only in about 1460 that he began to devote himself increasingly to sculpture. Quite possibly he was encouraged in this by Donatello, who maintained a workshop in Siena in 1457–59. Vecchietta had been a member of the painters' guild since 1428. His earliest surviving work is a fresco, dated 1441, in the Sala del Pellegrino in the Ospedale di Santa Maria della Scala. Generally regarded as among the sculptural works from his early years are the painted wooden figure of a resurrected Christ from the Villa Chigi in Vico Alto (Ragghianti 1940), probably created in 1442 for the high altar of the cathedral in Siena, a wooden *Annunciation* group in the Louvre (Del Bravo 1970), and a wooden *Pietà* in San

Donato in Siena (Bagnoli 1989). In 1446–49 he painted the frescoes in the former sacristy of Santa Maria della Scala, and in 1450–53 the ones in Siena's Baptistry.

In 1460 Vecchietta was in Rome, where he presented Pope Pius II with a wooden model for the Piccolomini family loggia in Siena. In 1460–62 he created the marble statues of St. Peter and St. Paul for the Loggia della Mercanzia in Siena and one of the altar paintings for the cathedral in Pienza. He was again in Rome in 1464. Shortly afterward, beginning in 1467, he produced his first works in bronze. These include the figure of Mariano Sozzini in the Bargello (1467), intended for a tomb monument proposed for San Domenico in Siena but never executed; the large ciborium for the high altar of Santa Maria della Scala in Siena (now on the high altar of the Duomo); and the *Flagellation* relief in London's Victoria and Albert Museum. A bronze relief of the Resurrection in the Frick Collection in New York dates from 1472, the wooden statue of St. Antony Abbot in the cathedral in Narni from 1475, and the bronze statuette of the resurrected Christ in Santa Maria della Scala in Siena from 1476. In these years (1472–76) he also created three silver figures, no longer surviving, for the cathedral in Siena, as well as the signed wooden statue of St. Bernard of Siena in the Bargello. Vecchietta's last work is a wooden relief of the Dormition of the Virgin in Lucca (originally in San Frediano, now in the museum of the Villa Guinigi). A *persona assai maninconica e solitaria*, as Vasari (1550) portrays him, Vecchietta dedicated himself from 1476 on to the construction and ornamentation of his own chapel and tomb in the Church of the Ospedale in Siena. He wrote his will on May 10, 1479, and died on June 6, 1480.

Vasari [1550, 1568]; Milanesi 1854–56; Borghesi and Banchi 1898; Schubring, *Plastik*, 1907; Cellini 1930; Vigni 1937; Middeldorf, review of Vigni, 1938; Ragghianti 1940; Maltese 1946–48; Carli 1951; Ragghianti, "Vecchietta," 1954; Pope-Hennessy 1958 (1985); Del Bravo 1970; Os 1974; Morani and Cairola 1975; Pfeiffer 1975; Lavin 1977–78; Os 1977; Os 1978; Carli 1980; Kühlenthal 1982; Bagnoli 1989.

212
St. Peter

1460–62. Marble, 68½″ high. Loggia della Mercanzia, Siena

On July 8, 1458, Vecchietta was commissioned by the Operai of Siena's cathedral to create a statue of St. Paul for the Loggia della Mercanzia. Two additional statues, those of St. Bernardine and St. Ansanus, were entrusted to Donatello and Federighi. Donatello's was never delivered. In 1460 Vecchietta was asked to provide a figure of St. Peter as well. Both statues, his earliest known works in sculpture, were completed in 1462.

The *St. Peter* statue, signed on the base, stands next to the left pillar of the loggia in front of a slender niche. He is holding keys in his right hand, a book in his left. The twist of his body and the direction of his gaze correspond to those of the other loggia statues and are obviously oriented toward the viewer approaching from the Via di Città. In style, the work is clearly indebted to Donatello—not so much his *St. Mark* from Orsanmichele, as Del Bravo (1970) insists, but rather his later statues. One notes especially the saint's gaunt form, his tentative stance—his feet extend beyond the edge of the plinth like those of Donatello's *Magdalene*—and his distinctly aged features.

213; figs. 53, 54
The Resurrected Christ

High Altar Ciborium. 1467–72. Bronze. Duomo, Siena

This ciborium (fig. 53), intended for the high altar of Santa Maria della Scala in Siena, was commissioned by the hospital chapter on April 30, 1467. Vecchietta had already provided a full-size tempera design of the work on canvas (fig. 54). That sketch, 11 feet 6 inches tall (350 centimeters), is specifically referred to in the contract and is still preserved in Siena's Pinacoteca. The work was completed in November 1472, and in 1506 it replaced Duccio's *Maestà* on the high altar of the Duomo. On the base at the back is the inscription OPUS LAURENTII PETRI PICTORIS AL[IAS] VECHIETA DE SENIS MCCCCLXXII.

This is the most elaborate and artistically important freestanding altar ciborium from the Early Renaissance. In its overall form it is patterned after earlier examples, such as those in Siena's Baptistry and in the cathedral in Volterra; however, it far surpasses them in size, elegance, and grace, and in the richness of its figural and ornamental decor. Pfeiffer (1975) quite rightly stresses the ciborium's delicate balance, a feature perhaps inspired by the Tomb of the Cardinal of Portugal by Antonio Rossellino (see plate 193). The cylinder containing the Host rises above a tall base adorned with putti and musical angels. Niches set off by pilasters alternate with panels of grillwork around the sides of the cylinder itself, and in these niches sit the theological Virtues: Faith, Hope, and Charity. The lower part of the cupola atop the cylinder is also ringed with putti. Towering above these is a figure of the risen Christ standing on a chalice supported by two angels. This use of Christ as a finial figure is explained by the presence of the Eucharist in the vessel below, the adoration of which dates from the Late Middle Ages. It is a common motif in Tuscan art from the Quattrocento (Middeldorf 1962).

214
The Resurrection

1472. Bronze, 21⅜ × 16¼″ (54.3 × 41.2 cm.). The Frick Collection, New York

This relief, said to have belonged to the Chigi family, was acquired by the Frick Collection in 1916. The inscription on the sarcophagus reads: OPUS LAURENTII PETRI PITTORIS AL[IAS] VECHIETTA DE SENIS MCCCCLXXII. Seymour (1966) suggests that this is actually the door from the ciborium that Vecchietta created for Santa Maria della Scala in Siena in 1472. However, this seems unlikely, both because there is no keyhole and because it presents so many figures.

The figure of Christ, seen rising out of his tomb, is surrounded by a mandorla of cherubim. Sleeping soldiers lie in a confusing sprawl in front of the tomb, while adoring angels stand on top of tall rocks on either side. Christ's pose—especially the twist to his body—and the way his wafting shroud still clings to his legs are wonderfully suggestive of hovering upward movement. The soldiers crowded on top of each other in apparent exhaustion in the foreground are clearly patterned after those of Donatello's *Resurrection* relief on the north pulpit in San Lorenzo (plates 146, 147).

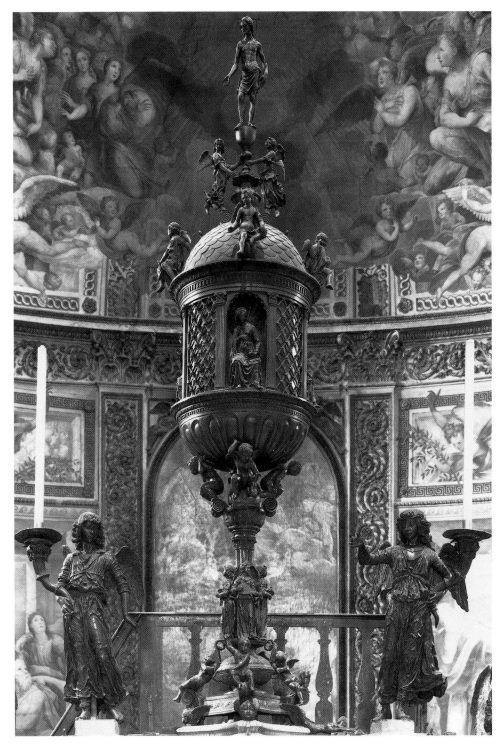
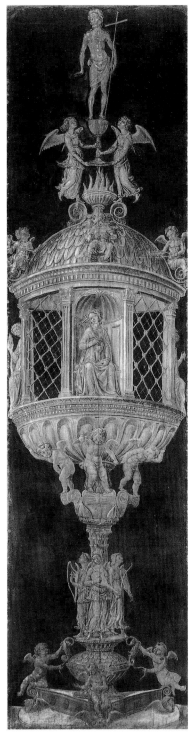

53 Vecchietta. High Altar Ciborium. Duomo, Siena

54 Vecchietta. Design for the High Altar Ciborium in the Duomo, Siena. Pinacoteca, Siena

215
The Resurrected Christ

1476–77. Bronze, 72⅞" high (185 cm.). Santa Maria della Scala (Santissima Annunziata), Siena

Vecchietta had created this bronze figure of the risen Christ for a Salvator Chapel in the hospital church that he himself had donated and in which he intended to house his own tomb. On its base is the inscription OPUS LAURENTII PETRI PICTORIS AL[IAS]

VECHIETTA DE SENIS MCCCCLXXVI. P[RO] SUA DEVOTIONE FECIT HOC. Despite this inscription, the artist himself speaks of the work on December 20, 1476, as "not yet finished." It was meant to stand before his own painting of a Madonna and Child attended by Sts. Peter, Lawrence, Paul, and Francis that now hangs in Siena's Pinacoteca. In the sixteenth century the statue was moved to the high altar of the hospital church. Of Vecchietta's tomb there is no trace.

This figure is similar in construction and gestures to the one

on top of the ciborium that Vecchietta had executed in 1472 (plate 213). Here, however, the curve of the body is more pronounced, the details more finely worked. Above all, there is a greater sense of suffering and pathos in this version of the figure. Christ is wearing a simple loincloth. He holds a staff topped with a cross in his left hand and his right foot rests on a serpent. He extends his right hand downward and to the side, following with his gaze. His body is quite slender, so that his head and hands seem especially heavy. The sculptor has taken pains to empha-

size his throbbing veins and the scars from his wounds, his distorted features, and his utter exhaustion, which is especially evident from his gaping mouth. He may have been inspired to create such a sorrowful portrayal of the resurrected Christ by Donatello's bronze statue of St. John the Baptist in Siena's cathedral and the *Resurrection* relief on the north pulpit in San Lorenzo (plate 149). Characteristically, however, Vecchietta has combined these expressive details with a pose so elegant that much of their effect is lost.

Matteo Civitali
(1436–1501)

Matteo di Giovanni Civitali was born in Lucca on June 5, 1436. He was that city's most important sculptor from the Quattrocento. There are documents suggesting that he was also a painter (Ferri 1982), but next to nothing is known of his activities in that capacity. It is likely that he was trained in the Rossellino brothers' workshop in Florence. The first mention of him is from 1468, when he was asked to appraise Antonio Rossellino's tomb for Filippo Lazzari in the cathedral in Pistoia. There are no known works from his early years. His first documented work is the Tomb of Pietro da Noceto in the cathedral in Lucca, completed in 1472. Civitali created a *Sacrament* tabernacle for the same cathedral in 1473–77. An uncompleted figure of Faith in Florence's Bargello may be another work from these same years.

The tomb that Domenico Bertini commissioned from Civitali for himself and his wife in Lucca's cathedral is dated 1479. At about this same time, Civitali also produced the *Madonna Salutis Portus* on San Michele in Foro, the *Madonna della Tosse* in Santa Trinità, and the choir screen in the cathedral. A short time later, between 1481 and 1484, he completed the tempietto in the Chapel of the Volto Santo and the Altar of St. Regulus. In 1486 he was contracted to produce twenty-two marble altars for the cathedral in Pisa, but these were never completed. His most important works from the following years are the tabernacle in San Frediano (1489, now the baptismal font), the altar and shrine of St. Romanus (1490), and the marble pulpit in the cathedral at Lucca (1494–98). In 1495 the Pisans commissioned a bronze equestrian monument to Charles VIII, which Civitali was to have executed together with the goldsmith Francesco da Marti, but the project came to naught. After 1496 Civitali delivered six marble statues for the Chapel of St. John in the cathedral at Genoa.

Another work from his late period was the statue of St. George that stood atop a column in front of the Palazzo Comunale in Sarzana until it was destroyed in 1797. It is possible that his last work was the marble *Pietà* for the sacrament altar in the parish church at Lámmari (near Lucca), for which he was still receiving payments as late as 1501. Civitali was closely associated with various humanists, collected works of art from antiquity, and in

1477 set up the first printing shop in Lucca. He died in Lucca on October 12, 1501, and was buried in the Church of San Cristoforo.

Trenta 1822; Vasari-Milanesi 1878; Ridolfi 1879; Ridolfi 1882; Yriarte 1886; Procacci 1931; Meli [1934]; Bertini Calosso 1940; Pope-Hennessy 1958 (1985); Middeldorf 1977; Negri Arnoldi, "Civitali," [1978]; Petrucci 1980; Ferri 1982; Bule 1987; Bule 1988.

216
Tomb of Pietro da Noceto

1472. White and red marble, partially painted, 25'5" × 11'6" (775 × 350.5 cm.). Duomo, Lucca

Pietro de' Nobili da Noceta served as first secretary to Pope Nicholas V. After the pope's death, he retired to his hometown of Lucca, where he died on February 18, 1467. It is possible that his son Nicolao da Noceto commissioned his tomb monument immediately afterward. On December 4, 1469, Civitali entered into an agreement with the Milanese sculptor Domenico Orsolini to share a workshop, and this may have had something to do with the execution of the tomb (Bule 1988). The work was not completed until 1472, however, as its inscription makes clear. Civitali was paid a total of 450 gold ducats—100 more than originally agreed upon. The bonus was the result of an appraisal of the work by Antonio Rossellino on June 8, 1473. Rossellino had been called in after previous appraisers failed to agree on its value. An additional 50 ducats were obviously spent on gilding.

The overall design of the tomb owes a great deal to the Bruni and Marsuppini monuments (see plates 187, 199). However, the tublike sarcophagus with its lions' feet, the form of the funeral bed, the decoration of the base, and a number of specific details show the influence of Antonio Rossellino and Mino da Fiesole. The ornamentation is also similar to that of the above-mentioned Florentine tombs. One motif borrowed from Mino's Guigni tomb in the Badia in Florence is the use of profile portraits of Pietro da Noceto and his son Nicolao on either side of the *Madonna* tondo in the lunette.

217

Adoring Angel

1473–77. Marble. Duomo, Lucca

Domenico Bertini commissioned Civitali to create a *Sacrament* tabernacle for the cathedral in Lucca in 1473, and the work was finished by 1477. It was moved from its original location in about 1567. Two angels from the tabernacle are all that remain in Lucca's cathedral, while the ciborium, signed on the base, is now in the Victoria and Albert Museum in London. These kneeling angels stood on either side, turned toward the ciborium in adoration of the sacrament within. Their placement and postures are patterned after those of the angels on the sarcophagus in Antonio Rossellino's Tomb of the Cardinal of Portugal (plate 193). However, it would appear that for his overall design, Civitali borrowed from the tabernacle created by Mino da Fiesole for the cathedral in Volterra. The latter is freestanding, to be sure, whereas Civitali's tabernacle stood against a wall. This is clear from the fact that neither the angels nor the ciborium itself are completely finished on the back.

218, 219

Altar and Tomb of St. Regulus

1484. White and red marble, partially gilt, 19′8¼″ (without predella) × 12′9½″ (at base) (600 × 390 cm.). Duomo, Lucca

As early as 1460, the city of Lucca set aside a sum of 300 florins for new and more elegant decorations for the Altar of St. Regulus, but these were never produced. So in the early 1480s Nicolao da Noceto donated an entirely new altar for the chapel in which he had erected the monument to his father ten years before. The inscription on the base of this altar informs us that it was completed in 1484. At that time all that remained to be done was the gilding, which was entrusted to the painter Michele Ciampianti on October 7, 1485.

The work's two-story design was occasioned by its double function as both altar and tomb, and it is in part based on that of the Coscia monument in the Florentine Baptistry (plate 63). The retable consists of three niches framed by pilasters and containing figures of St. John the Baptist, St. Regulus, and St. Sebastian, whose respective martyrdoms are depicted in reliefs on the predella immediately below. Above the retable, resting on a slab supported by large consoles, is the sarcophagus of St. Regulus, flanked by a pair of boys holding candlesticks that are unquestionably patterned after those of Desiderio's sacrament tabernacle (plate 205). Above the sarcophagus, in a niche interrupting the upper entablature, is a seated Madonna and Child. A low segmental arch completes the structure. The profile portraits of a young man and an older one on either side of the predella reliefs are probably portraits of Pietro and Nicolao da Noceto. The surviving coats of arms in the frieze at the base refer to the Guinigi, the family to which the wife of Nicolao da Noceto belonged, while the ones that have been obliterated were doubtless those of the Noceto family.

The figural style and ornamentation of the *St. Regulus* altar constitute a definite advance beyond those of the Noceto tomb. These figures, for all their borrowings from Desiderio da Settignano, are rounded and full-bodied. Their drapery is quite ample, yet supple enough to permit its broad folds to accommodate to the forms of the limbs beneath. The ornaments are rich and varied. No longer are they exclusively Florentine in style, but rather more Roman, especially close to those of Andrea Bregno. This would suggest that Civitali sojourned in Rome about 1480. Such a visit would also explain the altogether un-Florentine decor of his Volto Santo tempietto in the cathedral in Lucca, also completed in 1484.

Francesco Laurana
(c. 1430–1502)

Francesco Laurana was born about 1430 in Vrana, near Zara, in Dalmatia. He had been completely forgotten until the end of the last century, and even today there is much about his artistic development that is unclear, so that attributions and dating tend to be vague. Nothing certain is known about his activities before July 17, 1453, when he is first mentioned as being in Naples and collaborating with Pietro da Milano and others on the triumphal arch for Alfonso I. It is likely that he had followed Pietro da Milano to Milan from Ragusa. Laurana continues to be documented in Naples until 1458, but a short time later it would appear that he went with Pietro da Milano to France, to the court of King René of Anjou. A number of signed and dated medallions—including portraits of King René and Jeanne de Laval (1463)—show him to have been working in France between 1461 and 1466.

Laurana left France in 1466 or 1467, and from the end of 1467 until 1471 he worked in Sicily, executing, together with Pietro de Bonitate, the entry arch for the Mastrantonio Chapel in the Church of San Francesco d'Assisi in Palermo. His first documented statues also date from this period. They include the *Madonna* statues in the Palermo cathedral (1468–69) and in the Church of the Crucifix in Noto (1471).

In the early 1470s Laurana was once again in Naples. The majority of his famous portrait busts may well date from this

time. His *Madonna* above the portal of the Chapel of St. Barbara in the Castelnuovo is dated 1474. Some scholars assume a visit to Urbino in the years 1475–76. It is certain, however, that from late in 1476 Laurana was again working in France, where he was engaged until 1483 on the sculptures for the Chapel of Saint-Lazare in the old cathedral in Marseille. Between 1478 and 1481 he created a retable of Christ carrying the cross for the Church of the Celestines in Avignon (now in St.-Didier). Between 1484 and 1492, and again between 1493 and 1498, he was presumably in Italy, then from 1498 on back in France, where he died in early 1502.

Bode 1888; Bode 1889; Fabriczy 1899; Fabriczy, "Triumphbogen," 1902; Burger, *Laurana*, 1907; Rolfs [1907]; Valentiner 1942; Causa 1954; Pope-Hennessy 1958 (1985); D'Elia 1959; Kennedy 1962; Patera 1965; Bernini 1966; Accascina 1970; Kruft, "Madonna," 1970; Kruft, Review of Hersey, 1970; Middeldorf and Kruft 1971; Kruft, *Gagini*, 1972; Kruft, "Pietro," 1972; Hersey 1973; Kruft and Malmanger 1974; Gvozdanovic 1975; Kruft and Malmanger, "Portal," 1975; Kruft and Malmanger, "Triumphbogen," 1975; Pane 1975–77; Patera 1975; Patera 1980; Goss 1981; Mognetti 1981; Salet 1983.

220–22; figs. 55, 56
Triumphal Arch of Alfonso I

c. 1452–71. Marble. Castelnuovo, Naples

Alfonso of Aragon had captured Naples on June 2, 1442, and on February 26, 1443, even before the pope had officially granted him the kingdom, he celebrated his victory with a triumphal procession *all'antica*. The spectacle is described by a number of contemporary sources. On that occasion, a triumphal wooden arch, painted and gilded, was erected on the Piazza del Mercato. Planning for a permanent marble arch may well have waited until 1451. In the winter of 1451–52, and again in the spring of 1452, Alfonso attempted to interest Pietro da Milano, then working in Ragusa, in undertaking the project. On July 17, 1453, Pietro received payment along with other sculptors— among them Francesco Laurana—for work in the Castelnuovo.

Work on the marble portions of the triumphal arch was begun in 1455. On January 31, 1458, Isaia da Pisa, Antonio Chellino, Pietro da Milano, Domenico Gagini, Francesco Laurana, and Paolo Romano contracted to complete the arch. However, their work was interrupted for a considerable time as the result of Alfonso's death on June 27, 1458. It was only resumed in 1465, by which time Pietro da Milano was solely responsible for seeing it through to completion. The arch was finally finished in the fall of 1471.

The richly decorated structure, wedged between two massive round towers, is both a triumphal arch and a portal (fig. 55). Its extreme height and two-story design were prescribed by the existing castle architecture. Two arched openings, each with its own high attic, and a culminating, segmental arch pediment are the basic elements of its showy façade. The lower, taller arch (plate 220), patterned after the Triumphal Arch of Sergins in Pola, is flanked by two pairs of columns and adorned with the Aragonese coat of arms and with cornucopias and griffins. On its inner surfaces are two reliefs: on the left (plate 222) Alfonso's

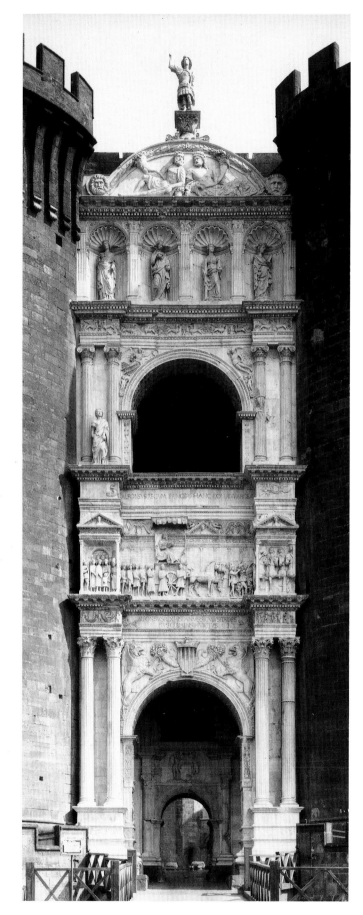

55 Triumphal Arch of Alfonso I. Castelnuovo, Naples

433

56 Pisanello circle. Design for a Triumphal Arch. Museum Boymans-van-Beuningen, Rotterdam

son, Ferrante, is depicted as commander of the Aragonese forces; on the right Alfonso is shown in the identical role. In the frieze above this lower arch is the inscription ALFONSUS REX HISPANUS SICULUS ITALICUS PIUS CLEMENS INVICTUS.

The attic above this, projecting forward on either side, presents the monument's chief scenic sculpture. This is a depiction of Alfonso's triumphal progress, moving from left to right in front of a wall marked off by pilasters and topped with triangular gables and volutes. The king is seated beneath a baldachin on a tall ceremonial car. In his left hand he carries a sphere, and in his right—now broken off—there was surely once a scepter. At

his feet is a flame, one of the devices in his emblem, the so-called *sedia pericolosa*. The train accompanying the king is made up of intimate associates, ambassadors, courtiers, canopy bearers, musicians, and heralds. The team of horses drawing his chariot is driven by a victory goddess. A bust of Athena Parthenos adorns the gable above these horses. Completing the attic is an entablature bearing the inscription ALFONSUS REGUM PRINCEPS HANC CONDIDIT ARCEM.

Above this comes the second, smaller opening. This one is flanked by half-columns and, on the left side, a statue, generally interpreted as the *virtù guerriera* (virtuous warrior), dressed in armor and a cloak. The spandrel ornaments above this arch include putti with cornucopias and victories with wreaths. According to a drawing in Rotterdam by an artist close to Pisanello (fig. 56), this opening was originally supposed to have been filled with an equestrian statue of the king, and it was presumably in relation to this statue that Alfonso was twice in contact with Donatello. That plan was never executed. The upper arch is topped by an entablature with griffins on its frieze, which is obviously patterned after the one on the Temple of Antoninus and Faustina in the Roman Forum. Above this is a second attic with four niches containing statues of Justice, Temperance, Fortitude, and Prudence. Crowning the whole is a segmental arch gable with two recumbent rivergods in its tympanum and a statue of St. Michael that was originally flanked by figures of St. Antony Abbot and St. George (fig. 59).

Despite its heterogenous design and its accommodation to the already existing architecture, the portal is deliberately classical in feeling. It incorporates borrowings from the Arch of Sergius in Pola, the Arch of Trajan in Benevento, and the triumphal arches in Rome. A number of artists have been credited with the portal's architectural design, but Pietro da Milano and Francesco Laurana are the only two worthy of serious consideration, the former more than the latter, to judge from the inscription on his tomb in Santa Maria la Nova in Naples. The tomb itself has long since been destroyed, but Giovanni Antonio Summonte quotes the text of its inscription.

Surviving documents mention eight of the artists involved in the execution of the monument's reliefs and statues by name: Pietro da Milano, Francesco Laurana, Pere Johan, Paolo Romano, Isaia da Pisa, Domenico Gagini, Andrea dell'Aquila, and Antonio Chellino. Of these, Francesco Laurana was unquestionably the most important as a sculptor. One of the chief challenges to scholars researching the triumphal arch has always been the problem of distinguishing between the contributions of these known artists, not to mention their numerous assistants. Among those who have concerned themselves with this problem most strenuously in recent years are Hersey (1973) and Kruft and Malmanger ("Triumphbogen," 1975). According to the latter, Laurana provided the so-called Tunisian group in the triumphal frieze (plate 221), the two putti holding coats of arms on the inner arch, portions of the left-hand army relief (plate 222), the frieze below the army relief on the right side, the figure of Justice, and the so-called *virtù guerriera*. It is unlikely that the puzzle will ever be solved with absolute certainty; however, it would appear that in addition to the Tunisian group some of the other portions of the triumphal frieze—especially the row of barons in the left-hand section—should be attributed to Laurana rather than to Pietro da Milano.

223
St. Jerome and St. Gregory the Great

1468–69. Marble. Entry arch, Mastrantonio Chapel,
San Francesco d'Assisi, Palermo

On June 2, 1468, Laurana and Pietro de Bonitate, a Lombard sculptor of whom no known sculptures survive, were contracted to construct and embellish the chapel of Antonio di Mastrantonio. They were to do so within a period of a year and a half and to receive 200 ounces of gold for their work. Included in the project was the chapel's entry arch, which was to be executed in accordance with a drawing the two artists had submitted. In the reconstruction required after the church was damaged by bombs in 1943, this arch was moved from the fifth chapel to the fourth. Its design was obviously influenced by the chapel façades in the Tempio Malatestiano in Rimini (fig. 47), as is especially clear from the relief decoration on the pilasters. Depicted on the left-hand pilaster are a putto with cornucopia, Sts. Jerome and Gregory, St. Mark, St. John the Evangelist, and Jeremiah; on the right-hand one a putto with cornucopia, Sts. Ambrose and Augustine, St. Luke, St. Matthew, and Isaiah.

Scholars disagree about the extent of Laurana's contribution to these arch reliefs. Bernini (1966) concludes that Laurana produced the ones on the left pilaster, Pietro de Bonitate those on the right. Kruft, however ("Pietro," 1972), is willing to credit Laurana with the overall design of the arch and the relief presenting the Church Fathers Jerome and Gregory—both of which had already been claimed for the sculptor by Burger (*Laurana* 1907) and Rolfs ([1907])—but the only other works he chooses to add to these are the *St. Luke* relief and the putto relief on the left-hand base of the arch.

All of the reliefs of the Church Fathers and the Evangelists follow a similar design. The flat coffered ceiling, used here to mark off the foreground space at the top, can also be seen in the army reliefs on the triumphal arch in Naples (plate 222). In these Palermo reliefs, however, the space of the background has been expanded. The architectural prospect in the Jerome and Gregory relief is especially elaborate and believable, reminiscent of idealized views in paintings from the period, such as the one in the Galleria Nazionale in Urbino. The reliefs on the left-hand pilaster are superior to those on the right. The figures in all of the latter are extremely thin and elongated. This alone would tend to confirm that the relief of Jerome and Gregory and the one of St. Luke are the work of the same sculptor. The figures in all of the pilaster reliefs betray a strong indebtedness to Donatello's reliefs in the Old Sacristy in San Lorenzo. Burger (*Laurana*, 1907) was the first to point out that the *St. Luke* relief was clearly modeled after Donatello's *St. John* tondo.

224
Bust of Battista Sforza

c. 1475. Marble. Museo Nazionale del Bargello, Florence

This bust, mentioned already in the sixteenth century in the inventory of the Medici collections, was first attributed to Laurana by Bode (1888). It was probably created about 1475 and is a posthumous portrait of the second wife of Federigo da Montefeltro, the duchess of Urbino, who died at the age of twenty-seven in 1472. The inscription on its base, which is part of the same block as the bust, reads: DIVA BAPTISTA SFORTIA URB. RG. A death mask served Laurana as a model in his carving of the bust—possibly the one that is now in the Louvre. The bust's overall design and its facial features are marked by a strict symmetry and absolute absence of motion. The face is drawn back unusually far in relation to the shoulders, which heightens the impression of aloofness. Typical of Laurana are the extreme smoothness of the surface, the polish that serves to round out each swelling, and the high degree of abstraction and delicate stylization. The latter are foreign to the more vital and animated portrait sculpture of Florence, even though Laurana was strongly influenced by it, especially the work of Desiderio da Settignano.

225; figs. 57, 58
Bust of Isabella of Aragon (?)

c. 1490. Marble and wax, painted, 17⅜" high (44 cm.).
Kunsthistorisches Museum, Vienna

Valentiner (1942) was the first to suggest that the subject of this bust is Isabella of Aragon, one of the daughters of Alfonso II of Naples. Isabella was married to Gian Galeazzo Sforza in 1489 and thus became the duchess of Milan. His identification is by no means certain, however. The same is true of the related busts in the Louvre in Paris and the Galleria Regionale in Palermo. Nevertheless, all three are unquestionably late works by Laurana—as Valentiner was also the first to recognize.

Although by the same sculptor, the Vienna bust differs considerably from the earlier one of Battista Sforza (plate 224). This one has no base. The figure's posture is less rigid, her head and shoulders forming an organic unit with much more rounded contours. Its smooth modeling and polished surface are combined with features that are much more lifelike than those of the bust in the Bargello. The painting serves to make them even more convincing. The stylish coiffure with its elegant hairnet (fig. 57) can be seen in Milanese portraits of the period about 1490, such as the *Portrait of a Lady,* attributed to Ambrogio de Predis, in the Pinacoteca Ambrosiana. The painting on the Vienna bust is the original. When the work was cleaned some years ago it was discovered that the flowers in the hairnet are made of wax. (We are indebted to M. Leithe-Jasper for this information.)

The polish on the Vienna bust is uniformly smooth, but on the one in the Galleria Regionale in Palermo (fig. 58) it is so pronounced that the work seems abstract and stylized. Another difference in his Palermo bust is the distinctly softer modeling of the facial features, as though the artist were attempting to reproduce Leonardo's *sfumato* in the medium of portrait sculpture. It was this type of female bust that reawakened interest in Laurana around the turn of this century. The Palermo museum acquired their example from the Cloister of Santa Maria del Bosco di Calatamauro in 1887. Patera (1965; 1980) attempted to prove that it is not a likeness of Isabella but rather a posthumous idealized portrait of Eleonora of Aragon. The latter, who died in 1405, was a benefactress of the Cloister of Santa Maria del Bosco and the wife of the Sicilian vice-regent Guglielmo Peralta. The bust stood above her tomb from at least the seventeenth century

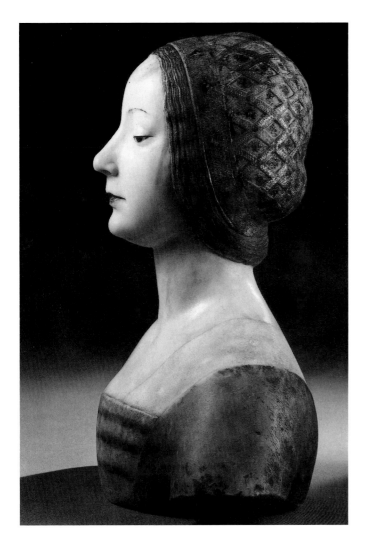

on; however, it is not certain that this was the case in the fifteenth century as well. The lady's youth and her style, altogether in accordance with that of the late Quattrocento, suggest that this is not a posthumous tomb portrait.

57 Francesco Laurana. *Bust of Isabella of Aragon (?).* Kunsthistorisches Museum, Vienna

58 Francesco Laurana. *Bust of Isabella of Aragon (?).* Galleria Regionale della Sicilia, Palermo

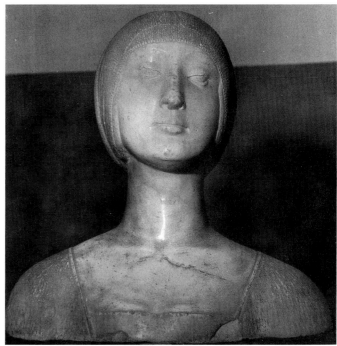

Paolo Romano
(c. 1415–1470)

Paolo di Mariano Tacconi, better known as Paolo Romano, was probably born in Sezze about 1415. The first documentary reference to him is from 1451, at which time he was doing stonemason's work on the Palazzo del Senatore in Rome and collaborating on the construction of two chapels next to the Ponte Sant'Angelo. For the next nine years there is no mention of his being in Rome. More likely he spent the time in Naples, where he is documented in 1453 and 1458 and worked with the team of sculptors engaged on the Triumphal Arch of Alfonso I of Aragon. According to Kruft and Malmanger ("Triumphbogen," 1975), his chief contributions to that monument are the sculptures in the spandrels of the upper arcade and the gable crowning the entire structure (fig. 59).

Between 1460 and 1467 there are again ample documents attesting to Paolo's activity back in Rome. He was engaged in both simple stonemasonry and figural sculpture. During the

pontificate of Pius II, he was the favored sculptor of the papal court. In the early 1460s he played a decisive role in the redesign, initiated by Pope Pius II, of the steps and atrium façade of Old St. Peter's. In 1460–61 he received payment for stone work on the stairs, while in 1461–62 he was paid for the statues of the apostles Peter and Paul that once flanked the bottom step (replaced by new figures in 1847) as well as two portraits of Sigismondo Malatesta that have been destroyed. In 1462–63 he created the statue of St. Andrew for the tabernacle on the Ponte Molle, and in 1463 the bust of Pius II that is now in the Borgia Apartment. In the years 1463–64 it is clear that Paolo collaborated on the benediction loggia of Pius II. In these same years he created still another statue of St. Paul that was also placed in front of St. Peter's, and together with Isaia da Pisa he produced the St. Andrew ciborium for the basilica, of which three lunette reliefs in the Vatican grottoes are all that survive.

In 1465 Paolo contracted to produce a marble tabernacle for San Lorenzo in Damaso. According to Caglioti (1988–89), that work survives in the parish church in Monteflavio Sabina. For the same church, in 1467, he created the tomb for Cardinal Scarampi, now lost. Another work documented as his is the left-hand angel in the tympanum of the main portal of San Giacomo degli Spagnoli. It appears that he is to be credited as well with the design, and possibly some of the execution, of the Tomb of Pope Pius II, now in Sant'Andrea della Valle (fig. 67). On March 29, 1470, Paolo made his will. It is presumed that he died later in that same year.

Vasari [1550, 1568]; Müntz 1878–82; Bertolotti 1881; Leonardi 1900; Corbo 1966; Seymour 1966; Rubinstein 1967; Corbo 1973; Kruft and Malmanger, "Triumphbogen," 1975; Caglioti 1988–89.

226
St. Paul

1463–64. Marble. Ponte Sant'Angelo, Rome

Payments were made to Paolo Romano for this statue of St. Paul from July 1463 to February 1464. The documents repeatedly state that the work was to stand on the top step in front of St. Peter's, but they do not specify its location more precisely. Pope Clement VII had the figure moved to the Ponte Sant'Angelo, where a companion figure of St. Peter by Lorenzo Lotti was placed across from it. Paolo's St. Paul, which is also identified as his by Vasari (1550), is one of his best surviving works, although the right hand and the sword have been restored.

Paolo reveals himself to be considerably more assured in his composition of this statue, in its ponderation and proportions, than in his figures of the two Apostles from two years before. Those earlier works had been placed at the bottom of the steps leading up to the basilica and are now in the Vatican Palace. Paolo's figures for the steps of St. Peter's were the first monumental freestanding statues all'antica to be commissioned in the

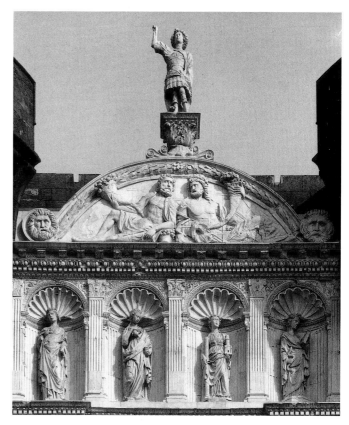

59 Triumphal Arch of Alfonso I (top). Castelnuovo, Naples

Quattrocento, and in this second attempt at a St. Paul he solves the problem far more satisfactorily than before. His St. Andrew from 1462–63 was already a considerable advance in this regard. Nevertheless, even this St. Paul from the Ponte Sant'Angelo reveals an almost slavish imitation of antiquity, a tendency of Paolo's work in general and one that is especially apparent in his handling of drapery.

Giovanni Dalmata
(c. 1440–after 1509)

Giovanni Dalmata (Ivan Duknović) was born in Traù about 1440. He created his most important works in Rome, where he first appeared in the 1460s and was possibly employed in the workshop of Paolo Romano. Since 1901 (Fabriczy), it has been thought that his earliest work is the coat of arms of Pope Pius II in the courtyard of the Maresciallo in the Vatican (dated 1460); however, it is likely that this is a mistaken attribution. In the second half of the 1460s, Dalmata collaborated on the tomb for Cardinal Tebaldi (d. 1466) in Santa Maria sopra Minerva, his most notable contribution being the figure of the cardinal himself. In 1469 he was contracted to create the Altar of the

"Madonna della Palla" in Norcia. At about this same time he produced the figural decoration for the main portal of San Giacomo in Vicovaro and the Madonna in the Vatican grottoes. In the mid-1470s Dalmata collaborated with Mino da Fiesole on the Tomb of Pope Paul II, and in these same years — also together with Mino — he created the wall tabernacle for San Marco as a commission from Cardinal Barbo. Among his other chief works from his Roman years are the Tomb of Cardinal Roverella (d. 1476) in San Clemente and the Tomb of Cardinal Eroli (d. 1479), which once stood in St. Peter's and now survives only in fragments.

Dalmata left Rome about 1480, having been invited by King Matthias Corvinus to work at the court of Hungary. It is possible that before taking up that post, he completed the signed statue of St. John the Evangelist in the Orsini Chapel of the cathedral in Traù. Very few of the works he created in Hungary survive—at least there are few that can reasonably be attributed to him. There is a severely damaged *Madonna* relief from Diósgyór in the National Gallery in Budapest and the fragment of a fountain in Visegrád. Dalmata is known to have been back in Traù in 1497. In 1498 he was in Venice, where he worked on the altar of the Scuola Grande di San Marco. Other works ascribed to him from this period are a *Madonna* relief in the Museo Civico in Padua and a bust of Carlo Zen in the Museo Correr in Venice. The sculptor was in Traù once again in 1503, at which time he produced the statue of St. Thomas for the Orsini Chapel in the cathedral. In 1509 he was commissioned to create the tomb for Beato Girolamo Giannelli in the cathedral in Ancona. This is the last mention of him in contemporary documents. It is not known just when he died.

Tschudi 1883; Fabriczy 1901; Meller 1947; Prijatelj 1957; Pope-Hennessy 1958 (1985); Prijatelj 1959; Balogh 1960; Seymour 1966; Fisković 1967; Fisković 1971–72; Cordella 1981; Cordella, "Aggiunta," 1982; Cordella, "Madonna," 1982; *Matthias Corvinus* 1982; Zander 1982–84; Cordella 1984; Röll 1990.

227, 228; figs. 60–62
Reliefs from the Tomb of Pope Paul II

c. 1475–77. *Hope.* Marble, 52 × 30¼″ (132 × 77 cm.); *Creation of Eve.* Marble, 52 × 32¼″ (132 × 82 cm.). St. Peter's, Rome (now in the Fabbrica di San Pietro)

Pope Paul II died on July 26, 1471. His tomb, which originally stood against the south wall of Old St. Peter's, was first taken apart in 1506. It was set up again in 1547, then dismantled a second time and moved down into the Vatican grottoes in 1606. Currently its separate parts—with the exception of the base, which is in the Louvre—are in the Fabbrica di San Pietro, where they are being restored. Zander (1982–84) has supplied a laudable proposal for its reconstruction based on a drawing in the Kupferstichkabinett in Berlin (fig. 62), which was discovered by De Nicola (1908) and attributed by Hülsen (1933) to Giovanni Antonio Dosio. In that drawing one can still read the inscription that once adorned the base: MARCUS BARBUS CAR. S. MARCI PATRIARCHA AQUILEIEN CONSANGUINEO B. M. AN SAL. MCCCCLXXVII. Thus it is clear that the monument, commissioned by the pope's nephew Cardinal Marco Barbo, was completed six years after the pontiff's death.

None of the tomb monuments to popes or prelates erected in Rome up to this time could compare with this one in size,

60 Giovanni Dalmata. Sarcophagus with figure of the pope from the Tomb of Pope Paul II. St. Peter's, Rome (now in the Fabbrica di San Pietro)

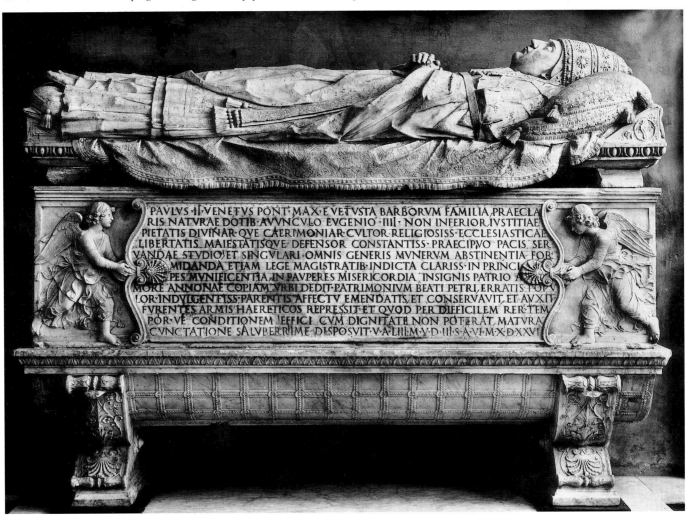

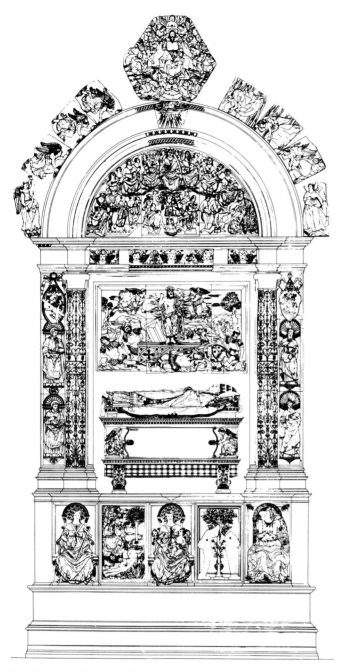

61 Giovanni Dalmata and Mino da Fiesole. Tomb of Pope Paul II.
Reconstruction according to Zander (1982–84)

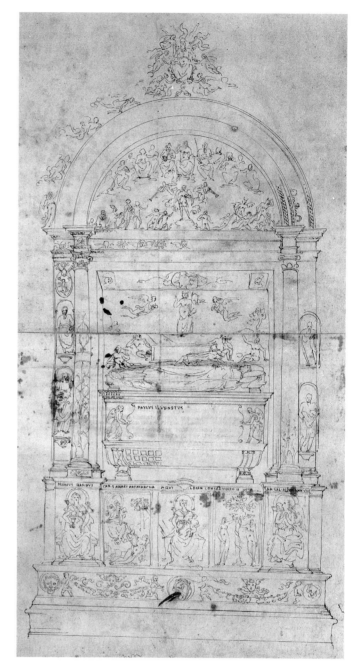

62 G. A. Dosio (?). Drawing of the Tomb of Pope Paul II in St. Peter's.
Kupferstichkabinett, Berlin

splendor, or richness of figural ornament. The base is adorned with putti holding garlands between medallions containing lions' heads and the papal coat of arms. Above this was an upper pedestal story presenting five reliefs. From the left they depict Faith, the Creation of Eve, Charity, the Fall, and Hope. The niche containing the sarcophagus had a double frame, for in front of the outer pillars adorned with statues of the Evangelists and the pope's coats of arms stood a pair of richly ornamented columns. According to Röll (1990), these were spoils from antiquity. A double round arch completed the monument's frame. A relief of the Last Judgment filled the tympanum, and at the very top, surrounded by adoring angels, was a *God the Father*

giving benediction. In the niche just above the sarcophagus was a *Resurrection* relief.

Vasari (1550) relates that the commission was actually given to Mino da Fiesole. The *Charity* relief is, in fact, signed OPUS MINI (plate 211); however, the relief of Hope (plate 227) has the signature [I]OANNIS DALMATAE OPUS. Thus it is clear that Giovanni Dalmata was a major collaborator on the work. Based on these two signed reliefs, it is possible to attribute to Mino—in addition to the *Charity*—the *Faith*, the left half of the base, the relief of the Fall, the Evangelists Luke and John in the bottom two niches, the *Last Judgment*, the putto frieze on the entablature, and the adoring angels above the left side of the arch.

439

Dalmata's contribution—aside from the *Hope* relief—consisted of the right half of the base, the *Creation of Eve* (plate 228), the sarcophagus and effigy of Pope Paul II (fig. 60), the Evangelists Matthew and Mark in the two upper niches, the *Resurrection* relief, the *God the Father* above the arch, and the right-hand adoring angels.

There is no compelling reason to attribute the overall design of the work to Mino rather than to Dalmata. On the contrary, its richly orchestrated, yet clear, architectonic arrangement is too unlike those of the monuments Mino had created in Florence. The only aspect of the work that seems specifically characteristic of Mino is the detail of the bier supporting the sarcophagus. The large inscription panel, by contrast, is much more in the Roman style of the time than in the Florentine. The same can be said of the framing pilasters adorned with figural niches and the rich relief ornament. As for the subject matter of the reliefs, it is unusual to find depictions of the Resurrection of Christ and the Last Judgment on monuments such as this even in Rome, and one must assume that these were expressly requested by the cardinal when he commissioned the work (Röll 1990).

229; fig. 63
Tomb of Cardinal Roverella

After 1476. Marble. San Clemente, Rome

Cardinal Bartolomeo Roverella died in 1476. His tomb in the right-hand aisle of San Clemente—like the Tomb of Pope Paul II and the former wall tabernacle in San Marco—was another collaborative effort involving Giovanni Dalmata. Such joint endeavors were typical in the sculpture of Rome in the second half of the fifteenth century. In this case Dalmata's partner was Andrea Bregno, who was probably responsible for its overall design. The monument differs from the tombs of other Roman prelates of the period in that a tall, wide, and shallow-vaulted niche rises above the sarcophagus between the pilasters. Another motif uncommon in tomb monuments of the time is the half-figure of God giving his blessing in the calotte. This figure is much larger than the others, and one wonders if this relief was not originally intended for some other setting. It is unquestionably the work of Dalmata, as are the *Madonna and Child* and the two angels flanking the sarcophagus. All of the rest was executed by Bregno and his assistants. A relief to the left of the *Madonna* depicts St. Peter commending the cardinal to her, while the one

63 Giovanni Dalmata and Andrea Bregno. Tomb of Cardinal Roverella. San Clemente, Rome

on the right shows St. Paul. That votive relief and the lamenting putti holding coats of arms on the base link this work to the Tomb of Pietro Riario in Santi Apostoli (fig. 66).

Andrea Bregno
(1418–1503)

Andrea Bregno was born in 1418 in Osteno, near Como. He settled in Rome in the 1460s. Nothing certain is known of his career prior to that time. His earliest Roman works are thought to be the votive relief for the Tomb of Nikolaus von Kues (d. 1464) in San Pietro in Vincoli and the Tomb of Cardinal d'Albret (d. 1465) in Santa Maria in Aracoeli. However, his only signed works are the marble tabernacle in Santa Maria del Popolo from

1473 and the Piccolomini Altar in the Duomo in Siena from 1481–85. From these documented works it is possible to infer that a considerable number of tombs of Roman prelates originated in Bregno's workshop in the 1470s and 1480s. Together with Giovanni Dalmata he created the Tomb of Cardinal Roverella (d. 1476) in San Clemente (fig. 63), and with Mino da Fiesole the Tomb of Cardinal Pietro Riario (d. 1474) in Santi

Apostoli. After Giovanni Dalmata and Mino da Fiesole had left the city about 1480, Bregno was clearly the leading sculptor in Rome. Other tomb monuments from this time attributed either to him or to his workshop are those of Giovanni de Coca (d. 1477) in Santa Maria sopra Minerva, Raffaello della Rovere (d. 1477) in Santi Apostoli, Cardinal Ferricci (d. 1478) in Santa Maria sopra Minerva, and Cardinal Cristoforo della Rovere (d. 1478) and Cardinal Pietro Guglielmo Rocca (d. 1482), both in Santa Maria del Popolo.

We know that in 1486, 1487, and 1498 he worked on the tombs of Bishops Paradinas and Fuendalida, formerly in San Giacomo degli Spagnoli and now in Santa Maria in Monserrato. In 1490 he was commissioned to produce the high altar of Santa Maria della Quercia near Viterbo, and in 1500 the sacrament tabernacle in Santa Maria del Popolo, the latter of which no longer survives. After 1495 the Tomb of Cardinal Savelli in Santa Maria in Aracoeli was executed in his workshop, and in 1498 he is mentioned in connection with works on the Palazzo della Cancelleria in Rome.

Raphael's father, Giovanni Santi, praised Bregno in his rhymed chronicle as "*sì gran compositore cum bellezza,*" and in a letter of May 15, 1481, to Lorenzo the Magnificent designated him "*sculptor egregius.*" Bregno was a collector of antiquities and at one time was the owner of the *Torso Belvedere* (see Egger 1927 and Maddalo 1989). His thorough knowledge of classical art was distinctly evident in his work, which was distinguished not so much for its artistic originality as for its decorative elegance and quality of execution. Bregno died in September 1503 and was buried in Santa Maria sopra Minerva. The tombstone erected to him in 1506, complete with a portrait bust, is still preserved.

Schmarsow 1883; Steinmann 1899; Schmidt 1906; Davies 1910; Lavagnino 1924; Pope-Hennessy 1958 (1985); Battisti 1959; Seymour 1966; Sciolla, "Bregno," 1970; Cellini 1981; Strinati 1981; Cetti 1982; Maddalo 1989.

64 Andrea Bregno. Former High Altar Tabernacle. Sacristy, Santa Maria del Popolo, Rome

LEFT: 65 Tabernacle of the Sacrament. San Gregorio Magno, Rome

230; figs. 64, 65
Tabernacle

c. 1473. Marble. Sacristy, Santa Maria del Popolo, Rome (formerly on the high altar)

This tabernacle (fig. 64), commissioned for the high altar of Santa Maria del Popolo by Cardinal Rodrigo Borgia, was intended to serve as a monumental frame for a highly revered painting of the Madonna given to the church by Pope Gregory IX in 1231. It was replaced by the present altar structure in 1627 and moved to the sacristy of the church. An inscription on its gable relates that on October 18, 1473, while Bregno was engaged on the tabernacle, his seven-year-old son was killed in an accident.

In its overall design, the tabernacle is patterned after Roman tomb monuments of the 1460s and 1470s. Its base, with an

Borgia coat of arms on either side, was presumably not originally part of the structure. The same is true of the Rovere cardinal's coat of arms on the gable. In the niches of the frame are statues of St. Jerome (upper left), St. Peter (lower left), St. Augustine (upper right), and St. Paul (lower right). Above the round arch are angels posed in adoration of the image of the Madonna.

If one compares this work with the wall tabernacle in San Gregorio Magno, dated 1469 (fig. 65), one sees quite clearly the change that took place in Roman sculpture in these years. The tabernacle in Santa Maria del Popolo is not only more unified in its overall design and more graceful in its decor; it also reveals a greater homogeneity in the proportions of its figures and their relation to the niches provided them. Its uncommonly varied ornaments are no longer limited to plant motifs and already show the influence of the architectural sculpture from the Palazzo Ducale in Urbino.

231; figs. 66, 67
Tomb of Cardinal Pietro Riario

c. 1474. Marble, 21′3¾″ × 11′2¼″ (650 × 340 cm.). Santi Apostoli, Rome

Pietro Riario, a Franciscan and the cardinal of San Sisto, died at the age of twenty-eight on January 5, 1474. It is presumed that his uncle, Pope Sixtus IV, commissioned the cardinal's tomb monument (fig. 66) for the choir of Santi Apostoli immediately after his death. The design of this tomb is similar in large part to that of Pope Pius II (fig. 67). Its framing pillars are more successfully unified into the whole, and here the figures in the niches are no longer allegories of the Virtues. Instead, as was the

66 Andrea Bregno and Mino da Fiesole. Tomb of Cardinal Pietro Riario. Santi Apostoli, Rome

67 Tomb of Pope Pius II. Sant'Andrea della Valle, Rome

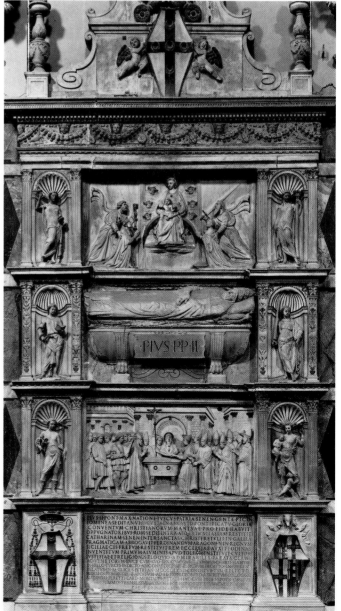

case on the D'Albret tomb, we are here presented with saints: on the left St. Francis and St. Louis of Toulouse, on the right St. Anthony and St. Bernardine. The gable at the top encloses a large medallion with the coat of arms of Sixtus IV. The shields with the cardinal's own coat of arms are supported by lamenting putti on the base; similar figures appear on the later Roverella tomb in San Clemente (fig. 63).

The sarcophagus is supported by three sphinxes facing forward and is ornamented on the front with dancing putti, garlands, and heads of Medusas. On the back wall above the sarcophagus is an enthroned *Madonna and Child*. On the left, St. Peter commends the deceased to her, and on the right St. Paul is presenting his brother Girolamo. These flanking reliefs were obviously inspired by the votive reliefs on the Tomb of Pope Pius II. One cannot help but notice the similarity, in both motif and

style, to the corresponding figures on the Roverella tomb or the niche figures on the tabernacle in Santa Maria del Popolo. Unusual ornamental features are the broad chalice-shaped volute capitals—based on classical capitals from Castel Sant'Angelo—and the frieze adorned with cornucopias, leaf masks, and palmettes on the upper entablature, which bears a distinct resemblance to the Urbino style.

The execution of the monument is uneven, yet it is likely that Bregno was responsible for its overall design and the majority of its carving. The *Madonna*, however, whose proportions, drapery, and facial expression are unlike those of the other figures, has always been believed to be the work of Mino da Fiesole, with whom Andrea Bregno frequently collaborated in Rome. Mino has also been credited by some scholars with the sphinxes on the sarcophagus (Steinmann 1899).

Antonio Rizzo
(1430/40–c. 1499)

Antonio Rizzo, the most important Venetian sculptor of the fifteenth century, was born about 1430/40, probably in Verona. His father was presumably Giovanni Rizzo, a stonecutter and marble dealer originally from either Milan or Como. Even before 1464 Antonio Rizzo is celebrated as a sculptor in two epigrams by Gregorio Correr. His earliest works are the altars in San Marco in Venice, commissioned about 1464 and completed in 1469. In 1474 and 1478–79 he took part in the defense of Scutari against the Turks, but in the interim, in 1476, he executed a spiral stair and marble pulpit, after designs by Gentile Bellini, for the chapterhouse of the Scuola Grande di San Marco (destroyed by fire in 1485). Among the works attributed to him—although these attributions have been increasingly disputed of late (Pohlandt 1971; Schulz 1983; Huse and Wolters 1986)—are the Tomb of Vittore Cappello (d. 1467) in Santa Elena in Isola, the Tomb of Giovanni Emo (d. 1483), formerly in Santa Maria dei Servi and preserved only in fragments, and the tomb of the doges Marco and Agostino Barbarigo (d. 1486 and 1501, respectively), which once stood in Santa Maria della Carità. Of this last, only a few reliefs and the figure of Agostino Barbarigo are preserved in the sacristy of Santa Maria della Salute.

One work that is unquestionably Rizzo's is the Tomb of Doge Niccolò Tron in Santa Maria dei Frari, created between 1476 and 1480. In 1483 Rizzo was engaged on various projects in the Palazzo Ducale, apparently including the Arco Foscari. At about this time, presumably, he created the figures of Adam and Eve, his most important statues and the only ones signed by him. In 1484 he was named Protomagister of the ducal palace. His most important achievement in that role was the construction of the Scala de' Giganti. In 1498 he was found guilty of embezzling funds intended for construction work on the Palazzo Ducale and was forced to flee Venice. He first went to Cesena, where he is known to have been as late as February 1499, and subsequently

resided in Ferrara. The last documentary mention of him is from May 4, 1499. It is not known just when or where he died, although he had been celebrated by his contemporaries more than any other Venetian sculptor of the fifteenth century.

Sansovino 1581: Paoletti 1893; Rambaldi 1910; Planiscig 1921; Planiscig 1926; Mariacher 1948; Mariacher 1950; Arslan 1953; Pope-Hennessy 1958 (1985); Romanini 1964; Franzoi 1965; Munman 1968; Pincus 1969; Munman 1971; Pohlandt 1971; Munman 1973; Pincus 1976; Munman, "Rizzo," 1977; Pincus 1981; Schulz 1981; Schulz 1983; Huse and Wolters 1986.

232; fig. 68
Altar of St. Paul

c. 1464–69. Marble, 12'3¼" × 5'6⅞" (374 × 170 cm.).
San Marco, Venice

The Altar of St. Paul, together with ones for St. James and St. Clement, was donated by Doge Cristoforo Moro, presumably in 1464 or, at the earliest, in 1462. Rizzo was given a final payment for all three altars on June 28, 1469. The St. Paul and St. James altars in the north and south transepts of San Marco are similar in design and decor. The Altar of St. Paul (fig. 68), by contrast, is of considerably higher quality and, moreover, includes a relief scene of the conversion of Saul below the statue of the saint. These altars constitute the first appearance of pure Early Renaissance forms in fifteenth-century Venetian sculpture. Up until this time Venice had continued to favor multipaneled retables in the Late Gothic style, but these are here replaced by an aedicula of the Florentine type, with a large niche containing a figure in the center, classical framing architecture, and figures crowning the whole.

In the statue of St. Paul, with its drapery clinging to the body and forming ridgelike folds, Rizzo reveals an indebtedness to

Mantegna. The open book the saint is absorbed in is also a motif from Mantegna. The aedicula's decor is extremely delicate and varied and quite similar to that of Desiderio da Settignano's tabernacle for San Lorenzo in Florence from 1461 (plate 204; Schulz 1983). This is especially true of the capitals and double vines of the pilasters. Florentine influence is also apparent in the *Saul* relief, where one sees the sculptor making use of the possibilities of Donatello's *rilievo schiacciato*, although somewhat heavy-handedly.

68 Rizzo. Altar of St. Paul. San Marco, Venice

233; fig. 69
Tomb of Doge Niccolò Tron

1476–79. White and colored marble, limestone, partially gilt and painted; statue, 74½″ high (189.8 cm.). Santa Maria dei Frari, Venice

Niccolò Tron died on July 28, 1473. His son Filippo, who commissioned his tomb, was given permission on April 17, 1476, to erect the monument on the left wall of the choir in the Frari church. At that time nothing had yet been done on the work itself. However, it was completed at the latest in the spring of 1480, probably even by the end of 1479. The monument is attributed to Rizzo and his workshop on the basis of its style.

The Tron monument, which takes up almost the entire left wall of the choir (fig. 69), is not only immense; it also represents a new type of Renaissance tomb monument for Venice. No longer based on Florentine models, it derives chiefly from Roman papal tombs such as those of Pope Pius II (fig. 67) and Pope Paul II (fig. 61). A structure of four distinct stories, with projecting pillars fitted out with niches, towers above a tall base. The side pillars combine with a round arch at the top to create one huge niche in which the sarcophagus seems somewhat lost. Niches containing figures appear not only on the pillars but also as the dominant elements on the top and bottom stories. This abundance of niches is in the Venetian tradition, but their configuration, at least, is similar to that of Roman tomb monuments. However, everything in the way of foliage decor has been confined to the bottom story, the architectonic elements of which are distinguished in other ways as well from the lighter forms of the upper levels.

The figure of the doge (plate 233) in the center arcade of this bottom story is clearly emphasized by its larger size, central placement, splendid robes, and immediate proximity to the viewer. It is flanked on the left by a figure of Prudence, on the right by one of Charity. The second story presents an inscription framed by pairs of putti. Above this comes the sarcophagus, with an effigy of the deceased, and personifications of Peace, Abundance, and Security (Schulz 1983). The niches of the framing pillars and the top story are filled with armed warriors and female allegories clearly representative of the Arts and the Virtues. Inside the arch Christ is seen rising up from his tomb, while the Angel of the Annunciation and the Virgin stand on either side. Above the crown of the arch is a depiction of God the Father giving benediction. The painted curtain that fills the remaining surface of the choir wall is also part of the monument.

Scholars are divided over the degree to which Rizzo borrowed from Pietro Lombardo in creating this design, specifically from Lombardo's tomb for the doge Pietro Mocenigo (see fig. 70). To judge from the similar multistoried architecture, it would appear that Rizzo patterned his work after Roman tomb monuments and that it was he who influenced Lombardo, whose architectural design is more varied and centered. The execution of the monument's individual elements is of extremely uneven quality. The best works are unquestionably the three marble statues, most likely created by Rizzo himself, in the bottom arcades. The statue of the doge is characterized by a lapidary simplicity of outline and strikingly individualized facial features. In the female figures, by contrast, the emphasis is on the flow of movement beneath their lightweight drapery. The placement of a

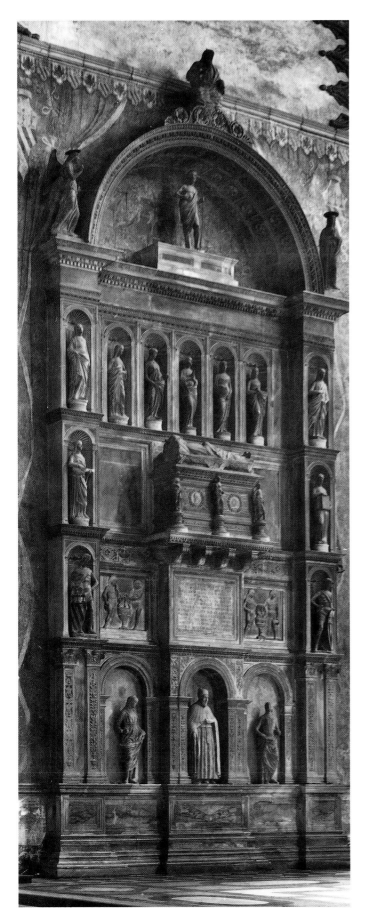

69 Rizzo. Tomb of Doge Niccolò Tron. Santa Maria dei Frari, Venice

statue of the deceased in the center of the monument is an obvious parallel to the Tomb of Pietro Mocenigo; however, since as early as the fourteenth century it was not uncommon in Italy to combine a tomb monument with a secular one.

234, 235
Adam and Eve

c. 1483. Marble, 85″ high (216 cm.); 84¼″ high (214 cm.). Palazzo Ducale, Venice

These two statues were originally placed against the east side of the Arco Foscari in the Doges' Palace, to the left and right of the arch, where bronze copies now stand. In large letters on the base of the Eve is the signature ANTONIO RIZO. It is unclear just when Rizzo created these statues, whether before the death in 1471 of Doge Cristoforo Moro, under whom the architecture on the east side of the Arco Foscari was completed, or at a later date. The latest they could have been executed is 1485–86, as there is already a mention of them from about that time. Most recent scholarship has strongly favored a date of before 1471 (Pohlandt 1971; Schulz 1983). Sometime after 1480 seems more likely, however, that is to say after the completion of the Tron monument.

No other sculptor of the Early Renaissance had been given the chance to create two larger-than-lifesize nude figures such as these, and clearly Rizzo recognized the uniqueness of his opportunity and made the most of it. These statues represent the high point of his career, and even during his lifetime they were widely celebrated. The figure of Eve, whose right hand has been restored, is based on the classical type of the *Venus pudica*, such as the famous *Medici Venus* in the Uffizi. While *Eve* is very self-contained, *Adam*, by contrast, is filled with lively movement. His head tilts back, his lips are parted in speaking, and his right hand is raised to his chest in emphatic protestation of his innocence. At the same time his left hand clutches the forbidden fruit. Although the two figures are different in their characterization, they form a pair due to their sure sense of design and the clear articulation of their bodies. The modeling of their anatomy is precise, their gestures clear and forceful, and the conception of both as freestanding sculptures is virtually complete, even though they were intended to stand in niches.

Although Rizzo may well have been influenced by Pollaiuolo (Schulz 1983), it is unlikely that this could have happened as early as 1470, as it would be too close to the date of the San Marco altars. Even a comparison with the statues of Prudence and Charity (fig. 69) from the Tron monument reveals that the sculptor had not yet attained this degree of freedom of movement and masterful ponderation, although the *Prudence* comes closer to it than the *Charity*. As for his artistic connections to Mantegna, which have also been rightly stressed in this context, these too suggest a later date for Rizzo's two figures. Both in its proportions (for example the relation between the head and the shoulders) and its subtle anatomical modeling, the figure of Adam is not as close to Mantegna's painting of St. Sebastian in Vienna's Kunsthistorisches Museum, from about 1470, as to the later version in the Louvre in Paris.

Pietro Lombardo
(c. 1435–1515)

Pietro Lombardo, the most important sculptor from the Early Renaissance in Venice, after Rizzo, was born in Carona on Lake Lugano about 1435. In 1462–63 he was engaged on San Petronio in Bologna. It is likely that he had formerly worked in Florence, for his first documented sculpture, the tomb monument to Antonio Roselli in the Santo in Padua, would seem to suggest as much. He stayed in Padua from 1464 to 1468. From 1474 on at the latest he took up residence in Venice, where he came to be extremely active as a sculptor and architect and as the director of a large workshop.

Beginning in 1471 he collaborated on the construction of the choir chapel of San Giobbe. After 1474, probably only at the beginning of the 1480s, he created the tomb monument to Doge Niccolò Marcello (formerly in Santa Marina, now in Santi Giovanni e Paolo), and between 1476 and 1481 the one to Doge Pietro Mocenigo in Santi Giovanni e Paolo. In the 1480s Pietro Lombardo assumed the supervision of the ornaments for the main courtyard of the Scuola di San Giovanni as well as the building and ornamentation of the churches of Santa Maria de' Miracoli and Sant'Andrea della Certosa.

In 1482, at the behest of the *podestà* (mayor) of Ravenna, Bernardo Bembo, he carved a relief for the Dante monument in that city and shortly afterward the tomb for Jacopo Marcello (d. 1484) in Santa Maria dei Frari. In 1485 he was entrusted with the tomb for Bishop Giovanni Zanetti and the completion of the choir chapel and cupola for the Duomo in Treviso. In 1488–90 he worked with his sons Tullio and Antonio and with Giovanni Buora on the Scuola Grande di San Marco. From 1499 on he served as the chief architect of the Doges' Palace, succeeding Rizzo in that capacity. In his last years, Pietro limited himself to planning and overseeing various building projects in Mantua, Treviso, and Venice. He died in June 1515.

Paoletti 1893; Moschetti 1913–14; Planiscig 1921; Paoletti 1929; Mariacher 1955; Pope-Hennessy 1958 (1985); Zorzi 1959–64; Beck 1967–68; Munman 1968; Brand 1977; Munman, "Lombardo," 1977; Schulz, "Giustiniani Chapel," 1977; McAndrew 1980; Schulz 1981; Huse and Wolters 1986.

236
Tomb of Doge Pasquale Malipiero

c. 1470. Limestone and marble, 27′10½″ × 13′1⅜″ (850 × 400 cm.). Santi Giovanni e Paolo, Venice

Pasquale Malipiero died in 1462. Scholars attribute his tomb monument to Pietro Lombardo solely on the basis of its style. There is some disagreement, however, about the dating of this tomb, the first Venetian monument executed solely in Renaissance forms. It is unclear whether it was created before 1464 or after 1467, that is, before or after the Roselli monument in Padua.

In its architecture, the Malipiero monument is largely indebted to Florentine wall tombs such as those of Leonardo Bruni and Carlo Marsuppini. The winged shell below the sarcophagus is a borrowing from the latter. The placement of the aedicula atop consoles is a Venetian tradition, but there is also a parallel in Donatello's Cavalcanti tabernacle. Also traditional to Venice is the tentlike baldachin sheltering the sarcophagus and effigy,

although it is odd that it was retained here inside the aedicula. Other non-Florentine features are the motif of the Pietà in the monument's lunette, the half-figures ending in leafy vines on the base, and the delicacy of the botanical decor throughout. The architectural design and its decorative details are similar to those of the portal and choir of San Giobbe, on which Pietro Lombardo and his workshop were engaged beginning in 1471. The female figures flanking the gable represent Charity or Abundance (left), Justice (center), and Faith or Peace (right).

70 Pietro Lombardo. Tomb of Doge Pietro Mocenigo. Santi Giovanni e Paolo, Venice

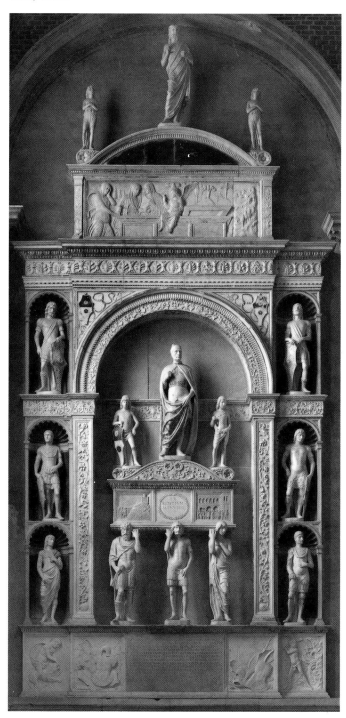

237–39; fig. 70
Tomb of Doge Pietro Mocenigo

1476–81. Limestone and marble, partially gilt and polychromed, 49′2″ high (1500 cm.). Santi Giovanni e Paolo, Venice

Pietro Mocenigo died on February 23, 1476. His tomb, commissioned by his heirs Niccolò and Giovanni, was presumably completed in 1481. Thus it was created during the same years as the Tomb of Niccolò Tron in the Frari church, and like that work it reveals a considerable increase in size and splendor over earlier Venetian tomb monuments. It also employs a similar architectural scheme, although one more artfully designed (fig. 70). The large center niche is emphasized by an imitation arcade. Above it is an attic containing a relief depicting the three women at Christ's tomb and a segment gable crowned by a figure of the resurrected Christ and two angels. The Christ figure was originally flanked by the statues of St. Mark and St. Theodore (?) that now stand to the side of the church's main portal, next to the monument to Alvise Mocenigo. A large inscription on the base is framed by trophies and depictions of two of the labors of Hercules, the slayings of the Nemean lion and the Hydra.

The six niches flanking the central arch contain statues of warriors or emperors, some of them wearing laurel wreaths or crowns, while in the center arch three additional warriors carry the sarcophagus on their shoulders. The doge is not laid out as a corpse above the sarcophagus, as was the custom, but rather stands above it in a pose of stern command, accompanied by a coat of arms and insignia bearers. He is dressed in splendid armor, and presumably his right hand once held a flag. It is possible that this standing figure was modeled after the one on the older monument to the Venetian admiral Vittore Pisani (d. 1380) in Santi Giovanni e Paolo. The reliefs on the front of Mocenigo's sarcophagus present two of the doge's military successes, on the left the entry into Scutari, on the right the transfer of the keys of Famagusta to Caterina Cornaro, which confirmed her as queen of Cyprus.

The execution of the individual parts of the monument is varied but of uniformly high quality. The decor is extremely delicate. New for Pietro, and apparently attributable to the influence of Rizzo, are the distinct physicality of the niche and the sarcophagus bearers, the movement in their varied stances, and the way their drapery appears to be both transparent and crumpled—an effect especially striking in the righthand figure.

The inscription EX HOSTIUM MANUBIIS in the center of the sarcophagus implies that the monument was erected with funds from war booty. The work is predominantly a triumphal monument celebrating the doge's military exploits. In its dimensions and its architecture it is obviously patterned after the Tron monument, while the standing figure of the doge was prefigured in older tombs for generals and condottieri. The only monument presenting a comparable blend of Christian and pagan pictorial motifs, however, is the Tomb of Bartolommeo Colleoni in Bergamo (plate 242), completed in 1476. A pilgrim named Faber, from Ulm, has left a description of the doges' tombs in Santi Giovanni e Paolo from about 1490 (see Huse and Wolters 1986), and from it we have some idea of the mixed emotions they aroused in contemporary viewers.

Amadeo
(c. 1447–1522)

Giovanni Antonio de' Amadei, the most important Lombard sculptor of the Early Renaissance, was born in Pavia about 1447. The most striking feature of his work is his virtuosic decor, which at times exhibits a formal variety verging on the bizarre. He is first documented as a sculptor—we must pass over his equally extensive activities as an architect—in 1466–67. In these years he received payments for works in the large cloister of the Certosa di Pavia and created the signed portal in the Certosa's front cloister, the most important sculptural monument of his early period. Other works ascribed to his early years are the terra-cotta lavabo in the same cloister, the relief of the Coronation of the Virgin on the lavabo of Santa Maria del Carmine in Pavia, and the small relief of a Madonna of Humility in the Misericordia in Florence (Middeldorf 1956).

In the years after 1470 he constructed the Colleoni Chapel in Bergamo, an achievement that brought him such renown that after the mid-1470s he was deluged with commissions. In August 1474 he and the Mantegazza brothers were entrusted with the sculptural ornamentation of the Certosa façade. In the 1480s, a time when Amadeo's works were greatly influenced by the Mantegazzas, he produced for San Lorenzo and for the Duomo in Cremona the shrines of Sts. Marius, Martha, Audifax, and Habakkuk (1484), St. Himerius (1481–84), and St. Orialdus. Only individual reliefs from these works are preserved, all of them in the Duomo in Cremona. Amadeo's last major sculptural undertaking is the Shrine of San Lanfranco, completed about 1498, in the church of the same name in Pavia. In the following year he ceased work on the decoration of the Certosa façade, a project he had taken up again in 1491, and henceforth, until his death in 1522, he worked only as an architect and adviser on various building projects.

Calvi 1865; Magenta 1897; Meyer 1897–1900; Majocchi 1903; Malaguzzi Valeri 1904; Lehmann 1928; Dell'Acqua 1948; Arslan 1950; Middeldorf 1956; Pope-Hennessy 1958 (1985); Meli 1966; Meli 1970; Bernstein 1972; Piel 1975; Morschek 1978; Morschek 1984.

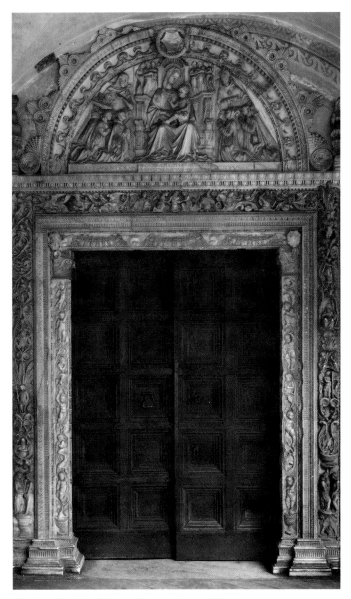

71 Amadeo. Portal, Front Cloister, Certosa di Pavia

portal's richly decorated frame, the sculptor intertwines plant and figural motifs. Putti climb up a grapevine on the pilasters of the inner frame, and David, as the conqueror of Goliath, is juxtaposed with Hercules, the slayer of Antaeus. The double vine of the outer frame shelters angels bearing the instruments of the Passion, an Annunciation, the symbols of the Evangelists, and—in the center of the lintel—a Christ as Man of Sorrows. The sculptor has not executed all the various sections of the frame in the same manner or with the same degree of quality. The decor of the outer frame seems especially old-fashioned, almost Late Gothic in feeling.

241
Tomb of Medea Colleoni

c. 1470–75. White and black marble. Colleoni Chapel, Bergamo

Medea, the daughter of Bartolommeo Colleoni, died at the age of sixteen on March 6, 1470. However, her tomb, as its inscription suggests, was only completed after the death of her father, that is about or shortly after 1475. Originally it stood in the Dominican Church of Santa Maria della Basella near Urgnano, and it was only in 1842 that it was moved to the Colleoni Chapel.

Richly decorated pilasters and a slender cornice serve to frame the niche sheltering the sarcophagus. Suspended from the cornice are the Colleoni family coat of arms and a curtain tied back at the sides. The sarcophagus stands on the heads of cherubim. Its front is divided by small pilasters into three panels, with the Colleoni coat of arms in the outer ones and in the center a relief of the Man of Sorrows. Across the base of the sarcophagus runs the signature IOVANES. ANTONIUS. DE AMADEIS. FECIT. HOC. OPUS.

The figure of the deceased is laid atop the sarcophagus. Above her, against the back wall of the niche—its facing of black and white tiles is from the nineteenth century—is an inscription panel in the form of a curling parchment. Above this panel, in flat relief, is a seated Madonna and Child, with a kneeling St. Catharine to the left and St. Clara to the right. The somewhat casual relationships between these figures is characteristic of Amadeo. Some of the decorative details in this work are still quite similar to those of the Certosa portal, and in the drapery of the three seated figures one sees the Gothic traces that characterize that earlier work. By contrast, the relief on the front of the sarcophagus, in which the Man of Sorrows reveals the wound in his side to flanking angels, seems altogether a work of the Early Renaissance.

240; fig. 71
Madonna and Child Enthroned

c. 1467. Marble. Portal, Front Cloister, Certosa di Pavia

In 1466 and 1467 Amadeo was paid for unspecified work in the large cloister of the Certosa. At about this time he may also have created the portal that leads from the church's south transept to the front cloister and bears in the tympanum the signature IOHANNES ANTONIUS DE MADEO FECIT OPUS (fig. 71). This is the first known work by Amadeo and, as such, it already reveals his typical predilection for sumptuous decor and a blend of Christian and pagan pictorial motifs. The wide doorway, surrounded by a double rectangular frame, is crowned by a narrower tympanum flanked by angels holding armorial shields. The Madonna is seated with her Child in the center of the tympanum. St. John the Baptist and St. Bruno are commending to her the group of Carthusian monks kneeling at her feet in adoration. In the

242, 243; figs. 72, 73
Tomb of Bartolommeo Colleoni

c. 1470–76. White and red marble. Flagellation relief, 22 × 26⅜″ (56 × 67 cm.). Colleoni Chapel, Bergamo

Bartolommeo Colleoni, commander of the Venetian forces, died on November 3, 1475. The tomb chapel he had had built for himself next to Santa Maria Maggiore in Bergamo was near enough to completion that he was buried in it in January 1476. This was the first building in Lombardy to be wholly constructed

72 Amadeo. Façade, Colleoni Chapel, Bergamo

and decorated in the Early Renaissance style. The chapel's
sumptuous decor is made up of richly ornamented pilasters and
entablatures as well as numerous reliefs, statues, and busts on
both pagan and Biblical themes. Its ostentatious display of
classical reminiscences is like that of the contemporary Tempio
Malatestiano or the Triumphal Arch of Alfonso I.

Across the base of the façade are ten reliefs with scenes from
the Old Testament; on either side are two reliefs depicting the
labors of Hercules. Female figures stand to the sides and on top
of the portal and on either side of the window arches. Busts of
Caesar and Augustus have been placed like epitaphs above the
windows, and medallions containing portraits of additional em-
perors are the chief ornaments on the corner pilasters (fig. 72).

The interior of the chapel has been reworked in the Baroque
style. Opposite the entrance stands the condottiere's three-story
tomb (fig. 73). A large, boxlike sarcophagus, in which Colleoni's
remains were indeed found in 1969, is supported by four pilas-
ters and four square columns. It is decorated with five scenes
from Christ's Passion: the Flagellation, Christ Bearing the
Cross, the Crucifixion, the Lamentation, and the Resurrection.
The three reliefs on the front are framed by allegories of the
Virtues: Faith, Fortitude, Charity, and Temperance. Above this
sarcophagus, resting on squat, balusterlike columns, is a sec-
ond, smaller one presenting reliefs of the Annunciation, the
Nativity, and the Adoration of the Magi. This sarcophagus was
possibly intended for the condottiere's wife, who died in 1471
(Piel 1975). Figures of three Roman emperors, flanked by
Samson (?) and David (?), sit below and to the front of this upper

73 Amadeo. Tomb of Bartolommeo Colleoni. Colleoni Chapel, Bergamo

casket. Above it rises a large niche supported by fluted columns and half-columns, housing a gilt wooden equestrian statue of Colleoni flanked by female figures, possibly Delilah and Judith. This wooden statue was not erected until 1501, apparently to replace an original marble one (Piel 1975). It was traditional in northern Italy to place equestrian statues atop the tombs of military commanders, but the Colleoni monument, with its imposing design, its numerous figures, and its blending of countless classical motifs with Christian ones, is without parallel in its time.

The statues and reliefs are of very uneven quality. Closest to the Certosa portal, especially in the design of the drapery, are the reliefs on the fronts of the two sarcophagi (plate 242). Those on the lower one reveal an increasing expansion of the picture space. It is only in the reliefs on the sides of the lower sarcophagus (the *Flagellation* [plate 243] and the *Resurrection*) that the sculptor comes into his own. Here the settings are both more spacious and more clearly structured. Moreover, these works are distinguished from the monument's other reliefs by their uniform flatness, their carefully studied movements, and their refinement of detail. Gothic reminiscences are no longer in evidence. These were undoubtedly the last of the reliefs to be completed, at roughly the same time as those of Hercules and the Old Testament scenes on the base of the chapel façade.

244; fig. 74
The Mocking of Christ

c. 1485. Façade, Certosa di Pavia

The first provisions for the construction of Certosa's splendid façade (fig. 74) were made on January 14, 1473, when the monks contracted with the stonemason's lodge of Milan's cathedral for the delivery of marble over a ten-year period. Then on October 7, 1473, they commissioned the Mantegazza brothers to execute its sculptural ornaments. Apparently an identical agreement had been reached beforehand with Amadeo, so that a quarrel ensued. At the urging of Duke Galeazzo Maria Sforza, it was ultimately agreed that Amadeo should produce half of the works for the façade, and the resultant contract is dated August 20, 1474.

The documents provide virtually no details about the progress of the undertaking through the 1470s and 1480s. Amadeo is repeatedly mentioned as being in residence at the Certosa in 1481 and 1485, but not in direct connection with construction work. It was only in 1491 that he began to supervise the erection of the façade in earnest. By 1498 it had been completed as far as the first loggia. In addition to Amadeo, the chief sculptors involved were Antonio Mantegazza, Antonio della Porta, better known as Tamagnino, and Giovanni Stefano de Sesto. According

74 Façade, Certosa di Pavia

to the chronicle of Valerio, the architectural design had been provided by Giacomo Antonio Dolcebono and Ambrogio da Fossano. From the same chronicle we learn that Amadeo had produced a terra-cotta model of the façade. Amadeo resigned from his job in January 1499. Briosco undertook to create the main portal—some of the reliefs for its base had already been completed by Amadeo—in 1501, and it was finished in 1506. A contract was drawn up with Briosco and Tamagnino for the completion of the entire façade in 1508, but it was not until fifty years later that the work was finally accomplished.

When construction of the façade got underway in 1491, it is likely that the Mantegazza brothers had already executed a number of its elements. Scholars continue to have difficulty distinguishing their contribution from that of Amadeo. Most credit Amadeo with some of the reliefs depicting scenes from the life of Christ, certain of the medallions of caesars on the base, and the decoration around the windows. The scenic reliefs on the base to the right of the portal are among those generally attributed to Amadeo. One of these depicts the Mocking of Christ. The otherwise insignificant motif of the equestrian statue in the background serves to identify the work as his, for we find it in a similar form and position in the *Flagellation* relief (plate 243) on the Colleoni tomb. Otherwise the two works are quite different. The architectural backdrop in this scene is much more monumental. The figural groupings are also more clearly prescribed by the perspective prospect than before.

Moreover, these figures are not nearly so three-dimensional. Their proportions are elongated, their movements angular, their outlines and drapery forms paper-sharp, and their limbs and features come to a point. All of these qualities are most reminiscent of Amadeo's works in Cremona. Here the architectural background is more imposing, to be sure, and perhaps already influenced by the early Bramante (Santa Maria presso Santo Satiro, Milan). The rigorous perspective, the affected poses, the pointed hands and feet, and the sharp-edged, crumpled drapery—similar as it is to that of the Mantegazzas—have their closest analogies in Bramante's Previdari engraving from 1481.

245; fig. 75
The Return of St. Lanfranc to Pavia

c. 1498. Marble. Shrine of St. Lanfranc, San Lanfranco, Pavia

The Shrine of St. Lanfranc, in the choir of San Lanfranco near Pavia, is a signed work from Amadeo's late years. From the inscription on its front, which gives the age of its donor—the commendator abbot Pietro Pallavicino da Scipione—as fifty-two years, it would appear that the work was completed in 1498. The monument comprises a sarcophagus atop six balusterlike columns and an ornamental superstructure (fig. 75). The sides of the sarcophagus present a total of eight reliefs with scenes from the life of St. Lanfranc, and the upper part has six scenes from the life of Christ. The middle scene on the front of the sarcophagus shows the saint returning from exile to Pavia and blessing the faithful (plate 245). The backdrop for the scene is a landscape stretching far into the distance. Typical of the late Amadeo is the elongation of the figures, with an emphasis on their silhouettes. For all his tendency toward expressive stylistic

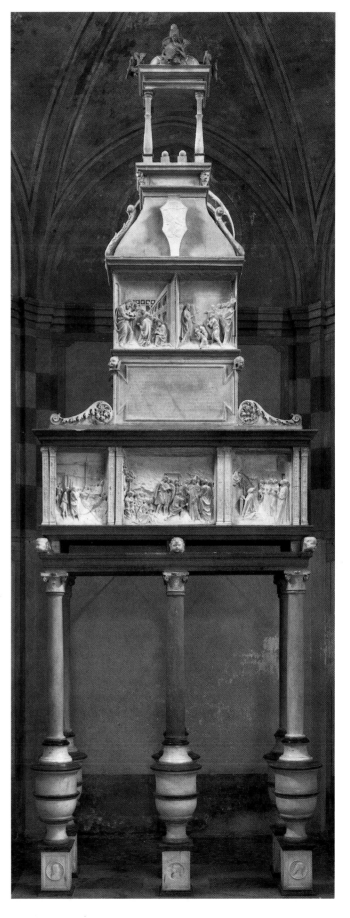

75 Amadeo. Shrine of St. Lanfranc, San Lanfranco, Pavia

451

devices, however, one notes an indebtedness to classical models that was by no means evident in his work from the 1480s. He has obviously abandoned the crumpled folds, learned from the Mantegazza brothers, and given his figures a greater individuality. He also employs a new restraint in his decor and keeps all of the shrine's architectural elements extremely simple.

Niccolò dell'Arca
(c. 1435–1494)

Niccolò d'Antonio, called after his masterpiece Niccolò dell'Arca, was Emilia's most important sculptor from the Quattrocento. He was born about 1435. Some documents refer to him as a native of Bari, or Apulia, while others suggest he was from Ragusa. On his *Lamentation* group in Santa Maria della Vita he signed himself as "Nicolaus de Apulia." Of his earliest years nothing certain is known, although scholars have offered a variety of possible biographies. Gnudi, for example (1942; [1972]), has suggested that before he settled in Bologna in about 1460 he had spent his apprenticeship in Naples and possibly even worked with Giorgio da Sebenico. However, Beck ("Niccolò," 1965) proposes Florence and Siena as the decisive way stations in his early development, while Del Bravo (1974) argues for Florence and Venice.

The first documentary reference to the sculptor is from Bologna in 1462 (Beck, "Niccolò," 1965). At that time he was executing the *Lamentation* group for Santa Maria della Vita (now in the Pinacoteca Nazionale, Bologna). In 1469 Niccolò was commissioned to add a superstructure with numerous figures to the marble shrine of St. Dominic in the Dominican church in

Bologna, and this he accomplished by 1473. Other certain works of his in Bologna include: a terra-cotta bust of St. Dominic in San Domenico Maggiore (1474–75), which once stood above the monastery's vestry door (now in the Museo di San Domenico); the *Madonna di Piazza* on the façade of the Palazzo del Comune (1478); and a terra-cotta eagle above the main portal of San Giovanni in Monte (c. 1481). Two terra-cotta reliefs—an *Annunciation* and an *Adoration of the Magi*—that he created in 1492 for Santa Maria Maddalena have been lost, as has a figure completed in 1493 for the Bolognini Chapel in San Domenico.

In the sixteenth century, a signed marble statue of John the Baptist that Niccolò had willed to his daughter somehow found its way to Spain, where it was rediscovered by De Salas (1967) in the Escorial. Niccolò made his will on October 6, 1484, and died on March 2, 1494. He was buried in San Giovanni Battista, Bologna's Celestine church. The chronicler Girolamo Borselli, who had been attached to Bologna's Dominican monastery since 1457 and doubtless knew the artist well, remarked on the occasion of his death that he was a highly competent sculptor, but otherwise a man with an eccentric imagination (*fantasticus*),

76 Niccolò dell'Arca. *Lamentation*. Pinacoteca Nazionale, Bologna

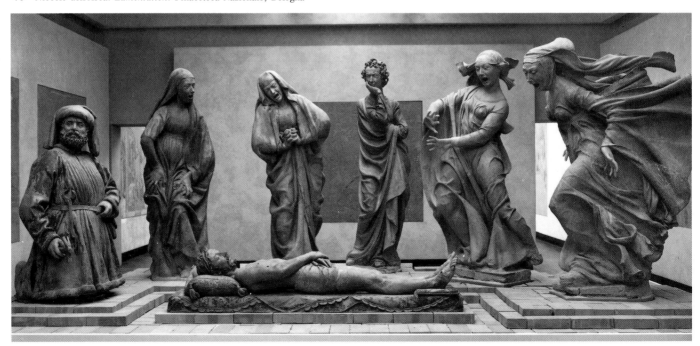

barbarian habits (*barbarus moribus*), and uncommon bull-headedness (*caput durum habens*), and that he had refused to accept any pupils.

Vasari [1568]; Schubring 1904; Fabriczy 1908; Gnudi 1942; Gnudi 1952; Toesca 1956; Alce 1958; Ghidiglia Quintavalle 1958; Pope-Hennessy 1958 (1985); Belli D'Elia 1964; Bottari 1964; Beck, "Niccolò," 1965; Salas 1967; Gnudi [1972]; Del Bravo 1974; Gramaccini, "Déploration," 1983; Agostini and Ciamitti 1985.

246, 247; fig. 76
Lamentation

c. 1462–63 or c. 1485. Terra-cotta. Pinacoteca Nazionale, Bologna

This group (fig. 76), which is signed on Christ's pillow OPUS NICOLAI DE APULIA, originally stood in the Church of Santa Maria della Vita. Except for traces, the original polychrome painting on the terra-cotta figures has worn away. It is likely that the group once included a figure of Joseph of Arimathea, which is said to have borne the features of Giovanni Bentivoglio II and was possibly deliberately destroyed (Gramaccini, "Déploration," 1983). In an inventory of the Ospedale of Santa Maria della Vita from 1601, the *Lamentation* group is listed as having been created in 1463, and for a long time this was accepted as a certainty. Gnudi, however (1942), rejected that date in favor of a later one, sometime after 1485. A document since discovered by Beck ("Niccolò," 1965) would seem to be an indirect confirmation of the original dating. It asserts that the rent owed to the Fabbrica di San Petronio for Niccolò's workshop in April 1462 was paid by the Ospedale della Vita, suggesting that the hospital was his employer at that time.

Niccolò's group is the prototype for all subsequent monumental terra-cotta groups, a form especially favored in the province of Emilia, yet it far surpasses them in its grandiose movement, its graphic impact, and its vivid emotion. The most powerful figures are the two wailing women on the right, whose ecstatic delirium is underscored by their ballooning garments (plates 246, 247). Gnudi's assumption (1942; [1972]) that the group was only created in the 1480s was based on these specific figures. The difference between them and the others, all quite compact and restrained, is indeed considerable, and is not simply the result of a change in technique or narrative approach. Their whole design is more masterful, their movements are freer and more expansive, their gestures and facial expressions more fully coordinated. The bodies beneath the drapery are more clearly articulated, and, moreover, the drapery itself, quite apart from its obvious contrast with that of the remaining figures, has become a primary means of expression. For all these reasons, it would appear that for these two right-hand figures, at least, the date advanced by Gnudi (1942), based in part on his perception of the influence of Ferrara's painters in Bologna, still seems quite plausible.

248, 249; fig. 77
Candelabrum Angel and Evangelists from the Shrine of St. Dominic

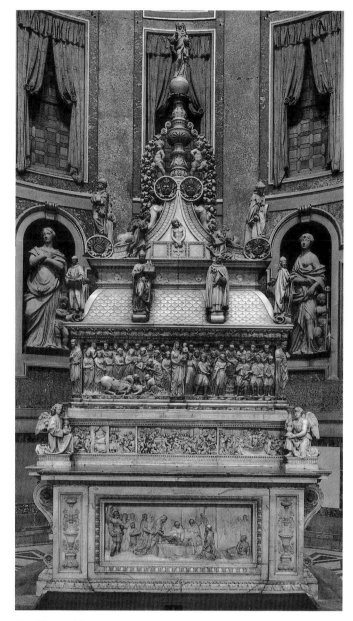

77 Shrine of St. Dominic. San Domenico, Bologna

1469–73. *Angel*. Marble, 20½″ high (52 cm.); *St. John the Evangelist*. Marble, 25⅝″ high (65 cm.); *St. Matthew*. Marble, 26⅜″ high (67 cm.). San Domenico Maggiore, Bologna

The boxlike marble Shrine of St. Dominic, with reliefs on all four sides, had been created by Nicola Pisano and his workshop in 1267. It stood in the right aisle of San Domenico Maggiore until 1411, when it was placed in a chapel created especially for it. In this new location a more imposing sculptural adornment seemed called for. The papal legate and the city fathers of Bologna determined to commission additional sculpture for the shrine on June 5, 1469. Their contract with Niccolò dates from July 20 of that year. Within a period of two and a half years, the sculptor was to create, in accordance with a model he had submitted, the superstructure and its twenty-one statues—the

453

opus clipei et ornamenti—and the predella. A clay model of each individual figure was to be prepared in advance.

The superstructure was placed on the shrine on July 16, 1473 (fig. 77). After that date there is no mention of further work on it, although the terms of the contract had not been met, for in 1494, after Niccolò's death, three of the missing figures were entrusted to Michelangelo. The predella, by Alfonso Lombardi, and a fourth statue, by Coltellini, were only completed in 1532 and 1539, respectively. Niccolò's contributions include the curved roof of the shrine with its candelabrumlike finial and the following figures: God the Father giving benediction at the very top; the two putti holding garlands; the Man of Sorrows and adoring angels; the four Evangelists on the upper volutes; Sts. Francis, Dominic, Florian, Agricola, and Vitale standing at the edge of the roof; and the angel holding a candlestick on the left side of the altar. Michelangelo carved the matching angel for the right side in 1494–95.

The overall design of the superstructure and many of its decorative details, notably the candelabrum-shaped finial and hanging garlands, were influenced by Desiderio da Settignano and his Marsuppini tomb. Its figures, however, are not so easily related to the sculpture of Florence. In type, to be sure, if not in appearance or details of its clothing, the angel holding a candlestick (plate 248) can be traced back to the ones created by Luca della Robbia for the Duomo in Florence in 1448–51. For models for the upper statuettes, scholars have had to look further afield, to the Burgundian followers of Claus Sluter or to Giorgio da Sebenico (Gnudi 1942; [1972]).

It is true that the opulent excess of fabric in these altogether unclassical garments, the corresponding masses of wavy hair, the turbanlike head coverings, and other costume details are most unusual in Italian sculpture in the years around 1470. Parallels for many of these features are most easily found in sculpture from north of the Alps. Even there, however, the high drama in the demeanor of these Evangelists—the ecstatic abandon of St. John, St. Matthew's utter absorption in the scroll he is reading as he walks, or St. Mark feverishly writing against his bent knee, would still be quite unusual. It may have been inspired in part by Donatello's bronze doors and his *Evangelist* tondi from the Old Sacristy. The Evangelists are presumably among the first works completed from the project and date from about 1470. The statues of Sts. Francis and Dominic were likely carved later, as they are distinguished from the Evangelists by their simpler structure, more conventional drapery, and more composed expressions. It is possible that the sculptor's employers suggested this obvious change in his manner of portrayal, asking him to place more emphasis on the subject's dignity than on his individual personality.

Guido Mazzoni
(c. 1450–1518)

Guido Mazzoni, a painter, goldsmith, and sculptor, was born in Modena about 1450, the son of the notary Antonio Mazzoni. He is first mentioned in 1466, as a beneficiary in the will of his uncle Paganino. According to local tradition, he began his artistic career as a mask maker. In 1472 he received payment for paintings in the sacristy of Modena's cathedral. In June 1476 he produced the backdrop for a pageant based on the labors of Hercules, a spectacle given in honor of Duke Ercole I and Duchess Eleonora d'Este. Later, in Naples, he was again employed in the creation of stage sets. The earliest work attributed to him is the terra-cotta group of the Lamentation of Christ in the Church of Santa Maria degli Angeli in Busseto, which he created in 1476–77 (Mingardi 1975).

In subsequent years his renown as an artist was based chiefly on works of this kind. His *Lamentation* group for the Church of Santa Maria della Rosa in Ferrara (now in the Church of Il Gesù) was completed before 1485. About 1485 he produced one for the Ospedale della Buona Morte in Modena (now in San Giovanni Battista), and in 1485–89 the *Adoration* group for the Observantist monastery in Modena (now in the crypt of the Duomo). Between 1485 and 1489 Mazzoni created still another *Lamentation* group for the Monastery of San Antonio di Castello in Venice, of which only fragments are preserved in the Museo Civico in Padua. In 1489 he was called to Naples, where by 1492 he had produced the *Lamentation* group, his last and most important work of this type, for Santa Anna dei Lombardi. In 1495 he traveled with King Charles VIII to France, where he was to stay for more than two decades. His chief work from this late period was the bronze tomb for Charles VIII (d. 1498) in Saint-Denis, which was destroyed in 1793. In 1516 Mazzoni returned to Modena, where he died on September 12, 1518.

Vasari [1550, 1568]; Pettorelli 1925; Gnudi 1952; Pope-Hennessy 1958 (1985); Morisani 1966; Riccòmini 1966; Hersey 1969; Mingardi 1972; Mingardi 1975; Pane 1975–77; Verdon 1978; Gramaccini, "Mazzoni," 1983; Larson 1989.

250

Lamentation

c. 1485. Terracotta, polychrome, 50¾″ high (129 cm.).
San Giovanni Battista, Modena

This group, on display in San Giovanni Battista since the nineteenth century, was originally in the Oratory of the Brotherhood

of St. John of the Good Death (Ospedale della Buona Morte). According to Gnudi (1952) and others, this is not the one that Mazzoni created for the same brotherhood between 1477 and 1480, but dates from 1485 at the earliest. This claim is supported by Tommasino Lancillotti's notation from 1509 to the effect that the work had been created "twenty-five years ago." The present polychrome painting dates from the nineteenth century.

Compared to the *Lamentation* groups in Busseto and Ferrara, this one reveals both a greater intensity in the movements and expressions of the individual figures and a more compact grouping. These features also support a date of about 1485. It is possible that the group created for the Ospedale della Buona Morte in 1477–80 was only a sample, as the relatively low price of 60 ducats would suggest. Mazzoni has here made use of life casts for the hands and faces of his Nicodemus and Joseph of Arimathea (Verdon 1978)—another innovation that sets this group apart from the earlier one for Ferrara. According to Venturi (1884), we are to interpret these two male figures as portraits of his patrons, in this case the brotherhood's superiors.

251
Adoration of the Child

c. 1485–89. Terra-cotta, polychrome. Crypt, Duomo, Modena

This work, originally from the Observantist monastery, was in the Church of Santa Margherita from the late sixteenth until the early nineteenth century and has been on view in the crypt of the Duomo since 1851. It is not documented as Mazzoni's, but scholars are unanimous in attributing it to him. There is some disagreement about its dating, however. Gnudi (1952) and Verdon (1978) chose to place it shortly before the *Lamentation* group in San Giovanni Battista. Given its drapery forms, however, which are more irregular and more highly varied, it is likely that it was executed later, sometime in the late 1480s. In addition to the surviving figures, the Madonna and Child, a servant girl, St. Anne, and St. Joachim (or Joseph?)—the latter said to be a portrait of the presumed donor, Ser Francesco Porrini—there may once have been others. At the time of this writing (spring 1990) the group is undergoing restoration.

Bartolomeo Bellano
(1437/39–1496/97)

Bartolomeo Bellano was born in Padua, the son of the goldsmith Bellano di Giovanni, about 1437/39. He was a goldsmith and stone sculptor, but above all a sculptor in bronze who was greatly influenced by the late work of Donatello. It is possible that he even served an apprenticeship in Donatello's workshop in Padua. The first definite mention of him is as an assistant to Donatello in Florence in 1456. It is clear that he was then in Padua in 1458 and 1459. A limestone *Madonna* relief in the Boston Museum of Fine Arts is signed and dated 1461, but both the authorship of the work and its date are highly questionable. In 1462 Bellano brought a suit against Pietro Antonio Mainardi in Padua in connection with his payment for four terra-cotta reliefs. In 1463 he was obviously once again in Florence, where he may have collaborated on Donatello's pulpits for San Lorenzo. At the end of 1466 he left Florence for Perugia, and by October 1467 he had created there a bronze statue of Pope Paul II that was placed in a niche on the façade of the Duomo. That work was melted down in 1798. It is possible that in this period he also worked in Rome, where according to Vasari (1568) he created "numerous smaller works in marble and bronze" for Pope Paul II.

In 1468/69 Bellano settled in Padua, and in the following years, until the beginning of 1473, he produced the marble facing on the reliquary shrine in the sacristy of the Santo. In 1475 he quarreled with the heirs of Raimondo Solimani, who were dissatisfied with the figures he had created for the Solimani tomb monument in the Eremitani church (now destroyed). In 1479 the republic of Venice proposed to send him, together with Gentile Bellini, to the court of Mohammed II in Constantinople, and in anticipation of that mission he wrote out his will on September 7. It is uncertain whether or not he actually made the trip to Constantinople, although it seems probable (Krahn 1988). Between 1479 and 1483 Bellano took part in the competition for the Colleoni monument in Venice. In 1484–90 he created ten bronze reliefs of scenes from the Old Testament for the choir of the Santo. In about 1492 he produced the tomb for Pietro Roccabonella (d. 1491) in San Francesco in Padua. Attributed to Bellano, in addition to the works already mentioned, are the Tomb of Giacomo Zocchi in Santa Giustina in Padua, a number of *Madonna* reliefs, a *Lamentation* relief in the Victoria and Albert Museum in London, and countless smaller bronzes. Chief among the latter are two *David* statuettes (in the Philadelphia Museum of Art and in the Metropolitan Museum of Art in New York) and a seated *St. Jerome* removing a thorn from a lion's paw (Louvre, Paris). The last documentary reference to Bellano is from October 27, 1495. He died about 1496/97 in Padua. A few years later he is unflatteringly referred to in the treatise of Pomponius Gauricus (1504) as *ineptus artifex* (bungler).

Gauricus 1504; Michiel [1521–43]; Vasari [1550, 1568]; Bode 1891; Semrau 1891; Planiscig 1921; Scrinzi 1926; Bettini 1931; Sartori 1962; Sartori 1976; Negri Arnoldi 1983–84; Sartori 1983; Lorenzoni 1984; *Donatello e i suoi* 1986; Krahn 1988.

252
Miracle of the Host

1469–73. Marble. Sacristy, Basilica del Santo, Padua

From 1469 to 1473 Bellano worked on the richly decorated marble reliquary shrine that takes up the entire west wall of the Santo's sacristy. His last payment dates from January 8, 1473. The monument was a gift from the Gattamelata's widow. Its figural ornaments consist of four putti, four angels, four statues of saints (Louis and Bernardine below, Francis and Anthony above), and this relief of the Miracle of the Host, which forms the top of the screen wall. For the subject matter of the relief, see page 401.

Despite many changes in the overall arrangement of the scene and in the style of its figures, Bellano has clearly borrowed from the corresponding relief by Donatello on the Santo altar (plate 124). The column architecture suggested in the background is strictly symmetrical. The altar retable, cut off at the top, depicts the Madonna and Child between St. John the Baptist and St. Sebastian. In front of the altar, St. Anthony bends down so as to extend the Host to the donkey kneeling in devotion. Crowds of astonished onlookers fill the space to the left and right of the altar. The scene's restricted space betrays an indebtedness to the late Donatello, as do the flatness of the figures, the angularity of their silhouettes, and the sharply defined folds of the drapery. Somewhat in contrast to the above are the highly detailed ornaments, which are especially lavish on the entablature below the relief. This degree of detail and the repertoire of decorative

motifs are very similar to those of the portals of the Palazzo Ducale in Urbino, although the specific motif of this frieze is one used by Mantegna in the Eremitani's Ovetari Chapel (Krahn 1988).

253, 254
Samson Destroying the Temple of the Philistines; David Slaying Goliath

1484–90. Bronze, 26 × 33″ (66 × 83.5 cm.). Basilica del Santo, Padua

Until 1651, the twelve bronze reliefs of Old Testament subjects were mounted on the outside of the Santo's marble choir screens rather than on the inside. Ten of them were created by Bellano, and the final two were completed by Riccio (Andrea Briosco) twenty years later. The subjects are as follows: Cain and Abel making offerings; Cain killing Abel; the Sacrifice of Isaac; Joseph being sold by his brothers; the Passage of the Israelites through the Red Sea; the Golden Calf; the Brazen Serpent; Samson destroying the temple of the Philistines; David killing Goliath; David's entry with the Ark of the Covenant (Riccio); the Judgment of Solomon; Judith killing Holofernes (Riccio); Jonah being thrown into the sea.

In 1483 the trustees of the Shrine of St. Anthony had arranged for Bertoldo di Giovanni to submit two sample reliefs, one of Jonah and one of the Israelites passing through the Red Sea. After seeing only the Jonah relief, they declared themselves

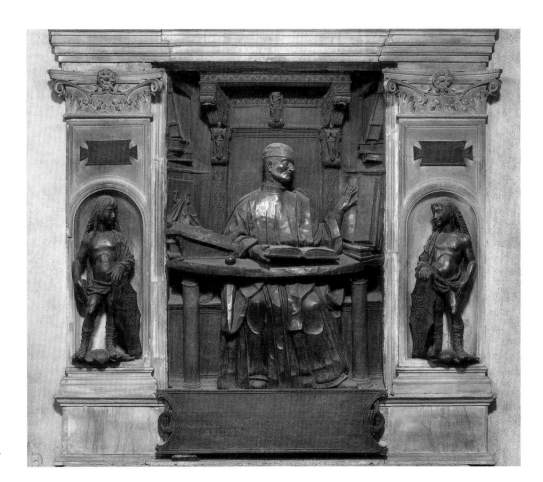

78 Bellano. *Scholar* relief from the Tomb of Pietro Roccabonella. San Francesco, Padua

unsatisfied, and in the following year they turned instead to Bellano. In the summer of 1484 Bellano delivered the *Samson* relief, it too only a sample. A contract for the entire series was drawn up later that same year and is dated November 26 and 29. Bellano was to complete them all by Easter 1487, yet the payments to him continued until June 1490.

Vasari (1550) implies that Bellano drew on designs by Donatello for these choir-screen reliefs, but their modest command of narrative and composition fail to bear him out. Bellano clearly had difficulty with the spacious settings appropriate to most of these scenes. Although less apparent in the *Samson* relief, this is unmistakable in his portrayal of David and Goliath, where the landscape formations and figures or groups of figures are scattered across the large picture plane in accordance with a compositional scheme that is much too superficial. Donatello's influence on the construction of the figures in both reliefs is undeniable; however, the conspicuous motif of the equestrian duel in the center of the *David* relief may well be a borrowing from Leonardo.

255; fig. 78
Madonna and Child with Saints, from the Tomb of Pietro Roccabonella

1492–98. Bronze, $77\frac{5}{8} \times 62\frac{5}{8}''$ (197×159 cm.).
San Francesco, Padua

The Venetian philosopher and physician Pietro Roccabonella died in 1491. His tomb, largely the work of Bellano but completed by Riccio in 1498, was dismantled in the sixteenth century. Its chief components, two large bronze reliefs presenting a Madonna enthroned between two saints and a scholar in his study (fig. 78), are now mounted on the walls of the transepts in San Francesco. The crowned Madonna is seated on a richly ornamented throne topped by a semicircular arch. With both hands she supports the Child standing on her lap and leaning into her. The frieze of putti on the base of the throne derives from Nicolò Pizolo's Ovetari Altar in the Eremitani church in Padua. St. Francis and St. Peter Martyr stand somewhat cramped to the left and right. In their postures and their placement immediately next to the Madonna's throne, they are obviously patterned after the statues from the Santo altar. Their stiff drapery, which looks almost like buckled metal, is characteristic of Bellano. Here it is modeled in larger forms than in his earlier works. Bellano also created the two boys holding coats of arms on either side of the scholar relief. Riccio supplied only the inscription panel and—according to Michiel (1521–43)—the three statuettes on the baldachin of the Roccabonella relief. He also did the chiseling on Bellano's *Madonna* relief.

Francesco di Giorgio
(1439–1501)

The son of a poultry seller, Francesco di Giorgio Martini was born in 1439 in Siena, where he is listed as having been baptized on September 23. As an architect, sculptor, painter, civil and military engineer, and architectural theorist, he was one of the most versatile artists of the Early Renaissance. Most likely he spent his apprenticeship under Vecchietta. His first documented work is a wooden statue of John the Baptist in Siena's Pinacoteca (fig. 41), which he created in 1464 for the Compagnia della Morte in Siena (Carli, "Recovered," 1949). In the early 1470s he maintained a workshop together with Neroccio de' Landi. Known paintings from this period are the *Coronation of the Virgin* (1472), for the Chapel of Sts. Sebastian and Catharine in Monteoliveto Maggiore, and the *Adoration of the Infant Jesus* (1475), for San Bernardino, the church of the Sienese monastery Monteoliveto fuori Porta Tufi. Both are now in the Pinacoteca.

In 1476 or 1477 Francesco di Giorgio went to Urbino, and with the exception of intermittent sojourns back to Siena he remained there, in the service of Duke Federigo da Montefeltro and his successor Guidobaldo, until 1489. During these years he created his architectural masterpiece, the Church of Santa Maria del Calcinaio near Cortona. During this period he also produced a bronze relief in Santa Maria del Carmine in Venice and a bronze medallion of Federigo da Montefeltro (British

Museum, London). His bronze relief in the Galleria Nazionale in Perugia, however, and his so-called *Discordia* relief—preserved in two stucco versions, one in the Victoria and Albert Museum in London, the other in the Palazzo Chigi Saracini in Siena—were more likely executed in the 1490s.

In 1488–90 Francesco produced two bronze candelabrum angels for the high altar of the Duomo in Siena. Additional sculptures attributed to him are a wooden *St. Christopher* in the Louvre (Fabriczy 1907; Ingendaay 1979) and the bronze statuette of a Hercules or Asclepius in the Albertinum in Dresden (Schubring, *Plastik*, 1907). In 1490 Francesco spent some time in Milan, where he had been asked to appraise the crossing cupola of the Duomo, then under construction, and where he met Leonardo da Vinci. In the same year he sojourned in Bologna as well, and between 1491 and 1495 he is documented in any number of other towns in Italy. In 1499 he was appointed chief architect of the Duomo in Siena. He died at Volta a Fighille, his country house near Siena, in November 1501.

Vasari [1550, 1568]; Bode 1893; Fabriczy 1907; Schubring, *Plastik*, 1907; Hartlaub 1939; Weller 1943; Carli, "Recovered," 1949; Carli 1951; Pope-Hennessy 1958 (1985); Del Bravo 1970; Ingendaay 1979; Carli 1980; Fumi 1981; Gallavotti Cavallero 1985; *Donatello e i suoi* 1986; Toledano 1987; Bagnoli 1989.

256
Lamentation

c. 1476–77. Bronze, 33⅞ × 29½″ (86 × 75 cm.).
Santa Maria del Carmine, Venice

This work, attributed to Francesco di Giorgio by Schubring (*Plastik*, 1907), only came to the church in Venice in 1852. It was originally in the Oratory of the Compagnia di Santa Croce in Urbino, having been commissioned for that body by Duke Federigo da Montefeltro. As Bode (1893) was first to point out, Federigo is portrayed in the relief behind the mourning St. John, together with his small son Guidobaldo, born in 1472. Taking the approximate age of the child depicted, we can deduce that the relief was executed in roughly 1476–77. Weller (1943) goes so far as to suggest that the person kneeling behind Federigo is a self-portrait of the sculptor, but this is not certain. More likely it is some other member of the ducal family—although not the duke's wife Battista Sforza, as Schubring (*Plastik*, 1907) and Carli (1980) have assumed.

It is unusual to find calmly praying donors in the middle of a scene as full of dramatic movement as the Lamentation. The main figures—the dead Christ, the two women bending over him, and the weeping St. John—are here placed in the immediate foreground. For close parallels to the seated or crouching mourners, one need only turn to Francesco di Giorgio's own *Flagellation* relief in Perugia or the late work of Donatello (the San Lorenzo pulpits; the *Lamentation* relief in London, plate 138). Also reminiscent of Donatello is the pointed contrast between the silent mourners and those giving full vent to their anguish. It is highly unusual to find lamenting angels hovering about the *empty* cross; however, their presence is perhaps ex-

plained by the fact that the work was originally commissioned for the Oratory of Santa Croce. The sculptor has obviously left most of the surfaces of his figures raw and unpolished so as to heighten their expressive effect—undoubtedly under the influence of Donatello's late pulpit reliefs.

257
Candelabrum Angel

1488–90. Bronze, 49¼″ high (125 cm.). Duomo, Siena

Of the four candelabrum angels that stand next to Vecchietta's 1472 ciborium on the high altar of Siena's cathedral (fig. 53), two were created by Giovanni di Stefano and two by Francesco di Giorgio in collaboration with Giacomo Cozzarelli. Unlike the ciborium, they were intended for the high altar from the outset. Fumi (1981) was able to determine from payment records that the preparation of models and the casting of all four figures were accomplished in the years 1488–90. However, the final payment to Francesco di Giorgio was only made in 1499.

All of the angels are dressed in thin, flowing garments and carry candlesticks shaped like cornucopias. The ones executed by Francesco di Giorgio are more graceful in their poses, the curve of their bodies matching those of the candelabra. They are further distinguished from di Stefano's in that they do not stand on rectangular bases. Instead, they have been mounted directly on round marble bases, with no intervening bronze plinth, a touch that further enhances their freedom of movement. Their drapery is also fluid. Despite its ample folds, it clings to the body more convincingly than that of the di Stefano angels. In the latter it is clear that actual fabrics were used for the casting models.

79 Francesco di Giorgio. So-called *Discordia* relief. Victoria and Albert Museum, London

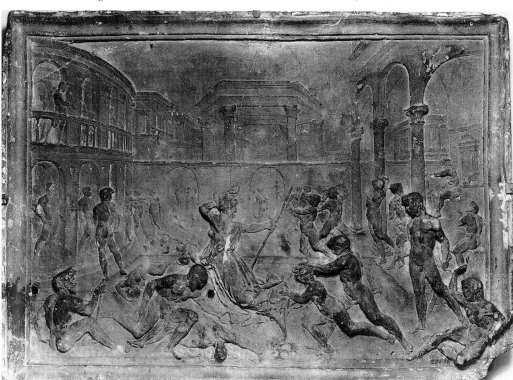

258; fig. 79
The Flagellation of Christ

c. 1490–95. Bronze, 21¾ × 16″ (55.5 × 40.5 cm.). Galleria Nazionale dell'Umbria, Perugia

This relief was given to the Perugia University museum by Count Demetrio Boutourline in 1882. The original location for which it was intended is unknown. Schubring (1907) was the first to attribute the work to Francesco di Giorgio, and his attribution has never been disputed.

The overall design of the architectural backdrop corresponds to that of the so-called *Discordia* reliefs in London (fig. 79) and Siena. The flagellation itself takes place on a stagelike podium. Figures occupy the spaces in front and back of this podium, and the façades of palaces can be seen on either side. There are subtle differences between the modeling of the figures and that of the architecture. The figure of Christ and the man whipping him are emphasized by their greater three-dimensionality, whereas Pilate is distinguished by his elevated position, his commanding gesture, and the presence of the man arguing with him from below.

The remaining figures are mostly silent onlookers and mourners. Especially compelling are the ones seated on the ground in the foreground, seemingly stunned with grief. Expressive mourners like these can be traced back to either classical sarcophagi or Donatello's reliefs from the south pulpit (the *Crucifixion*, the *Entombment*) in San Lorenzo. The soldier with lance and shield standing on the right is also a familiar figure from Donatello's reliefs. However, the compositional scheme of this *Flagellation* relief is altogether unlike that of Donatello's late works. It also represents a significant advance over the relief in the Carmine church in Venice (plate 256). Its larger space is clearly defined, its figures are more compressed and rounded, and there is a greater softness in the modeling of drapery. The proportions of these figures and their drapery forms suggest that the Perugia relief was also created sometime after the bronze angels for the high altar of the Duomo in Siena, or presumably about 1490–95. Del Bravo (1970) rightly sees the influence of Leonardo on this relief, as evidenced by the gestures of its figures and its use of *sfumato*, another indication that the work dates from this later period.

Antonio del Pollaiuolo
(1431/32–1498)

Antonio di Jacopo d'Antonio Benci, called del Pollaiuolo after the occupation of his father, a poultry dealer, was born in Florence in 1431 or 1432. He underwent early training as a goldsmith, but it is not known with whom. According to both the *Codice Magliabechiano* (1537–42) and Vasari (1550), he worked as an assistant in Ghiberti's workshop on the *Gates of Paradise*, or at least on its bronze frame. His earliest documented work is the large silver reliquary cross for the Florence Baptistry (now in the Opera del Duomo), which he produced in 1457–59 in collaboration with Miliano di Domenico Dei and Betto di Francesco Betti. He also executed other works as a goldsmith in the 1460s, but these have not survived.

In the same period he submitted designs for a parament in the Baptistry. In 1466 he and his brother were paid for the altar painting in the Chapel of the Cardinal of Portugal (now in the Uffizi). Even before this, it appears that Antonio had turned increasingly to painting. It was probably still in the early 1460s that he produced the three Hercules paintings for the Sala Grande in the Palazzo Medici. Although these have been lost, they are known from Antonio's mention of them in a letter to Gentile Virginio Orsini on July 13, 1494, and from the thorough description in Vasari (1550). The famous engraving of warring nudes, signed by Antonio, dates from the 1470s, although Fusco (1984) places it in the late 1480s. Vasari (1568) tells us that Antonio's *Martyrdom of St. Sebastian*, for the Pucci family chapel in Santissima Annunziata (now in London's National Gallery), was painted in 1475. In these years Antonio continued to work as

a goldsmith as well, and in 1478–80 he created the relief of the Birth of John the Baptist for the silver altar of the Baptistry in Florence.

From 1484 on, Antonio spent most of his time in Rome. He first worked on the Tomb of Pope Sixtus IV—his sculptural masterpiece—and later, beginning in roughly 1492, on the one for Pope Innocent VIII. It is documented that he also collaborated in these years on the sacristy of Santo Spirito in Florence and the Church of Santa Maria dell'Umilità in Pistoia, and submitted a proposal for the façade of the Duomo in Florence. The latter came no closer to actual execution than did his proposed equestrian monument to Duke Francesco Sforza, two studies of which survive (Graphische Sammlung, Munich [fig. 80]; Lehman Collection, New York). Apparently these date from the period about 1480, that is, before Leonardo was entrusted with the creation of the monument. In the above-mentioned letter from 1494, Antonio speaks of a bronze bust he planned to produce of Virginio Orsini, the duke of Bracciano, adding that he hoped to expand it into an equestrian monument. The work has not survived—if indeed it was ever completed.

Antonio died in Rome on February 4, 1498. He was buried in San Pietro in Vincoli next to his brother Piero, who had collaborated on almost all of his works and had died two years before. Both brothers are commemorated by a marble epitaph with portrait busts. In a letter to Giovanni Lanfredini of 1489, Lorenzo the Magnificent mentions how very highly his contemporaries thought of Antonio as an artist.

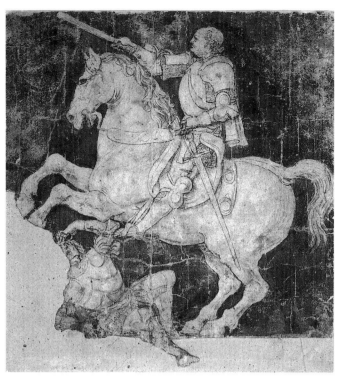

80 Antonio del Pollaiuolo. Design for the equestrian statue of Francesco Sforza. Staatliche Graphische Sammlung, Munich

Vasari [1550, 1568]; Cruttwell 1907; Sabatini 1944; Mather 1948; Ortolani 1948; Ettlinger 1953; Pope-Hennessy 1958 (1985); Ettlinger 1972; Borsook 1973; Spencer 1973; Haines 1977; Bush 1978; Covi 1978; Ettlinger 1978; Fusco 1979; Liscia Bemporad 1980; Parronchi, "Croce," 1980; Szabo 1981; Carl 1982; Carl 1983; Beck 1984; Fusco 1984; Angelini 1986.

259; fig. 81
Hercules and Antaeus

c. 1470. Bronze, 17¾" high (45 cm.). Museo Nazionale del Bargello, Florence

This bronze group is first mentioned in the inventory of the Palazzo Medici of 1492. At that time it stood in Giuliano de' Medici's apartment. The subject of Hercules and Antaeus was one that Antonio returned to a number of times. As early as about 1460 he had produced three large paintings for the Palazzo Medici depicting the Labors of Hercules, including his defeat of Antaeus. These have not survived. The Uffizi has two small-format panels, however, in which Hercules is portrayed in combat with Antaeus (fig. 81) and with the Hydra. Whether these served as models for the paintings for the Palazzo Medici or were copies of them—or were wholly independent creations—is a matter of debate (Ettlinger 1978). The bronze group in the Bargello differs from the corresponding picture in the Uffizi in certain details, but they are definitely similar. It is altogether characteristic of Antonio to repeat specific figural types with only minor variations.

Antaeus, the son of Poseidon and Gaia, received new strength whenever he touched the ground; therefore, Hercules was only able to defeat him by crushing him in mid-air. This is the moment depicted in the small bronze, and Antonio seems to have been fascinated by the acrobatic movements of the two combatants. He has combined a sense of violent struggle and calculated ponderation with great virtuosity. Using all his strength, Hercules has raised his opponent off the ground, squeezing him so tightly around the waist that he writhes helplessly with pain. The sculptor has made certain that his group is effective from every angle, even allowing for varying points of view by placing it on a triangular base supported by turtles. With its remarkable mastery of the human figure in extremes of movement and exertion, Antonio's bronze far surpasses earlier depictions of the subject matter. Vasari (1550) speaks with special admiration of the *viva forza* in the works of Antonio del Pollaiuolo and insists that he had made a more thorough study of human anatomy than anyone else in his time. This is, of course, what made him such a decisive influence on Verrocchio and Leonardo.

260
Bust of a Warrior

c. 1475–80. Terra-cotta, polychrome, 19⅝″ high (50 cm.).
Museo Nazionale del Bargello, Florence

This bust is incomplete. However, it is unlikely that the upper arms and the head covering were removed; more likely they were never executed. It is possible that the artist never bothered with them, as the terra-cotta was only meant to be a model for a bust in bronze (Pope-Hennessy 1985). The surviving pigment, in tones imitative of bronze, would support such an assumption.

We do not know who the bust is meant to portray. There are neither documents relating to the work nor early references to it. Given the subject's youth, it is unlikely that this work has anything to do with the projected bronze bust of Virginio Orsini mentioned in 1494. The attribution to Antonio del Pollaiuolo is based primarily on the young man's physiognomy and the skillful classical decoration of his armor, although there are parallels for these ornaments on other busts of warriors from the late 1470s, for example, Verrocchio's *Bust of Giuliano de' Medici* in the National Gallery in Washington, D.C.

In the center of the breastplate is an emperor's head copied from coins from the reign of Nero, while two nude male figures fill the space on either side. The one on the left is struggling with a dragonlike monster, the one on the right with two serpents. Both are probably portrayals of Hercules, although these creatures do not appear in the traditional recounting of his labors (Ettlinger 1978). The two men fling their limbs outward in powerful, angular movements, and their bodies are strong and muscular. In every way they resemble Antonio's other warring nudes.

261–63; fig. 82
Tomb of Pope Sixtus IV

1484–93. Bronze. Tesoro, St. Peter's, Rome

Pope Sixtus IV died in Rome on August 12, 1484. The splendid bronze tomb monument erected to him was commissioned by his nephew, Cardinal Giuliano della Rovere, the later Pope Julius II. Just when this occurred is not known, but it must have been shortly after Sixtus's death. The monument was completed in 1493. It bears the signature OPUS ANTONI POLAIOLI FLORENTINI ARG AUR/PICT AERE CLARI/AN DOM MCCCCLXXXXIII. According to the *Codice Magliabechiano* (1537–42), Antonio's brother Piero collaborated with him on the work, but his contribution was surely only secondary. The tomb originally stood on a base of green porphyry in the center of the chapel that Sixtus IV had erected on the south side of Old St. Peter's, the so-called Choir of Sixtus IV. It was moved to the sacristy of Old St. Peter's in 1609, and over the course of the following centuries it was again moved several times. A few years ago it was finally placed in the Tesoro.

The Tomb of Pope Sixtus IV is a freestanding floor monument (fig. 82) and thus differs from most other papal monuments from the fifteenth century, which were placed against walls. The only one of similar form is the Tomb of Pope Martin V in the Lateran (fig. 34). These two are also alike in that they are executed in bronze, although in the case of Pope Martin's monument it is only the tomb slab itself that was cast, whereas this one is entirely

bronze. The Sixtus monument is also significantly larger and more elaborate in its decor. The broad, catafalquelike base with its many figural reliefs and its volutes of acanthus leaves is especially opulent. The figure of the pope is laid out above this base on a simple mat. A sequence of ten reliefs encircles the concave, sloping edge of the base. These are allegories of the Liberal Arts—the conventional seven plus Prospective (optics), Philosophy, and Theology. Framing the pope's effigy on the top of the base is another relief series, this one presenting the Virtues: Charity, Hope, Temperance, Justice, Faith, Prudence, and Fortitude. On the corners are the Rovere family and papal coats of arms, and beneath the pope's feet is an inscription glorifying the deceased and naming Giuliano della Rovere as the donor of his monument. Acorns and oak leaves, the emblems of the Rovere family, recur in numerous variations.

It is common to find the Virtues included in the sculptural program of an elaborate tomb such as this; however, the appearance of the Liberal Arts is a distinct innovation. Undoubtedly they seemed appropriate in that Sixtus IV was a man of considerable learning and the founder of the Vatican Library. The female figures personifying the Arts are given their traditional attributes and accompanied by illuminating quotes from ancient and medieval writers (see Ettlinger 1978). No other cycle of the Arts presents such narrative fullness and figural grace. Airy and richly folded garments drape the voluptuous bodies of these ladies in their charming, langorous poses—a distinct contrast to the unmoving figure of the deceased pope in the center of the monument.

The pope's face, directly modeled after a death mask and framed by his splendid vestments, is especially expressive. The sculptor has heightened the effect of its withered, shrunken features by enlarging the eye sockets. The hands are folded above the pallium, beneath which a band running up the center of the chasuble is ornamented with engraved figures of the Virgin, Sts. Peter and Paul, and saints of the Franciscan order: Francis himself, Anthony, and Bonaventure. In their richness, with a variety of ornament in addition to the figures mentioned, these vestments are similar to those from the Tomb of Pope Martin V. That earlier work may indeed have served as a model for the Sixtus tomb, although it was to be considerably outdone in size and splendor here.

264, 265; fig. 83
Tomb of Pope Innocent VIII

1492–98. Bronze, partially gilt and painted. St. Peter's, Rome

Pope Innocent VIII died on July 25, 1492, and his bronze wall monument was commissioned by his nephew, Cardinal Lorenzo Cibo. The work must have been completed before January 30, 1498, for on that day the pope's remains were placed inside it. According to the *Codice Magliabechiano* (1537–42), Antonio's brother Piero collaborated on this tomb as well, but, as in the case of the monument to Sixtus IV, he can only have played a subordinate role. Originally the tomb stood in the south transept of St. Peter's next to Innocent's Oratory of the Sacred Lance. In 1507 it was moved, together with the oratory, into the right aisle, and in 1621 to its present location in the basilica's left aisle. In

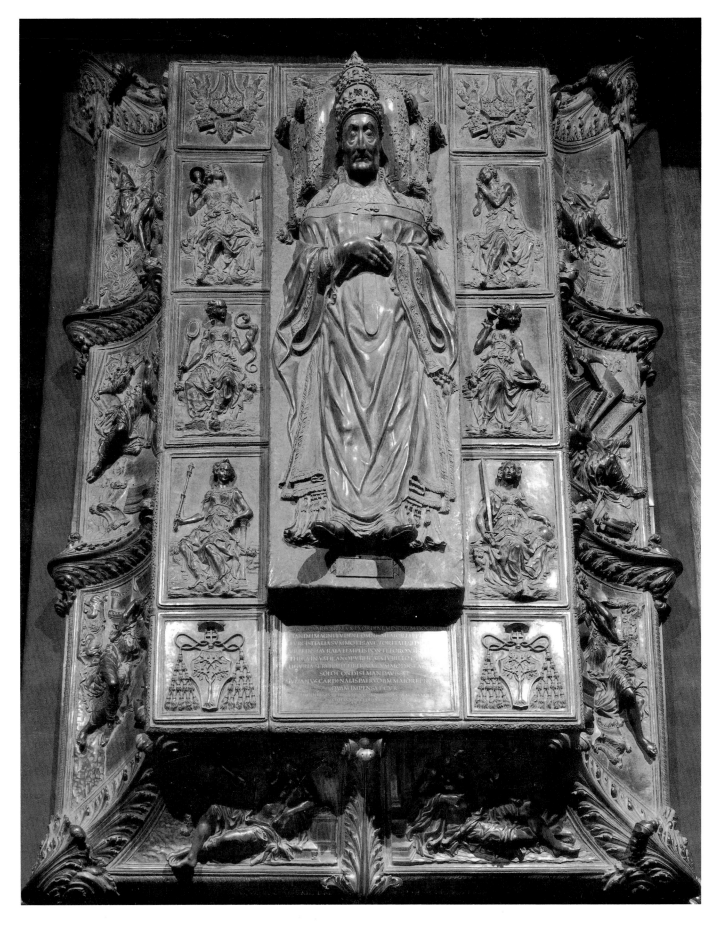

82 Antonio del Pollaiuolo. Tomb of Pope Sixtus IV. Tesoro, St. Peter's, Rome

83 Seventeenth-century drawing of the Tomb of Pope Innocent VIII.
Kupferstichkabinett, Berlin

this last move the original arrangement of the monument was altered in that the sarcophagus was placed below the enthroned pope instead of above him. The original arrangement is preserved in an anonymous drawing from the early seventeenth century (fig. 83), which mistakenly depicts a Madonna and Child in the tympanum, and also in a drawing by Maerten van Heemskerck, both of which are preserved in Berlin's Kupferstichkabinett.

Like the Tomb of Pope Sixtus IV, this one for Innocent VIII is made entirely of bronze, but in this case it is richly gilt. It differs from all earlier papal monuments in that the pope is portrayed in life as well as in death. He sits enthroned in his ceremonial vestments in the center of the composition. In his left hand he holds the tip of the sacred lance, a priceless relic given to him by Sultan Bajazet II, while his right hand is raised in benediction. There had been precedents for combining living and dead figures of the deceased in late medieval tomb monuments, but only in the tombs for Venetian doges from about 1480, notably the ones for Niccolò Tron (fig. 69) and Pietro Mocenigo (fig. 70), is the living figure as dominant as this one. In this respect the Tomb of Pope Innocent VIII was an important precursor of later papal tombs, such as those for Leo X, Clement VII, and Paul III.

Innocent's monument, like the one for Sixtus IV, is framed by allegories of the Virtues. Justice and Fortitude appear on the left, Temperance and Prudence on the right, Faith, Hope, and Charity in the tympanum. Those of the Cardinal Virtues are based on the designs already utilized in the Tomb of Pope Sixtus IV (Ettlinger 1978). As in that earlier work, the coat of arms of the cardinal who paid for the work, the pope's nephew, appears alongside that of the pope. The original marble framing, consisting of an arch flanked by decorated pilasters, has not survived.

Verrocchio
(c. 1435–1488)

Andrea di Michele di Francesco de' Cioni, known as Verrocchio, was born in Florence about 1435. The first documentary reference to him is from 1452. Like his contemporary, Antonio del Pollaiuolo, he was a goldsmith, sculptor, bronze caster, and painter. Moreover, as Vasari (1550) takes pains to point out, he was also a *musico perfettissimo*. He was originally trained as a goldsmith and may have apprenticed under Antonio di Giovanni Dei (Carl 1982). The Medici were his chief patrons. He first appeared as a marble sculptor in the 1460s. In 1461 he competed with Desiderio da Settignano and Giuliano da Maiano for the contract for the decoration of a Chapel of the Madonna in the Duomo in Orvieto. About 1465–67, in Florence, he created the tomb for Cosimo de' Medici in San Lorenzo. In 1468 he produced a large bronze candelabrum for the Sala dell'Udienza in the Palazzo Vecchio (now in the Rijksmuseum, Amsterdam), and between 1468 and 1471 the bronze ball that crowns the cupola of the Duomo. The lavabo in the Old Sacristy of San Lorenzo, often ascribed to the early Desiderio, is more likely an early work by Verrocchio (Passavant 1981).

In 1469 Verrocchio stayed for a time in Venice and Treviso (Covi 1983). In 1471 he was contracted to execute the sculptural decoration for the choir screens of the Duomo in Florence, but the project was soon abandoned. In these years, during which Leonardo was a member of his workshop, Verrocchio must have already enjoyed a considerable reputation as a painter and sculptor in bronze, for in 1466 he was given the important contract for *Christ and the Doubting Thomas* on Orsanmichele, and in 1469 he entered the competition for the cycle of paintings of the Virtues in the council room of the Università dei Mercatanti, which was created instead by the Pollaiuolo brothers and Botticelli. In 1472 Verrocchio completed the Tomb of Piero and Giovanni de' Medici in San Lorenzo. In the same year he is listed as a member of the Brotherhood of St. Luke.

Verrocchio's only documented altar picture, a *Sacra Conversazione* donated to the Duomo in Pistoia in the will of Bishop Donato de' Medici (d. 1474), is, in fact, largely the work of his pupil Lorenzo di Credi. Another painting credited to Verrocchio in the early sources is the *Baptism of Christ* from the Monastery

463

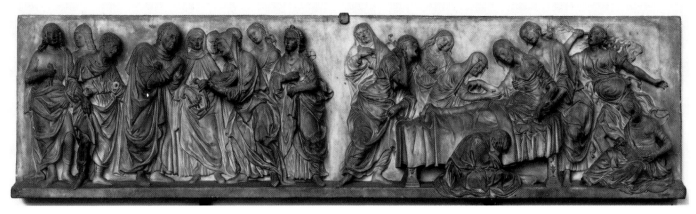

84 Verrocchio. Relief from the Tomb of Francesca Tornabuoni. Museo Nazionale del Bargello, Florence

of San Salvi (now in the Uffizi), which was actually completed by Leonardo. For the rest of his œuvre as a painter, see Passavant (1959; 1969).

In the years after 1475 Verrocchio appears to have turned exclusively to sculpture. In 1477, thanks to the intervention of Lorenzo the Magnificent, he was awarded a contract for the marble cenotaph of Cardinal Forteguerri in the Duomo in Pistoia. In 1478–80 he produced the relief of the Beheading of St. John the Baptist for the silver altar of the Baptistry in Florence. At about this time Verrocchio may also have worked on the Tomb of Francesca Tornabuoni, of which a single marble relief in the Bargello is all that survives (fig. 84). Additional works from these years are the terra-cotta bust of Giuliano de' Medici and a marble *Alexander* relief in the National Gallery in Washington, D.C.; a terra-cotta figure of a sleeping youth in the Staatliche Museen in Berlin-Dahlem; a terra-cotta relief of a Lamentation of Christ that was formerly in Berlin's Kaiser-Friedrich Museum but is now lost; and a terra-cotta relief of a Resurrection of Christ, probably created in collaboration with Leonardo, in the Bargello in Florence. The *Christ and the Doubting Thomas* group was finally installed on Orsanmichele in 1483. The following years were devoted above all to work on the equestrian monument of Bartolommeo Colleoni, which had occupied him since 1480. Verrocchio did not live to cast the monument himself. He died in Venice in 1488 and was buried in the Church of Sant'Ambrogio in Florence.

Vasari [1550, 1568]; Bode 1882; Fabriczy 1895; Mackowsky 1896; Fabriczy, "Hl. Ludwig," 1900; Cruttwell 1904; Sachs 1904; Kennedy, Wilder, and Bacci 1932; Planiscig 1933; Middeldorf 1934; Middeldorf 1935; Planiscig 1941; Mather 1948; Valentiner, "Verrocchio," 1950; Pope-Hennessy 1958 (1985); Passavant 1959; Balogh 1962; Stites 1963; Covi 1966; Shearman 1967; Covi, "Date," 1968; Covi, "Unnoticed," 1968; Kennedy 1968; Heil 1969; Passavant 1969; Seymour 1971; Cannon-Brookes 1974; Pope-Hennessy 1974; Negri Arnoldi, "Monumento," [1978]; Clearfield 1981; Passavant 1981; Carl 1982; Herzner 1982; Covi 1983; Dalli Regoli 1983; Carl 1987; Covi 1987; Pope-Hennessy 1988; Adorno 1989; Fletcher 1989; Passavant 1989.

266
David

Before 1469. Bronze, 49⅝" high (126 cm.). Museo Nazionale del Bargello, Florence

This statue, which is mentioned in Tommaso del Verrocchio's inventory from 1496, was presumably created for Piero de' Medici in the late 1460s. It is not know where the work was originally meant to stand. On May 10, 1476, it was sold to Florence's Signoria for 150 florins by Piero's sons Lorenzo and Giuliano and placed in the Palazzo Vecchio. In the early seventeenth century it found its way to the Guardaroba Ducale, in 1704 to the Uffizi, and before 1870 to the Bargello. Its marble base is not the original.

As a freestanding figure, and also in its pose and gestures, Verrocchio's statue is a direct descendant of Donatello's two *David* figures, although it preserves little of the complexity and controlled drama of the Donatello works. The chief features taken over from Donatello's marble *David* (plate 41) are the slight twist of the body, the challenging level gaze, and the left arm brazenly propped against the hip. From his bronze *David* (plate 105) come the indolent pose, the capacity to be viewed from all angles—although preference is definitely accorded to the front—and the emphasis on nudity. Verrocchio tones down the latter by having only the limbs, the shoulders, and the throat exposed. He combines a distinct realism, evident in the angularity of the figure's silhouette, his bony physique, and his somewhat mature-looking features, with a deliberate striving for decorativeness and beauty. Fringes and broad borders ornamented with vines and Kufic writing embellish the boy's skirt, doublet, and boots, and his hair is richly curled.

His lean, angular physique and his facial features—large, wide-spaced eyes, sharply ridged brows, narrow nose, and thin-lipped mouth—are like those of Desiderio's figures of young men. Also reminiscent of Desiderio are the explicit nakedness of the shoulders and revealing neck opening, as well as the affected placement of the fingers. On the other hand, the angular pose and the emphasis on the ribs, veins, and tendons are features the work shares with figures by Antonio del Pollaiuolo. Here we see why Vasari (1550) is correct when he stresses Verrocchio's *maniera alquanto dura e crudetta* (somewhat hard and crude manner), which is not so evident in his later figures. The *David* was probably not created in the 1470s, as is generally—and arbitrarily—assumed, but rather in the late 1460s. Passavant (1969) quite rightly concludes from the fact that both Medici brothers sold the figure to the Signoria that it had either belonged to Piero de' Medici, who died in 1469, or had at least been

commissioned by him. Yet he does not question the traditional dating of the work to the 1470s. Other scholars, namely Schubring (1919), and more recently Seymour (1966; 1971) and Cannon-Brookes (1974), have argued that the work was completed even before 1469.

267; fig. 85
Tomb of Giovanni and Piero de' Medici

1472. Marble, pietra serena, red and green porphyry, and bronze, 14' 9" × 7' 10⅞" (450 × 241 cm.). San Lorenzo, Florence

Giovanni and Piero de' Medici were the sons of Cosimo the Elder. Giovanni died in 1463, Piero in 1469. Their tomb monument, as its inscription relates, was commissioned by Lorenzo and Giuliano de' Medici, Piero's sons. It was completed in 1472. There are no records of payments; however, the tomb is included in the list of works the artist had executed for the Medici that was compiled by Verrocchio's brother Tommaso in 1496. Verrocchio is also credited with the creation of the monument in the *Libro di Antonio Billi* (1516–20), the *Codice Magliabechiano* (1537–42), and by Vasari (1550).

The double tomb occupies a large opening in the wall between the Old Sacristy and the adjacent chapel — also a Medici chapel, dedicated to Sts. Cosmas and Damian — and thus corresponds to a type of tomb monument that was already common in Florence in the Trecento (Bardi and Baroncelli tombs [fig. 85] in Santa Croce) and the early Quattrocento (Tomb of Onofrio Strozzi, in the sacristy of Santa Trinità). The Medici tomb in San Lorenzo is nevertheless by far the largest and most lavish monument of this kind. Its marble base rests — seemingly only temporarily — on four bronze turtles and is ringed by large letters of a dedicatory inscription. Above it stands the rectangular porphyry sarcophagus, supported by bronze lions' feet sprouting splendid bronze acanthus leaves and stems that wind luxuriantly around the corners. The model for this type of foliage decor was surely the sarcophagus of the Marsuppini tomb in Santa Croce (plate 199).

In the center of each of the casket's fronts is a round slab of green porphyry, framed by a bronze wreath of fruits and foliage, on which appear the names and ages of the deceased. The tall lid of the sarcophagus, made of marble, porphyry, and bronze, is lavish in its design. It is crowned by a diamond, the emblem of the Medici, rising out of a cluster of acanthus leaves, while additional leaves and cornucopias originating from the same cluster twist to either side. Bronze cordage forms a net over the lid and links it to the grating of the same pattern that fills the round-arch opening above. On the arch itself the Medici emblem of a diamond ring is combined with garlands of flowers rising up out of slender vases on either side.

The monument has neither figural decor nor Christian imagery. The precious materials have been carefully combined for maximum effect. Antique ornamental marbles brought specially from Rome have been used even more lavishly than on the tomb of the Portuguese cardinal or on Cosimo's tomb slab. Another feature of the design is its elegant weightlessness, for each of its horizontal elements appears to be unsupported. The bronze

85 Baroncelli Tomb. Santa Croce, Florence

decor seems almost like filigree. Its blending of various forms and materials—foliage, lions' paws, shell-shaped cornucopias, imitation cordage, diamonds, etc.—far surpasses Desiderio's ornamental repertoire. The decorative foliage on the marble frame is heavier and less varied and may well have been carved by assistants. The inscription on the base reads: LAURENT. ET IUL. PETRI F. / POSUER. PATRI PATRUOQUE / MCCCCLXXII; the ones on the sarcophagus: PETRO / ET IOHANNI DE / MEDICIS COSMI P.P. F. / H.M.H.N.S. and PET. VIX. / AN. LIII. M. V. D. X. V. / IOHAN. AN. XLII. M. IIII. / D. XXVIII. The beginnings of the inscriptions and the coat of arms at the top of the arch mark the side facing the chapel as the main one. The precise indication of the ages of the deceased (ANNOS . . . MENSES . . . DIES . . .) is found on Cosimo's tomb slab as well and reflects the popularity of ancient Roman customs that was just taking hold in these years.

268
Woman with Posy

c. 1475 (?). Marble, 24″ high (61 cm.). Museo Nazionale del Bargello, Florence

This bust, said to have belonged to the Medicis, was acquired by the Bargello shortly after 1880 and was first recognized as a work of Verrocchio's by Venturi (1908). Earlier attempts to attribute it to Leonardo, or at least to claim that he had collaborated on it, have quite rightly been rejected by more recent scholars. Even so, there is a certain similarity to Leonardo's *Portrait of Ginevra de' Benci* from about 1474–76 (National Gallery, Washington, D.C.), which was originally larger than it is now and probably also included the subject's hands. Portraits in the form of half-figures, apparently under the influence of Flemish examples, were not uncommon in Florentine painting of this period. Verrocchio could also have been inspired by half-figure busts from antiquity (Passavant 1969).

We do not know the name of the sitter. Earlier writers tried to identify her as Lucrezia Donati or Ginevra de' Benci, but without any real justification. Schuyler (1976) has recently argued again in favor of the latter identification. The woman's gaze is turned slightly to the side. However, her hands are more eloquent and expressive than her face. They carefully shelter a small bouquet of flowers wrapped in a veil against her breast. The subject's hair is fashioned in the same way as Ginevra de' Benci's, and the cut and button closing of her shift are also identical. However, her gown is made of a very thin fabric gathered in tiny folds at the neck. This feature is reminiscent of the portrait of Smeralda Brandini (?) in the Victoria and Albert Museum, which is attributed to Botticelli and dates from roughly 1471 (Lightbown 1989). That woman's hair and somewhat angular features are also similar to those of Verrocchio's bust.

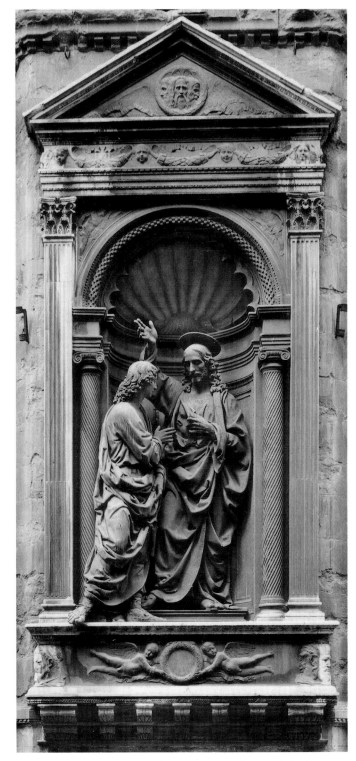

86 Verrocchio. *Christ and the Doubting Thomas.* Orsanmichele, Florence

269; fig. 86
Christ and the Doubting Thomas

1467–83. Bronze. Figure of Thomas, 78¾″ high (200 cm.); figure of Christ, 90½″ high (230 cm.). Orsanmichele, Florence

On March 26, 1463, the by then politically ineffectual Guelph party sold its tabernacle on Orsanmichele to the Mercatanzia, Florence's merchants' guild. It had been erected by Donatello, along with his statue of St. Louis, some forty years before. Three days after the sale, on March 29, the Mercatanzia decided to

466

place a statue of its patron saint in the newly acquired tabernacle. There was no mention of two figures until March 1468. Verrocchio was given the commission in 1466, and a first payment was made to him on January 15, 1467. On March 30, 1468, it was agreed that he would receive monthly payments of 25 lire for his work on the bronze figures, and the bronze was weighed out on August 2, 1470. Yet the work dragged on for years. The payments were increased in 1476 and again in 1480. Finally, on April 22, 1483, the figures are described as "almost finished," and a short time later, on June 21, 1483, they were set in place.

Aside from the special case of the *Four Crowned Martyrs*, only single figures, the patron saints of the various guilds, had been set in the tabernacles on Orsanmichele. The Mercatanzia's decision to have its St. Thomas portrayed together with Christ, rather than alone, was unprecedented and was probably only made at the urging of Verrocchio himself. His scenic concept of statuary is altogether consistent with the artistic leanings of the 1460s, which valued richly contrasting arrangements of figures and framing architecture such as had already distinguished the tomb of the Portuguese cardinal from the Bruni monument and ultimately derived from the works of Donatello from the 1430s.

By the 1460s, a statue strictly subordinated to its framing niche would have seemed somehow old-fashioned—at least in Florence. Verrocchio avoided this by portraying Thomas in his confrontation with the resurrected Christ. No longer was the patron saint to be placed in the center of the tabernacle facing outward; rather, he became a secondary figure viewed only from the side. One first sees the figure of Christ inside the niche, elevated on a plinth. With one hand he opens his shirt to reveal his wound, while the other is raised so that his side is clearly visible. Thomas, reaching out a hand as though to touch the wound, quite naturally stands outside the frame of the niche. The strong twist of his body and the emphasis on his lagging right foot serve to direct our gaze into the focus of the encounter.

Particularly striking in this Verrocchio work are the rich and carefully studied arrangement of drapery folds and the elegantly curling, shoulder-length hair that serves to set off the handsome features of both his figures. With this hair and a decorous wavy beard, Christ looks like that of a proper Nazarene and is imbued with such ideal good looks that Verrocchio's contemporary Luca Landucci (1483) could refer to it as "the most beautiful head of the Savior ever created."

There are obvious differences in the design of the drapery and in the faces of the two figures, which are explained by the length of time it took to produce the work and Verrocchio's changing style over the course of those years. The *Christ* figure's robe falls in broad, graceful folds and largely obscures his body. In the *Thomas* figure, by contrast, the body emerges from beneath to dominate the drapery. The excess fabric in his garments is more clearly organized, and here the sculptor displays an obvious preference for folds that are puckered and rounded. If one compares the two faces, it also becomes clear that the *Christ* was the one completed earlier, the *Thomas* later. The figure of Christ was finished by 1479 at the latest (Passavant 1969), while at that point the *Thomas* figure had not yet been cast. Verrocchio created a model of the *Thomas* figure that the Mercatanzia had set up in its council room in 1483, but it has disappeared.

270
Madonna and Child

c. 1480. Terra-cotta, painted, $33\frac{7}{8} \times 26''$ (86×66 cm.). Museo Nazionale del Bargello, Florence

This relief is not documented as the work of Verrocchio; however, since Bode attributed it to him (1892–1905), it has been unanimously accepted as such. In the nineteenth century it belonged to the hospital of Santa Maria Nuova. In 1901 it was acquired by the Uffizi and two years later was moved to the Bargello. Only traces of the original paint are preserved (Passavant 1969).

The Madonna does not hold her Child on her lap but rather steadies him as he stands on a cushion and gives his blessing. This arrangement ultimately derives from the tympanum reliefs of Bernardo Rossellino and Desiderio da Settignano on the Bruni and Marsuppini tombs. The Bargello relief is especially close to Desiderio's tondo (plate 200), in which the Madonna's full cloak falls across the lower part of the frame. Also related to it is the *Madonna* relief in the National Gallery in Washington, D.C. (Kress Collection) that Pope-Hennessy ("Altman Madonna," 1970) attributes to Antonio Rossellino. That relief is itself heavily indebted to Desiderio's Marsuppini tondo.

In accordance with developments in Florentine sculpture in the 1460s and 1470s, Verrocchio's figures are considerably more three-dimensional, their body forms fuller, their drapery more voluptuous. In fact, the drapery is not unlike that of the *Christ* figure from Orsanmichele, while the Madonna's physiognomy—a pointed, oval face, high forehead, shallow-set eyes, prominent nose, dimples at the corners of the mouth—is similar to that of *Faith* in Pistoia. Thus it is most likely that the relief was created about 1480, as Planiscig (1941) proposed.

271
Putto with Dolphin

c. 1480. Bronze, $26\frac{3}{8}''$ high (67 cm.). Palazzo Vecchio, Florence

Listed by Tommaso del Verrocchio in 1496 as *el bambino di bronzo*, this small figure was originally the crowning ornament on a fountain at the Medicis' Villa at Careggi. Sometime between 1550 and 1568 it came to the Palazzo Vecchio, where it again adorned a fountain in the interior courtyard. In 1959 it was replaced by a copy and moved inside the Palazzo. Tommaso speaks of lion protome and bronze heads that may have been among the ornaments for the fountain in Careggi as well, but these have not survived. Passavant (1969) conjectures that the basin of the original fountain was an antique porphyry one that is now in the second interior court of the Palazzo Vecchio. He also presents convincing reasons for assuming that the putto was originally mounted in such a way that it could be turned in any direction.

It is possible that the motif of a putto embracing a dolphin was suggested by an ancient bronze. However, the Renaissance sculptor has given his figure a distinctly unclassical, dancelike pose that engages his whole body. This virtuoso pose, delicately balanced and complete with a half-twist of the body for the sake of multiple points of view, becomes the dominant interest, while

the dolphin only serves as a means of maintaining balance, strengthening the twist, underscoring the figure's untroubled zest for life. In this latter aspect the putto is more closely related to figures like Donatello's "*Amor-Atys*" than to ancient bronzes. Although it was intended to be viewed from all sides, it is only as one approaches the front that it presents a number of equally interesting faces. The masterful command of movement in the pose of this putto, its evocation of the transitory moment, the roundness of its body, and the softness of its strands of hair all suggest that it was created long after the bronze *David*, most likely sometime close to *Christ and the Doubting Thomas* group.

272
Beheading of St. John the Baptist

1478–80. Silver, 12⅜ × 16½″ (31.5 × 42 cm.). Museo dell'Opera del Duomo, Florence

In 1477 the Arte di Calimala decided to add reliefs to the sides of the Baptistry's fourteenth-century silver altar. Accordingly, it announced a competition, and five artists took part, including Verrocchio. By August 2, 1477, he had submitted two models; however, his contract from January 1478 calls for only one, namely, the lower one on the left-hand side, which was to portray the beheading of John the Baptist. He was expressly admonished to follow the format and technique of the older reliefs from the front of the altar, making his figures the same size as theirs. He delivered the finished relief in 1480.

The Baptist kneels in prayer in a courtyard closed off at the back by arcades. The executioner, his sword raised for the fatal blow, is set apart from the others in that he is almost completely nude. His pose and his brawny form present an image of great strength. Encircling the executioner and his victim are a number of soldiers wearing fantastic, richly ornamented armor. One of the three at the back is approaching the Baptist, and his look and raised left hand betray his sympathy, yet in his right hand he holds the tray on which he will bring the head to Herod's table. The two in the right-hand foreground are grimly focused on each other. One of them takes hold of his mace as though he is about to strike, while the other places his hand to his breast to reassure him.

The artist is clearly concerned in this relief with powerful movements, expansive gestures, lively expressions, and a bizarre splendor in the ornamentation of the armor. Ignoring the injunction to keep to the overall scheme of the older reliefs, he emphasizes his figures rather than the overall layout and architectural background. He further heightens the drama of the scene by layering his figures at an angle and alternating front and back views of them. In Verrocchio's other works from before 1480, one only encounters such violent, enraged expressions as these in his *Resurrection* relief from Careggi (illus. p. 47), and it is highly likely that they are the result of Leonardo's influence.

273; figs. 87, 88
Cenotaph of Cardinal Niccolò Forteguerri

1476–88. Marble. Duomo, Pistoia

Cardinal Forteguerri died in Viterbo on December 21, 1473, and was buried in his titular Church of Santa Cecilia in

87 Cenotaph of Cardinal Niccolò Forteguerri. Duomo, Pistoia

Trastevere in Rome. Very soon afterward, on January 2, 1474, the council of his hometown of Pistoia decided to erect a cenotaph to him in the Duomo. A competition was announced, and five artists submitted their designs on May 25, 1476. Verrocchio's design was selected; however, the commission could not agree to proceed because of the high fee the artist demanded. An additional design from Piero del Pollaiuolo was therefore requested. Once this one had been submitted as well, in March 1477, the council called in Lorenzo de' Medici to choose between the two. Before the month was out he had decided in favor of Verrocchio.

The contract had been officially awarded to him well before this, in November 1476. However, the first mention of his work on the monument is from April 1483, and in November of that year it is spoken of as "nearly finished." Nevertheless, by the

88 Verrocchio. *Bozzetto* for the Forteguerri cenotaph in Pistoia. Victoria and Albert Museum, London

time Verrocchio died in 1488 he had completed only seven of the nine marble figures called for: the Christ, four angels, Faith, and Hope. It was not until 1514 that the sculptor Lorenzo Lotti was asked to finish the cenotaph. He produced only the figures of Charity and the kneeling cardinal; the latter, now in the Museo Civico, was probably completed by Giovanni Francesco Rustici (Middeldorf 1935).

The monument was given its present form (fig. 87) in 1753, when it was moved and reassembled. The sarcophagus, the bust of the cardinal, the mourning putti, and the frame were created at that time. A repeatedly restored *bozzetto* (sketch-model) in the Victoria and Albert Museum (fig. 88), which is probably the model submitted by Verrocchio in 1476 (Passavant 1969), gives us some idea of the artist's original concept. Despite the later repairs and additions to this terra-cotta model, we see from it that the cardinal, kneeling on the sarcophagus, was supposed to be looking up at the figure of Christ, who gives his benediction from a mandorla supported by four angels. Charity, hovering above the cardinal and holding a torch in her raised right hand, was to function as an intermediary. Faith and Hope were to appear on either side of the cardinal.

The gestural link between the cardinal and Christ, crucial to the entire ensemble, was considerably weakened by Lorenzo

Lotti. Instead of looking straight down while pointing upward, his *Charity* turns to face the *Hope* figure. Even the figures completed by Verrocchio and his workshop differ sharply from those of the *bozzetto*. The marble figures are more awkward, more uniform, and crowded more closely together than the much freer and more varied figures of the model. The relief with the inscription on the base, although probably also from Verrocchio's workshop, is especially poorly executed.

In its design and motifs, this monument was without precedent. The only works to anticipate it even remotely are those Roman tomb monuments from the Early Renaissance (the Tomb of Pope Pius II in Sant'Andrea della Valle, fig. 67; the Tomb of Pietro Riario in Santi Apostoli, fig. 66) on which the deceased kneels before the Madonna. Yet the Forteguerri cenotaph far surpasses these in the number of its figures, its movement, and its unified design. In all these respects it more closely resembles the gable relief of the Porta della Mandorla or the tomb of the Portuguese cardinal than it does any Roman tomb monuments.

274, 275
Two Angels

c. 1480. Terra-cotta, 15 × 13¾" (38 × 35 cm.). Louvre, Paris

Both of these reliefs, which have later repairs and restorations in a number of areas, were first included in the Verrocchio œuvre by Bode (1892–1905). The angels rush forward in rapturous motion across a carpet of clouds. They once must have supported a cloud mandorla framing a seated Christ or a Virgin borne upward into heaven. They resemble the angels of the Forteguerri cenotaph and may have been sample sketches for that work, in which case the figures were considerably modified in the final version (Middeldorf 1934). The differences in the execution of the two angels are considerable and have to do with both their proportions and the articulation of their bodies. The one on the left is more logically constructed, the twisting of its body more assured. It is likely that this one was created by Verrocchio himself. The limbs and wings of the one on the right are more two-dimensional. The excess of fabric in her garments is also somewhat exaggerated, an effect underscored further by fluttering ribbons. The twist to her body has not been caught with the same certainty, so that the legs do not appear connected to the torso. Given these obvious artistic weaknesses, it is difficult to imagine that this right-hand angel is the work of Leonardo, as has been suggested (Passavant 1969). More likely it is by an anonymous member of Verrocchio's workshop.

276, 277
Equestrian Monument of Bartolommeo Colleoni

1479–88 (96). Bronze, 12'9½" high without base (395 cm.). Campo Santi Giovanni e Paolo, Venice

Bartolommeo Colleoni, the captain general of the Venetian forces, died on November 3, 1475. In his will he left a considerable sum of money to the Venetian republic, with the wish that an equestrian monument be erected to him on the Piazza San

Marco. It was only on July 30, 1479, that the Signoria took up his request, deciding to place the monument next to Santi Giovanni e Paolo instead. The sculptors Alessandro Leopardi and Bartolomeo Bellano competed with Verrocchio for the commission. A letter from Ferrara's ambassador to Florence to the duke of Ferrara, Ercole d'Este, informs us that by July 16, 1481, Verrocchio had completed a lifesize wooden model of the horse. In his letter he requests free transport for the model through the province of Ferrara. The equestrian models by all three artists taking part in the competition were displayed in Venice in 1483.

In 1486 Verrocchio moved to Venice to work on the monument, and he died there in 1488, probably on June 30. By that time he had managed to complete only the full-size clay model of his horse and rider. In his will, written on June 25, 1488, he recommended that the Signoria have his pupil Lorenzo di Credi finish the *opus equi*. The Signoria ignored his suggestion, and in 1489 it entrusted the completion of the work to Alessandro Leopardi. The horse and rider were cast in 1492. The design of the base, altogether un-Florentine in style, was also left to Leopardi. The monument was unveiled on March 21, 1496. The horse's girth bears the inscription ALEXANDER LEOPARDUS V. F. OPUS. Leopardi is to be credited not only with the bronze casting, but also with the ornaments and other details only worked out in the process of chiseling.

The artistic precedents for this work were Donatello's *Gattamelata* and the equestrian monuments of antiquity. Its elevated position, dominating the square, and the rider's commanding gesture are especially reminiscent of the former. Verrocchio has deliberately made his *Colleoni* more aggressive, emphasizing the tension in his body, the latent strength of both horse and rider. The especially muscular horse advances, his rider pressing into his sides with his knees. Sitting tall, the general leans back, thrusts his chest forward commandingly, and fixes his stern gaze on some distant objective over his left shoulder.

The action is frozen at this specific moment. The desired effect of strength and determination is enhanced by the commander's exaggerated expression and the resolve with which he holds his baton. His bridle and armor—unlike those of the *Gattamelata*—are altogether contemporary in style. One notes, however, that the rider does not carry a sword at his side. It is possible that the artist omitted it, fearing that it would interfere with the powerful *contrapposto* he had developed in his horse and rider. Verrocchio's concerns were obviously influenced by Leonardo, who at about this same time—since roughly 1483—was engaged in the first designs for his own equestrian monument to Francesco Sforza in Milan. Leonardo initially pictured his rider in action on a rearing horse, thereby avoiding the theatrical tricks that characterize the *Colleoni* (illus. p. 36).

Bertoldo di Giovanni
(c. 1440?–1491)

We know neither the place nor the year of Bertoldo's birth. However, it cannot have been later than about 1440 or earlier than about 1420. In a letter to Lorenzo de' Medici from July 29, 1479, Bertoldo himself states that he was a pupil of Donatello's. According to Vasari (1550), he was engaged in the completion of the pulpits for San Lorenzo, which can only mean that he helped with the chiseling of the reliefs. Bertoldo was almost exclusively a bronze sculptor and medalist. He is first documented in 1476 (Foster 1981). His medallion of Emperor Friedrich III, from 1469, is thought to be his earliest surviving work. In 1478 he created a medallion commemorating the Pazzi conspiracy, and in 1480–81 the one of Sultan Mohammed II, the only medallion that he signed. In 1483 Bertoldo sought to obtain a contract for the bronze reliefs on the choir screens in the Santo in Padua. The sample relief he submitted obviously failed to meet the expectations of the jury, however, for the commission was awarded to Bellano. The signed *Bellerophon* in Vienna's Kunsthistorisches Museum may have been executed at about this time.

Other works by him are two reliefs in the Bargello, one of a battle scene, the other a Crucifixion. A *Centaur* mentioned in the Medici inventory of 1492 no longer survives. Numerous other small bronzes are attributed to Bertoldo. They include a *Hercules* on horseback in the Galeria Estense in Modena; two coat-of-

arms bearers, one in the collections of the Princes of Liechtenstein in Vaduz, the other in the Frick Collection in New York; two *Hercules* statuettes, one in London's Victoria and Albert Museum, one in the Frederiks Collection in The Hague; and statuettes of a prisoner and a St. Jerome, both formerly in the Kaiser-Friedrich Museum in Berlin. In his late years Bertoldo belonged to Lorenzo de' Medici's inner circle and apparently served as his adviser in artistic matters. As such, he presumably introduced the young Michelangelo to the Medici's collection of antiquities. Vasari (1550) exaggerates when he designates him, in retrospect, the director of a Medici academy. Bertoldo died on December 28, 1491, at Lorenzo's villa in Poggio a Caiano.

Michiel [1521–43]; Vasari [1550, 1568]; Wickhoff 1882; Bode 1895; Bode 1902 (1921); Bode [1907–12]; Bode [1923]; Bode 1925; Hill 1930; Planiscig 1930; Pope-Hennessy 1958 (1985); Pope-Hennessy 1963; Lisner 1980; Foster 1981; Leithe-Jasper 1981; Negri Arnoldi 1983–84; Draper 1984; *Donatello e i suoi* 1986.

278
Bellerophon and Pegasus

c. 1480–85. Bronze, 12¾″ high (32.5 cm.).
Kunsthistorisches Museum, Vienna

This bronze group is one of two surviving signed works by Bertoldo, the other being the medallion of Mohammed II. On the underside of the base, which is of a piece with the figures, is the inscription EXPRESSIT ME BERTHOLDUS CONFLAVIT HADRIANUS. Adriano Fiorentino, a pupil of Bertoldo's, left Florence about 1485, so that the *Bellerophon* group was probably created sometime before that date. Michiel (1521–43) relates that at the beginning of the sixteenth century the work was in Padua, in the house of Alessandro Cappella.

Bellerophon is taming the winged horse by holding tightly to its muzzle with his left hand while threatening it with a switch in his right. If the sculptor was influenced at all by the ancient horse tamers on the Quirinale in Rome, it was only in a very general way. The figure's backward twist and the shift in his center of gravity are so emphatic that they cannot have been based on classical models. Such extreme twisting is one of Bertoldo's favorite artistic devices, as we see from the *Hercules* in Modena and the *Battle Relief* in the Bargello (plate 279). Also typical is the way he has constructed the group in parallel planes. The work is meant to be viewed primarily from the side. The way Bertoldo coordinates the various motifs of movement is altogether similar to his method in the *Battle Relief*. The proportions of this Bellerophon figure, with its slender waist and broad shoulders, are also like those of the figures in his relief, less so the execution of its anatomical details, which in the latter work is more precise.

279; fig. 89
Battle Relief

c. 1485–90. Bronze, $16\frac{7}{8} \times 39''$ (43×99 cm.). Museo Nazionale del Bargello, Florence

This relief is listed in the 1492 inventory of the estate of Lorenzo de' Medici. It hung above the fireplace in a room across from the Sala Grande and was later placed in the Guardaroba Medicea and finally in the Bargello. Vasari (1568) first identified it as the work of Bertoldo, and it is now generally considered his masterpiece. It was obviously patterned after the half-destroyed front relief from a Roman sarcophagus in Pisa's Campo Santo (fig. 89). While the sculptor retained the subject matter and overall composition of the classical work, he clearly altered many of its details and added new ones. In contrast to the ancient relief, for example, his warriors are either completely naked or very nearly so. Also the naked figures of a man and woman flanking the scene, like the Victories and bound captives next to them, are free inventions on Bertoldo's part. Wickhoff (1882) took this couple to be Helen and Hector, but surely he was mistaken.

Bertoldo has also increased the number of figures and the violence of their movements. In so doing he has reinterpreted the ancient cavalry battle and made it a genuine work of the Quattrocento, whose imposing number of figures, poses, and expressive details seems a virtual tour de force. Lisner (1980) identifies the central mounted figure as Hercules, and the lion's skin does suggest as much. Not the winged helmet, however. This ambiguity in the use of attributes is but one example of Bertoldo's somewhat vague definition of the subject matter in general.

280
The Crucifixion

c. 1485–90. Bronze. Museo Nazionale del Bargello, Florence

This relief, first recognized as the work of Bertoldo by Tschudi (1887), is also mentioned in the 1492 Medici inventory. Christ's

89 Battle sarcophagus. Roman. Campo Santo, Pisa

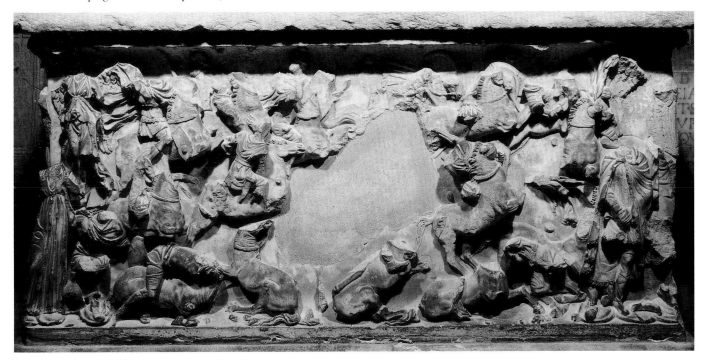

cross faces front between the two angled crosses of the robbers. Below is a throng of men and women lamenting and gesturing toward the Savior, among them St. Francis (the second figure from the left, with flaming stigmata on his hands and feet) and St. Jerome (far left). Two women at the foot of the cross are tearing their hair in a frenzy of grief and holding up whole handfuls of it. To the left and right of these stand Mary and St. John the Evangelist. The male figure standing with his back to us on the right and pointing up at Christ is less easily identified, but he is probably St. John the Baptist. An unusual feature of this portrayal is that we are only shown the mourners at the base of the cross, all of them focused on Christ with an intensity reminiscent of Leonardo, whereas the henchmen, soldiers, and Pharisees traditionally included are nowhere to be seen.

Here, as in his *Battle Relief*, it was clearly Bertoldo's prime intention to present the greatest possible variety of movement and emotion with a limited number of figures. The strict reduction to figures alone is also typical of Bertoldo; he omits all traces of landscape, with the exception of the strips of clouds uniformly distributed across the sky. Otherwise there is but little effort to structure the space of the picture. These same lightweight, often clinging, garments and their sharply defined, calligraphic clus-

ters of thin folds can be seen on the framing figures at the sides of the *Battle Relief*.

281
Apollo or Orpheus (?)

c. 1485–90. Bronze, 17⅜″ high (44 cm.). Museo Nazionale del Bargello, Florence

It was Bode (1895) who first attributed this charming statuette to Bertoldo. Just who it represents is unclear. Bode himself preferred to think of the youth playing a violin as Orpheus or Apollo rather than Arion. He wears a goatskin around his shoulders and a wreath of leaves on his head. Typical of Bertoldo are the combination of forward movement and a dramatic twist to the body, the figure's proportions, its almost complete nudity, and the modeling of its details. Only the legs, trunk, and face have been chiseled; the rest has been left rough. Especially successful is the way the small figure appears to be wholly caught up in his music, an effect produced by the dancelike step, the turn of the body, and the enraptured upward gaze.

Benedetto da Maiano
(1442–1497)

Benedetto da Maiano was born in 1442, probably in Maiano, near Florence, the son of the wood-carver Leonardo d'Antonio. Presumably he began his artistic career as a wood-carver and intarsist in his father's workshop. He is first mentioned in 1466 and 1467 in connection with works he executed with his older brother Giuliano for the Chapel of the Cardinal of Portugal in San Miniato al Monte. Vasari (1550) claims that he traveled to the court of King Matthias Corvinus in Hungary, but there are no documents that confirm this. He probably received his training as a stone sculptor in the workshop of Antonio Rossellino. The marble Shrine of St. Sabinus in the Duomo in Faenza, a work created between 1468 and 1471 and attributed to him, would suggest as much.

Benedetto joined the Arte dei Maestri di Pietra e Legname in 1473. In that same year he spent some time in Rome and probably Naples. In subsequent years Benedetto's workshop in Florence turned out countless altars, tomb monuments, tabernacles, pulpits, statues, and busts. His patrons were not all from Florence. From 1472 to 1475 he worked on the marble altar, including the tomb of the saint, for the Chapel of St. Fina in the Collegiata di San Gimignano, which had been built by his brother Giuliano; in 1474 the bust of Pietro Mellini, now in the Bargello in Florence; in 1475 the bust of Filippo Strozzi (Louvre, Paris); and in 1480 the Madonna dell'Ulivo in the Duomo in Prato. The portal in the Sala dei Gigli in the Palazzo Vecchio occupied him between 1476 and 1481. Works from the 1480s include the marble ciboria in the Collegiata in San Gimignano and San Domenico in Siena; the pulpit in Santa Croce in Florence; the Tomb of Maria of Aragon for the Piccolomini

Chapel in Santa Anna dei Lombardi in Naples (begun by Antonio Rossellino); and the marble altar retable for the Terranuova Chapel in the same church. Benedetto was still receiving payments for both the tomb and the altar in early 1491.

Dated works from the 1490s are the Strozzi monument in Santa Maria Novella in Florence (1491–95), the Altar of St. Bartolus in Sant'Agostino in San Gimignano (1492–94), the terra-cotta statue of a Justice in the Collegio del Cambio in Perugia, and a bust of Onofrio Vanni for the Collegiata in San Gimignano (1493). Also from his late period are the *Coronation* group in the Bargello, intended for Naples; the wooden *Crucifix* from the high altar of the Duomo in Florence; and the marble statues of the Madonna and Child and St. Sebastian in the Oratory of the Misericordia in Florence. More likely from his early years, on the other hand, is the wooden *Magdalene* statue in Santa Trinità in Florence, which Vasari (1550) insists was begun by Desiderio da Settignano and only completed by Benedetto. Countless additional works, in both stone and terra-cotta, are either documented as his or attributed to him. He wrote his will on April 19, 1492, and died on May 24, 1497. He was buried in the Church of San Lorenzo.

Albertini [1510]; Vasari [1550, 1568]; Borghini 1584; Bode 1884; Bode 1887; Fabriczy 1897; Schmarsow, "Kaiserkrönung," 1897; Fabriczy 1903; Bacci 1904; Poggi 1908; Fabriczy 1909; Dussler 1924; Cèndali [1926]; Mather 1948; Lisner, "Benedetto," 1958; Pope-Hennessy 1958 (1985); Caspary 1964; Borsook, "Documenti," 1970; Borsook, "Documents," 1970; Friedman 1970; Hersey, Blunt, and Borsook 1972; Pane 1975–77; Paolucci 1975; Tessari 1975–76; Carl 1978; Morselli 1979; Radke 1985; Lein 1988.

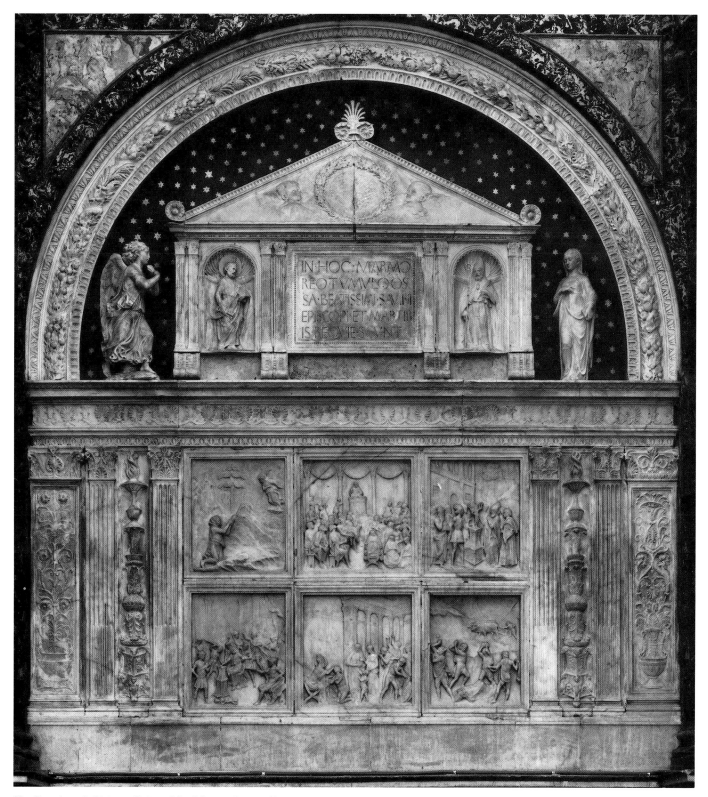

90 Benedetto da Maiano. Shrine of St. Sabinus. Duomo, Faenza

282; fig. 90
Scenes from the Life of St. Sabinus

1468–71. Marble. Shrine of St. Sabinus, Duomo, Faenza

Madonna Giovanna Vestri, the wife of Astorgio Manfredi II, left funds for the marble Shrine of St. Sabinus in her will in 1468. It

was completed in 1471. Its attribution to Benedetto da Maiano, which goes back to Vasari (1568), has recently been given renewed credibility by Radke (1985). The shrine originally stood in the Duomo's St. Andrew Chapel. In 1616 it was moved to the Ivo Chapel, at which time it was somewhat altered. The pilasters that originally divided the relief wall into equal sections

473

were moved to the sides (fig. 90). In its design, the monument is of the arcosolium type of tomb introduced in Florence by Bernardo Rossellino (Tomb of Orlando de' Medici in Santissima Annunziata; Tomb of Giannozzo Pandolfini in the Badia).

A round-arch niche above a rectangular base serves as the frame for the saint's sarcophagus. The inscription in the center panel of the shrine is flanked by niches containing figures of St. Peter and St. Sabinus, while to the left and right of the sarcophagus stand the figures of an *Annunciation* group. The reliefs on the wall of the base present six scenes from the life of St. Sabinus: the saint, withdrawn into the mountains near Fusignano, is instructed by an angel to go to Assisi and preach the Gospel; the saint preaches in Assisi; the saint destroys a heathen idol; the saint's hands are cut off on the base of the idol he destroyed; the healing of the blind Priscianus; the stoning of the saint.

The reliefs clearly reveal Benedetto's schooling in the workshop of Antonio Rossellino. The one in which the saint preaches his sermon is similar, both in overall design and details, to the relief from Antonio's Lazzari tomb in the Duomo in Pistoia, completed in 1468. There are also parallels to the reliefs on the pulpit in Prato's Duomo from 1473. On the whole, however, the Faenza reliefs are more spacious than Antonio's. In his design of these reliefs, Benedetto has treated his figural groupings and his backdrops as distinctly separate layers, and in most cases the architecture is abruptly cut off by the upper border. Both of these characteristics link these works to Donatello's reliefs from the pulpits in San Lorenzo. Benedetto obviously knew them well. This is clear from his figure of the saint praying in the wilderness, reminiscent of Donatello's *Christ Praying on the Mount of Olives* (plate 139), or from the columns crowned with putti in the background of the sermon relief, prefigured in Donatello's *Pilate* relief (plate 144). The façade of a palace in the relief showing the destruction of the idol is clearly patterned after that of the Palazzo Rucellai. In his depiction of landscape, however, Benedetto chose to follow the example of Ghiberti (Lein 1988).

283
Bust of Pietro Mellini

1474. Marble, 20⅞" high (53 cm.). Museo Nazionale del Bargello, Florence

This marble bust is signed and dated and bears the inscriptions BENEDICTUS MAIANUS FECIT, PETRI MELLINI FRANCISCI FILII IMAGO HEC, and AN. 1474. The merchant Pietro Mellini, who also commissioned Benedetto to create a pulpit for Santa Croce, is dressed in a splendid brocade cloak. Unlike earlier busts from the Quattrocento, the breast section of this one is rounded at the bottom in the classical manner. So as to lighten the rigid symmetry of its frontal view, a portion of the cloak has been turned back over the right shoulder. The extraordinary sharpness of detail in the carving of the creases in his face, undoubtedly achieved with the help of a life mask, is reminiscent of ancient Roman portrait busts. The severe axiality of the work, however, and the extremely lifelike tension in the facial features, which makes the eyes and mouth seem particularly sinister, are less dependent on classical precedent. Benedetto failed to achieve the same degree

of lifelike expression in his bust of Filippo Strozzi in the Louvre, which was probably created in 1475 (Borsook, "Documenti," 1970).

284, 285
St. John the Baptist; Justice

1476–81. Portal in the Sala dei Gigli. Marble. Figure of St. John, 52¾" high (134 cm.). Palazzo Vecchio, Florence

Benedetto and his brother Giuliano collaborated on the splendidly decorated portal in the Palazzo Vecchio that leads from the Sala dell'Udienza to the Sala dei Gigli. The intarsias in the doors themselves and the simpler marble frame on the side of the Sala dell'Udienza are attributed to Giuliano (Fabriczy 1903). Benedetto created the more richly designed marble frame in the Sala dei Gigli and the statues above the portal, on one side a youthful *St. John the Baptist*, on the other a *Justice*. They began the work in February 1476, and the final payment to them was made on November 27, 1481.

Benedetto's youthful *Baptist* is unmistakably patterned after Desiderio's "*Giovannino Martelli*" (plate 203), even though his posture is more relaxed, his body softer and fuller, his overall appearance less ascetic. The *Justice* is more clearly developed as a three-dimensional figure. In this respect, and also in the rounded fullness of the fabric of her garments, she anticipates the figural type that would come to dominate Benedetto's work from the 1480s and 1490s. Her nose is damaged, and the hands are missing. According to Vasari (1568), she once held a sword in her right hand and an orb in her left.

286–88; fig. 91
Sermon Pulpit: Scenes from the Life of St. Francis (Ordeal by Fire Before the Sultan; Stigmatization)

c. 1480–85. Marble, partially gilt, 28 × 26¾" (reliefs) (71 × 68 cm.). Santa Croce, Florence

Stone pulpits became increasingly common in Tuscany in the second half of the fifteenth century. Following the example of the Dominicans in Santa Maria Novella, the Franciscans also had one erected against one of the nave pillars of Santa Croce. It was donated by the Florentine merchant Pietro Mellini, whose coat of arms appears on the main console. There are no documents relating to either the artist or the dates of the pulpit's creation. However, there is no reason to doubt the testimony of Vasari (1550), who refers to the pulpit as the work of Benedetto. Scholars are nevertheless in disagreement about its dating. Some place it as early as 1472–75 (Dussler 1924; Pope-Hennessy 1985), others in the period 1480–85 (Schottmüller 1909; Radke 1985; Lein 1988).

Abandoning the round form that had been usual since Donatello created his exterior pulpit in Prato, Benedetto made his pulpit hexagonal (plate 287), undoubtedly adapting it to its six-sided supporting pillar. Between the richly decorated consoles supporting the box of the pulpit are wide niches with seated figures of Faith, Hope, Charity, Fortitude, and Justice. In front

91 Benedetto da Maiano. *Pope Innocent III Confirming the Rule*. Terra-cotta model. Victoria and Albert Museum, London

of the pulpit's corners are small Corinthian columns supporting a projecting entablature. Details such as these reveal that Benedetto had undertaken a study of classical architectural forms on his own. The pulpit's chief ornaments are the five reliefs on its balustrade, depicting: Pope Innocent III confirming the Franciscan rule (with ancient Roman monuments in the background); St. Francis's ordeal by fire before the Sultan (plate 288); the stigmatization of St. Francis (plate 286); the obsequies for St. Francis; the martyrdom of the seven Franciscans in Ceuta.

The reliefs are by no means uniform in their execution. The *Stigmatization* is surely one of the first completed, the *Confirmation of the Rule* one of the last. The sculptor has increasingly abandoned flat relief, limiting it to his backdrops at most. The figures are larger in relation to the picture space than those in the earlier reliefs on the Shrine of St. Sabinus (plate 282). Their volumes and the abundance of soft drapery exceed those of the *Justice* in the Palazzo Vecchio (plate 285) and come closer to those of the *Annunciation* altar in Naples. It seems most probable that the pulpit reliefs were therefore carved in the first half of the 1480s.

Six terra-cotta models for the pulpit reliefs are listed in the inventory of Benedetto's estate from 1497. Four of these are presumably the ones preserved in the Victoria and Albert Museum in London and the Bode Museum in Berlin. Since the three in London have traces of gilding, it has been suggested (Lein 1988) that they may have been temporarily mounted on the pulpit until the marble ones were completed, but as they are roughly five centimeters smaller than the latter, this is far from certain.

289
Madonna and Child

1491–95. White, red, and black marble. Tomb of Filippo Strozzi, Santa Maria Novella, Florence

Filippo Strozzi died on May 15, 1491. In his will, dated May 14, it states that his tomb was still unfinished. Benedetto received his first payment for it on December 13, 1491, his last on March 27, 1495. However, it is clear that the monument was not set up in the Strozzi Chapel until 1497. The wall niche that shelters the sarcophagus is framed by a round marble arch richly decorated on the front with candelabra, vines, masks, and the Strozzi coat of arms. The sarcophagus itself is made of black marble (*pietra di paragone*) like those of the tombs in the Sassetti Chapel in Santa Trinità. The upper part of the niche is filled with a *Madonna* tondo flanked by hovering angels.

The arrangement is still essentially that of the Tomb of the Cardinal of Portugal in San Miniato. The figures fill the frame more completely than in earlier *Madonna* tondi, whether by Antonio Rossellino or by Benedetto himself. In addition, they are placed closer together, and their poses are dictated somewhat more by the circular frame. Here the Child does not sit forward to give benediction, but rather leans back in his mother's arms and looks up at her, a motif repeated in others of Benedetto's late tondi (*Scarperia* and *Prepositura* in the Elvehjem Art Center, Madison, Wisconsin) and in his *Madonna* statue in the Misericordia (plate 291).

290
Coronation of Ferrante I of Aragon

c. 1494. Marble. Museo Nazionale del Bargello, Florence

The Bargello acquired this group in 1870. It is mentioned in the inventory of Benedetto's estate from 1497 and was part of the figural decor for the "Porta Reale"—presumably the Porta Capuana—in Naples, which Vasari mentions (1550). Five figures of musician listed in the same inventory were also intended for that work, which Benedetto left unfinished. This group depicts the papal legate Cardinal Latino Orsini crowning Ferrante I of Aragon king of Naples, an event that took place on February 4, 1459. The group was probably left unfinished as the result of Ferrante's death in 1494.

Especially striking in this reconstruction of that imposing ceremony are the sharply contrasting emotions: the king sits on his throne serenely, the orb and scepter in his hands, while the cardinal twists toward him with great intensity, holding the crown above his head. The urgency of his motion is underscored in that the cardinal's face is half-obscured by his raised arm and the mass of gathered drapery drawn with it. These weighty garments and compact figures are typical of Benedetto's late work. The six musicians meant to frame the *Coronation* group appeared on the art market in 1969 and were purchased for the Bargello. These are surely the "*musici*" mentioned in the estate inventory, although there are five rather than six.

291
Madonna and Child

c. 1497. Marble. Oratory of the Misericordia, Florence

This *Madonna* is listed in the 1497 inventory of Benedetto's estate as a "Mary figure" and is one of the last of the sculptor's works. Its surface was left unfinished. The Child, cradling a small cross in its arms, stands on his mother's thigh and leans back against her arm so as to look up into her face. The traditional type of enthroned Madonna with standing Child is here dramatically modified. The complex movement of the Child's figure is highly unusual. Moreover, the body and drapery forms are more massive than those of older Quattrocento *Madonnas*, and her earlier grace and loveliness have given way to a more serious expression. There is as yet no sign of this in the tondo from the Strozzi tomb (plate 289). Similarities between this Misericordia *Madonna* and the early Michelangelo, which have been noted by various scholars, may be the result of the younger sculptor's influence on Benedetto rather than the other way around.

292
St. Sebastian

c. 1497. Marble. Oratory of the Misericordia, Florence

This statue is mentioned in the 1497 inventory of Benedetto's possessions. Like the *Madonna* (plate 291), it too is unfinished and came into the possession of the Misericordia in 1550. The saint, clad only in a loincloth, stands bound to the trunk of a tree, his eyes lifted toward heaven. Antonio Rossellino had portrayed him in much this same way twenty years before (plate 196). Benedetto's *Sebastian* expresses greater pathos, however; he is much stronger, with a more athletic physique. His proportions, his standing pose, and the treatment of details of his anatomy betray a study of ancient sculpture. The figure is built up in almost classical *contrapposto* as far as the shoulders, yet the extreme twist of the upper body, the angles of the arms tied to his back, and the upward gaze give it a most unclassical feeling. This sense of fettered strength is altogether foreign to Rossellino's *Sebastian*. The motif would have been especially intriguing to Michelangelo—if indeed it is not already a reflection of the younger sculptor's early work in the late work of Benedetto.

Bibliography

Accascina, M. "Inediti di scultura del Rinascimento in Sicilia," *Mitteilungen des Kunsthistorischen Institutes in Florenz* 14 (1970): 251–96.

Adorno, P. "Andrea del Verrocchio e la tomba di Cosimo il Vecchio," *Antichità Viva* 28, no. 1 (1989): 44–48.

Agghàzy, M. G. "La statuette équestre de Léonard de Vinci," *Bulletin du Musée Hongrois des Beaux-Arts* 36 (1971): 61–78.

Agostini, G., and L. Ciamitti. "Niccolò dell'Arca: Il Compianto sul Cristo di Santa Maria della Vita." In *Tre artisti nella Bologna dei Bentivoglio: Francesco del Cossa, Ercole Roberti, Niccolò dell'Arca* (exhibition catalogue), 225–362. Bologna, 1985.

Alberti, L. B. *De pictura.* [1435, 1436]. Edited by C. Grayson. Rome and Bari, 1975.

————. *Leon Battista Alberti's Kleinere kunsttheoretische Schriften.* Edited by H. Janitschek. Vienna, 1877.

Albertini, F. *Memoriale di molte statue e pitture della città di Firenze.* [1510]. Edited by G. Milanesi, C. Guasti, and C. Milanesi. Florence, 1863.

————. *Memoriale di molte statue e pitture.* Florence, 1510. Reprint. Leipzig, 1869.

Alce, V. "Documenti per la data del busto di San Domenico di Nicolò dell'Arca," *Arte Antica e Moderna* 1 (1958): 406–7.

Ames-Lewis, F. "Art History or 'Stilkritik'? Donatello's Bronze David Reconsidered," *Art History* 2 (1979): 139–55.

Angeli, D. "I due Mino," *Nuova Antologia* 113 (1904): 423–35.

————. *Mino da Fiesole.* Florence, 1905.

Angelini, A. "Considerazioni sull'attività giovanile di Antonio Pollaiuolo 'horafo' e 'maestro di disegno'," *Prospettiva* 44 (1986): 16–26.

Arslan, E. "Sui Mantegazza," *Bollettino d'Arte* 35 (1950): 27–34.

————. "Oeuvres de jeunesse d'Antonio Rizzo," *Gazette des Beaux-Arts* 42 (1953): 105–14.

Avery, C. "The Beauregard Madonna: A Forgotten Masterpiece by Desiderio da Settignano," *The Connoisseur* 193 (1976): 186–95. (Also in C. Avery, *Studies in European Sculpture,* 25–34. London, 1981.)

————. "Three Marble Reliefs by Luca della Robbia," *Museum Studies: The Art Institute of Chicago* 8 (1976): 7–37. (Also in C. Avery, *Studies in European Sculpture,* 1–24. London, 1981.)

————. "Donatello's Madonnas Reconsidered," *Apollo* 124 (1986): 174–82.

Bacci, P. "Documenti su Benedetto da Maiano e Andrea da Fiesole relativi al 'Fonte battesimale' del duomo di Pistoia," *Rivista d'Arte* 2 (1904): 271–84.

————. *Jacopo della Quercia: Nuovi documenti e commenti.* Siena, 1929.

Bagnoli, A. "Donatello e Siena: Alcune considerazioni sul Vecchietta e su Francesco di Giorgio." In *Donatello-Studien.* Italienische Forschungen (Florence), no. 3, vol. 16, pp. 278–91. Munich, 1989.

Baldinucci, F. *Notizie dei professori del disegno da Cimabue in qua.* [1681–1728]. Edited by F. Ranalli. 5 vols. Florence, 1845–47.

Balogh, J. "Ioannes Duknovich de Tragurio," *Acta Historiae Artium Academiae Scientiarum Hungaricae* 7 (1960): 51–78.

————. "Un capolavoro sconosciuto del Verrocchio," *Acta Historiae Artium Academiae Scientiarum Hungaricae* 8 (1962): 55–98.

Band, R. "Donatellos Altar im Santo zu Padua," *Mitteilungen des Kunsthistorischen Institutes in Florenz* 5 (1937–40): 315–41.

Barocchi, P. *Atys.* Florence, 1986.

————. *Niccolò da Uzzano.* Florence, 1986.

Battisti, E. "I Comaschi a Roma nel primo Rinascimento." In *Arte e artisti dei laghi lombardi,* vol. 1, 3–61. Como, 1959.

————. *Filippo Brunelleschi.* Milan, [1976].

Bearzi, B. "Considerazioni di tecnica sul S. Ludovico e la Giuditta di Donatello," *Bollettino d'Arte* 36 (1951): 119–23.

————. "Leonardo da Vinci ed il monumento equestre allo Sforza," *Commentari* 21 (1970): 61–65.

————. "Un itinerario tra i bronzi di Donatello." In *Atti del Convegno sul restauro delle opere d'arte 1976,* vol. 1, 95–100. Florence, 1981.

Becherucci, L. *Donatello, i pergami di S. Lorenzo.* Florence, 1979.

Becherucci, L., and G. Brunetti. *Il Museo dell'Opera del Duomo a Firenze.* 2 vols. [Milan, 1969–70].

Beck, J. H. "An Important New Document for Jacopo della Quercia in Bologna," *Arte Antica e Moderna* 5 (1962): 206–7.

————. "Jacopo della Quercia's Portal of S. Petronio in Bologna." Ph.D. diss., Columbia University, 1963.

————. "Jacopo della Quercia's Design for the Porta Magna of San Petronio in Bologna," *Journal of the Society of Architectural Historians* 24 (1965): 115–26.

————. "Niccolò dell'Arca: A Reexamination," *The Art Bulletin* 47 (1965): 335–44.

————. "A Notice for the Early Career of Pietro Lombardi," *Mitteilungen des Kunsthistorischen Institutes in Florenz* 13 (1967–68): 189–92.

————. "Donatello's Black Madonna," *Mitteilungen des Kunsthistorischen Institutes in Florenz* 14 (1970): 456–60.

————. *Jacopo della Quercia e il portale di S. Petronio a Bologna.* Bologna, 1970.

————. "An Effigy Tomb Slab by Antonio Rossellino," *Gazette des Beaux-Arts* 95 (1980): 213–17.

————. "Ghiberti giovane e Donatello giovanissimo." In *Lorenzo Ghiberti nel suo tempo,* vol. 1, 111–34. Florence, 1980.

————. "Desiderio da Settignano (and Antonio del Pollaiuolo): Problems," *Mitteilungen des Kunsthistorischen Institutes in Florenz* 28 (1984): 203–24.

————. "New Notices for Michelozzo." In *Renaissance Studies in Honor of Craig Hugh Smyth,* vol. 2, 23–35. Florence, 1985.

————. "Reflections on Restaurations: Jacopo della Quercia at San Petronio, Bologna," *Antichità Viva* 24, nos. 1/3 (1985): 118–23.

————. "Donatello and the Brancacci Tomb in Naples." In *Florilegium Columbianum: Essays in Honor of Paul Oskar Kristeller,* 125–45. New York, 1987.

Beck, J., and A. Amendola. *Ilaria del Carretto di Jacopo della Quercia.* Lucca, 1988.

Belli D'Elia, P. "Niccolò dell'Arca: Aggiunte e precisazioni," *Commentari* 15 (1964): 52–61.

Bellosi, L. "Ipotesi sull'origine delle terracotte quattrocentesche." In *Jacopo della Quercia fra Gotico e Rinascimento,* edited by G. Chelazzi Dini, 163–79. Florence, 1977.

————. "Per Luca della Robbia," *Prospettiva* 27 (1981): 62–71.

————. "La 'Porta Magna' di Jacopo della Quercia." In *La Basilica di San Petronio a Bologna,* vol. 1, 163–212. Bologna, 1983.

Bennett, B. A., and D. G. Wilkins. *Donatello.* Oxford, 1984.

Berence, F. "Une terre cuite du jeune Léonard de Vinci?," *Bulletin de l'Association Léonard de Vinci* 3 (1962): 13–17.

Bergstein, M. "La vita civica di Nanni di Banco," *Rivista d'Arte* 39 (1987): 55–82.

————. "The Date of Nanni di Banco's 'Quattro santi coronati'," *The Burlington Magazine* 130 (1988): 910–13.

Bernini, D. "Francesco Laurana: 1467–1471," *Bollettino d'Arte* 51 (1966): 155–63.

Bernstein, J. G. "The Architectural Sculpture of the Cloisters of the Certosa di Pavia." Ph.D. diss., New York University, 1972.

Bertelà, G. *San Giorgio*. Florence, 1986.

Bertini Calosso, A. *Matteo Civitali*. Lucca, 1940.

Bertolotti, A. "Urkundliche Beiträge zur Biographie des Bildhauers Paolo di Mariano," *Repertorium für Kunstwissenschaft* 4 (1881): 426–42.

Bettini, S. "Bartolomeo Bellano 'ineptus artifex'?," *Rivista d'Arte* 13 (1931): 45–108.

Biasiotti, G. "Di alcune opere scultorie conservate in S. Maria Maggiore di Roma," *Rassegna d'Arte* 18 (1918): 42–57.

Billi, A. *Il libro di Antonio Billi esistente in due copie nella Biblioteca Nazionale di Firenze*. [1516–20]. Edited by C. Frey. Berlin, 1892.

Bisogni, F. "Sull'iconografia della Fonte Gaia." In *Jacopo della Quercia fra Gotico e Rinascimento*, edited by G. Chelazzi Dini, 109–18. Florence, 1977.

Bocchi, F. "Eccellenza del San Giorgio di Donatello . . . [written 1571], Florence, 1584." In *Trattati d'arte del Cinquecento fra manierismo e controriforma*, edited by P. Barocchi, vol. 3, 125–94. Bari, 1962.

———. *Le bellezze della città di Fiorenza*. Florence, 1591.

Bocchi, F., and G. Cinelli. *Le bellezze della città di Firenze*. Florence, 1677.

Bode, W. von. "Die italienischen Skulpturen der Renaissance in den Königlichen Museen: II. Bildwerke des Andrea del Verrocchio," *Jahrbuch der Preussischen Kunstsammlungen* 3 (1882): 91–105, 235–67.

———. "Jugendwerke des Benedetto da Maiano," *Repertorium für Kunstwissenschaft* 7 (1884): 149–62.

———. "Neue Erwerbungen für die Abteilung der christlichen Plastik in den Königlichen Museen," *Jahrbuch der Preussischen Kunstsammlungen* 7 (1886): 203–14.

———. *Italienische Bildhauer der Renaissance: Studien zur Geschichte der italienischen Plastik und Malerei auf Grund der Bildwerke und Gemälde in den Kgl. Museen zu Berlin*. Berlin, 1887.

———. "Desiderio da Settignano und Francesco Laurana: Zwei italienische Frauenbüsten des Quattrocento im Berliner Museum," *Jahrbuch der Preussischen Kunstsammlungen* 9 (1888): 209–27.

———. "Desiderio da Settignano und Francesco Laurana: Die wahre Büste der Marietta Strozzi," *Jahrbuch der Preussischen Kunstsammlungen* 10 (1889): 28–33.

———. "Lo scultore Bartolomeo Bellano da Padova," *Archivio Storico dell'Arte* 4 (1891): 397–416.

———. *Denkmäler der Renaissance-Sculptur Toscanas*. 12 vols. Munich, 1892–1905.

———. "Una tavola in bronzo di Andrea del Verrocchio," *Archivio Storico dell'Arte* 6 (1893): 77–84.

———. "Bertoldo di Giovanni und seine Bronzebildwerke," *Jahrbuch der Preussischen Kunstsammlungen* 16 (1895): 143–59.

———. "Donatello als Architekt und Dekorator," *Jahrbuch der Preussischen Kunstsammlungen* 22 (1901): 3–28.

———. *Florentiner Bildhauer der Renaissance*. Berlin, 1902; 4th enl. ed., Berlin, 1921.

———. "Luca della Robbia." In W. von Bode, *Florentiner Bildhauer der Renaissance*, 126–91. Berlin, 1902; 4th enl. ed., Berlin, 1921, 125–73.

———. *Die italienischen Bronzestatuetten der Renaissance*. 3 vols. Berlin, [1907–12]; rev. ed., Berlin, [1923].

———. *Studien über Leonardo da Vinci*. Berlin, 1921.

———. *Bertoldo und Lorenzo dei Medici*. Freiburg im Breisgau, 1925.

———. *Mein Leben*. 2 vols. Berlin, 1930.

Boito, C. *L'altare di Donatello e le altre opere nella Basilica Antoniana di Padova*. Milan, 1897.

Borghesi, S., and L. Banchi. *Nuovi documenti per la storia dell'arte senese*. Siena, 1898. Reprint. Soest, 1970.

Borghini, R. *Il Riposo*. Florence, 1584. Reprint. 2 vols. Milan, 1967.

Borsook, E. "Documenti relativi alle cappelle di Lecceto e delle Selve di Filippo Strozzi," *Antichità Viva* 9, no. 3 (1970): 3–20.

———. "Documents for Filippo Strozzi's Chapel in Santa Maria Novella and Other Related Papers," *The Burlington Magazine* 112 (1970): 737–45, 800–804.

———. "Two Letters Concerning Antonio Pollaiuolo," *The Burlington Magazine* 115 (1973): 464–68.

———. "Cults and Imagery at Sant'Ambrogio in Florence: Mino da Fiesole's Tabernacle," *Mitteilungen des Kunsthistorischen Institutes in Florenz* 25 (1981): 178–81.

Borsook, E., and J. Offerhaus. "Storia e leggende nella Cappella Sassetti in Santa Trinità." In *Scritti di storia dell'arte in onore di Ugo Procacci*, vol. 1, 289–310. Milan, 1977.

Bottari, S. *L'Arca di S. Domenico in Bologna*. Bologna, 1964.

Bozzoni, C., and G. Carbonara. *Filippo Brunelleschi: Saggio di bibliografia*. 2 vols. Rome, 1977–78.

Braghirolli, W. "Donatello a Mantova," *Giornale di erudizione artistica* 2 (1873): 4–10.

Brand, H. G. "Die Grabmonumente Pietro Lombardos: Studien zum venezianischen Wandgrabmal des späten Quattrocento." Ph.D. diss., Erlangen, 1977.

Brandi, C. *Il Tempio Malatestiano*. Turin, 1956.

Brockhaus, H. "Die Paradieses-Tür Lorenzo Ghiberti's." In H. Brockhaus, *Forschungen über Florentiner Kunstwerke*, 1–50. Leipzig, 1902.

Brugnoli, M. V. "The Sculptor." In A. M. Brizio, M. V. Brugnoli, and A. Chastel, *Leonardo the Artist*, 96–135. London, 1981.

———. "Il monumento Sforza e il cavallo colossale." In *Leonardo e Milano*, edited by G. A. Dell'Acqua, 89–112. Milan, 1982.

Brunetti, G. "Giovanni d'Ambrogio," *Rivista dell'Arte* 14 (1932): 1–22.

———. "Ricerche su Nanni di Bartolo 'il Rosso'," *Bollettino d'Arte* 28 (1934): 258–72.

———. "Iacopo della Quercia a Firenze," *Belle Arti* (1951): 3–17.

———. "Jacopo della Quercia and the Porta della Mandorla," *The Art Quarterly* 15 (1952): 119–31.

———. *Ghiberti*. Florence, 1966.

———. "I Profeti sulla porta del campanile di Santa Maria del Fiore." In *Festschrift Ulrich Middeldorf*, 106–11. Berlin, 1968.

———. "Riadattamenti e spostamenti di statue fiorentine del primo Quattrocento." In *Donatello e il suo tempo*, 277–82. Florence, 1968.

———. "Un'aggiunta all'iconografia brunelleschiana: Ipotesi sul 'Profeta imberbe' di Donatello." In *Filippo Brunelleschi: La sua opera e il suo tempo*, vol. 1, 273–74. Florence, 1980.

Buddensieg, T. "Donatellos Knabe mit den Schlangen." In *Forma et subtilitas: Festschrift für Wolfgang Schöne zum 75. Geburtstag*, 43–49. Berlin and New York, 1986.

Bule, S. "Matteo Civitali: Four Major Sculptural Programmes." Ph.D. diss., Ohio State University, 1987.

———. "Nuovi documenti per Matteo Civitali," *Rivista dell'Arte* 40 (1988): 357–67.

Burckhardt, J. *Der Cicerone: Eine Anleitung zum Genuss der Kunstwerke Italiens*. Basel, 1855; 4th ed., edited by W. von Bode, 2 vols. Leipzig, 1879.

———. *Die Kultur der Renaissance in Italien: Ein Versuch*. Basel, 1860.

———. *Beiträge zur Kunstgeschichte von Italien: Das Altarbild—Das Porträt in der Malerei—Die Sammler*. Basel, 1898.

———. "Randglossen zur Skulptur der Renaissance." In J. Burckhardt, *Gesamtausgabe*, edited by H. Wölfflin, vol. 13, 167–366. Stuttgart, 1934.

Burger, F. *Geschichte des florentinischen Grabmals von den ältesten Zeiten bis Michelangelo*. Strassburg, 1904.

———. "Donatello und die Antike," *Repertorium für Kunstwissenschaft* 30 (1907): 1–13.

———. *Francesco Laurana: Eine studie zur italienischen Quattrocentoskulptur*. Strassburg, 1907.

Burns, H. "San Lorenzo in Florence Before the Building of the New Sacristy: An Early Plan," *Mitteilungen des Kunsthistorischen Institutes in Florenz* 23 (1979): 145–54.

Bush, V. L. "Leonardo's Sforza Monument and Cinquecento Sculpture," *Arte Lombarda* 50 (1978): 47–68.

Caglioti, F. "Per il recupero della giovinezza romana di Mino da Fiesole: Il 'Ciborio della neve'," *Prospettiva* 49 (1987): 15–32.

———. "Paolo Romano, Mino da Fiesole e il tabernacolo di San Lorenzo in Dàmaso," *Prospettiva* 53–56 (1988–89): 245–55.

Calvi, G. L. *Notizie sulla vita e sulle opere dei principali architetti, scultori e pittori che fiorirono in Milano durante il governo dei Visconti e degli Sforza*. Vol. 2. Milan, 1865.

Cannon-Brookes, P. "Verrocchio Problems," *Apollo* 99 (1974): 8–19.

Caplow, H. M. *Michelozzo*. 2 vols. New York and London, 1977.

Cardellini, I. *Desiderio da Settignano*. Milan, 1962.

Carl, D. "Der Fina-Altar von Benedetto da Maiano in der Collegiata zu San Gimignano: Zu seiner Datierung und Rekonstruktion," *Mitteilungen des Kunsthistorischen Institutes in Florenz* 22 (1978): 265–86.

———. "Zur Goldschmiedefamilie Dei mit neuen Dokumenten zu Antonio Pollaiuolo und Andrea Verrocchio," *Mitteilungen des Kunsthistorischen Institutes in Florenz* 26 (1982): 129–66.

———. "Addenda zu Antonio Pollaiuolo und seiner Werkstatt," *Mitteilungen des Kunsthistorischen Institutes in Florenz* 27 (1983): 285–306.

———. "A Document for the Death of Antonio Rossellino," *The Burlington Magazine* 125 (1983): 612–14.

———. *Il David del Verrocchio—Verrocchio's David.* Florence, 1987.

Carli, E. "Una primizia di Jacopo della Quercia," *La Critica d'Arte* 8 (1949): 17–24.

———. "A Recovered Francesco di Giorgio," *The Burlington Magazine* 91 (1949): 33–39.

———. *Scultura lignea senese.* Milan and Florence, 1951.

———. *Donatello a Siena.* Rome, 1967.

———. *Gli scultori senesi.* Milan, 1980.

Carrara, L. "Nota sulla formazione di Mino da Fiesole," *La Critica d'Arte* 3 (1956): 76–83.

Caspary, H. "Das Sakramentstabernakel in Italien bis zum Konzil von Trient: Gestalt, Ikonographie und Symbolik, kultische Funktion." Ph.D. diss., Munich, 1964.

Castelfranco, G. *Donatello.* Milan, 1963.

Causa, R. "Sagrera, Laurana e l'Arco di Castelnuovo," *Paragone* 5, no. 55 (1954): 3–23.

Cavalcaselle, G. B., and J. A. Crowe. *A New History of Painting in Italy.* Vol. 1. London, 1864.

Cecchi, A. "Vasari e Rossellino: un progetto per la sistemazione della tomba della Beata Villana in Santa Maria Novella," *Antichità Viva* 24, nos. 1–3 (1985): 124–27.

Cellini, P. "La reintegrazione di un'opera sconosciuta di Lorenzo di Pietro detto il Vecchietta," *La Diana* 5 (1930): 239–43.

———. "Un'architettura del Bregno: L'altare maggiore di S. Maria del Popolo." In *Umanesimo e Primo Rinascimento in S. Maria del Popolo. Il Quattrocento a Roma e nel Lazio*, no. 1, 99–109. Rome, 1981.

Cèndali, L. *Giuliano e Benedetto da Maiano: Sancasciano Val di Pesa.* [Florence, 1926].

Cennini, C. *Il libro dell'arte.* [c. 1395]. Edited by F. Brunello. Vicenza, 1971.

Cetti, B. "Scultori comacini: i Bregno," *Arte Cristiana* 70 (1982): 31–44.

Chastel, A. "Le traité de Gauricus et la critique donatélienne." In *Donatello e il suo tempo*, 291–305. Florence, 1968.

———. *Art et humanisme à Florence au temps de Laurent le Magnifique: Études sur la Renaissance et l'humanisme platonicien.* 3rd ed. Paris, 1982.

———. "Donatello tra Roma e Firenze," *Art e Dossier* 1, no. 3 (1986): 4–5.

Ciaccio, L. "Scoltura romana del Rinascimento: Primo periodo (sino al pontificato di Pio II)," *L'Arte* 9 (1906): 165–84, 345–56, 433–41.

Cicognara, L. *Storia della scultura dal suo risorgimento in Italia sino al secolo di Napoleone.* 8 vols. Venice, 1813–18; 2nd ed., Prato, 1823–25.

Clark, K. *The Florence Baptistry Doors.* London, 1980.

Clearfield, J. "The Tomb of Cosimo de' Medici in San Lorenzo," *The Rutgers Art Review* 2 (1981): 13–30.

Il Codice Magliabechiano. [1537–42]. Edited by C. Frey. Berlin, 1892.

Colasanti, A. *Donatello.* Rome, [1930].

———. "Donatelliana," *Rivista d'Arte* 16 (1934): 45–63.

Coolidge, J. "Observations on Donatello's Madonna of the Clouds." In *Festschrift Klaus Lankheit*, 130–31. Cologne, 1973.

Coppel, R. "A Newly-Discovered Signature and Date for Filarete's 'Hector'," *The Burlington Magazine* 129 (1987): 801–2.

Corbo, A. M. "L'attività di Paolo di Mariano a Roma," *Commentari* 17 (1966): 195–226.

———. "Un'opera sconosciuta e perduta di Paolo Romano: il tabernacolo di San Lorenzo in Damaso," *Commentari* 24 (1973): 120–21.

Cordella, R. "Un'opera inedita di Giovanni Dalmata a Norcia (Umbria): l'altare della 'Madonna della palla'," *Acta Historiae Artium Academiae Scientiarum Hungaricae* 27 (1981): 233–46.

———. "Aggiunta all'articolo 'Un opera inedita di Giovanni Dalmata . . . ,'" *Acta Historiae Artium Academiae Scientiarum Hungaricae* 28 (1982): 263–64.

———. "Un'opera inedita da restaurare a Norcia: l'altare della 'Madonna della Palla' di Giovanni Dalmata." In *VIII Mostra nazionale di grafica e di maestri contemporanei per il restauro dell'altare della 'Madonna della Palla' della chiesa di S. Giovanni a Norcia*, 7–14. Norcia, 1982.

———. "Restaurate due sculture di Giovanni Dalmata." In *IX Mostra nazionale di grafica e di maestri contemporanei per il restauro dell'altare della 'Madonna della Palla' della chiesa di S. Giovanni a Norcia*, 5–8. Norcia, 1984.

Cornelius, C. *Jacopo della Quercia: Eine kunsthistorische Studie.* Halle, 1896.

Corti, G., and F. Hartt. "New Documents Concerning Donatello, Luca and Andrea della Robbia, Desiderio, Mino, Uccello, Pollaiuolo, Filippo Lippi, Baldovinetti and Others," *The Art Bulletin* 44 (1962): 155–67.

Corwegh, R. *Donatellos Sängerkanzel im Dom zu Florenz.* Berlin, 1909.

Courajod, L. *Les origines de l'art moderne: Leçon d'ouverture du cours d'histoire de la sculpture, du Moyen-Age, de la Renaissance et des temps modernes.* Paris, 1894.

Covi, D. A. "Four New Documents Concerning Andrea del Verrocchio," *The Art Bulletin* 48 (1966): 97–103.

———. "The Date of the Commission of Verrocchio's 'Christ and St. Thomas'," *The Burlington Magazine* 110 (1968): 37.

———. "An Unnoticed Verrocchio?," *The Burlington Magazine* 110 (1968): 4–9.

———. "Nuovi documenti per Antonio e Piero del Pollaiuolo e Antonio Rossellino," *Prospettiva* 12 (1978): 61–72.

———. "Verrocchio and Venice, 1469," *The Art Bulletin* 65 (1983): 253–73.

———. "More About Verrocchio Documents and Verrocchio's Name," *Mitteilungen des Kunsthistorischen Institutes in Florenz* 31 (1987): 157–61.

Cruttwell, M. *Luca and Andrea della Robbia and Their Successors.* London and New York, 1902.

———. *Verrocchio.* London and New York, 1904.

———. *Antonio Pollaiuolo.* London and New York, 1907.

———. *Donatello.* London, 1911.

Czogalla, A. "David und Ganymedes: Beobachtungen und Fragen zu Donatellos Bronzeplastik 'David und Goliath'." In *Festschrift für Georg Scheja zum 70. Geburtstag*, 119–27. Sigmaringen, 1975.

Dalli Regoli, G. "Una sepoltura di Andrea del Verrocchio: Note sui rapporti tra figuralità e astrazione nella scultura toscana del XV secolo." In *La scultura decorativa del Primo Rinascimento: Atti del I Convegno internazionale di studi 1980*, 67–74. Rome, 1983.

Danilova, I. "Sull'interpretazione dell'architettura nei bassorilievi del Ghiberti e di Donatello." In *Lorenzo Ghiberti nel suo tempo*, vol. 2, 503–6. Florence, 1980.

Davies, G. S. *Renascence. The Sculptured Tombs of the Fifteenth Century in Rome.* London, 1910.

De Angelis, P. *Basilicae S. Mariae Maioris de Urbe a Liberio papa I usque ad Paulum V. Pont. Max. descriptio et delineatio.* Rome, 1621.

De Francovich, G. "Appunti su Donatello e Jacopo della Quercia," *Bollettino d'Arte* 9 (1929): 145–71.

Del Bravo, C. "Proposte e appunti per Nanni di Bartolo," *Paragone* 12, no. 137 (1961): 26–32.

———. *Scultura senese del Quattrocento.* Florence, 1970.

———. "L'umanesimo di Luca della Robbia," *Paragone* 24, no. 285 (1973): 3–34.

———. "Nicolò dell'Arca," *Paragone* 25, no. 295 (1974): 26–40.

D'Elia, M. "Appunti per la riscostruzione dell'attività di Francesco Laurana," *Studi e contributi dell'Istituto di Archeologia e Storia dell'Arte dell'Università di Bari* 3 (1959): 1–23.

Dell'Acqua, G. A. "Problemi di scultura lombarda: Mantegazza e Amadeo," *Proporzioni* 2 (1948): 89–107.

Del Migliore, F. L. *Firenze città nobilissima illustrata.* Florence, 1684. Reprint. Bologna, 1968.

De Nicola, G. "Il sepolcro di Paolo II," *Bollettino d'Arte* 2 (1908): 338–51.

———. "La Giuditta di Donatello e la Madonna Panciatichi di Desiderio," *Rassegna d'Arte* 17 (1917): 153–60.

Disegni italiani del tempo di Donatello (exhibition catalogue). Edited by A. Angelini. Florence, 1986.

Dixon, J. W., Jr. "The Drama of Donatello's David: Re-examination of an 'Enigma'," *Gazette des Beaux-Arts* 93 (1979): 6–12.

Donatello e i suoi: Scultura fiorentina del primo Rinascimento (exhibition catalogue). Edited by A. P. Darr and G. Bonsanti. Florence and Milan, 1986.

Donatello e il restauro della Giuditta (exhibition catalogue). Edited by L. Dolcini. Florence, 1988.

Donatello e il suo tempo: Atti del VIII Convegno internazionale di studi sul Rinascimento 1966. Florence, 1968.

Donatello e la Sagrestia Vecchia di San Lorenzo: Temi, studi, proposte di un cantiere di restauro (exhibition catalogue). Florence, 1986.

Donatello-Studien. Italienische Forschungen (Florence), no. 3, vol. 16. Munich, 1989.

Doren, A. "Das Aktenbuch für Ghibertis Matthäus-Statue an Or San Michele zu Florenz." In *Italienische Forschungen,* vol. 1, 1–58. Berlin, 1906.

Draper, J. D. "Bertoldo di Giovanni: His Life, His Art, His Influence." Ph.D. diss., New York University, 1984.

Dunkelman, M. L. "Donatello's Influence on Italian Renaissance Painting." Ph.D. diss., New York University, 1976.

———. "Donatello's Influence on Mantegna's Early Narrative Scenes," *The Art Bulletin* 62 (1980): 226–35.

Dussler, L. *Benedetto da Maiano.* Munich, 1924.

Egger, H. "Kardinal Antonio Martinez de Chaves und sein Grabmal in San Giovanni in Laterano." In *Miscellanea Francesco Ehrle,* vol. 2, 415–31. Rome, 1924.

———. "Beiträge zur Andrea Bregno-Forschung." In *Festschrift für Julius Schlosser zum 60. Geburtstag,* 122–36. Zurich, 1927.

Einem, H. von. "Bemerkungen zur Bildhauerdarstellung des Nanni di Banco." In *Festschrift für Hans Sedlmayr,* 68–79. Munich, 1962.

Eroli, G. *Erasmo Gattamelata da Narni: Suoi monumenti e sua famiglia.* 2nd ed. Rome, 1879.

Esch, A., and D. Esch. "Die Grabplatte Martins V. und andere Importstücke in den römischen Zollregistern der Frührenaissance," *Römisches Jahrbuch für Kunstgeschichte* 17 (1978): 209–17.

Ettlinger, L. D. "Pollaiuolo's Tomb of Pope Sixtus IV," *Journal of the Warburg and Courtauld Institutes* 16 (1953): 239–74.

———. "Hercules Florentinus," *Mitteilungen des Kunsthistorischen Institutes in Florenz* 16 (1972): 119–42.

———. *Antonio and Piero Pollaiuolo.* Oxford, 1978.

Euler-Künsemüller, S. *Bildgestalt und Erzählung: Zum frühen Reliefwerk Lorenzo Ghibertis.* Frankfurt-am-Main, 1980.

Fabriczy, C. von. *Filippo Brunelleschi: Sein Leben und seine Werke.* Stuttgart, 1892.

———. "Andrea del Verrocchio ai servizi de' Medici," *Archivio Storico dell'Arte* 1 (1895): 163–76.

———. "Toscanische und oberitalienische Künstler in Diensten der Aragoneser zu Neapel," *Repertorium für Kunstwissenschaft* 20 (1897): 87–120.

———. "Der Triumphbogen Alfonsos I. am Castel Nuovo zu Neapel," *Jahrbuch der Preussischen Kunstsammlungen* 20 (1899): 1–30, 125–58.

———. "Donatellos hl. Ludwig und sein Tabernakel an Or San Michele," *Jahrbuch der Preussischen Kunstsammlungen* 21 (1900): 242–61.

———. "Ein Jugendwerk Bernardo Rossellinos und spätere unbeachtete Schöpfungen seines Meissels," *Jahrbuch der Preussischen Kunstsammlungen* 21 (1900): 33–54, 99–113.

———. "Giovanni Dalmata: Neues zum Leben und Werke des Meisters," *Jahrbuch der Preussischen Kunstsammlungen* 22 (1901): 224–52.

———. "Ancora del tabernacolo col gruppo del Verrocchio in Or San Michele," *L'Arte* 5 (1902): 46–48, 336–40.

———. "Neues über Bernardo Rossellino," *Repertorium für Kunstwissenschaft* 25 (1902): 475–77.

———. "Neues zum Triumphbogen Alfonsos I.," *Jahrbuch der Preussischen Kunstsammlungen* 23 (1902): 3–16.

———. "Giuliano da Maiano," *Jahrbuch der Preussischen Kunstsammlungen* 24, supp. (1903): 137–76.

———. "Michelozzo di Bartolomeo," *Jahrbuch der Preussischen Kunstsammlungen* 25, supp. (1904): 34–110.

———. "Una statua senese nel Louvre," *L'Arte* 10 (1907): 222–25.

———. "Niccolò dell'Arca: Chronologischer Prospekt samt Urkundenbelegen," *Jahrbuch der Preussischen Kunstsammlungen* 29, supp. (1908): 29–41.

———. "Kritisches Verzeichnis toskanischer Holz- und Tonstatuen bis zum Beginn des Cinquecento," *Jahrbuch der Preussischen Kunstsammlungen* 30, supp. (1909): 1–88.

Fechheimer, S. *Donatello und die Reliefkunst.* Strassburg, 1904.

Fehl, P. P. "The Naked Christ in Santa Maria Novella in Florence: Reflections on an Exhibition and the Consequences," *Storia dell'Arte* 45 (1982): 161–64.

Ferrara, M., and F. Quinterio. *Michelozzo di Bartolomeo.* Florence, 1984.

Ferri, C. "Nuove notizie documentarie su autori e dipinti del '400 lucchese," *Actum Luce* 11 (1982): 53–72.

Filarete. *Antonio Averlino Filarete's Tractat über die Baukunst.* [c. 1451–64]. Edited by W. von Oettingen. Vienna, 1890.

———. *Trattato di architettura.* [c. 1451–64]. Edited by A. M. Finoli and L. Grassi. 2 vols. Milan, 1972.

Filippo Brunelleschi: La sua opera e il suo tempo. 2 vols. Florence, 1980.

Fiocco, G. "I Lamberti a Venezia: II. Pietro di Niccolò Lamberti," *Dedalo* 8 (1927/28): 343–76.

———. "Fragments of a Donatello Altar," *The Burlington Magazine* 60 (1932): 198–204.

———. "L'altare grande di Donatello al Santo," *Il Santo* 1 (1961): 21–36.

———. "La statua equestre del Gattamelata," *Il Santo* 1 (1961): 300–17.

———. "Ancora dell'altare di Donatello al Santo," *Il Santo* 3 (1963): 345–46.

———. *Donatello al "Santo."* Padua, 1965.

Fisković, C. "Ivan Duknović Dalmata," *Acta Historiae Artium Academiae Scientiarum Hungaricae* 13 (1967): 265–70.

———. "Duknovićev kip apostola Ivana u Trogiru," *Peristil* 14/15 (1971–72): 123–28.

Fletcher, J. "Bernardo Bembo and Leonardo's Portrait of Ginevra de' Benci," *The Burlington Magazine* 131 (1989): 811–16.

Fontana, G. *Un'opera del Donatello esistente nella chiesa dei Cavalieri di S. Stefano di Pisa.* Pisa, 1895.

Foster, P. "Donatello Notices in Medici Letters," *The Art Bulletin* 62 (1980): 148–50.

———. "Lorenzo de' Medici and the Florence Cathedral Façade," *The Art Bulletin* 63 (1981): 495–500.

Franceschini, P. *L'Oratorio di San Michele in Orto in Firenze.* Florence, 1892.

Franchi, R., G. Galli, and C. Manganelli Del Fá. "Researches on the Deterioration of Stonework: VI. The Donatello Pulpit," *Studies in Conservation* 23 (1978): 23–37.

Franzoi, U. "La Scala dei Giganti," *Bollettino dei Musei Civici Veneziani* 10 (1965): 8–34.

Freytag, C. "Jacopo della Quercia: Stilkritische Untersuchungen zu seinen Skulpturen unter besonderer Berücksichtigung des Frühwerks." Ph.D. diss., Munich, 1969.

Friedman, D. "The Burial Chapel of Filippo Strozzi in Santa Maria Novella in Florence," *L'Arte,* n.s., 3 (1970): 109–31.

Frosinini, C. "Un nuovo documento per la compagnia di Donatello e Michelozzo (con note su alcune maestranze di scalpellini settignanesi)," *Rivista d'Arte* 39 (1987): 435–41.

Fumi, F. "Nuovi documenti per gli angeli dell'altar maggiore del Duomo di Siena," *Prospettiva* 26 (1981): 9–25.

Fusco, L. "Antonio Pollaiuolo's Use of the Antique," *Journal of the Warburg and Courtauld Institutes* 42 (1979): 257–63.

———. "Pollaiuolo's Battle of the Nudes: A Suggestion for an Ancient Source and a New Dating." In *Scritti di storia dell'arte in onore di Federico Zeri,* vol. 1, 196–99. Milan, 1984.

Gaborit, J. R. "Ghiberti e Luca della Robbia, à propos de deux reliefs conservés au Louvre." In *Lorenzo Ghiberti nel suo tempo,* vol. 1, 187–93. Florence, 1980.

Gai, L. "Per la cronologia di Donatello: un documento inedito del 1401," *Mitteilungen des Kunsthistorischen Institutes in Florenz* 18 (1974): 355–57.

———. *L'altare argenteo di San Iacopo nel Duomo di Pistoia: contributo alla storia dell'oreficeria gotica e rinascimentale italiana.* Turin, 1984.

Galassi, G. *La scultura fiorentina del Quattrocento.* Milan, 1949.

Gallavotti Cavallero, D. "'Francesco di Giorgio di Martino, architetto, ingegniere, scultore, pittore, bronzista' per la SS. Annunziata di Siena," *Paragone* 36, no. 427 (1985): 47–56.

Gauricus, P. *De sculptura '1504.'* Edited by A. Chastel and R. Klein. Geneva and Paris, 1969.

Gaye, G. *Carteggio inedito d'artisti dei secoli XIV, XV, XVI.* 3 vols. Florence, 1839–40. Reprint. Turin, 1968.

Gelli, G. B. *Vite d'artisti.* [c. 1550]. Edited by G. Mancini. *Archivio Storico Italiano* 17 (1896): 32–62.

Gerola, G. "Una croce processionale del Filarete a Bassano," *L'Arte* 9 (1906): 292–96.

Geymüller, H. von. "Die architektonische Entwicklung Michelozzos und sein Zusammenwirken mit Donatello," *Jahrbuch der Preussischen Kunstsammlungen* 15 (1894): 247–59.

Ghiberti, L. *Denkwürdigkeiten (I Commentarii)* [c. 1447]. Edited by J. von Schlosser. 2 vols. Berlin, 1912.

————. *I Commentarii.* [c. 1447]. Edited by O. Morisani. Naples, 1947.

Ghiberti e la sua arte nella Firenze del '3-'400. Edited by M. G. Rosito. Florence, 1979.

Ghidiglia Quintavalle, A. "Una terracotta di Nicolò dell'Arca," *Arte Antica e Moderna* 1 (1958): 373–74.

Glasser, H. *Artists' Contracts of the Early Renaissance.* New York and London, 1977.

Glasser, H., and G. Corti. "The Litigation Concerning Luca della Robbia's Federighi Tomb," *Mitteilungen des Kunsthistorischen Institutes in Florenz* 14 (1969/70): 1–32.

Gloria, A. *Donatello fiorentino e le sue opere mirabili nel tempio di S. Antonio di Padova.* Padua, 1895.

Gnoli, D. "Le opere di Donatello in Roma," *Archivio Storico dell'Arte* 1 (1888): 24–31.

Gnudi, C. *Niccolò dell'Arca.* Turin, 1942.

————. "L'arte di Guido Mazzoni," *Bollettino di Storia dell'Arte* (Salerno), 2 (1952): 98–113.

————. *Nuove ricerche su Niccolò dell'Arca.* Rome, [1972].

————. "Per una revisione critica della documentazione riguardante la 'Porta Magna' di San Petronio." In *Jacopo della Quercia e la facciata di San Petronio a Bologna.* Rapporto della Soprintendenza per i Beni Artistici e Storici per le Province di Bologna, Ferrara, Forlì e Ravenna, no. 29, edited by R. Rossi Planaresi, 13–52. Bologna, 1981. (Also in *Römisches Jahrbuch für Kunstgeschichte* 20 [1983]: 155–80.)

Goldberg, V. L. "'The School of Athens' and Donatello," *The Art Quarterly* 34 (1971): 229–37.

Goldner, G. "The Tomb of Tommaso Mocenigo and the Date of Donatello's 'Zuccone' and of the Coscia Tomb," *Gazette des Beaux-Arts* 83 (1974): 187–92.

————. "A Drawing by Desiderio da Settignano," *The Burlington Magazine* 131 (1989): 469–73.

Golzio, V., and G. Zander. *L'arte in Roma nel secolo XV.* Bologna, 1968.

Gonzati, B. *La basilica di S. Antonio di Padova.* 2 vols. Padua, 1852–53.

Gosebruch, M. "'Varietà' bei Leon Battista Alberti und der wissenschaftliche Renaissancebegriff," *Zeitschrift für Kunstgeschichte* 20 (1957): 229–38.

————. *Donatello: Das Reiterdenkmal des Gattamelata.* Stuttgart, 1958.

————. "Florentinische Kapitelle von Brunelleschi bis zum Tempio Malatestiano und der Eigenstil der Frührenaissance," *Römisches Jahrbuch für Kunstgeschichte* 8 (1958): 63–193.

————. "Osservazioni sui pulpiti di San Lorenzo." In *Donatello e il suo tempo,* 369–86. Florence, 1968.

Goss, V. P. "I due rilievi di Pietro da Milano e di Francesco Laurana nell'Arco di Castelnuovo in Napoli," *Napoli nobilissima* 20 (1981): 102–14.

Gottschalk, H. "Antonio Rossellino." Ph.D. diss., Kiel, 1930.

Grabski, J. "L'Amor-Pantheos di Donatello," *Antologia di Belle Arti* 3 (1979): 23–26.

Graevenitz, G. von. *Gattamelata "Erasmo da Narni" und Colleoni und ihre Beziehungen zur Kunst.* Leipzig, 1906.

Gramaccini, N. "La déploration de Niccolò dell'Arca: Religion et politique aux temps de Giovanni II Bentivoglio," *Revue de l'Art,* no. 62 (1983): 21–34.

————. "Guido Mazzonis Beweinungsgruppen," *Städel-Jahrbuch* 9 (1983): 7–40.

Grassi, L. *Tutta la scultura di Donatello.* 2nd ed. Milan, 1963.

Greenhalgh, M. *Donatello and His Sources.* London, 1982.

Guasti, C. *Il pergamo di Donatello del duomo di Prato.* Florence, 1887.

Gvozdanovic, V. "The Dalmatian Works of Pietro da Milano and the Beginnings of Francesco Laurana," *Arte Lombarda* 42/43 (1975): 113–23.

Hadeln, D. von. "Ein Rekonstruktionsversuch des Hochaltars Donatellos im Santo zu Padua," *Jahrbuch der Preussischen Kunstsammlungen* 30 (1909): 35–55.

Hahr, A. "Donatellos Bronze-David und das praxitelische Erosmotiv," *Monatshefte für Kunstwissenschaft* 5 (1912): 303–10.

Haines, M. "Documenti intorno al reliquiario per San Pancrazio di Antonio del Pollaiuolo e Piero Sali." In *Scritti di storia dell'arte in onore di Ugo Procacci,* vol. 1, 264–69. Milan, 1977.

————. *La Sacrestia delle Messe del Duomo di Firenze.* Florence, 1983.

————. "La colonna della Dovizia di Donatello," *Rivista d'Arte* 37 (1984): 347–59.

Hanson, A. C. *Jacopo della Quercia's Fonte Gaia.* Oxford, 1965.

Hartlaub, G. F. "Francesco di Giorgio und seine 'Allegorie der Seele' im Kaiser-Friedrich-Museum," *Jahrbuch der Preussischen Kunstsammlungen* 60 (1939): 197–211.

Hartt, F. "New Light on the Rossellino Family," *The Burlington Magazine* 103 (1961): 387–92.

————. *Donatello—Prophet of Modern Vision.* New York, [1973].

Hartt, F., G. Conti, and C. Kennedy. *The Chapel of the Cardinal of Portugal 1434–1459 at San Miniato in Florence.* Philadelphia, 1964.

Hatfield, R. C. "Sherlock Holmes and the Riddle of the 'Niccolò da Uzzano'." In *Essays Presented to Myron P. Gilmore,* vol. 2, 219–38. Florence, 1978.

Heil, W. "A Marble Putto by Verrocchio," *Pantheon* 27 (1969): 271–82.

Hersey, G. L. *Alfonso II and the Artistic Renewal of Naples 1485–1495.* New Haven and London, 1969.

————. *The Aragonese Arch at Naples: 1443–1475.* New Haven and London, 1973.

Hersey, G. L., A. Blunt, and E. Borsook, "Alfonso II and the Artistic Renewal at Naples (Letters)," *The Burlington Magazine* 114 (1972): 242–44.

Herzner, V. "Donatellos 'pala over ancona' für den Hochaltar des Santo in Padua: Ein Rekonstruktionsversuch," *Zeitschrift für Kunstgeschichte* 33 (1970): 89–126.

————. "Donatello in Siena," *Mitteilungen des Kunsthistorischen Institutes in Florenz* 15 (1971): 161–86.

————. "Donatellos Madonna vom Paduaner Hochaltar—eine 'Schwarze Madonna'?," *Mitteilungen des Kunsthistorischen Institutes in Florenz* 16 (1972): 143–52.

————. "Die Kanzeln Donatellos in San Lorenzo," *Münchner Jahrbuch der Bildenden Kunst* 23 (1972): 101–64.

————. "Bemerkungen zu Nanni di Banco und Donatello," *Wiener Jahrbuch für Kunstgeschichte* 26 (1973): 74–95.

————. "Donatello und Nanni di Banco: Die Prophetenfiguren für die Strebepfeiler des Florentiner Domes," *Mitteilungen des Kunsthistorischen Institutes in Florenz* 17 (1973): 1–28.

————. "Donatello und die Sakristei-Türen des Florentiner Domes," *Wiener Jahrbuch für Kunstgeschichte* 29 (1976): 53–63.

————. "David Florentinus: I. Zum Marmordavid Donatellos im Bargello," *Jahrbuch der Berliner Museen* 20 (1978): 43–115.

————. "Regesti donatelliani," *Rivista dell'Istituto Nazionale d'Archeologia e Storia dell'Arte* (Rome) 2 (1979): 169–228.

————. "Zwei Frühwerke Donatellos: Die Prophetenstatuetten von der Porta del Campanile in Florenz," *Pantheon* 37 (1979): 27–36.

————. "Die 'Judith' der Medici," *Zeitschrift für Kunstgeschichte* 43 (1980): 139–80.

————. "David Florentinus: II–IV," *Jahrbuch der Berliner Museen* 24 (1982): 63–142.

————. "Ein neues Donatello-Dokument aus dem Florentiner Domarchiv," *Zeitschrift für Kunstgeschichte* 46 (1983): 436–43.

————. "Eine Hypothese zum 'Hl. Jacobus' an Orsanmichele in Florenz," *Wiener Jahrbuch für Kunstgeschichte* 41 (1988): 61–76.

Heydenreich, L. H. "Bemerkungen zu den Entwürfen Leonardos für das Grabmal des Gian Giacomo Trivulzio." In *Studien zur Geschichte der europäischen Plastik; Festschrift Theodor Müller,* 179–94. Munich, 1965.

Hill, G. F. *A Corpus of Italian Medals of the Renaissance Before Cellini.* 2 vols. London, 1930.

Horne, H. P. "Notes on Luca della Robbia," *The Burlington Magazine* 28 (1915–16): 3–7.

Horster, M. "Nanni di Banco: 'Quattro Coronati'," *Mitteilungen des Kunsthistorischen Institutes in Florenz* 31 (1987): 59–80.

Hubala, E. *Venedig.* Reclams Kunstführer Italien, vol. II, pt. 1. 2nd ed., Stuttgart, 1974.

Hülsen, C. *Das Skizzenbuch des Giovannantonio Dosio im Staatlichen Kupferstichkabinett zu Berlin.* Berlin, 1933.

Huizinga, J. *Herbst des Mittelalters.* Munich, 1924; 11th ed., edited by K. Köster. Stuttgart, 1975.

————. *Das Problem der Renaissance—Renaissance und Realismus.* Tübingen, 1953.

Huse, N. "Beiträge zum Spätwerk Donatellos," *Jahrbuch der Berliner Museen* 10 (1968): 125–50.

Huse, N., and W. Wolters. *Venedig: Die Kunst der Renaissance.* Munich, 1986.

Ilg, A. "Madonna mit dem Kinde: Marmorrelief des Rossellino," *Jahrbuch der Kunsthistorischen Sammlungen des A. H. Kaiserhauses* 1 (1883): 116–17.

Ingendaay, M. "Rekonstruktionsversuch der 'Pala Bichi' in San Agostino in Siena," *Mitteilungen des Kunsthistorischen Institutes in Florenz* 23 (1979): 109–26.

Intra, G. B. "Donatello e il Marchese Lodovico Gonzaga anno 1450 e 1455," *Archivio Storico Lombardo* 13 (1886): 666–69.

Italian Renaissance Sculpture in the Time of Donatello (exhibition catalogue). Detroit, 1985.

Jacopo della Quercia fra Gotico e Rinascimento: Atti del convegno di studi 1975. Edited by G. Chelazzi Dini. Florence, 1977.

Jacopo della Quercia nell'arte del suo tempo (exhibition catalogue). Florence, 1975.

Jansen, A. Review of *Donatello, seine Zeit und Schule*, by H. Semper. *Zeitschrift für Bildende Kunst* 11 (1876): 316–19.

Janson, H. W. *The Sculpture of Donatello.* 2 vols. Princeton, N. J., 1957; 2nd ed., Princeton, N.J., 1963.

———. "Giovanni Chellini's 'Libro' and Donatello." In *Studien zur toskanischen Kunst: Festschrift für Ludwig Heinrich Heydenreich zum 23. März 1963*, 131–38. Munich, 1964.

———. "Donatello and the Antique." In *Donatello e il suo tempo*, 77–96. Florence, 1968.

———. "Die stilistische Entwicklung des Agostino di Duccio mit besonderer Berücksichtigung des Hamburger Tondo," *Jahrbuch der Hamburger Kunstsammlungen* 14/15 (1970): 105–28.

———. "Review of *Donatello und Nanni di Banco*, by M. Wundram. *The Art Bulletin* 54 (1972): 546–50.

———. "The Pazzi Evangelists." In *Intuition und Kunstwissenschaft: Festschrift für Hanns Swarzenski*, 439–48. Berlin, 1973.

———. "La signification politique du David en bronze de Donatello," *Revue de l'Art*, no. 39 (1978), 33–38.

———. "The Birth of 'Artistic License': The Dissatisfied Patron in the Early Renaissance." In *Patronage in the Renaissance*, 344–53. Princeton, N. J., 1981.

Kaczmarzyk, D. "La Madonna dei candelabri d'Antonio Rossellino," *Bulletin du Musée National de Varsovie* 12 (1971): 55–58.

Kaegi, W. *Jakob Burckhardt: Eine Biographie.* 7 vols. Basel, 1947–82.

Kauffmann, G. "Zu Donatellos Sängerkanzel," *Mitteilungen des Kunsthistorischen Institutes in Florenz* 9 (1959): 55–59.

Kauffmann, H. "Florentiner Domplastik," *Jahrbuch der Preussischen Kunstsammlungen* 47 (1926): 141–67.

———. "Eine Ghibertizeichnung im Louvre," *Jahrbuch der Preussischen Kunstsammlungen* 50 (1929): 1–10.

———. *Donatello: Eine Einführung in sein Bilden und Denken.* Berlin, 1935.

Kecks, R. G. *Madonna und Kind: Das häusliche Andachtsbild im Florenz des 15. Jahrhunderts.* Berlin, 1988.

———. "Zur künstlerischen Entwicklung Lorenzo Ghibertis in der Madonnendarstellung," *Mitteilungen des Kunsthistorischen Institutes in Florenz* 32 (1988): 525–36.

Keller, H. "Ursprünge des Gedächtnismals in der Renaissance," *Kunstchronik* 7 (1954): 134–37.

Kennedy, C. "Documenti inediti su Desiderio da Settignano e la sua famiglia," *Rivista d'Arte* 12 (1930): 243–91.

———. Synopsis of *Bernardo Rossellino*, by M. Tyszkiewicz. *Rivista d'Arte* 15 (1933): 115–27.

———. "A Clue to a Lost Work by Verrocchio." In *Festschrift Ulrich Middeldorf*, 158–60. Berlin, 1968.

Kennedy, C., E. Wilder, and P. Bacci. *The Unfinished Monument by Andrea del Verrocchio to the Cardinal Niccolò Forteguerri at Pistoia.* Northampton, Mass., 1932.

Kennedy C., and R. W. Kennedy. *Four Portrait Busts by Francesco Laurana.* Northampton, Mass., 1962.

Keutner, H. "Hektor zu Pferde: Eine Bronzestatuette von Antonio Averlino Filarete." In *Studien zur toskanischen Kunst: Festschrift für Ludwig Heinrich Heydenreich zum 23. März 1963*, 139–56. Munich, 1964.

Klotz, H. "Jacopo della Quercias Zyklus der 'Vier Temperamente' am Dom zu Lucca," *Jahrbuch der Berliner Museen* 9 (1967): 81–99.

Komorowski, M. "Donatello's St. George in a Sixteenth-Century Commentary by Francesco Bocchi: Some Problems of the Renaissance Theory of Expression in Art." In *Ars auro prior, Studia Ioanni Bialostocki sexagenario dicata*, 61–66. Warsaw, 1981.

Kosegarten, A. "Das Grabrelief des San Aniello Abbate im Dom von Lucca: Studien zu den früheren Werken des Jacopo della Quercia," *Mitteilungen des Kunsthistorischen Institutes in Florenz* 13 (1968): 223–72.

Krahn, V. *Bartolomeo Bellano: Studien zur Paduaner Plastik des Quattrocento.* Munich, 1988.

Krautheimer, R. "Ghibertiana," *The Burlington Magazine* 71 (1937): 68–80.

———. "A Drawing for the Fonte Gaia in Siena," *The Metropolitan Museum of Art Bulletin* 10 (1952): 265–74.

———. *Lorenzo Ghiberti.* Princeton, N. J., 1956; 3rd ed., Princeton, N.J., 1982.

———. "Quesiti sul sepolcro di Ilaria." In *Jacopo della Quercia fra Gotico e Rinascimento*, 91–97. Florence, 1977.

Kreytenberg, G. "Das Statuettenpaar über Ghibertis Matthäustabernakel." In *Art the Ape of Nature: Studies in Honor of H. W. Janson*, 97–104. New York, 1981.

———. "Masaccio und die Skulptur Donatellos und Nanni di Banco." In *Studien zu Renaissance und Barock: Manfred Wundram zum 60. Geburtstag*, 11–19. Frankfurt am Main and Bern, 1986.

Kris, E. *Meister und Meisterwerke der Steinschneidekunst in der italienischen Renaissance.* 2 vols. Vienna, 1929.

Kruft, H.-W. "Die Madonna von Trapani und ihre Kopien: Studien zur Madonnen-Typologie und zum Begriff der Kopie in der sizilianischen Skulptur des Quattrocento," *Mitteilungen des Kunsthistorischen Institutes in Florenz* 14 (1969–70): 297–322.

———. Review of *Alfonso II and the Artistic Renewal of Naples 1485–1495*, by G. L. Hersey. *Kunstchronik* 23 (1970): 151–66.

———. *Domenico Gagini und seine Werkstatt.* Italienische Forschungen, no. 3, vol. 6. Munich, 1972.

———. "Pietro da Bonate und der Frühstil Francesco Lauranas," *Storia dell'Arte* 15/16 (1972): 223–35.

Kruft, H.-W., and M. Malmanger. "Francesco Laurana: Beginnings in Naples," *The Burlington Magazine* 116 (1974): 9–14.

———. "Das Portal der Cappella di Santa Barbara im Castelnuovo zu Neapel," *Acta ad Archaeologiam et Artium Historiam pertinentia* 6 (1975): 307–14.

———. "Der Triumphbogen Alfonsos in Neapel: Das Monument und seine politische Bedeutung," *Acta ad Archaeologiam et Artium Historiam pertinentia* 6 (1975): 213–305. Offprint. Tübingen, 1977.

Kühlenthal, M. "Studien zum stil und zur Stilentwicklung Agostino di Duccios," *Wiener Jahrbuch für Kunstgeschichte* 24 (1971): 59–100.

———. "Zwei Grabmäler des frühen Quattrocento in Rom: Kardinal Martinez de Chiavez und Papst Eugen IV," *Römisches Jahrbuch für Kunstgeschichte* 16 (1976): 17–56.

———. "Das Grabmal Pietro Foscaris in S. Maria del Popolo in Rom, ein Werk des Giovanni di Stefano," *Mitteilungen des Kunsthistorischen Institutes in Florenz* 26 (1982): 47–62.

Landucci, L. *Diario fiorentino dal 1450 al 1516.* Edited by I. Del Badia. Florence, 1883.

Lang, S. "Leonardo's Architectural Designs and the Sforza Mausoleum," *Journal of the Warburg and Courtauld Institutes* 31 (1968): 218–33.

Lange, H. "Mino da Fiesole: Ein Beitrag zur Geschichte der florentinischen und römischen Plastik des Quattrocentos." Ph.D. diss., Munich, 1928.

Langton-Douglas, R. "'Mino del Reame'," *The Burlington Magazine* 86/87 (1945): 217–24.

———. "'Mino del Reame' (Letter)," *The Burlington Magazine* 88 (1946): 23.

Lányi, J. "Der Entwurf zur Fonte Gaia in Siena," *Zeitschrift für Bildende Kunst* 61 (1927–28): 257–66.

———. "Zur Pragmatik der Florentiner Quattrocentoplastik (Donatello)," *Kritische Berichte zur kunstgeschichtlichen Literatur* 4, 1932–33 (1936): 126–31.

———. "Le statue quattrocentesche dei profeti nel campanile e nell'antica facciata di Santa Maria del Fiore," *Rivista d'Arte* 17 (1935): 121–59, 245–80.

———. "Tre rilievi inediti di Donatello," *L'Arte* 38 (1935): 284–97.

———. "Il profeta Isaia di Nanni di Banco," *Rivista d'Arte* 18 (1936): 137–78.

———. "Donatello's Angels for the Siena Font: A Reconstruction," *The Burlington Magazine* 75 (1939): 142–51.

———. "Problemi della critica donatelliana," *La Critica d'Arte* 4, no. 2 (1939): 9–23.

Larson, J. "A Polychrome Terracotta Bust of a Laughing Child at Windsor Castle," *The Burlington Magazine* 131 (1989): 618–24.

Lavagnino, E. "Andrea Bregno e la sua bottega," *L'Arte* 27 (1924): 247–63.

Lavin, I. "The Sources of Donatello's Pulpits in San Lorenzo: Revival and Freedom of Choice in the Early Renaissance," *The Art Bulletin* 41 (1959): 19–38.

———. "On the Sources and Meaning of the Renaissance Portrait Bust," *The Art Quarterly* 33 (1970): 207–26.

———. "The Sculptor's 'Last Will and Testament'," *Allen Memorial Art Museum Bulletin* 35 (1977–78): 4–39.

Lawson, J. G. "New Documents on Donatello," *Mitteilungen des Kunsthistorischen Institutes in Florenz* 18 (1974): 357–62.

Lazzaroni, M., and A. Muñoz. *Filarete scultore e architetto del XV secolo.* Rome, 1908.

Lehmann, H. *Lombardische Plastik im letzten Drittel des XV. Jahrhunderts.* Berlin, 1928.

Lein, E. *Benedetto da Maiano.* Frankfurt am Main, 1988.

Leithe-Jasper, M. "Inkunabeln der Bronzeplastik der Renaissance: Aus der Sammlung für Plastik und Kunstgewerbe des Kunsthistorischen Museums in Wien," *Weltkunst* 51 (1981): 3188–90.

Leonardi, V. "Paolo di Mariano marmoraro," *L'Arte* 3 (1900): 86–106, 258–74.

Leonardo da Vinci. *The Literary Works.* Edited by J. P. Richter. 3rd ed. 2 vols. London and New York, 1970.

Liess, R. "Beobachtungen an der Judith-Holofernes-Gruppe des Donatello." In *Argo: Festschrift für Kurt Badt zu seinem 80. Geburtstag,* 176–205. Cologne, 1970.

Lightbown, R. W. "Giovanni Chellini, Donatello, and Antonio Rossellino," *The Burlington Magazine* 104 (1962): 102–4.

———. *Donatello and Michelozzo: An Artistic Partnership and Its Patrons in the Early Renaissance.* 2 vols. London, 1980.

———. *Sandro Botticelli: Leben und Werk.* Munich, 1989.

Liscia Bemporad, D. "Appunti sulla bottega orafa di Antonio del Pollaiuolo e di alcuni suoi allievi," *Antichità Viva* 19, no. 3 (1980): 47–53.

———. "Giusto da Firenze e Antonio del Pollaiuolo: una soluzione, un problema," *Annali della Scuola Normale Superiore di Pisa* 18, no. 1 (1988): 195–214.

Lisner, M. "Die Büste des hl. Laurentius in der Alten Sakristei von S. Lorenzo. Ein Beitrag zu Desiderio da Settignano," *Zeitschrift für Kunstwissenschaft* 12 (1958): 51–70.

———. "Zu Benedetto da Maiano und Michelangelo," *Zeitschrift für Kunstwissenschaft* 12 (1958): 141–56.

———. "Zur frühen Bildhauerarchitektur Donatellos," *Münchner Jahrbuch der Bildenden Kunst* 9/10 (1958–59): 72–127.

———. *Luca della Robbia: Die Sängerkanzel.* Stuttgart, 1960.

———. "Zum Frühwerk Donatellos," *Münchner Jahrbuch der Bildenden Kunst* 13 (1962): 63–68.

———. "Gedanken vor frühen Standbildern des Donatello." In *Kunstgeschichtliche Studien für Kurt Bauch,* 77–92. Munich and Berlin, 1967.

———. "Intorno al crocifisso di Donatello in Santa Croce." In *Donatello e il suo tempo,* 115–29. Florence, 1968.

———. "Ein unbekanntes Werk des Michelozzo di Bartolomeo," *Pantheon* 26 (1968): 173–84.

———. *Holzkruzifixe in Florenz und in der Toskana.* Italienische Forschungen, no. 3, vol. 4. Munich, 1970.

———. "Josua und David: Nannis und Donatellos Statuen für den Tribuna-Zyklus des Florentiner Doms," *Pantheon* 32 (1974): 232–43.

———. "Zu Jacopo della Quercia und Giovanni d'Ambrogio," *Pantheon* 34 (1976): 275–79.

———. "Appunti sui rilievi della Deposizione nel sepolcro e del Compianto su Cristo morto di Donatello." In *Scritti di storia dell'arte in onore di Ugo Procacci,* vol. 1, 247–53. Milan, 1977.

———. "Die Skulpturen am Laufgang des Florentiner Domes," *Mitteilungen des Kunsthistorischen Institutes in Florenz* 21 (1977): 111–82.

———. "Form und Sinngehalt von Michelangelos Kentaurenschlacht mit Notizen zu Bertoldo di Giovanni," *Mitteilungen des Kunsthistorischen Institutes in Florenz* 24 (1980): 290–344.

List-Freytag, C. "Beobachtungen zum Bildprogramm der Fonte Gaia Jacopo della Quercias," *Münchner Jahrbuch der Bildenden Kunst* 36 (1985): 57–71.

———. "Quercia in Lucca," *Jahrbuch des Zentralinstituts für Kunstgeschichte* 2 (1986): 9–46.

Lloyd, C. "A Bronze Cupid in Oxford and Donatello's 'Atys-Amorino'," *Storia dell'Arte* 28 (1976): 215–16.

Longhi, R. "Un'osservazione circa il monumento d'Ilaria," *Vita artistica* 1 (1926): 94–96. (Also in R. Longhi, *Edizione delle opere complete* 2, vol. 1, 49–52. Florence, 1967.)

Longhurst, M. H. *Notes on Italian Monuments of the 12th to 16th Centuries.* London, [1962].

Lord, C. "Solar Imagery in Filarete's Doors to St. Peter's," *Gazette des Beaux-Arts* 87 (1976): 143–50.

Lorenzo Ghiberti 'Materia e ragionamenti' (exhibition catalogue). Florence, 1978.

Lorenzo Ghiberti nel suo tempo: Atti del Convegno internazionale di studi 1978. 2 vols. Florence, 1980.

Lorenzoni, G. "Dopo Donatello: da Bartolomeo Bellano ad Andrea Riccio." In *Le sculture del Santo di Padova.* Fonti e studi per la storia del Santo a Padova, Studi 4, edited by G. Lorenzoni, 95–107. Vicenza, 1984.

Lotz, W. *Der Taufbrunnen des Baptisteriums zu Siena.* Berlin, 1948.

McAndrew, J. *Venetian Architecture of the Early Renaissance.* Cambridge, Mass., 1980.

Macchioni, S. "Il San Giorgio di Donatello: storia di un processo di musealizzazione," *Storia dell'Arte,* nos. 36/37 (1979): 135–56.

Mackowsky, H. "Die Lavabo in San Lorenzo zu Florenz," *Jahrbuch der Preussischen Kunstsammlungen* 17 (1896): 239–44.

Maddalo, S. "'Andrea Scarpellino' antiquario: lo studio dell'Antico nella bottega di Andrea Bregno." In *Roma, centro ideale della cultura dell'Antico nei secoli XV e XVI. Convegno 1985,* 229–36. Milan, 1989.

Magenta, C. *La Certosa di Pavia.* Milan, 1897.

Majocchi, R. "Giovanni Antonio Amadeo scultore-architetto secondo i documenti degli archivi pavesi," *Bollettino della Società Pavese di Storia Patria* 3 (1903): 39–80.

Malaguzzi Valeri, F. *Gio. Antonio Amadeo—scultore e architetto lombardo.* Bergamo, 1904.

Maltese, C. "Il ciborio del Duomo di Siena," *Belle Arti* 1 (1946–48): 298–310.

Mandach, C. de. *Saint Antoine de Padoue et l'art italien.* Paris, 1899.

Manetti, A. *The Life of Brunelleschi by Antonio di Tuccio Manetti.* [c. 1485]. Edited by H. Saalman. University Park, Pa., 1970.

———. *Vita di Filippo Brunelleschi [um 1485] preceduta da "La novella del Grasso."* Edited by D. De Robertis and G. Tanturli. Milan, 1976.

———. "Uomini singolari in Firenze dal MCCCC innanzi [circa 1495]." In *Operette istoriche,* edited by G. Milanesi, 159–68. Florence, 1887.

Marangoni, M. "Donatello e la critica," *La Nuova Italia* 8 (1930): 1–8.

Marchini, G. "Di Maso di Bartolommeo e d'altri," *Commentari* 3 (1952): 108–27.

———. *Il tesoro del duomo di Prato.* Milan, 1963.

———. *Il pulpito donatelliano del Duomo di Prato.* Prato, 1966.

———. "Calchi donatelliani." In *Festschrift Klaus Lankheit,* 132–34. Cologne, 1973.

———. "Nella bottega di Donatello," *Prato* 14 (1973): 5–16.

Mardersteig, G. "Leon Battista Alberti e la rinascita del carattere lapidario romano nel Quattrocento," *Italia Medioevale e Umanistica* 2 (1959): 285–307.

Mariacher, G. "Profilo di Antonio Rizzo," *Arte Veneta* 2 (1948): 67–84.

———. "Problemi di scultura veneziana (II): Aggiunte ad Antonio Rizzo," *Arte Veneta* 4 (1950): 105–7.

———. "Pietro Lombardo a Venezia," *Arte Veneta* 9 (1955): 36–53.

Markham, A. "Desiderio da Settignano and the Workshop of Bernardo Rossellino," *The Art Bulletin* 45 (1963): 35–45.

Marquand, A. *Luca della Robbia.* Princeton, N. J., 1914.

———. "Note sul sacrificio d'Isacco di Brunelleschi," *L'Arte* 17 (1914): 385–86.

Marrai, B. "Il tabernacolo col gruppo del Verrocchio in Or San Michele," *L'Arte* 4 (1901): 346–52.

———. "Ancora del tabernacolo col gruppo del Verrocchio in Or San Michele," *L'Arte* 5 (1902): 185–89.

———. *Donatello nelle opere di decorazione architettonica.* Florence, 1903.

Marrucchi, E. "Dove nacque Mino da Fiesole," *Rivista d'Arte* 21 (1939): 324–26.

Martinelli, V. "Donatello e Michelozzo a Roma (I–II)," *Commentari* 8 (1957): 167–94, and 9 (1958): 3–24.

———. "La 'compagnia' di Donatello e Michelozzo e la 'sepoltura' del Brancacci a Napoli (I)," *Commentari* 14 (1963): 211–26.

Mather, R. G. "Nuovi documenti Robbiani," *L'Arte* 21 (1918): 190–209.

———. "Donatello debitore oltre la tomba," *Rivista d'Arte* 19 (1937): 181–92.

————. "New Documents on Michelozzo," *The Art Bulletin* 24 (1942): 226–31.

————. "Documents Mostly New Relating to Florentine Painters and Sculptors of the Fifteenth Century," *The Art Bulletin* 30 (1948): 20–65.

Matteucci, A. M. *La Porta Magna di S. Petronio in Bologna*. Bologna, 1966.

Matthias Corvinus und die Renaissance in Ungarn, 1458–1541 (exhibition catalogue). Schallaburg, 1982.

Meli, A. *Bartolomeo Colleoni nel suo mausoleo*. Bergamo, 1966.

————. *Bartolomeo Colleoni ritrovato nel suo mausoleo (21 novembre 1969)*. Bergamo, 1970.

Meli, F. *L'arte di Matteo Civitali*. Lucca, [1934].

Meller, P. "La fontana di Mattia Corvino a Visegrád," *Annuario.—Istituto Ungherese di Storia dell'Arte* (Florence) 1 (1947): 47–73.

Meyer, A. G. *Oberitalienische Frührenaissance: Bauten und Bildwerke der Lombardei*. 2 vols. Berlin, 1897–1900.

————. *Donatello*. 2nd ed. Leipzig-Bielefeld, 1908.

Micheletti, E., and A. Paolucci. *Brunelleschi scultore* (exhibition catalogue). Florence, 1977.

Michiel, M. *Der Anonimo Morelliano (Marcanton Michiel's Notizia d'opere del disegno*. [1521–43]. Edited by T. Frimmel. Vienna, 1888.

Middeldorf, U. Review of *The Unfinished Monument by Andrea Verrocchio to the Cardinal Niccolò Forteguerri at Pistoia*, by C. Kennedy, E. Wilder, and P. Bacci. *Zeitschrift für Kunstgeschichte* 3 (1934): 54–58. (Also in U. Middeldorf, *Raccolta di scritti*, vol. 1, 169–78. Florence, 1979–80.)

————. "New Attributions to G. F. Rustici," *The Burlington Magazine* 66 (1935): 71–81. (Also in U. Middeldorf, *Raccolta di scritti*, vol. 1, 199–210. Florence, 1979–80.)

————. Review of *Donatello*, by H. Kauffmann. *The Art Bulletin* 18 (1936): 570–85. (Also in U. Middeldorf, *Raccolta di scritti*, vol. 1, 229–62. Florence, 1979–80.)

————. Review of *Römische Porträtbüsten der Gegenreformation*, edited by A. Grisebach. *The Art Bulletin* 20 (1938): 111–17. (Also in U. Middeldorf, *Raccolta di scritti*, vol. 1, 389–400. Florence, 1979–80.)

————. Review of *Lorenzo di Pietro detto il Vecchietta*, by G. Vigni. *Art in America* 26 (1938): 142.

————. "The Florentine Sculptures at Toledo," *Art in America* 28 (1940): 13–30. (Also in U. Middeldorf, *Raccolta di scritti*, vol. 2, 21–35. Florence 1980.)

————. "The Tabernacle of S. Maria Maggiore," *Bulletin of the Art Institute of Chicago* 38 (1944): 6–10. (Also in U. Middeldorf, *Raccolta di scritti*, vol. 2, 55–59. Florence, 1980.)

————. "Ein Jugendwerk des Amadeo." In *Kunstgeschichtliche Studien für Hans Kauffmann*, 136–42. Berlin, 1956. (Also in U. Middeldorf, *Raccolta di scritti*, vol. 2, 207–16. Florence, 1980.)

————. "Un rame inciso del Quattrocento." In *Scritti di storia dell'arte in onore di Mario Salmi*, 273–89. Rome, 1962. (Also in U. Middeldorf, *Raccolta di scritti*, vol. 2, 275–85. Florence, 1980.)

————. "Filarete?," *Mitteilungen des Kunsthistorischen Institutes in Florenz* 17 (1973): 75–86.

————. "Quelques sculptures de la Renaissance en Toscane occidentale," *Revue de l'Art*, no. 36 (1977): 7–26. (Also in U. Middeldorf, *Raccolta di scritti*, vol. 3, 141–67. Florence, 1981.)

————. "Die Zwölf Caesaren von Desiderio da Settignano," *Mitteilungen des Kunsthistorischen Institutes in Florenz* 23 (1979): 297–312. (Also in U. Middeldorf, *Raccolta di scritti*, vol. 3, 257–69. Florence, 1981.)

Middeldorf, U., and H.-W. Kruft. "Three Male Portrait Busts by Francesco Laurana," *The Burlington Magazine* 113 (1971): 264–67. (Also in U. Middeldorf, *Raccolta di scritti*, vol. 2, 319–23. Florence, 1980.)

Milanesi, C. "Della statua equestre di Erasmo da Narni detto il Gattamelata," *Archivio Storico Italiano* 2 (1855): 45–64.

Milanesi, G. *Documenti per la storia dell'arte senese*. 3 vols. Siena, 1854–56.

————. *Catalogo delle opere di Donatello e bibliografia degli autori che ne hanno scritto*. Florence, 1887.

————. *Nuovi documenti per la storia dell'arte toscana dal XII al XV secolo*. Florence, 1901. Reprint. Soest, 1973.

Mingardi, C. "Problemi mazzoniani," *Contributi dell'Istituto di Storia dell'Arte Medioevale e Moderna dell'Università Cattolica del Sacro Cuore* 2 (1972): 163–87.

————. "Il Mortorio di Guido Mazzoni in Santa Maria degli Angeli a Busseto," *Biblioteca* 70, no. 4 (1975): 99–110.

Mitchell, C. "Il Tempio Malatestiano." In *Studi malatestiani*, edited by the Istituto Storico Italiano per il Medio Evo, 71–103. Rome, 1978.

Mode, R. L. "Adolescent *Confratelli* and the *Cantoria* of Luca della Robbia," *The Art Bulletin* 68 (1986): 67–71.

Mognetti, E. "Francesco Laurana: Sculpteur du Roi René en Provence." In *Le Roi René en son temps: 1382–1481* (exhibition catalogue), 131–82. Aix-en-Provence, 1981.

Morani, U., and A. Cairola. *Lo Spedale di Santa Maria della Scala*. Siena, 1975.

Moreni, D. *Delle tre sontuose cappelle medicee situate nell'Imp. Basilica di S. Lorenzo*. Florence, 1813.

————. *Memorie storiche dell'imperial basilica di San Lorenzo*. Continuazione 1–2. Florence, 1816–17.

Morisani, O. *Studi su Donatello*. Venice, 1952.

————. *Tutta la scultura di Jacopo della Quercia*. Milan, 1962.

————. "Per una rilettura del monumento Brancacci," *Napoli nobilissima* 4 (1964–65): 3–11.

————. "Mazzoni e no." In *Arte in Europa: Scritti di storia dell'arte in onore di Edoardo Arslan*, vol. 1, 475–79. Milan, 1966.

Mormone, R. "Donatello, Michelozzo e il monumento Brancacci," *Cronache di Archeologia e di Storia dell'Arte* 5 (1966): 121–33.

Morschek, C. R. *Relief Sculpture for the Façade of the Certosa di Pavia 1473–1499*. New York and London, 1978.

————. "Keystones by Amadeo and Cristoforo Mantegazza in the Church of the Certosa di Pavia," *Arte Lombarda* 68/69 (1984): 27–37.

Morselli, P. "The Proportions of Ghiberti's *Saint Stephen*: Vitruvius's *De Architectura* and Alberti's *De Statua*," *The Art Bulletin* 60 (1978): 235–41.

————. "Corpus of Tuscan Pulpits 1400–1550." Ph.D. diss., University of Pittsburgh, 1979.

————. "Il soffitto del pulpito di Donatello nel Duomo di Prato," *Prato* 27 (1986): 4–7.

Moschetti, A. "Un quadriennio di Pietro Lombardo a Padova (1464–67): Con una appendice sulle date di nascita e di morte di Bartolommeo Bellano," *Bollettino del Museo Civico di Padova* 16 (1913): 1–99, and 17 (1914): 1–43.

Moskowitz, A. "Donatello's Reliquary Bust of Saint Rossore," *The Art Bulletin* 63 (1981): 41–48.

Müller, T. *Leonardo da Vinci—Il Cavallo*. Berlin, 1948.

Müntz, E. *Les arts à la cour des papes pendant le XVe et le XVIe siècle*. 3 vols. Paris, 1878–82. Reprint. Hildesheim, 1983.

————. *Donatello*. Paris, [1885].

————. *Les collections des Médicis au XVe siècle: Le musée, la bibliothèque, le mobilier*. Paris, 1888.

————. *Histoire de l'art pendant la Renaissance*. 3 vols. Paris, 1889–95.

Munman, R. "Venetian Renaissance Tomb Monuments." Ph.D. diss., Harvard University, 1968.

————. "The Monument to Vittore Cappello of Antonio Rizzo," *The Burlington Magazine* 113 (1971): 138–45.

————. "Antonio Rizzo's Sarcophagus for Nicolò Tron: A Closer Look," *The Art Bulletin* 55 (1973): 77–85.

————. "The Last Work of Antonio Rizzo," *Arte Lombarda* 47/48 (1977): 89–98.

————. "The Lombardo Family and the Tomb of Giovanni Zanetti," *The Art Bulletin* 59 (1977): 28–38.

————. "The Evangelists from the Cathedral of Florence: A Renaissance Arrangement Recovered," *The Art Bulletin* 62 (1980): 207–17.

————. Review of *Antonio Rizzo: Sculptor and Architect*, by A. M. Schulz. *Renaissance Quarterly* 37 (1984): 466–71.

————. *Optical Corrections in the Sculpture of Donatello*. Transactions of the American Philosophical Society, vol. 75, pt. 2, Philadelphia, 1985.

Natali, A. "Exemplum salutis publicae." In *Donatello e il restauro della Giuditta* (exhibition catalogue), 19–32. Florence, 1988.

Negri Arnoldi, F. "Un Desiderio da Settignano vero (e uno falso)," *Paragone* 15, no. 175 (1964): 69–73.

————. "Un marmo autentico di Desiderio all'origine di un falso Antonio Rossellino," *Paragone* 18, no. 209 (1967): 23–26.

————. "Matteo Civitali scultore lucchese." In *Egemonia fiorentina ed autonomie locali nella Toscana nord-occidentale del primo Rinascimento: vita, arte, cultura. Atti del VII Convegno internazionale 1975*, 225–82. Pistoia, [1978].

————. "Il monumento sepolcrale del Card. Niccolò Forteguerri in Santa Cecilia a Roma e il suo cenotafio nella cattedrale di Pistoia." In *Egemonia*

fiorentina ed autonomie locali nella Toscana nord-occidentale del primo Rinascimento: vita, arte, cultura. Atti del VII Convegno internazionale 1975, 211–33. Pistoia, [1978].

———. "Isaia da Pisa e Pellegrino da Viterbo." In *Il Quattrocento a Viterbo*, 324–40. Rome, 1983.

———. "Bellano e Bertoldo nella bottega di Donatello," *Prospettiva* 33/36 (1983–84): 93–101.

Nicco, G. *Jacopo della Quercia*. Florence, 1934.

Nilgen, U. "Filaretes Bronzetür von St. Peter: Zur Interpretation von Bild und Rahmen." In *Actas del XXIII Congreso internacional de historia del arte 1973*, vol. 3, 569–85. Granada, 1978.

———. "Filaretes Bronzetür von St. Peter in Rom: Ein päpstliches Bildprogramm des 15. Jh.," *Jahrbuch des Vereins für Christliche Kunst in München* 17 (1988): 351–76.

Omaggio a Donatello. 1386–1986: Donatello e la storia del Museo (exhibition catalogue). Florence, 1985.

L'Oro del Ghiberti: Restauri alla Porta del Paradiso (exhibition catalogue). Florence, 1985.

Ortolani, S. *Il Pollaiuolo*. Milan, 1948.

Os, H. W. van. *Vecchietta and the Sacristy of the Siena Hospital Church: A Study in Renaissance Religious Symbolism*. Kunsthistorische Studien van het Nederlands Instituut te Rome, no. 2. s'Gravenhage, 1974.

———. "Vecchietta and the Persona of the Renaissance Artist." In *Studies in Late Medieval and Renaissance Painting in Honor of Millard Meiss*, 445–54. New York, 1977.

———. "Lorenzo Vecchietta und seine soziale Stellung als Künstler," *Mitteilungen der Gesellschaft für Vergleichende Kunstforschung in Wien* 30, no. 2 (1978): 5–6.

Paatz, W., and E. Paatz. *Die Kirchen von Florenz: Ein kunstgeschichtliches Handbuch*. 6 vols. Frankfurt-am-Main, 1940–54.

Pachaly, G. *Nanni di Antonio di Banco*. Heidelberg, 1907.

Padoa Rizzo, A. "Luca della Robbia: la lunetta urbinate." In *Urbino e le Marche prima e dopo Raffaello*, edited by M. G. Ciardi Dupré Dal Poggetto and P. Dal Poggetto, 31–33. Florence, 1983.

Palmieri, M. *Vita civile*. Edited by G. Belloni. Florence, 1982.

Pane, R. *Il Rinascimento nell'Italia meridionale*. 2 vols. Milan, 1975–77.

Panofsky, E. "Die Perspektive als 'symbolische Form'." In *Vorträge der Bibliothek Warburg 1924/25*, 258–330. Leipzig and Berlin, 1927.

———. *Grabplastik: 4 Vorlesungen über ihren Bedeutungswandel von Alt-Ägypten bis Bernini*. Edited by H. W. Janson. Cologne, 1964.

Paoletti, J. T. "Donatello and Brunelleschi: An Early Renaissance Portrait," *Commentari* 21 (1970): 55–60.

———. "The Bargello David and Public Sculpture in Fifteenth-Century Florence." In *Collaboration in Italian Renaissance Art*, 99–111. New Haven and London, 1978.

———. *The Siena Baptistry Font: A Study of an Early Renaissance Collaborative Program, 1416–1434*. New York and London, 1979.

Paoletti, P. *L'architettura e la scultura del Rinascimento in Venezia*. 2 vols. Venice, 1893.

———. *La Scuola Grande di San Marco*. Venice, 1929.

Paoli, M. "Jacopo della Quercia e Lorenzo Trenta: nuove osservazioni e ipotesi per la cappella in San Frediano di Lucca," *Antichità Viva* 19, no. 3 (1980): 27–36.

Paolozzi Strozzi, B. *David di bronzo*. Florence, 1986.

Paolucci, A. "I musici di Benedetto da Maiano e il monumento di Ferdinando d'Aragona," *Paragone* 26, no. 303 (1975): 3–11.

———. "Il crocifisso di Brunelleschi dopo il restauro," *Paragone* 28, no. 329 (1977): 3–6.

Parlato, E. "Il gusto all'antica di Filarete scultore." In *Da Pisanello alla nascità dei Musei Capitolini: L'Antico a Roma alla vigilia del Rinascimento* (exhibition catalogue), 115–34. Milan and Rome, 1988.

Parronchi, A. "Per la ricostruzione dell'altare del Santo," *Arte Antica e Moderna* 22 (1963): 109–23. (Also in A. Parronchi, *Donatello e il potere*, 157–75, Bologna and Florence, 1980.)

———. "Storia di una 'Gatta malata'," *Paragone* 14, no. 157 (1963): 60–68. (Also in A. Parronchi, *Donatello e il potere*, 139–53. Bologna and Florence, 1980.)

———. "L'aspetto primitivo del sepolcro Federighi," *Paragone* 15, no. 179 (1964): 49–52.

———. "Sulla collocazione originaria del tabernacolo di Desiderio da Settignano," *Cronache di Archeologia e di Storia dell'Arte* 4 (1965): 130–40.

———. "Il soggiorno senese di Donatello del 1457–61." In *Donatello e il suo tempo*, 163–77. Florence, 1968. (Also in A. Parronchi, *Donatello e il potere*, 245–60. Bologna and Florence, 1980.)

———. "L'autore del 'Crocifisso' di Santa Croce: Nanni di Banco," *Prospettiva* 6 (1976): 50–55.

———. "La croce d'argento dell'altare di San Giovanni." In *Lorenzo Ghiberti nel suo tempo*, vol. 1, 195–217. Florence, 1980.

———. *Donatello e il potere*. Bologna and Florence, 1980.

———. "Mercurio e non David." In A. Parronchi, *Donatello e il potere*, 101–26. Bologna and Florence, 1980.

———. "Su tre crocifissi." In A. Parronchi, *Donatello e il potere*, 51–67. Bologna and Florence, 1980.

———. "Un tabernacolo brunelleschiano." In *Filippo Brunelleschi: La sua opera e il suo tempo*, vol. 1, 239–55. Florence, 1980.

———. "Il busto bronzeo di Giovane del Bargello." In *Scritti di storia dell'arte in onore di Roberto Salvini*, 301–7. Florence, 1984.

Passavant, G. *Andrea del Verrocchio als Maler*. Düsseldorf, 1959.

———. *Verrocchio: Skulpturen, Gemälde und Zeichnungen*. London, 1969.

———. "Beobachtungen am Lavabo von San Lorenzo in Florenz," *Pantheon* 39 (1981): 33–50.

———. "Beobachtungen am Silberkreuz des Florentiner Baptisteriums." In *Studien zum europäischen Kunsthandwerk: Festschrift Yvonne Hackenbroch*, 77–105. Munich, 1983.

———. "Zu einigen toskanischen Terrakotta-Madonnen der Frührenaissance," *Mitteilungen des Kunsthistorischen Institutes in Florenz* 31 (1987): 197–236.

———. "Überlegungen zur Rotationsmechanik von Verrocchios Delphinputto," *Mitteilungen des Kunsthistorischen Institutes in Florenz* 33 (1989): 105–12.

Patera, B. "Sull'attività di Francesco Laurana in Sicilia: Precisazioni, ipotesi e conferme," *Annali del Liceo Classico 'G. Garibaldi' di Palermo* 2 (1965): 526–50.

———. "Scultura del Rinascimento in Sicilia," *Storia dell'Arte* 24/25 (1975): 151–58.

———. "Francesco Laurana a Sciacca," *Storia dell'Arte* 38/40 (1980): 167–84.

Pedretti, C. "The Sforza Sepulchre," *Gazette des Beaux-Arts* 89 (1977): 121–31.

———. "Leonardo's Studies for the Sforza Sepulchre," *Gazette des Beaux-Arts* 91 (1978): 1–20.

Perkins, C. C. *Italian Sculptors*. London, 1868.

Perrig, A. *Lorenzo Ghiberti: Die Paradieses-tür. Warum ein Künstler den Rahmen sprengt*. Frankfurt-am-Main, 1987.

Petrucci, F. *Matteo Civitali e Roma*. Florence, 1980.

Pettorelli, A. *Guido Mazzoni da Modena plasticatore*. Turin, 1925.

Pfeiffenberger, S. "Notes on the Iconology of Donatello's Judgment of Pilate at San Lorenzo," *Renaissance Quarterly* 20 (1967): 437–54.

Pfeiffer, A. "Das Ciborium im Sieneser Dom: Untersuchungen zur Bronzeplastik Vecchiettas." Ph.D. diss., Marburg, 1975.

Piel, F. *La Cappella Colleoni e il Luogo Pio della Pietà in Bergamo*. Bergamo, 1975.

Pincus, D. D. "A Hand by Antonio Rizzo and The Double Caritas Scheme of the Tron Tomb," *The Art Bulletin* 51 (1969): 247–56.

———. *The Arco Foscari: The Building of a Triumphal Gateway in Fifteenth-Century Venice*. New York and London, 1976.

———. "The Tomb of Doge Nicolò Tron and Venetian Renaissance Ruler Imagery." In *Art the Ape of Nature: Studies in Honor of H. W. Janson*, 127–50. New York, 1981.

Planiscig, L. *Venezianische Bildhauer der Renaissance*. Vienna, 1921.

———. *Die Bronzeplastiken*. Kunsthistorisches Museum in Wien: Publikationen aus den Sammlungen für Plastik und Kunstgewerbe, vol. 4, edited by J. Schlosser. Vienna, 1924.

———. "Das Grabdenkmal des Orsato Giustiniani: Ein Beitrag zur Geschichte der venezianischen Skulptur im Quattrocento," *Jahrbuch der Kunsthistorischen Sammlungen in Wien* 1 (1926): 93–102.

———. *Piccoli bronzi italiani del Rinascimento*. Milan, 1930.

———. "Andrea del Verrocchios Alexander-Relief," *Jahrbuch der Kunsthistorischen Sammlungen in Wien* 7 (1933): 89–96.

———. *Donatello*. Vienna, 1939.

———. *Lorenzo Ghiberti*. Vienna, 1940.

———. *Luca della Robbia*. Vienna, 1940.

————. *Andrea del Verrocchio*. Vienna, 1941.

————. *Bernardo und Antonio Rossellino*. Vienna, 1942.

————. *Desiderio da Settignano*. Vienna, 1942.

————. "I profeti sulla Porta della Mandorla del Duomo fiorentino," *Rivista d'Arte* 24 (1942): 125–42.

————. *Nanni di Banco*. Florence, 1946.

————. "Di alcune opere falsamente attribuite a Donatello," *Phoebus* 2 (1948–49): 55–59.

Poeschke, J. Review of *Donatello und Nanni di Banco*, by M. Wundram. *Kunstchronik* 24 (1971): 10–23.

————. Review of *Studien zum frühen Donatello*, by A. Rosenauer. *Kunstchronik* 30 (1977): 340–45.

————. *Donatello: Figur und Quadro*. Munich, 1980.

————. Review of *Donatello e i suoi* (exhibition catalogue). *Kunstchronik* 39 (1986): 505–10.

————. "Il rapporto tra statua e spazio nel concetto del giovane Donatello." In *Donatello-Studien*. Italienische Forschungen (Florence), no. 3, vol. 16, pp. 146–54. Munich, 1989.

————. "Donatello als Zeichner?" In *Studien zur Künstlerzeichnung: Festschrift für Klaus Schwager zum 65. Geburtstag*, 20–30. Stuttgart, 1990.

Poggi, G. "Un tondo di Benedetto da Maiano," *Bollettino d'Arte* 2 (1908): 1–5.

————. *Il Duomo di Firenze: Documenti sulla decorazione della chiesa e del campanile tratti dall'Archivio dell'Opera*. Berlin, 1909. Reprint. 2 vols. Edited by M. Haines. *Italienische Forschungen*, vols. 2–3. Florence, 1988.

Poggi, G., L. Planiscig, and B. Bearzi. *Donatello: San Ludovico*. New York, [1949].

Pohl, J. *Die Verwendung des Naturabgusses in der italienischen Porträtplastik der Renaissance*. Würzburg, 1938.

Pohlandt, W. "Antonio Rizzo," *Jahrbuch der Berliner Museen* 13 (1971): 162–207.

Pointner, A. *Die Werke des florentinischen Bildhauers Agostino d'Antonio di Duccio*. Strassburg, 1909.

Pope-Hennessy, J. *Donatello's Relief of the Ascension*. London, 1949. (Also in J. Pope-Hennessy, *Essays on Italian Sculpture*, 37–46. London and New York, 1968.)

————. *The Virgin with the Laughing Child*. London, 1949. (Also in J. Pope-Hennessy, *Essays on Italian Sculpture*, 72–77. London and New York, 1968.)

————. *Italian Gothic Sculpture (An Introduction to Italian Sculpture*, pt. 1). London, 1955; 3rd ed., New York, 1985.

————. *Italian Renaissance Sculpture (An Introduction to Italian Sculpture*, pt. 2). London, 1958; 3rd ed., New York, 1985.

————. "The Martelli David," *The Burlington Magazine* 101 (1959): 134–39. (Also in J. Pope-Hennessy, *Essays on Italian Sculpture*, 65–71. London and New York, 1968.)

————. "Some Donatello Problems." In *Studies in the History of Art Dedicated to W. E. Suida on his Eightieth Birthday*, 47–65. London, 1959. (Also in J. Pope-Hennessy, *Essays on Italian Sculpture*, 47–64. London and New York, 1968.)

————. "Italian Bronze Statuettes I," *The Burlington Magazine* 105 (1963): 14–23.

————. *Catalogue of Italian Sculpture in the Victoria & Albert Museum*. 3 vols. London, 1964.

————. *Essays on Italian Sculpture*. London and New York, 1968.

————. "The Altman Madonna by Antonio Rossellino," *The Metropolitan Museum Journal* 3 (1970): 133–48. (Also in J. Pope-Hennessy, *The Study and Criticism of Italian Sculpture*, 135–54. New York and Princeton, N.J., 1980.)

————. *Sculpture, Italian. The Frick Collection: An Illustrated Catalogue*. Vol. 3. New York, 1970.

————. "Some Newly Acquired Italian Sculpture: A Relief of the Rape of Europa," *Victoria & Albert Museum Yearbook* 4 (1974): 11–19.

————. "The Medici Crucifixion of Donatello," *Apollo* 101 (1975): 82–87. (Also in J. Pope-Hennessy, *The Study and Criticism of Italian Sculpture*, 119–28. New York and Princeton, N.J., 1980.)

————. "The Madonna Reliefs of Donatello," *Apollo* 103 (1976): 172–91. (Also in J. Pope-Hennessy, *The Study and Criticism of Italian Sculpture*, 71–105. New York and Princeton, N.J., 1980.)

————. "Donatello and the Bronze Statuette," *Apollo* 105 (1977): 30–33. (Also in J. Pope-Hennessy, *The Study and Criticism of Italian Sculpture*, 129–34. New York and Princeton, N.J., 1980.)

————. "The Evangelist Roundels in the Pazzi Chapel," *Apollo* 106 (1977): 262–69. (Also in J. Pope-Hennessy, *The Study and Criticism of Italian Sculpture*, 106–18. New York and Princeton, N.J., 1980.)

————. *Luca della Robbia*. Oxford, 1980.

————. "The Sixth Centenary of Ghiberti." In J. Pope-Hennessy, *The Study and Criticism of Italian Sculpture*, 39–70. New York and Princeton, N.J., 1980.

————. *The Study and Criticism of Italian Sculpture*. New York and Princeton, N.J., 1980.

————. "A Terracotta 'Madonna' by Donatello," *The Burlington Magazine* 125 (1983): 83–85.

————. "Donatello's Bronze David." In *Scritti di storia dell'arte in onore di Federico Zeri*, vol. 1, 122–27. Milan, 1984.

————. *Donatello*. Frankfurt-am-Main and Berlin, 1986.

————. "Deux madones en marbre de Verrocchio," *Revue de l'Art*, no. 80 (1988): 17–25.

Previtali, G. "Una data per il problema dei pulpiti di San Lorenzo," *Paragone* 12, no. 133 (1961): 48–56.

Prijatelj, K. *Ivan Duknović*. Zagreb, 1957.

————. "Profilo di Giovanni Dalmata," *Arte Antica e Moderna* 5 (1959): 283–97.

Prinz, W. "L'autoritratto di Donatello," *Antichità Viva* 28, no. 4 (1989): 36–39.

Procacci, U. "Il tempietto sepolcrale dei SS. Pellegrino e Bianco di Matteo Civitali," *Rivista d'Arte* 13 (1931): 406–19.

————. "Le Catasto florentin de 1427," *Revue de l'Art*, no. 54 (1981): 7–22.

Pujmanova, O. "Sculture di Mino da Fiesole nel Duomo di Olomouc," *Prospettiva* 49 (1987): 75–79.

Radcliffe, A. "The Forzori Altar Reconsidered." In *Donatello-Studien*. Italienische Forschungen (Florence), no. 3, vol. 16, 194–208. Munich, 1989.

Radcliffe, A., and C. Avery. "The 'Chellini Madonna' by Donatello," *The Burlington Magazine* 118 (1976): 377–87.

Radke, G. M. "The Sources and Composition of Benedetto da Maiano's San Savino Monument in Faenza," *Studies in the History of Art* (Washington, D.C.) 18 (1985): 7–27.

Ragghianti, C. L. "Notizie e letture," *La Critica d'Arte* 5, no. 2 (1940): XXIII–XXV.

————. "Donatello giovane," *Sele Arte* 2, no. 7 (1953): 29–40.

————. "Aenigmata Pistoriensia I," *Critica d'Arte* 1 (1954): 423–38.

————. "Vecchietta scultore," *Critica d'Arte* 1 (1954): 330–35.

————. "Problemi di Agostino di Duccio," *Critica d'Arte* 2 (1955): 2–21.

————. *Filippo Brunelleschi: Un uomo, un universo*. Florence, 1977.

Ragghianti, L., and C. L. Ragghianti. "Il calvario di Mattia Corvino e Antonio Pollaiuolo," *Critica d'Arte* 51, no. 8 (1986): 48–54.

Rambaldi, P. L. *La Scala dei Giganti nel Palazzo Ducale di Venezia: Memorie storiche e documenti sul restauro del 1728*. Venice, 1910.

Ravaioli, C. "Agostino di Duccio a Rimini," *Studi Romagnoli* 2 (1951): 113–20.

Reymond, M. *Les Della Robbia*. Florence, 1897.

Ricci, C. *Il Tempio Malatestiano*. Milan and Rome, [1924].

Riccoboni, A. *Roma nell'arte: La scultura nell'evo moderno dal Quattrocento ad oggi*. Rome, 1942.

Riccòmini, E. *Guido Mazzoni*. Milan, 1966.

Richa, G. *Notizie istoriche delle chiese fiorentine divise ne' suoi quartierti*. 10 vols. Florence, 1754–62.

Ridolfi, E. *L'arte in Lucca studiata nella sua cattedrale*. Lucca, 1882.

Ridolfi, M. *Scritti d'arte e d'antichità*. Florence, 1879.

Rigoni, E. *L'arte rinascimentale in Padova: Studi e documenti*. Medioevo e umanesimo, no. 9. Padua, 1970.

Roeder, H. "The Borders of Filarete's Bronze Doors to St. Peter's," *Journal of the Warburg and Courtauld Institutes* 10 (1947): 150–53.

Röll, J. "Giovanni Dalmata." Ph.D. diss., Würzburg, 1990.

Rolfs, W. *Franz Laurana*. Berlin, [1907].

Romanini, A. M. "L'incontro tra Cristoforo Mantegazza e il Rizzo nel settimo decennio del Quattrocento," *Arte Lombarda* 9 (1964): 91–102.

————. "Donatello e la 'prospettiva'," *Commentari* 17 (1966): 290–323.

Rondelli, N. "Jacopo della Quercia a Ferrara, 1403–1408," *Bullettino Senese di storia Patria* 71 (1964): 131–42.

————. "Notizie relative alla Madonna del Pane o del Melograno di Jacopo della Quercia di Siena nel museo del duomo di Ferrara 1403–1408." In *La cattedrale di Ferrara: Atti del convegno nazionale di studi storici 1979*, 493–502. Ferrara, 1982.

Rose, P. "Bears, Baldness, and the Double Spirit: The Identity of Donatello's *Zuccone*," *The Art Bulletin* 63 (1981): 31–41.

Rosenauer, A. Review of *Donatello and Nanni di Banco*, by M. Wundram. *Mitteilungen der Gesellschaft für Vergleichende Kunstforschung in Wien* 26 (1973): 28–30.

———. *Studien zum frühen Donatello: Skulptur im projektiven Raum der Neuzeit*. Vienna, 1975.

———. "Bemerkungen zu einem frühen Werk Agostino di Duccios," *Münchner Jahrbuch der Bildenden Kunst* 28 (1977): 133–52.

———. "Zum Geremia vom Florentiner Campanile," *Münchner Jahrbuch der Bildenden Kunst* 33 (1982): 67–76.

———. "Zu Donatellos Putten im Musée Jacquemart-André," *Wiener Jahrbuch für Kunstgeschichte* 40 (1987): 295–301.

Rossi, A. "Prospetto cronologico della vita e delle opere di Agostino d'Antonio scultore fiorentino," *Giornale di erudizione artistica* 4 (1875): 3–25, 33–50, 76–83, 117–22, 141–52, 179–84, 202–11, 241–49, 263–75.

Rubinstein, R. O. "Pius II's Piazza S. Pietro and St. Andrew's Head." In *Essays in the History of Architecture Presented to Rudolf Wittkower (Essays Presented to R. Wittkower on his Sixty-fifth Birthday)*, vol. 1, 22–33. London, 1967.

Rumohr, C. F. von. *Italienische Forschungen*. 3 vols. Berlin and Stettin, 1827–31.

———. *Italienische Forschungen*. Edited by J. Schlosser. Frankfurt-am-Main, 1920.

Saalman, H. "The San Lorenzo Pulpits: A Cosimo Portrait?," *Mitteilungen des Kunsthistorischen Institutes in Florenz* 30 (1986): 587–89.

Sabatini, A. *Antonio e Piero del Pollaiuolo*. Florence, 1944.

Sachs, C. *Das Tabernakel mit Andreas del Verrocchio Thomasgruppe an Or San Michele zu Florenz*. Strassburg, 1904.

Salas, X. de. "The 'St. John' of Niccolò dell'Arca." In *Essays in the History of Art Presented to Rudolf Wittkower (Essays Presented to R. Wittkower on his Sixty-fifth Birthday)*, vol. 2, 89–92. London, 1967.

Salet, F. Review of *Masques de femme de Francesco Laurana*, by C. de Mérindol. *Bulletin Monumental* 141 (1983): 322–23.

Salmi, M. "Il Tempio Malatestiano," *Studi Romagnoli* 2 (1951): 151–67.

———. "Bernardo Rossellino ad Arezzo." In *Scritti di storia dell'arte in onore di Ugo Procacci*, vol. 1, 254–61. Milan, 1977.

Sanpaolesi, P. *Brunellesco e Donatello nella Sacristia Vecchia di San Lorenzo*. Pisa, 1948.

———. "Aggiunte al Brunelleschi," *Bollettino d'Arte* 38 (1953): 225–32.

Sansovino, F. *Venetia città nobilissima, et singolare*. Venice, 1581.

Sartori, A. "Documenti riguardanti Donatello e il suo altare di Padova," *Il Santo* 1 (1961): 37–99.

———. "Il donatelliano monumento equestre a Erasmo Gattamelata," *Il Santo* 1 (1961): 318–44.

———. "L'armadio delle reliquie della Sacrestia del Santo e Bartolomeo Bellano," *Il Santo* 2 (1962): 32–58.

———. "Di nuovo sulle opere donatelliane al Santo," *Il Santo* 3 (1963): 347–58.

———. *Documenti per la storia dell'arte a Padova*. Fonti e Studi per la storia del Santo a Padova, 4. Vicenza, 1976.

———. *Archivio Sartori: Documenti di storia e arte francescana*. Vol. 1. Edited by G. Luisetto. Padua, 1983.

Sauer, B. "Die Randreliefe an Filarete's Bronzetür von St. Peter," *Repertorium für Kunstwissenschaft* 20 (1897): 1–22.

Schlegel, F. *Gemälde alter Meister, mit Kommentar und Nachwort von H. Eichner und N. Lelless*. Darmstadt, 1984.

Schlegel, U. "Zu Donatello und Desiderio da Settignano: Beobachtungen zur physiognomischen Gestaltung im Quattrocento," *Jahrbuch der Berliner Museen* 9 (1967): 135–55.

———. "Problemi intorno al David Martelli." In *Donatello e il suo tempo*, 245–58. Florence, 1968.

Schlosser, J. von. *Werke der Kleinplastik in der Skulpturensammlung des A. H. Kaiserhauses*. Vol. 1. Vienna, 1910.

———. *Leben und Meinungen des Florentinischen Bildners Lorenzo Ghiberti*. Basel, 1941.

Schmarsow, A. "Meister Andrea," *Jahrbuch der Preussischen Kunstsammlungen* 4 (1883): 18–31.

———. *Donatello: Eine Studie über den Entwicklungsgang des Künstlers und die Reihenfolge seiner Werke*. Breslau and Leipzig, 1886.

———. "Die Kaiserkrönung im Museo Nazionale." In *Festschrift zu Ehren des Kunsthistorischen Instituts in Florenz*, 54–74. Leipzig, 1897.

———. "Die Statuen an Or San Michele." In *Festschrift zu Ehren des Kunsthistorischen Instituts in Florenz*, 36–53. Leipzig, 1897.

Schmidt, J. von. "'Maistro Andrea de Monte Caballo'," *Repertorium für Kunstwissenschaft* 29 (1906): 468.

Schneider, L. "Donatello's Bronze David," *The Art Bulletin* 55 (1973): 213–16.

———. "Some Neoplatonic Elements in Donatello's Gattamelata and Judith and Holofernes," *Gazette des Beaux-Arts* 87 (1976): 41–48.

———. "More on Donatello's Bronze 'David'," *Gazette des Beaux-Arts* 94 (1979): 48.

Schottmüller, F. *Donatello: Ein Beitrag zum Verständnis seiner künstlerischen Tat*. Munich, 1904.

———. "Benedetto da Maiano." In *Allgemeines Lexikon der bildenden Künstler von der Antike bis zur Gegenwart*, edited by U. Thieme and F. Becker, vol. 3, 309–13. Leipzig, 1909.

———. *Königliche Museen zu Berlin. Beschreibung der Bildwerke der christlichen Epochen, V. Die italienischen und spanischen Bildwerke der Renaissance und des Barocks*. Berlin, 1913; 2nd ed., Berlin, 1933.

Schroeteler, H. "Zur Rekonstruktion des Donatello-Altars im Santo zu Padua." Ph.D. diss., Bochum, 1969.

Schubring, P. "Niccolò da Bari," *Zeitschrift für Bildende Kunst* 15 (1904): 209–18.

———. *Luca della Robbia und seine Familie*. Bielefeld and Leipzig, 1905.

———. *Donatello*. Stuttgart and Leipzig, 1907.

———. *Die Plastik Sienas im Quattrocento*. Berlin, 1907.

———. *Die italienische Plastik des Quattrocento*. Handbuch der Kunstwissenschaft. Berlin and Neubabelsberg, 1919.

Schulz, A. M. "The Giustiniani Chapel and the Art of the Lombardo," *Antichità Viva* 16, no. 2 (1977): 27–44.

———. "A New Venetian Project by Verrocchio: The Altar of the Virgin in SS. Giovanni e Paolo." In *Festschrift für Otto von Simson zum 65. Geburtstag*, 197–208. Frankfurt-am-Main and Berlin, 1977.

———. *The Sculpture of Bernardo Rossellino and His Workshop*. Princeton, N.J., 1977.

———. "Pietro Lombardo's Barbarigo Tomb in the Venetian Church of S. Maria della Carità." In *Art the Ape of Nature: Studies in Honor of H. W. Janson*, 171–92. New York, 1981.

———. *Antonio Rizzo: Sculptor and Architect*. Princeton, N.J., 1983.

Schuyler, J. *Florentine Busts: Sculpted Portraiture in the Fifteenth Century*. New York and London, 1976.

Sciolla, G. C. "Profilo di Andrea Bregno," *Arte Lombarda* 15, no. 1 (1970): 52–58.

———. *La scultura di Mino da Fiesole*. Turin, 1970.

Scrinzi, A. "Bartolomeo Bellano," *L'Arte* 29 (1926): 248–60.

Semper, H. "Die Vorläufer Donatellos," *Jahrbücher für Kunstwissenschaft* 3 (1870): 1–69.

———. *Donatello: Seine Zeit und Schule*. Vienna, 1875. Reprint. Osnabrück, 1970.

———. *Donatello's Leben und Werke*. Innsbruck, 1887.

Semrau, M. Review of *Michelozzo di Bartolommeo*, by H. Stegmann. *Repertorium für Kunstwissenschaft* 13 (1890): 193–96.

———. *Donatellos Kanzeln in S. Lorenzo: Ein Beitrag zur Geschichte der italienischen Plastik im XV. Jh.* Breslau, 1891.

———. "Donatello und der sog. Forzori-Altar." In *Kunstwissenschaftliche Beiträge August Schmarsow gewidmet*, 95–102. Leipzig, 1907.

Seymour, C., Jr. "The Younger Masters of the First Campaign of the Porta della Mandorla 1391–1397," *The Art Bulletin* 41 (1959): 1–17.

———. *Sculpture in Italy: 1400 to 1500*. The Pelican History of Art. Harmondsworth and Baltimore, 1966.

———. *Michelangelo's David: A Search for Identity*. Pittsburgh, 1967.

———. "'Fatto di sua mano': Another Look at the Fonte Gaia Drawing Fragments in London and New York." In *Festschrift Ulrich Middeldorf*, 93–105. Berlin, 1968.

———. "Some Aspects of Donatello's Methods of Figure and Space Construction: Relationships with Alberti's 'De statua' and 'Della pittura'," In *Donatello e il suo tempo*, 195–206. Florence, 1968.

———. *The Sculpture of Verrocchio*. Greenwich, Conn., 1971.

———. *Jacopo della Quercia Sculptor*. New Haven and London, 1973.

———. "Some Reflections on Filarete's Use of Antique Visual Sources," *Arte Lombarda* 18, no. 38/39 (1973): 36–47.

Shearman, J. "A Suggestion for the Early Style of Verrocchio," *The Burlington Magazine* 109 (1967): 121–27.

Siebenhüner, H. "Der hl. Georg des Donatello," *Kunstchronik* 7 (1954): 266–68.

Silvan, P. "Il ciborio di Sisto IV nell'antica basilica di San Pietro in Vaticano: ipotesi per una ideale ricomposizione," *Bollettino d'Arte* 69, no. 26 (1984): 87–98.

Simon, E. "Der sogenannte Atys-Amorino des Donatello." In *Donatello e il suo tempo*, 331–51. Florence, 1968.

Spencer, J. R. "Two Bronzes by Filarete," *The Burlington Magazine* 100 (1958): 392–95.

———. "Francesco Sforza and Desiderio da Settignano: Two New Documents," *Arte Lombarda* 13, no. 1 (1968): 131–33.

———. "Sources of Leonardo da Vinci's Sforza Monument." In *Évolution générale et développements régionaux en histoire de l'art: Actes du XXIIe Congrès international d'histoire de l'art 1969*, 735–42. Budapest, 1972.

———. "Il progetto per il Cavallo di bronzo per Francesco Sforza," *Arte Lombarda* 18, no. 38/39 (1973): 23–35.

———. "Filarete's Bronze Doors at St. Peter's: A Cooperative Project with Complications of Chronology and Technique." In *Collaboration in Italian Renaissance Art*, 33–57. New Haven and London, 1978.

———. "Filarete, the Medallist of the Roman Emperors," *The Art Bulletin* 61 (1979): 550–61.

Spina Barelli, E. "Note iconografiche in margine al Davide in bronzo di Donatello," *Italian Studies* 29 (1974): 28–44.

Stefanac, S. "Una proposta per Agostino di Duccio a Venezia," *Antichità Viva* 29, no. 4 (1990): 31–38.

Stegmann, C. von, and H. von Geymüller. *Die Architektur der Renaissance in Toscana*. 11 vols. Munich, 1885–1909.

Stegmann, H. "Michelozzo di Bartolommeo." Ph.D. diss., Munich, 1888.

Steinmann, E. "Andrea Bregnos Thätigkeit in Rom," *Jahrbuch der Preussischen Kunstsammlungen* 20 (1899): 216–32.

Stites, R. S. "Leonardo scultore e il busto di Giuliano de' Medici del Verrocchio," *Critica d'Arte* 10, no. 57/58 (1963): 1–32, and no. 59/60 (1963): 25–38.

———. "Un cavallo di bronzo di Leonardo da Vinci," *Critica d'Arte* 17, no. 110 (1970): 13–34.

Strinati, C. "La scultura." In *Umanesimo e Primo Rinascimento in S. Maria del Popolo. Il Quattrocento a Roma e nel Lazio*, no. 1, 29–51. Rome, 1981.

Strom, D. "A New Chronology for Donatello's Wooden Sculpture," *Pantheon* 38 (1980): 239–48.

———. *Studies in Quattrocento Tuscan Wooden Sculpture*. Ann Arbor and London, 1981.

———. "Desiderio and the Madonna Relief in Quattrocento Florence," *Pantheon* 40 (1982): 130–35.

———. "A New Look at the Mellon Christ Child in the National Gallery of Art," *Antichità Viva* 22, no. 3 (1983): 9–12.

———. "A New Identity for the Dudley Madonna and Child in the Victoria & Albert Museum," *Antichità Viva* 23, no. 4/5 (1984): 37–41.

Studniczka, F. "Niccolò da Uzzano?" In *Festschrift Heinrich Wölfflin*, 135–53. Munich, 1924.

Szabo, G. "Notes on XV Century Italian Drawings of Equestrian Figures: Giambono, Pollaiuolo, and the Horses of San Marco," *Drawing* 3, no. 2 (1981): 34–37.

Tanfani Centofanti, L. *Donatello in Pisa*. Pisa, 1887.

Tessari, A. S. "Benedetto da Maiano tra il 1490 e il 1497," *Critica d'Arte* 21, no. 143 (1975): 39–52, and 22, no. 145 (1976): 20–30.

Tigler, P. *Die Architekturtheorie des Filarete*. Berlin, 1963.

Toesca, P. "On Niccolò dell'Arca," *The Art Quarterly* 19 (1956): 271–77.

Toledano, R. *Francesco di Giorgio Martini pittore e scultore*. Milan, 1987.

Trenta, T. "Memorie intorna alla famiglia dei Civitali." In *Memorie e documenti per servire all'istoria del ducato di Lucca*, vol. 8, 53–73. Lucca, 1822.

Trudzinski, M. *Beobachtungen zu Donatellos Antikenrezeption*. Berlin, 1986.

Tschudi, H. von. "Giovanni Dalmata," *Jahrbuch der Preussischen Kunstsammlungen* 4 (1883): 169–90.

———. "Filarete's Mitarbeiter an den Bronzetüren von St. Peter," *Repertorium für Kunstwissenschaft* 7 (1884): 291–94.

———. *Donatello e la critica moderna*. Turin, 1887.

Vaccarino, P. *Nanni*. Florence, [1950].

Valentiner, W. R. "Donatello and Ghiberti," *The Art Quarterly* 3 (1940): 182–215. (Also in W. R. Valentiner, *Studies of Italian Renaissance Sculpture*, 44–69. London, 1950.)

———. "Laurana's Portrait Busts of Women," *The Art Quarterly* 5 (1942): 273–98.

———. "Mino da Fiesole," *The Art Quarterly* 7 (1944): 151–80. (Expanded in W. R. Valentiner, *Studies of Italian Renaissance Sculpture*, 70–96. London, 1950.)

———. "Donatello or Nanni di Banco," *La Critica d'Arte* 8 (1949): 25–31.

———. "Rediscovered Works by Andrea del Verrocchio." In W. R. Valentiner, *Studies of Italian Renaissance Sculpture*, 97–112. London, 1950.

———. *Studies of Italian Renaissance Sculpture*. London, 1950.

———. "Towards a Chronology of Donatello's Early Works." In *Festschrift Friedrich Winkler*, 71–83. Berlin, 1959.

Valtieri, S. "La fabbrica del Palazzo del Cardinale Raffaele Riario (La Cancelleria)," *Quaderni dell'Istituto di Storia dell'Architettura* (Rome) 169/174 (1982): 3–25.

Vasari, G. *Le vite de' più eccellenti architetti, pittori et scultori italiani*. [Florence, 1550]. Edited by L. Bellosi and A. Rossi. Turin, 1986.

———. *Le vite de' piu eccellenti pittori scultori ed architettori*. 2nd ed. [1568]. Edited by G. Milanesi. 9 vols. Florence, 1878–85.

Venturi, A. "Di un insigne Artista modenese del secolo XV," *Archivio Storico Italiano* 14 (1884): 339–66.

———. *Storia dell'arte italiana*. Vol. 6: *La scultura del Quattrocento*. Milan, 1908.

Verdon, T. *The Art of Guido Mazzoni*. New York and London, 1978.

———. "Donatello and the Theater: Stage Space and Projected Space in the San Lorenzo Pulpits," *Artibus et Historiae* 7, no. 2 (1986): 29–55.

Vespasiano da Bisticci. *Vite di uomini illustri del secolo XV*. [c. 1485]. Edited by P. D'Ancona and E. Aeschlimann. Milan, 1951.

Vigni, G. *Lorenzo di Pietro detto il Vecchietta*. Florence, 1937.

Vöge, W. *Raffael und Donatello: Ein Beitrag zur Entwicklungsgeschichte der italienischen Kunst*. Strassburg, 1896.

———. "Donatello greift ein reimsisches Motiv auf." In *Festschrift für Hans Jantzen*, 117–27. Berlin, 1951.

Wackernagel, M. *Der Lebensraum des Künstlers in der florentinischen Renaissance: Aufgaben und Auftraggeber, Werkstatt und Kunstmarkt*. Leipzig, 1938.

Warburg, A. M. *Ausgewählte Schriften und Würdigungen*. Edited by D. Wuttke. 2nd ed. Baden-Baden, 1980.

Weinberger, M., and U. Middeldorf. "Unbeachtete Werke der Brüder Rossellino," *Münchner Jahrbuch der Bildenden Kunst* 5 (1928): 85–100. (Also in U. Middeldorf, *Raccolta di scritti*, vol. 1, 55–68. Florence, 1979–80.)

Weise, G. "Donatello und das Problem der Spätgotik," *Zeitschrift für Kunstgeschichte* 17 (1954): 79–88.

Weller, A. S. *Francesco di Giorgio 1439–1501*. Chicago, 1943.

Wester, U., and E. Simon. "Die Reliefmedaillons im Hofe des Palazzo Medici zu Florenz," *Jahrbuch der Berliner Museen* 7 (1965): 15–91.

White, J. "Donatello's High Altar in the Santo at Padua," *The Art Bulletin* 51 (1969): 1–14 and 119–41.

———. "Donatello." In *Le sculture del Santo di Padova*. Fonti e Studi per la storia del Santo a Padova, 4, edited by G. Lorenzoni, 31–94. Vicenza, 1984.

———. *The Birth and Rebirth of Pictorial Space*. 3rd ed. London and Boston, 1987.

Wickhoff, F. "Die Antike im Bildungsgange Michelangelo's," *Mitteilungen des Instituts für Österreichische Geschichtsforschung* 3 (1882): 408–35.

Wilkins, D. G. "Donatello's Lost *Dovizia* for the Mercato Vecchio: Wealth and Charity as Florentine Civic Virtues," *The Art Bulletin* 65 (1983): 401–23.

Wind, E. "Donatello's Judith: A Symbol of 'Sanctimonia'," *Journal of the Warburg and Courtauld Institutes* 1 (1937/38): 62–63.

Wittkower, R. "A Symbol of Platonic Love in a Portrait Bust by Donatello," *Journal of the Warburg and Courtauld Institutes* 1 (1937/38): 260–61.

———. "Desiderio da Settignano's 'St. Jerome in the Desert'," *Studies in the History of Art* (1971–72): 7–37. (Also in R. Wittkower, *Idea and Image*, 137–49. [London], 1978.)

Wixom, W. D. "A Wax Bozzetto Close to Leonardo da Vinci," *The Bulletin of the Cleveland Museum of Art* 58 (1971): 115–22.

Wolff, F. *Michelozzo di Bartolommeo: Ein Beitrag zur Geschichte der Architektur und Plastik im Quattrocento*. Strassburg, 1900.

Wolters, W. "Freilegung der Signatur an Donatellos Johannesstatue in S. Maria dei Frari," *Kunstchronik* 27 (1974): 83.

Wulff, O. "Giovanni d'Antonio di Banco und die Anfänge der Renaissanceplastik in Florenz: Zur Davidstatue des Kaiser-Friedrich-Museums," *Jahrbuch der Preussischen Kunstsammlungen* 34 (1913): 99–164.

Wundram, M. "Die künstlerische Entwicklung im Reliefstil Lorenzo Ghibertis." Ph.D. diss., Göttingen, 1952.

————. "Donatello und Ciuffagni," *Zeitschrift für Kunstgeschichte* 22 (1959): 85–101.

————. "Albizzo di Piero: Studien zur Bauplastik von Or San Michele in Florenz." In *Das Werk des Künstlers: Hubert Schrade zum 60. Geburtstag*, 161–76. Stuttgart, 1960.

————. "Der Meister der Verkündigung in der Domopera zu Florenz." In *Beiträge zur Kunstgeschichte: Eine Festgabe für H. R. Rosemann zum 9. Oktober 1960*, 109–25. Munich and Berlin, 1960.

————. "Niccolò di Pietro Lamberti und die Florentiner Plastik um 1400," *Jahrbuch der Berliner Museen* 4 (1962): 78–115.

————. *Lorenzo Ghiberti: Paradiestür*. Stuttgart, 1963.

————. "Jacopo della Quercia und das Relief der Gürtelspende über der Porta della Mandorla," *Zeitschrift für Kunstgeschichte* 28 (1965): 121–39.

————. *Donatello: Der heilige Georg*. Stuttgart, 1967.

————. "Donatello e Nanni di Banco negli anni 1408–1409." In *Donatello e il suo tempo*, 69–75. Florence, 1968.

————. *Donatello und Nanni di Banco*. Berlin, 1969.

Yriarte, C. *Rimini: Un condottiere au XVe siècle*. Paris, 1882.

————. *Matteo Civitali: Sa vie et son oeuvre*. Paris, 1886.

Zander, G. "La possibile ricomposizione del monumento sepolcrale di Paolo II," *Rendiconti della Pontificia Accademia Romana di Archeologia* 55/56 (1982–84): 175–243.

Zervas, D. F. "Ghiberti's *St. Matthew* Ensemble at Orsanmichele: Symbolism in Proportion," *The Art Bulletin* 58 (1976): 36–44, and 59 (1977): 657–58.

Zorzi, G. "Architetti e scultori dei laghi di Lugano e di Como a Vicenza nel secolo XV." In *Arte e artisti dei laghi lombardi*, edited by E. Arslan, vol. 1, 343–61 and 366. Como, 1959–64.

Addenda

Adorno, P. *Il Verrocchio: Nuove proposte nella civiltà artistica del tempo di Lorenzo il Magnifico*. Florence, 1991.

Agghàzy, M. G. *Leonardo's Equestrian Statuette*. Budapest, 1989.

Avery, C. *Donatello: Catalogo completo delle opera*. I gigli dell'arte, no. 22. Florence, 1991.

Beck, J. *Jacopo della Quercia*. 2 vols. New York, 1991.

Butterfield, A. "Verrocchio's Christ and St. Thomas: Chronology, Iconography and Political Context," *The Burlington Magazine* 134 (1992): 225–33.

Cuccini, G. *Agostino di Duccio: Itinerari di un esilio*. Perugia, 1990.

Donatello 1386–1466: 1986—Celebrazioni nel VI centenario della nascita. Accademia di Studi Italo-Tedeschi (Studi italo-tedeschi, no. 10). Merano, 1988.

Draper, J. D. *Bertoldo di Giovanni, Sculptor of the Medici Household: Critical Reappraisal and Catalogue Raisonné*. Columbia, Mo., 1992.

Patera, B. "Francesco Laurana e la cultura lauranesca in Sicilia." In *I Congresso Nazionale di Storia dell'Arte 1978*, 211–30. Rome, 1980.

Rosenauer, A. "Donatellos römische Grabmäler." In *Skulptur und Grabmal des Spätmittelalters in Rom und Italien, Akten des Kongresses "Scultura e monumento sepolcrale del tardo medioevo a Roma e in Italia*," edited by J. Garms and A. M. Romanini, 423–30. Vienna, 1990.

Schofield, R. V., et al., eds. *Giovanni Antonio Amadeo: Documents/ I documenti*. Como, 1989.

Seidel, M. "Studien zur Skulptur der Frührenaissance: Francesco di Giorgio, Giovanni Antonio Amadeo," *Pantheon* 49 (1991): 55–73.

Verdon, T. "Guido Mazzoni in Francia: nuovi contributi," *Mitteilungen des Kunsthistorischen Institutes in Florenz* 34 (1990): 139–64.

Verrocchio and Late Quattrocento Italian Sculpture. Brigham Young University and the Harvard University Center for Italian Renaissance Studies at Villa I Tatti, Series Bibliotheca. Edited by S. Bule et al. Florence, 1992.

Wilk, S. B. *Fifteenth-Century Italian Sculpture: An Annotated Bibliography*. Boston, 1986.

Photograph Credits